Feminist Futures of Spatial Practice:
Materialisms, Activisms, Dialogues, Pedagogies, Projections

FEMINIST FUTURES OF SPATIAL PRACTICE

MATERIALISMS
ACTIVISMS
DIALOGUES
PEDAGOGIES
PROJECTIONS

Feminist Futures of Spatial Practice:
Materialisms, Activisms, Dialogues, Pedagogies, Projections

Edited by Meike Schalk, Thérèse Kristiansson, Ramia Mazé

Published in 2017 by AADR – Art Architecture Design Research,
an imprint of Spurbuchverlag
1. print run 2017
Am Eichenhügel 4, 96148 Baunach, Germany
www.aadr.info / www.spurbuch.de.

ISBN 978-3-88778-489-8

The Deutsche Nationalbibliothek lists this publication in the
Deutsche Nationalbibliografie.
www.dnb.de

Layout and Graphic Design: Maryam Fanni, Stockholm
Typeset in Lipstick by Kerstin Hanson and Myriad

Printed in the European Union

Published with support by the Strong Research Environment
'Architecture in Effect' (Swedish Research Council Formas).
architectureineffect.se

CONTENTS

ACKNOW-
LEDGEMENTS

This book has been completed with the generous support of *Architecture in Effect: Rethinking the Social*, a Strong Research Environment (SRE) funded by the Swedish Research Council Formas, located at the KTH School of Architecture in Stockholm, Sweden. *Architecture in Effect* granted research time for preparing this book and for printing. We also thank Ivar och Anders Tengboms fond for funding five roundtable conversations, which were held during the writing and development process with invited peer reviewers. We are grateful to our peer-reviewers Nora Räthzel, Nel Janssens, Nina Lykke, Irene Molina and Despina Stratigakos, who came from near and far to respond to our work-in-progress with invaluable comments and important suggestions.

We also thank *W.I.S.P. - Women in Swedish Performing arts* for collaborating with and hosting us and the course 'Feminist Futures' at their beautiful venue during autumn 2011. We thank the students of 'Feminist Futures', the themed course of Introduction to Architecture and Gender taught by the Critical Studies at the KTH School of Architecture through Thérèse Kristiansson and Meike Schalk. Some of the attending students have contributed to this book, including Jenny Andreasson, Sara Brolund de Carvalho, Ragnhild Claesson, Anja Linna and Josefin Wangel.

The Individual lectures and workshops of the course, which were open to the public, were made possible due to generous support from the Stockholm Architects Association (for Despina Stratigakos' participation), IASPIS The Swedish Arts Grants Committee (for Doina Petrescu and Ruth Morrow), the Goethe Institute (for Yvonne P. Doderer) and the KTH Erasmus teacher's exchange (for Kim Trogal and Nishat Awan). Other events hosted contributing participants, including the AHRA conference preparatory meeting (Liza Fior, Elke Krasny and Jane da Mosto) and Critical Projections Workshop (Sophie Handler), both funded through *Architecture in Effect*. We would also like to thank The Swedish Centre for Architecture and Design ArkDes for kindly opening their facilities for a number of our meetings.

We thank the lecture and workshop leaders of the course: Karin Bradley and Ulrika Gunnarsson-Östling, Yvonne P. Doderer, FATALE (Katarina Bonnevier, Brady Burroughs, Katja Grillner,

Meike Schalk), Ramia Mazé and Josefin Wangel, *MFK – Malmö Fria Kvinnouniversitetet* (Malmö Free University of Women) (Johanna Gustavsson and Lisa Nyberg), Ruth Morrow, Annika O Bergström, The New Beauty Council (Annika Enqvist, Thérèse Kristiansson and Kristoffer Svenberg) and Christina Zetterlund, many of whom have contributed to this book. Special thanks goes to Ulrika Gunnarsson-Östling, who was part of conceptualizing the different theme sections in an early phase of this book.

We thank our copy-editors Hedvig Marano, Linda MacAllister and Evan Reed for their careful work. We owe great thanks to our fabulous graphic designer Maryam Fanni, who participated in several roundtable conversations and has accompanied this project from the start. We thank our publisher AADR – Art Architecture Design Research at Spurbuch, and its curatorial editor Rochus Hinkel for his patience. Last, but not least, we want to thank our companion Stig for lightening up our Northern working sessions.

INTRODUCTION: ANTICIPATING FEMINIST FUTURES OF SPATIAL PRACTICE

MEIKE SCHALK,
RAMIA MAZÉ,
THÉRÈSE KRISTIANSSON
AND MARYAM FANNI

Within a rapidly changing and diversifying world, many institutions and professions – indeed, many of us – are rethinking the values enacted through our practices. Can we act, each of us, from within our everyday practices, as part of larger socio-political entities, in the here and now, and affect the future? Understanding such entities and futures to be constructed, the authors of this book are committed to their construction in particular terms. Arguing that feminism continues to be one of the most powerful movements for social justice, bell hooks, activist and educator, posits feminism as a broad vision for the rights of *all* bodies, identities, voices and viewpoints. She articulates: "Feminist movement happens when groups of people come together with an organized strategy to take action to eliminate patriarchy" (hooks 2000, xi). She traces a long history of feminist movement and its effects: from struggles such as 'black liberation' and 'women's liberation', to an evolving feminist legacy established through activism and scholarship, which uncovered suppressed voices and histories, and, finally, to contemporary feminist theory, which engages with critical theories to explore differences and to empower the construction of more just futures.

Architecture, the arts, and other spatial practices have never been neutral in social struggles. Even when architecture is formulated as a 'service profession' to clients, it takes part in the reproduction of values. Thus, the most trivial act of reproduction opens up the possibility either for conforming and affirming existing values, or for divergence, transformation and change. These possibilities give rise to the futurity inherent in architecture – as philosopher Elizabeth Grosz elaborates, "The future is that openness of becoming that enables divergences from what exists." (2001, 142)

Indeed, architecture and the arts have long been on the forefront of socio-spatial struggles, in which equal access to spaces and resources, representation and expression are at stake in our cities, communities and everyday lives. In this book, *Feminist Futures of Spatial Practice*, examples of such struggles in the public realm include: the R-Urban resilient bottom-up strategy in France by atelier d'architecture autogérée (Doina Petrescu); gender dimensions of large-scale resistance to urban development projects

such as *Stuttgart 21* in Germany (Yvonne P. Doderer); and understandings of different groups in society through historical, *feminine* social movements (Elke Krasny and Meike Schalk). Examples of struggles for spatial representation are expressed in: diasporic maps of Kurdish immigrants in London (Nishat Awan); conflicting identities and priorities in notions of 'cultural heritage' within an increasingly diverse Swedish society (Ragnhild Claesson); contested urban aesthetics as in the graffiti debate in Stockholm (Macarena Dusant in conversation with The New Beauty Council); struggles for access to civic spaces in Swedish suburbs (Sara Brolund de Carvalho and Anja Linna); and the invisibility and marginalization of 'older people' in the discourse around aging as well as in the public realm (Sophie Handler).

Attentive to the spatiality of social struggles, this book can be understood within a critical feminist tradition examining how power, in the form of political hegemonies and social injustice has been resisted and reconstructed through spatial practice. *Feminist Futures of Spatial Practice* wants to contribute to developing new forms of activism, expanding dialogues, engaging materialisms, transforming pedagogies, and projecting alternatives. Contributing authors trace experiences and examples, theoretical dimensions and practical tools. We enquire generally and collectively: What knowledges and imaginaries are necessary for engendering social change? How do we develop and mediate these to create more gender sensitive, just and environments? What are implications for what we learn and teach in architecture and academia, what roles can education have in questions of difference and equality? How can we direct our future spatial practices to meet challenges posed by climate change, economic crises and uneven global development? Such questions require rethinking our basic assumptions and concepts as well as our practical skills and projects. We do not want to defer this necessary task to an indefinite future nor to sit back and 'wait for the revolution'. We are concerned with exploring and shaping feminist futures in the here and now. Contributions in the book query the presence, temporalities, emergence, histories, events, durations – and futures – of feminist spatial practices. 40 established and emerging voices have contributed here, writing critically from within

their institutions, professions, and their activist, political and personal practices.

This book is the culmination of a much longer process set into motion in 2011. At that time, a course themed 'Feminist Futures' was organized in Stockholm, Sweden, by the Critical Studies unit at the Royal Institute of Technology (KTH) School of Architecture in collaboration with the organization *Women in Swedish Performing Arts* and the art project *The New Beauty Council*. Organized as a series of lectures and workshops for students and the public, the course became a platform for interaction among our local network and international contributors from architecture, the arts and other fields. We made connections across disciplines and, significantly, we wanted to respond constructively to the lack of more hands-on methods and tools concerning critical feminist practices. We focused on moving together beyond analysis and theorizing, and the series was particularly effective in the mix of practical concrete examples with theories, references and methods, all directed at working, teaching, drawing, organizing and designing for feminist futures. In the course, we treated *futures* as times and places of radical openness, in which different norms, structures, rules and cultures may emerge, an opening for playful experimentation, utopic possibilities, a stage for testing various feminist scenarios and subject positions. This prompted a process for developing this book, in which we articulate different and common perspectives. *Feminist Futures of Spatial Practice* materializes our discourses, practical examples, methods and tools in a form that we hope can be even more widely accessed, spread and further developed.

Feminist spatial practice

'Spatial practice' is a broad term for architectural, artistic, design and other disciplinary and inter-disciplinary practices engaged in studying and transforming space. As argued by the writer and architectural theorist Jane Rendell, contemporary challenges of urbanization have necessitated an emerging discourse across geography, anthropology, cultural studies, history, art and architecture. Synergies among disciplines have generated knowledge relevant far beyond the urban, a terrain

of spatial theory that reformulates the ways in which space can be understood. Our concept of feminist spatial practice builds on Rendell's notion of 'critical spatial practice' (2006, 2011). She clarifies the *critical* dimension: "Projects that put forward questions as the central tenet of the research, instead of, or as well as solving or resolving problems, tend to produce objects that critically rethink the parameters of the problem itself" (2004, 145). She also articulates the need not only for spatial theory or critical thinking in general, but for critical spatial *practice*. The urgent challenges of our time such as peak oil, global food crises, climate change, and political conflict require understanding and awareness, but also action and resistance to "the dominant social order of global corporate capitalism". Critical spatial practice, responds to these by involving creativity and social critique, which occur in the form of "everyday activities and creative practices" (Rendell 2011, 24).

Feminist spatial practice further extends critical spatial practice. Rendell identifies five prevalent themes – collectivity, interiority, alterity, materiality, and performativity – that "start to hint at the subject matters that resonate with feminists as well as modes of operation that feature strongly in a predominantly feminist mode of critical spatial practice" (2011, 24). While critical spatial theory may generally examine how a particular social-spatial order is constructed, and critical spatial practice may work to destabilize that order, feminist spatial practice questions and opposes, but it also projects, activates, and enacts alternative norms or ideals – for example as 'embodied utopias' (Grosz 2001), and through 'practicing otherwise' (Petrescu, 2007). Transgressing the boundaries of disciplines as well as theory and practice, feminist spatial practice develops new terms of engagement, including tactics and ethics of practice. Learning from the geographers J.K. Gibson-Graham (2008), we see feminist spatial practice as developing different terms upon which everyday life and all social relations of society can be organized, premised on alternative experiences, worldviews and subjectivities. They are, thus, practices of ontological reframing, re-viewing (or re-doing) differently, and cultivating forms of creativity that emerge from an experimental,

performative and ethical orientation to the world. Feminist spatial practice, as an ontological project, reconstructs both our present practices and, even more radically, our desired futures.

Feminist Futures of Spatial Practice explores feminist and intersectional modalities and implications of spatial practice both through methods widely recognized in an academic context, such as action research, backcasting in futures studies, historiography and discourse analysis, and an expanding range of emerging methods. Examples include: silent protest, sharing-counteracting-connecting, commoning, navigating through intersectionality, carnivalesque intervention, re-doing heritage, urban caring, instructing conversation, rehearsals, writing around the kitchen table, making time, mapping otherwise, making hard things soft, acting out, flirting, transversal pedagogy, mimicking, producing spaces of feminist anticipation, rewriting a city vision, urban curating, introducing counter-narratives, critical fictions, ludic resistance, foregrounding new and old radicalisms, decolonizing thought, constructing alternate futures and exploring non-representational modes for architecture production. Through such hands-on tactics, strategies, techniques and methodologies, exploration here takes place in situated, generative and reflective forms, as practices through which futures are explored in their emergence. Within the chapters, furthermore, some contributors experiment with writing methods such as dialog, critical fiction and architecture-writing (MYCKET; Macarena Dusant; Hélène Frichot, Katja Grillner and Julieanna Preston; and Sophie Handler).

Femininisms and futures

Feminism offers optimistic outlooks on the future; every feminist politics believes that things can be otherwise and that they can be changed (Söderbäck, 2012). There are, nonetheless, many varieties of feminism, or feminisms, and notions about what feminism contributes to the future and how such a future could be produced. bell hooks' *Visionary Feminism* (2000, x-xv) points to three fundamental components for achieving social change: feminist theory, environments for intellectual exchange, and feminist pedagogy. Feminist theory involves critical interrogation crucial for developing, as hooks puts it, 'a revolutionary blueprint for the movement' to act. The revolutionary force of visionary feminist theory is to "challenge, shake us up, provoke, shift our paradigms, change the way we think, turn us around" (hooks 2000, xiv-xv). She also argues for the collective production of common environments where sustained dialectal critique and exchange can take place. Most of all, she regards feminist pedagogy as providing the possibility for everyone to take part in the movement, for everyone to develop critical consciousness. Together – though each from her own perspective – we might find a common language to spread the word.

Besides environments and access to theory and education, architects and spatial practitioners need to develop other notions of time in order to construct a better future, argues philosopher Elizabeth Grosz (2001). Instead of regarding time as planned development, in which the future is fundamentally the same as the past, she directs our attention to a notion of time as 'becoming', connected to lived experience and bodies. Motivating her term 'embodied utopias', she critiques utopian visions as idealizations of the future in which the body is an object of utopic, political, and temporal speculation, even as embodiment is not granted a place in the future. The notion of embodied utopias is a productive paradox that functions to critically rethink exclusionary politics, discrimination and racism. It combines the projection of utopia – which is both nowhere, at no time, and anywhere at any time – with the recognition of duration and transforming, matter and bodies, of sexual, racial and other spe-

cificities, the "differential values of its subjects" and their utopic visions (2001, 143). Embodied utopias evoke critical consciousness of multiple visions, which claim space and time, and imply that all must take part in shaping a common future.

Temporality is also reconsidered by the philosopher Fanny Söderbäck in her notion of 'revolutionary time' (2012). Revolutionary time is an alternative temporal model that rejects patriarchal conceptions of time, for example in distinctions made within philosophy between linear and cyclical notions of time that reflect (gendered) divisions of labour. Linear notions, premised on linear-progressive development, aim toward an idealized (timeless) future, whereas cyclical notions repeat the past and are often associated with qualities of nature, immanence and femininity. 'Revolutionary time' seeks to move beyond such binary divisions. Modelled on the perpetual return, critical interrogation of the past and change through displacement, 'revolutionary time' also includes aspects of embodiment repressed in the linear-cyclical paradigm. As in Grosz's critique of utopia, Söderbäck recognizes embodiment as the foundation for a politics of change and futurity that evades a pre-defined future that leaves too little space for difference and diversity.

The notion of embodied utopias is also relevant to philosopher Luce Irigaray's claim ([1984] 1993) that gender or sexual difference is the locus from which all difference can be understood. Grosz reminds us that sexual difference "entails the existence of *at least two* points of view, sets of interests, perspectives, two types of ideal, two modes of knowledge". Sexual difference is thus not (or at least not exclusively) a biological distinction, but a philosophical and political claim – indeed, in very practical terms, it is "one of the present's ways of conceptualizing its current problems" in a diversifying world, when the work of "producing alternative knowledges, methods, and criteria has yet to begin" (2001, 147).

These concepts have gained fresh relevance during this time of rising nationalist, sexist and racist tendencies in Europe, the US and around the world. Many Western countries have become destinations for those fleeing warzones and the effects of climate

change and poverty, for those seeking a different and better future. Visions offered by nationalist and racist politics speak about a return to an idealized past (Söderbäck) and the project of an idealized future (Grosz), in which both past and future typically presume particular bodies and gendered divisions. In these difficult times, feminisms offer a varied and expanding range of approaches that question the status quo and the past, present and future dominance of particular hegemonies. Feminist futures, thus, articulate alternative ways of being (subjectivities) and a diversity of ways for organizing our societies (collectivities).

Precedents, peers and beginnings

Several landmark works concerning feminist spatial practice have been crucial leading up to this book. Among the most important precedents and a great source of inspiration here is *Gender Space Architecture: An Interdisciplinary Introduction*, edited by Jane Rendell, Barbara Penner and Iain Borden (1999). An indispensable and comprehensive reader in our teaching and research, it brings together key contemporary texts both from within and outside of architecture. Another invaluable source for us, our students and other spatial practitioners is *Altering Practices: Politics and Poetics of Space*, edited by Doina Petrescu (2007). The anthology can be understood as an attempt to map "a particular located and materialized transformation of the contemporary project in architecture" (Petrescu 2007, 3). The work focuses on the transformative power of practicing "otherhow", for example through "feminist (collective) reconstructions", producing space by teaching, writing, building, etc., according to 'altered' rules, "enabling new coalitions between different intellectual, aesthetic and political positions" and "subverting the critical divisions between thinking and doing" (Petrescu 2007, 5). A more recent anthology is *Feminist Practices: Interdisciplinary Approaches to Women in Architecture* edited by Lori A. Brown (2011), which evolved from a travelling exhibition through the United States and Australia. "Design through feminist critiques questions whose voice the designer ultimately represents, whose vision is being created, and what the products need to be",

Brown argues (2011, 4). These works have influenced our thoughts in conceiving and realizing this book and our editorial criteria.

The process culminating in this book was set into motion during the 'Feminist Futures' course in 2011. The course was composed as a teaching and workshop series, part of the 'Introduction to Architecture and Gender' module that has been offered since 2008 by the Critical Studies unit of KTH School of Architecture in Stockholm.[1] Open to students of all levels and subjects from architecture and other departments and universities, the course has been particularly unique in additionally welcoming those from outside academia, such as professionals interested in further education. All sessions were open to the public. The course therefore addressed a diverse group, from many generations (from those in their twenties to those in their seventies), and from many disciplines including art, architecture and planning, the social and political sciences, as well as the humanities, technical and design disciplines.

2011 was the first time we offered the course with a theme 'Feminist Futures', and we relocated to a place outside the university, the premises of *Women in Swedish Performing Arts*. The series consisted of ten sessions, one afternoon per week, each with a lecture and workshop. A tea break in between was a recurrent ritual, a moment of refreshment, pause and mingling. Learning, teaching and sharing were supported by a blog, through which readings, images, reflections, assignments, information and discussions could be shared internally. The workshops were an important pedagogical foundation, enabling experiential and embodied engagement with the lecture content. Workshops included various making activities, for example, collages, drawings, models, doing crafts, explicitly full-bodied as well as reflective activities, such as writing individually and together, and performances of various kinds. During the course, these experiences of 'learning through doing', or practicing 'otherhow', became increasingly important. The training workshop for utopia by the feminist art project MFK (Malmö Free University for Women), for example, included the writing of a manifesto and delivering a speech. Through such activities, we found diverse ways of learning and expressing through our own experiences as well as

for discussing and collaborating with others.

As the course concluded, our sense of urgency to further develop our common ground into a book took a new form. Five 'roundtable' sessions were organized between May and August 2014 by two of us, Meike and Thérèse. Some roundtables took place at the Swedish Centre for Architecture and Design (Ark-Des), some at a local studio, and one at the Institute for Housing and Urban Research in Uppsala invited by Irene Molina. Contributors to the course in 2011 and previous years were asked to develop texts and projects for this book. Roundtables took the form of intimate conversations of texts circulated in advance, closely read and carefully commented by participants and a designated 'peer reviewer'. Peer review fulfils the quality demands of the academic system in which many of us work. More importantly here, we developed peer review for our own purposes to support feminist forms of dialogue and pedagogy, including peer-learning and, to borrow the notion from Doina Petrescu (2007), 'feminist collective reconstructions'. Instead of the 'blind' peer review and judgement in academic journals, we developed a review process through 'the pleasure of 'conversation' (see Nel Janssens, prologue for 'Dialogues') across disciplines. We invited a peer-reviewer for each roundtable, who sought out and articulated the common issues as well as the significant contributions of each text, and all participants acted as peer-to-peer reviewers to one another.

This book, itself conceived as a form of feminist practice, has particular qualities and offers specific opportunities. As a culmination of an intensive collaborative work process and social platform, it is a materialization both of individual positions and of collective discourse. We see the production of this book as a pedagogical queering-tool for spatial practice and education – meaning bringing in gender not only as an analytical perspective, but also for transforming our personal practices and by that to produce 'other worlds' (Mouffe, 2007, Petrescu, 2007, Gibson-Graham, 2008).

Voices and contents

Feminist Futures of Spatial Practice is structured through five themes: Materialisms, Activisms,

Dialogues, Pedagogies and Projections. Collecting and connecting the chapters, each theme section is introduced with a prologue by a peer reviewer from the roundtables. During and since the roundtable sessions, the themes continued to develop and the structure of this book has altered over time. This learning-through-doing has produced some important openings. For example, Despina Stratigakos, reviewer from the last roundtable, originally wrote a prologue that has turned, instead, into an epilogue for this book. The epilogue is written from the perspective of her historical work *A Women's Berlin* (2008) and looks forward through a view to the past. It concludes our work, returning at the end of the book to ideas of the beginning and thus acknowledges the process in full circle.

Materialisms

In her prologue to 'Materialisms',[2] **Nina Lykke** reminds us that discourse and matter are intertwined. Connecting feminist materialist, queer and decolonizing perspectives, she frames the contributing chapters in this section as materially concrete, but also open-ended world-making practices. As material-discursive activities they move from critical to reparative or affirmative modes, transgressing seemingly fixed boundaries and non-negotiable taxonomies. Through this frame, she highlights methodologies that are hopeful, performative, and, simultaneously, robust enough for a messy world in which other dynamics than the utopian unfold through urban planning programmes and neoliberal economies. She argues that new 'interference patterns' emerge from the transformative practices of the authors and their collaborators, patterns that allow for movements between academic and poetic genres.

Within 'Materialisms', **Nishat Awan** argues for critical practices of making maps. Mapping can open the imagination to other possible futures and, thus, mapping has both criticality and agency in thinking 'otherwise'. She takes migration and consequent diasporas as a point of departure, searching for forms of representation to adequately express the experiences of those who have journeyed across geographies and cultures. Identifying shortcomings of typical approaches to mapping, she articulates

making maps as a situated, experiential and social practice. Diverse (non-Western) representational practices are discussed through examples that open towards many possible futures. **Ragnhild Claesson** also calls for recognizing and formulating cultural heritage in terms of diversity. In her chapter, she states that some established definitions of history and heritage are patriarchal. Instead, she argues for 'glocal' constructions, in which memories, artefacts and knowledges are 'situated', embodied, collaborative, and 'throwntogether'. She elaborates through an example of collaboration with a women's association, an artist and some urban planners, a study carried out in the central and predominantly immigrant district of Rosengård in Malmö. **MYCKET**'s chapter takes the form of a conversation among the three members of the design, art, architecture practice. Inspired by Audre Lorde, bell hooks and Eve Kosofsky Sedgwick, they share experiences, insights and guidance from their practice characterized by values such as trust, the importance of relationships, different evaluations of time, risk-taking and their ethics of care. MYCKET stresses that an important task of future feminist practices must as 'reparative', be to move beyond modernist and patriarchal constraints and aesthetics. Likewise speaking about her practice, **Ruth Morrow** exemplifies and elaborates her experiences of founding, defining and managing the company *Tactility Factory* with her business partner and friend Trish Belford. Her chapter is a personal account of professional life that has wide relevance. She unfolds dilemmas and positions from within her textile, technology and architecture practice, which are further unfolded through feminist concepts and literature that ground, expand and reveal new dimensions of material practice in general.

Activisms

In her prologue to 'Activisms',[3] **Irene Molina** suggests intersectionality, as both, a theoretical approach for power analysis, as well as a methodological tool for action and activism. She urges spatial analysts, for example geographers and planners, to take into account an intersectional perspective in order to reveal, to themselves and to others, how underlying power structures of privilege and discrimination play out spatially. She also reminds feminists to investigate how spaces and power structures intersect, in order to disclose and address the dynamics of underlying spatial injustices to decision makers and to all of us.

Within 'Activisms', **Doina Petrescu** argues for reconstruction of the commons as a political project for the future through the example of her practice atelier d'architecture autogérée (aaa). She notes that the participants working with aaa for over 15 years in Paris and Colombes were, for the most part, women. Referring to Luce Irigaray and Rosi Braidotti, Petrescu argues that the development of social-spatial relations, the commons and collective subjectivity requires feminist knowledge. She explicates the shift in roles and subjectivities within aaa projects, in which participants became activists and stakeholders. This requires understanding architecture beyond buildings and physical space, as a social and political practice. **Yvonne P. Doderer** gives an account of social-spatial activism in 'Stuttgart 21', and she elaborates on gender roles in the movement, including issues of representation and power. Through her own involvement as an activist, and through interviews with women in the protests, she highlights forms of resistance beyond speech. In spite of the threat of being neither seen nor heard, she observes feminist resistance that consciously avoids the promotion of 'leaders', and instead, takes a more powerful, militant and anarchistic approach. Actions included the organization of spaces, to take care for demonstrators, the collection and spread of information, and the staging of deliberately silent protests and other performative expressions of resistance. **Macarena Dusant**'s chapter is an interview-essay exploring the motivations, logics and interventions of the art group and project **The New Beauty Council**, which is discussed in further detail in the epilogue. In their chapter, **Elke Krasny** and **Meike Schalk** give accounts of a protest, an exhibition and a strike, which demonstrate temporalities and geographies relevant to feminist practices in art and architecture. Through the historical examples, they query practices of sharing, counteracting and connecting to build 'imaginary communities', which they propose as prerequisites for the emergence of 'resilient subjects'.

Dialogues

In her prologue to 'Dialogues',[4] **Nel Janssens** suggests the notion of 'conversation' (bringing together) as an alternative to knowledge production through 'discussion' (separating). While traditional forms of academic exchange may emphasize discussion, she argues that conversation highlight different qualities such as sense-making through shared and reciprocal experiences. Conversation is syncretic, in which contradictions can be tolerated, and its non-linear evolution allows for detours, preferences, emotions. Thus, it supports ways of knowing and producing knowledge through forms of collective sense-making. Nel proposes curated conversations with help of 'instructs' as a research tool particularly appropriate for practices in the arts and the design field.

Within 'Dialogues', **Liza Fior**, **Elke Krasny** and **Jane da Mosto** share a conversation about their collaboration, in relation to a work for the Architecture Biennial in Venice. They reflect upon qualities of their conversations in terms of resistance to imposed regimes of time and critical relations between detail and strategy. Subject of the conversation is the (unsuccessful) attempt to extend muf's project for the Venice Biennial to the city of Venice and its inhabitants. In their conversation, the example relates to concurrent emergence of 'We are here Venice', an organisation developed by Jane, with input by Liza and Elke, to raise awareness of the city's environmental situation and to envision more resilient futures. The chapter by **Hélène Frichot**, **Katja Grillner** and **Julieanna Preston** brings together three voices in six acts 'around the (kitchen) table' as a point of departure for experiments in architecture-writing, site-writing, ficto-criticism and performance writing. Each, through their own perspective, recalls each act of exploring alternative approaches to architectural design practice and research. Through the text, we follow their voices across different times, places and experiences acknowledging peers, companions and colleagues as crucial partners within a broad network of research practices. Through this, we are reminded of the values of mutual support within feminist academic research. **Petra Bauer** and **Sofia Wiberg**'s art project *Rehearsals*, together with **Marius Dybwad Brandrud** and **Rebecka Thor** is

staged within their chapter as a dialogue among various perspectives and standpoints, where different actors take various roles: hosts, facilitators, workshop leaders, participants, and interviewees, also foregrounding the diversity of the participants in the project. The project is discussed in depth within the epilogue.

Pedagogies

In her prologue to 'Pedagogies',[5] **Nora Räthzel**, introduces Augusto Boal's method *Forum Theatre*, an interactive form of theatre aiming at creating a forum for social change. In this, she sees potential for a feminist education including consciousness-raising, self-reflexivity, self-empowerment and horizontal collective action. The function of play hereby is an important factor, she stresses, which gives a possibility for testing perspectives that need not immediately be taken so 'seriously'. Another important aspect of Forum Theatre is the collective attempt to work out – act out different solutions to conflicts. In removing blame from individual actors, it becomes a political technique that shifts attention to the effects of larger social and power structures.

Within 'Pedagogies', **Brady Burroughs** suggests 'architectural flirtations' as a pedagogical tool to decentre the traditional model of studio critique in architecture education. A performative practice of flirtations can address serious issues through playful experimentation, without the pressure of failure (which is, in fact, where new knowledge is produced). Thus she questions the habits of architectural culture regarding critique and criticism. Re-orientating or displacing the centre of traditional architecture pedagogy, architecture flirtations suggest 'other ways of doing things'. **Kim Trogal** develops and conveys a nuanced understanding of feminist pedagogy, by example of three alternative classroom arrangements. She reminds us that education is a reproductive activity concerned with reproducing values, beliefs and norms of a culture and its social and cultural hierarchies. If we want different futures, she argues, we will need modes of education to produce them. She addresses education in learning environments with students of highly diverse backgrounds and emphasizes the importance to focus on more inclusive, transversal

and mutual relations. She articulates education as a collective practice and vision (involving teachers and students), which must take equality as a principle, yet work with difference rather than same-ness. **Sara Brolund de Carvalho** and **Anja Linna** present their mapping of a suburb of Stockholm, in which the 1950s residential typology includes an infrastructure of affordable, souterrain spaces. Typically occupied today by neighbourhood associations and small businesses, these spaces are mostly run by women, and cater to women. The authors also map the development of such social spaces, over the past century, revealing the disappearance of common and collective spaces under increasingly dominant economic pressures and regimes. Their chapter makes visible the need for such endangered social practices, and calls for a production of social spaces for nurturing an urban culture of care.

Projections
In her prologue to 'Projections',[6] **Helen Runting** applies the metaphor of the 'Waiting Room', an ambiguous figure which is often associated with an atmosphere of emptiness and sadness. However, she suggests that one of the qualities of the waiting room is anticipation, which evokes a feeling of possibilities that anything can happen here, at any moment. She associates the 'waiting room' and the Greek concept of 'chora', which has played a significant role in feminist discourse, and argues for the necessity of curating anticipation in order to get prepared for feminist futures. Her thought-provoking and hopeful prologue introduces the last theme of this book.

Within 'Projections', **Ramia Mazé** and **Josefin Wangel** give an account of their collaborative work across their disciplines of design and futures studies. Their chapter explores alternative concepts of time and futurity relevant to feminist futures, including those that are embodied, messy, and open, as opposed to modernist, linear and masculine models of progress that have traditionally colonized futures studies. Instead, they argue for professional and academic repositioning, in which critical practitioners engaged with alternative ideologies and ontologies, can destabilize the status-quo and open up for other and feminist futures. In her chapter, **Helena Mattsson** offers an original insight into the feminist architecture scene in Sweden during the late 1970s and early 1980s. She demonstrates how this scene has contributed to a wider debate in the Swedish context. She draws out an alternative historiography of postmodernism fundamentally engaged in activism and construction, in contrast to the traditional understanding of deconstruction, critique and formalism which dominate most histories of postmodern architecture. Examples include the feminist architecture networks 'BiG' (Living Together) and 'Kvinnors byggforum' (Women's Building Forum), the latter being a professional association of and for women in the building industry, which still exists and is strongly present in Swedish societal discourse. As a case to learn from, Mattsson revisits postmodern-feminist notions in Swedish architecture such as 'utopia in reality' and 'practical activism', which have self-empowered the movement. The chapter of **Karin Bradley**, **Ulrika Gunnarsson-Östling** and **Meike Schalk** with **Jenny Andreasson** critiques the practice of city vision-making, proposing an alternative Stockholm Vision 2030 from a feminist perspective, which is discussed at length in the epilogue. In the last chapter, **Sophie Handler** poses a critique of concepts, images and languages concerning 'ageing' in spatial design and policymaking. The chapter unfolds a more imaginative engagement with ageing, in which storytelling – in the form of a feminist and experimental material-writing practice – addresses too often silenced issues such as marginalization, invisibility and objectification.

Despina Stratigakos' epilogue relates historical and contemporary examples of feminist strategies, through her work on a women's guidebook of Berlin from 1913. Referring to the city in transformation in response to industrialization and shifting gender roles, she highlights the new opportunities this change had presented for women: establishing new institutions like a women's bank and the German Lyceum Club had tremendous effects on women's possibility for self-empowerment. She points to similar strategies of mirroring and mimicking today by discussing three chapters in this book. Stratigakos argues that her examples from the past and discussion of present projects remain meaningful as lessons for imagining feminist futures.

Editorial and design form of the book

Feminist Futures of Spatial Practice aims to contribute to spatial theories and practices through feminist, intersectional and critical perspectives. The process of developing, editing and designing the book has been a critical feminist practice in itself, a practice of building community and collectivity as well as nurturing individual author, co-author and peer voices and dialog from a wide variety of disciplines and backgrounds. Contributors come from across architecture, the arts, art history, curating, cultural heritage studies, environmental sciences, futures studies, film, visual communication, design and design theory, queer, intersectional and gender studies, political sciences, sociology, and urban planning. Addressing practitioners, students, researchers and activists in these and more fields, our intention is that this book should be relevant for all those engaged in critical societal, institutional and urban transformation.

As with any book, *Feminist Futures of Spatial Practice* is limited in some respects. Contributors represent a predominently female, proximate and Western network. This is due to beginnings of the book within a course and its contributing lecturers, who represented a wide range of disciplines listed above but who were able to take part in the course in Stockholm. For the roundtables, we succeeded in inviting contributions from farther afield through some additional means of support and collaboration (see 'Acknowledgements'). While we are well aware of such limitations, we made a concerted attempt to make space for a nonetheless wide variety of contributing voices. Authors write from different backgrounds and experiences; having grown up and been educated in various political systems and cultures from East and West, the global North and the South. Perhaps due to the educational beginnings of the book in a course, we have been attentive to different generations, engaging emerging voices as well as established perspectives. Even if writing styles and 'languages' of expression in this book may vary considerably, our 'common language' (hooks, 2000) is a shared commitment to feminist futures of spatial practice.

The development process of the book has enabled other qualities to flourish, and we have focused on the exchange and learning possible through varied forms of dialog extended over time. Each chapter has been evolved through several phases of peer-review, both in the roundtables and through subsequent revision cycles with editors. Many of the chapters involve co-authorship and many of the chapters involve different forms of dialogue. The process has been an experiment in itself, continually open to revision and redirection.

Section prologues were written after the chapters and are not peer-reviewed contributions. They represent a 'moderator' type of standpoint on the contents of each section and evoke a personal or thematic atmosphere to frame contributions within the section. Within the chapters, citation and reference standards vary – since the 'style guides' governing such standards differ considerably across disciplines, this variation is a direct expression of the interdisciplinarity of the book contents. We have collected all references in a common 'style' standard at the end of the book (see 'Bibliography'), as a kind of collective set of sources, a common list for us, and also for you.

The typeface used on the front cover and for chapter titles in the book is called Lipstick, designed by graphic designer Kerstin Hanson. This is its debut in a printed publication. Lipstick took shape in 2008 when Kerstin was experimenting in the print shop, playing with form and colour. The typeface used in this book is a digitalised version of the handmade graphic prints.

Our perspective on what form 'feminist futures' might take has evolved through our experiences as editors and participants through the course and the book development process. Through critical re-flection along the way and especially in retrospect, we recognize preferences, limits and constraints in our choices and actions. Just as standard academic peer-review, editorial standards and style guides have their normativities and exclusions, we can recognize our own as we reproduce these or produce others. We have also learned by doing, through continual forms of dialogue, about our differences as well as our commonalities. As a critical, feminist and experimental practice, we hope this book is understood as an opening for others to experiment,

to develop their own voices and forms of dialogues concerning spatial practice.

Our experience through this book development process concerning feminist spatial practice is the value of an 'imagined community' of supporters, enthusiasts, critics and utopianists, as well as academic and non-academic spaces and environments where feminist practices can emerge. Equally important to the privilege of 'imagined communities' and venues is time. Feminist futures are becoming when common projects – e.g. a course, a conference, an exhibition, a carnival, a series of 'rehearsals', etc. – not only momentarily produce an alternative space, but effect new connections and social relations that can alter ingrained patriarchal structures as many of us still experience them, i.e. in hierarchical and competitive educational systems and disciplinary structures (see Stengers and Despret, 2014; and Ahmed, 2012).

Feminist Futures of Spatial Practice wants to deepen and broaden how we can understand and engage with different genders, bodies and peoples, diverse voices and forms of expression, alternative norms and ways of living together. We hope that this book with accounts of historical as well as emerging feminist practices will be an inspiration for continuing to think and act critically and projectively, towards different, common and more just futures.

1
The forerunner for this module was the electable course 'Jalusi' (Jalousie) created by Katarina Bonnevier, in 2004, on request of students desiring an education with a queer-feminist approach to architecture that would include gender analysis. It was later run as 'Introduction to Architecture and Gender I', by the group FATALE – Feminist Architecture Theory Analysis Laboratory Education (initiated by Brady Burroughs, Katarina Bonnevier, Katja Grillner, Meike Schalk and Lena Villner).
2
'Materialisms' has beginnings in the third roundtable 'Playing with Materialism', which took place in the garden and a seminar room at ArkDes, May 21, 2014, with the gender studies scholar Nina Lykke as peer-reviewer, Katarina Bonnevier, Ulrika Gunnarsson-Östling, Thérèse Kristiansson, Ruth Morrow, Annika O Bergström and Meike Schalk.
3
'Activisms' has beginnings in the fourth roundtable, themed 'Making Space for a Variety of Narratives', which took place on May 23, 2014 by the invitation of the geographer Irene Molina at the Institute for Housing and Urban Research at the University of Uppsala. In addition to Irene, contributers included Nishat Awan, Ragnhild Claesson, Annika Enqvist, Maryam Fanni, Elke Krasny, Meike Schalk and Christina Zetterlund.
4
'Dialogues' has beginnings in the second roundtable themed 'Future Imaginaries' and 'Writing the Private into the Public', which took place on May 16, 2014 at ArkDes. The architect and spatial planner Nel

Janssens was peer-reviewer and contributers included Brady Burroughs, Maryam Fanni, Hélène Frichot, Katja Grillner, Thérèse Kristiansson, Kajsa Lawaczeck Körner, Ramia Mazé, Doina Petrescu, Meike Schalk and Josefin Wangel.
5
'Pedagogies' has beginnings in the first roundtable 'Taking Care for Political Futures', which took place on May 2, 2014, in the kitchen of a local studio. Contributors included the sociologist Nora Räthzel, who was peer-reviewer, Lisa Nyberg, Kim Trogal, Thérèse Kristiansson and Meike Schalk.
6
'Projections' has beginnings in the last roundtable, which took place on August 30, 2014 in the meeting room of a local studio with architecture historian Despina Stratigakos as peer-reviewer and contributors Petra Bauer, Hélène Frichot, Thérèse Kristiansson, Meike Schalk and Sofia Wiberg.

MATERIALISMS

ANTICIPATING FEMINIST FUTURES WHILE PLAYING WITH MATERIALISMS

NINA LYKKE

Strong trends in feminist theory have in recent decades engaged with new materialisms to come to terms with the ways in which discourse and matter are interconnected. Poststructuralist feminisms did a great job analyzing discursive constraints and the performativity of language. But as feminist theorist Karen Barad noticed: while having sophisticated analyses of the ways in which discourses come to matter, poststructuralist feminisms did not have much to say about 'material constraints' and the ways in which 'matter comes to matter' (Barad 1998, 90–91). This problem is basically what has prompted the unfolding of new feminist materialisms. For the discussion of feminist futures, I consider it to be crucial to take into account the intertwinement of discourse and matter. Moreover, architecture and spatial practices – the focus of this book – are arenas, where it seems indispensable to reflect on the constraints and potentials of materials and material space, and their interrelations with discourse. Therefore, a section focusing on these issues is important for this book.

However, playing with materialisms is an open-ended heading, which can unfold in many directions. The great texts in this section urge me to explore the theme in rich and inspiring ways. But across differences there are also strong contiguities and convergences between the texts. An issue which I am invited to think through by several authors is, intersectionally embodied and collectively inhabited, spatio-temporalities. Furthermore, I am asked to really think-feel-sense the material, fleshy, physical and sensuous dimensions of the world, as well as to explore how to change our co-becoming and worlding practices for the better. The authors are also jointly encouraging me to move from a critical to an affirmative or reparative mode. The texts give great examples of alternative practices, embedded in queer, feminist and decolonizing theorizing. They passionately outline how to move from mere critiques of fixed maps and taxonomies with excluding borders and linearly ordered timelines

to different, materially concrete, but open-ended worldmaking practices. I feel warmly invited to take part in an open-ended conversation about these practices within a framework of feminist materialist, queer and decolonizing perspectives, which the texts offer their readers as a theoretical entrance point. So I shall use this introduction to enter into such a conversation.

Nishat Awan's 'Mapping Otherwise: Imagining other possibilities and other futures' reflects upon the effects and performative qualities of maps, and alternative mapping activities as a methodology. She takes her example from research in diasporic settings, Kurdish and Turkish people living in Hackney, London. Among others, the research included asking research participants to draw mind-maps of Kurdistan, and mapping the ways in which a specific distribution of *kahvas* (Turkish and Kurdish social clubs) in a street in Hackney somehow resonated with geographies of regions in Turkey. Against this background, Awan discusses the ways in which mapping practices may transgress the abstract – and illusionary – performance of neutrality and objectivity, which conventionally is associated with maps, and instead make invisible geographies visible. She suggests that imaginary constructions of maps which include experience and subjectivity can contribute to empowering visibilizations of marginalized perspectives.

Ragnhild Claesson's 'Doing and Re-doing Cultural Heritages: Making space for a variety of narratives' also deals with diasporic spaces and their potential to generate change. Cultural heritage perspectives and memory work are included in her methodology. Claesson organized a series of workshops together with an artist and a women's association having many members with experiences from transnational migration. The idea was to influence urban planning in the municipality of Malmö. The memory work and art practice which took place in the workshops was successful and led to a promising proposal for a new kind of public meeting places in Malmö. The proposal was inspired by the workshops in general, and in particular by one participant's vivid story of a childhood memory: a family gathering around a specific oven (an Asian *tandoor*) in a wintery Tehran. The dialogue with the planners from the municipality was positive. But it also made it clear that there are strict boundaries and taxonomies in regards to questions such as: what is cultural heritage? And whose cultural heritage matters in which contexts?

MYCKET's (Mariana Alves Silva, Katarina Bonnevier and Thérèse Kristiansson) work; 'Through Our Dance We Weave the Dance Floor and Ceiling' focuses on the potentials of a queering of both time and space. The example is a re-enactment of 'Göteborgskarnevalen' – a carnival held in Gothenburg from the beginning of the 1980s to the early 1990s. Starting in archival studies, which revealed the historic Gothenburg carnival as an extremely heteronormative, straight and patriarchal institution, MYCKET, together with a bigger group of collaborators, decided to re-enact

it as an inclusive queer event. This re-enactment took place in 2013 as part of the Gothenburg International Biennial for Contemporary Art. Reclaiming the carnival, MYCKET and their collaborators made visible what had been excluded. On the one hand, they publicly demonstrated a queer feminist critique of the historical carnival, but, on the other hand, they also committed themselves and the many participants in the re-enacted carnival to an affirmative approach with future-oriented potentials.

Ruth Morrow's 'Material Witchery: Tactility Factory as a site of emerging ethical practice' takes the readers to another kind of exciting worldmaking practices which, like the other contributions, involve promising transgressions of fixed boundaries and apparently non-negotiable taxonomies. Here, the key boundaries transgressed are those between such different kinds of materials as 'hard' concrete and 'soft' textile. The Tactility Factory is a project, which Morrow and her friend, Trish Belford, a re-nowned textile designer, in an over 10-year long process, have developed, based on feminist methodologies of situated knowledge and ethics. As part of an endeavour to 'make hard things soft', the Factory works experimentally with the creation of new kinds of material where the upper surface of concrete is merged with textiles; Morrow and Belford named their invention 'Girli concrete'. From 2013, the work of the factory is also commercialized in terms of a production of Girli concrete wall panels.

One of the things that strike me, when reading all texts, is a cross-cutting com-mitment to hope and a utopianism, situated firmly in the here and now. At stake is the kind of utopianism that feminist scholar Davina Cooper theorized as 'everyday utopianism' (Cooper 2014). Utopian thought has been criticized for its modern focus on linear time, as well as for universalizing hegemonic, homogenizing and, in the end, exclusionary blueprints for the 'good' life and the 'good' society. But other strands in utopian thought have distanced themselves vis-à-vis such frameworks, and instead fo-cused on utopianism as multiple and open-ended anticipations of alternative futures, which may materialize momentarily as part of a messy here and now. Cooper (2014) defines everyday utopias as utopian processes and moments which are always already mixed up with societal mechanisms and forces of the here and now, for example, neoliberalism, which pushes or pulls into other directions than utopian ones.

What I find in all contributions to this section are rich examples of methodologies for crafting such hopeful, open, multiple and temporarily utopian moments. They emerge in Awan's alternative mapping activities, in the proposals for alternative public spaces in Malmö, generated by Claesson's workshops, in MYCKET's queer carnival, and in Morrow's and Belford's experimentations with mergers of concrete and textiles. The methodologies, used in these examples, are all hopeful, utopian and performative, but appear to be sustainable and robust enough to work in a messy world, where other dynamics than utopian ones are to be taken into account – from urban planning programmes to neoliberal economies.

A second commitment which cross-cuts all the texts concerns the already mentioned move from critique to affirmation, which queer scholar Eve Kosofsky Sedgwick (2003) theorized as a move from paranoid to reparative modes of interpreting. In order to push this discussion into the realm of new materialisms, I would like also to bring forward the concept of 'diffraction', profiled by feminist theorists Donna Haraway (1997) and Karen Barad (2007) as a methodology appropriate for a new feminist materialist toolbox. I suggest that there is an affinity between the move from paranoia to reparation, proposed by Sedgwick, and the one from reflection to diffraction discussed by Haraway and Barad, and that the latter works better within the framework of new materialisms than the former, which stays on the level of readings and discourse.

Both reflection and diffraction are concepts with a basis in optical physics, but they are clearly distinguished from each other. Against this background, both Haraway and Barad suggest that we use the optical phenomenon of diffraction as a metaphor for a critical thinking technology, which creates an alternative to the more conventional metaphor of reflection. A reflexive methodology uses the mirror as a critical tool, Haraway notes, pinpointing that this analytical strategy has its limitations, when it comes to making a difference. The mirror as a critical tool does not bring us beyond the static logic of the Same. In a mirror image foreground and background remain the same. By contrast, diffraction is a dynamic and complex process, implying a continuous "production of difference patterns in the world, not just of the same reflected – displaced – elsewhere" (Haraway 1997, 268). I think all four examples from the texts – the ways of mapping otherwise, suggested by Awan, the alternative meeting places in Malmö, discussed by Claesson, the queer carnival in Gothenburg, presented by MYCKET, and the experimental mergers of concrete and textiles, invented by Morrow and Belford – are well suited to be described by the metaphor of diffraction. They are precisely not just critical mirror images of the Same in the shape of conventional maps of London, municipally planned meeting places in Malmö, the historic Gothenburg carnival, and simple hybrids of concrete and textile. They are all something different; new interference patterns have emerged out of the transformative processes, initiated by the authors and their collaborators.

A third, cross-cutting commitment, which I will stress as shared by all the texts is a dedication to 'situated knowledges' (Haraway 1991). In each their way, the texts stress situatedness as a methodology and ethics. This means an obligation to start from somewhere instead of pretending to start from nowhere or everywhere such as conventional maps, for example, do, as discussed by Awan. Situatedness, underlined by Claesson, is also not just about being local, but instead considers the global in the local, i.e. work from a glocal perspective. This requires us to take thoroughly into account what is excluded, i.e. to use the phrase of MYCKET 'to exclude me in'. Finally,

to stress a point made by Morrow, situatedness is about working not only with technical specifications when designing materials for built environments, but also taking human specifications, including unexpected ones such as tactility into account.

At a meeting on this section of the book in the beautiful garden of the Architecture and Design Centre in Stockholm on a sunny day in May 2014, we also touched upon the importance of transgressing the boundaries between academic and creative modes of writing, including using what feminist theorist Patti Lather called "messy texts" (Lather 2001, 201). A messy text makes space for affect and allows for shifts between academic and poetic genres. To memorialize this part of the production of the book, and to approach the texts in this section from another angle, I shall end this introduction with my poem:

Preparing for feminist futures

To leave the conventions of 'neutral' mapmaking,
instead drawing maps from the margins,
mapping Kurdistan or *kahvas*,
used by Kurdish and Turkish diasporas in Hackney of London;

To imagine a public space in Malmö of Sweden,
where you share stories,
while meeting around a warm Asian *tandoor*,
protecting you against cold Swedish evenings;

To re-enact a carnival in the streets of Gothenburg of Sweden,
as an inclusive, queer event, prepared collectively
by loving, strong and sexy queer feminists dressed up
in hoodies, baseball caps and summer clothes from earlier decades;

To invent and produce 'Girli concrete'
making it possible for people
to enjoy tactile pleasures
when touching their walls;

These are all ways to anticipate open-ended, feminist futures,
while playing with materialisms.

1

MAPPING OTHERWISE: IMAGINING OTHER POSSIBILITIES AND OTHER FUTURES

NISHAT AWAN

My interest in mapping started with an interest in migration and diasporas. I wanted to represent the way space is experienced by those whose lives span different cultures, spaces and times, as well as the spatial experiences of those who are situated at the margins. Maps of course have a long history of narrating power and they have been instrumental tools in the claiming of territory. Yet, as many contemporary mapping practices have shown, maps can also be used in opposition to dominant narratives. Perhaps a key feature of all maps is their ability to visually depict different realities by distilling and privileging some information over others. In this sense, maps are always political and should be read as such. They are also always partial and perspectival, regardless of their claims to authority.

The relation of maps to representation is therefore fundamental; they frame, codify and distil. That this quality of maps is often hidden or left unacknowledged might be one important issue for a feminist mapping practice. How to draw a situated map that is still readable and useable, but does not resort to the bird's eye view of conventional maps? Or does the point of view matter, as long as the content is oppositional? In the collection *An Atlas of Radical Cartography*,[1] the editors state that in choosing the maps to include in the book, they realised that for them it was the content that held a radical potential, and not necessarily the way that they were drawn. It is true that the topographic conventions of Western mapmaking, including the adoption of longitude and latitude, are fundamental to what we now consider to be a map and without such conventions perhaps we lose a sense of what a map is, and what it is for. Yet, the dominant tropes of such mapmaking leave out much: scale, colour-coding, longitude, and latitude do not account for temporality, touch, memory, relations, stories and narratives—in fact, it is experience that is altogether removed.

Maps and agency

James Corner describes the "agency of mapping" as a tool for design in which the focus is on mapping as an activity rather than the map as artefact.[2] In this sense, mapping is considered propositional and

could be a way of imagining different futures. As Corner writes, "mappings do not represent geographies or ideas; rather they effect their actualisation."[3] Corner is here writing on how mapping can be used within the disciplines of planning and architecture, of its role in design as an act that works with projections of the future. Citing David Harvey, he writes about "a utopia of process rather than form,"[4] that mapping as practice can contribute towards. Corner's account of mapping's agency is illustrated through maps that are grappling with ways of showing time and space in its dynamism through practices of drifting, layering and through the use of game boards on which to map out potential futures as scenarios. Yet, what is always missing in these accounts of mapping is the body. Perhaps this has something to do with Corner's original definition of mapping as abstraction, which, according to him, is the fundamental quality of all maps.

Whilst it is true that one way in which mapping operates is through abstraction, in a feminist mode of imagining the future, it would be an abstraction that is always returning to the real – it is a movement back and forth. The feminist philosopher Elizabeth Grosz describes the real as: "The uncontained, the outside of matter, of things, of that which is not pragmatically available for use, is the object of different actions than that of intelligence and the technological."[5] The real therefore is the world before we apprehend it, it is outside representation. What Grosz refers to as "the thing" is the necessary process of making sense of this multiplicity, it is "the real we both find and make."[6] If maps are both abstractions that strive towards the real and things that point to a spatial and temporal specificity of the real, then they should also operate in ways that are able to access both these registers. On the one hand, maps should deal with a knowledge that is related to representations, measurements and symbols, and this is something that maps are very good at. But, on the other, they should also deal with a knowledge that is more intuitive and is accessed through bodily gestures and postures. In describing mapping as a practice that performs this movement back and forth, another conception of time also emerges, one that is related to matter – both matter in the sense of the map itself as object but also matter in relation to the bodies of those involved in the process of mapping. As Karen Barad states, "one of matter's most intimate doings" is "its materialising of time. Matter doesn't move in time, matter doesn't evolve in time. Matter materialises and enfolds different temporalities."[7] This enfolding of different temporalities and spatialities could be one way of describing the practice of mapping otherwise and its relation to imagining other futures.

If maps are a way of working across the real, it is also useful to think what place such a practice of mapping could hold within a wider process. In the book *Spatial Agency*,[8] we were concerned with an underlying idea that the potential of agency, that is the power and freedom to act for oneself, was somehow inherently spatial – it had a spatial dimension. We were interested in exploring how agency might emerge through spatial practices, and it is interesting to note that many of those featured in the publication were using forms of mapping as part of their work. Our conception of agency was based on the classical duality, the ability to act independently, on the one hand and the constraints of social structures on the other. We followed Anthony Giddens' thinking that agency emerged through the interplay of these two poles, what he described as "the capability of acting otherwise."[9] He writes of the reciprocal relationship between human agency and social structure and we followed this human-centred approach to think of agency as always residing in the architect or the user. We wrote of acting on behalf of others or acting with others. Corner's undefined notion of the agency of maps is aligned to this definition, where the agency of maps is embedded in their use by architects, planners, the users of spaces etc. But perhaps a different definition of agency would lead to a different notion of the use of maps in imagining possible futures.

What is missing from the above account and also from Corner's account is the question of materiality, the body, and of imagining agency as not only the privilege of humans, or at the very least not only emanating from human social structures and their relation to individuals. A different version of agency linked to the discussion of the real above is developed by Grosz, who describes another genealogy of thinking freedom and its relation to subjectivity. She

starts from the writings of Henri Bergson, who did not rely on the Western philosophical tradition of setting up binary distinctions. For Bergson, the freedom to act was neither confined to the subjectivity of individuals nor to the structural conditions of society, instead, he posited that acts themselves are free. Free acts are conceived as those that take part in the becoming of the subject, that is, they express the subject in transformation. In couching free acts as such, Bergson's concept of agency is affirmative, it is embedded within actions, in their possibility and in their performance. As Grosz makes clear in her appraisal of Bergson, neither the determinist position of structural conditions that will only allow one choice to be made, nor the libertarian position that allows a choice of a number of outcomes that are equally possible and remain available to the free will of the individual, acknowledge that the different outcomes were never equal in the first place. In this, Grosz is critiquing a notion of agency that relies solely on oppositional modes and is advocating a form of agency that arises through the creative potential held within life and matter.

In claiming such a notion of agency embedded within free acts, a feminist practice of mapping could be imagined that facilitates a move from abstracted possibilities caught within the oppositional logic of struggles towards the production of materially real potentialities that are more open and creative. For Grosz, this is more a capacity of the body than that of the mind, "linked to the body's capacity for movement, and thus its multiple possibilities of action."[10] This reinforces, again, the crucial movement back and forth that mapping has to make between an abstracted realm that necessarily deals with representations and a knowing through the body.

Mapping otherwise

Maps and mapmaking could hold a privileged position here in the unexpected ways in which they are able to bring together disparate knowledges and claims, juxtaposing ways of seeing the world. But this is a practice of mapping that is far removed from the abstracted nature of standard cartographic modes, and also from the ubiquity of contemporary mapping tools such as Google maps. In the type of mapping practice I am advocating, the abstractions of maps would be used in such a way as to mediate between the realm of representation and lived realities. This could mean, for example, moving away from a dominant mode of mapping where experience is elided through a mode of representation that privileges precision over the messy reality of life. Maps could instead describe social relations or connections that transcend spatial proximity. At the same time, maps can be used to mediate between different types of knowledge and constructions of space, from the professionalised world of architects or cartographers to more accessible forms of representation.

A different approach to mapping that does not rely on standard cartographic conventions will also imply a different understanding of space and time. Rather than the Euclidean concept of space as territory with fixed and stable spatial geometries, a topological understanding of space requires a relational approach that privileges continuity through change. Dynamic associations are made not due to spatial proximity but because of common properties. In cultural understandings of topological spaces, it is not only a question of the connections that are made but also of their quality, their temporal dimensions, historical reach, etc.[11] Time is no longer thought of as an accumulation or sequential movement, as the steady progress of one homogenous flow of time. It is instead thought of as duration. Time would be multiple, allowing for multiple future possibilities. This also has consequences for the ways in which the future is constructed. Mapping could be a mode that allows us to speak of the future not as pure projection, or as something that is in thrall to the past, but as a future that resides in and shares our present.

The term 'mapping otherwise' tries to capture some of these aspects of thinking space and time, as well as the notion of agency described above as an assemblage of acts, objects and relations. Choosing to use 'mapping' over 'cartography' is important in making a break from the professionalised world of cartographers and to valorise instead the amateur knowledge of the non-professional specialist. This reveals a different ethics of mapping, one that

neither takes the position of the powerful and the elite nor an explicitly oppositional stance, preferring instead a mode where the politics of representation allows others to be included in the mapping process, as well as acknowledging the mapmakers' own positioning.

In the remaining section, I use a series of maps I have made to relate how mapping can be used to represent a lived knowledge of space, particularly in the case of diasporic subjects.[12] In diasporic lives, notions of space and time are most obviously topological since migration displaces subjects, producing specific modes of inhabitation through dislocated gestures and practices borrowed and adapted from other spaces and times. The ways in which notions of belonging and inclusion are constructed within diasporic lives is also topological, the differential inclusions of host societies, what Alain Badiou has called 'an excess of inclusion over belonging',[13] all point to ways in which diasporic lives construct space, time and belonging in ways that are different from those who remain in their place of origin.

These diasporic maps were all made along a single stretch of street in the London Borough of Hackney, which is situated in the northeast of inner London. The southern tip of the borough sits adjacent to the City with private development encroaching northwards. The site of the project, Stoke Newington High Street/Kingsland Road, runs north-south and extends from Stoke Newington to Dalston. The area has a large Turkish and Kurdish population and, being situated close to the site of the London Olympics of 2012, was undergoing significant transformation at the time the maps were made between the summer of 2007 to the end of 2008. This included the demolition of prominent existing buildings, the construction of new residential towers, as well as new transport infrastructure. Such private/public regeneration is often accompanied by the production of many maps—development plans indicating opportunities, constraints, zones, and phases. These mappings typically represent a bureaucratic exercise intended to create a formal record of a developmental process rather than encouraging a situation in which dialogue and participation is possible. They are also highly selective in what they choose to represent, they are

neither a faithful description of an urban condition at a particular moment nor are they a representation of an idealised situation in the future that could be realised; instead, they are merely a predetermined stage in the process of urban development. These maps are linked to the requirement for participation and user consultation in the planning process. Although opinions are sought and questions asked, in the end, the limited nature of the choices and what is highlighted and enframed in these consultations leaves no room for any real discussion or conflict— the outcome is predetermined and the maps record a process in order to meet the obligation to consult residents. It is within this context that I carried out the mappings described below, which aimed to reveal the types of spaces that would be displaced through the development process, spaces that were marginal to the dominant use and understanding of the street. These mappings were concerned with revealing the different inhabitations of the street by its diasporic users, including the narratives of other places, and stories of how people came to be there.

Drawing Kurdistan in London

Starting with the premise that diasporic subjects reterritorialise space and often internalise the geographies of other places, I conducted a series of interviews with Kurds and Turks from very different political and social backgrounds. I wanted to understand how Kurdistan as an 'imagined home' was constructed by the Kurdish people strewn across national borders, and also how it was constructed for those who are opposing the desire for an independent Kurdish state. At the same time, I was interested in how to map such border struggles without resorting to the dominant narratives of those in power. In a context where contested borders were not even allowed the ambiguity of dotted lines on official pieces of paper, how might these borders and territories be drawn through the experiences of those whose lives are affected by these contested spaces?

During the interviews, I asked people to draw a map of 'Kurdistan' as they saw it in their mind. The conversations we had together whilst they were drawing the maps revealed how their experience of

urban space in London was also inflected through the way in which they conceptualised Kurdistan. For some, Kurdistan was a geographic location, for others, a concept or a hope, and, for others still, it was embodied through a person, Abdullah Ocalan, the leader of the Kurdish Workers Party (PKK). Drawing or mapping thus became a tactic for speaking about these contested borders and situations, which were inscribed onto the subjectivity of those I interviewed. The maps produced during these sessions vary enormously, both in what they choose to represent and in the way they were drawn. A wider question that these maps pose is whether where you are and who you are affects what you draw. In this case, it certainly did, producing mental constructions of what always fails to be represented in the hegemonic accounts of those in power. For the Kurds, until recently it was the refusal of the Turkish state to recognise their separate ethnicity, being referred to as 'mountain Turks' instead. Mapping therefore functioned as a mediatory practice, a ruse for speaking about difficult journeys and personal stories. The gesture of hand-to-paper, which began as a self-conscious, deliberate stroke, slowly became a non-articulated movement, sometimes almost an auto-drawing, tracing maps made of gestures.

For some, the drawings were a description of home, for others, a journey or a narrative, as the act of drawing provoked stories that augmented the maps. For some, the map was drawn following their own journey, with the compass directions switched in order to follow their path. Where someone chose to start the map was also important. Diana, an Iranian Kurd who worked for a women's rights organisation, was the only person to start her map in an area that could geographically be designated as a future Kurdistan. She had lived in the Kurdish areas of Iran, Iraq and Turkey and said that she felt at home in them all. For her, the continuity of this space was a reality and her map reflected this attitude, the national borders of the surrounding states being just sketched out in the barest of lines, as a quick gesture. Another map tells the story of the invasion of Iraq as seen from the eyes of Derin, a young Turkish waiter who worked in a local café. Here, the map is a narrative of politics and promises. For him, drawing Kurdistan was almost impossible.

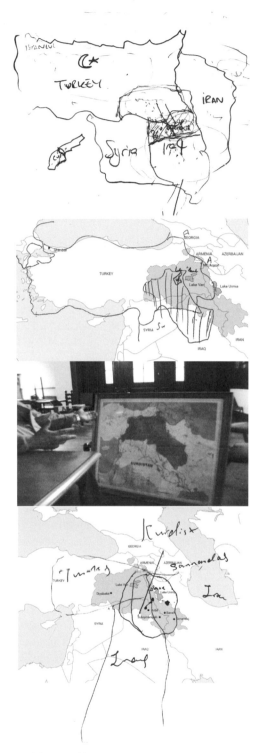

Fig 1.1 Hand drawing of Derin's map
Fig 1.2 and 1.3 Explaining Kurdistan through maps
Fig 1.4 Hand drawing of Diana's map

The story of the US invasion of Iraq, and what he saw as their complicity in establishing a "Kurdish state", was the main topic of concern. (Fig 1.1 Derin's map) (Fig 1.4 Diana's map)

In each of these maps, the words are just as important as the drawings. It is the process of mapping rather than the final product that is important; the movement of hands and the words spoken. If I had permission, these sessions were recorded on film and some of the mappings include stills from these videos. Whilst the drawings produced could be described as 'mental mapping' they are also a 'material mapping'. The places where we spoke, the props that were used, such as a map of the area brought over by one of the interviewees, are all part of the mapping. (Fig 1.2 and 1.3 Explaining Kurdistan through maps)

An allegorical map of Turkey

Summer 2007
Walking along Stoke Newington High Street you could almost miss the signs, open doors leading down into basements, shop fronts that could be empty but are not. Chairs sitting in a patch of sunlight on the Victorian pavement. There is another world here that I don't see, but which also may not see me.

Spring 2014
The basements seem to have disappeared. There are cafés here but they are different. They have confidence, a way of appropriating the pavement with many chairs and tables. Things are a little different now.

When I first started exploring the high street, I was told that if you were to map all the kahve *on this one street, you would get a perfect map of Turkey, down to the last village. This little anecdote caught my imagination. Is there another map of this familiar street that others use to navigate by? A map that is not included in the London A-Z or on my phone?*

(See map on next spread)

The *kahve* are Turkish and Kurdish social clubs or small cafés that operate as members only spaces where usually men gather to drink tea, play cards and chat. They are said to mimic the geography of Turkey, each place being affiliated to a certain area or a regional football team. The names of the *kahve* give an indication to their loyalties (Besiktas, Adana, Gurun…), which are usually those of the owner. In the space of the street there is an overlapping of the physical location of the *kahve* with their toponymic distribution that alludes to regional affinities elsewhere. This other geography overlaid on to the physical space of the street forms an allegorical map of Turkey that is performed daily in the everyday comings and goings of the *kahve*'s diasporic users. I wanted to map this hidden layer that remains unseen for those users of the street who will never visit a *kahve*. In order to do this, I took a plan of the street and overlaid it with two maps of Turkey that were distorted according to the regional affiliations of the *kahve* on the street. On one of the maps, the country is elongated with Cyprus moving up to the middle, whilst the other map remains much closer to the original. Since the practice of naming reterritorialises space and produces borders related to the regional and political conflicts, solidarities and nostalgias of another place, it makes me wonder if this is a coincidence. Or did the owners actively seek to set up their *kahve* in proximity to others from their region? The geography that the map describes is gone now, displaced by another wave of territorialisation; this time it is the consumer culture of hip young Londoners.

Mapping possible futures

The maps described here operate in different ways; they depict marginal uses of space or tell stories that allow an understanding of how space is inflected through political subjectivities. Neither of the maps described above are propositional in the sense that designers and architects might think, but in their attempt to map space through other perspectives, they are thought of as propositional devices that open up future possibilities. What might the developments in that area of London have looked like if they had to address these uses of space and the pol-

itics embedded within them? Through mapping the invisible geographies that only reveal themselves through spending time there, both maps attempt to describe a space that is not merely physical. In the case of the *kahve* map, it would be difficult, if not impossible, to find all the locations without being there and talking to those who visit the *kahve*. In the mapping of Kurdistan, the map itself acted as a mediator, it prompted the conversation and was a way of broaching difficult subjects. These mappings and observations were part of an attempt to explore the production of diasporic space through processes of reterritorialisation and displacement. Through making these maps, sometimes on my own, sometimes with others and sometimes by others, a practice of 'mapping otherwise' emerges, where experience is re-introduced. They are ways of exploring different possibilities or futures by giving voice to other narratives and uses of space. In thinking about maps not just as drawings or objects, but as ways of producing and disseminating knowledge about the world, the maps themselves take on a certain agency.

My concern in this chapter has been to explore what a feminist practice of mapping could be and how it might contribute towards imagining feminist futures. In much of the mainstream literature on mapping, a fundamental quality of maps is described as their ability to abstract, but in a feminist mode, this abstraction has to work in a back and forth movement with a different logic, one based in the bodily understanding of space. Bodies (and matter more generally) allow us access to the real and provide a glimpse into the multiplicity of space and time, its "co-constitutive dis-continuities," as Barad describes it.[14] We can then imagine a different notion of the future, one where the creative potential of life, its singular ability to differentiate, means that there is never just one future but many possible futures.

1
An Atlas of Radical Cartography, ed by Lize Mogel and Alexis Bhagat (Los Angeles: Journal of Aesthetics and Protest Press, 2008).
2
James Corner, 'The Agency of Mapping', in *Mappings*, ed by Denis E. Cosgrove (London: Reaktion Books, 1999), pp. 214–253.
3
Ibid., p. 225.
4
Ibid., p. 228.
5
Elizabeth Grosz, *Architecture From the Outside: Essays on Virtual and Real Space* (Cambridge, MA: MIT Press, 2001), p. 179.
6
Ibid., p. 168.
7
Karen Barad, 'Re-membering the Future, Re(con)figuring the Past: Temporality, Materiality, and Justice-to-Come', Feminist Theory Workshop Keynote, Duke University, 2014. www.youtube.com/watch?v=cS7szDFwXyg&feature=youtube_gdata_player [accessed 17 March 2015].
8
Nishat Awan, Tatjana Schneider and Jeremy Till, *Spatial Agency: Other Ways of Doing Architecture* (London: Routledge, 2011).
9
Anthony Giddens, *Social Theory and Modern Sociology* (Cambridge: Polity Press, 1987), p. 216.
10
Elizabeth Grosz, 'Feminism, Materialism, and Freedom', in *New Materialisms: Ontology, Agency, and Politics*, ed by Diana Cole and Samantha Frost (Durham: Duke University Press, 2010), pp. 139–157 (p. 152).
11
Rob Shields, 'Cultural Topology: The Seven Bridges of Königsburg, 1736', *Theory, Culture & Society*, 29 (2012), 43–57 <doi:10.1177/0263276412451161>.
12
This research was carried out as part of my doctoral thesis at Sheffield School of Architecture and funded by the Arts and Humanities Research Council.
13
Alain Badiou, *Being and Event*, New Ed (London: Continuum, 2011).
14
Barad (2015).

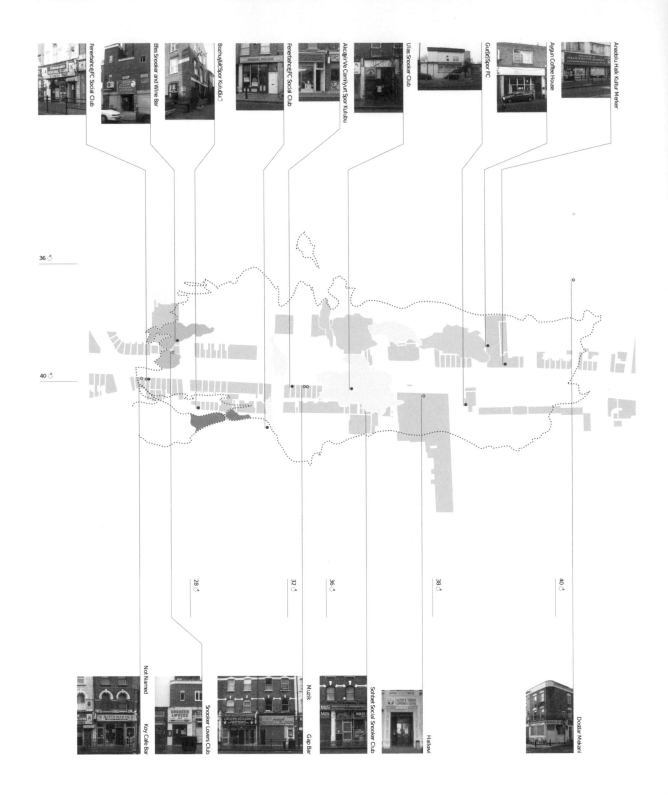

Fenerbahçe FC Social Club

Efes Snooker and Wine Bar

Bozhüyük Spor Kulübü

Fenerbahçe FC Social Club

Akçağrı Ve Camiiyurt Spor Kulübü

Ulaş Snooker Club

Gudül Spor FC

Aygun Coffee House

Anadolu Halk Kültür Merkez

36 ♂

40 ♂

28 ♀

32 ♀

36 ♀

38 ♀

40 ♀

Not Named

Köy Cafe Bar

Snooker Lovers Club

Müzik

Gap Bar

Sohbet Social Snooker Club

Halkevi

Dostlar Mekanı

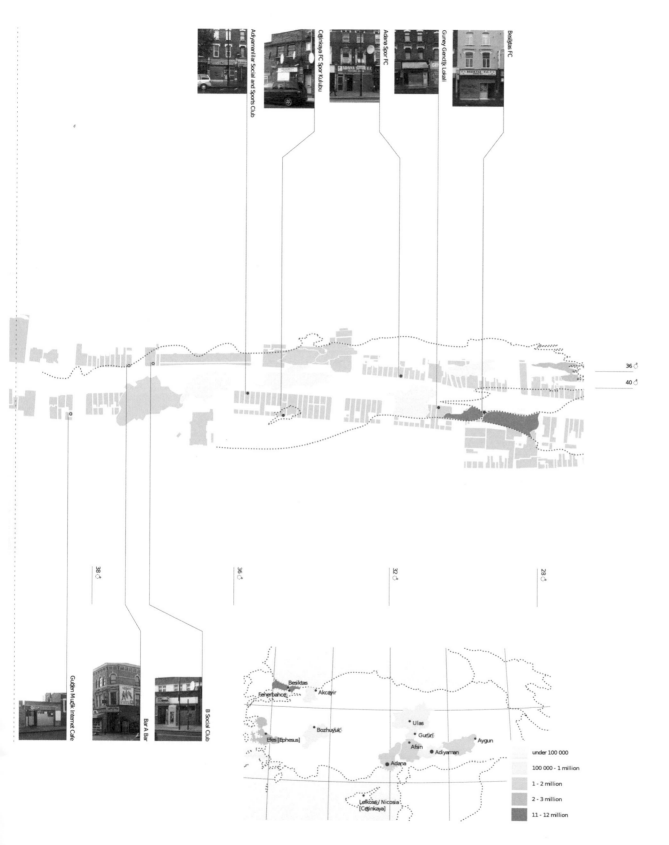

Adıyamanlılar Social and Sports Club

Çejinkaya FC Spor Kulübü

Adana Spor FC

Guney Gençlik Lokali

Beşiktaş FC

36 ♂
40 ♂

38 ♂

36 ♂

32 ♂

28 ♂

Gülden Muzik Internet Cafe

Bar A Bar

B Social Club

Beşiktaş
Fenerbahçe
Akcayir
Efes [Ephesus]
Bozhuyluk
Ulas
Gurun
Afsin
Adiyaman
Aygun
Adana
Lefkosa / Nicosia
[Cejinkaya]

under 100 000
100 000 - 1 million
1 - 2 million
2 - 3 million
11 - 12 million

2

DOING AND RE-DOING CULTURAL HERITAGES: MAKING SPACE FOR A VARIETY OF NARRATIVES

RAGNHILD CLAESSON

Introduction

This chapter presents a research project which elaborates on narrating and 'doing'[1] cultural heritages in urban planning. The first intention was to study how municipal urban planners in Malmö, Sweden, worked with aspects of cultural heritage within a sustainability programme in the neighbourhood Rosengård. As it turned out, the planners did not include cultural heritage aspects, which in any event had only been a suggestion in the programme. In light of this, my research embarked on a tentative elaboration on what urban planning could involve, if narratives and memories of past places were incorporated into the process. I also wanted to take into account how cities consist of a variation of cultural expressions in a 'glocal' context, where pasts are located in near as well as distant places, and what this could entail for future planning. This means here that I acknowledge how local and global relations are mutually constitutive, that 'the global' is not an abstract process independent of local conditions, and that these relations bring about 'glocal' spaces which are stratified by power relations (Robertson 2012 [1994], Swyngedouw 2002). Considering how urbanisation and migration processes transform cities, a city with mobile citizens will inevitably have relations to places both near and far, consisting of various cultures, identities and pasts. Such worldwide relations are part of what constitutes cities, and urban spaces thus have connections far beyond their territorial boundaries (Massey 1994, Sassen 2006, Glick Schiller & Çağlar 2011). This is also shown in Swedish local contexts by Olsson (2008) and Listerborn (2013), who see extensive, worldwide networks of social, cultural and commercial exchanges being active in what are often stigmatised as marginalised neighbourhoods in the peripheries of cities. Listerborn has further shown how urban planners can impose a localising perspective when addressing marginalised neighbourhoods, while the residents in fact often have a wide "'glocal' mental mapping" of the world (Listerborn 2007:72). That glocal cities bring together a variety of spaces, relations, cultural practices and pasts is the first point of departure in this study.

Obviously, urban planning and place-making

strategies are not neutral. Sandercock sees a need for critical inquiry into how narratives are selected and given weight in urban planning, stating that "the telling of stories is nothing less than a profoundly political act" (Sandercock 2003:26). Place-marketing projects, in their ambitions to attract new investments, can from this point of view be seen to select narratives that risk homogenising space, creating a 'we' which is supposedly marketable but not necessarily inclusive (Syssner 2012). Massey finds that single-directed narratives and processes can work as *closures* of space, and therefore points to the importance of imagining and narrating space as open, to be able to make relations that are not exclusive or reductive. She argues that there is always an opening somewhere, which is the character of space, or the *chance* of space (Massey 2005). An understanding of urban planning as not neutral, as consisting of acts that can both homogenise *and* heterogenise space and work towards exclusion or inclusion – of closing or opening up space – is the second point of departure in this study.

The third point of departure is the view that the cultural heritage field, through its policies and practices, risks to make narratively dominant or closed spaces. Acts of listing buildings and objects by documenting, valuing, and making preservation programmes and interventions in physical spaces, are very specialised, distinct and legalised practices which can block out alternative interpretations. Preservation practices can themselves be said to constitute a tradition – a tradition of making heritage rather than a practice of preserving a past *per se*. An 'authorised heritage discourse' (Smith 2006) can be seen to legitimise what becomes an official heritage, i.e. that which is subjected to the heritage professionals performative practice. Promoted in such a way, a dominating heritage may implicitly categorise people and support certain identities and cultures while excluding others (Smith 2006, Anderson 1991, see also Hobsbawm and Ranger 1983, on inventing tradition). In this chapter, I investigate and discuss how narratives may stretch across urban and national scales, i.e. across those scales and borders which are traditionally perpetuated by institutions of cultural heritage. The methodology applied in this study includes seeing from the margin, situating

knowledges and performing glocal relations and narratives, and is an attempt to open up planning practices to various ways of narrating space. The intention is however not to find best practice, but to problematize how, why and for whom urban space is narrated in planning and heritage preservation. I also want to problematize how place-making may reflect or rework notions of national and transnational identities.

With these three points of departure, I attempt to elaborate on how cultural heritages can be made or re-worked in an urban planning project. The questions I ask are: *How is it possible to make, or re-do, connections between narratives of past, present and future places? How can this be done to make meaning in the glocal here and now through a place-making process?* In reference to Massey (2005), I acknowledge how dominating narratives can be played out as spatial closures. Consequently, the study also includes considerations of how to 'open up' space and planning practices for a variety of (glocal) narratives to 'take place'.

Following this introduction, the section "The Workshop Series" describes three workshops I conducted as part of this research project, where handicraft, design and urban planning were combined. The aim was to tentatively and playfully elaborate on doing and re-doing memories and narratives, or notions of cultural heritages, in relation to urban planning. The section presents the urban planning context in Rosengård and Malmö, as well as the workshop participants: a women's association, an artist, three municipal planners (in the last workshop), and myself. The different steps in the workshop series are described in detail, including a design proposal which was prepared and presented to the municipal planners. Quotes from interviews with an association member and the municipal planners on whether or not the proposal could be regarded as cultural heritage ends this section. In "Methodology and Conceptual Framework" I first give examples of projects which have inspired this study, before discussing the methodological approach of situating knowledges (Haraway 1988, Harding 2004) and seeing from the margin (hooks 1984). I then present and discuss the conceptual framework, which brings together

Massey's (2005) *throwntogetherness*, Mouffe's (1992, 2005) discussion on *political and collective identities* with Butler's (1993, 2004 and Butler and Athanasiou 2013) theorising of performativity and *performative acts* as political possibilities to transform dominating discourses. Analysis and reflective considerations are woven into the chapter as it develops. It ends with "Doing and Re-doing Heritages through Planning Practice?" where I argue that the workshop process potentially 'opened up' a new space in established planning practices. I also reflect on some challenges, such as disagreements between workshop participants, and how we performed gendered identities in an unproblematized way. I conclude by pointing to the need for urban planning processes to imagine space as open and accessible, in order for citizens to be able to make a variety of narratives, and maybe also to do, or re-do, notions of (national) cultural heritage.

In the chapter, the term 'planners' denotes all those who represent the municipality in urban planning processes – as architects, engineers and heritage professionals – as well as those trained and titled as urban or city planners. The concepts 'narrative' and 'story' have many interpretations and applications, but here they are used mainly in three senses: first, narrating as a meaning-making process which connects fragments of recognition and memories into larger sequences of individual or collective meanings (Somers 1994). Second, as specific stories used in place-making and place-marketing to consciously or unconsciously move a process in a certain direction; these stories often connect to larger discourses in society of development, growth, sustainability or nationality (Sandercock 2003, Massey 2005, Syssner 2012). Finally, narratives also refer to preserved, institutionalised histories authorised as cultural heritage, as stories of a nation (see Smith 2006). These three approaches to narrating are of course interrelated, and their potential connections were part of the tentative elaborations in the workshops in this study.

The Workshop Series

To tentatively elaborate on making glocal narratives and heritages, I conducted three workshops,

2012–2014, in Malmö, Sweden. The workshop series was a part of a larger research project[2] which from various perspectives studied the municipal sustainability and planning programme *Rosengårdsstråket* in the neighbourhood Rosengård. The municipality's ambition was to break segregation and connect poorer and richer parts of the city, i.e. the inner, eastern district Rosengård with the more well-off seaside areas. This included the regeneration of a bicycle path, and the building of three new meeting places (a commercial space; a small garden; and a recreation place for girls) along the path (Malmö City 2009, 2010). The planners selectively invited three citizen groups into the planning process: shopkeepers, a work cooperative employing women who have migrated to Sweden, and a group of teenage girls. The proposed meeting places were already in large part themed by the planners, and the influence of the citizens was thus confined within these limits. One of the ideas in the programme was to connect stories of the past to new artwork along the bicycle path; the programme stated that "art can be an effective identity-creating factor, used for telling the history, present and future of these places" (Malmö City 2010:21). However, this idea was not expanded upon, and the design of the new meeting places did not explicitly relate to history or past places. Neither did the activities in the programme connect inner parts of Malmö with the sea, instead being limited to Rosengård itself.

My initial intention was to study how the municipal planners engaged with notions of cultural heritage. When it became clear that history would not be included in the planning, it seemed appropriate to make my own elaborations. I asked a citizen group (which potentially could have been invited by the planners) to collaborate; unlike the planners' invited groups, this was a grassroots organisation. I thought of the workshops as a way of *planning otherwise*,[3] but we were aware of the municipal activities and interventions (the bicycle path cuts through central parts of Rosengård). The municipal process worked as a backdrop to our elaborations. Like the municipal programme, our workshops were located in the neighbourhood Rosengård, but unlike the planners we also made investigations in other parts of Malmö.

Participants, roles and ethical considerations

I wanted to collaborate with citizens with various glocal relations and experiences of transnational migration. The women's association I contacted was made up of many members who had migrated to Malmö, mainly from Asia and Europe. I learned that handicraft, education and catering are among the association's main formal activities, and that a strong commitment to social support between the members, families and friends across the world is present in all activities. The association cooperates within national and international organisations to support women, and has taken part in several local projects arranged by the municipality, NGOs or the city university (including this study). Different languages are spoken in the association – mainly Arabic, Dari, Kurdish, Pashto, Persian, Swedish and Urdu – with many members being multilingual, used to switching between languages and able to interpret for each other. Some speak fluent Swedish and others very little. Ten to twenty members participated in each workshop, with a core group of around six members who consistently took part.

I also engaged an artist, skilled in textile handicraft and the experience of making art and handicraft across cultures. I was already acquainted with the artist as a good friend, which helped to create a safe and friendly space from the start. She initially took care of material preparations (as all participants did in due time) and assisted with follow-up work and practicalities throughout the workshop series. She also took part in the narrating and textile work, as did every other participant. I too participated in the narrating work, and tried to step outside (to take notes, prepare, or take leadership) as seldom as possible. As I have previously worked in the cultural heritage field, and before that studied fine arts, I made a conscious attempt to keep a low profile, so as not to impose aesthetic directions or steer the narrating process. There were different professions represented amongst us: teachers, weavers, dressmakers, artists, artisans; an engineer, an economist, a researcher. An additional group of participants, three urban planners from Malmö municipality, was invited to the last day of the final workshop. This group consisted of an architect, a landscape architect and an engineer – all female.

As a group, we were between twenty and sixty years old, and had lived in Malmö for various lengths of time (from one to thirty years, and some all their life). Many of us had previously lived in various parts of Sweden, Europe and Asia, but also other parts of the world. Only about half of the participants were residents of Rosengård at the time. Thus, we had various kinds of local, national and transnational experiences and relations to Rosengård and Malmö. The workshops were mainly held in a locale, a three room flat which the women's association had on temporary loan in Rosengård, which came to affect the workshop process: due to being an insecure, non-contract lease, we were never sure where we would meet from one session to the next. This was an insecurity the association has dealt with for ten years, forced to move between different locales.

I suggested textile as the main working material, thinking we should use materials which most of us felt familiar and comfortable with, as an alternative to architectural drawings and maps. Some of the members and the artist had previously been involved in social integration projects where women who have migrated to Sweden were engaged in textile work. They had experienced some interesting synergies of textile traditions and ideas, but with an overhanging feeling of exploitation of their knowledge and labour.[4] No one had seen any permanent employment as a result of these projects. We discussed these issues and reflected critically on our different social positions within Swedish society and within the workshops. I recognised my privileges as white and middle-class, and that my connection to the city university could give me an advantageous epistemic position in relation to narrating as knowledge production. As a way of challenging hierarchies between the participants, as well as power relations in urban planning, the methodology in the workshops involved an attempt to situate knowledges and to make knowledge together. We did not further scrutinise the differences or hierarchies between us, but accepted some opaqueness as we focused primarily on working together across differences. Neither did we really problematize notions of gender; this might have taken the process in another, more gender-conscious direction, a point

I will discuss further at the end of the chapter. In any event, we decided to proceed slowly and to stop if discomfort arose. It turned out that we had to take a long pause for about one year between the second and third workshops, which is described below.

Structuring the workshops around themes

I had conceived of the workshops as collaborative, playful elaborations of working together and re-working narratives and potential heritages, and this was also the aim which I initially presented to the association and the artist. The focus on *working* together – even if playfully – was also the reason why the association and the artist were paid for participating.[5] After a pilot workshop where ideas were tested and discussed, three workshops were held. Each workshop lasted for around ten hours: two days in a row, five hours a day, including a lunch break which we enjoyed together in the locale. I adapted myself and the activities to each new situation, in order to make the workshop process open, dynamic and not so controlled by me. The work was made with different kinds of textiles, but also cardboard, photos, screen print, paint and text. Each workshop started off with a theme: past, present or future.

For the *first* workshop, on the *past*, we all brought objects of memory: for example, a photograph, or a piece of jewellery. We shared narratives connected to these objects, and collaboratively expressed and reworked the narratives in a large, textile application, allowing the narratives to grow, merge and repel one another and with the textile materials.

The *second* workshop, on the *present*, consisted of investigations of urban spaces in Malmö. Some participants had previously photographed special places they found bad, good, interesting, boring etc. We visited and talked about these and other places, and shared thoughts of what kind of places we needed and wanted for the future. These investigations were elaborated on together with the narratives and textile application from the first workshop.

The *third* workshop, on the *future*, was divided into two parts. During the first day, we formulated a design proposal for new public meeting places in Malmö. On the second day, three municipal urban planners participated, and the proposal was presented to them. We visited one of the locations of the proposal, and discussed possible ways to realise the proposal, as well as potential obstacles.

Narrating together, making a proposal

The initial narratives in the first workshop stemmed from our memories, which evolved around common human experiences such as births and deaths, love and separation, political struggles, wars, economy, labour and family and friends, of wine, food, cities, villages, mountains, woods and lakes… The narratives were further developed through textile applications made on working tables covered with white linen cloth. Around the room, there were boxes and piles of various fabrics, yarn and threads (contributed by all). Some applications became more like patterns, rhythms and abstract landscapes; others were more illustrative. Conversations of small and large topics influenced the work, and some memories and narratives attracted more elaborations than others. During the second workshop, photographs, screen prints and drawings of contemporary places in Malmö were mixed with the previous narratives and patterns. For example, one of the participants in the first workshop, from Afghanistan, had talked about a real city pulse (Malmö, with its 300 000 citizens is a small town compared to Kabul's three million), and combined with stories of Copenhagen, we imagined moving the whole of Copenhagen into Malmö (which we reckoned would add a million inhabitants to Malmo). As Malmö is very flat, mountains were made too. A memory of walking in the woods, represented as a three dimensional tree in the first workshop, was transformed into an abstracted tree pattern, transferred to a screen print frame, and printed onto photographs of buildings, covering the building structures with this tree pattern. The narrative of walking in the woods had turned into a narrative of walking in the millions-strong city of Kabul, and of finding one's way without the need of specific, legible pathways (the last comment was a wink to the investments the city of Malmö made into making the path in Rosengård legible – a standard bicycle path which already was well known).

Fig 2.1 Around the room, there were tables, boxes and piles of various fabrics, yarn and threads, all contributed by the participants. Photo: Re-Doing Heritage Project.

We told and developed narratives, ranging from the story-like to the realistic.

The process was open and playful. We were planners, artists, designers, researchers, leaders and assistants, interchangeably. This ambiguity helped us formulate and connect ideas in new ways, though it occasionally created some confusion. These situations were resolved as we continued, but at one point we had to take a long break. This occurred during the framing of the last workshop, and how to approach the municipal planners. We had different understandings of the relationship citizen–municipality: is it wiser to make an appeal to the municipality through a forum established by the municipality, or should we instead make the more activist move of claiming a right to space? Or better yet, to proceed as planned – to invite the municipality to our locale and work process (which in the end, we did)? The disagreements, together with uncertainties regarding the lease on the workshop locale, led to postponing the final workshop by an entire year. During this intermission, we met occasionally just to talk and drink tea, and to shore up our alliance. Gaining some distance, we could now talk about what we had done in the previous workshops, and what it could mean in a larger context. When discussing heritage, identity and living in a new society as a migrant, one insight we reached was that it was important to have somewhere safe and permanent to meet in the first place, to be able to develop a culture – or what could be called identities or a cultural heritage – at all. This reasoning was based on the association's experience of a constant struggle (and ultimately failure) to secure a long-term contract for a locale for the members' activities.

At one of these meetings, one of the participants recounted a memory of drinking tea with her family in Tehran on a dark winter's night, snow falling. This remembrance sparked new ideas in the group, and everybody enjoyed the story:

> When I was a little girl in Tehran, I sat with my family in the yard around a low table, drinking tea. It was a winter's evening, and the mountains rose high and dark behind the house. We all had blankets and sat close to each other. White, big snowflakes fell slowly in the dark, and my grandmother told stories about when she was a little girl. It was warm and cosy under the blankets.

This narrative opened up an imaginative space we all could share, and several of the participants had positive memories of similar experiences. We decided to create such places for Malmö, and conceived a way to continue with the third workshop based on this idea. The narrative was connected to previous investigations of Malmö: for example, the fact that many citizens are living in crowded, small flats, which makes outdoor meeting places especially appreciated. But Sweden is cold, so we imagined places where we could keep warm. Someone brought up the tandoor, a type of oven common in many parts of Asia which can bake flat, round bread in a few minutes. A resulting look at the public barbeque grills in Malmö confirmed that some models could possibly be converted into tandoors. We made a proposal for three new meeting places in Malmö: one in a small park in Rosengård, one in a large central park, and one by the sea. The three places connect inner parts of Malmö to the sea, along an imagined east-western line (just as the Rosengårdsstråket programme initially intended to do, but never did). The proposed places consisted of low tables, easy to sit around with blankets, and a tandoor for baking bread. "Imagine", said the woman from Tehran, "we could sit there and tell stories to our children, of what it was like when *we* were little girls".

The proposal was presented to three municipal planners, whom we had invited to the last day of the workshop. Along a wall in the locale, we arranged a presentation made from simple and inexpensive materials: maps (for the first time); drawings, photographs and collages; pieces of texts written in several languages; small cardboard models of tables and tandoors; a low table laid with colourful cloths and a nice teapot and glasses. We all took turns in presenting the proposal, each explaining different parts of it and interpreting for each other when needed. We argued for how well the proposal fit with the objectives of the city's comprehensive plan.[6] We then visited a nearby park which was one of the proposed meeting places. Back at the locale, we shared a lunch and discussed how to proceed with realising the proposal.

Interviews reflecting on the workshops as doing heritage

Directly after the workshop, I conducted short interviews with one of the association members as well as the municipal planners, individually. The association member said, "I've always thought that it's complicated, that you have to use difficult words… and a lot of products and techniques… but I feel you can be light and simple; you don't need the [Swedish] language to present something that feels right". When asked why she thought the presentation had gone so well, she answered, "I don't know. Is it this environment, that they came *here*… if we would go *there*, how would we present?". For her, the situatedness of the proposal and the presentation was relevant. When asked if she thought the proposed places could be regarded as cultural heritage, she answered "Yes, it is actually culture". "But what about cultural *heritage*?" I asked. She answered, "Yes, in fifty years, we will talk about these places we build in Malmö now, as heritage". I interpreted this as meaning that she conceived of cultural expressions as being a reality in the present, with cultural heritage denoting something more remote, in a past or future.

The planners appreciated the presentation as well. One remarked, "We could *never* have come up with these ideas". They suggested a collaboration between the association and one or two municipal departments for realising the proposal, and saw possibilities for funding from an EU-grant or a local beautification fellowship. They also expressed their belief that the project had a good chance to receive funding from the National Board of Housing, Building and Planning, which specifically provides special funding opportunities for supporting "gender equality in public environments" (even though we had not presented the proposal as a gender equality project). I asked the planners if the narrating part of the presentation had been important for understanding the overall idea, to which they replied, yes, absolutely – in particular, the narrative of the night in Tehran had made a big impact. Furthermore, the accounts of overcrowding and the need for warm meeting places were seen as valuable. They answered with a spontaneous yes when I asked if they could imagine themselves making use of the proposed meeting places.

A couple of weeks later, I interviewed the three planners again, this time in a group interview at their office. Even if they were not engaged in the municipality's cultural heritage work (a task exclusively for heritage professionals), I thought it would be interesting to get their view on what cultural heritage might mean in an urban planning context in Malmö. On the question if the proposal could be regarded as cultural heritage, they first hesitated, answering, "It depends on what one means by cultural heritage. In the planning process, cultural heritage is something that cannot be touched, something that should be preserved". One planner said, "We shouldn't call this proposal cultural heritage in Sweden, because it isn't *our* culture", to which another immediately replied, "…but it could be!" Importantly, they all agreed that the *term* "cultural heritage" is confusing: "Of course, the tandoor belongs to *their* cultural heritage, and it *is* actually a cultural heritage, if one should use that term – a cultural heritage which can fit in our culture too, on our chilly summer evenings." The discussion went on: "…but the question is if it is an *important* term to use? It could create confusion… I think you can save a lot of trouble by applying another term if you want the proposal to be realised, because the question will first be encountered by the cultural committee, and then the building committee… people will become irritated". Laughing, they then joked about how they found the question irritating already. I said, "It's interesting that you think that this differentiation is so important." One answered, "Yes, it's important; it's our cultural heritage; it's really heavy, I thought about it the other day, it's so connected to the Swedish culture…", and the discussion seemed closed when she ended with, "It's our home environment!".

According to the planners' understanding, cultural heritage is something which is clearly connected to Sweden and is dealt with by specific professionals. However, the planners also displayed ambivalence and contradictions: a low table with a tandoor *is* already cultural heritage; and while it shouldn't currently be referred to as such in Sweden, it could possibly *become* Swedish cultural heritage.

Fig 2.2 The workings of a tandoor is demonstrated for urban planners in the last workshop. Photo: Re-Doing Heritage Project.

Fig 2.3 A happy baker standing next to a tandoor, with wood, oven mitts, bread and patterned table cloths. Photo: Re-Doing Heritage Project.

Fig 2.4 A picnic table (with colourful blankets to keep warm) placed in a park. The green lightboxes to the left could be switched out for tandoors. Photo: Re-Doing Heritage Project.

This view implies that objects and practices have to be manifested in Swedish territory first, for some length of time, before they can be regarded as cultural heritage. And as the planners asked, is it really important to call them cultural heritage? Similarly, the association member thought of the proposal as a heritage for the future. These reflections are perhaps not surprising, as we were in fact discussing places not even built yet. Presenting our proposal as cultural heritage pushed us to imagine future, past and present simultaneously in an unusual juxtaposition. However, to consciously create heritage in the present is not as unusual as one might think: the National Property Board of Sweden, for example, claims that it "*creates* tomorrow's cultural heritage" (NPBS 2016, italics added).

Methodology and Conceptual Framework

The framing of the workshops was inspired by previous planning and architecture projects which have attempted to transform practices while problematizing the tendency of expert roles and inaccessible languages to create exclusions. For example, the feminist design collective Matrix, which was active in London in the 1980s, challenged patriarchal, man-made environments. By producing architecture and knowledge together with women and users of architecture, they attempted to create a new language of space and aesthetics, accessible to everyone involved (Matrix 1984). The research project *Spatial agency*[7] acknowledge spatial production as belonging to more actors than just architects, and that various knowledges, intentions, voices and activities can also be part of an architectural process. Like Matrix, the Spatial Agency project also points to the need for a new language of space, finding that many architects lack a professional vocabulary to be able to talk about the informal (Awan, Schneider & Till 2011). Their approaches encouraged me to use handicraft in the workshops, and to downplay the importance of professional architectural drawings, maps and spoken language. Inspiration also came from cooperative, environmental conservation projects which have demonstrated that knowledge production concerning biology, ecology and environmental management often depends on local,

situated practices as well as global, collaborative approaches. Some of these environmental projects also problematize rational knowledge made by scientists from distanced positions (see for example Fortmann 2008 and Arora-Jonsson 2013). Managing an *urban* landscape can likewise be a matter of situated knowledges of management and care – knowledges which can be of a glocal character.

Situating knowledges together

Viewed collectively, the citizens of a city have an endless number of glocal relations. As soon as you start to study a certain connection, you immediately find, or make yourself, new connections (new people, places, texts, images etc.). In the workshops, we wanted to mobilise those glocal relations which were experienced as meaning-making for us, here and now. The workshop series was therefore framed as a process of *situating knowledges*. This meant that the participants, including myself, made partial investigations and knowledge claims together situated in a particular time period (2012–2014) and in a specific space (Malmö and Rosengård). Haraway (1988) has shown how situating knowledges can work as a strategy to navigate between positivism and postmodernism. It is a way to avoid both making (elusive) context-independent knowledge *and* falling into the trap of an irresponsible kind of relativism, both of which Haraway has described as playing the 'god-trick' of leaping out of the scientist's body and presenting knowledge as though made through a gaze from nowhere. I think situating knowledges also allows us to take responsibility in the here and now, but without neglecting universalising ideas of justice and democracy, keeping in mind that these notions are not static and need to be continuously and critically recaptured – performatively exercised – in every planning situation. A crucial, political opportunity of situating (glocal) knowledges, as I see it, is that it enables us to avoid falling into either a rationalised universalism or a particularistic essentialism.[8]

Our position in the margin of the city led us to see the planning interventions in the neighbourhood, as delivered from the municipal planning office in the city centre, in a different light than from

the typical central position. Sharing this margin-alised position helped us to identify and validate alternative ideas together. In *Feminist theory: from margin to centre* (1984), hooks shows how seeing from the margin can be advantageous: from this position, both the inside and the outside perspective, the centre and the margin can be understood. In our case, this meant that we could understand what the municipal planners were trying to accomplish, but also how they imposed *their* meaning-making and desired identities in the place-making process onto the neighbourhood, which did not necessarily correlate to the residents' various perspectives, needs and wishes.

Another way of further conceptualising the way we collaborated in the workshops is to think of our work as sharing a feminist standpoint[9] (Harding 2004) through mobilising a temporary group alliance, across differences. We did not see ourselves as sharing an ontology of womanhood, or intrinsically belonging to this place or another. More simply: during this period we shared a position and viewpoint from where to study the city. Making a safe workshop space was key for accepting ambivalences and to play with roles of being (alternately) citizens, artists, leaders, planners, architects and researchers. We also shared a concern for the environments of Rosengård and Malmö, and for all citizens. Through this alliance, we tried to make sense of some places in Malmö, a work which allowed our partialities to come together and form something coherent and legible, which ultimately resulted in the design proposal.

Throwntogetherness, performativity and citizenship

To examine how urban planning can make glocal connections between narratives of past, present and future places through place-making, I brought together concepts that theorise processes of narrating, identification, political subjectification and space. I find Massey's (2005) image of *throwntogetherness* helpful for approaching urban planning as an open, glocal narrating process. It emphasises space as process, where different life-courses and imaginations are being 'thrown together' in a mutually consti-

tutive process of weaving a space-time. 'Here and now' becomes where spatial narratives meet up and form configurations – a place where people's life courses or trajectories become 'stories-so-far', with their own temporalities. Identities, spaces and times are mutually and continuously being made in this process, and can therefore never be fully defined (2005:138–142). This implies that it is impossible to completely close space – for example by conquering, reduction or homogenisation – to one single trajectory: "there are always cracks in the carapace" (2005:116). As an example of closure, Massey discusses the dominant narrative of modernity, and how notions of 'advanced' and 'underdeveloped' countries reduce the world into one single trajectory, one history, and one imagination of growth and development. Narratives, she argues, do not have to be about unfolding one internalised story (i.e., of Europe) with already established identities (Massey 2005, see also Chakrabarty 2000).

In such a single-directed perspective, some countries, cities, districts and neighbourhoods are implicitly regarded (and thus treated) as 'underdeveloped' in planning documents (see Sandercock 1998). This pattern also emerged in the Rosengårdsstråket programme, which addressed some parts and residents of the city as in need of change to break segregation, but not others. Massey has coined the term *power geometry* to denote how unequal social relations often place different social groups and individuals in disparate ways in relation to globalisation and (glocal) place-making processes (Massey 1993, 2005). Gender discrimination and inequality can likewise be seen reflected and materialised as a patriarchal 'geometry' or order of space and architecture, as investigated by Weisman (1994) and Rose (1993). For example, in the municipal Rosengårdsstråket programme, the invited citizens' groups consisting of women and girls were connected variously to kitchen gardening, culture, sharing and a stage for girls' dance, while the shopkeeper group was made up predominantly of men and was connected to trade and making business prosperous.

Thinking of urban planning and place-making as a *throwntogetherness* suggests that identities – or rather identity positions (as architect, planner,

resident, (illegal) migrant, teenage girl, teenage boy, land owner, researcher…) – are spatially repeated and confirmed through these processes. How space, time and social relations are imagined in planning practice and documents therefore become a deciding factor for which identity positions (political, professional or citizen categories) are possible to make, or expected, within a planning discourse. Planners and citizens, who try to make sense of the city and themselves as well, then become part of larger constitutional processes of repeating and confirming these identity positions. These processes can be seen to produce identities which, in line with Butler's theory of performativity (Butler 1993, 2004), are not inherent or fixed, but constituted through performative acts that reiterates identity positions offered by discourse (see Dent & Whitehead 2002 on performing professional identities). The performative voice of authority can be understood not only as represented by the planners, but also through planning images, maps, drawings and symbols (Glass 2014; see also Harley 1988 on the articulating, structuring and manipulative power of maps).

When public spaces are negotiated within participative planning projects, these activities are thus also entangled with practices of citizenship in a more general sense, and are often framed by municipal planning offices as democracy-enhancing projects, as well. Mouffe discusses an aesthetic dimension in the political which concerns the symbolic ordering of social relations – a dimension which can be played out through the 'discursive surfaces' of public spaces that always are structured by power relations (Mouffe 2013). To Mouffe, political communities and a 'we' are partly constituted through identification processes within such discourses, with shared or contested images of the social, ethical and political (1992). She describes dominating discourses as hegemonies, and argues that these can never be wholly complete systems of order as every order is based on inclusions and exclusions of possibilities: a society could always be built in another way. Therefore, every order always has cracks (at the very least, a 'last suture' in a given system is always missing), making hegemonies open for interventions, conflicts and transformation. Instead of striving for consensus, which implicitly and consistently creates

a constitutive outside – a 'them' – Mouffe argues that it is important that differences and clashes of different positions are acknowledged to bring about a well-functioning democracy. Those actions that dis-articulate and intervene in hegemony – actions which demonstrate that the order is not given – are regarded by Mouffe as counter-hegemonic struggles (Mouffe, 2005, 2013). Massey refers to Mouffe's politisation of identification processes as both political *and* spatial processes (2005:10).

In Butler's reasoning, the performative carries a political promise of transforming dominant discourses: a failure or resistance to reiterate a given identity position can be acted upon to challenge that very discourse or politics which normalises exclusion or hostility. When bodies mobilise space and materials to form alliances, they can enact the social orders or identities they seek to bring about. This can be seen variously in the Arab Spring, the Occupy Movement and Pride parades; and by squatters and demonstrating 'illegal' migrants, who performatively 'appear' in public space by starting to take the rights they ask for, such as free speech, housing or legitimate existence (Butler and Athanasiou, 2013). Butler draws on Arendt's notion of "space of appearance" for how people appear 'explicitly' before each other: to be deprived of such space is to be deprived of reality (Arendt 1998 [1958]:198–199). Material environments take part in the mutual interrelationships between citizens, citizen groups and authorities. Following Massey's *throwntogetherness*, these relations are always spatial and temporal as well as political and identity-constitutive. As such, architecture can both open and close for possibilities for citizens to 'appear' through public space in various ways. Simultaneously and mutually, meanings of the material environment may be resignified by performative acts (see discussion in Butler 2011).

Swyngedouw and Kaïka (2003) present a similar image as Massey and Mouffe, where (the story of) modernity, traditionally expressed or mirrored by a city, is seen as cracked and fissured. They see that in these cracks "that are opened up in our contemporary fragmented 'glocal' cities… new urban experiments, often in the midst of social exclusion" are growing. These emerging new forms of urbanity are practices which need spatialisation (Kaïka and

Swyngedouw 2003:19). In our workshops, we opened the planners' eyes to something which was to them unknown and unexpected: to identity positions and glocal practices which are part of the contemporary city, but in need of further spatialisation.

Doing and Re-doing Heritages through Planning Practice?

In the municipal Rosengårdsstråket planning programme, the extent to which participating citizens could contribute was limited, as the place-making was already contextualised by the planners. Within the workshops in this study, everything was possible to imagine, at least initially. This made us open for new ideas, and we played with doing and re-doing narratives of pasts, presents and futures, and doing and re-doing of (potential) cultural heritages. We made new glocal, temporal and narrative connections, and played with shifting professional identities. However, this openness also led to a few disagreements over what direction the workshops should take, including our relation to the municipal planning office. Our temporal alliance helped us to stay put despite these differences, and eventually we were able to mobilise ourselves around, and proceed with, a design proposal for new meeting places – a proposal which expressed glocal, cultural relations.

Massey's image of *throwntogetherness*, which sees space, time, identification and narrating processes as mutually constitutive; Mouffe's understanding of how political collectives (as a 'we') are identification processes, made through hegemonic and counter hegemonic struggles; and Butler's reasoning that performative acts potentially can be used politically, are all concepts and theorisations which have guided this study. A strategic way to performatively challenge dominating norms and hierarchies played out through urban planning could be to shift narrating roles, methods and mediations (maps etc.). Our workshops showed that traditional ideas of national belonging and normative narratives of the city can be challenged, and possibly reworked, by 'appearing' in planning practices in new social, spatial and material configurations.

The performative force of insisting on 'other' narratives through 'appearing' in urban space, may thus potentially be a way of opening up dominating narratives or discourses. Massey, Mouffe and Butler speak of cracks and fissures in discourse, which can occur when norms are challenged. Understood through the concept of *throwntogetherness*, such discursive cracks are also spatial and temporal. These images of cracks are hopeful possibilities or passages to more open, varied, and equal futures. To recognise, believe in and act upon such cracks in dominating discourses, narratives and spaces can be a move towards making feminist futures.

Still, I am aware that the workshops reproduced a stereotyped view of women by performing activities that are strongly connected to biased understandings of the identity 'woman', seen for example in the use of many home-associated activities simultaneously (textile handicraft, cooking, caring and sharing). The fact that we did not problematize these stereotypes shows that even with a feminist-oriented methodology, gendered identities can pass as givens if repeated. Imagining that this had been an authorised cultural heritage project, this would demonstrate how gendered identities in protected narratives have the implicit risk of being further cemented when being preserved, if they are not explicitly problematized. What now came through as gendered performative acts might have originated as my own biased expectations of the association members' preferences. However, in understanding these activities (though feminised) as nevertheless important for society, we were able to bring these traditionally private activities into the public sphere by imagining them in outdoor urban space, thereby re-contextualising them and giving them a new relevance.

I argue that, for a short while in the last workshop, we succeeded in opening up an unexpected space for countering dominant narratives and traditional planning roles. The municipal planners made a physical shift, moving their bodies from the central planning office to our marginalised position, to see the city together with us from our perspective and to produce knowledges together. We exchanged roles with the planners: they took part in our planning process and our way of framing space, instead of the other way around (as is the

usual procedure). Thus, we destabilised authority and their habitual ways of acting and seeing the city. For this to happen, space needs to be accessible and imagined as open and available in urban planning, as our presentation and proposal implied. As Massey says: *for* the future to be open – space must be open too (Massey 2005:12).

1
The *doing* is here thought of as performative acts (Butler 2004, 2011, Butler and Athanasiou 2013) of narrating the city in contexts outside of institutions where cultural heritage is traditionally legitimised and constituted by authority. See further discussion in the methodology section of this chapter.
2
The study was part of the research project "Transforming dual cities. A study of integrating sustainability through urban passages of mobility" at Malmö University/Urban studies, 2011–2015, jointly financed by Formas and the Swedish National Heritage Board (for overview of sub-projects see Listerborn et al. 2014). The workshop series study also received a grant from the strong research environment "Architecture in Effect", funded by Formas.
3
See Awan, Schneider & Till (2011)
4
For investigations in how stereotyping, racializing notions of 'immigrant women' are constructed through integration projects with textile work, see Lundstedt 2005. Mc Glinn (2014) has discussed how migrants become 'raw material' in a European market of integration projects.
5
The association was paid an equivalent of a PhD student hourly wage per participant (paid to the association for collective use) and the artist was paid for the actual workshop hours only. No one was paid for attending the meetings we held between workshops.
6
It was however easy to concretise the comprehensive plan's quite abstract formulations: "Urban spaces are important for desirable social development"; "More social spaces are needed and safety and equality in the city's urban spaces must increase"; "it is essential that steps are taken to increase participation in the planning processes"; "existing parks must be developed"; "Malmö will develop as a mixed-function city" (Malmö City 2014:3,6).

7
The project has created a database collecting architectural projects where the social in architecture is elaborated: www.spatialagency.net/
8
Mouffe in *The democratic paradox* (2009) discusses the universalist-particularistic dilemma. She argues for keeping the contradiction open, dynamic and conflictual. Consensus approaches, she argues, conceal inequalities and conflicts which however will always be at work.
9
The concept of a feminist standpoint was introduced by Hartsock (2003 [1983]) correlating to the Marxian 'proletarian standpoint' as a privileged vantage point from which to understand the bourgeoisie, because the vision from the dominating position is precisely that what structures the unjust relations. The concept of a feminist standpoint has from the start been an arena for debate, for example critiqued for essentialism and for cementing a contested man-woman dichotomy (Ramazanoglu and Holland 2002, 60, 63–64). Harding, however, suggests a standpoint close to Haraway's situated knowledges, and argues that situatedness means a 'stronger objectivity' than the positivist objectivity, which is unaware of its situatedness. For further discussions, see authors and debates in Harding 2003.

3

THROUGH OUR DANCE WE WEAVE THE DANCE FLOOR AND CEILING

- A CONVERSATION AMONGST MYCKET

**MYCKET
(MARIANA ALVES SILVA,
KATARINA BONNEVIER
AND THÉRÈSE KRISTIANSSON)**

Who we are

We, MYCKET (MKT), form a collaborative practice in art, design and architecture. Our group consists of Mariana Alves Silva, Katarina Bonnevier and Thérèse Kristiansson. With this essay we write the story of an extensive project in 2013 with several outcomes; the full scale re-enactment and exhibition of a queer feminist carnival, *Exclude Me In*; the map of the queer geography of Göteborg at the turn of the 20th century; and the docufiction film *History as we know it*. Standing on top of a park bench at Esperantoplatsen, dressed in our best poster-costumes, we gave a speech to start off the carnival *Exclude Me In*, here are the first lines:

> Vi är det återfunna karnevalståget
> som har legat och jäst i bomullsmagasinet
> Vi är en bakteriekultur som återfanns av en händelse
> Vi är den saknade pusselbiten.
> Vi är Göteborgskarnevalens queera batterla.
> Vi återupprättar arkeologin,
> Vi är Packet, the Cake Mob,
> men vi stannar inte i boxen.
> I det rosa rummet.
> Vi smittar,
> vår kultur är mitt i samhällskroppen,
> går inte att medicinera,
> eller skicka gay straight to hell.
> Vi utgör motivet, hemmet, hjärtat.
> Utan oss ingen metabolism,
> ingen rörelse, ingen transformation.
> Vi är den klarnande tanken,
> den levande kroppen.
> Vår berättelse skriver inte his/toria,
> inte heller her/storia,
> vi skriver hen/storia.
> Minst.[1]

M (Mariana Alves Silva) In MYCKET we often say that we work with "minimalistic maximalism". It doesn't mean that we have to do a lot of things or make a lot of objects but we focus carefully on the details in each and every object. To take care takes time, both in action and thought. The process is open and ideas can be reformulated

as we rework the materials. What's more, we also claim that we want to create "maximalism with minimal effort". To do a lot does not necessarily have to be time consuming. Possibly a bit contradictory, but there's no need to be consistent, as Audre Lorde puts it; the difference between painting a back fence and writing a poem is only one of quantity, and that there is no difference between writing a good poem and moving into sunlight against the body of a woman I love.

K (Katarina Bonnevier) When I think about our project *Exclude Me In* I recall the massive feeling that overtook my body as I walked from Esperantoplatsen to the night club Nefertiti in the midst of the boiling carnival parade. Surrounded by people, strangers, lovers, passers-by, accomplices, who chose to stand out, dress up and join us to act out queerness and reclaim not only the street but also the history of Göteborg.

T (Thérèse Kristiansson) I know, I always get overwhelmed when I understand that we are many who feel the same, hurt the same, and believe in the same things. And how we change things, not through hatred and violence, although violence is used against us, but through love. Our different experiences of difference are what make us the same. Like bell hooks says, that when love is present the desire to dominate and exercise power cannot rule the day, and that when we choose to love we choose to move against fear – against alienation and separation. The choice to love is a choice to connect – to find ourselves in the other. Loving is an active choice, it's not a noun, it's a verb, and on a political level, it is certainly hard work. But how could you outsmart hatred otherwise? Only through loving, right?

MKT Since the beginning of our collaboration in 2012 MYCKET has been working with staged events that, in different ways, work as reparative spaces, and spaces of sharing and learning. Our passionate group has been busy doing, collaborating (often with a large network of people), and reflecting, and now, here in this text, we take the chance to formulate some of those reflections in writing. We structure this essay through elaborations on in-depth questions, which we pose to ourselves and to each other, experimenting with the writing and formulating process as a kind of pedagogical momentum in itself.

Dreams, preferences and aspirations

T I had actively been looking for people to collaborate with for years. It's hard to find people you love working with on a daily basis. I'd been working full time in another art collaboration[2], where the other members didn't have the possibility to devote as much time to it as I could, and I felt lonely and sad in that position. I was representing a collective rather than actually being part of one. Katarina had been my mentor and teacher, and I had checked up on Mariana and her work and admired her from afar until she joined me in an open art project I hosted. So when Katarina quit teaching, and I had gotten closer to Mariana, I was convinced that I wanted to work together with the two of you. I remember being overwhelmingly happy when we started our first project in 2012. Our collaboration felt like coming home, it still does. Just like when I received the first part of this text from you, Katarina. I'm actually kind of tired and stressed out by other work currently, but receiving this text, and being asked to respond to it, made me so happy!

Our collaboration nourishes me professionally but also privately, since work and life intermingle for me. I think it's key that we all share the same ideas and ideals on how we want to work, how much, what is most important to us, in which tone we speak to one another and to ourselves. Are we loving and forgiving or harsh and punishing? MYCKET is a professional and political organisation as well as a love story that grows stronger and stronger and I'm very keen on taking good care of it and to let us grow over time, until we're old. I want us to be 80 years old and still work together – sitting in the garden with coffee, cakes and home-grown tobacco, designing things.

M Before we all became close, I had been longing

to find someone, or –ones, for a continuous collaboration. Just like you describe, Thérèse. People who also wanted to realize that which for others might seem like castles in the air. I felt like I had started to strangle the love I felt for my practice, in a state where I couldn't move beyond the critical anymore. I was mainly involved in teaching and I felt more and more exploited intellectually, because I inspired others to do what I was longing to do myself.

When you asked me to collaborate I remember that I was thinking that I should push myself to do my utmost and be the best version of myself for you. However, the effort wasn't necessary. There is intensity and sharpness in our collaboration but also the space for recuperation, where I can relax every muscle.

> Vi tog plats här i bomullsmagasinet utan eget tak,
> vi drömmer om att räddas
> genom att rädda det förflutna.
> Vi har alla tvingats bära skammen,
> skammen över att vara annorlunda.
> Men vi och våra medvarelser
> har rätt att vara tillsammans
> på de sätt vi själva väljer
> utan insyn, kontroll eller pålagda definitioner.
> Vi är fria och myndiga i ett land med mötesfrihet.
> Helt enkelt.
> Vi vet att ensam är svag.
> Vi letar inte efter vår andra hälft.
> Vi vet att vi inte behöver lära oss reglerna
> för att kunna bryta mot dom.
> Vi vet att var sak på sin plats är en lögn.
> Tillsammans går vi över och bortom regler
> satta av självgoda vita män.
> Vi begär mer.
> Vi slår tillbaka. Hit & Miss.
> An Army of Lovers Cannot Lose.[3]

Messy process

K People close to us often describe how messy our process looks from the outside. When I do projects outside MYCKET I feel a need to know everything, and have an answer for everything. I need to be in control. However, in our collabo-

ration I am relieved of this pressure since I don't need to be in control. It works, since I trust you and I know that whatever decisions you make or actions you take, I will like the appearance of it and support the thoughts behind it.

T It has a lot to do with trust. I trust and respect the work both of you do, and I trust and respect the ideas behind it. If your opinions differ from mine initially, I know that you have valid reasons, maybe I have a blind spot, or you do. I prefer when we are physically in proximity when working together (because it's so much fun, and we're so smart together;) but I also know we're capable of taking on stuff on our own. That we ask for help when we need it, or make decisions on our own when we don't.

M I really identify with what you write, Katarina. The balance between trust and control is relevant in every relationship; in close ones, such as ours, as well as in the larger perspective of society. When trust is strained or absent, the need for control increases. I have a great deal of faith in both of you and I admire you for what you do. Through our collaboration I have also strengthened my trust in myself. The combination has helped me redirect my way of working, from the idea of a straight and aligned order to a more organic process. Since I know that we stand firm when it comes to our political intentions and perspectives, I feel that there is space for experimentation, trials and testing. And, yes, certainly, it can look messy from outside.

MKT We, MYCKET, share a common ground in our strife to practice our work based on a set of intersecting perspectives and entities; queer, feminist, class-aware, anti-racist. However, we were not sharing the same physical space or moment in time when we started writing down these words (Katarina sat on a train bound for Norrköping, Mariana in the breakfast room of a hotel in Göteborg and Thérèse on the hillside of an agricultural village in Italy). Since then we have circulated the text between us for quite some time, laughing over it and debating it, as

we have continued to move in and out of a long series of other professional and private engagements, up to this point where we find ourselves within the solid walls of our shared space at the Center for Architecture and Design in Stockholm, finalizing this writing.

The vast span of situations which parallels and influences this textual production have, compared to an instantaneous interview, already altered the ways we think about or practice even as we continue to write it. For us, this essay has partly performed what we set out to accomplish, simultaneously it is a performance in writing that happens in the here and now; when we share these words with you. We decided to keep the interview format of the process of writing to underscore the performative force of the text, a force, which Judith Butler has taught us relies on theatrical quotations which come out as speech; the way in which we say what we say and the way in which we write our bodies into the text as well.

There is, as you have already read, a common voice in this essay, that of us, MYCKET. This plural voice frames the situation but never behaves as an omniscient observer, rather we try to open the door to our internal conversation and welcome the audience of readers into our space. You have also met the three voices of the respective group members, fashioned to display difference and character. Before we continue our conversation we want to tell you some more about the project *Exclude Me In*.

Reparative practices and spaces/ A project that put history right

In short, *Exclude Me In* was a re-enactment for Göteborg International Biennal for Contemporary Art, GIBCA, 2013 based on the carnival which took place in Göteborg from the beginning of the 1980's to the early 90's.[4] 'Göteborgskarnevalen' was a grassroots initiative with close links to the large illegal club scene of the time, at its height involving 200 000 people, which has never been part of the formal history of the city. But what is more intriguing is that *Exclude Me In* was based on an absence in Göte-

borgskarnevalen. When going through the personal archive of the chairman of 'Karnevalsföreningen', filled with fanzines, photos and VHS recordings, we found the beautiful abundance of a carnival, but also an overwhelming representation of straightness, patriarchal values is such ways that there were men with names (such as the DJs and musicians) and anonymous women (such as the artists painting the banners and decor). We did not know what to do with that material. There was no room for us and people like us. Our qualified guess is that shame, fear and hate made it impossible for an overt expression of queerness at the time of *Göteborgskarnevalen*. We had to do something about that. MYCKET ventured into an exploration of the queer and feminist club scene in Göteborg. With the help of a large social network we mapped every night club and association we could find from the 1980's until today and built our own carnival based on this mapping. The mapping was carried out on social media, via e-mails, and phone calls. One key figure led to another. Alongside our extended group, we created costumes, hats and instruments for more than a hundred people, inspired by the outfits of the various clubbers, banners with the names of the clubs and mythical figures of the scene. On Sep 6, 2013 with music and dancing, we realized the dream of what should have been there, with all the people who came to play with us.

K A dilemma when writing about what we do is that there are always so many collaborators and people assisting us. Take for instance August, 2013, when we were producing the material for the carnival and we went to work in *Sågen*, an old abandoned sawmill in the farmlands of Östergötland. We lived in the old Workers' house *Haga*, which I share with my partner and another couple, and on and off there were so many people; the three of us, Annika Enqvist and Maja Gunn, and three small children, Sam, Otto and Charlie, two assistants Minna Magnusson and Moa Sjöstedt, supportive friend Patriez van der Wens, partners Marie Carlsson and Carolina Hemlin – everyone played important roles in the production and all of us were necessary for the outcome of the project. We did not plan it, but

when we stopped for a moment we realized that we were actually doing a live action roleplay of the collective work of the carnival, re-staging the anonymous female textile painters.

In our laugh about the situation the rural backdrop became a perfect set with abundant summer days, sun and rain, old wooden houses with worn-down floor-boards, light seeping in through the panels. Queer feminists dressed in hoodies, baseball caps and summer clothes from earlier decades, with a shared space, the material privilege of a place to work and passionate work to be done. So much love and devotion, all these helping hands supporting the project with time, patience, and money. Cooking supper, playing with kids, negotiating our differences. Pretty intense, don't you think?

T Hahaha, yup pretty intense!

I think we have this talent, all of us, for not really understanding what we're getting ourselves into. Sometime it means that stuff becomes too much for us, but if we didn't have this fearless curious joy-driven approach to our work, it would never turn out the way it does. I think we'll have to cope with this all our lives, knowing that we sometimes do stuff that is really pushing our boundaries, and knowing that from the beginning. We might have to be a little bit more cautious though, just a little bit.

M Yes, it was definitely intense! I remember that time very vividly, possibly because it was a completely new phase in my life. I had a new-born child when we were doing this project, and Sam was with me everywhere. I remember that as soon as Sam fell asleep, I immediately picked up where I had left off. Brought out the wood and the knife – cut and paint! Every second was precious! The constantly disrupted process gave me a corporeal experience I had not had before; I experienced the importance of the collective support for the possibility to be able to express oneself artistically at all. As if we had been moved forty years back in time when childcare was not developed in Sweden. And at the centre of that was the feminist struggle, not only in

the artistic piece that was growing through our hands, but also in the efforts of everyday life.

K Another aspect is the temporal part of materiality, the particular presence in the production of material spaces and objects. I'm always underestimating how much effort it takes to do things. It is like a time of its own, filled with all the details that need care and my full concentration. Moving, finding, repairing, painting, lifting, joining, constructing, copying, adding. Being on site. This particular presence is for me the most surprising and gratifying in my shift from the more distant position in relation to materiality I had as an educator to the more hands-on practice MYCKET is engaged in.

T I'm also surprised by how much time it takes to physically build things. I think I haven't had enough practical experience to really know how much time everything takes; all the things that are part of building, to go back and forth to the hardware store because you forgot stuff, to explain to people what is happening so they can help, to take care of all the relationships in a project (phew!), eat enough, have enough – but not too much – coffee, waiting for the right paint to arrive, for the technician to come back from lunch. I feel like Katarina, I love that part of the project, but I think it's hard giving it the time it deserves, the time that makes it enjoyable and not stressful. I also need a little time to get started. Somehow I'm always a little nervous before starting to build, or paint, etc.

This means that I need to take time from other things, say no to lecturing, teaching, writing texts like this one for example. I think I would like to be better at unifying projects, not have them dispersed and spread out over time. To do more, one thing at a time. And do less.

M I have a specific memory from working in *Sågen*, of how the aesthetic expression developed as I was carving the instruments, the tambourines.

I carved and added paint, and when I didn't get it right I carved it off and tried again with a new shape. I consider the process of crafting

similar to that of dancing. When dancing, you can do prescribed steps and gestures, or you can improvise completely, not knowing anything about the outcome, as we do on the dance floor. Listening to the music, letting ourselves follow the rhythm and changing technique in the moment, repeating moves and sometimes pushing the limits trying something new, a surprising twist with your hip. Either you like the feeling of it or you don't. It is about the hands' and the body's ability to carry out certain activities. Through our lived bodies we have a strong sense of our capacities and limitations.

In the making of the instruments for the carnival this was actualized – how much crafting as a method is present in our method. It is about not having everything under control, always making space for the unpredictable, as a way to learn new experiences but also, and maybe even more importantly – to find new aesthetical expressions. We know that we need to take risks, neither follow the straight line from A to B, nor a concept all the way. That we need to take detours to be surprised. And, what's more, even if you try to plan the deed you can never be completely certain of the outcome.

This kind of process is crucial for how I want to work. And it does take time, because of all that comes with it, like getting the material before you can even start building. I remember once when I was so stressed out about all the tedious doings of life, showering, eating, grocery shopping, and you reminded me of the importance of making these actions significant, to see this as equally useful and important. As when Audre Lorde speaks about the erotic as a resource rooted in the power of our unexpressed or unrecognized feeling. That the erotic is not a question only of what we do; it is a question of how acutely and fully we can feel in the doing.

I have noticed, not only for the sake of the body, but also for my practice, that the care in each step of the process at the end actually gives me more time. For example, counted in minutes it takes a very long time for me to read and answer you in this text, but this is how it becomes important.

Future designs

K Since I started researching the relationships between architecture and gender I often get questions about future designs; how would it look if you were to design and build queerness? What can you do with these theories if you were to design out of them? I have ways of answering those questions, such as "queerness is in the perspective, if I claim it as queer it is queer". However, they also challenge me. I can find queer spaces in history, but what if I were to design queer spaces, how would I go about it? My aim now, within the collaboration of MYCKET, is to further the feminist and queer theories I'm working with by crafting, proposing and suggesting what they can look and feel like. To invest in them and explore them in spaces and objects that others can experience. Like with *Exclude Me In*, where the queer space of the carnival becomes an experience in the bodies of the participants. It is both a pedagogical project directed towards an audience of guests, participants and strangers, and a reparative project where I seek to mend, care for, and bring out historical and social rifts and absences. Like, for instance, in the film *History as we know it*.

MKT *History as we know it* is a film we, MYCKET, did to finish the project about *Göteborgskarnevalen* and the missing queer scene. *History as we know it* is a correction of history, where we cross-cut footage from the queer carnival parade of September 2013 with gathered video footage from the historical carnival archive material. It is now in the archives of the city of Göteborg and accessible on the Internet.[5] Through our work we develop methods to critique and construct at once. We dig into historical reference materials, found in both public and private archives, connect that to contemporary matters and conditions, invite participants with relevant experiences and interpret all that to create a new situation. A situation which relies on a mass of references but never tries to be a copy or a direct re-enactment, rather it is a critical fiction. *History as we know it* challenges the idea of the authen-

ticity of the archive. Archives are always fictional in the way they tell history. Our work is restoring, we add the dream of what the carnival could have been and meant for people like us which can be thought of as an act of reconciliation.

> Vi finns igår, vi finns förut, vi finns här,
> vi finns i alla dagar,
> då som nu,
> vi äger rum bortom den linjära tideräkningen.
> Vår tid är ständig.
> Mer Svett, mjölk och musik, mer dans.
> Nu.
> Vi tar ansvar för vårt umgänge och nöje.
> Vi anser att den normativa, officiella
> och legala historieskrivningen är otillräcklig.
> Därför gynnar vi aktivt konstruktioner
> av drömmar och tankeexperiment,
> hittepå och byggandet av luftslott.[6]

M I think that anger is an important driving force for many, which often results in criticism as a strategy for resistance, where everything circles around punctuating patriarchal and racist ideas, and to counteract them. It affects people to constantly have to fend something off. When the body is constantly located in a hostile or threatening situation. It influenced me a lot for a long time and eventually I felt clogged by all the rotten ideas and their attached forms. And actually the aesthetics weren't challenged enough either. So, to start working suggestively instead was a survival technique/manoeuvre. It's not helping us to constantly pronounce what we think is ugly, instead we need to define what we think is beautiful and wonderful. That is generous, and generosity spreads. It takes courage to suggest, since one has to try and navigate through what is often unknown grounds. And such a process requires a lot of support, which we give each other. In some way it becomes a simultaneous process where we provide space for both ourselves and for others. There is an urgent need for more spaces with conditions for suggestive work to develop.

K Eve Kosofsky Sedgwick's texts in *Touching Feeling*

gave me words to understand what I'm striving for; criticality is significant, but the promise lies in the proposal that touches you.

T Oh, what a lovely way to put it… "the promise lies in the proposal that touches you". I think I'm still struggling with doing what I long for, rather than doing what I was taught to do – the modernistically and patriarchally disciplined brain and body. Our practice, with the pedagogical tools that we use with/on each other, help repair me. And I think that if we heal, what we do and build will heal others. If instead of being prestigious, we are generous, it makes it easier for other people to be generous too. If we're honest and vulnerable, others might dare to as well. And in intimidating rooms, I think the strength lies in claiming, and then just acting; to claim it is the only alternative, to treat everyone as equal (not give in to any kind of power structures – be it between men and women, old and young, queers and straights, teacher and students, artists and museum technicians, artist and curators, architects and constructors and so on) and to resist explaining yourself. Why should you? But for this you need support, right? So, I think the extrovertly reparative in our practice is that we try to create spaces that hold this support for others. So they can claim as well. Claim their right to their particular being, as equals to others.

> It's about being on the margins, defining ourselves;
> it's about gender-fuck and secrets,
> what's beneath the belt and deep inside the heart;
> it's about the night.
> Being queer is "grass roots"
> because we know that everyone of us,
> every body, every cunt, every heart and ass and dick
> is a world of pleasure waiting to be explored.
> Everyone of us is a world of infinite possibility.
> And we are an army of lovers
> because it is we who know what love is.
> Desire and lust, too.

We invented them.
We come out of the closet,
face the rejection of society,
face firing squads,
just to love each other!
Every time we fuck, we win.[7]

M I also hope that we will shape our work in the way it helps/serves us most/best, which doesn't trap us into certain ideas on how to organize. I remember that we've talked about if we should do a project at all if not all three of us can participate for example. We could transform into some kind of architectural office or design firm where the three of us could advance into leading figures and start hiring employees. But this idea assumes that we would want to expand according to the capitalist structures, which are so readily available.

T In our projects, we work in very different scales. I mean our projects are everything from designing a single protest banner to designing an urban beach. Or an exclusive club for 30 people, or an open carnival for hundreds of people. I think I sometimes wrongly presume the bigger and the more, the better; but actually I really appreciate very small things, and small gestures. This is the preaching side of me, thinking that I have a message that should reach as many people as possible. Some people think what we do is rather exclusive I've been told, and other people think it is very inclusive. I'm wondering what your thoughts are, about inclusiveness and exclusiveness in our work, through our projects and our writings, etc.?

K Well, preach away honey, as long as some creatures are listening! Actually, even if you are just practicing your voice all alone. There is too much inequality for you to be silent. I think one of the things we have in common in MYCKET is that we all appreciate and are intrigued by slapstick, that which is easily understood and shared by many. The kind of aesthetic exclusivity, which stays behind fancy front windows is not in our interest. Inclusiveness/exclusiveness is very tied to the

situation, the space, the actions and the purpose of the event. I'm glad some people felt they could join the carnival spontaneously on their way home from school. But if they hadn't been comfortable with the queer and feminist expressions of the parade, I would not have changed it just to make them feel more included. Rather I would do my best to explain the knowledge, stories and research behind it.

M It never takes long before you get critique for being too exclusive, when you work with a focus on power perspectives. In *Exclude Me In* we consciously worked with queer and feminist stories (which still are seen as minority questions(!)).

MKT In a patchwork of quotes from *Queer Nation-manifest*[8] the fanzines of *Karnevalsföreningen* and our own writing we made a speech "Tale from the hide-outs" referencing all the clubs we found during our Gothenburg mapping of the queer, feminist and lesbian scene from the 1990s until today. You have been able to read the verses interwoven into this text. We held the speech at Esperantoplatsen – the starting point and dressing room for our parade. In the chorus we asked our guests to join in, about 200 people loudly shouted the words together. The chorus went:

Do you remember the time when air was clean and sex was something dirty?
Touch me, touch me now.
I want to work and love,
make love to each one of you.
Every street is our sexual geography.
A city of longing and total satisfaction.[9]

T I think especially if I'm behind something myself, if I'm organizing it, I get just as startled every time, that people show up and participate, out of their own will, because of their own necessity. We also have to dare to let go of the situation, let people take it over, make it theirs. I have a hard time doing that, but I try. My body isn't really with me on this, although my mind is.

M It's very important to think every single situation through without focusing on the people who are going to meet, and not stressing to make everyone feel comfortable. Because as soon as we start talking in terms of everyone or as many as possible there is a risk that we compromise, not least in aesthetic expression, according to assumptions of who likes what. And this doesn't leave any openings or possibility for surprises. Friction isn't only something negative. Rather, insights happen when things don't run too smoothly.

T Right, that's why it's interesting to use the idea of the carnival as a tool to reinterpret urban conditions, to point out blind spots and highlight suppressed friction. The carnivalesque idea serves as a metaphor for how we can temporarily let go of our official opinion and try out a different one, to mentally cross-dress and in a way sort of change the costume of our brain. During carnival it becomes evident that the space is performed through a certain stage setting, the users of which are active performers, dressed to fit into the play. The play of the everyday is harder to detect. The carnival can serve as a rich world of metaphors for thoughts in trying to make values, norms, hierarchies and structures visible. So, for us, what's really interesting with the idea of the carnival is that it makes everyday hierarchies obvious since the carnival makes visible the conditions of the everyday stage.

MKT The day after our carnival we hung everything, all the costumes, props and banners, in the main exhibition space of Göteborgs konsthall at the top of Avenyn (which is the epic street of demonstrations and parades in Göteborg). They were hung low in a kind of labyrinth, so the bodies of the exhibition would brush against everything. We also installed sound recordings from the parade in the space. Only the ghostly remnants, without the actual bodies of the crowd, the maze of *Exclude Me In* never the less created an in-your-face historical presence of queerness at the heart of the city.

T In relation to applying for a PhD position last year, I started to imagine what we would be doing in five years – a question that might come up in an interview situation. I thought a lot about it, but it was all kind of diffuse. We talked about if MYCKET wanted to become an institute, an educational but also a practicing one. Now I feel that one thing leads to the other and I'm not quite sure what I wish for in the future. I like that we are doing very different kinds of projects. What do you wish for in the future Mariana and Katarina? I mean we're dealing with the past a lot as a way to propose a future, like we do through *Exclude Me In*.

Our projects are almost always propositional. But for our lives and our practice, what would the feminist future contain for you? The feminist future of MYCKET?

K I love the process where one thing leads to another as you write Thérèse (which is very far from 'anything goes', we are navigating) and also the beautiful image you drew earlier in the text where we're in a garden collaborating on some design when we're eighty (I guess we can be much older than that). For me, resistance against death, violence and destruction, and hope for a better future for all of us, is awakened when I encounter adults who play, who take their desires seriously. What we build together is a common feminist future – a life practice of continued artistic research. Right now, I imagine us on the verge of developing an aesthetic expression beyond modernist and patriarchal constraints. We will share how easily all of us can provoke, take care of, and alter that which surrounds us. Later on, I imagine we will make things stay put for a longer time – as long as they have a significant role to play – at the same time as getting better and better at moving stuff around. To tear down, or open up walls when needed, but re-use the same bricks, wood, steel or concrete to build other more purposeful structures. We will never create any waste. In the immediate future we will broaden our skills, I will learn how to weld and work in metal (a good complement to all the textiles we're working with), Mariana will start to

carve, drill and cut stone and Thérèse will learn how to build earth ships of glowing recycled plastic.

M Haha, how sweet of you Katarina to lift my dreams on how to shape stone. That's about me wanting to continue to take on challenges where my entire body is present, not only on an intellectual level, but also where the manual coexists. Right now this is central in our method, where we not only plan, but also realize the designed shape physically. I hope that we will always see this as an important part of our practice. I say hope precisely because I know about myself that I have such a hard time to look far ahead into the future. I hope that whatever we do in ten, thirty, or fifty years we'll do it because we dared to, and still dare, to take risks. And that we have great fun while doing so!

> We are the rediscovered carnival parade
> Lefto to ferment/rise in the cotton warehouse
> We are a bacterial culture retrieved by chance
> We are the missing puzzle piece.
> We are the queer battery/batterie of Göteborgs-skarnevalen
> We reinstate the archaeology,
> We are the Rabble/Riff-Raff, the Cake Mob,
> but we don't stay inside the box.
> Inside the pink room.
> We are contagious,
> our culture is at the centre of society/the public body,
> you can't medicate it,
> or send gay straight to hell.
> We make up the motive/motif, the home, the heart.
> Without us, no metabolism,
> no motion, no transformation.
> We are the dawning thought,
> The living body.
> Our tale doesn't write his/tory,
> or her/story,
> We write hir/story.
> At the very least.
>
> We took our places in the cotton warehouse

without a roof of its own.
We dream about being saved
by saving the past.
We have all been forced to bear the shame,
the shame of being different.
But we, and our co-creatures,
have the right to be together
in ways of our own choosing
without transparency, control or applied definitions.
We are free and of age in a country with right of assembly.
Simple as that.
We know that there is no strength in solitude.
We search for our other half.
We know that we don't have to learn the rules
in order to be able to break them.
We know that everything in its place is a lie.
Together, we move above and beyond rules
instated by self-righteous white men.
We demand more.
We bash back. Hit & Miss.
An Army of Lovers Cannot Lose.

We exist yesterday, we exist before, we exist here,
we exist all days,
then as well as now,
we exist beyond linear time.
Our time is eternal.
More sweat, milk and music, more dance.
Now.
We take responsibility for our company and our pleasure.
We consider the normative, official, and legal writing of history inadequate.
Therefor we actively favour the construction of dreams and thought experiments,
of make believe and building of castles in the air.

It's about being on the margins, defining ourselves;
it's about gender-fuck and secrets,
what's beneath the belt and deep inside the heart;
it's about the night.
Being queer is "grass roots"

because we know that everyone of us,
every body, every cunt, every heart and ass and dick
is a world of pleasure waiting to be explored.
Everyone of us is a world of infinite possibility.
And we are an army of lovers
because it is we who know what love is.
Desire and lust, too.
We invented them.
We come out of the closet,
face the rejection of society,
face firing squads,
just to love each other!
Every time we fuck, we win

Do you remember the time when air was clean
and sex was something dirty?
Touch me, touch me now.
I want to work and love,
make love to each one of you.
Every street is our sexual geography.
A city of longing and total satisfaction.

We blow our noses in the cotton from the warehouse stock,
we dance over the ocean, feed the horses,
we like cleaning and we don't care for starvation economy.
Love begets love.
There is more.
We celebrate all the lesbians,
queers, dykes, nymphs, vibes,
transbodies, hasbeens, ladyboys,
kings and queens, homos, Bacchants,
cryptics, all the castaway deviants of the night,
amorous and scabrous.
We are a queer hotel where all the guests are shameless,
the concierge is bicephalous and Fête for Fight.
Phantoms from the streets finding their way inside
in the constant shadowland.
Our costume projects us,
and our dance, movement,
becomes a then, a now,
becomes one with what's coming.
We are the dive, the sheltering walls,

The outstretched arms, slum sisters.
We won't stop.
Through our dancing we weave the dance floor
and the ceiling.
Our body is one body,
here for your body,
wants to feel your body.

Chorus:
Do you remember the time when air was clean
and sex was something dirty?
Touch me, touch me now.
I want to work and love,
make love to each one of you.
Every street is our sexual geography.
A city of longing and total satisfaction.
Next year, we do this naked.[10]

1
We would like to thank Nina Lykke and the group of the Feminist Futures roundtable for their support in advancing this text.
"The tale from the hide-outs" (Talet från gömmorna), verse 1, speech by MYCKET, held at Esperantoplatsen, *Exclude Me In*, Sep 6, 2013.
2
The New Beauty Council, a collaborative art project that was founded in 2007 by Kristoffer Svenberg, Anna Kharkina, Annika Enqvist and Thérèse Kristiansson.
3
"The tale from the hide-outs" (Talet från gömmorna), verse 2, speech by MYCKET, held at Esperantoplatsen, *Exclude Me In*, Sep 6, 2013.
4
We were invited together with the New Beauty Council (Thérèse Kristiansson and Annika Enqvist) by the curator Claire Tacoons to work on the archive of *Göteborgskarnevalen* (1982–1993) together with a large group of artists for one part of GIBCA, 2013. This became *AnarKrew* an afternoon/night of performances, Sep. 6, 2013, and an exhibition at Göteborgs konsthall, Sep-Dec, 2013. We invited fashion designer and theorist Maja Gunn to collaborate with us. There was a large group of people who assisted and worked with us to make this project come alive: Moa Sjöstedt and Minna Magnusson, Marie Carlsson, Adam Gustafsson, Stefan Nordberg, Partiez Van Der Weens, Hanna Kisch, Moa-Lina Croall, Karin Drake, Emma Lundqvist, Alireza Arabi, Rebecca Vinthagen, Malin Holgersson, Iki Gonzalez Magnusson, Eddie Mio Larsson, Olle Gunn, Carolina Hemlin, Dwayne Edmondson, Inger Kristiansson, Hannah Goldstein.
5
History as we know it, published by Mariana Alves, Nov. 1, 2013, accessed at www.youtube.com/watch?v=VZ-QFqT2azI A film by Karnevalsföreningen, Britt-Inger Hallongren, Lars Printzen, MYCKET, The New Beauty Council, Maja Gunn, Marie Carlsson, AnarKrew, Fotohögskolan Göteborgs Universitet.
6
"The tale from the hide-outs" (Talet från gömmorna), verse 3, speech by MYCKET, held at Esperanto platsen, *Exclude Me In*, Sep 6, 2013.
7
"The tale from the hide-outs" (Talet från gömmorna), verse 4 (This verse comes directly from *Queers read this*, demonstration pamphlet by Queer Nation, 1990), speech by MYCKET, held at Esperanto platsen, *Exclude Me*

In, Sep 6, 2013.

 8

Queer Nation-manifestet (orig. *Queers Read This*, Queer Nation, 1990), transl. to Swedish by Elin Bengtsson and Lyra Ekström Lindbäck, Stockholm: Lesbisk Pocket, 2013. The original Queer Nation Manifesto was written 1990 in the midst of the AIDS crisis.

 9

"The tale from the hide-outs" (Talet från gömmorna), chorus, speech by MYCKET, held at Esperanto platsen, *Exclude Me In*, Sep 6, 2013.

 10

"The tale from the hide-outs" (Talet från gömmorna), chorus, speech by MYCKET, held at Esperanto platsen, *Exclude Me In*, Sep 6, 2013.

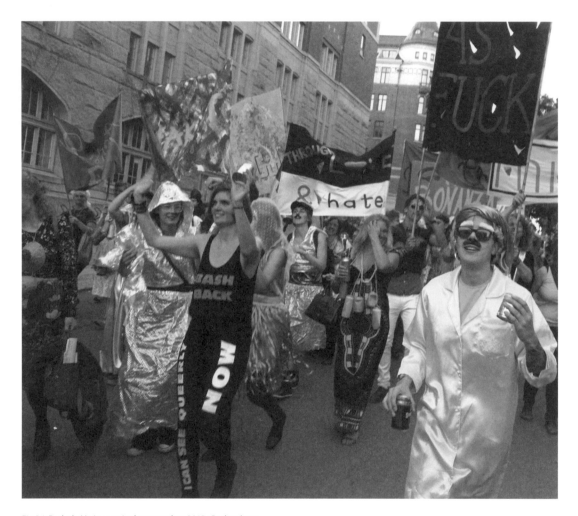

Fig 3.1 *Exclude Me In*, carnival, september 2013, Gothenburg.
Image: Maja Gunn

Fig 3.2 Group picture, Sågen, St.Annas skärgård. From bottom left: Patriez van der Wens, Moa Sjöstedt, Minna Magnusson, Carolina Hemlin (with little Sam). Second row: Annika Enqvist (with little Charlie), Maja Gunn (with little bit bigger Otto), Thérèse Kristiansson. Top row: Katarina Bonnevier, Mariana Alves Silva, Marie Carlsson.
Image: Patriez van der Wens

Fig 3.3 Working in Sågen, St.Annas skärgård, 2013. Image: Marie Carlsson

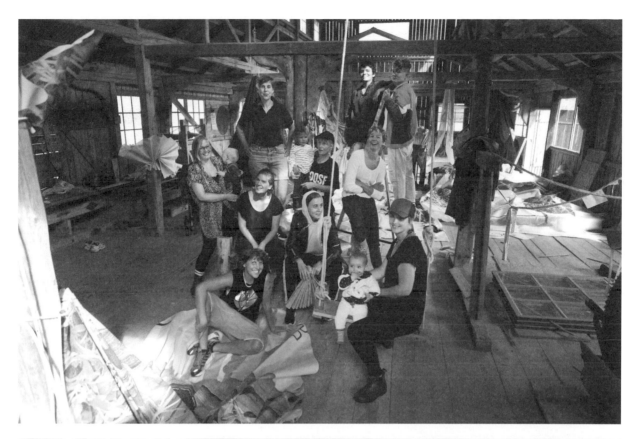

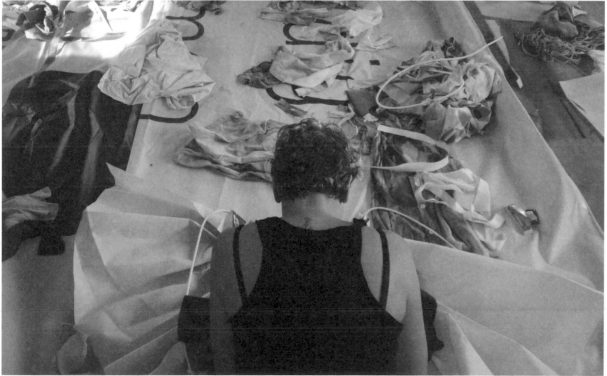

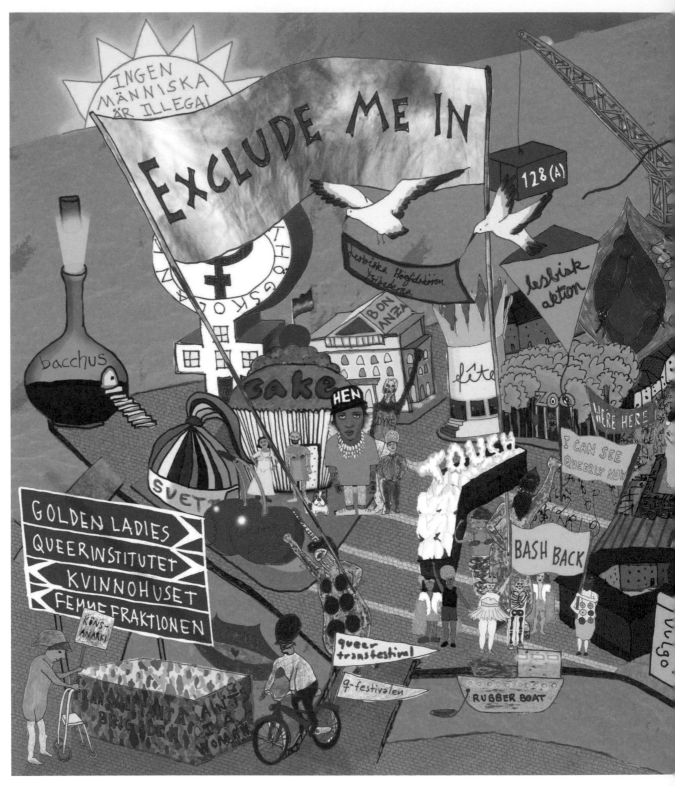

Fig 3.4 *Exclude Me In*, map, produced for the journal Glänta, #2-3 , 2013.
Image: MYCKET (Mariana Alves Silva, Katarina Bonnevier, Thérèse Kristiansson), NBC (Annika Enqvist) and Maja Gunn.

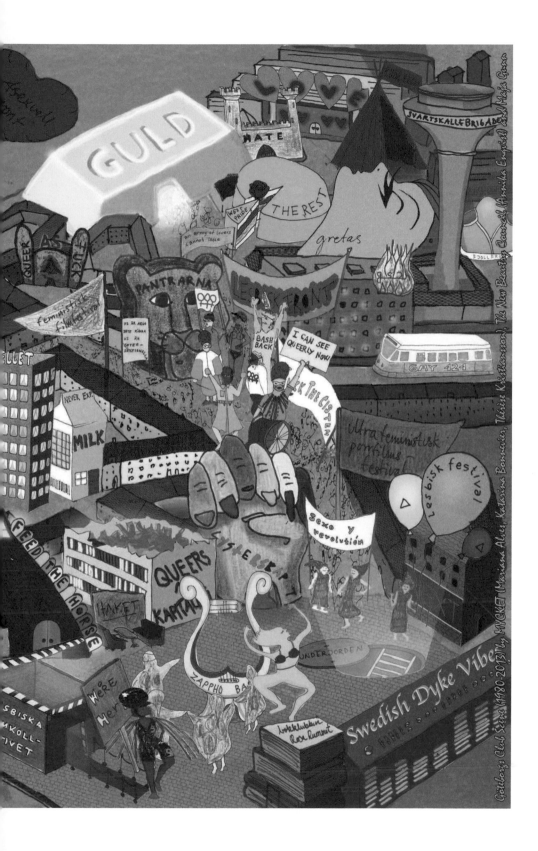

Götlenzs Club Scene (1980–2013) by MYCKET (Mariana Alves, Katarina Bonnevier, Thérèse Kristiansson), The New Beauty Council (Annika Enqvist) and Mija Gravier

MATERIAL WITCHERY: TACTILITY FACTORY AS A SITE OF EMERGING ETHICAL PRACTICE

RUTH MORROW

The warp and weft

Autumn Stanley dedicated her career to writing and researching women and technology, resulting in multiple papers and the seminal publication 'Mothers and Daughters of Invention: Notes for a Revised History of Technology' (Stanley, 1995). In a later essay, 'Women hold up two thirds of the sky', she argues that technologies only become lauded and understood as significant once they are appropriated by men. She cites the example of herbal remedies developed by women becoming understood as medicine and drugs, only when 'invented' by men (Stanley, 1998). For Stanley, Catholic institutions and their male doctors discredited healers and wise women, branding them as witches as a means to 'wrestle control of medicine from their herbally-trained female counterparts'. In recognition of Autumn Stanley's wise women, I claim the term 'witchery' as a mark of expertise and persistence in areas, and in a manner, outside the normative and frequently gendered conventions of material practice and technology.

This essay examines a collaborative material practice built up by two women and imbued with such witchery. The collaboration is between Trish Belford, a renowned textile designer and researcher, and myself, Ruth Morrow, architect and academic. Our working relationship stems from a mutual interest and respect for each other's discipline, but we quickly decided on the utopian challenge of *making hard things soft* as a means to bring purpose and focus to our collaborative practice. The ambition of the project also draws on a long-term engagement with inclusive design and feminist critiques of the built environment that I as an architect have previously been involved in.[1]

Two observations that evolved out of inclusive design thinking were: the paucity of sensory stimulation in the built environment, and that: the majority of materials, products and systems that make up the built environment are designed to meet a technical specification and not a human specification. These observations combined with an understanding that feminist practice demands a conceptual shift meant that our work has sought to strategically contribute to the built environment

not in form, but rather in detail and concept. This is a deliberate push to link conceptual and utopian thinking with the *experienced* narratives of every-day spatial encounters, through a practice-based and situated methodology.

The now ten-year long, part-time collaboration began initially as a project, called Girli Concrete (2005), based in Interface, a research institute in the University of Ulster. By late 2009 we had formed a company, Tactility Factory, to commercialize the material products of the collaboration. Tactility Factory survived initially on small commercial grants, awards and commissions until January 2014 when we gained significant investment funding and were able to employ staff and move to more appropriate premises. By that stage we also had several patentable technologies that underpinned a range of new materials, where textiles and concrete permanently co-formed the upper surfaces of concrete elements. The company that we co-founded as Tactility Factory commercializes this technology as interior wall panels.

The technical challenges behind bringing two very distinct, and at times almost antithetical, material types (concrete and textiles) together have required equal amounts of technical rigor and witchery. Tactility Factory has been the site of a collision of cultures and potent dichotomies: textiles and concrete, academia and commerce, economics and ethics, real-life and utopian. Our material practice is often a bubbling, dynamic cauldron of tensions and challenges. It calls for an ethics to emerge that shifts focus away from holding onto pre-formed ethical principles to the development of an ethical practice. As Stacy Alaimo and Susan Hekman point out, 'Ethical Practices – as opposed to ethical principles – do not seek to extend themselves over and above material realities, but instead emerge from them, taking into account multiple material consequences.'(Alaimo and Hekman, 2008:8). We now understand Tactility Factory as the site of an emerging and dynamic ethical material practice that constantly negotiates the landscape it traverses.

In managing these tensions, I have turned repeatedly to the source of the initial impetus i.e. inclusive feminism.[2] Engaging with such work has helped to contextualize the issues, find a balance concerning discourse and matter; and strategize viable responses. And in those moments when problems have seemed insurmountable, feminist readings have been a source of comfort, courage and community.

The essay will outline the nature of Tactility Factory and what has led to this practice. It will demonstrate how active engagement with a range of feminist theory and writing has led to a permanent intertwining of theory and matter. It will then explore in more detail four conceptual areas around time, language, technology and networks that have been significant over the last ten years, again contextualizing them through feminist thinking and theory. The essay also includes a graphic timeline of key actions, moments, images, language and characters, and will conclude with a summary of the things we strive after in order to build and sustain an ethical material practice. In this way we hope to inform future feminist material practices.

Spinning the yarn: The background to Tactility Factory

The seeds of Tactility Factory were sown in 2005 when Trish and I met and decided to work together. We had no project in mind initially but Trish started to make strange concoctions and brews of inter-woven materials and I joined in. Within a few days we had settled on the idea of *making hard things soft* and summoned an array of imaginary substances and garments: woven metal, knitted glass, appliquéd stone, column socks. We began by trying to 'soften' concrete, naively thinking that we could resolve the technology of one material combination and move on to others. Over time we have had to resolve ourselves to the depth of the technical challenges, eventually focusing on applying the techniques, technologies, and thinking of textiles to concrete production.

Concrete is an interesting and somewhat mystical material in itself, changing state from fluid and manipulable, to solid and structural, in an exothermic process. It is also a ubiquitous and low-tech material that impacts on the lives of everyone, everywhere. It is reputed to be the second most consumed material after water, and underpins one

of the world's largest industries – with the global ready-mix concrete market predicted to be worth over $100Billion in 2015 (WBSC, 2009 and GIA, 2010). Within the built environment professions, concrete is regarded as technically adaptable, structurally robust, and globally accessible. In Architecture, it has achieved a cult status afforded only to a few materials. Viewed almost as the archetypal architectural material, concrete links the progressive history of modernism to the uber-cool present: it is, as Adrian Forty writes, 'the ultimate modern material'. But beyond the built environment professions, concrete is widely perceived as a harsh material with little emotional value. Adrian Forty notes that 'An element of revulsion seems to be a permanent structural feature of the material.' (Forty, 2012:10)

Concrete also has poor environmental credentials. Despite extensive efforts by industry and academia working together to develop recycled aggregates; more efficient processes and mixes; non-cementitious concrete; and ways to better exploit concrete's thermal mass properties, the vast majority of concrete production and consumption remains highly unsustainable. Likewise, the textile industry is known for depleting resources, high water and energy consumption, and polluting processes (RFS, 2013). Both concrete and textiles are equally pervasive and environmentally challenging materials. It would be easy to desist from using both materials based on their environmental credentials alone but due to their ubiquity, we chose instead to try to reconceptualise them and transform their negative characteristics.

Initially, because of lack of resources and experience, we chose to work with existing generic concrete mixes and textile technologies. More recently, with better resources and increased understanding, we have begun to go back to source and unpick those 'givens', experimenting with non-cementitious concrete mixes; locally grown and produced yarns; and working with a few remaining local Irish textile manufacturers. In this way we hope to build a more sustainable process and product from the ground up. This twisting and weaving of our ethical path, at times through the thorny issues of sustainability, is perhaps the clearest indication of us *trying* to build an ethical practice, rather than adhering to a set of ethical principles that recoil from 'dirty' engagement.

Physically, we manipulate the constituent parts of concrete to suit each construction of textile used, but the real technical *witchery* lies in the textiles. We initially tested and selected a range of yarns to identify those that survive in the alkaline environment of concrete. With this knowledge we are able to carefully source and specify textiles from manufacturers whose yarn, construction and finishing are suitable. We then deconstruct and reconstruct these textiles in such ways that they can integrate with the concrete to co-form the surface. Where textiles become multi-layered we have to ensure that the method of bonding can also survive in a concrete environment. These technical processes have advanced over many years, hand-in-hand with the design of the surfaces. The resultant technologies that we developed, to create our 'infused' or co-formed textile and concrete surfaces, have subsequently been patented.[3] Autumn Stanley reminds us that almost 95% of all US patents are still granted to men; and in Britain and other developed nations the situation is markedly worse (Stanley, 1995); so achieving those patents, whilst not our initial aim, was something we shared with pride.

The resulting surface technology or 'faces' are cast with a further 'back' layer of concrete to create solid and stable panels. The panels are typically 10–15mm thick in total, 1.2m wide and 2.2m–3.5m tall. They can be flat, folded or curved and are either fixed directly onto existing wall surfaces using bonding technology, or cast with an integrated lightweight metal frame and fixed into walling systems. Tactility Factory currently commercialises four techniques: Linen Concrete, Stitched Linen Concrete, Velvet Concrete, and Crystal Bead Concrete (see Fig 4.1). All techniques use specifically designed, multi-layered textiles and techniques, and all require specific concrete recipes. The results are beautiful to touch and elicit strong responses. Tactility Factory is currently targeting high-end interiors markets as the entrance market. Such luxury markets are contrary to our politics, however given the level of innovation in the products, we hope that these exclusive, *haute couture* markets will be able to subsidize further efforts to bring the technology to wider *off-the shelf*

applications. The technology we have developed
has the potential not only to be used decoratively
but also to more generically extend the characteris-
tics and thus the potential of concrete, from a cold,
grey, acoustically harsh and unappealing substance
into a material that is warm, colourful, acoustically
soft and humane. As such, the technology could also
be applied to more everyday spaces where concrete
is exposed to increase the thermal mass but which
would benefit from a softer acoustic environment.
In addition, our technology is able to manipulate the
upper surface of precast concrete without the need
for expensive moulds or costly post-production
processes: it is the textiles that articulate the surface
and create the magic.

Beyond creating beautiful products, Tactility
Factory is also actively engaged in cultural produc-
tion. We exhibit work in cultural contexts; contribute
to discussions around creativity and enterprise; and
write and talk frequently about the work in relation
to textiles, architecture, craft, feminist practices and
material cultures. This is a double strategy.

As people engaged in teaching and learning we
instinctively want to share our learning with others
in the hope that others might build off our efforts.
And in turn by presenting our work we are forced to
articulate, edit and tighten the process.

Summoning the muses: How and where does feminist writing support this practice?

Tactility Factory's work has been informed by femi-
nism and a politics of inclusion from the beginning.
Prior to involvement in the Tactility Factory project,
inclusive design had been one of my main areas of
interest.[4] Through that research I met the architectur-
al academic Leslie Kanes Weisman, then a frequent
contributor and keynote speaker at international
universal design conferences. She had also been one
of the cofounders of the Women's School of Planning
and Architecture that ran between 1975–1981. Her
work was based on a belief in equality and on a
society that honours human difference. Her term,
'honoring difference' alongside the title of her pub-
lication: 'Discrimination by Design' acted as an early
provocation for me (Weisman, 1992). Like Weisman, I
had initially thought that reconfiguring architectural

Fig 4.1 Tactility Factory's four techniques, i.e: Linen Concrete, Stitched
Linen Concrete, Velvet Concrete and Crystal Bead Concrete

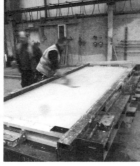

Technological Development of Materials

Objective	Method
Material Development and Testing	Material experiment and comparability tests: using a process of 'spreadsheet' critique (where each trial is critiqued aesthetically, practically and estimated time and risk involved in resolving technical problems)
	Testing fibres and chemical processes related to textile production for resistance in alkaline environment of concrete
	Trialling permeability of textile constructions to concrete constituents
Developing Textiles only for use in concrete	Developing and trialling textiles with various woven structures.
	Deconstructing and reconstructing existing base textiles to suit processes.
	Investigating textile finishing techniques and interaction with concrete
Developing Concrete for use only with textiles	Developing mix for 'face-mix' specifically adjusted to textiles and developing a separate 'back-mix' that creates the overall structure of the panel
Refining Process and Product	Refining and 'crafting' the technology through quality controlled processes and simple repetition, both in the textile and concrete production
	Initial Acoustic Testing (with University of Sheffield) and Development of Surfaces/ Fire Testing (BRE)
	Developing Fixing methods for various contexts
	Trialling technology with external partners (concrete and textiles) to test scalability in production.
	Investigating other potential applications of the technology developed (working with Building Research Establishment and Concrete Centre)

Fig 4.2 Dying, pattern thinking, printing, mixing, pattern detailing, pouring, curing

Tactility Factory Timeline

People	Key Dates	Language
Ruth and Trish (part-time)	2005 Project starts Wins innovation awards /Creative industries funding	2005 Dec First named 'Girli concrete'
Production people – Concrete and Textiles (ad hoc/part-time/full-time)		
Designers Graphic designers Photographers Other textile designers		2007 Third nomenclature... the naming of things in our own terms... skins
		2008 Conceptual language 'ooh-ouch experience'
Consultants Patent attorneys Marketing consultants Business consultants	2009 Project moves out of academia	2009 'Making mad ideas sane' 2009 Renamed: 'Tactility Factory'
University support		
Family support		
Board		
CEO (full-time)		
	2012 Private investor comes on board 2012–13 Scoping out the marketplace	
		2013 Insisting on 'She' throughout the investment contracts
	2014 Feb Large investment 2014 April New Premises/ CEO appointed 2014 Aug Additional Staff appointed 2015 Jan Permanent Staff appointed	2014 Strokies

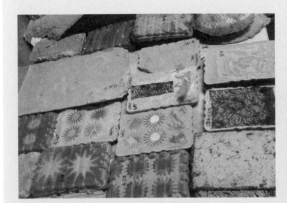

Fig 4.3 First trials

Fig 4.4 'Strokies'

2006 Jan (started), Blog- girliconcrete.
blogspot.co.uk

2007 Sept, Introduction to business plan
culture through UK Research Council's
business plan competition – included
weekend workshop and shortlisted for
mentoring

2008 Nov, First commission: Presentation
plaque for HRH Princess Anne from WISE
(women into Science and Engineering)

2008 April, The Animation – early tool to show
the scale of ambition at a time when the
technology was still unresolved

2008 Dec, Big Idea Award

2009 March, competitively won commission:
Derry Playhouse

2009 Sep, 25K (Invent) award

2009 Jan, Patenting process begins

2009 Nov, New company premises

2009 Aug, Local Commission. Private Client

2010 Aug-Oct Embracing Technology' curated
by Angela O'Kelly, Craft Council of Ireland
and the National Craft Gallery. Kilkenny
Arts Festival

2011 Sept/2011 Dec, Local commissions
Restaurant and Private Residence

2011 Dec, Pitching for investment

2012 April, Private investor

2012–13, Marketing consultant

2012 International tradeshow

2013 summer, International commissions – all
female specifiers

2013 Sept, UK patent

2013 July, Women's hour- BBC Radio 4–9
minute feature – 6 million listeners

2014 Jan, Large-scale investment

2014 Feb, First US patent!

2014 April, Appointment of full-time CEO

2014 April, Building of new office in new
premises: The TRYpod

2014– ongoing, International Commissions

2011, 2012, 2012 Eco Build, London. Exhibited
on Lafarge Stand

2012 Palestine Sunbird Pavilion, Dreamspace
Gallery, London. British 2010 Nov,
Council's International Architecture and
Design Showcase. Bangkok International
Design Festival, Central World

2013 Jan–ongoing, Museum of the Here
and Now. Panels on display as part of
Showcase of Northern Irish Innovation,
Innovation Centre, North Ireland Science
Park, Belfast. Showcasing 14 of NI most
innovative companies.

Fig 4.5 The trypod

Fig 4.6 Wall installation at the Playhouse Theatre in Derry

space/product was the key and should be the focus of my work. However Inclusive design also highlights the need to bring the users' experience into the heart of the design process and, perhaps more importantly in respect to where our work in Tactility Factory has gone, it emphasizes the significance of sensory stimuli, beyond the visual, to allow a wider spectrum of people to access and interact with and within the built environment. The concept of tactility is also part of wider critiques of modernism in architecture, which challenge the dominance of the visual and call for the corporal and psychological experience of space to be better understood and elevated to greater significance (Levin, 1993; Holl et al. 1994). This sensibility was also echoed in the engineer Peter Rice's plea to reinstate the 'trace de la main' in the construction process, or, to

> '[..] make real the presence of the material in use in the building, so that people warm to them, want to touch them, feel a sense of the material itself and of the people who made and designed it.' (Rice, 1994: 76–77)

This concern for those who build the built environment or make the materials and components of the built environment is frequently overlooked in inclusive design discourses, mostly because the politics that initially drove inclusive and universal design, i.e. disabled rights, was more concerned with the end user than those constructing the building. But it is also because the production of buildings (and their elements) is perceived as a mechanistic and more or less anonymous process. This removal of the maker's presence and sense of hand leaves us with the building materials and components that meet technical performance standards but rarely human performance standards. In other words, the core materials, components and systems that make up the built environment are, in themselves, devoid of humane characteristics. We rely instead on the skill of the architect to use these *technically performing* building elements to create environments that *perform for people*.

By collaborating with Trish, I began to see that somewhere in the space between manufacturing of building products to meet technical specification,

and designing spaces for people, there was a unique position for our project. Rather than waiting for the architect to intervene at a spatial level, the archi-tect/ designer could drive a 'humane' specification process by sitting right at the heart of the manufacturing process of building components and materials. Trish and I deliberately interweave processes to ensure the product is 'felt' into being as much as it is pre-imagined and designed. The processes of design and fabrication, digital and analogue, inform and are formed by one another. By collapsing the space between representation and fabrication we hope that the surfaces speak of craft, care, precision and intimacy. 'No matter how technically complex or theoretically informed the process is, or how effective or innovative the manufacturing becomes, the single most important characteristic of Tactility Factory surfaces is the quality of the user experi-ence.' (Morrow and Belford, 2012:399)

Alongside the subject of Tactility Factory's interests i.e. tactility and the emotional aspect of materials, our processes and the dynamic of the work are strongly influenced and supported by feminist thinking. One such influence is the feminist author and activist, bell hooks. In her 1989 bio-graphical-theoretical essay, 'Choosing the Margin as a Space of Radical Openness' hooks documents her own struggles, as a black woman becoming an educated social activist and author. Most relevant to our experience is hooks' incitement to move to the location of radical operation; to choose *not* to position oneself on the side of what she calls the 'colonizing mentality', but to stand in political resistance. She writes that, 'The choice is crucial. It shapes and determines our response to existing cultural practice and our capacity to envision new, alternative, oppositional aesthetic acts (hooks, 1989:203). However our instinct, and more recently our insistence, has been to hold positions that are both mainstream and peripheral; that allow for 'madness' and utopia, alongside deliverable out-comes. We aim neither to conform nor retreat, but this is of course a challenging position to maintain. At the same time, hooks also speaks of the need to use the oppressor's language in order to communi-cate: so even when one occupies a marginal posi-tion, one can still use mainstream tools in order to

function, and indeed reach a wider audience. When translated to the work of Tactility Factory, we readily acknowledge that we work within worlds that are not *easily* ours (commerce and concrete). These are not places where we feel *wholly* comfortable, yet we understand the importance of holding those positions and making use of those contexts and cultures in order to achieve our goals.

We were also empowered, perhaps unexpectedly, by Charlotte Perkins Gilman's 1892 novel, *The Yellow Wallpaper*, regarded as one of the earliest pieces of feminist writing (Gilman and Bauer, 1998). It has acted as a muse on several levels not least the idea of a replicating a yellow wallpaper surface Fig 4.5. It is the story of a woman suffering from post-natal depression, confined by her husband to an attic bedroom. In her sky-lit room, the yellow wallpaper initially becomes her obsession and finally the manifestation of her madness. Denied access to writing material, her mental health deteriorates. She narrates the wallpaper – charting how patterns within patterns appear and disappear depending on the light, the time, her mood. Ultimately, she becomes part of the wallpaper, taken into the skin of the wall and freed from her torment. It is a distressing story, but there is also a liberation in it: a discovery of the complexity and potential of simple patterns within patterns, an intellectual release in allowing the imaginative mind to find another place to exist: a place of 'ecstatic' freedom.

In our own dark moments we compare Tactility Factory to that attic room: as a place to be free of the orthodoxy of conventional practice and escape through pattern and surface to a place of other potentials. We also hope to add an addendum to *The Yellow Wallpaper*, offering Tactility Factory as a place where the woman in Gilman's novel can regain her sanity. During the course of the work we have frequently talked about 'making mad ideas sane', but in order to do so, we first have to create a space that supports madness (Morrow and Belford, 2012).

These feminist authors, Weisman, hooks and Gilman and others, provide provocation and stimulus to our work but across the time span of Tactility Factory there have also been four reoccurring areas of reflective development in our practice. We think of them as: *the timing of work; mediating nomencla-ture; tacit technology,* and *weird networks*. They have irritated, festered and eventually been managed if not resolved. Again it has been writings on the female experience that have supported the shift in our understanding and gradual gain in confidence.

The timing of work (and play)

Time plays a significant role in gender studies. Breaking free of domestic drudgery through time-saving domestic devices, such as washing machines and dishwashers, has supposedly led to an increase in women's involvement in the labour market (Roberts, 1991, Birch et al. 2009). Yet the 'second shift' phenomenon first identified by the sociologists Arlie Hochschild and Anne Machung in the late 80's, where working-women return home to complete the housework shift, is still evident in current research findings and continues to curtail women's engagement with high-demand careers (Hochschild and Machung, 1989).[5] Spatially, the planning of cities into distinctive zones (shopping, work, residential) also impacts women's time. Their caring roles frequently lead to protracted and multi-nodal journeys between home, school, work, and health services (OECD, 1995). Valerie Bryson defines this strain on women's time as 'time poverty' and argues that the unequal distribution of disposable time amongst the genders affects women negatively in two ways (Bryson, 2007: 145–148). Firstly, that having disposable time for the individual is a 'primary good in itself,' and secondly, that it is a resource that citizens need if they are to further themselves; promote their concerns; and contribute to local politics and decision-making. As such, time poverty acts as a constraint on the active and valued citizenship of women but, perhaps more critically, she argues that women fall outside normative 'time cultures' and that their temporal rhythms do not sync with the 'commodified clock time of the capitalist culture'. Hence women's time is undervalued and fails to connect to mainstream power structures. Kathi Weeks brings the discussion to another level, in 'The Problem with Work: Feminism, Marxism, Antiwork Politics and Postwork Imaginaries', where she critiques the 'sometimes pro-work suppositions and commitments' of feminism (and Marxism) (Weeks,

2011: 12–13)., and fundamentally questions whether work is in fact an inevitable activity at a time when increasingly 'there is not enough work to go around' (Weeks, 2011: 35). She argues for a reduction in work-hours without a reduction in pay, as much to enhance peoples' productive and creative practices and experiences, as to provoke a re-conceptualisation of the role and value of work in society. Hers is a deliberate provocation designed 'to challenge the dominant legitimating discourse of work'. Thus, in Kathi Weeks' petition for reduced working hours, she is also hoping to engage us in a deeper questioning, politicizing, and thereby, reforming of the work environment.

Time/work/play relationships have certainly created significant moments of reflection for us in Tactility Factory. Maintaining a playful attitude is critical when developing ideas and 'things' beyond normal realms. So accepting that the interrelationship of work and play (non-work) has always been critical for women in society, helps us to understand how to manage the tensions and resist two-dimensional readings of how we handle our own time/work/play relationships. We have faced time-strains in two *obliquely mirrored* areas, firstly within the materialist culture of business, and secondly within the culture of material practice.

Fig 4.7 Surface inspired by Charlotte Perkins Gilman's 1892 novel, *The Yellow Wallpaper*

Time in a materialist culture

The project of Tactility Factory has always been a part-time endeavour. Both co-founders provide the sole income for their respective households, so maintaining a full-time paid job in academia has been a necessity. But being part-time in Tactility Factory (i.e. one day a week, evenings and week-ends) has inevitably meant that the development of Tactility Factory has been slow. The general perception in business is that slow growth indicates low market and potentially no-market traction. In addition working 'part-time' is frequently understood as a sign of lack of commitment and, as Bridgit Fowler and Fiona Wilson suggest in relation to architectural practice: being part-time risks marginalization (Fowler and Wilson, 2004:101–119). However we argue that our prolonged engagement in the development of Tactility Factory (ten years) is in fact a sign of doggedness and determination. Maintaining intellectual engagement in the project has never been a problem, however, sustaining emotional commitment over such a protracted period has been, we would contest, an extraordinary feat of belief and willpower – especially during challenging times. Of course the undisclosed reality of 'part-timers' is that they tend to be multiple part-timers: they, and we, carry out multiple roles at the same time – as workers, mentors, carers, volunteers etc.

This lack of understanding of the basic drive behind part-time engagement is of course identified as one of the reasons why women fail to break through glass ceilings. As a Wall Street journal essay suggests, the key is to 'rethink the clock' by designing jobs that 'enable people to contribute at varying levels of time commitment whilst still meeting our overall goals for the company' (Millar, 2013). One consequence of working part-time is that collaborative pre-planning becomes critical in order to evade last minute, rushed decision-making. In this aspect, the technology of 'the cloud' and synced diaries has been liberating for us. Similarly the Wall Street Journal essay differentiates between 'availability' and 'absolute time commitments', suggesting that women might be willing to be more reachable during out-of-office hours if they could trade that for more flexible blocks of time. Similarly, Parlour, the insightful Australian project that 'brings together re-

search, informed opinion and resources on women, equity and architecture', published guides that aim to improve the architecture profession for women. Of their eleven guides to 'Equitable Practice', three deal directly with the work/ time relationship i.e. 'Long-hours culture', 'Part-time work' and 'Flexibility', demonstrating not only the significance of time in work cultures but also pragmatic ways to bring about change (Parlour, 2015). There is clearly an urgency to re-conceptualize work/time relationships.

Time and material cultures

Acknowledging that time really is *of the essence* in Tactility Factory, we have learned to manage it tightly and look for ways to be more effective in shorter periods. Nevertheless we also know the importance of 'taking time': an understanding that emerges from working with the materials themselves.

In the early stages we talked of creating a hybrid material, a textile/concrete surface (Morrow and Belford, 2008 and 2010). But describing the work as hybrid somehow implied that the process was simply a matter of 'sticking' two materials together – and for the most part that is what onlookers still think we are doing. The quiet, unassuming quality of the surfaces, however, belies the complexity of the technology, the cyclical and incremental processes of testing and development, and the craft and technical expertise invested in the process (see the table for elaboration on the process). In addition, we bring together not only two materials but also their two distinctive cultures of making and technique. It is no coincidence that the two cultures have rarely been placed together: they seem at times to be almost antithetical. Both have strong gender associations and both have differing stances to technology. Tactility Factory has created a space where the two cultures meet, work together and form a third culture and a new material practice. This requires not just transformation of established processes and tools but also soft, personally held beliefs. Such cultural shifts also take time.

We no longer use the term hybrid since it gives an incomplete impression. The outcome is not equivalent to 1+1 but rather produces an outcome that is much more than the sum of its parts. This is a new material from a new type of material praxis.

In this context time, or rather part-time engagement (which in turn becomes down-time, up-time, thinking-time and drawn-out time), has been the context for a reflective and critical process. Time in such contexts becomes the underwriter of quality, and indeed may also prove to be the guardian of our Intellectual Property. Where intellectual knowledge can always be replicated and transferred, tacit knowledge or knowhow, gained through experience of the technology over time, is, as our patent attorney explained, the acknowledged way to secure IP from illicit replication.[6] But, 'taking time' is an unusual strategy in the 'bring-it-to-market-as-fast-as-you-can' culture of commercialisation. Without the influence of those feminist writings that disclosed the potential for time itself to be a gendered concept we might have been more prone to anxiety about the time-scale of Tactility Factory's processes. As it is, one might now argue that contemporary material practices need more, not less, part-time engagement.

A mediating nomenclature

It is argued in feminist writing that the association of masculine with rationality is due to the colonisation of language by men (Hekman, 1990). Barbara Fried notes that the development of gender identity in children occurs at the same time as their language development, declaring that 'Language does not simply communicate the link between one's sex and one's gender identity; it constitutes that link' (Fried, 1979:39). In other words, language has the potential to lock us into gender roles and the societal misconceptions and misrepresentations that surround them. More recent thinking is that language forms and is informed by reality. Deborah Orr's appropriately textile-related argument is that for the philosopher, Wittgenstein 'the body and lived experiences are the weft into which language is woven to create the pattern of our lives' (quoted in Hekman, 2008:115). Throughout Tactility Factory we have developed and deployed language on several levels: initially as a means to excommunicate, that is, to exclude people from our discussions and more latterly to create a common language, fit for purpose, across a diverse team with unique processes and products.

In the early stages of development, we found that trying to respond to the enquiries of sceptics was time-consuming and at times degrading. As designers, what we understood as conceptual maquettes, looked to others like rather poor concrete samples. It looked unskilled and risible, so once, when asked what we were doing, we spontaneously called the work 'girli concrete'. Our provocative response effectively closed down further discussion.[7]

As the project has developed we have created new names for the designs. In the discipline of textiles, designs, patterns, colours and ranges are all, very purposefully, named. As an architect, I was unfamiliar with this almost anthropomorphic naming process. It is of course functional in terms of cataloguing, but it also serves to crystallize the conceptual thinking behind the object and, to some extent, legitimise the process. It is also a pleasurable, reflective and mischievous moment when we mark the significance of a completed design.

Less consciously and driven more by necessity, we have named the new technical processes by which we combine concrete and textiles. We have adopted language that allows people to understand what it is we do and what we have achieved. And in this respect we try to use more accessible, 'bridge-building' phrases. Such examples are:

Making mad ideas sane. This is a challenging phrase since madness is rarely a declared tactic in the world of business, but we use it to assert that we are experts in controlling creative transformations.

'Linen and concrete is like vinegar and chips'. This phrase is used to explain how two unconnected, disparate materials can work uncannily well together.

The ooh ouch experience. This phrase emerged to talk directly about the contrasting, tactile and emotive experience of Tactility Factory surfaces.

When we write and talk about our work we like to use titles that convey transgression and reveal our gender. Titles such as 'Fabrication and Ms-conduct' or, as in this case, 'Material Witchery' are used to indicate an anti-authoritarian stance – we are, after all, not only women but also designers. Over the last few years we have gone through two investment processes that involved lengthy legal documentation. In the first process we were trusting in the professionals around us but by the second time we wanted more control and clarity. We asked for each piece of legal jargon to be explained, if need be, several times until we understood it and no longer accepted the lawyers' arguments that the law regards the term 'he' as neutral. On revisiting Leslie Kanes Weisman's writing we found reference to Dale Spender's book, 'Man Made Language' (Spender, 1980; Weisman, 1992) which led us to read more about the link between language and feminism. Susan Hekman explains that the terms 'he' and 'man' are neither neutral nor generic, nor indeed do they include the experience of both men and women. (Hekman, 2008:37) She argues that if 'he' and 'man' cannot replace the terms 'she' and 'woman' in *every* instance, then they can not replace them at *any* instance; and she references Dale Spenders clever use of the provocative phrase 'he had a difficult childbirth' to evidence the nonsense of gendered language. So despite our qualms, we insisted that the language be changed throughout the company's legal documentation in order to recognise that Tactility Factory had been founded and driven by two women. The language changed overnight to 'she'. It was a small gain; probably no one noticed the change, but it was a significant moment for us. We call it our 'she-she' moment.

On a normal day, words and phrases specific to Tactility Factory are used that have never been used in those structures or combinations before. We have become increasingly aware of the language shifts we are engaged in. An email from our CEO (male) contained the phrase *'I've just packed a Lichen in Fig plus a Smoke Strokie and will send it this evening.'* The term 'strokie' is the name Trish generated to describe the samples we send to clients to demonstrate our palpable expertise in creating tactile surfaces. The development of this mediating nomenclature is in one way a necessary outcome of a practice across two diverse cultures. But it offers more than a pragmatic underpinning of collaboration – it also is a place of self-determinacy: illuminating and generating new possibilities. New language drives new practice, or, in tune with the theme of this essay, spoken incantations invoke transformation.

Tacit technology

Our aim of making hard things soft is supported not just by cultural and conceptual drivers but also by technology. Understanding the concepts of technology became a central investigation for the work. We turned again to feminist writers for insight and found the majority of the writing centred on technology and the body, reproduction, communication and cyberspace (Hopkins, 1998; Layne et al. 2010). However Judy Wajcman offered a feminist view on technology and more specifically a three-layered definition of technology that has remained significant throughout our efforts (MacKenzie and Wajcman 1985; Wajcman, 1991). The first layer of the definition is the technological 'things': the hardware and software, those components we usually associate with the term technology. The second layer is a form of knowledge that surrounds the 'thing' and arises during the making, repairing and maintaining of the thing. This, she says, is a tacit form of knowledge, which is visual, even tactile rather than simply verbal or mathematical. This is knowhow. The third layer of the definition is the interaction of people with knowhow and the thing. For Wajcman, human interaction is an implicit component of technology. All three layers of the definition are interdependent. This socialisation of technology is also emphasised by Deborah Johnson when she explains, 'Technology *is* the combination of artifacts together with social practices, social relationships and arrangements, social institutions, and systems of knowledge.' (Johnson, 2010:39)

In Tactility Factory we have become interested in the definition of technology, chiefly through our comparative conceptions of, and approaches to, technology, across architecture and textiles. Technology occupies a central position in architectural practice both operationally and theoretically. Across history many conceptual and stylistic shifts in architecture have been interdependent with technological advancements. Such technology-led architecture often has strong visual impact, but the experience of the resultant spaces can be asocial and at times alienating. Alberto Perez Gomez suggested that in such instances; 'Technology substitutes a "picture" for the world of our primary experience' (Pelletier

and Pérez Gómez, 1994:5). In contrast, interacting with a textile is personal and unique: a cosy, cuddly, slippy, scratchy, warm encounter. Simultaneously one experiences an intimate physical and aesthetic reaction. Trish, as an experienced textile designer, has spent her career using chemical and mechanical processes (abrasive/corrosive technologies) yet she had never described herself as a technologist – until I did. It is the noteworthy achievement of textile designers to take a variety of *hard-core* technologies and use them to transform and combine yarns into an artifact that evokes emotive response. In other words, technology may be core to the textile designer's process but it is rarely present in the final experience of the product. For architects, the textile designer's skill, in using technology, gives us much to reflect on.

Of course, the relationship to and manipulation of technology isn't just a consequence of the practice of various creative domains, it is also gendered. According to Cynthia Cockburn it was the historical segregation of the labour market that led to the 'construction of men as strong, manually able and technologically endowed, and women as physically and technically incompetent' (Cockburn, 1983:203). Johnson sees this from another angle, arguing that 'domains of knowledge and skill mastered by men are called technical or technological while those mastered by women are considered crafts' (Johnson, 2010:37). And perhaps this is historically what happened with textiles: that somehow, whether by design or context, the technology inherent in textiles was downplayed in favour of a narrative that spoke of the sensory experience of the outcome. In Tactility Factory we have learned to vary the story depending on who is listening. To the interior sector, we talk of the sensuous nature of the surfaces; the ability to create atmosphere and quality experience. To architects and engineers we speak about the cutting edge technologies, the patents and our awards for technical innovation. We make the most of explaining that it is the textile technology that is the *clever* component of our surfaces – it's a coded and loaded emphasis of course. So does this mean that Tactility Factory generates feminist technology? The anthropologist Linda Layne asks: 'Are feminist technologies simply or necessarily artifacts "de-

signed by women, for women"? If a technology is feminist, how did it get that way? Is the feminism in the design process, in the thing itself, in the way it is marketed, or in the way it is used by women and/or by men?' (Layne et al. 2010:6–7). In the case of Tactility Factory, whilst the process was initiated and led by two women, both genders and gendered cultures have been part of its development. While the process is certainly informed by feminism, we would agree with Layne's concluding statement that 'what matters is their [technologies'] effect and not their intended effect'. Certainly our wish has been to create a wider understanding of technology that includes us and allows us to practice with confidence but in a manner that produces outcomes for all people. In the end, of course, only the user can really judge our success.

Weird networks: Women supporting women

The term 'Weird Networks' bears witness to two references. Firstly Shakespeare's 'Weird Sisters' later to become the 'Three witches' in Macbeth, and secondly to the derivation of the word 'weird' from the German verb 'werden' meaning 'to become', hence this section looks briefly at women's networks and their role in *becoming*.

The American Architectural Historian, Sara Holmes Boutelle, in her seminal work brought the prolific work of the architect Julia Morgen (1872–1957) for the first time to the attention of the public and profession. Morgen had headed up her own architectural practice for over 40 years in San Francisco, and by her death at the age of 85 in 1957 had completed over 700 buildings. Boutelle records that over fifty percent of her clients were 'institutions for women or women commissioning domestic buildings' (Boutelle, 1981:94). At that time in history not only was it surprising that Julia Morgen was such a successful architect but that so many women (acting either as individuals or leaders of organizations) were even recorded as clients. Like men, women clearly draw on networks but it might also be argued that Morgan's existence 'drew out' and developed a female clientele. Boutelle concludes that 'These women's institutions and the women clients have a consciousness about their woman-

hood and about the support of other women that led them to patronize a woman when a qualified woman was available' (Boutelle, 1981:94). Despite being told that only men have the financial acumen to purchase our products, we have witnessed the same phenomenon in Tactility Factory, where the overwhelming majority of our commissions come from women.[8] Of course, they might in the end be spending men's money but it is women who decide how to spend it and they seem to take pleasure in commissioning the work of other women. We have also been greatly supported by those who curate exhibitions, promote innovative business ideas, and look for new applications of concrete and whilst such supporters may not be exclusively female, they are predominantly so. What interests us is the potential for practices, like Tactility Factory, to create relationships that haven't been in existence before. We think/hope such work as ours allows others to reflect on their own work with confidence and renewed spirit. In this we are not so much interested in female-only networks but rather the development of open, charged, organic and friendly networks i.e. *weird networks*.

Spinning spells: Closing/opening observations on Tactility Factory

> *'She changes everything she touches, and everything she touches changes.'* (Starhawk, 1979)

In conclusion I would like to re-examine how the practice of Tactility Factory has endeavoured to be ethical, and discuss the tactics and thoughts that have helped sustain this practice and may support future practices.

Our instinct has led us to engage with *stuff,* on the ground, and in the melee, despite this being an at times challenging strategy. Our preference is to develop an ethical practice rather than be assured of, or purport to have, well defined ethical principles. This ethical journey began through a commitment to inclusive, human-responsive environments, where we initially sought to amplify sensory stimuli, designing built environment materials as much for human performance as technical.[9] Increasingly we have tried to condense the care and craft of the

maker so that the resulting surfaces feel and are *touched*. Indeed the longer we work on the project the more we realise just how radical the enticement to touch can be. When people engage through touch they do so out of an honest, intuitive urge, that is beyond the intellect and almost beyond their conscious control. Looking at Tactility Factory's surfaces is never sufficient. We frequently observe the moment when an individual realizes that only by touching do they fully understand. It is of course a fleeting experience yet perhaps it is a growing societal need. Perhaps we are witnessing the manifestation of Dutch trend forecaster Li Edelkoort's 2012 prediction that, 'super technology is going to ask for super tactility' i.e. that the more we live through the virtual the more we crave the material (Edelkoort, 2012).

Alongside this interest in tactility and touch, we are keen to understand how the technology and tactics of Tactility Factory might trickle into other areas. Recently we have begun to work with local manufacturers and with sustainable concrete and textiles, returning to earlier processes to unpick and rethink an ecological approach. In such a dynamic landscape we try to hold onto an ethical approach by intertwining and juxtaposing action with theory, utopia with 'real-life' and detail with strategy. Doing so allows us to actively compare, contextualize and analyse the practice of Tactility Factory, helping us to better articulate our position and share experiences. Sharing through writing, presentations and teaching is part of our ethical concern for open dialogue. However, by far the most demanding ethical dimension of our practice is the on-going attempt to consciously engage in business as women i.e. as people who sit outside normative business cultures and structures. Defining and refining our position (for example, in relation to time, language, technology and networks) through feminist reading has unquestionably helped in this endeavour. For the most part, other people's writing helps us understand what the problems are and to resist attributing them to localised conditions and/or internalising them. At times we have looked for positive insights or acknowledgements that might support Tactility Factory, but to no avail. It's here that reading Elizabeth Grosz helps us understand that this might be the condition of all of us struggling for a feminist path forward (Grosz, 2010). In her essay, 'Feminism, Materialism and Freedom' – an essay I read several times before the moment occurred in my life when it made sense – I recognised a shared frustration with feminism being constrained by 'the paradigm of recognition'. She asks 'who is it that women require recognition from?' Instead she opens up the concept of freedom, suggesting we consider not freedom *from* (oppression, coercion) but rather pursue the concept of freedom *to*… act, give voice etc. She says that the challenge facing feminism is 'no longer only how to give women a more equal place within existing social networks and relations but how to enable women to partake in the creation of a future unlike the present' (Grosz, 2010: 154). And it is at the moment of reading that final sentence in her essay that I know we are on the right track. We have been fortunate enough to have the freedom of being located in the academia, and we have used that freedom as best we can in order to develop an approach and set of outcomes (physical and cultural) that are unlike anything that has been before – to help create a future unlike the present.

And what about the question of being valued? Whilst we have the support of many women, sometimes we wonder whether our witchery has created something that only women can see! The lack of mainstream interest in the work of Tactility Factory to date is marked. Of course Grosz is correct in asserting that we need to build our own value systems. Yet like many women we still sit within systems in which we have to deliver outcomes in a way that matches to the dominant construct. As full-time academics this means justifying the work as academic research. To that end we were supported and inspired by the academic and artist, Jane Rendell. We have chosen her words to acknowledge the importance of other feminists to this body of work and to our growing commitment to material witchery.

Only by acknowledging the work of earlier feminists, can we operate 'behind', adopting ways of working that critique those who have gone before. Only by going forward can we imagine a world as a yet-unrealised female subject. Only

in this state of mind, between past and future, can we open ourselves up to encounters with the other. We travel the distance to transform as well as transgress. (Rendell, 2007:80)

Our greatest challenge in Tactility Factory has definitely been to maintain a playful, transgressive state of mind, avoiding default and conventional positions. So the spinning, twisting and threading of a feminist approach throughout the practice has strengthened our resolve and commitment to the work. Perhaps it has even become physically embedded in the surfaces. Certainly the resultant artefacts of this witchery help to sustain our en-gagement. The surfaces are beautiful, tactile, and always surprising and even when encountered on a daily basis they still retain an enchanting, magical materiality.

Acknowledgements: to all those cited in the text and to my friend and collaborator, Trish.

1
Previous writings that reflect this are:
Morrow, R., 2000. 'Why the shoe doesn't fit – architectural assumptions and environmental discrimination' in David Nicol and Simon Pilling (eds.) *Changing Architectural Education: towards a new professionalism*. E. & F. N. Spon.
Morrow, R., 2007. 'Building clouds, drifting walls' in Petrescu, D., (ed.) *Altering practices: Feminist politics and poetics of space*. London: Routledge.
Morrow, R., and Belford, P., 2012. 'Fabrication and Ms Conduct: Scrutinising Practice Through Feminist Theory' *Architectural Theory Review* 17/2–3 (2012): 399–415

2
There is no clear agreed definition of inclusive feminism that I am aware of. It goes beyond acknowledging the importance of intersectionality and the need to bring all women to the table; and it goes beyond Naomi Zack's attempt in *Inclusive Feminism: A Third Wave Theory of Women's Commonality* (2005), to define commonality across 'women-hood' – which naturally then sets up the boundary conditions that Julia Serano challenges in *Excluded: Making Feminist and Queer Movements More Inclusive'* (2013) as a yet a further source of discrimination for those that identify as bi, trans, fluid, or a-gender. My personal understanding has been influenced by early involvement in the inclusive design movement (the feminist Leslie Kanes Weisman and her text, *Discrimination by Design* (1992) was key for me) which developed from the disability movement and sought to develop an understanding from those in the most critical positions and moments in their lives in order to improve the built environment for all people. That's how I view inclusive feminism: as a critical movement, able to identify underlying behaviours and cultures that exclude and undervalue people, enabling us to build inclusive futures, acceptance of difference and the on-going need to negotiate, in order to empower and liberate all people – regardless of their given, adopted and/or assumed identities. Other texts referenced later in this chapter have contributed to an ethic of inclusion.

3
We currently hold two US patents, one UK patent, and two EU patents pending.

4
Inclusive design is also known as universal design and design for all. See the following websites for further information on inclusive/universal design: www.designingbuildings.co.uk/wiki/Inclusive_design#Inclusive_design_and_universal_design
also UK's Design Council Guide on Inclusive design principles see:
www.designcouncil.org.uk/resources/guide/principles-inclusive-design
Also own writing on *'Building and Sustaining a Learning Environment for Inclusive Design'* (2002) at pure.qub.ac.uk/portal/files/13453576/CEBE_Building_and_Sustaining_a_Learning_environment_for_inclusive_design_full_report.pdf
Other international organisations promoting inclusive / universal design are:
www.humancentereddesign.org (USA)
www.inclusivedesign.no (Norway)
universaldesign.ie (Ireland)

5
See also: McGinnity, F. and Russell, H., 2008. *Gender inequalities in time use: The distribution of caring, housework and employment among women and men in Ireland*. Dublin: The Equality Authority; Economic and Social Research Institute. www.lenus.ie/hse/bitstream/10147/76678/1/EqualityInequalities.pdf

6
See also: Arora, A., 1995. 'Licensing Tacit Knowledge: Intellectual Property Rights And The Market For Know-How' in *Economics of Innovation and New Technology* 4/1 (1995): 41–60.

7
Interestingly the term girli concrete stuck. We used it for the name of our first blog; others continue to refer to it; and indeed we still hold the EU trademark for the term 'girli'!

8
We were approached by a producer to be interviewed for BBC Radio 4 Programme, Women's Hour, one of our business advisors queried the return on time invested in such a programme, given that 'women did not have the money to buy our products'. We argued that cultural exposure to 6 million weekly listeners was critical.

9
Thanks to Meike Schalk for identifying that the role of the architect in material development is relatively unique and worthy of more discussion. Within the scope of this chapter it wasn't possible but we will aim to address it in future writing.

ACTIVISMS

WHEN SPACE INTERSECTS FEMINISM

IRENE MOLINA

The chapters in this section address – each from its own perspective – the issues of women taking place, challenging masculinist norms and excluding practices in public space. From feminist social movements and other activisms as in Doderer and in Krasny and Schalk, to the question of the commons from a feminist point of view by Petrescu and the "relational aesthetics" of the built environment (as Dusant presents it in a conversation with the New Beauty Council), these four works all deal in one way or another with gender-spatial relations.

"The reinvention of the commons needs space and time for sharing", as Doina Petrescu reminds us in her chapter. That space is relational is something that we have learned from feminist space theorists, in particular the works of Doreen Massey, who recently passed away;[1] this prologue is a tribute to her work. I met Massey for the first time in the middle of the 1990s: she was a well-established critical geographer, and I was a PhD student at Uppsala University. I was part of the group of female PhD students which had invited her, looking for both theoretical inspiration and the chance to learn strategies to cope with a masculinist academia. The term masculinist space was established by another pioneer in feminist geography, Gillian Rose, who also visited Uppsala's PhD students in the nineties, providing a great inspiration with her approach on paradoxical spaces, i.e. hegemonic spaces created and dominated by men 'for women'; these were spaces imagined and conceived by a masculinist gaze under masculinist norms. In spite of this, Rose asserts that women should not be seen as victims of spatial oppression: on the contrary, they are active agents (Rose 1993); through collective action, paradoxical spaces of exclusion become spaces for resistance, political activism and social change.

Both Rose and Massey were engaged in activism, and their research has been strongly influenced by practices of women occupying and remaking public space. Perhaps it was that spirit of solidarity that led them to accept our humble invitations. As young scholars, we only had small budgets for these projects; we were barely able to cover the cost for hotels, but both Massey and Rose kindly accepted our invitations, to our delight. One thing in particular that astonished me – besides the sense

of feminist solidarity demonstrated by this – was their modesty when talking about their contributions to the geographical field of thought. While Gillian Rose apologized for not having dealt with postcolonial studies and intersectionality, Doreen Massey, though acknowledging that she was a feminist, didn't recognize herself as a feminist theorist of importance. But these two scholars had already been enormously influential for feminist postcolonial geographers worldwide. I allow myself in this text to refute their modest assertions, in particular Massey's, and suggest that her works have indeed meant a lot for feminist thinking within and outside of human geography. For this task of writing a prologue to the theme 'Activisms', I use in particular Massey's small but enormously influential article "A global sense of place" (1994), and the works devoted to the understanding of space as relational. Several of her works address this matter, but I take my point of departure from *For Space* (2005). Massey's understanding of space as relational can be a great contribution to the theoretical approach of intersectionality, as well as for understanding activisms.

Activating relational space

It has become common in a wide range of research in social sciences and humanities to incorporate the dimension of space. The insight that space matters has influenced academic disciplines other than geography for a long while. Above all, the works of feminist sociologists, philosophers, anthropologists and architects have introduced a much needed discussion on space from a relational and intersectional perspective.

The increasing interest in space is likely a result of several trends in society at large. Among these, globalization discourse should be considered as one of the most important, as it means that attention is directed to the various geographical scales that can affect and are affected by global relations (Massey 1994). Another contributing factor may be the recognition of the spatial context within social constructivism, given the concern of phenomenas' dependence on particular (spatial) contexts (contingency). Interest in space seems likely to keep increasing in the future, not least within feminism. But while space today may appear to be a hardly questioned factor, the occasionally problematic ways in which it is conceived of creates an opening for many questions. What kind of space is being referred to? Is it a '(meta)physical' kind of space, a kind of static material container for all human activities, and therefore deemed insignificant for the formation of social and power relations like class, gender or racial oppression? Or is it rather a social space, a constructed category marked by all the social relations set in and around it?

For example, research on housing, and even some urban research, has historically contributed to a primarily static view of spatial form and the built environment, disregarding the temporal dimension of human behavior in urban studies. Cities have been

understood as separate parts rather than as dynamically interrelated: not just in terms of different areas and districts, but also in the separation of people from the built environment in research, the separation of work from residence in urban planning practices, etc. Neither the people nor the dynamics of these processes have received enough attention. Even worse, this type of research seldom links to the wider power relations hidden behind social structures, including racial, gender and class relations. Both studies and policy documents that affect the built environment (housing, urban planning, housing research, etc.) have for too long been about numbers and abstract images of the planning target (Molina 1997). In this way, people and their bodies, with concrete conditions of life, feelings and needs have been neglected (see Listerborn 2007). Simultaneously, however, the relational perspective has been gaining ground in social sciences and the humanities. One of the most illustrative examples is the rise of the intersectional perspective in feminism.

Spatial intersectionalities

The theory of *intersectionality* was originally introduced to feminist studies by the lawyer and civil rights activist Kimberlé Crenshaw (1991) in the United States in an attempt to show the courts that racial and gender discrimination often occur simultaneously and are difficult to separate and distinguish. Ten years later, the concept was introduced in Sweden by Paulina de los Reyes, myself and Diana Mulinari (2002) in an anthology that aimed to show how racism, sexism and class oppression are three non-equivocal structuring elements in power landscapes, and how they manifest themselves 'even in Sweden', to paraphrase Allan Pred (2000).

At this point, it is necessary to make a distinction between two different orientations within intersectionality research. The first focuses on identity and explores what it means for an individual to belong to several different categories simultaneously: thus, it doesn't deal primarily with structures of power, but focuses on identity politics instead. The second is more interested in revealing and destabilizing the ideological systems of sexism, racism and class oppression of capitalism which are at the core of power structures. It is this type of intersectionality that I am interested in. The political potential of intersectionality is that it challenges the power structures that exist in society which affect everyone's everyday life through a general structure of privileges and multiple modes of discrimination.

Intersectionality can be considered both as a theoretical approach and as a methodological tool for feminist researchers and activists. Within the social sciences and humanities, the concept is widely used by feminists and refers to intersections between oppressive power structures, as well as to the role played by these structures in the multiple formations of power. As the term intersection suggests, and to bring

us back to the discussion on space, there is an underlying cartographical metaphor at work, referring to the intersections between different coordinates. That illustration is adequate, inasmuch as intersectionality is a perspective that aims to map the landscape of power and – despite its complexity – enables an orientation in the ways in which the different dimensions of power interact, thus paving a path from analysis to action.

What I argue for here is the need to include space and time as some of the relationships that must be understood from an intersectional perspective and vice versa. Space theorists like Henri Lefebvre (1991), David Harvey (1989), Edward Soja (2000), Gillian Rose (1993) and Doreen Massey (1994, 2005) have dealt with space as a relational reality: a dialectical materialist space, where this reality is created by and at the same time creates power relations. Space and time as analytical categories have not been in the foreground, although they have been latently present in the conceptualization of intersectionality. Nevertheless, as it is relational, the concept has allowed scholars to make several nexus between gender and queer theory, postcolonial theory, theories of class oppression and theories of disability and age.

The intersectional approach has facilitated a more holistic understanding of feminist struggles, resistances and activisms as a response to structures and mechanisms of oppression. It is important to note that one issue which postcolonial feminists (under the prism of intersectionality) have paid attention to is precisely the relationship between these three previously mentioned and other oppressive mechanisms (Hill Collins, 1990, 2012, Brah, 1992, 2006, Lewis 2000, 2004). These intersections do not occur in a vacuum; time and space are contingent in the sense that they act as contexts: everything happens at some time and at some place. But more than that, time and space are constitutive for all power relations. Time and space, history and geography are always present in the articulation of power relations, though in highly particular ways. Thus, the notion of intersectionality needs a revision in order to incorporate an understanding of time and space for any particular configuration of power (Massey 2005). It is in that commitment that feminist geography can help us to conceive feminist futures.

Intersectional activisms

In summary, space and time should be further theorized within the intersectional current of thought and vice versa an intersectional perspective needs to be adapted in space theories, in order to expand upon their relational character. This would provide feminist future theories and activisms with better possibilities of making nexus between different but simultaneous mechanisms of oppression. To this end, the works of feminist geographers, in particular Massey, could play a central role. When asserting

that power is exerted in space and by space, Massey turns the attention back to the multiple struggles and activisms that 'take place' somewhere. She puts special emphasis on the importance of place and the local. For instance, when the mothers and grandmothers of the Plaza de Mayo (discussed in Krasny and Schalk's chapter) chose that specific public space for their protest actions, that specific place was transformed eternally and definitely, and continues to transform. That space matters is a notion that will increasingly inform feminist art, actions and resistances and the research on them in the future.

1
Doreen Massey died the 11th of March of 2016, leaving a vacuum among scholars and activists. Massey had a life-long engagement with social justice and a critical and conscious geography.

5

BEING-IN-RELATION AND REINVENTING THE COMMONS

DOINA PETRESCU

This chapter explores how the 'commons' is a political project that is central to feminist strategies for reconstructing our social, political, affective and cognitive agency in contemporary society. The paper draws on a number of projects developed by *atelier d'architecture autogérée,* with residents in Paris and its suburbs, to demonstrate how these processes of gendered, spatial and ecological reinvention – whose 'agents' are mostly women – produce new social relations of and for the commons.[1]

for the most part, women

I have written about our practice on a number of occasions (Petcou and Petrescu 2005, 2007, 2010, 2013), and I will mention it again to speak about its contribution to the reinvention of the commons. I will introduce in this context the work of certain participants (for the most part, women) in our projects – work I would not identify immediately as 'feminist'. I would rather say that the reinvention of the commons is a work of the 'relational' and the 'differential' in which feminine subjectivity has an active role to play.

The agents of this reinvention of the commons, who in our projects are *for the most part women,* form a collective subject that remains indeterminate and unstable and does not belong to a single gender, but is nevertheless defined by sexual difference as long as it is constructed by reference to 'women'. To be considered, this subject needs a sort of 'realist essentialism' (Stone 2006), an essentialism whose statements are based on unmediated experience and long-term observation. *For the most part, women*: a provisional, partial collective subject, not quite homogenous not quite heterogeneous; 'feminine', and possibly 'feminist' but without guarantee, evolving and changing continually.

As such, the imagining of a collective subjectivity that reinvents the commons requires the mobilization of feminist knowledge, such as Luce Irigaray's work on *l'être-en-relation* (of women) and on sexual difference as a fundamental articulation of our relation with nature and culture (Irigaray 2004).[2]

The question of the *commons* is also at the heart of current discussions on democracy. According to Marxist philosopher Antonio Negri, the contem-

porary revolutionary project is concerned with capturing, diverting, appropriating and reclaiming these commons as a key constituent process.[3] It is a re-appropriation and at the same time a reinvention. This undertaking needs new categories and new institutions, new forms of management and governance, and new spaces and actors – an entire infrastructure that is both material and virtual. Setting up this infrastructure is a relational process: it is the creation of connections and links, a networking of ideas, tools and subjectivities. This networking should be itself a form of 'commons': accessible, fair, sustainable, and so on. The reinvention of the commons needs space and time for sharing, it needs continual and sustained 'commoning' – social processes to maintain and reproduce the commons.[4] It needs specific agencies based on a different way of meeting needs and provision through cooperation and shared values, as well as 'agents', who are active individuals with their subjectivity and their way of engaging with each other.

I'll take as example a few instances from my experience with atelier d'architecture autogérée (aaa),[5] a collective platform founded in 2001 in Paris by Constantin Petcou and myself, to conduct explorations, actions and research that encourage local residents to participate in the reappropriation and self-managed use of space in the city. For us as architects, the revival of the commons involves a tactical reappropriation and a collective investment of immediately accessible spaces in order to invent new forms of property and shared living that are more ethical and more ecological. We have identified a particular type of space – urban interstices, leftovers and wastelands – as a possible territory to be collectively reappropriated as a specific form of urban commons in the contemporary city.[6] These are commons that are reclaimed and reinvented in fragments, through small abandoned or unused spaces which by their temporary and uncertain nature have, until now, resisted land speculation. These forms of spatial commons contribute to the reinvention of other social, cultural and environmental commons.

aaa's practice started in 2001 with the realization of a temporary garden made out of reclaimed materials on a derelict site in La Chapelle in the north of Paris. This garden, called *ECObox,* has been supplemented with other mobile facilities (kitchen, library, media lab, DIY workshop) and has progressively extended into a platform for urban creativity that has catalysed activities in the whole neighbourhood. The platform has since moved several times within the area, using the same principles,[7] but taking different forms in different locations and involving new users. This approach was continued in the *Passage 56* project, which started in 2006 on a 200-square-metre empty plot located on rue Saint Blaise, in a high-density residential area in the 20th arrondissement in Paris. The plot, which was formerly a passageway, was considered non-constructible and therefore abandoned for many years. aaa designed and initiated various uses (such as gardening, compost making, repairing, skill exchange, organic vegetable distribution in the neighbourhood) for the space, and developed ecological practices with the participation of residents. *Passage 56* is a prototype of 'open source' architecture that experiments with forms of collectively produced space and pioneers unusual partnerships between institutions, professionals, local organizations and residents that challenge the current stereotypical models of urban management. The project is socially and ecologically sustainable, currently being self-managed by residents of the area. Since 2011, we have developed *R-Urban*, a participative strategy of resilience based on a network of civic hubs which support citizen resilient practices and connect them through locally closed ecological loops. *R-Urban*'s first two hubs– *Agrocité* and *Recyclab*– are collectively run, and catalyse existing activities with the aim of introducing and propagating resilient routines and lifestyles which residents can adopt and practice on individual and domestic levels, such as retrofitting properties to accommodate food cultivation, waste recycling and energy generation.

Our projects propose a wider understanding of architecture above and beyond buildings and physical space, affirming its multiple forms based on social relationships and new forms of collaboration that develop the active participation of users and conduct to their gradual transformation into stakeholders.

We have initiated as such a series of self-man-

aged spaces such as gardens, mobile facilities or collective hubs of resilient practices, where those who take part can use rather than possess, explore ways of sharing, and take responsibility towards what is shared. They are, as Félix Guattari puts it, "local hotbeds of collective subjecting" (Guattari 1980: 56). The collective subjecting is in fact the process of becoming subject of a collective of separate individuals that meet around a shared project.

We have initiated such processes, that took spatial, social or cultural forms, and lead to other processes – political or emotional – generated this time by the collectives that form around these spaces. These processes produce a new collective subjectivity that is local, relational and differential, and at the same time sharing a common spatial infrastructure: they produce a community and at the same time the space for it.[8]

We qualify our projects as 'relational' because they create connectivity: they stimulate desire and pleasure but also prompt political and civic responsibility on the local level, giving collectives of local residents the possibility of appropriating space in the city through daily activities (say, gardening, cooking, games or DIY). Rather than objects, we design *agencies*.

The activities of the commoning agency

Architecture is for us an agency shared with the users of our projects. We shared the knowledge necessary for the appropriation of space, the conception and management of architecture, a principle which conducts to what we call 'architecture autogérée' (self-managed architecture).[9] Instigating commoning activities (gardening, cooking, repairing, recycling), we consequently challenged the users of our projects to take active positions. The spatial transformation somehow generated transformations within the users themselves and changed their motivations and their engagement. We noticed that not all users were involved in the same way in the spatial transformation; nor did they resubject themselves in the same way. Some began as gardeners, and little by little have started to take on other roles and involve themselves in the self-management of the space, eventually becoming political

subjects, aware of the political implications of such reclaiming and reconstruction of urban commons.

Diagramme 5.1 shows how individuals have been involved in time in different commoning activities, resubjecting themselves from gardeners to cultural workers, managers and civic activists, fighting politically for reclaiming new spaces for the continuation of the project when the project was threatened with eviction in 2005. Diagramme 5.2 (in which gender is represented through colour convention: green for male, purple for female) shows how those who have resubjected themselves politically were for the most part women.

One of the most important commoning activities that tactically drove this process of resubjecting was 'gardening', which started as a simple leisure activity but later developed into a complex agency involving other activities and networks: a 'gardening agency'. The gardening agency involves large-scale environmental processes while also being adapted to small-scale, quotidian uses and practices. Over time, this way of acting can produce a constituent space for collective modes of functioning that generates commoning practices.

After a while, we came to the realisation that the most active 'gardening' agents in our projects were, as mentioned, *for the most part, women*.

This is not because they have more time than others – that is, time for unpaid minor volunteer activities – but primarily because they see an importance in these activities, and understand their political, ethical and environmental impact. We have realised that with this kind of project, we succeed in opening up a space in which a particular type of feminine subjectivity finds an area of creativity and innovation: projects that are cared for, engaged in and in which you see the results of your engagements with others; projects that teach the patience and attention of the reproductive work.

Political philosopher Sylvia Frederici has remarked that across the globe, much of the work of reproduction is done by women, for the most part: not only at home, but at the community level, in hospitals, schools, neighbourhoods, villages and cities, in both the Northern and Southern hemispheres.[10] This work of reproduction

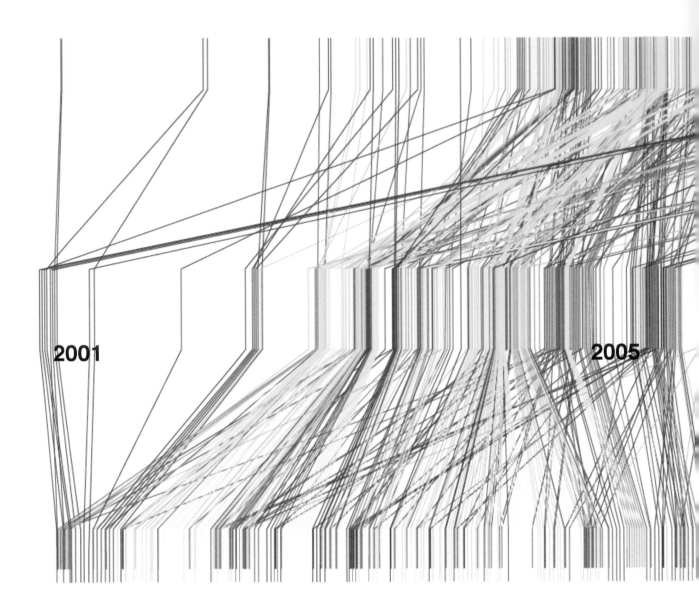

2001

2005

Diagram 5.1 Users' subjectivation through participation in the Ecobox
project activities, diagram by aaa

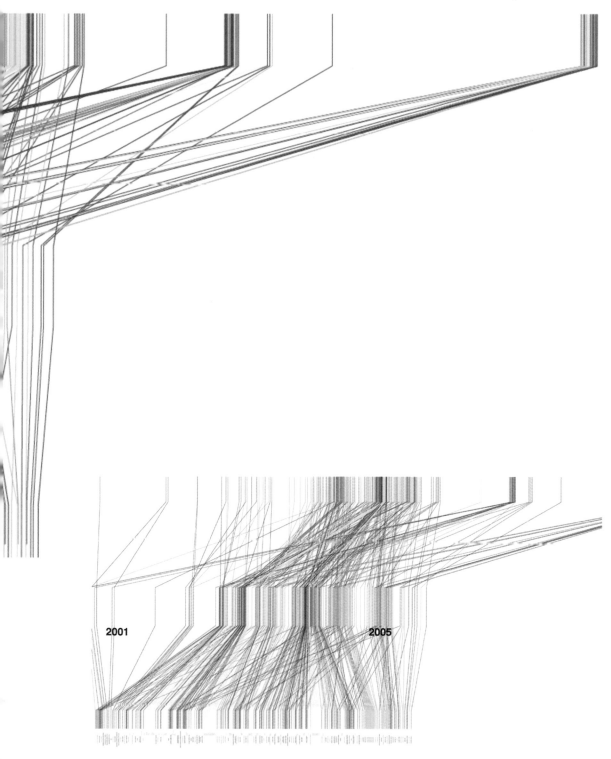

2001

2005

Diagram 5.2 Gender based subjectivation through participation in the
Ecobox project activities, diagram by aaa

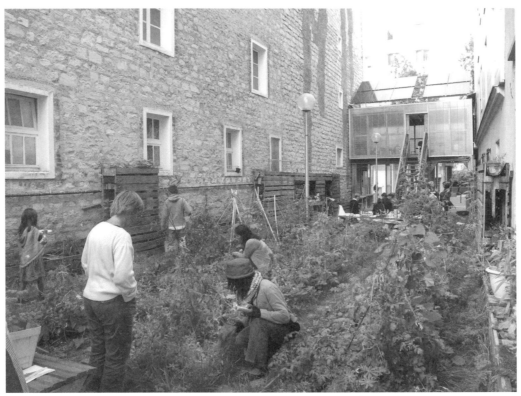

Fig 5.1 Passage 56, collectively managed cultural and ecological space, Paris20e, 2006, photo credit: aaa

is a particular way for women to construct their own subjectivity, as subjects connecting to other subjects.

Being-in-relation

Irigaray began talking about feminine subjectivity and its *être-en-relation* – its capacity to be-in-relation – in the 1970s. In the 1990s, this idea of feminine subjectivity took a new twist with Rosi Braidotti's work on 'nomadic' subjectivity (Braidotti 1994) and Judith Butler's on 'performative' subjectivity (Butler 1990). Despite the large differences in position, all three have understood a particular capacity of the female subject to make herself 'available': to devote herself to and allow herself to be affected by different agencies at once (say, social, cultural, political, sexual and emotional), and to create relations and be transformed by relations.

In our projects, most of the women came first to garden and after a number of years of activity began to take on responsibilities in the group, sometimes

becoming engaged citizens and arriving on the 'edges of the political', to borrow Jacques Rancière's concept (Ranciere 1988). Their personal transformation and subjectivity re-construction was part of both the construction of the group as well as the processes that made up the project. In Diagramme 5.2, we see clearly how the critical mass of women involved in fighting for reclaiming new spaces for the continuation of the project when the project was threatened with eviction created a 'line of flight' towards a collective political moment within the project.

Most of the women in the group have taken part in the invention of new activities and processes in our projects, spaces and active processes, and new objects of the commons – all with a strong reproductive dimension. These included, in the case of *ECObox*, mobile facilities, such as a library, kitchen or a participatory urban laboratory, flea markets and other forms of alternative economy or, in the case of *Passage 56* and *R-Urban*, ecological processes, such as urban food production, dry toilets, water collec-

tors, compost making, chicken and bee keeping, local energy production and green roofing. The work of reproduction induced by our projects has strong ecological dimensions, as reflected in their main activities: reparation, recycling, reuse, resilience.

Our role as architects has been to develop, sometimes initiate, and then support and prop up the networks that emerge around these different activities, spatial systems, processes and effects that allow both personal futures and collective futures.

A relational and co-operative practice, like the one we have developed, has a different temporality and a different aim than those of a neo-liberal practice: rather than looking for a material value of profit, it creates the conditions for a liberating experience that changes both the space and the subjects.

Just like the 'gardeners', our socio-spatial and ecological devices have played the role of 'mediators'[11] in the networks' development within the project. For example, in the *ECObox* project, a mobile device for an urban kitchen was used very successfully by African women who were living in the area of La Chapelle.[12] Most of them were not working outside the home, and some did not even speak French, but they came with their kids and realised they could use their skills and be part of the project by setting up a small informal business, which allowed them to have a social role in the neighbourhood. The mobile kitchen moved across chosen locations and attracted the most diverse cross-section of users to the project, with their individual knowledge and motivations; it also connected the garden with other spaces in the neighbourhood, and imagined spaces suggested by the recipes and ingredients that were used. Certain users, *for the most part, women,* also invented other 'mediators': a shared library, flea markets, artisan markets, and so on. These mediators influenced and differentiated the nature of the project. We thus moved from gardening-dominant activities and the free-use of time towards cultural, political and poetic production and distribution. These agent-users suggested new economic forms, which stressed personal exchange, reciprocity and giving (for example, 'honesty stalls', flea markets and 'feminine' knowledge exchanges at *ECObox*

and communal picnics, teas and film projections at *Passage 56*).

Similar economic forms emerged in one of the *R-Urban* hubs, *Agrocité,* which is an agricultural hub comprising commons including an experimental micro-farm, community gardens, educational and cultural spaces. Vegetable and animal products (eggs, honey, worm compost) are distributed locally through the minimarket, the canteen and the shop. Among the many groups using the infrastructure of *Agrocité* economically and ecologically, the canteen group provided a hybrid economic model, where a group of unemployed inhabitants from the area (mostly women) took turns to prepare meals once a week, cooking dishes with vegetables from the garden and donating 20% of the profit to cover part of *Agrocité*'s expenses. The canteen supported other initiatives within *R-Urban*, such as *Ecole du Compost* [School of compost], whose trainees ate their lunch at *Agrocité*, or the elderly group, who received a cooked meal once a week. This approach aimed for a local economy that mixed reciprocal exchange (hardware and know-how), contribution to the commons and also provided personal benefits.

Feminist economists Katherine Gibson and Julie Graham referred to 'community economies' which are the invisible, often informal underground parts of the economic iceberg, of which only the market economy is visually displayed.[13] These 'community economies' create "ethical and political space of decision in which interdependence is constructed as people transform their livelihoods and lives".[14] Initiatives such the canteen constructed interdependence within the commons of Agrocité, along with the evolution of the project.

These interdependences are also forms of resilience within the project. In this context, resilience is understood not only as adaption and thriving in changing circumstances, but as the opportunity for transformation and reinvention through reproductive work, knowing that this process has to take place on the micro-scale, with each individual and each subjectivity, in order to have effects on larger scales. Resilience takes a political dimension in our projects because it relates explicitly to practices of commoning. However, this communing, which conducts to new forms of social and ecological

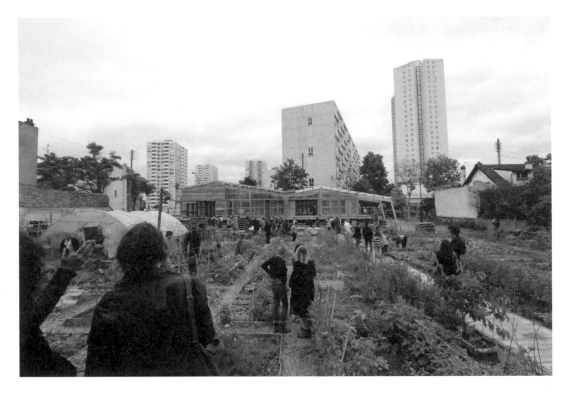

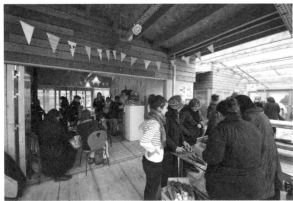

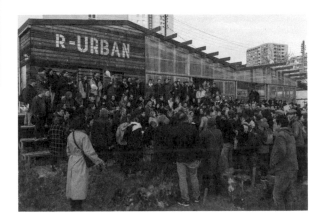

Fig 5.2 Agrocite /R-Urban – Urban Agriculture Civic Hub, Colombes92, 2013 photo credit: Andreas Lang

Fig 5.3 Agrocite – R-Urban Day event, 2015, photo credit: aaa

Fig 5.4 #saveRURBAN protest at Agrocite – 16 february 2016, photo credit: Analia Cid

self-governance, can be interpreted as a threat by mainstream politicians. This was the case with *R-Urban* in Colombes, where – despite the social and ecological benefits of the project – the right-wing government decided to evict *Agrocité* in order to build a temporary car park. Here, once again, women for the most part were the agents of the process of resistance, organizing protest campaigns, collecting funds, and mobilising support. When governments cease to represent the interest of their populations, alternative forms of politics are needed, in which women have a role to play.

These agents are carriers of a kind of resilient revolution: a struggle to (re)conquer the city's overlooked territories by alliances and not by war; to transform them into new forms of commons, into shared spaces and temporalities. It is these agents who initiate and maintain the ecological work of the commons. They are the humble gardeners of a rhizomatic reproduction and reinvention of democracy in times of change.

1
This chapter is a revised and extended version of an article originally published in French in the 'majeure' of the journal *Multitudes*, Issue 42, 2010. The English translation of the article by Tom Ridgway had been amended and completed by the author, and was first published as 'Gardeners of the Commons' in Petrescu, D., Petcou, C. and Awan, N. (eds.) (2011) *Trans-Local -Act*, London: aaa peprav. A revised version of that text, 'Gardeners of Commons, *for the most part, women*' became a chapter in Rawes, P. (2013), *Relational Architectural Ecologies*, Abingdon: Routledge, pp. 261–274.

2
The relationship between sex, nature and culture is one of ontological significance in Irigaray's work. "Without working through this relation from the very beginning", Irigaray argues, "we cannot succeed in entering into relation with all kinds of other, not even with the same as ourselves" (Irigaray, L. (2004), *Key Writings*, New York: Continuum, quoted in Raws, P. (2009), 'Building Sexuate Architectures of Sustainability', paper at the Luce Irigaray Circle Conference, Hofstra NY, p. 9). Peg Rawes notes that for Irigaray, it is through sexuate difference that "real sexed and ethical relations (i.e. relationships as 'ecologies') can be actualized in cultural and natural environments" (ibid.).

3
Ravel, J. and A. Negri (2008), *Inventer le commun des hommes* (Inventing the common), Multitudes No. 31. Paris: Éditions Amsterdam.

4
In his definition of the commons, Massimo de Angelis underlines the importance of three elements: a non-commodified common pool of resources; a community to sustain and create commons; and the process of 'commoning' that binds the community and the resources together. This third element is arguably the most important for understanding the commons, in Massimo's opinion (de Angelis, M. and Stavrides, S. (2010). "Beyond Markets or States: Commoning as Collective Practice", *An Arkitektur*).

5
See also: www.urbantactics.org

6
The 'commons' traditionally referred to common pool resources – usually, forests, atmosphere, rivers or pastures – of which the management and use was shared by the members of a community. They were spaces that no one could own but everyone could use. The term has now been enlarged to include all resources (whether material or virtual) that are collectively shared by a population.

7
ECObox, for example, has been moved and reinstalled several times by users, and the organisational and occupational systems have been reproduced in other independent initiatives (whether citizen-based or professional) in the neighbourhood and elsewhere. We call this a rhizomatic transmission – in which the prototype has the capacity to transmit all the information necessary for its reproduction, and where the product of this transmission – the reproduction of the prototype – becomes itself a new transmission source of the information, whether independently or in a chosen relation to the original prototype. These projects' existence at different sites may only be temporary, but the accumulation of knowledge through experience is nevertheless passed on and reproduced in new projects which, though new and original, carry the torch and serve as the continuation of the same model, a similar protocol and process.

8
For more on this subject, see my text 'How to make a community as well as the space for it' (Petrescu, D. (2007), 'How to make a community as well as the space for it' in PEPRAV. Available online: www.peprav.net/tool/spip.php?article31.

9
Autogéstion is a word that has a particular significance in French political history, referring directly to the ideological struggles and anti-statist social movements of the nineteenth century, and to the idea of 'workers' control'. Following other thinkers like Lefebvre, Castoriadis, Gullierm, we are fully aware of this meaning, but in our case, the figure of the 'worker' is replaced by that of 'inhabitant' or 'user'.

10
Frederici, S. (2012), *Revolution at Point Zero: Housework, Reproduction, and Feminist Struggle*, Oakland: PM Press.

11
Bruno Latour's analysis of the 'social' in his Actor Network Theory (ANT) mentions the active elements that human and non-human actors share and that take on the role of 'mediators': they transport, translate and transform the content and the nature of the network's links. Latour, B. (2005) *Reassembling the Social: An Introduction to Actor Network Theory*, Oxford: Oxford University Press.

12
La Chapelle is a neighbourhood in North of Paris in which the percentage of residents with immigrant backgrounds was amongst the highest in Paris (30%). The area has a strong African presence, having been known in the 1990s for the high numbers of immigrant squats, and more recently being one of the privileged locations of refugee informal camps.

13
Gibson-Graham, J.K. (2006), *A Postcapitalist Politics* (Minneapolis: University of Minnesota Press).

14
Gibson-Graham, J.K. and Roelvink, G. (2009), *Social Innovation for Community Economies*, in MacCallum, D., Moulaert, F., Hillier, J. and Haddock, S. (eds.). 2009. *Social Innovation and Territorial Development* ; London: Ashgate Publishing, pp. 25–38.

6

STRATEGIES USED BY WOMEN IN RESISTANCE: THE EXAMPLE OF STUTTGART 21

YVONNE P. DODERER

For almost three years, from 2010 to 2012, the theme of *Stuttgart 21*, and the resistance against this large-scale railway and urban development project, was featured not only in the local German press, but also in national and international media, as far afield as China. The protest against *Stuttgart 21* became a symbol of resistance and civic involvement, the likes of which had never been experienced in any city in Germany before. For the first time in German history, this resistance movement resulted in a fact-check, a so-called 'mediation' between those responsible for the project and the representatives of the resistance.[1] This event, which in total took place over a period of 9 days, was broadcast live during the months of October and November in 2010. The resistance against Stuttgart 21 was one of the reasons why a representative of the Green Party (Bündnis 90/Die Grünen) became the Premier of a German Federal State for the first time, and furthermore spelled the end for the autocratic reign of the Conservatives in the government of Baden-Württemberg, the third largest state in Germany. Because of this shift in power, a referendum was held in the state for the first time. The opponents of the project lost this vote, albeit by a narrow margin. Finally, in 2012, a member of the Green Party was elected as the mayor of Stuttgart, the first Green Party mayor of a German city. Although the referendum ended with a decision that was to the disadvantage of the project's opponents, the procedures surrounding *Stuttgart 21* clearly left their mark on the whole of the Federal Republic of Germany: since then, no such large-scale projects have been pushed through.[2]

This resistance movement was not only unusual in that it mobilised a large number of people to take part in persistent and resourceful protests, opening up new discussions on democracy and citizens' rights, common good, freedom of information and the difference between the real and alleged participation of citizens in the development of their cities. Importantly, it also succeeded in exposing the underlying technocratic ideology[3] of a large-scale development project. Through self-organised education and the independent exchange of information, this movement succeeded in permanently liberating itself from the 'depoliticised public sphere'.[24]

In these conflicts regarding a large-scale develop-

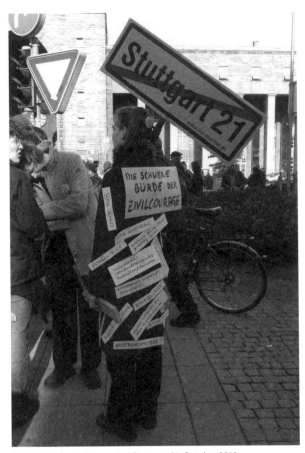

Fig 6.1 Demonstration against Stuttgart 21, October 2010,
Photo: Yvonne P. Doderer

views with various female activists from the resistance movement in 2012. The focus was not on how representative they were, but more on the mediation of the positions and the (self-) assessment of a selected spectrum of well-known and unknown activists who had attracted my attention during my own participation in this movement as a queer feminist activist, an artist and an urban researcher.

Global Women's Resistance Movements

Given the widespread non-perception of women as politically active, activist personalities in society perpetuates their exclusion from political participation in the collective consciousness. This applies especially to women who offer resistance from a far less comfortable position than the situation we find ourselves in in Germany or other well-situated countries.

All over the world, women participate in socio-political and feminist movements under the most adverse conditions. They fight for their political rights, for improvements in their living and working conditions, for their right to self-determination and for their physical and mental integrity. At the same time, they are fighting for a liveable, democratic and social society. The list of these activists is a long one. Some groups at least succeed in temporarily gaining some measure of media and international attention: for example *Madres de la Plaza de Mayo* (Mothers of the Plaza de Mayo),[5] who fought against the enforced disappearance of political opponents to the Argentinian military dictatorship for over 30 years; or the feminist punk rock and performance band Pussy Riot in Russia, who criticised the Putin government. In contrast, much less attention was given to the importance of feminist and LGBTTIQ activists at the Gezi Park protests in Istanbul,[6] or the struggle of the Kurdish Women's Defence Units (YPJ) against the Islamic State. This also applies to the resistance of individual women like Mao Hengfeng in China, who campaigns for reproductive rights and against forced eviction, activities for which she was sentenced to two and a half years at a labour camp in November 2012. At this point it should be mentioned that, in the meantime, it is not uncommon for feminist topics to be functionalised by various parties whose intentions are anything but feminist.

ment project, women have not been passive onlookers. They have played an active role and continue to sustain the movement through their efforts, even though the movement has diminished considerably since the referendum was lost. Many women from various different backgrounds – workers, employees, academics, housewives, pensioners, migrants, women with and without children, women who live alone, lesbian and transsexual women – all actively participated in the resistance against *Stuttgart 21*. In doing so, a substantial number of these women stepped out of the traditional 'female domain', i.e. domestic or social and welfare tasks. These women refused to be intimidated by water cannons and the threat of punishment; to this day they continue to put up persistent and tireless resistance. The activism of these resistant women is often overlooked in politics, the media and scientific research.

In light of this observation, I carried out inter-

Gender Relations in Germany

Although women enjoy a high level of freedom in countries like Germany, their lives are still governed by their responsibility for domestic and care work and the gender-differentiated structures that control gainful employment. Germany is no role model in this respect; in many areas, it is at the bottom of the ranking in Europe.

This is apparent for example in the annual statistics regarding the differences in pay between women and men. It feels almost banal to mention the fact that work such as childcare, nursing and other social services in Germany – one of the richest countries in the world – enjoys very little financial and social esteem, or that the concept of the man as the breadwinner, responsible for supporting women and children, is firmly anchored in German society. What other explanation exists for the fact that representative politicians fight for the preservation of classical 'male' jobs in the remaining production plants of the automobile industry, whilst no attempt is made to protect female employment when, for example, a large German drugstore chain declares bankruptcy? A similar picture emerges in education, the media and politics. The ratio of female professors to male professors in Germany lies at a little over 20 per cent.[7] The situation in the media sector is not much better: in the year 2013, only 9 out of 356 newspapers were run by women.[8] On political programmes and talk shows, women are mainly restricted to the role of announcers and hosts, whilst men function predominantly as the 'experts'. The conditions in politics are similar: in the year 2016, men make up over 63 per cent of members of the German Bundestag. Even a female German Chancellor remains an exception; and along with her conservative/neoliberal approach, topics like gender democracy are not on her agenda. In an interview, the political scientist Barbara Holland-Cuntz speaks of the "Merkel effect" as a "kind of perceived modernisation." Although Germany's outward image appears to be modern, it remains "a patriarchal/conservative country."[9]

Since this interview was published in 2006, very little has changed; quite the opposite, in fact. As the new rightist movements gain strength, there are protests in Germany against gender-neutral language and gender mainstreaming, same-sex marriage and the acceptance of sexual diversity.[10] The protesters do not content themselves with verbal agitation: concrete threats are made towards individual female scientists working in the field of gender research.[11] I find this digression necessary at this point in order to illustrate that there are more wide-ranging issues linked to women's participation in the resistance against *Stuttgart 21*.

The 'Chance of a Century'!?

Returning to the theme of *Stuttgart 21* – this future 'new heart of Europe' is part of the 'Stuttgart-Ulm Rail Project', as it is now officially called by *Deutsche Bahn*. The other part of the rail project entails the construction of a high-speed railway line between Stuttgart and Ulm, as a section of the planned 'Magistrale' line linking Paris and Bratislava. The project *Stuttgart 21*[12] incorporates the removal of the former freight station and the partial demolition and lowering of the former overground terminus and Stuttgart central station, which currently provide easy access for the disabled. In the 'restructuring' process, a reduction from 16 overground to 8 underground tracks will be made, leading to the construction of 55 kilometres of tunnels in the inner city area alone. In the course of these measures, a total of 100 hectares of inner-city surfaces will become available. On the one hand, then, *Stuttgart 21* involves the restructuring and acceleration of the Trans-European Transport Network (TEN-T)[13], and on the other it is yet another example of investment-oriented city development politics, as practiced in many European cities and elsewhere.

Financing for the *Stuttgart 21* project is provided primarily by *Deutsche Bahn AG*, the state of Baden-Württemberg and the state capital Stuttgart.[14] In order to support the project in the preliminary stages, the city bought up plots of land from *Deutsche Bahn AG* for the sum of 459 million euros.[15] From 2013, the planned construction costs of *Stuttgart 21* were estimated at 6.5 billion euros, but *Deutsche Bahn AG*'s cost projections had to be corrected several times due to public pressure. The Federal Audit Office also clearly criticised the official

projections on several occasions, albeit without success. Since the middle of 2016, the Federal Audit Office has predicted that the construction costs will run to 10 billion euros, a figure long since predicted by the opponents of the project.[16]

Protests against *Stuttgart 21* were triggered not only by the question of the railway station and the blatant lies regarding the costs, but also by the large number of statutory exemptions made for example in the areas of monument conservation and fire prevention. One particularly contentious issue was the plan to destroy a section of the park *Mittlerer Schloßgarten*, situated adjacent to the railway station; in the meantime, this area, populated with trees up to 250 years old (having survived even two World Wars), has been demolished. Trees in other parts of the town have also been cut down. Additional points of criticism were related to defects in planning and safety, the potential threat to Stuttgart's mineral water resources (the second largest in Europe) and the lack of citizen participation, to name only a few. Another important reason contributing to the development of resistance to *Stuttgart 21* is the fact that, even in an established democracy like Germany, there exists a grave lack of information and participation policies. Last but not least, criticism was directed at the urban development project linked with *Stuttgart 21*: in spite of citizen participation, it ultimately served the demands of a purely capital-based production of urban space. A major argument that contributed to *Stuttgart 21* gaining official support was that the railway project was the 'chance of a century' for inner urban development. But as early as 1997, when the Stuttgart municipal council adopted the reference framework plan[17] that formed the basis of *Stuttgart 21*, it had been agreed upon that the railway project was not a mandatory requirement for inner city development.[18]

And yet for years, and up to this day, it has been argued that this project was indispensable and without alternative. The land freed up by the demolition of the former freight station, the so-called 'Europaviertel', has now been almost completely developed.[19] It now consists of a complex of banks and new office buildings, sealed-off residential areas, a luxury 18-storey apartment and hotel tower and a three-part building complex containing around 43,000 square metres of shopping and office spaces, with 415 rented apartments situated on the roof of this shopping mall. The only public building in this new urban district is a new public library, which, due to its austere architecture, is commonly known as the 'prison for books' or 'Stammheim II'.[20] No definite plans exist for the development of the future vacant areas, although it is intended to use them as residential zones. Since the development of the 'Europaviertel', there have been no changes in the non-binding nature of citizen participation in the planning process, in spite of a 'Green' municipal government.

Resistance Against Stuttgart 21

The history of the project and of the resistance movement against *Stuttgart 21* is complex and so extensive that it cannot be described in its entirety here. However, certain aspects will be outlined in the following section. The so-called Monday demonstrations, which have been ongoing since November 2009, were an important platform for information and exchange. They continue to play a significant role, although there has been a decrease in the number of demonstrators.

From the very beginning, demonstrations, human chains and campaigns have been a consistent aspect of the protests. However, when the north wing of the Stuttgart main station was threatened with demolition, more and more citizens from the city and surrounding regions became actively engaged. Various groups and initiatives were founded, too numerous to be listed here. An action group made up of various organisations and subgroups was of great importance to the resistance movement, as was the group lobbying for the preservation of the park, including its web platforms.[21] A considerable number of large demonstrations, action weeks, action conferences and even an action camp were organised. Lectures, cultural events and concerts were held; exhibitions such as *Die Kunst nicht dermaßen regiert zu werden (The art of not being ruled in this way)*[22] were shown; films, songs and music videos were produced; many books were published; even an opera was performed. A vast number of imaginative protest posters, stickers,

badges and art objects were created, information brochures and flyers were printed, and newspapers were founded. Twice, the site fence around the demolished north wing of Stuttgart main station was made into a wall newspaper, receiving nationwide attention.[23] Not only the police but also the resistance movement developed their own tools of documentation and communication, making use of the right to freedom of information.

Resistance against *Stuttgart 21* has been predominantly self-organised and self-financed. Countless hours of unpaid work were and are still being performed to research the background and details of the project, organise the large number of activities and communicate information. All resistance activities against *Stuttgart 21* have remained peaceful, with one exception: in June 2011, there was a skirmish with the police and an undercover officer during the occupation of the construction site for groundwater management.

Of course, there have been continual internal conflicts and discussions, especially when certain individuals attempted to push themselves into the foreground. But overall, the movement was remarkably solidary and cooperative, characterised by a high level of mutual acceptance and respect. One female interviewee remarked: "In general, I experienced the resistance movement as extremely positive and open. ... It had the effect of encouraging members of society to open up to one another, both within generational groups and across generations."[24] Another said: "It was a very valuable and beneficial experience, sometimes life can be so good. It gave me the feeling of not being alienated – I am no longer willing to allow myself to be instrumentalised for interests that are detrimental to the well-being of myself and others like me, interests that are not legitimate. And I shared this experience with thousands and tens of thousands of others. That is why it felt so good to be in the resistance. I feel more at home in Stuttgart now. I can identify with this city much more, because I see that there are many people living here who think about things, who take on responsibility, who don't just let things happen. In my view, that increases the quality of life in this city."[25]

Fig 6.2. Demonstration against the large-scale railway and urban development project Stuttgart 21, Mai 2011. Photo: Yvonne P. Doderer

Women in Resistance

From 2010 up to the present day, there has been a continuous round-the-clock picket next to the station building. Functioning as a public information and contact point, it is organised primarily by women. "We have many men who are committed, but the majority of us are definitely women",[26] said one of the female activists involved in the picket. When asked why they are active in the picket, another interviewee replied: "That is a very difficult question – there are so many reasons, and that is often a problem for us. Basically, we have too many arguments in too many different areas. Sometimes it can be too much for new members who join us, especially if they don't have specific interests of their own ... We have grown with the resistance, so to speak. One of the things we keep coming back to is what happened on the 30th of September 2010. The fact that people were beaten though they had done nothing wrong, and that children and old people

Fig 6.3 Performance during a demonstration against Stuttgart 21, October 2010, Photo: Yvonne P. Doderer

Fig 6.4 Park Mittlerer Schloßgarten with "Unser Pavillon" (Our Pavilion) and view of a part of the "Zeltstadt" (Tent City), September 2011, Photo: Yvonne P. Doderer

were confronted with this unbelievable brutality – that's something you simply cannot forget."[27]

The day she refers to, known as 'Black Thursday', is an important occasion in the conflicts surrounding *Stuttgart 21*. A peaceful demonstration in the park *Mittlerer Schloßgarten*, initiated by pupils, was met by violent police attacks using water cannons. Over a period of several hours, more than 300 demonstrators were injured, four of them seriously. One of the activists describes the day as follows: "As I came from Schillerstraße past the Landespavillon and saw the injured lying on the ground, I really thought I wasn't cut out for a situation like this. But then I was carried along by the crowds, and suddenly I found myself standing in the front row facing the police, who were helmeted and armed. At that moment, something happened to me, I suddenly had a feeling of freedom and self-empowerment. The police began pushing people away, and one of them touched me on the breast – not on purpose, he couldn't help it – but I said, 'Take your hands off my breast', and I saw that he was afraid of me. I had touched a spot where the police are vulnerable, something that could be turned against them, and I saw real fear in his eyes. Since then, I have never felt afraid again. It was a real turning point for me."[28]

The background for this police operation was that by mid-2010, the resistance against *Stuttgart 21* had begun to receive increasing public attention: so much so that the German Chancellor felt compelled to publically defend the sustainability of Germany as an industrial location, and the large-scale projects this involved. Subsequently, it seems that the then-acting Conservative Premier deemed it necessary to implement stronger countermeasures, including the use of police.[29]

Following this crucial experience, the above-mentioned interviewee became involved in 'Our Pavilion', an information and exhibition location initiated and built by artists. It was in operation during the two-year occupation of the park. This occupation consisted of a self-governed tent city housing activists from completely different social and cultural backgrounds. This form of self-organised cohabitation was not without its conflicts, but on the whole it remained peaceful over the entire period. In answer to the question of how she experienced the cooperation in the pavilion group, she replies: "I fought for the pavilion to stay, because it quickly became a social meeting place. Until it got really cold, we organised events such as lectures, readings, concerts and film screenings, kept the flag flying. But far more important was just being there for people, giving them a hug, letting them have a good cry. They could get things off their chests, and I could act as a mediator if required. That was the most important thing for me, providing a social environment where people could meet, exchange information and devise plans for the next move."[30]

Taking Action and/or Speaking Out

All of these accounts reflect a situation in which resistance movements are not free from prevailing gender relations. On the one hand, the commitment of women in resistance continues to have a caring/social component. On the other, participation in resistance breaks through the barriers of a formerly internalised 'female' gender identity. Since her experiences during Black Thursday, for example, the pavilion activist has taken part in actions of civil disobedience, where she made the following observation: "I experienced women as being a lot calmer and more courageous in dangerous situations, even in blockades. If you just look at who is carried away – some of them are men, but most of them are women. That's something I'm really proud of: I have brought up three children, and I am the leader of the pack, yes! My approach is to go straight to the centre of the action, but other women are different. On the whole, it's noticeable that women are tougher. I can't judge whether or not they're better organised. But as far as public presentation is concerned – that's what the men do."[31]

In the same way as in everyday life, many women in resistance initially behave in a practical/organisational way. In an interview, this is clearly pointed out by a well-known female cabaret artist, who also took part in the resistance: "The women, it seemed to me, were incredibly resilient when it came to making things happen, especially organising and initiating. They invested a lot of time and energy. Do they shy away from going up on stage? Perhaps it is just not so important to them to be in an exposed position,

Fig 6.5 Action "Stuttgart verrohrt", demonstration against Stuttgart 21, February 2011, Photo: Yvonne P. Doderer

to be recognised as individuals. I often perceive that they concentrate on the matter at hand; everything else takes second place. It really doesn't matter whether or not you are up on stage talking about it, or whether you are someone who is pulling the strings backstage."[32]

Another female resistance participator answers the question of whether women are far less likely to rise up to speak: "I have definitely made this observation. I think you would have to be blind not to see that it is the case, and I also think it's a real shame. There are several explanations for it, but it is not a new phenomenon; it certainly existed before *Stuttgart 21*." She also observes: "However, what I find really gratifying about the resistance movement against *Stuttgart 21* – something I noticed a few times – was that men actively encouraged women to speak. Many of them thought it was a shame

that women did not dare to speak in public. I hear women saying that it is not important to them. But I don't really believe them, because I see this statement as a kind of rationalisation. 'I don't want what I can't have' – it is easier to take this stance than to be in a continual state of conflict with oneself and the environment."[33]

At this point, it becomes apparent that even women who are politically active still shy away from expressing and positioning themselves in public. Another interviewee, the chairwoman of a nationwide environmental protection association and the only woman[34] from the resistance movement who was involved in the 'mediation', also made this observation: "In environmental organisations or other social groups, women are indispensable. They play strong, valuable roles in the everyday running of local associations, district groups or on the basis

of other resistance movements. Without women, their unlimited commitment and their organisational talent, many activities in these groups would simply collapse. However, it comes to my attention again and again that the women too often shy away from assuming leadership roles or even external responsibilities. Often, women do not push themselves forwards enough, they do not say that they would like to get up on stage – they wait until they are asked. On the other hand, there are also many women who consciously stay In the background. I always call on them to speak out, encouraging them to have more confidence in themselves."[35]

This 'silence' can be read as the expression of an internalised non-possibility of speaking in public. It possibly stems from a general non-perception or prevention of women expressing themselves verbally, not only on an individual level, in gender-specific socialisation, but also within the collective/social sphere. However, there is also another possible interpretation: the position of 'not speaking' can also be used as a more or less conscious strategy of refusal, a simple withdrawal from male-dominated expert discussions. The rejection of a verbal/public positioning and the concentration on a practical form of action that is nevertheless resistance can, according to Habermas's definition of civil disobedience, certainly be classified as 'a public act', and thus as a powerful gesture.[36] Another activist observes: "If I look at the movement, it is mostly the women who do the creative work. There are a lot of women working in the picket or the 'DIY stop construction' camp. There is a lot of work involved that is fun to do. Whilst preparing for the

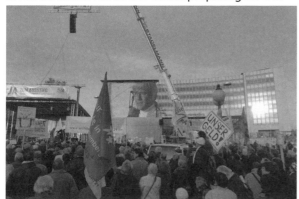

Fig 6.6 Manifestation adjacent to the old Stuttgart train station, November 2011, Photo: Yvonne P. Doderer

women's blockade workshop, it became clear that a lot of women totally refuse to take on a leadership position. This form of conscious refusal can also be seen as a valid alternative. I don't need people who stand up on stage and tell me what to do. I know that myself. I have met a lot of women in the movement who are of the same opinion."[37]

The price of this refusal is high: it leads to non-visibility and facelessness. One artist who participated in the pavilion made the following criticism: "The crux of the matter is that background work generally gains little recognition, even within our own ranks. For this reason, it is not considered valuable. It can be blanked out too easily ... But it is Important to listen to one another. There are a lot of voices that no one notices, although they have something to say. In a resistance movement, it is important to speak with one voice. Everyone else was expected to play along. ... If you didn't agree with the general opinion, you were not given the chance to air your views. Because of the legitimate wish to show common strength, a lot of issues fell by the wayside."[38]

Outward View

The fact that certain voices are not heard and the work of women is not seen also holds true for the portrayal of the resistance movement in the media and scientific research. In a discourse-oriented quarterly journal on architecture and urban development, for example, a presentation and timeline of *Stuttgart 21* was published which focused entirely on the male protagonists of the project and the resistance.[39]

A similar slant was seen in a scientific study[40] promoted by a petroleum company (!), investigating not only *Stuttgart 21* but also other 'civil protests' in Germany. The study was of a purely qualitative[41] nature, and this approach, along with many other possible points of criticism, constitutes the risk of being dependent on the perception and attitude of the interviewers and moderators, even though social scientific methods are used.[42] In summary, one result culminated in the following statement: "We are speaking primarily about men here. There is a clear predominance of men in the activist groups

of contemporary civil protests. In the sample of the study presented here, at least 70% were male."[43] The research did not critically reflect that this result was possibly due to their own research perspective, which focused on "interviews with central actors and activists."[44] It continues: "People with master's degrees and doctorates set the pace. To be more precise: the graduate engineer is the typical central figure taking part in current civil protests."[45] "The retired engineer, in particular, often throws himself into protest work with absolute commitment and enthusiasm."[46] With regard to the role of women, the following is stated: "Nevertheless: one-third of the females in our study groups participate in protests in the energy and urban development sectors. Initiatives in the areas of education and schools are plainly female terrain."[47] Attention is then drawn to the fact that "children and career constitute a considerable hurdle for the commitment of women, whilst the actions of men are not negatively influenced by these two factors."[48]

However, the piece of information that stood out most in the media reception of this study was that the most recent protest movements in Germany are run by middle-aged or older male members of the educated classes. The *Stuttgart 21* resistance movement, for example, was presented by the press as a movement driven by (naturally) male "hillside citizens", i.e. the middle classes who lived in the wealthy hillside locations of Stuttgart. It must be noted, however, that this movement had already achieved its first successes before members of this sector of society joined its ranks; in the initial phases they were waiting in the side-lines, bashfully concealed in the folds of their expensive garments. Regarding the demonstration following 'Black Thursday', one of my interviewees, a female journalist, rightfully pointed out: "I mean, there aren't even a hundred and twenty thousand people living in the hillside areas here in Stuttgart. It cannot be true. But there were a hundred and twenty thousand out on the streets."[49]

But even in the resistance movement itself, the questions of women's rights, gender equality and a feminist-oriented planning critique are not topics of public debate. This was reflected in the contributions of the speakers at demonstrations, which were only partly spoken in gender-sensitive language.

A one-off women's blockade was also met with incomprehension: "Many men felt excluded by the women's blockade, and the women were accused of causing a division between men and women. I didn't understand this, because it wasn't stated anywhere that men were not allowed to attend. I was shocked at the men's lack of emancipation. Why didn't they show solidarity and come along, instead of sounding off? Some women also objected to the blockade. Our intention was not understood in the right way. The emphasis was on discarding existing structures and leadership positions, living together, working together, how we communicate with one another."[50] Another feminist activist made the following remark with regard to the resistance movement against Stuttgart 21: "I think that the women's movement was much more powerful, militant and more anarchistic. We were fighting for new rights, we were fighting against discrimination."[51]

Future Outlooks

Nevertheless the resistance movement against *Stuttgart 21* made it very clear that there was more at stake than a railway station: "The reason for taking part in the resistance was mainly a rejection of this technocratic faith in the future regarding such a useless construction project, leading to the senseless destruction of the city."[52]

And even if this resistance movement, seen from a historical and contemporary point of view, is just one of many episodes in a long history of small and large-scale battles for the democratisation of the city and society, it shows that a fundamental restructuring of our approach to ways of life and the economy is needed, in light of 'limits to growth'. From this perspective, the destruction of listed buildings, urban flora and fauna, park and recreation areas and natural resources is not a negligible sacrifice made in the name of 'progress', but the expression of a political approach that has failed to recognise the signs of the time and the tasks that face us in the 21st century, acting in favour of a few individuals and to the detriment of the common good. For the city is also a valuable resource, and any changes made to it must be well thought out and implemented by means of transparent informa-

tion and binding participation. This also applies to the city as a social arena, as a resource incorporating a diversity of social, political and cultural life and lives, economic activity and coexistence. In view of the fact that more and more people all over the world live in cities, an urban policy and development that is ecological *and* social, and also gender equitable, is the order of the day. These are all things that have long since been recognised by many of the active women participating in the resistance movement against *Stuttgart 21*.

1
The 'result' of the 'mediation' itself, which was supported by the moderator (a former Conservative politician), consisted of a combined overground and underground system for the station. At this time, it has not been pursued in a serious way.

2
For example, plans for the partial development of the former airport at Tempelhof in Berlin were rejected in a referendum. Hamburg's application to host the Olympic Games was also rejected by the population in a referendum.

3
Habermas, Jürgen. *Technik und Wissenschaft als ›Ideologie‹*. Frankfurt a.M.: Suhrkamp Verlag, 1968, p. 100.

4
ibid.

5
For a discussion on the protests of the Mothers of the Plaza de Mayo, see Krasny and Schalk's chapter in this theme section.

6
Ellialtı, Tuğçe «Resist with Tenacity, Not with Swear Words". Feminist Interventions in the Gezi Park Protests.» (2014), Source: councilforeuropeanstudies.org/critcom/resist-with-tenacity-not-with-swear-words-feminist-interventions-in-the-gezi-park-protests/ (23.07.2016)

7
cf. Simone Schmollac "Nur 'BamS' hat bald eine neue Frau", *TAZ* online, 16.09.2013, source: www.taz.de/Medienschelte-von-Pro-Quote-Lobbyisten/!5059029/ (20.07.2016).

8
ibid.

9
"Vielleicht wird Feminismus wieder schick", Barbara Holland-Cunz in an interview with Heide Oestreich. In: *TAZ*, 25.11.2006. Source: www.taz.de/1/archiv/archiv/?dig=2006/11/25/a0143 (26.06.2010).

10
This was also the case in Stuttgart, where in 2015, Conservative and Christian fundamentalists protested against the adoption of "sexual diversity" in school curriculums with the slogan "Father, mother, child – family comes first". The red/green state government of the time backed down, changing their concept to "Tolerance and acceptance of diversity".

11
For example, against the Kassel-based professor of sociology Elisabeth Tuider, who was threatened in a blog with gang rape and shooting. Source: jungle-world.com/artikel/2014/30/50269.html (30.06.2016) See also: Kemper, Andreas. *Die Maskulisten Organisierter Antifeminismus Im Deutschsprachigen Raum*. Münster: Unrast-Verlag, 2012.

12
The planning for *Stuttgart 21* goes back to the year 1985. The idea received an initial boost in the year 1994 with the founding of the formally privatised concern *Deutsche Bahn AG*, resulting from a merger between the two former German railway companies. In 1997, the master plan was approved by the municipal council, but for various reasons the official beginning of the construction project would not take place until ten years later. In 2010 the symbolic start of construction for the lowering of the railway terminus took place. Until it was partially demolished, Stuttgart main station, which was a protected building constructed by the architects Paul Bonatz and Friedrich Scholer between 1914 and 1928, was one of the most punctual railway stations in Europe. Meanwhile, it is certain that the future underground station will have considerably less capacity than the previous terminus station.

13
cf. ec.europa.eu/transport/infrastructure/tentec/tentec-portal/site/en/abouttent.htm and ec.europa.eu/inea/en/ten-t/ten-t-projects (27.07.2016)

14
Further financers were the *Verband Region Stuttgart*, *Stuttgart Airport GmbH* and the European Union also contributed to the financing.

15
See source: www.s-oe-s.de/archives/2011/07/27/was-kostet-die-stadtebauliche-chance-transparente-zahlen-zu-den-grundstucksgeschaften-bei-stuttgart-21/ (10.03.2016) This waiver does not improve the budgetary situation of the city of Stuttgart. Even in the automobile metropolis Stuttgart, where everyone and everything is dependent on the automotive industry, it has resulted in e.g. the postponement of urgently needed roadwork by several decades.

16
To put these costs in context, the Central Emergency Response Fund (CERF) of the United Nations General Assembly writes in its 2015 annual report: "In January 2015, the UN and its partners appealed for $16.4 billion to provide urgent humanitarian assistance to 57 million people in 22 countries. By the end of 2015, the humanitarian situation worldwide had worsened, and it was estimated that 87 million people required urgent humanitarian assistance at an estimated cost of $20 billion." Central Emergency Response Fund, *Annual Report 2015*, p. 5, source: docs.unocha.org/sites/dms/CERF/CERF_AR_2015_FINAL.compressed.pdf (23.07.2016).

17
State capital Stuttgart, *Stadtplanungsamt* (Urban Planning Office) (ed.) (1997) *Rahmenplan Stuttgart 21* (Reference Framework Plan Stuttgart 21), approved by the Municipal Council of the State capital Stuttgart on 24 July 1997]. A reference framework plan describes only the rough guidelines of the undertaking and makes basic statements regarding building density, usage, infrastructure, development and the planning of green spaces. Source: www.stuttgart.de/img/mdb/publ/2735/58825.pdf (08.05.2016), p. 16.

18
Through the lowering of the station and the removal of the tracks, only 25 of the total 100 hectares have been freed up.

19
The construction of these rented apartments is due to the *Stuttgart 21* reference framework plan, which stipulates that an admittedly modest proportion of 25% of the site be used as residential space.

20
'Stammheim' is the name of a high security prison where the first generation of the Red Army Faction (RAF) was held in the mid-1970s; their trial also took place here.

21
www.kopfbahnhof-21.de/; www.bei-abriss-aufstand.de/; www.parkschuetzer.de/ (23.07.2016)

22
This project was developed in a cooperation between Iris Dressler and Hans D. Christ, the directors of the *Württembergischer Kunstverein* in Stuttgart (one of the largest art associations in Germany), the artist couple Sylvia Winkler and Stephan Köperl, and myself. It was shown from 8 November 2010 to 9 January 2011 as part of the exhibition *Re-/designing the East. Politisches Design von Asien und Europa* at the *Württembergischer Kunstverein*, and later as part of the exhibition *The Lucifer Effect* at the Center for Contemporary Art (DOX) in Prague. See: www.wkv-stuttgart.de/en/program/2010/exhibitions/the-art-of-not/ (23.07.2016).

23
This even led to the texts, drawings and objects published there being later moved to the 'Haus der Geschichte' (Museum of History) in Stuttgart, where they became museum objects.

24
Doderer, Yvonne P., Württembergischer Kunstverein (ed.) *Rote Rosen statt Zerstörung. Frauen im Widerstand gegen Stuttgart 21*. Stuttgart: Württembergischer Kunstverein Stuttgart, 2013, p. 94. The full names of the participants were revealed in the interviews published here.

25
ibid., pp. 126 –127.

26
ibid., p. 80.

27
ibid., p. 77.

28
ibid., p. 155.

29
There were two commissions of inquiry at the Stuttgart Landtag on the question of the launching of the police operation. It was classified as illegal by the Stuttgart Administrative Court in November 2015. There have been a large number of legal proceedings against *Stuttgart 21*.

30
Doderer, Y. P. (2013), pp. 155–156.

31
ibid., p. 158.

32
ibid., p. 217.

33
ibid., pp. 124–125.

34
There was also only one woman (the then Environment and Transport Minister) amongst the representatives of the project proponents. This meant that the large circle of politicians, experts, organisation representatives and resistance fighters included only two women. The group of park preservationists had refused to attend this event from the beginning, because they (rightly) assumed that the 'mediation' would not prevent or significantly change the construction of *Stuttgart 21*.

35
Doderer, Y. P. (2013), p. 67.

36
Habermas makes the following definition: "Civil disobedience is a morally justified protest which may not be founded only on private convictions or individual self-interests; it is a *public* act which as a rule is announced in advance and which the police can control as it occurs; it includes the *premeditated transgression* of legal norms without calling into question obedience to the rule of law as a whole; it demands the readiness to *accept* the legal consequences of the transgression of those norms; the infraction by which civil disobedience is expressed has an exclusively *symbolic character* – hence is derived the restriction to *nonviolent* means of protest." Habermas, Jürgen, "Ziviler Ungehorsam – Testfall für den demokratischen Rechtsstaat" in: Glotz, Peter (ed.), *Ziviler Ungehorsam im Rechtsstaat*, Frankfurt/M.: Suhrkamp Verlag, 1983, p. 35.

37
Doderer, Y. P. (2013), p. 253.

38
ibid., p. 148.

39
Schüler, Ronny; Schneider, Dorit; Drohsel, Karsten, "Fallstudie Stuttgart 21" in: *ARCH +*, Krise der Repräsentation, no. 204, October 2011, pp. 158–169.

40
Walter, Frank, (ed.). *Die Neue Macht der Bürger. Was motiviert die Protestbewegungen?* BP Social Study, Reinbek near Hamburg: Rowohlt, 2013.

41
In this research study from 2012, 80 individual interviews and 18 group discussions with 6 to 11 participants were held and 'actively observed'. Occasionally, reference was made to other purely explorative studies. (I was personally a 'victim' of such a group discussion and my experience of the setting and the moderator was not particularly pleasant or productive).

42
For example, focused interviews consisting of a mix of open and guided questions.

43
Walter, F. (2013), pp. 434–435.

44
ibid., p. 21

45
ibid., p. 431.

46
ibid., p. 432.

47
ibid., p. 435.

48
ibid.

49
Doderer, Y. P. (2013), p. 194.

50
ibid., p. 254.

51
ibid., p. 53.

52
ibid., p. 239.

ARTISTIC STRATEGIES, MASKED EXPLORATIONS AND EMBODIED DISPLACEMENTS – *THE NEW BEAUTY COUNCIL*

MACARENA DUSANT IN CONVERSATION WITH THE NEW BEAUTY COUNCIL (ANNIKA ENQVIST, THÉRÈSE KRISTIANSSON AND KRISTOFFER SVENBERG)

This text is based on a conversation that took place in Slussen[1] on April 2016. I, Macarena Dusant, engaged in conversation with Annika Enqvist, Kristoffer Svenberg and Thérèse Kristiansson, three of the founding members of the collaborative art project The New Beauty Council (2007–2014).

Slussen in Stockholm is a good starting point. I want to take the city tour Invisible Spaces – bodies shaping places and places shaping bodies. I love city tours.

Intro

The New Beauty Council (a.k.a. the city tour guides) arrives with buckets to sit on and fruit picked on communal city ground; they are wearing neon yellow vests with the words "Snyggheten och Tryggheten" (Neatness and Safety) written on the back. From the Södermalmstorg square, the tour group takes the pedestrian tunnel Gula gången, a tiled, yellow tunnel that used to lead to the club Kolingsborg. The tour guides talk about Slussen as a democratic space, offering the possibility to hide, to deviate and to grow. A space where things can be shaped and expressed without camera surveillance. Where graffiti writers have made the place a constantly changing sketchbook.[2]

On this day, Gula gången has been sealed off with a new plank wall. Slussen is under construction. EU-migrants have converted the corner into a temporary storage space and concert posters cover the wooden walls. The spaces that used to make up Slussen are now redirected – engulfed – and no longer accessible.

We turn left instead and circle down the stairs to the bus terminal. Something has happened here: there are more posters, more tags, more graffiti, more presence. Perhaps the reconstruction has created a more permissive existence. Perhaps the repeal of paragraph nine in the City of Stockholm's graffiti policy has made the city more alive? Perhaps the city faces bigger problems than chasing after graffiti writers and independent culture organizations putting up posters. Perhaps the increasing migration has renegotiated the rules governing Sweden's public space, stretched them somewhat.

The tour passes by past the café at the bus

terminal, winds upstairs, passes by a space that is undefined, returns to the surface, goes by the elevator up to the restaurant Gondolen. The day is sunny. Twenty-five people standing with buckets full of fruit and neon yellow vests screaming NEATNESS AND SAFETYNESS.

This city tour group of twenty five people takes up space waiting for the elevator, and they take up space inside the elevators. Once at the top, they take up space next to the Gondolen outdoor dining area. Here, the tour guides create a lecture space. What are the boundaries between the public and the private in this building? Who does the Katarina elevator belong to? In the space, they try out what it means to use public spaces in other ways than intended, with their own bodies.

The tour guides bring up the issue of representation in the city regarding gender, class, sexuality and ethnicity. This is one of the purposes of the tour: to question how norms and social structures are (re-)presented in the built environment. How these are re-presented through the details and expressions of architecture and design, and through the functions of architecture and design in the city. The tour group sits down on blankets and talks about public space, taste and power. We take up the in-between spaces, greet passers-by. We enjoy the fruit provided by the city, the defiance and displaced perspectives.

Acting upon a context

In the late 2000s, the City of Stockholm formulated its vision for the future as becoming *The Capital of Scandinavia*. The city's future visions, meant to attract business to the city, were showered on us by politicians, civil servants, city planners, architects and construction companies. With the conservative party dominant in Swedish government across the country, neoliberal capitalism gained more prominence. Large parts of the public housing sector were seriously diminished and sold off.[3] Swedes started to build visible fences around properties such as recently purchased apartments and became wealthy on bank loans.[4] Certain places were to be cleaned up and made attractive to social groups with greater spending power. The conservative party

used making Stockholm the world's cleanest city as a campaign issue; tax money was spent cleaning graffiti off walls in tunnels that few people ever used or saw, and politicians were unable to discuss graffiti as Stockholm's Zero Tolerance Policy on graffiti prohibited it.[5] Not only that, but in a sudden confused event haze, Stockholm was also to be transformed – for one summer – into "Love Stockholm" when the royal family was celebrating a princess' wedding.[6] There was an idea that Stockholm should become like Berlin, but a clean Berlin, a well-adjusted Berlin.[7] Rather than cities existing for their citizens, cities should be consumer spaces for tourists: *En stad i världsklass* (A World-Class City).

These are a few of the urgent reasons that led to the organising of the art project The New Beauty Council in 2007. Annika Enqvist, Anna Kharkina,[8] Thérèse Kristiansson and Kristoffer Svenberg met at a Master's course at Konstfack, University College of Arts, Crafts and Design, and began to discuss the neoliberal rhetoric in society expressed by politicians, civil servants and city planning officials. They decided to join forces, forming The New Beauty Council, a feminist collaborative art project in a Swedish art, architecture and city-planning context. Their name is premised on the actual, or oldest, Beauty Council in Stockholm: Skönhetsrådet. Skönhetsrådet (the Beauty Council) is an advisory organisation without formal power that functions as a lobby group, formally financially supported and administrated by the City of Stockholm, with space on the city website. The council is presented as a municipal authority and receives zoning plans and building permits sent over for inspection, referred from the City Planning Office. The council also receives matters from the Development Office, the Traffic Administration and the Public Administration Office.[9] An almost century-old institution, the full name of the organisation is The Council for the Protection of the Beauty of Stockholm.[10]

"The New Beauty Council were specifically interested in the idea of *a beauty council*, as beauty is often used as an argument against different non-controlled expressions in the city. The name somehow indicates that there is a threat against something that needs protection. But there is no specification of what is to be protected, or from

what." Annika Enqvist, Anna Kharkina, Therérèse Kristiansson and Kristoffer Svenberg presented themselves as *The New Beauty Council*. "Some people would frown because they didn't know what to expect from us and they asked if we were an alternative to The Beauty Council," recalls The New Beauty Council, and continues, "Why address oneself as an alternative? Why not be the real thing?"

Fig 7.1 The New Beauty Council logotype

The New Beauty Council examined how architecture and urban planning can be seen in different ways, in terms of form and representation, and in rethinking the public sphere and the challenges of city-space and urban conditions. They say: "When we prepared the walk by furnishing the square with our buckets we were immediately asked by passers-by what we were selling, as if the only raison d'être on the public plaza is commercial. People who saw we had fruit wanted to buy it, too, even though the fruit market was right next to us, and the fruits we offered were free, we had picked them from trees in nearby urban parks." The New Beauty Council focused on how the social and performative aspects of the city can be recognised and changed through additions and actions which can open alternative ways of experiencing the public realm. "Our urban environment, the environment we move through in everyday life, is more political than we may think as we go from point A to point B; the things we don't pay attention to; the things we take for granted; the things that affect us ideologically."

Inspired by sociologist Catharina Törn and the urban researchers Moa Tunström and Carina Listerborn, the group took an interest in the words politicians active in city planning used. "Politicians,

such as the city commissioner at the time, Kristina Alvendal, civic servants, and architects spoke of cleaning up places that were seen as messy and burdened with criminal activity. Industrial areas, for example, were to be torn down to make space for apartment buildings or new housing areas. It is a rhetoric of fear as opposed to safety, to tear down areas that are fully functional for different types of activities," the group states in our conversation, adding that the word improvement is also common. A word that somehow enables the exclusion in planning and design.

The catchy rhetoric of safety of the late 2000s veiled neoliberal capitalist motivations and set the terms for the ways in which the city would be shaped over the years to come. "Some rhetoric was completely void of class perspective. An example is the use of the contradictory term 'positive gentrification processes'. But a gentrification process is never positive for the people who are forced to move away," says The New Beauty Council.

What happens if the rhetoric is used for artistic exploration? The vests that The New Beauty Council were wearing, with the words *Neatness* and *Safetyness* on the back, was one of the group's strategies in turning the rhetoric on its head. *Neatness* and *Safetyness*, were characters they put on as a comment on the phrase *"neat and safe"*, one of the conservative party's slogans for the concept *En stad i världsklass* (A World-Class City).[11]

Neatness and *Safetyness* printed on neon yellow vests created a contradictory meaning, when worn by people walking around the city surrounded by a tour group. "Words like neatness and safety leave little room for deviation. It doesn't really get more totalitarian than that," says the group. The *neat and safe* slogan is still used in some Swedish municipalities.

The New Beauty Council paraphrased political parlance, the sort of language that is reproduced by the media without any problematization of the rhetoric among those in power. Repetitions that become a matter of course. Displacements of language, roles, and norms are core components of the group's work.

A queer-feminist interpretation of the carnivalesque space

The New Beauty Council used the carnivalesque to challenge norms and displace actions and bodies which are taken for granted as something natural. Informed by writings on performativity by gender theorist Judith Butler and architect and researcher Katarina Bonnevier The New Beauty Council used the carnivalesque situation in order to show how normality (for eg heterosexuality, straightness and gender) are performed.[12,13] Drawing on philosopher Mikhail Bakhtin's definition of the carnivalesque, the group made their own queer feminist carnivalesque interpretation. For Bakhtin, the carnivalesque stands for resistance against hierarchies that take shape in pre-defined formulations, order and taste. Bakhtin uses François Rabelais' writings and his foundation in the popular humour culture connected to the rituals of the carnival and the theatrical. The carnivalesque has its own rules and plays out in an overturned existence where social hierarchies cease to exist, and where people are buried and reborn at the same time.[14]

"The carnivalesque is a space where actions which are not given room in the excluding structures of society are allowed to take place. In the carnivalesque, bodies can depart from the norm within the space that opens. However, the carnival is not unproblematic, as it risks becoming a gesture of permission from dominant powers. The carnival potentially confirms the social hierarchy rather than overthrowing it."[15]

How can the city be interpreted through the carnivalesque? As a method, the carnivalesque makes displacements and examinations of power structures possible. "The carnivalesque teaches us that everything isn't static, that situations can have different meanings depending on opportunity and context. The interesting thing about the carnival is that it allows for transfers in identity and association. It allows you to mentally cross-dress and, in a way, sort of change the costume of your brain", says The New Beauty Council; "The carnival is something temporary and temporary spaces make renegotiations of norms and living terms possible."

For The New Beauty Council, the carnivalesque could be expressed by taking on different roles and having some of the invited persons participate in the carnival, sometimes knowingly, sometimes unaware. The city tours were an interpreted form of the carnival, where the group members became the characters *Neatness* and *Safetyness*, a staging that the participants became part of. "One lady was angered by the fact that the city tour was political. She felt misled."

They often used makeup and costuming for public events. The New Beauty Council tell me "For one lecture we came dressed in certain distinguishing clothing and discovered that the politician we were to debate with was wearing the same colour scheme, so everyone in the panel was matching." The politician became a part of the staging, both by accepting the subtle disguise and by coincidentally becoming part of the carnival.

The carnivalesque filled several purposes in the art project. As an artistic method, it was instrumental in challenging and exposing the surrounding people, and the group itself, in order to destabilise safety and security. Through disguise, one's own professional role and its conventions were examined. Disguising oneself also provides protection from the unknown when transgressing boundaries.

Since The New Beauty Council was the *new* beauty council, the discussion on taste was always present: what is allowed, and why? The act of disguise does something to the idea of taste in formal situations, as it creates confusion and a sense of absurdity in a more formal space. "We take an understanding of aesthetics as politics as our starting point, and taste is an important concept for us, since we believe the physical environment is developed through decisions based on opinions of what can pass as acceptable, normal, and desirable, or inappropriate, unbecoming, unsuited and unwanted, which is tied to a system of capitalist patriarchy maintaining gender, class and race hierarchies," says The New Beauty Council.

The New Beauty Council staged strategic displacements and masked explorations.

Trying displacement of power through public meetings

The Moderna Museet (The Museum of Modern Art) maps Swedish contemporary art every four years in the exhibition *Modernautställningen* (The Moderna Exhibition). The New Beauty Council was invited in 2010 and participated with the work *Din trygghet är inte min trygghet* (Your Safety is Not My Safety). In conjunction with the exhibition, there was a performance in the shape of a public seminar called *Konsten att spegla sig i staden* (The Art of Mirroring Oneself in the City). The seminar was about public space and the power of the visual, and other significant voices within art and city planning participated.[16] All participants were asked to prepare a short text, to be read at the seminar by someone other than the person who wrote it. The New Beauty Council wanted people to hold one another's presentations to try out displacement in position: it was a masquerade, in which The New Beauty Council had distributed the texts strategically. A feminist researcher was made to read a dry bureaucratic text, and the director of one of Sweden's oldest public art galleries was made to read a feminist text.

The New Beauty Council also participated in the reading of others' texts, as it was important for them to be part of the situations they staged. "For our part the masquerade consisted in us dressing as Hannah Arendt for the occasion, since we were very influenced by her writings, especially the book *The Human Condition.* We painted skulls on our faces and built an altar to honour her, since the seminar took place on Dia de los muertos."[17] One of the male directors was clearly provoked by the unconventional staging and how the readings were organized. Despite being informed in advance, he made the excuse that he had left his glasses behind, and was thus unable to read the assigned text, which was a feminist one. The New Beauty Council recalls, "It was so clear that the person's actions broke the agreement and thereby expressed a position of power in front of the other participants. The person found the format uncomfortable and did not want to accept the staging. Luckily, another participant lent them their glasses." They continue:

"People with a lot of power often have a hard time accepting situations they can't control. Inviting civil servants to just represent their formal position was not interesting to us. It was important to expose the participants to destabilizing positions and for them to become something other than their rehearsed formulations. Public professional positions are also a mask. A constructed mask of bureaucracy."

The meeting of different actors and perspectives was important to The New Beauty Council. Citizens' movements, grassroots movements, theorists, politicians, city planners, civil servants and more were all meant to discuss things in public conversations, which was rare at the time. The idea was to challenge stories that were taken for granted as well as the notions of experts, and how they function within the predominant discourse. "Many actors in city planning shield themselves by pointing out that they deal with the practical within their assigned work. In this way, they are able to conceal values and subjective choices. Few talk about responsibility", says the group, who instead tried to bring the ideological and political dimensions of city planning to the fore.

The New Beauty Council's first work was a seminar at the Stockholm City Museum in 2009, *Changed Perspectives c/o The Stockholm City Museum.* This seminar program was a series of four talks with people from different fields and forms of organization. Among other things, questions regarding how norms and social structures are (re-)presented in the built environment – in the details and in its expressions, as well as in the functions of the city – were touched upon. "What became clear in this session was that the people with power over the city's future and history refuse to admit that taste and style influence judgements and decision-making. Words like 'architectonic qualities' and 'historical values' are seen as neutral words", the group states.

Pushing boundaries in the art field

Acting as an art project was important: it gave the group the space and position needed to explore and experiment, and it was a way to see what art could be, and connect it to other ideas and practices. The New Beauty Council did not want to be a nice artwork in the shape of an object. They were an art

Fig 7.2 The poster image for *Changed Perspectives c/o The Stockholm City Museum* – four public talks, Stockholm City Museum

project that didn't want to smooth things over, but rather wanted to take responsibility and question values. Art should take up space, and The New Beauty Council wanted to discuss important issues in society. "We wanted to create publicness. Not public representations that are nice to look at, which is a bad sort of way to make public art."

Since The New Beauty Council consisted of people with different professional roles such as artist, architect, curator, photographer, the group could adapt to push issues in different fora.[18] This chameleonisation that the group used made it possible for them to move between different fields and departments. By taking on one another's professional roles within the group, The New Beauty Council also challenged their own positions and what is allowed within a specific profession. The group says that it was difficult already back in art school, as they were given different conditions that referred back to their formal professional roles. They wanted to challenge hierarchies within the art field; to loosen up conditions was a driving force.

"Reputation is so important in the art field, and crossing boundaries within the profession means playing against the unwritten rules that one learns at art school and maintains in professional life. We wanted to push these boundaries, quite simply."

The curator took the role of the artist, the artist debated politicians, the architect did all sorts of things. All three of them became political operatives.

Acting within the institutions – getting drrrty

An important goal for The New Beauty Council has been to convey knowledge. "A problem in society, which needs to be looked at, is that the acquisition of knowledge is narrow. As citizens, we read to learn, but we don't create our own knowledge." The New Beauty Council worked actively with meeting people and situations. Meeting other professions, meeting power, meeting people. "This is something art school doesn't teach: the act of meeting."

There are similarities in the meeting of other people and the role of being a host. Hosting is not a given role, it demands more. "Hosting is imperative to getting something interesting out of a discussion. Hosting events demanded more of us because it

is about responsibility for the participants, for the situation and for the purpose of the project. It is about the details as much as it is about the whole." When The New Beauty Council invited speakers to the seminar at Moderna Museet, their strategy was to send invitations with chocolate and balloons and glitter, as well as fake moustaches should the invited people wish to disguise themselves. This was meant to create ambiguity and break the conventions of how an invitation to a seminar with researchers and directors should look.

Impacted by their times, when criticism of institutions set the tone in the art field, The New Beauty Council decided to utilize their positions and use the institutions as material. They had the tools to act within the institutions; in Sweden, formal institutional power is not at too great a distance. "If you have a certain background and position in society, it is possible to come quite close to those in power. It wasn't that we loved the institutions we worked with, but we thought we ought to roll up our sleeves and try working from within." The institutions were good material, since they are bodies of power in society. In addition, their names were used as senders, which had an impact on those invited to participate. "Collaborating with a brand that we didn't like also meant that we distanced ourselves from cold and cool criticism of institutions, that keeps away and thinks a lot of things without doing anything practical. It is easy to criticize, but who does anything? Who gets their hands dirty? It is worth doing something over doing nothing." Within the group, The New Beauty Council referred to this as relational make-out-institution-aesthetics, playing with the paraphrase of the influential term "relational aesthetics", coined by art critic Nicolas Bourriaud at the end of the 1990s.[19]

The New Beauty Council suddenly found themselves in a political field they hadn't anticipated and were not prepared for. This caused uncertainty in terms of what discussions of real politics mean with regard to responsibility. The potential of having an impact means having acquired a position of power. The group was invited on ministry level, discussing city planning with General Directors and the current Minister of Culture. The New Beauty Council was given the same space to express themselves. They

got to challenge politicians in public debates and were given a position which demanded other things than what they were used to.

"The artist is not trained to speak to decision-makers. The artist is rather used to working with herself."

Togetherness : More fun! More knowledge! More power!

The collective method has been important to The New Beauty Council. Collectivity provided the possibility to find the courage to work across borders and deal with the critical issues they addressed through their work. Being a group is a strategy to create authority; it gives weight to work behind a name. This, too, is a form of disguise. One of the strengths of the carnival is being part of a bigger context without being singled out. Safe spaces are created within the carnival. "This is the strength of working as a group, of being several people. You are more daring than when working alone. It also creates a sense of community and provides support, so you never have to face problems alone."

The group states that their bond is based on trust and exchange. "Humans are in a constant learning process and accepting this is a prerequisite for the group to develop. Evolving together gives the opportunity to dismantle positioning against each other within the art field." The New Beauty Council consciously worked with the collective to counteract the individualistic traits of the artist's profession. The collective is a matter of power, bodies and space: "Besides being braver, we're much cleverer together than alone. We have more fun, too. Artists are trained to be individuals and compete with one another, rather than cooperate."

Human bodies, bodies of buildings, institutional bodies, the city as body. Influenced by philosopher Elizabeth Grosz' problematization of the correlation between body and city constituting one another, The New Beauty Council addressed relationships between bodies.[20] A dialogue which is mutually productive. The group focused on the commonly experienced. To experience something physically and mentally provides another dimension compared to being a solitary viewer, or being a viewer at all.

We all experience the city; we use its spaces and functions in varied ways. It is impossible to examine without being present. In this way, mutual experience also becomes an act of sharing with others.

Another strength in the collective formation is the assembled knowledge a group holds. The New Beauty Council talk about the inadequacy in making research available. "There is so much knowledge within research that never reaches the public, because the solitary researcher carries the solitary responsibility to get their research out to a wider public, which is hard when one already has so much to do and manage." It is also important to The New Beauty Council to collect and make use of the knowledge from the different groups in society that use the city. Working within a feminist world of thought, lived and embodied experiences weighed just as heavily as academic knowledge. "There is knowledge that isn't academic research but lived experience."

Dreaming the utopia. The potential of the public

Stagings, seminars, city tours, debates and carnivals. Discussions on the terms of lived space took many shapes. A more poetic example is *Forest Food for Thought* where the masquerade as tool was explored. The New Beauty Council were invited to the art project *Power Landscapes* 2011.[21] The group was to create methods for meetings for the participants in the research conference Nordic Environmental Social Science (NESS) in Stockholm that year. NESS addresses questions about sustainability from the perspectives of different research areas and disciplines. "As invited artists we responded to the themes and details of the conference by exploring suggestive wishful thinking as a strategy for staging different futures. Out of this, a forest garden was born. The forest garden is the art and science of designing a garden that mimics the diversity, structure and function of a forest ecosystem. The aim was to create a self-sustaining, low maintenance, low input but high output garden with edible plants."

In *Forest Food for Thought,* workshops were arranged where researchers, students and other participants met during a picnic and wrote postcards describing how the forest, which didn't exist,

looked and felt. This masquerade took the shape of an imaginary forest and played with the notion of the parallel existence of a place.

"Utopia was dreamed here", says The New Beauty Council.

A forest garden was established on the university campus in 2013, greatly due to the efforts of Christina Schaffer, educational administrator at the Department of Physical Geography at Stockholm University. This also resulted in a recurring university course – Urban Gardening – Planning, Environment and Health – at the department.[22] Urban gardening is a method that highlights the possibilities in the city and questions guidelines in city planning through local influence and the act of commoning. Forest gardening is especially interesting from a democratic perspective. The university campus is royal land. The forest garden is open for anyone to take part in and to harvest from, and the university has incorporated the maintenance of the forest garden in their regular public management. *Forest Food for Thought* discusses the use of the public space, notions of ownership, and green city spaces. As an artwork, *Forest Food for Thought* is a political and an aesthetic act for accessibility and the potential of the public. Meanwhile, it manifests the The New Beauty Councils' ideology on diversity and openness as a self-evident condition in society for all sorts of bodies and sexualities to take place.

How we look at city spaces is crucial: for whom is the city for? "It is clear that building construction is connected to certain groups who expect to be in

Fig 7.3 *Jungalalsicoius*, facade tapestry by The New Beauty Council, part of *Forest Food for Thought* at Botkyrka Konsthall (2012)

certain places. We should adopt visions that resist the idea of commercializing open spaces to allow for futures that provide other values than western supremacy and don't serve the market. How our cities are currently reconstructed will very much influence how we will be able to live in them in the future." The New Beauty Council says that tunnels and secluded spaces provide protection and rest for groups who are not accepted on city squares or in the subway. The in-betweens and hidden spaces make place for other ways of behaving than dictated by patriarchy. To give an example, the legendary club Kolingsborg used to inhabit the labyrinths of Slussen beginning in the middle of the 1970s, hosting parties for all sorts of subversive behaviours.[23]

"Some spaces that are considered dangerous are safe for others. One thing that is certain is that Slussen, as a place, has been allowed to fall into disrepair or to look dilapidated in order for the public to perceive a need for change. To justify a reconstruction that leads to a *neat and safe* future."

Outro

11 April 2016. At 3.00 p.m. I have made an appointment to meet the group The New Beauty Council at the Södermalmstorg square in Stockholm. This place is chosen because the group has held city tours around the Slussen area, and arranged seminars at the adjacent City Museum. I tell The New Beauty Council that I would like to take their city tour of Slussen.

11 April 2016. Between 3.04 p.m. and 3.17 p.m. we are waiting for one of the group members, who is late. A Romani woman comes up to us and tells us about her four children. She shows her injured knee, pointing to a big scar for which she needs lotion. After a while, she moves on when she realizes we won't give her any more money.

11 April 2016. At 3.30 p.m. After the delayed member has arrived and coffee to go has been bought from the Pressbyrån convenience shop, I ask The New Beauty Council to stage their city tour for me. I have 24 imaginary participants with me.

I have taken on the role of disciple and The New Beauty Council are my masters. They chuckle and reject such a hierarchical form. They still struggle with their position as experts, acknowledging that they are but three residents among three million other expert-residents of Stockholm, or 9,5 million expert-residents in Sweden.

Selected works by The New Beauty Council:

Exclude Me In, in collaboration with MYCKET, Göteborg International Biennal for Contemporary Art Sep–Nov 2013; *Knitting House* with Elin Strand Ruin at Arkitekturmuseet, Stockholm (Jan-Mar 2013); *Jangalallcious* and *Be Careful of What You Think of – It Might Come True* in Cultivate! Planet Blue a green exhibition, Botkyrka Konsthall (May–Oct 2012); *Knitting House* with Elin Strand Ruin and *The Passerine* in collaboration with MYCKET at the Reykjavik Arts Festival (May 2012); *Home is Wherever I'm with You*, with Katarina Bonnevier in A Real Home, Sven Harry's Konstmuseum, Sthlm; *Twilight Walk* at The Gothenburg International Biennial for Contemporary Art Sep–Nov 11; *The Art of Mirroring Onself in the City*, Modernautställningen, Oct 2010–Jan 2011 at Moderna Museet, Stockholm; *Institutionalising Beauty* and *Beauty Salon* at 48 H Architecture, The Swedish Architecture Museum, Feb 2011; *Knitting House*, in collaboration with Elin Strand Ruin at Husby Konsthall, Stockholm Sep–Nov 2010; the dialogue *Walkie Talkie Tour Talk & Recycling Institutions* at Design Act, IASPIS Oct 09, *Safe Slut*, Screening, Centre for Contemporary Arts – Glasgow in Experiments in Living, Sep 2009; *Changed Perspectives* c/o *The Stockholm City Museum* – four public talks, Stockholm City Museum, Jan–Feb 2009. NBC City Walks as performances: *Invisible Spaces – Bodies shaping Spaces and Spaces Shaping Bodies* and NBC showing the city through Stockholm Green Map in *Do Only Rats Survive Here?*, Stockholm Cultural Festival (Aug–Sep 2009).[24]

1
Slussen ("The Lock") is located between Gamla Stan and Södermalm in Stockholm, in an area that connects Lake Mälaren with the Baltic Sea. It is a public transport hub and, most notably, a cloverleaf road interchange (the first in Europe).
2
It's no coincidence that Slussen is the central figure on the cover of the graffiti books *Overground 2* by Tobias Barenthin Lindbland and Malcolm Jacobson (Eds.), Stockholm: Dokument Press, 2006, and *1207* by Torkel Sjöstrand, Stockholm: Dokument Press, 2007. The books present the most prominent graffiti writers at that time in Stockholm and Scandinavia.
3
Between 2007–2014, 26 000 state owned rental apartments were sold to the private market in the inner city of Stockholm followed by occasional privatization in the suburb areas. Part of the privatization of the Swedish Welfare State was also medical care, public transport and public schools. For a discussion on the Swedish housing politics regarding deregulation see Crush, *13 myter om bostadsfrågan* ('13 Myths About the Housing Question'), Stockholm: Dokument Press, 2016.
4
Swedish households had a total mortgage debt of 2,721 billion SEK in 2016. The mortgage debts have grown faster than household incomes, which means that the debt ratio has risen up to 177 percent. Statistics Sweden, *Ingen avmattning på bolånemarknaden* ('No slowing down in the housing loan market'), www.scb.se/sv_/Hitta-statistik/Artiklar/Ingen-avmattning-pa-bolanemarknaden/. Accessed 2016-09-29.
5
The Zero Tolerance Policy on graffiti ("nolltolerans", formally called "Klotterpolicyn") was adopted in Stockholm during the 1990s and was an interpretation of New York's zero tolerance on illegal graffiti. In Stockholm, the interpretation and implementation of the policy led to censorship and a ban on arranging graffiti events that had been legal before. "The Zero Tolerance Policy also prevents conversations about graffiti as an art form. It states that neither civil servants nor politicians are allowed to discuss graffiti in any context that does not clearly condemn it. Riksteatern has experienced several instances where civic servants have declined to participate in debates with reference to this." Ceylan Holago and Rani Kasapi, *Policy strider mot yttrandefriheten* ('Policy at odds with freedom of speech'), *Svenska Dagbladet*, 2011-08-13, www.svd.se/policy-strider-mot-yttrandefriheten. Accessed 2016-04-30, translated by Hedvig Marano. Art historian Jacob Kimvall discusses the issue of zero tolerance on graffiti in Stockholm in his PHD-thesis *The G Word: Virtuosity and violation, negotiating and transforming graffiti*, Dokument Press, Stockholm: Stockholm University, 2014.
6
Hon är Stockholms kärleksgeneral ("She is Stockholm's Love General"), Press release from The City of Stockholm, www.mynewsdesk.com/se/stockholms_stad/pressreleases/hon-aer-stockholms-kaerleksgeneral-392319. Accessed 2016-04-30.
7
As part of the project *Kulturvision 2030* ("Culture vision 2013") launched 2008 by the city of Stockholm, some politicians and civil servants expressed that they thought the city "should be more like Berlin". See Sofia Curman, *Stockholm vill bli stad i världsklass* ("Stockholm Wants to be A World-Class City"), *Dagens Nyheter*, 2008-11-04, www.dn.se/kultur-noje/stockholm-vill-bli-stad-i-varldsklass/. Accessed 2016-07-28. A closer look at this rhetorical expression raises questions regarding exactly what image of Berlin is addressed. It unveils a desire of what Berlin represents in terms of culture with a diverse public space. However, the statement is more about an image of Berlin placed in a market context rather than reflecting the actual state of the city (I can't find an awareness expressed by the politicians or civil servants of Berlin's strained economy), which has been heavily affected by gentrification over the last ten years. For an interesting peek into the discussion of gentrification in Berlin from a graffiti perspective, see the article on graffiti writer Blue's illegal painting by Lutz Henke, 'Why we painted over Berlin's most famous graffiti', *The Guardian*, 2014-12-19, www.theguardian.com/commentisfree/2014/dec/19/why-we-painted-over-berlin-graffiti-kreuzberg-murals. Accessed 2016-07-28.

8

Historian Anna Kharkina was involved at the start of The New Beauty Council and at the group's first appearance at Gävle konstcentrum in 2008. At an early stage, Kharkina decided to concentrate on her PhD-thesis in history at Södertörn University and Stockholm University, and thus left The New Beauty Council.

9

Stockholms stad, www.stockholm.se/OmStockholm/Forvaltningar-och-bolag/Skonhetsradet/. Accessed 2016-04-30.

10

In Swedish the name is *Rådet till skydd för Stockholms skönhet*. Translated to English by Annika Enqvist and Thérèse Kristiansson.

11

A slogan which was criticized for homogenizing public space and leading to social sanitation. Architect and researcher Catharina Gabrielsson writes, "A while ago, I participated in a meeting about the imminent glass encapsulation of the Sergels torg area in central Stockholm. This issue has long been handled quietly and away from the public eye; free from the debate that sparked when the project was first initiated in 1998. When I asked about the actual purpose of these measures (which will lead to large parts of the Sergels torg plaza being claimed and commercialized) a representative of the police force replied: 'We want to get rid of the addicts, the immigrants, the youths, the homeless and the soup-kitchen attendees – we're the only ones who should be there.' There is no clearer way to express the reasons behind conservative party Moderaterna's election campaign slogan for Stockholm – 'Tidy and safe.' What is being presented as measures for increased comfort and safety is in reality a question of social decontamination. It means a homogenization of the city's inhabitants as well as its selection of businesses, since the 'upgrade' of the urban environment also means raised commercial property rent: only the major chains will remain. Democratically speaking, the issue is complex; however, since these types of measures seem to be what a majority of the population desires, 'Neat and safe' – like in glass-encased malls – is something most people like, isn't it? The fact that it means infringing on democratic rights and liberties, which can only be guaranteed on public land, doesn't seem to bother many. The question is, who are 'we' then? And, perhaps more importantly, who do 'we' want to be?." Catharina Gabrielsson, "Snyggt och Tryggt" ("Neatness and Safetyness"), *Dagens Nyheter*, 2007-10-17, www.dn.se/kultur-noje/kulturdebatt/snyggt-och-tryggt/. Accessed 2016-04-30. Translated by Hedvig Marano.

12

Foundational to queer theory is for example Judith Butler, *Gender Trouble: Feminism and the Subversion of Identity* (1990), London & New York: Routledge, 1999.

13

Architecture scholar Katarina Bonnevier has coined the term cross-cladding: "It combines Judith Butler's queer theoretical ideas on cross-dressing with Gottfried Semper's architectural theory of *Bekleidung*, cladding." See Katarina Bonnevier, *Behind Straight Curtains: Towards a Queer Feminist Theory of Architecture*, Stockholm: Axl Books, 2007, p. 217.

14

Mikhael Bakhtin, *Rabelais and His World* (1941), Trans. Hélène Iswolsky. Bloomington: Indiana University Press, 1993.

15

The use – translation – of the carnivalesque, when done by a privileged group, is something that should be problematized.

16

Participants in the seminar *Konsten att spegla sig i staden* ("The Art of Seeing Your Reflection in the City") were Maria Sandgren, psychologist and researcher at the department for Culture and Communication at Södertörn University, Jessica Sjöholm Skrubbe, art historian and researcher at Stockholm University, Mårten Castenfors, director of Liljevalchs Public Art Gallery and Stockholm Konst ("Public Art of the

City of Stockholm"), Per Hasselberg, artist, Marie-Louise Richards, architect. Thérèse Kristiansson and Annika Enqvist from The New Beauty Council moderated the seminar. See www.modernamuseet.se/stockholm/sv/utstallningar/modernautstallningen-2010/arbete-pagar/per-hasselberg-och-the-new-beauty-council/.

17

Dia de los muertos is a Mexican religious holiday that is a mixed result of indigenous practices and Catholic traditions when the dead are honoured in several ways.

18

For The New Beauty Council, this was also a strategy to survive on lectures that gave pay.

19

See Nicolas Bourriaud, *Relational Aesthetics*, Paris: Les Presse Du Reel, 1998.

20

See Elizabeth Grosz, *Space, Time and Perversion: Essays on the Politics of Bodies*, London & New York: Routledge,1995.

21

Within the framework of *Power Landscapes* (2011), which was also the theme of the annual NESS conference (Nordic Environmental Science Conference), The New Beauty Council created virtual platforms for collective thinking and writing, workshops and meetings between students and researchers, through outdoor picnics. The art project *Power Landscapes* was executed by artist and curator Po Hagström, and included several artists, exhibitions and smaller art projects connected to the *Power Landscapes* project. See Linda Soneryd (ed.), *Power Landscapes*, Botkyrka: Labyrint Press, Botkyrka konsthall, 2012. Available here: botkyrkakonsthall.se/PlanetBlue/

22

The university course covers 7,5 points and is given as a summer course in collaboration with Christina Schaffer and the Tillväxt ("Growth") network. Tillväxt works for a sustainable city through organizing urban gardening.

23

The New Beauty Council reminds me of the recurring clubs in Stockholm such as the Lesbian clubs G and *Bitch Girl Club*, synth club *Tech Noir* and indie club *Friends and Acquaintances*. I would like to add the legendary hiphop jams with hiphop artist Grandmaster Flash in the Bronx and graffiti writer Mode 2 in London.

24

NBC Contributions in publications: 'There is some accounting for taste', in *Objects, Journal of Applied Arts* (#4/10); 'The New Beauty Council om talande form' in the catalogue of the Graphic Design Awards *KOLLA!* (2010); 'Makten att formulera problemet' in *Röster från Slussen (2010)*. Stockholm: A 5 Press; 'The Whispering Game' in *Drömbyggen* (2009). Stockholm: Center for Architecture and design.

8

RESILIENT SUBJECTS: ON BUILDING IMAGINARY COMMUNITIES

**ELKE KRASNY
AND MEIKE SCHALK**

We propose a shift in how to understand the notion of 'resilience'. Generally, 'resilience' is defined as the ability of systems to cope with change.[1] Instead of the all too common framing of resilience in terms of systems, we discuss and reframe it here in terms of *resilient subjects*. This chapter reflects on feminist tactics for building resilient networks and *imagined communities* (as theorized by Chandra Talpade Mohanty 2003) which counteract societal challenges such as political, economic, and social injustice produced by global capitalism and patriarchal power structures. These counter-actions are not only reactions to current material and historic conditions but also proposed ways to act in future. More specifically, from our standpoints as curator (Elke) and architect (Meike), we foreground three examples, relevant to feminist practices in art and architecture, that have built imagined communities: one through a sustained act of resistance, another as an art piece, and a third as a strike. We further discuss how these perform a transgression between the domestic and the public realm – a recurrent theme in feminist thinking – where architecture becomes the symbolic space of appearance (Torre 2000).

'Subjects' are understood here both as what is constituted as subjects (i.e. subjecthood) and as subjects (i.e. as subject matter). The three examples of spatial practice that we discuss include the *Madres de la Plaza de Mayo* (initiated in Buenos Aires in 1977), the activist art project *The International Dinner Party* (organized by artist Suzanne Lacy in 1979), and walks and research of the *Precarias a la Deriva* (initiated in Madrid in 2002). All three examples emanate from groups that share experiences and demonstrate an ability to connect and build up networks and communities. In different ways, the examples illustrate the transformation of individuals and groups, and the emergence of new subjectivities through the process of moving from singular to common practices, as well as the appropriation of public and hegemonic spaces that are given new meanings. We, as a curator and an architect, building on our previous work,[2] consider how community formation is spatialized, which is relevant more generally within feminist practice in art and architecture.

Drawing on Chandra Talpade Mohanty's work

on transnational feminism, we connect her concept of 'imagined communities' and 'communities of resistance' with the notion of emerging resilient subjects, which counteract representational regimes and hegemonic power relations within globalized capitalism. We aim to understand how resilient subjects, through their transgressive practices, build lasting alignments between the personal, the social, the public, and the domestic.

Through this discussion of concepts and examples, our first aim is to show how these feminist spatial practices create solidarity and connectivity by way of sharing resources and knowledge. Secondly, we seek to foreground how these practices counteract hegemonic power relations, which affect violence through making and maintaining precarity. Finally, we are interested in how, taken together, practices of sharing and counteracting connect the domestic and the public space, transgressing historically-constructed and locally-situated boundaries between private and public. We argue that feminist practices reveal that a different understanding of these relations is needed in order to arrive at theorizing and practicing (as) resilient subjects.

Through these issues, we raise a number of questions central to our concept of resilience, which is social rather than technological, political rather than policy-based. What can we learn from practices like these? What are the spatial tactics that transgress historically forged boundaries between the private and the public? What are the forms of sharing, counteracting, and connecting that are developed in response to the different crises at hand?

Becoming-subjects, becoming-community

Within the recent materialist feminist philosophical and political discourse, opportunities are identified for new social relations, community building and new institutional practices that aim to foreground resilient futures and empowerment. A prerequisite for such positive change is the 'becoming' of different subjects (Braidotti 2011, Stengers 2008, Petrescu 2013, Gibson-Graham 2008). To understand the notion of 'becoming-subject', we refer to Rosi Braidotti: "[t]he subject is a process, made of

constant shifts and negotiations between different levels of power and desire, that is to say, wilful choice and unconscious drives" (2011:18). She further argues: "It implies that what sustains the entire process of becoming-subject is the will to know, the desire to say, the desire to speak, think, represent" (257). Becoming-subject is not an individual activity, but an interactive collective process that relies upon relations and social networks of exchange. Subjectivity thus involves significant sites for reconfiguring modes of belonging and political practice. These processes are mutually constitutive; they establish a "common interest" and a "common context of struggle" (Mohanty 2003:11). Common subjects then become also a shared resource where the conscious development of relevant common subjects is both a vehicle and an aim for becoming-subject.

Mohanty draws on Benedict Anderson's notion of 'imagined communities' (1983) to move away from essentialist notions of community. While Anderson referred to community in terms of the modern construct of the nation-state, Mohanty (2003) uses this concept to point to feminism as an 'imagined community' of subjects with divergent histories and social locations, united in a common political struggle of opposition to forms of domination that are not only pervasive but systemic. She uses the terms "imagined communities" or "communities of resistance" (Mohanty 1991:4–5; 2003:47) to suggest commitment and potential alliances and collaborations across divisive boundaries. Such terms also suggest political rather than cultural bases for alliances. Community is not a given, a readymade locatable entity. Rather, community has to be produced and reproduced. Community building, therefore, can be understood as a complex process of becoming political by way of actively producing and reproducing the very politics of community. "Community, then, is the product of work, of struggle" (Mohanty 2003:104).

In our reading of both Anderson and Mohanty, the notion of community reaches far beyond the local. In Mohanty and others, the theoretical discourse on community encompasses global, spatial and temporal perspectives, which highlights less visible scales – the body, the household – but stresses interconnections between the intimate and

the global (Katz 2001, Christie 2006, Elmhirst 2011, Nightingale 2011). Feminist thinking conceptualizes embodiment in its material and emotional dimensions (Grosz 1994). Thus, feminist conceptualizations of politics and subject-formation posit gender as intersecting with ethnicity, age, sexuality, etc., a constitutive process on all scales of analysis and action (Elmhirst 2011, see also Molina in the prologue of this section). In her introduction to *Feminism without Borders: Decolonizing Theory, Practicing Solidarity*, Mohanty states that "feminist practice … operates on a number of levels: at the level of daily life …; at the level of collective action … and at the levels of theory, pedagogy and textual creativity …" (2003:5). On all these levels, within public space and domestic space, as well as in terms of productive and reproductive labour, micro and macro variables are complexly interrelated and interdependent.

Imagined communities, or communities of resistance, are a means and an end. They are inherently unstable; they rely on transformative practices to come into being. These practices, as we will demonstrate in the three following examples of feminist community building, emanate from transgressive activities, which draw and sustain new connections between the public and the domestic realm. This is how we understand and work with such practices here, and we use a special term to underline this premise: resilient subjects, continuously investigating what it means to find common ground by way of connecting, sharing resources, counteracting violence, hegemonic power relations and precariousness.

Imaginary communities of resistance across times and geographies

We analyse resilient subjects through three different examples, in order to examine solidarity and community-building across different times and geographies. Using a literal meaning of *resilient* as our starting-point – at once flexible and strong, supple and tough – we will unpack the notion of *resilient subjects* in feminist practice with a special emphasis on activities of sharing, counteracting, and connecting. Our focus is on how these three activities work together in fostering the emergence

of resilient subjects as a basis for building communities against fragmentation, for transgressing essentializing notions of pre-given, stable entities of community, and for counteracting separations between domestic and public spaces.

Mothers of Plaza de Mayo: Transforming Public Space

Our first example of resilient subjects features the silent manifestations of the *Mothers of Plaza de Mayo*, initiated in 1977, in the most important public space of Buenos Aires. The manifestations have gained considerable international attention and inspired similar ones in other places around the world.[3] The manifestations involved women coming together to demand information and justice for their children and husbands who had 'disappeared' under the Argentine military regime between 1976 and 1983.[4]

The women first met incidentally at the Ministry of the Interior in their search for information about missing children and husbands. At the time, public demonstrations were strictly forbidden, and gatherings of more than two people in public space were promptly dispersed by security forces. At first, a group of fourteen women came to the plaza every Thursday after work, wearing white kerchiefs to identify themselves to one another. The *Mothers*, as they became known in the international press later, circulated in pairs, occasionally switching configurations within the pairs, to share information while observing the rule against demonstrations. In later demonstrations, the *Mothers* also shielded their bodies with cardboard signs representing their missing children and husbands. Eventually, they attracted the interest of international press and human rights organizations.

The *Mothers'* spatial appropriation consisted of quiet private acts of sharing personal issues, stories, and photographs that gained public significance. Their manifestation succeeded because it endured over many years. Initially ignored by the police and national press, because the *Mothers* seemed to represent no threat, their presence developed into a "powerful architecture of political resistance" (Torre 2000:142). The phenomena of women circling the May Pyramid monument in the center of the plaza,

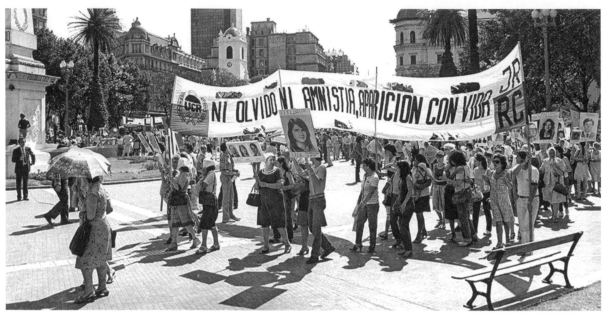

Fig 8.1 Last march of Mothers of Plaza de Mayo under the dictatorship, 8 December 1983.
Photo by Mónica Hasenberg-Brenni Quaretti. Courtesy Hasenberg-Quaretti Archive

their heads clad in white kerchiefs, was so widely photographed that it has become a visual symbol of this resistance movement.

In her seminal article about the movement, architect and critic Susana Torre stresses the significance of the thirty-year-long action for impacting politics, but also for transforming a previously marginalized group into one that remains widely recognized. This transformation is significant in a political climate that saw women either as politically and culturally colonized populations or as unintentional agents of a collective social project but not as actively participating in change (Torre 2000). Torre foregrounds the tactical practices of the *Mothers of Plaza de Mayo* in successfully appropriating a hegemonic space – "the nation's principal space of public appearance" – on their own terms.[5]

Although the 'Mothers' did not pronounce their protests as 'feminist', their spatial practice resonates well with bell hook's understanding, where "feminist movement happens when groups of people come together with an organized strategy to take action to eliminate patriarchy." (hooks 2000:xi). For most of the *Mothers*, it was the first time they participated in political statements, the first time they positioned themselves politically in society. Their activities also significantly changed traditional

understandings of gender representations and conventional assumptions of private and public spheres. This can be understood through the shift in their roles, from their more acceptable and traditional embodiments as wives and mothers to their emergence as resilient subjects. This emergence occurred both in spite of and because of, the threat of police violence. Thus, with their struggle to establish human rights, they did not merely inhabit, but also transform the public realm "as transformative subjects altering society's perception of public space and inscribing their own stories" (Torre 2000:141).

Torre relates the architecture and politics of the body with the architecture and spatial politics of the plaza. She credits the *Mothers* for their ability to establish presence by their own means, but also to appropriate an existing urban space, and giving it a new function and new symbolic meaning, through shared actions of corporeal, social and activist occupation of the space. The *Mothers* are still active in various social and political projects, acting as a constant reminder of human rights. In this sense, the *Mothers'* significance surpasses the specific agenda that initiated their original manifestations.

The International Dinner Party: Celebrating Global Sisterhood

A second example to continue this discussion of resilient subjects is one that practices sharing and connecting domestic and public space. The simultaneous worldwide event, *The International Dinner Party*, took place on March 14, 1979.

> Dear Sisters, We would like to ask you to participate with us in a worldwide celebration of ourselves. We are asking women in many countries to host dinner parties honoring women important to their own culture. These dinner parties, held simultaneously 14 March 1979, will create a network of women-acknowledging-women, which will extend around the world.[6]

This invitation was originally drafted by a group of California artists. Eventually, it fell to Suzanne Lacy and Linda Preuss to organize this simultaneous worldwide dinner happening to celebrate the opening of Judy Chicago's *Dinner Party*[7] at the San Francisco Museum of Modern Art.

> — Inspired by this work, several California artists want[ed] to expand the idea of honoring women from Western history to encompass living women of all cultures.[8]

The International Dinner Party shares the celebratory mood of the 1970s US American feminists. It was also a moment when women of color, feminists of color, lesbian women and lesbian feminist, had begun to challenge the notion of 'sisterhood' based on the generic category of 'woman'. *The International Dinner Party* points to an emerging understanding of sisterhood based upon concrete historical and political practice. Yet, it still assumed that sisterhood could, in fact, be built on the basis of gender. The project both negotiates and celebrates a complex constellation among different feminist politics – that of sisterhood based on gender and that based on a common practice (including sharing dinner on a global scale). It also connected domestic spaces (where the dinner parties were held) and public space (the opening of Judy Chicago's exhibition at the San Francisco Museum of Modern Art).

The International Dinner Party art project, with over 2000 participants from different parts of the world, demonstrated the great extent of feminist organizational capacity in a pre-Internet era. Women held dinner parties in 200 places across Africa, Asia, Australia, New Zealand, Europe, North America and South America. Following the task assigned to them by artist and activist Suzanne Lacy, women collectively drafted messages at their own dinner parties and sent them off via telegram to the San Francisco Museum of Modern Art. Upon arrival, these telegrams were put on a map of the world by Suzanne Lacy in a performance that lasted several hours. The messages commemorated women important to the local communities, which ranged from elders, community leaders, and grandmothers, to artists, goddesses, or activists. Many chose not to commemorate women from the past but, rather, to use the telegrams to express demands for a feminist future. Some messages include references to the demonstrations of women in Iran that had begun on March 8, 1979. Some make reference to the struggles for women's sexual and reproductive rights.

In retrospect, the imagined community of resistance that was initiated by *The International Dinner Party* is constituted by all the telegrams and messages written by all the participants. The project demonstrates the complexities of situated feminist politics, even as it demonstrates the capacity to share resources and to network internationally. The women who hosted dinners opened their homes, shared meals, and invited friends and colleagues. They also shared their memories, their beliefs, their convictions, their demands, and their claims with a museum audience. Thus, they connected their domestic space, in which they produced their contributions, with the public space of the San Francisco Museum of Modern Art. Read from a different vantage point, homes, in which the women hosted the parties for *The International Dinner Party*, appear as the primary sites from which imagined communities of resistance can emerge. Domestic space, it appears, both provides the means of supporting and the means of connecting the emergent phenomenon of resilient subjects.

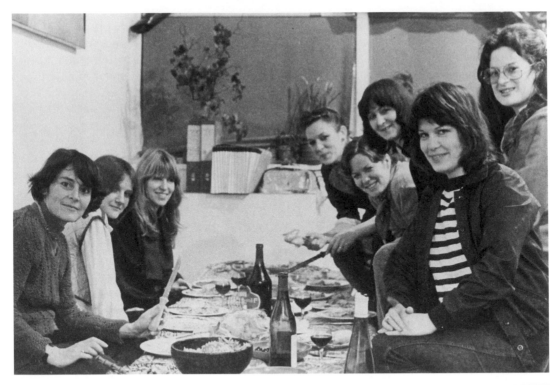

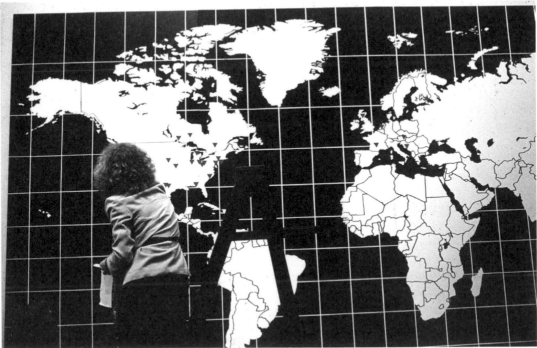

Fig 8.2 *The International Dinner Party*: Women from all over the world hosting dinners at home and sending telegrams to the San Francisco Museum of Modern Art to celebrate global sisterhood, 1979, courtesy Suzanne Lacy

Fig 8.3 *The International Dinner Party*: Suzanne Lacy's performance, at the San Francisco Museum of Modern Art, placing the telegrams from the dinner parties on a world map, 1979, courtesy Suzanne Lacy

Precarias a la Deriva: Politicizing Care Work

In a third and more recent example, we explore the emergence of resilient subjects through activism and research, or, more precisely through a strike. The initiative *Precarias a la Deriva* formed at the feminist social centre *La Eskalera Karakola* in Madrid. Initially, it was a response to the general strike throughout Spain called by the unions in June 2002. This initiative stood for the non-representation of all those – mainly women – who work informally and invisibly, neither recognized by the unions nor affected by the legislation that had provoked general strike (Precarias a la Deriva 2004). On the day of the general strike, a group of women decided to wander through the city and to ask other women 'What is *your* strike?' From that common experience, a research project was organized with the purpose of building a network of those united by the precarity of their work, even if the types of work were highly diverse, for example ranging from freelance design to sex work. Ultimately, the *Precarias* demanded a "collective construction of other life possibilities" (Ingrassia and Holdren 2006:43) through a shared and creative struggle, breaking through the logic of individual maximization, and replacing the profit economy with an 'ecology of care'.

As a method for research, *dérives* through the city was deemed adequate to encounter and learn about precarious work of women by moving through "quotidian environments, speaking in the first person, exchanging experiences, and reflecting together with women working in precarious and highly feminized sectors" (Precarias a la Deriva). In contrast to the Situationist *dérive*, or drift,[9] the *Precarias* state: "In our particular version, we opt to exchange the arbitrary wandering of the flaneur, so particular to the bourgeois male subject with nothing pressing to do, for a situated drift which would move through the daily spaces of each one of us, while maintaining the tactic's multisensorial and open character. Thus the drift is converted into a moving interview, crossed through by the collective perception of the environment" (Ingrassia and Holdren 2006:34).

In their struggle, the *Precarias* consider precarity not as a condition that concerns some and

not others, but as a tendency and process that is expanding to include more and more social sectors, which affects society as a whole. In this view, precariousness transgresses boundaries between private and public, involving migration policies, the conception of social services, working conditions, and household structures. While precarity is usually considered a strictly negative phenomenon, a term used to describe situations of vulnerability, insecurity, poverty and social exposure, the *Precarias* attribute a range of positive qualities as well. They argue for the accumulation of diverse knowledges, skills, and abilities through work and life experiences that are under permanent construction.[10] By re-evaluating their own situation, the *Precarias* actively counteract generalizing misrepresentations and homogenization. Judith Butler sees precarity in its multiple characterizations as forming a starting-point for political alliances against a logic of protection and security for some at the cost of many other people.[11]

For the *Precarias*, the development of affective connections is fundamental to overcoming the segmentation and isolation of precarious workers, whose life situations under post-Fordist working conditions demand permanent availability and limited labour rights, where time and care for others become scarce. Thus, they argue that the acknowledgement of social relationality as a crucial basis from which to act enables a new perspective of a 'logic of care' that enhances the status of care activities as political responses. It counteracts the common understanding of precarity as a threat because this 'logic of threat' cannot provide adequate answers. In contrast to this view, a 'logic of care' can be extended to a more collective and common notion, for example, a notion of a 'care community' or 'care citizenship', a *cuidadania*. Political-economic considerations, which followed a 'logic of care' as a starting point, would regard production and reproduction together, and thus divest the separation between private and public realms of its foundations.[12]

For that purpose, the *Precarias* called their strike a *care strike*. Here, a strike does not mean the suspending of care activities. On the contrary, care work was to be shifted to the center, thus interrupt-

ing the existing order, and politicizing care work, which, under the prevailing political and economic dispositions, was devalued as being private, feminine, and unproductive and, thus, made invisible. Consequently, the conflicts of care work are seldom perceived and understood. The *care strike* intended to expose the problematic to debate (Lorey 2015), thus also offering a possibility to move from singular to common practices in which exchanges could be possible.

Fig 8.4 *Precarias a la Deriva:* Filmstill from 'A la deriva, por los circuitos de la precariedad femenina' picturing the isolation of the 'precarious worker', 2003

Fig 8.5 *Precarias a la Deriva:* Filmstill from 'A la deriva, por los circuitos de la precariedad femenina' picturing a dérive, 2003

Concluding discussion: theorizing and practicing (as) resilient subjects

These three examples pose different notions of community, of resilient subjects. Across all three, *public utterances and visibility* are important for countering social atomization. For example, discrimination and precariousness were raised as a political issue in *Precarias a la Deriva* (2004). Through sharing, counteracting, and connecting they reveal themselves as resilient subjects. The *Mothers of Plaza de Mayo* become resilient subjects through leaving their homes, occupying public space with their own bodies, and by making their personal anguish visible through subversive spatial tactics. In this sense, resilience takes on a broader meaning, including resilience in emotional terms through painful existential conditions. Participants in *The International Dinner Party* connect domesticity and hospitality to the public institutional space of the museum, thus transgressing their geographical dispersion to co-produce a worldwide dinner that, quite literally, puts the politics of remembering women and feminist claims for the future on the map. The *Precarias* enter the streets and take up a spatial practice of *dérive* as a form of militant feminist research that transgresses boundaries of domestic space, workplace, and public space. Thus the *Precarias* expose how the isolation of subjects merely reinforces the conditions of precarity, and they claim, in fact, to be interdependent and separated only by false boundaries. For them, making a common cause, such as a care strike, is a step towards the formation of an imagined community of resistance.

Resilience is most often discussed in scientific terms, for example, to describe how ecological systems or technological systems can cope with change. It is sometimes used in the context of policy, but seldom to pose questions of politics, agency, and positionality. What can we learn from these examples of resilient subjects? In this chapter, we argue that a wider concept of resilience is generated through feminist theories and practices. Such a concept of resilience can include as we argue here, societal and political values expressed in the formulation of resilient subjects, in building imagined communities, and in terms of common

causes concerning political, economic, and social justice. Resilience and futures thinking are not part of Mohanty's work. However, we argue that the theoretical perspective that she advances can be extended to community-building, as a basis for the emergence of resilient subjects.

The becoming of resilient subjects requires the will to know and the desire to represent (Braidotti 2011). Resilient subjects form imagined communities that cannot be assumed on the basis of gender, ethnicity, or religion. They are never pre-given or stable entities. But through their transgressive practices, they build lasting alignments between the personal, the social, the public, and the domestic (Mohanty 1991, 2003). We propose feminist futures where solidarity and community-building is a constituting part. Such practices have the potential to transgress traditional boundaries and strengthen diverse claims to political and social change, altering assumptions, behaviours, processes and structures towards greater justice. The discussed subjects did that by appropriating public and institutional spaces through creative spatial tactics for changing structures from within. We conclude that feminist futures-oriented practices build communities, for opening an imaginary space for thinking real alternatives, and which transform real spaces for imagining alternatives for the future.

1
See for example, 'Resilience Dictionary', Stockholm Resilience Centre, www.stockholmresilience.org/research/resilience-dictionary.html [accessed 5 October 2016].
2
See e.g. Schalk, M., Gunnarsson-Östling, G., Bradley, K. (2016). "Feminist futures and 'other worlds': ecologies of critical spatial practice" In MacGregor, S. (ed.), Routledge International Handbook of Gender and Environment, Abingdon: Routledge and Krasny, E. (ed.) (2014). The Right to Green: Hands-On Urbanism 1850–2012, Hong Kong: MCCM Creations.
3
See also the Saturday Mothers in Istanbul, who came together following the example of the Mothers of Plaza de Mayo, in 1995–1999 and again since 2009 to raise awareness of state-sponsored violence and militarism and to demand that state-sponsored political murders be brought to light, as well as the installation of legal rights.
4
Torre, S. (2000), reprinted, first published in Agrest, D., Conway, P. and Kanes Weisman, L. (eds.) (1996). The Sex of Architecture. Between 1976–1983, an estimated 9000–30.000 people were kidnapped under military dictatorship, many burial sites are still undisclosed and many inquiries to the police about the fate of the 'disappeared' are still unanswered.
5
Hannah Arendt, quoted in Torre (2000), p. 141.

6
From the Invitation Letter, 'An International Dinner Party to Celebrate Women's Culture', 1979, Archive Suzanne Lacy.
7
Judy Chicago's monumental sculpture of the Dinner Party, based on women's collective histories, has raised a significant number of debates within feminism. It was criticized for its essentialism (Griselda Pollock), for excluding women artists of colour (Alice Walker), and for reproducing the model of the master artist (Chadwick). See Chadwick, W. (2012). p. 376. In her 1996 exhibition Sexual Politics: Judy Chicago's Dinner Party in Feminist Art History Amelia Jones critically engaged with the complex debates on sexual politics surrounding the work. Jones, A. (1996).
8
Suzanne Lacy, From the Invitation Letter, An International Dinner Party to Celebrate Women's Culture, 1979, Archive Suzanne Lacy.
9
Christel Hollevoet discussed the Situationist dérive in (1992) 'Wandering in the City. From Flânerie to Dérive and After: The Cognitive Mapping of Urban Space', in The Power of the City, The City of Power New York: Whitney Museum of American Art.
10
From the invitation to participate in the first dérive, October 2002, Precarias a la deriva (2004).
11
Butler, J. (2009). p. 32, quoted in Lorey, I. (2015). p. 91.
12
Lorey (2015), p. 93. For a discussion, see also, Mies, M. and Bennholdt-Thomsen, V. (1999).

DIALOGUES

COLLECTIVE SENSE-MAKING FOR CHANGE: ABOUT CONVERSATIONS AND INSTRUCTS

NEL JANSSENS

It took me quite a while before I even noticed, and at first, I didn't really understand why it irritated me. But now I am at the point where I consider it rather problematic: the choice of terms that is prevalent in the school of architecture where I work,[1] when it comes to naming certain types of meetings. When events are set up that involve some kind of organized exchange of ideas (workshops and the like) they are often called 'the x or y Battle', 'Clash-moments', 'Re-claiming this or that', ' the … Debate', 'Crash-tests', and 'Brain-Bar' or 'Café' as probably the most convivial one. One might say that these are merely catchy names (or 'sexy' names as they are also labeled) to point at the high level of energy and engagement the events are supposed to generate – and then again, what's in a name? The central notion in these meetings (or for that matter, meetings in general) is discussion. And the quality of the meeting is judged by the fierceness of the discussion. What is wrong with discussion, one might ask? Probably nothing really. But then why can't we just talk and have a 'simple' conversation without getting the implicit message that this would be to some extent weak? Is the quality of an exchange of ideas and thoughts only to be evaluated by the fierceness with which these ideas are stated ('statements', yet another beloved term) and claimed? And whose ideas and thoughts make it to the table (and to the 'action' column of the minutes) in that kind of competitive context?

I started to replace systematically the term 'discussion' with 'conversation' in every communication, notes, and papers, in an attempt to change the tone. But what is the difference between 'discussion' and 'conversation'? And, is it worthwhile getting picky about these terms that in common parlance seem closely related enough to be used almost interchangeably, merely indicating a difference in nuance? When in doubt, my first reflex is always to have a look at the etymology of the terms. The (originally Latin) prefixes 'dis' and 'con' clearly refer to distinctly different meanings. 'Dis' indicates

some kind of separation and friction, while 'con' refers to bringing together. The sense evolution of 'discussion' in Latin appears to have been from 'smash apart' to 'scatter, disperse'; then in post-classical times to 'investigate, examine,' then to 'debate'.[2]

In 'conversation' then, the emphasis is not on setting apart but rather on bringing together. The mid-14th century meaning was "living together, having dealings with others", also "manner of conducting oneself in the world", it refers to "the act of living with, keep company with".[3] It seems then that conversation is something that belongs to daily life and happens at the 'kitchen table', so to speak. Discussion, on the other hand, with its slightly more aggressive tone, apparently has a greater seriousness. Straightforwardly analytic in its weighing and testing attitude it seems to be pre-served for the professional world (the meeting table) where things are 'at stake', stand-points are 'put on the table', decisions are made and sound conclusions are drawn.

The seriousness related to discussion places it almost naturally in the academic world and the distinctive argumentative mode seems to fit well in a context of know-ledge production and research. It's about competing arguments, proving them true or false by testing their strength and weaknesses, pulling them apart into pros and cons in an analytic, examining manner. Sound logic, an impeccable reasoning and – an absolute winner – hard facts, all attesting to the rationality and the objectivity of a thorough investigation, define the quality of an exchange of arguments that aims to be decisive and preferably, unambiguous. The stakes are considered rather high here (albeit sometimes only on a personal level), different standpoints and ideas compete and one talks and listens with the specific purpose to determine the best (or winning) course of action to reach an often predetermined goal.

A conversation then follows a much more erratic path. It is like a flow of thoughts or, as said in 'Making Time for Conversations of Resistance' by Liza Fior, Elke Krasny and Jane da Mosto, "Conversations are meandering. They are filled with turns and detours. Their pleasure lies in not having a clearly defined objective... It is the very absence of an outlined goal that moves the conversation forward by building it word after word, pause after pause, turn after turn."

I would say that conversations are much more based on sharing experiences than exchanging arguments. This does not mean that conversations are necessarily friendlier, harmonious or consensus oriented. It's not about reaching an agreement and solving conflicts. Or as is reported in 'Rehearsals – On the Politics of Listening', by artist Petra Bauer and political scientist Sofia Wiberg: "We never aimed at coming to a point where we would share the same opinions, thoughts and feelings, have the same frames of reference, reach a common solution or even understand each other's different experiences... The purpose shouldn't be to extinguish all differences, of course, or to reach as much similarity as possible, ..." Conversations in that respect are fundamentally syncretic. Syncretism is about creating a new whole without re-

moving the contradictions among the parts. It offers another way of making sense, focusing on combining issues around questions, establishing unforeseen connections, and allowing contradictions (Janssens, 2012, 188–189). Being syncretic, conversations basically depart from a non-linear way of thinking. They are often open-ended processes without a well-defined, immediate goal (or one that tends to shift all the time). This purposelessness, according to Rebecka Thor, "allows for some type of relaxation or opportunity to be in the moment. It felt strange, since most of what we do is so extremely purpose-driven. I don't think there is any other situation where I can just completely exist in what is happening, without feeling like it has to amount to something. It provided me with a greater freedom to say something a bit rash, or to just be silent…"[4]

If we agree that conversations are more vested in experiences, we might assume that emotions, preferences, values and the personal form the natural base and direct resources through which a conversation evolves. The tone of a conversation is – by nature – less competitive since it's hard to weigh experiences against each other, they are not put to the test, there is no 'winning', true or false experience. Talking and listening based on experiences and emotions with no specific outcome in sight is very different than talking and listening based on arguments and logics with the aim to get to a (tangible) result. The question becomes then whether the conversational mode is suited for the academic world and whether this form of dialogue can be used at all in processes of knowledge production. Or as Fior, Krasny and da Mosto put it: "In what way are the current systems of evaluation of knowledge and the paradigm of university excellence annihilating the conversational mode?"

But what about knowledge production that uses experiences, preferences and emotions as its very resource, for instance, research in creative fields like architecture and the arts? It has been argued that in some forms of research, like in artistic and design research, emotions, values, purposes, preferences, etc. – contrary to what the traditional paradigm allows – are not the object of research but a full-fledged part of research.[5] This type of research, which explicitly utilizes emotions as resources, favors plausibility over accuracy and aims to improve on practices that inspire and enrich experiences rather than inform and explain.

In a culture of knowledge where experiences and preferences are the main resources to work with, 'making conversation' is an important skill to, as Fior, Krasny and da Mosto put it, "challenge theoretical thought just as much as practical thought". In recent times, individual emotions, preferences and experiences are increasingly recognized as necessary resources in the understanding of our interaction with the world. People need not only explanatory knowledge of the phenomena in the world but also knowledge to structure processes that generate purposeful and transformative interactions to create diversified life worlds (Janssens and de Zeeuw, 2017). From this

perspective, conversations can offer a context in which such knowledge, as a form of collective sense-making, can be generated. Sense-making in the general sense is a process of giving meaning to experience. More exactly, sense-making is the process of creating situational awareness and understanding in situations of high complexity or uncertainty in order to make decisions. It is "a motivated, continuous effort to understand connections (which can be among people, places, and events) in order to anticipate their trajectories and act effectively" (Klein et al. 2006, 71). Dana Cuff notes that in the context of design the necessary skill is not decision making but sense-making because the notion of sense-making implies a collective context in which we must make sense of a situation that is inherently social, interpret it, and make sense with others through conversation and action in order to reach agreements (Cuff 1991, 254).

I would say that aiming at collective sense-making, implies a subtle shift from moderating a discussion, to curating a conversation. To achieve a qualitative conversation the design and curating of the socio-material setting is not to be underestimated. This setting, I suggest, takes the form of what Gerard de Zeeuw and I have called an *instruct*.[6] Instructs are considered the base of every social (inter)action. They provide structures through which people can interact and improve their experience of inhabiting a world. Instructs help people interact to implement their purposes and improve their activities (de Zeeuw 2010). Instructions work by providing a structure (from the Latin 'in'-'struere') in which interactions can take place. It assumes an active process-with-a-purpose that cannot exist without people, their values and experiences. Instructions function as constraints because they suggest boundaries to the interaction. However, the boundaries set by instructions create an open collection of events. What is confined nonetheless remains open because instructions refer to possible experiences in the future. They don't predict what will be experienced but they anticipate experiences that might happen with the aim of making many different experiences possible, to improve these experiences and to prevent effects that are less desired (Janssens and de Zeeuw, 2017).

Given the definition or rather the working of 'in-structing' we might say that a design such as a building, is a kind of materialized instruction. It offers a structure in which a variety of experiences are made possible through the interactions between people, and between people and the material structure. Through the precise position of its boundaries, it also aspires to the reduction of unwanted experiences. Furthermore, acting as a kind of channeling device for experiences, the building as an 'in-struere' also facilitates a quality of interactions between people, and between people and the instruct (Janssens and de Zeeuw, 2017). In the light of improving conversations and enhancing situated knowledge production, the challenge is to design an instruct (material) and/or instruction (immaterial) that acts as a socio-material setting and in doing so, supports an open field of possible (enriched) experiences in which

people can vary and strengthen their interactions.

A very basic, yet often defining material instruct that occurs in conversations is the table. In 'Writing around the kitchen table' by Hélène Frichot, Katja Grillner and Julieanna Preston, tables are omnipresent in the different conversations. They appear in many shapes and forms and are assigned a multitude of meanings and functions. There is the "curation of four sets of instructions around four tables covered in garish plastic coated tablecloths". There is the table "that swallows up the room", that prevents those participating in the conversation to move around the table, it "held them at bay, in their own seats, as a collection of separate individuals". There is the table that is called "a plane of immanence, a site that collapses scales of action and temporal registers and allows for the co-habitation of interior and exterior forces". The table is a seemingly banal but at the same time an astonishingly sophisticated instruct that allows varying and improving interaction between those sitting at it. The socio-material dimension of the table, in its designed or made capacity, stresses the situated character of the conversation and the knowledge it generates.

This applies also when we move to the room acting as a socio-material setting that is specially designed to curate the conversation. In "Rehearsals – On the Politics of Listening", Bauer and Wiberg describe how they, together with the architect Filippa Ståhlhane and Tensta-Hjulsta Women's Centre, designed and constructed a room at Tensta konsthall to conduct eight acts, exploring the politics of listening. Here we have an interplay between the design of a room (described by one of the participants as "a non-existent room", "a bubble within a bubble", "functioning almost like a sort of time capsule") and the design of instructions, called 'acts' (e.g. dance party, walking without talking (audio walk)…) to curate the conversations.

The materialised instruct (the spatial setting) and the instructions (which can be rules of conduct, guidelines, methods…) reinforce each other to create situations in which individual experiences can be shared, common experiences can be generated, their quality can be examined and situated knowledge can be gained. The instruct and instructions hereby act as devices that channel values and preferences into a qualitative, intentional interaction. Important to notice is that they establish boundaries and constraints such that certain actions (and the experiences they generate) are limited or made impossible in order to improve on other (sometimes yet unknown) experiences to occur and develop. Or, as Sofia Wiberg puts it in her description of 'Act 2' of the Rehearsals, which instructed not to speak thereby creating an unusual and somewhat uncomfortable situation: "I think that is exactly what it takes, constructing certain obstacles and structures to make room for other things, and how we simultaneously feel limited by those structures because we cannot be 'ourselves'."

From the different examples described in the chapters presented here, we might preliminary conclude that the conversational mode definitely does have a role to play

in contexts of knowledge production and that such a culture of knowledge production can be further developed by using material design thinking to enhance the quality of the conversation. The purpose is to design something that has the capacity to allow for many possible, evolving and improving experiences by offering a structure to interact. The challenge is then to create instructions that allow situated knowledge to be generated in everyone who is acting freely within the constraints of the instruct. In architectural design research the notion of an instruct can be considered helpful because it enables the production of knowledge for interaction towards change. This type of knowledge production, contrary to traditional research, includes experiences, preferences and emotions in the research process and hence, I claim, benefits from a focus on conversations that, carefully and designerly, instructed can augment or extend each participant's resources to collective sense-making.

1
KU Leuven, Faculty of Architecture, Campus Sint-Lucas Brussels/Ghent – formerly the Sint-Lucas School of Architecture. The vast majority of the teaching staff (especially studio-teachers) and leadership are male; the student population, however, is much more gender-balanced with even a majority of female students in some years and programs.

2
The Online Etymology Dictionary further mentions that 'discussion' mid-14th century, holds the meaning of "examination, investigation, judicial trial," from Old French discussion "discussion, examination, investigation, legal trial," from Late Latin discussionem (nominative discussio) "examination, discussion," in classical Latin, "a shaking," from discussus, past participle of discutere "strike asunder, break up," from dis- "apart" (see dis-) + quatere "to shake" (see quash). Meaning "a talking over, debating" in English first recorded mid-15th century.

3
The Online Etymology Dictionary mentions that 'conversation' stems from Old French conversation, from Latin conversationem (nominative conversatio) "act of living with," noun of action from past participle stem of conversari "to live with, keep company with," literally "turn about with," from Latin com- "with" (see com-) + versare, frequentative of vertere (see versus). www.etymonline.com/index.php?allowed_in_frame=0&search=discussion (accessed 2 November 2016)

4
Interview with Rebecka Thor, one of the thirty participants to the 'Rehearsals – On the Politics of Listening' project. This interview was conducted by Marius Dybwad Brandrud and is part of the chapter 'Rehearsals – On the Politics of Listening' by Petra Bauer and Sofia Wiberg.

5
This argument has been developed in Janssens & de Zeeuw, Non-observational research: a possible future route for knowledge acquisition in architecture and the arts, in Nilsson, Dunin-Woyseth, Janssens eds. (2017), Perspectives on Research Assessment in Architecture and the Arts: Discussing Doctorateness, Abingdon: Routledge. This form of research has been explained by Gerard de Zeeuw as 'Non-Observational Research' (de Zeeuw, 2010).

6
The notion of an instruct as part of the knowledge production process in architectural design has been developed in Janssens & de Zeeuw, Non-observational research: a possible future route for knowledge acquisition in architecture and the arts, in Nilsson, Dunin-Woyseth, Janssens eds. (2017), Perspectives on Research Assessment in Architecture and the Arts: Discussing Doctorateness, Abingdon: Routledge.

MAKING TIME FOR CONVER-SATIONS OF RESISTANCE

**LIZA FIOR,
ELKE KRASNY
AND JANE DA MOSTO**

The reflections and questions raised in this essay grew out of ongoing conversations shared by the three of us: Vienna-based curator, writer, and educator Elke Krasny, Jane da Mosto, conservationist, environmental scientist and activist in Venice and Liza Fior, founding partner of muf architecture/art in London. We use conversing ('conversations of resistance') to work through some of the difficulties that we encounter in our respective projects due to the economic, political, social, and technological conditions which shape our everyday life as well as our cultural expressions.

Very concretely, our conversations evolved through a 'loss' and an 'emergence': the loss of a permanent destination for a structure intended as a gift for the city of Venice, the *Stadium of Close Looking*, and the emergence of *We Are Here Venice* (wahv), a non-governmental organization that promotes a more direct connection between research and actions designed for raising awareness among policy makers and increasing citizen engagement on issues affecting the future of Venice.[1] This essay is written and hosted by Elke, with interruptions, additions, modifications, updates and 'invisible and insistent mending' by Jane and Liza.

Our conversations take place around certain comparable ecological, economic, and political challenges presented by our respective locations — in London, Vienna and Venice — challenges of contemporary city life and 'urban ethics'.[2] Our conversations interrogate these challenges, which are not always clearly defined (or definable) by their underlying conditions. Equally, we put forward some contributions which conversations of resistance can make to feminist futures. As an example of why continuing conversations of resistance are relevant, even if a particular project does not reach its original objectives, we discuss the emergence of *We Are Here Venice* as an organization,[3] via the fate of the *Stadium of Close Looking*. The stadium was the centrepiece of muf's British Pavilion at the 2010 Venice Architecture Biennale, which subsequently sparked many conversations among us three, as well as an ongoing and close collaboration between Jane and Liza.

What's in a Conversation?

How are contemporary conditions of knowledge production, labour, social relations, and communication technologies changing what we used to call, simply, a conversation? In what ways are current systems of evaluation of knowledge and the paradigm of academic excellence annihilating the conversational mode? Conversations enable thinking out loud and acute listening. Is there still time to have a real conversation under the current temporal regimes? Are we prepared to retain certain skills and practices like that of having a conversation? Can we turn conversations into a powerful and inspirational force so they support the emergence of "communities of resistance"? (Mohanty 2003 :47) Following Mohanty's line of thought in this essay, we ask how to have 'conversations of resistance'? Understood in terms of resistance, conversations "must be forged in concrete historical and political practice and analysis" (Mohanty 2003:24).

Talking together, understood as thinking out loud while listening to each other, is at the core of the conversations of resistance. This thinking aloud in the midst of so much doing is the so-called 'luxury' and thus challenges theoretical thought just as much as practical thought.

Our conversations are not a debate, they are not about winning arguments, but much rather about opening up to perspectives on how to better understand the issues intersected by a question that arises through the course of the conversation. Arriving at the question in order to continue reworking the answers points to both the social and the political dimensions of the conversation. It requires the skill of listening. It allows for a nuanced elaboration of what has been said before as well as a subtle prodding of what has previously remained unsaid.

The social dimension of the conversational mode can be understood as a production of shared meaning. The political dimension of the conversational mode can be understood as a practice of giving equal importance to all speakers. Shared meaning, as we understand it, is connected to matters of public concern and common interest. "There must be no tyranny in conversation," as Madelaine de Scudéry writes in *Conversations sur divers sujets*

(1680), and "Let everyone have their share and have the right turn to speak" (Scudéry quoted in Kester 2004:26).[4] When everyone has their fair share and the right turn to speak, in social and political terms, we could call this the right to conversation. If everyone has the right to be heard and to listen to others, if what is being said adds on to what others are saying, we understand the political process as that which is collectively spoken or, in other words, that which comes into being through conversation. Both the social and political dimensions of such conversations require the skills of thinking out loud, of sharing concerns, listening to each other, building on one another's thoughts with sympathy, empathy and respect in order to keep the conversation open, alive and moving.

In different ways, in our respective cities and areas of work, the three of us intentionally make incomplete spaces, which invite others to contribute. For us, this is a quality of participatory practice, an openness also including those with whom you do not agree and those who, due to the power relations of a particular situation, may not listen to you. We have each been drawn into such ongoing conversations through a spontaneous albeit experimental feeling of trust: Jane, when she responded to Liza's unusual invitation to 'take advantage' of the British Pavilion at the 2010 Venice Architecture Biennale as a platform for Venice issues and, then, Elke's agreement to moderate a potentially fraught workshop infringing on the Arsenale following her precise commentary at a conference in Berlin, which had spurred Liza's invitation.

Richard Sennett speaks of "dialectic and dialogic conversations" (Sennett 2012:18). He emphasizes that these two types of conversations are in fact not mutually exclusive, but rather supplement each other. "Skill in practicing dialectic lies in detecting what might establish common ground." (Sennett 2012:19). Dialogic conversations, on the other hand, do not aim for this common ground. "'Dialogic' is a word coined by the Russian literary critic Mikhail Bakhtin to name a discussion which does not resolve itself by finding common ground. Though no shared agreements may be reached, through the process of exchange people may become more aware of their own views and expand their understanding of one

another." (Sennett 2012:20). We want to suggest that the dialogical corresponds to the social dimension of conversation and the dialectic to the political dimension of conversation. When rethinking this equation of the dialectic with the political and the dialogic with the social, we come to the conclusion that both the political and the social are in need of a combination of dialectic and dialogic conversation. They move forward as complex dynamics of agreement and disagreement, of concord and conflict in a conversation. While conversations, both literally and metaphorically, open windows of opportunity and build bridges of engagement, they also run the risk of impasse. Moving a conversation forward or, in other words, keeping the conversation alive in order to resuscitate the social dimension of the political and the political dimension of the social, requires not only the skills of dialectic and dialogic, but and above all, time.

Finding Time for Conversation

One of the main challenges for conversation today is the economic and technological restructuring of time and its far-reaching social and political repercussions. Labour,[5] social relations,[6] and communication technologies are all undergoing major restructuring.[7] They are not only transformed as such, but their complex interdependencies in turn impact how individual and collective time is redistributed. Time is profoundly impacted by the globalized restructuring of labour and the erosion of working conditions in accordance with neoliberal principles, the restructuring of social relations into networking to advance both collaboration and competition and the technological restructuring of communication.[8] Restructurings result in both shrinkage and expansion with regard to time. The time available for leisure, sociability, speaking, and listening seems to be shrinking, the time expended for labor and social networking constantly expands. In short, working and networking are expected to be almost uninterrupted and continuous. Work never stops, networking never stops. If these non-stop regimes govern life, it will be at the expense of devoting time to open-ended and open-minded processes without apparent immediate gains or returns.

Conversations belong to the latter. Therefore, they might appear expendable. Conversations are meandering. They are filled with turns and detours. The pleasure in conversation lies in not having a clearly defined objective. Conversations transgress the logics of evaluations and benchmarks.[9] It is the very absence of an outlined goal that moves a conversation forward as it is built word after word, pause after pause and turn after turn. The current regimes of time, described above are, strictly speaking, anti-conversational. Therefore, time spent, or more apt, time invested in conversation carries the potential to become a critical practice of resistance. Since constant activity has been transformed into a constant competition, the time of conversation in which everyone can have her or his turn at one's leisure is no longer part of the everyday.[10] It has become quite utopian. Therefore, a contemporary feminist demand, taking a cue from Virginia Woolf's essay *A Room of One's Own* (1929), has to be time together. Hence, conversation, which needs time to be together at leisure with everyone having their share and their right to take a turn. The issue is no longer solely spatial, for example concerning the room to work and produce freely and to define oneself, but temporal. A contemporary feminist demand is for more time to share conversations that can contribute toward futures yet to come.

Conversations without Predetermined Conclusions

Conversations among us (Liza, Jane, and Elke) feed into Jane's activist work in Venice and contribute to the complex processes of formulating the work agenda and determining priorities put forward by the platform *We Are Here Venice*. Conversationally, the three of us think together, from the inside out and the outside in. If this conversation was an institutionally supported project, what conversation happened where and what outcomes were generated when would have to be logged and recorded. Elke remembers trying out phrases to describe the planned as well as hypothetical activities in the Arsenale as 'Growing Venice' in a museum café, but we could not locate *what was discussed where* except through a trawl of emails of making arrangements

and afterthoughts.

Places where we speak with each other, not in isolation, but surrounded by the energy of many voices and many different conversations happening at the same time in the same place, are as conducive to thinking, such as for e.g. conferences, workshops, public and semi-public gatherings. They transgress the divide between the public and the private. Each of us, in different ways, uses public events and public spaces for thinking and speaking both in private and in public (with variable results for others listening). We use private meetings in domestic settings for thinking and speaking about public issues. Our conversations intersect issues of austerity, neoliberal globalization, conviviality, beauty, self-organization, public space, justice, solidarity, and the contemporary urban crises. We report from our own practice, and town, but Venice always is the exemplar for these themes.

Together we have explored how the plurality of our voices and, at times, long winded meanderings lead to unanticipated, surprising, and even contradictory insights. Based upon the conversational mode of thinking together, rather than the auctorial mode of singular intentionality, this essay takes up conversation as a mode of both speaking in private and public. The conversational mode differs from the distinct, respective practices, fields and ways of doing things for the three of us. Our conversation does not speak like an architect's or an environmentalist's, or a curator's lecture. The conversational mode affords a freedom from disciplinary constraints and normativity of speaking as an architect, environmental scientist or curator. It is this notion of openness, or at least the notion of an imagined lack of disciplinary or geographical boundaries, that makes the conversational mode freer. Boundaries are crossed, back and forth between research, practice, theory, architecture, activism and science, just to name a few of our experienced crossings.

Intersecting issues of the 'precarisation' of bodies, spaces, labour made vulnerable, fragile ecologies discussed in our different fields of architecture, activism, curating, and science, are public concerns. This raises a question about the public dimension of conversations, which are perhaps too often deemed to be private, personal, or even intimate. Conversa-

tions practice resilient thought, sustain long-term social relations, as utopian as this might seem, practices resilient thought, sustains long-term social relations, and have a political dimension with regard to both public space and public time.

How we met

In January 2010 muf were awarded the authorship of the British Pavilion at the Venice Biennale and Liza first came to Venice (and met Jane tor the first time) in February. The Biennale opened in late August so time was tight. The pavilion had, in part, been won by the promise that the installation would be made in Venice; the only objects brought from the UK were John Ruskin's notebooks, which were themselves bought by Ruskin in Venice approximately 150 years earlier. This undertaking would not have been possible without the growing exchange of knowledge with Jane, and in the making of the pavilion, a conversation developed.

For the XIII Venice Biennale, *People Meet in Architecture*, in 2010, the pavilion was re-named Villa Frankenstein, a nod to John Ruskin's regret at writing *The Stones of Venice* when he considered the endless terraced houses of South London with their Venetian details in brick "the Frankenstein's monsters of my own making". This was an *aide-memoire*, to recall that the translation of meaning and ways of doing things, from one place to another, can be both powerful and dangerous. The story of the afterlife of the stadium now reveals how context can poison even the most virtuous strategy and too much attention to detail can obscure awareness of context to the detriment of the larger strategy.[11]

The *Stadium of Close Looking*, a timber structure seating 120 people, was authored by muf, built in Venice and displayed during the Architecture Biennale, as the centrepiece of the British Pavilion. In another part of the pavilion, Jane, and her colleagues had assembled a live, ecologically-functioning salt marsh to further illustrate the concept of 'close looking'. Detail (this fragment of a salt marsh) was a means to communicate the urgent themes of protecting the Venice lagoon and the potential of the ecological interrelationships as metaphors for urban and civic issues (Fig 9.2). Just as in conversa-

tions, the anecdote explains a point:

muf architecture/art made a wooden 1 : 10 scale model representing a portion of the plan of the London stadium for the 2012 Olympics repurposed as a drawing studio. muf called it the *Stadium of Close Looking*, which jumped scale and was a call to arms for master planning, to begin with an understanding and valuing of what already exists before making proposals.

With the premise of 'brief obedience', a deliberate effort was made to realize Kazuyo Seijima's title for the Biennale that year *People Meet in Architecture* or more accurately 'People meet in architecture (if they buy a ticket)'. An attempt was made to connect the city more directly to the Giardini by sourcing and building the contents of the pavilion in Venice. In addition, the project also aimed to host some of Venice's concerns by offering the stadium as a platform for local meetings during the three months of the Biennale. The stadium, as a hybrid object, took a space for spectacle and repurposed it for making

(in this case drawing) as well as doing, for example, discussions and presentations.

The ambition was to arrive with nearly nothing from the UK (besides Ruskin's notebooks) and to take nothing back home (besides the notebooks). All materials used were to be dependent on what could be found in Venice and what came out of our meetings. Equally important was the objective to find a place and purpose for all the pavilion materials afterward. In retrospect, this was very ambitious and full of risk.

We agreed with local schools to host drawing lessons for children (that year, school art budgets in Venice had been cut), but it turned out this was almost impossible due to the need for a Biennale ticket in order to access the British Pavilion — even for the children whose school in Via Garibaldi is next to the Giardini where the British Pavilion was situated. On the very last day of the exhibition, when the Biennale was open to all Venetians for free, the *Stadium of Close Looking* hosted a day of

Fig 9.1 A day of discussions about some critical issues facing Venice, at the *Stadium of Close Looking*, 2010 Biennial *People meet in architecture*. Courtesy muf

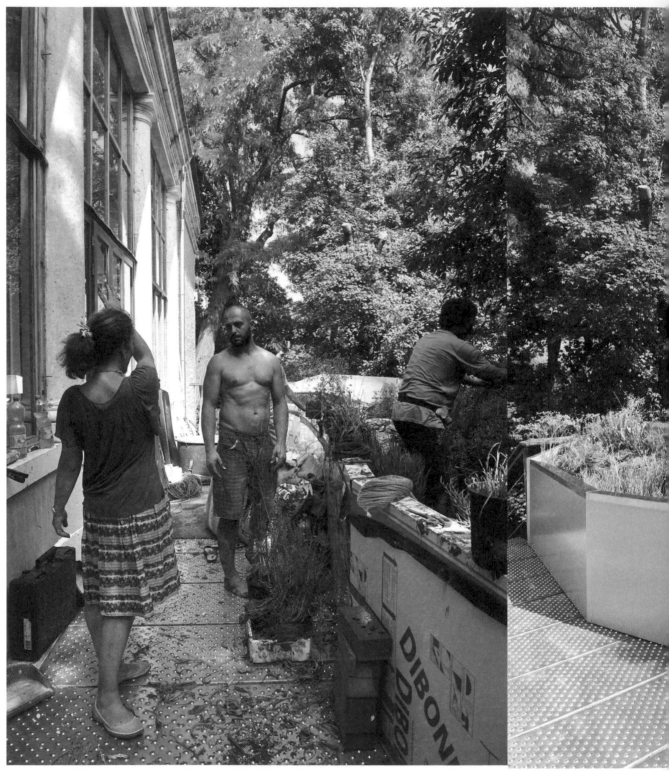

Fig 9.2 The model of the Lagoon at the 2010 Biennial *People meet in architecture*.
Photo by Cristiano Corte

discussions about some critical issues facing Venice (Fig 9.1) – water privatisation and threats to the lagoon system.

An ongoing collaboration between muf and Jane developed through the process of trying to arrange the re-use of the building materials from the stadium. The idea and act of 'seeing things through' became a shared experience and an extended rich conversation.

The stadium was designed for reuse — it was demountable and intended as a gift to Venice both as a physical resource and as a conceptual contribution to policy-making for the revitalisation of the city. We found a school with both enough space and a wish to have its own mini-theatre. After the Biennale, the stadium was transported to the school at the Giudecca, to be re-built. However, personnel changes and bureaucratic obstacles made putting the stadium into the school impossible. So the stockpiled components had to be removed from the school's garden in summer 2012. After 18 months of outdoor storage, all the materials were still in very good condition, beautifully covered by polythene.

By this time, muf knew they had been invited to exhibit again in the XIV Architecture Biennale, *Common Ground*, 2012. Jane, with her Venetian collaborators, was in the process of establishing the platform *We Are Here Venice*. wahv volunteered to explore alternative futures for the stadium, rather than outright disposal. A place at Forte Marghera (a public park on the edge of the lagoon) was identified, and an agreement was reached with the local administration (owners of the area) and the organisation responsible for managing Forte Marghera. The prospect of contributing to a bottom-up, community-led and spontaneous revitalization of this magical area and strategic resource for Venice was aligned with muf's original objectives.

The stadium would host performances, concerts, workshops, and it would be placed next to the *Museo dell'Imbarcazione Tradizionale*,[12] a living museum created and run by boat constructions experts and enthusiasts to rescue, restore and use traditional Venetian boats.[13] Forte Marghera management took responsibility for administrative procedures regarding the stadium's relocation (approval for erecting a new structure in a public park), while wahv and muf

planned the reconstruction and sought sponsorship for the afterlife.

It took 12 months to get the official approvals, during which time sponsorship offers had been withdrawn due to timing uncertainties. Meanwhile, Forte Marghera management evicted the flourishing *Museo dell Imbarcazione Tradizionale*, thereby removing the context within which the new stadium would have thrived. An alternative option inside another warehouse at Forte Marghera was proposed by a theatre group founded by one of the Spazio Legno directors.[14] However, this option also fell through due to bureaucratic failure in the Forte Marghera management. In April 2016, wahv received a message that the stockpile of stadium materials had been vandalised. All the valuable metal components had been stolen and the protective tarpaulin partially removed. Some of the wood had also been taken.

Despite restructuring of the Forte Marghera administration and replacement of the previous management team, prospects did not look promising. Would the *Stadium of Close Looking* ever find another life and location? Or would its transformation into another Frankenstein-like creature go unnoticed? Thanks to the collaboration of *Città Invisibile*, a cooperative that organizes events, the remaining materials are finally being taken to a place to be safely stored and will be used for whatever construction opportunities come their way. This is a lesson for any idealist, waiting for an imagined resolution of a stated ambition.

But 2012 was also the year when *We Are Here Venice* with *Theatrum Mundi* (a network on arts and public space at LSE Cities) arranged two sets of conversations to share expertise and experience between Venetians and relevant international experts exhibiting or participating in the Biennale. The conversations were prepared together with Elke, who also acted as moderator. Discussions centred around the future of the Arsenale of Venice, which covers a significant area of the city. They continue through wahv's active involvement in *Forum Futuro Arsenale*.[15]

Returning to the themes of the Architecture Biennales in two successive editions, 'people' did 'meet in architecture' (2010), through a set of

circumstances and conversations which brought an object into being. These were hosted by the object, the stadium itself, and continued afterwards, via the discussions that constituted part of the public programme of the following Biennale, entitled *Common Ground* (2012).

In Concluding

The *Stadium of Close Looking*, the example presented here, does not have a definitive and positive ending (yet). However, it was the impetus and context for ongoing conversations of resistance between Liza, Jane, and Elke, which still continue. We continue to try and better understand potentially poisonous contexts and a need to sometimes avoid too much obsession with detail. We want to emphasise that conversations of resistance are a crucial and open-ended outcome,[16] even though they very often appear to only happen informally in the cracks of time and the niche spaces afforded alongside formal get-togethers such as conferences, workshops, or over the phone. Our conversations happen at the same time as carrying on with one's own life, with the potential to take back time in order to have time together, sharing meaning and making space differently.

The concept of public space unites with a concept of public time. For us, it is not personal time made public via attention-seeking and attention-managing technologies of self-promotion, but, on the contrary, time dedicated to public life and urban resilience. Cities, as exemplified here, not only need public space where the public can meet but equally, a public disposition to invest themselves and their ideas and creativity into building public time and establishing common ground.

Why conversations of resistance? Why conversations of resistance as a feminist practice? Conversations here are understood as a practice that is open to learning, transformative, mutually supportive, meandering, inconclusive and ongoing processes, despite gaps and interruptions. Such feminist conversations resist neoliberal paradigms of utilitarian networking and self-enhancing success stories. Rather, they open and reflect on failures, doubts, hesitations, and also seek to redefine what

success might be in the context of challenges and impossibilities.

Even though this text also narrates the story of what one might call non-success, there are other stories about *We Are Here Venice* and the exchanges between Liza, Jane, and Elke that might have been told. Since the 2010 Venice Biennale that first brought Liza and Jane into conversation and a 2012 Berlin conference that led to a chance encounter between Liza and Elke, and many conversations later, *We Are Here Venice* has gone from idea to a recognized entity working on many levels and many scales to "address Venice's challenges as living city, and shares these findings globally."[17] As wahv exists to bridge gaps and promote action that wouldn't otherwise occur, the conversations of resistance provided very important validation and screening of thoughts, plans and hypotheses.

There is no time when we can do without conversations of resistance. Making time for them, and making them part of feminist futures, is an expression of trust in self-supported durational and open-ended structures. Over the years, our conversations of resistance have made us aware that, in order for these conversations to happen, they must resist immediate outcomes, they must not be turned into a project too soon, and they should remain open-ended (although specific action plans and project proposals may emerge and take on their own, separate, pathway). Such conversations are as much about speaking as they are about knowing that someone else is listening and sharing notions of possible urban change, and interpretations of meanings, despite disastrous and most depressing political and economic realities. Conversations of resistance are open-ended, they are not instrumental, but they are always useful. Conversations of resistance are about supporting each other, in not giving up and in not giving in.

1
See: weareherevenice.org
2
'Urban ethics' is a new term under consideration (by us) that refers to value systems and the conduct of life: the ability to appreciate what makes life better and to understand what makes life conditions worse.
3
The idea for *We Are Here Venice* emerged gradually in the years after the 2010 Venice Biennial. In 2015 it matured from an experimental phase to becoming a registered NGO. General aims are stated on its

website as follows: "wahv looks for ways to address Venice's challenges as a living city, and shares these findings globally. wahv monitors and measures critical parameters affecting Venice from an independent and objective standpoint, covering social, economic, physical and ecological indicators and future prospects (also in the light of past trends)." wearetherevenice.org/aims/

4

French writer Madelaine de Scudéry wrote in defense of women's education, which she perceived as a tool for social mobility. Her 1680 *Conversations Sur Divers Sujets* focuses on the art, the skills, and the rhetorics of salon conversation.

5

In *The Precariat. The New Dangerous Class* development studies scholar Guy Standing analyses how competition erodes long-term commitment to both work and consequently social relations. "Throughout history, trust has evolved in long-term communities that have constructed institutional frameworks of fraternity." (Standing 2011: 37). The erosion of long-term commitment results in permanent competition for work. Networking is paradoxically part of this competition for work. Networkers are more often than not competitors. The competitive networkers/networked competitors are consequently in constant short-term relations making them more vulnerable to precarity.

6

In *The Uprising. On Poetry and Finance* Franco Bifo Berardi explains the reasons as to why solidarity is endangered. "Thirty years of the precarization of labor and competition have jeopardized the very fabric of social solidarity, and worker's psychic ability to share time, goods, and breath made fragile... Solidarity is difficult to build now that labor has been turned into a sprawl of recombinant time-cells, and now that the process of subjectivation has consequently become fragmentary, disempathetic, and frail." (Berardi 2012: 54)

7

Berardi also points to the pitfalls of the virtualization of communication. "The virtualization of social communication has eroded the empathy between human bodies." (Berardi 2012: 54). The second decade of the 21st century ushered in a new wave of virtualization. Not only empathy between human bodies has eroded, now empathy with images is equally under pressure. Snapchat allows users to control the window of time recipients have to watch their images. Minimum is one second, maximum is ten seconds. Not only are social relations already running on the short-term perspective, the image relations are indicative of future vanishing of any form of commitment. What is fleeting, can not be committed to memory. Snapchat lives in the moment only. It becomes very difficult to build upon moments for long-term commitment and time-consuming reflection. In 2014, on the average a billion snapchats are viewed per day. (see: en.wikipedia.org/wiki/Snapchat)

8

In his *24/7: Late Capitalism and the Ends of Sleep* Jonathan Crary explores the nonstop conditions of neoliberal capitalism. Since the marketplace never ceases to work, human beings never cease to work either.

9

In *Women Who Make a Fuss. The Unfaithful Daughters of Virginia Woolf*, Isabelle Stengers and Vinciane Despret analyse the violence of evaluation and its detrimental effects on free thought. "Competition and the will to excel that allow for survival are today officially on the agenda as unavoidable imperatives. Violence no longer only characterizes the relationships among competitors, but also the means of evaluation to which they must all submit... Knowledge worthy of its name must not fear evaluation, they say to us, and this evaluation must be objective: how many articles, published in which journals? How many contracts? How many collaborations with other prestigious instituitions, thus contributing to the positioning of the university in the European or global market?" (Stengers and Despret 2014: 15)

10

In his 2012 essay 'In What Time do We Live?' Jacques Rancière emphasizes the difference between rest and leisure. He also draws the connections between leisure and emancipation. "A very old distinction, already formulated by Aristotle, opposed rest, which is an interruption in the time of work, to leisure, which is the use of time of those who are not subjected to the constraint of work. Emancipation then meant using the breaks in the time of work to blur the distinction between the time of rest and the time of leisure." (Rancière 2012: 27f) For us today this means that we have to find new ways of creating 'breaks' in time that effectively counteract the breaking up of time into ever shorter intervals of non-stop activity.

11

For a discussion on Detail/Strategy, see Katherine Schonfield's essay 'Premature Gratification and Other Pleasures' In *This is What We Do: A Muf Manual* by Liza Fior, Katherine Clark and Juliet Bidgood with essays by Katherine Schonfield and Adrian Dannatt, edited by Rosa Ainley, London: Ellipsis, 2000, pp. 14–23.

12

See: www.facebook.com/mit.venezia/?pnref=lhc

13

See also: www.ilcaicio.it

14

Spazio Legno is the joinery that built the wooden structure of the *Stadium of Close Looking*.

15

Forum Futuro Arsenale is an open group of local associations, advocacy groups, activists and residents that was formed after the public protest on 14 Oct 2012 against a draft law that would have taken away a significant portion of the Arsenale from the municipality and passed ownership instead to other institutions that didn't guarantee positive effects on the city by their use of the area, nor participatory planning in order to determine uses of the space.

16

One of the opportunities to carry on conversations of resistance was the 2014 pre-emptive research event hosted by Architecture in Effect at KTH for the 2016 Architectural Humanities Research Association Conference 'Architecture and Feminisms. Ecologies of Practice and Alternative Economies'. Elke, Jane, and Liza were all invited to have a public conversation on *Who's Afraid of Critical Practice?* How to activate your radical-feminist practices in art-architecture, urban curation and environmental activism.

17

wearetherevenice.org/aims

10

FEMINIST PRACTICES: WRITING AROUND THE KITCHEN TABLE

**HÉLÈNE FRICHOT,
KATJA GRILLNER
AND JULIEANNA PRESTON**

Listen carefully, for our voices murmur softly (please don't wake the children): we ask you to imagine the humble kitchen table as something more than a surface witness to familial meal-times. It has become, for our purposes, the intimate-expansive field of action around which feminist architects and spatial practitioners can begin to act and think otherwise. From this modest surface we propose to forward alternative methodologies and the means to revise creative spatial disciplines, with an emphasis on explorative writing practices. Each side of the kitchen table presents another horizon of action, or else a daunting cliff face across which our experiments promise to fly or to flail. Operating at many scales, metaphoric and literal, the kitchen table goes beyond the mere delimitation of our actions to a domestic sphere as we rally to the cry that the 'personal is political'.

Once we settle down to work, we want to table a contemporary and significantly partial history of six kitchen table events that have sheltered us and made us bold enough to launch forth with all manner of spatial-writing adventures. Around these kitchen tables we have explored other, alternative approaches to architectural design-practice research as an emerging and contested field. Our collective efforts are manifest in experiments in architecture-writing, site-writing, ficto-criticism and performance writing. As such, we offer a genealogy of six kitchen tables each with its own surface of actions, tools and tactics, dirty dishes, spilt liquids and family disputes. We write these events with our own respective voices, to capture our different perspectives and relative subjectivities. These writings are further indebted, inspired and entangled with the voices of those who have gathered around kitchen tables with us.[1]

1

This is a point we need to stress, all the work presented here develops from collaborative collective research, some of the names we want to acknowledge include: Katarina Bonnevier, Brady Burroughs, Thérèse Kristiansson, Meike Schalk, Helen Runting, Sara Vall, Maria Ärlemo, all the PhD and Masters level students of Critical Studies in Architecture, School of Architecture KTH past and present. All the PhD and Masters level students within Architecture+Philosophy, School of Architecture and Design, RMIT University. It is crucial to acknowledge we are but three voices speaking for the moment from amidst a great many, and there are always risks associated with speaking for those not immediately present. Furthermore, we could write a great deal more on how the motif of the kitchen table is present in the work of architect Sarah Wigglesworth, in bell hooks, and Sarah Ahmed's work, in the work of several feminist artists, and to all these precursors we make our dutiful acknowledgements.

01. Architecture+Feminism… A Roundtable Event: Level 12, Royal Melbourne Institute of Technology, Building 8, Program of Architecture Staff Room, Melbourne AUS, December 2007

Hélène:

Hesitating voices. Uncertain, stumbling vocabulary. We find ourselves stuttering and interrupting each other. Did we really forget so much of the feminist lexicon so quickly? How do we speak of these matters? Of what matters, and of what (feminine) bodies and performances can we speak? What bodies of knowledge matter? Julieanna Preston begins tentatively by discussing the role of the punctuation mark, the conjunctive capacities of a plus sign deceptively standing in for mathematical addition, where instead the word 'and' should have been. The conjunction trails off into ellipses, like a sigh, a murmur: Architecture+Feminism…There is a pause. That's right, we used to engage in more textual play then, subverting discursive structures. We used to explore the page space, allow the punctuation marks to undertake their own form of creation and critique. Withholding sense, collapsing sense, little shudders of pleasure in the text.

Karen Burns speaks up about the gross characterisation of historical waves that are habitually used to describe the history of women's emancipation movements. She argues that such large-scale sweeping accounts risk obliterating the minor voices; all the very little, seemingly inconsequential ripples that make up the feminist waves. Justine Clark wanders in and out of the room attempting to settle her small baby daughter and complaining that we have forgotten how to speak of such things. It is as though we must start over again, each time we meet around the table to discuss these shared matters of concern.

We are sitting around a table to discuss Architecture + Feminism…; it is a roundtable event, but it is also a kitchen table event, because we are all willing to acknowledge our situated knowledges, and because none of us are interested in the 'God trick' of speaking as though from a fully objective non-position.[1] The ellipses are here in our title to suggest an open project: An opening into a future, the 'yet to come', the women to come, our feminist futures. We are nervously aware of how many women and men, while sympathetic, tend to hide their feminist colours. Or worse, how many express open hostility to the idea. Stereotypes stick

Katja:

Six events are gathered on our kitchens' tables. /…/ Accidentally I just slipped on the keyboard, wrote kitchen *stables* /…/ I imagine a kitchen table surrounded by horses in their stable stalls. This figure lingers on in what follows.

Turning the 'I' into a 'she' her account begins. If 'she' is a nomadic subject, how might her presence and agency be accounted for?[1]

She finds herself at a feminism and architecture roundtable. The table is long and ovalish. The room is crowded and busy. A corner-office has turned meeting-room. Hand-scribbled notes are in her hands. The gathering is a response to her e-mail a couple of months earlier to a faraway colleague she had never met before (Hélène Frichot). It contained the question: What's happening with feminism and architecture in Australia right now? Earlier that autumn, in August, the feminist architecture group *FATALE*, had been formed in Stockholm.[2]

Around the table. Fruit-juice, sodas and snacks along the wall, a very tiny baby, pregnant women, and sitting men and women. An eighteen months old toddler from Sweden is elsewhere in Melbourne on that day (her son). Far away in Stockholm are four *FATALE* colleagues. Across the table Karen Burns, Julieanna Preston, names connecting to an earlier wave of, and other geographical locations for, feminist engagement in architecture. A question was asked: Why FEMINIST ArchiTecture Analysis Laboratory Education?[3] Is it wise or unwise to put the F-word on the table? Strategies exposed to sneak in feminist voices like Trojan horses (*there they are, the horses, again*) in reading lists. Concerns expressed. Presenting feminist horses in the architecture stable might prove a risky business.

It took her by surprise. That taking an explicit feminist position in teaching architecture could be thought of as essentially un-strategic. Scandinavian naivety? She argued that it is crucial that students understand where the critical methodologies that they are introduced to come from and to avoid that every wave of feminist engagement in architecture is eventually forgotten. There was agreement around the table, and yet, hesitation. The architectural institution is a strong fortress.

Julieanna:

What is that "+" doing? Is it holding Architecture and Feminism together, a binding mortar or sticky adhesive? Or is it adding one to the other, a seemingly unlikely concoction? Is one the accessory of the other or does it signify an intersection, a collision of two lines of circulation with no traffic light in sight? I wonder, how does such punctuation register the state of that particular entanglement? Why are we here?

The notes I prepared lie as soft blue inks blots absorbed by the moisture of the season and the cheap fibre of the serviette I absconded from the airplane. The marks record a contemplative muse on punctuation, specifically this equilateral cross (to bear) that from an autobiographical perspective recalls chalk lines carving out "four square" territories in the school yard, the plus-size label sewed into the seams of my garments, and the unrelenting realities of the Midwest American landscape that helped me make sense of Rosalind Krauss declaration that a grid was a space in art at once autonomous and autotelic.

The table swallows up the room, pressing, pinching us at the belly. It traps us in the periphery of the space. It is not possible to move around the table; there is only one exit, one door. I sit here fumbling my now illegible notes wondering if this spatial configuration has been preconsidered or is it an institutional hangover, a default unintended or all intended, an unwelcoming oversight? The table and the room conspire to regulate our actions; they prevent awkward polite handshakes or intimate bosom-to-bosom hugs. We are held at bay, in our own seats, as a collection of separate individuals, a spatial manifestation of "+".

Like the punctuation of language, geometry enforces order. The not-round table is by virtue of its planar shape the thing that brings us together but ironically holds us apart. Its oval egg-shape, ovate, oviform registers tell-tale signs around the table that we all know as the

fast, especially in the Australian context.

At the invitation of Justine, the current editor of *Architecture Australia*, Niki Kalms and I will write a review of the roundtable event we have organised. We are two hugely pregnant architecture design teachers, fecund and joyously heavy. This is also the first time I meet Katja Grillner, serious and bright-eyed. Tomorrow she will present a lecture for the Architecture + Philosophy public lecture series on the landscape and her lover.[2] She is one of the motivating forces behind the Architecture+Feminism… roundtable around which we now find ourselves seated. All she did was ask a question: what's happening with architecture and feminism over there, down under, on the other side of the world? We take the question and turn it into a gathering of voices, an event.[3]

Alone at the kitchen table, in the stable. The hay on the floor is tickling my nose. I sneeze and hear the horses stir. Rosi Braidotti insists that the nomadic subject is never in exile but constantly on the move.[4] She is not waiting outside the city walls to be let into her new home-town. She is merely resting before continuing her journey. In and out of cities, across the desert, over the ocean. If architecture was that city and the nomadic subject a feminist agent of *FATALE* should she settle long enough to build a house? "Nomadism", writes Braidotti, is "a gesture of non-confidence in the capacity of the *polis* to undo the power foundations on which it rests."[5] *FATALE* eventually built a house in the city and moved in. In institutional terms, a new foundation stone had been laid. (And new escape routes were excavated passing under the city wall).[6]

02. Writing Around the Kitchen Table: Captains of Industry, An Architecture+Philosophy Symposium, Melbourne AUS, June 2010

There is something that happens when sitting around the table for these discussions. The event-like character of these gatherings need to be better acknowledged as stages set for the performance of legitimate research. Research can take many forms, some which are less obviously durable, and less 'fit' for research assessment exercises, and yet which make a difference exactly in that they take place and produce a space for sharing thoughts and practices. What also needs to be acknowledged are all those who come together, even if fleetingly, to make such events possible. Loud and soft voices, faces that remain silent, as well as mouths that open wide to proclaim.

In our colloquium booklet, entitled, *Writing Around the Kitchen Table: Spatial Writing Practices*, we explained that we wanted to create a conversational forum (hence the kitchen table in our title), in which the role of writing as a creative and critical spatio-temporal practice could be discussed. The invited participants would arrive from a number of disciplines, from art, architecture and design, to media and communica-

I was in London. We had time to catch up over a coffee. Jane was going to Australia. We talked about our shared Australian connections, Naomi, Linda, Hélène… what everyone was doing, where our interests converged and where they might diverge. We agreed it would have been great for me to be there as well. I was not going.

Four years later I am having coffee with Hélène at my kitchen table in Stockholm. When browsing the photos she shows me of the event I see all familiar faces, adding here Stephen, Undine, Karen. I recognise a distributed family of sorts. A society of spatial writers, obsessed with the materiality of wordings, of relations between making sense and creating ambivalence, between precision and fabrication.[7] Exclusive and inclusive. I feel privileged.

ovum. An oval is a variant of an ellipse, a circle elongated in one direction along one of its axes, given a trunk, a thorax, an abdomen, a body. While increasing the perimeter, this deformation destroys the equality of equi-distance from the centre and any associations such configuration has to democracy. We were not the knights of Camelot. And yet, in terms of geometry, and perhaps feminism, the centre, the foci, is dislodged, bifurcated; when the "+" is tipped over things get multiplied. The inferences are obvious.

And with such pondering, my wondering wanders to whom is not present by virtue of invitation, geography, choice or protest. How many more axes could be extended and how many more foci could be generated? When might the gathering exceed the geometry and material constitution of the table and room, even the institution? At this point, it becomes readily apparent that the virtual prognosis of feminism as an agential force in architecture is the connective tissue, the rhizomatic network that brought all of us into the room and by extension, to many others.

Fig 10.1.H Program Booklets at the Writing Around the Kitchen Table: Critical Spatial Writing Practices symposium, 7 June 2010, Melbourne. Photography by Lauren Brown

A police report was filed at approximately 1:23 pm on 10 June 2010 by a member of the general public. The female caller cited a strange apparition on a large second story glass windowpane facing Elizabeth Street in the central business district of Melbourne. Such window is known to be the premises of Captains of Industry, a local venue dedicated to "Practical Men of Wide Experience offering the Good, the True and the Beautiful in Traditional Men's Outfitting and Dining". The report describes the woman's alarm at looking up beyond the edge of her umbrella into cold sharp raindrops to see the figures of many mouths suckling on the glass surface amongst the rise and fall of steamy vapours. (Fig 10.2.J) The woman reported that it looked like an orgy was taking place and protested the public display of objectionable content. She stated, "I want this stopped immediately, for the public good and safety of all our children!"

A pair of police officers were dispatched in

tions, creative writing and literature. Given the space I would enunciate an extended roll-call, the risk being that I would not be able to be exhaustive.[4] The non-institutional venue for this gathering, recommended by Caroline Vains, was called *Captains of Industry*, and it exists to this day, up a small Melbourne laneway, hidden above some secretive stairs. Jane Rendell was our invited guest and spoke to us about site-writing in her own work, and also in the pedagogical context. Karen Burns, Naomi Stead and Justine Clark, were all present, and notably went on to secure Australian Research Council funding for an ambitious project entitled, *Equity and Diversity in the Australian Architectural Profession: Women, Work, and Leadership*, in the process launching the inspiring Parlour – Architecture website.[5] Justine presented alongside her husband Paul Walker, and they brought the kitchen table straight into the discussion, talking of academic (*Fabrications: The Journal of the Society of Architectural Historians, Australia and New Zealand*) and professional (*Architecture Australia*) journals being prepared on a shared domestic surface in their family home.

Persuaded to leave our chairs and gather by the large windows, Julieanna Preston made everyone breathe against the glass panes before morning tea. We were performing by way of our breath-voices a women's emancipation protest in New Zealand. This was materially-semiotically superimposed upon the atmospheric effects of a volcano threatening to erupt. Stephen Loo and Undine Sellbach presented an early rendition of their cross-species picture book performance to wrap up the day, inspired by the pioneering bio-semiotic work of Jakob von Uexküll.[6] Everyone could eat a little chocolate lady-bug and wonder what capacities to affect and be affected a lady-bug might have, and in turn ask much the same question of themselves.

At the end of the day Naomi had to quickly leap into a taxi for the airport. For some reason I still see the yellow taxi pulled in at an angle down the narrow Melbourne laneway. I feel the light mist of fine rain coming down and wetting our upturned faces. The aftertaste of Portuguese tarts, little sandwiches, coffee and tea. A barber, a tailor, a shoemaker, and the question we all departed with: Can a girl be a captain of (architectural) industries too? In all the event had launched a provocation to action rendered powerful through the deployment of writing practices.

due course to the scene of the alleged crime. Approaching the scene from Elizabeth Street, they observed no evidence of reported "suckling". After climbing the stairs to the barbershop/café/ art studio, they found the premises vacant except for the barista who did not speak any English. The window glass bore a substantial area of oily smudges. The photographs documenting the venue reveal that a group had indeed gathered at this space that day. Strewn amongst the veritable landscape of chairs, stools, tables, benches, coffee cups, crumbs and plates, the investigators found discarded programmes, handwritten notes and sketches. Significant to the case, was the discovery of one sheet of crumpled paper discarded in the toilet room waste bin. It read:

"Go to the window. With your face against the glass, breathe heavily, amply and readily. Do so until the moistness of your breath obscures the transparency of the crystalline structure and starts to mingle to the heavy breath of the person on each side of you."

Further inquiry reveals that the event was not in fact an orgy but merely a gathering of academics, artists and scholars exploring the practice of architecture-writing. It has been confirmed that there were feminists amongst them. As such, the case has been closed after determining that neither the event nor the participants pose any short-term risk, harm or potential impact to the general public. The venue's owners were given a verbal warning for a possible infraction of the health code and asked to clean the window.

Fig 10.2.H Participants at the Writing Around the Kitchen Table: Critical Spatial Writing Practices symposium, 7 June 2010, Melbourne. Photography by Lauren Brown

Fig 10.2.J The window in question. Image by Julieanna Preston 2014

03. Whirlwinds, Sexuate Subjects, Politics, Poetics & Ethics Symposium and Exhibition at 5th Luce Irigaray Circle Conference, Bartlett School of Architecture, UCL, London UK, December 2010

It was impossible. I could not attend. Children, funding, lack of institutional support, simple incommensurable impossibilities and incompatibilities, some of which would eventually send me on a long and treacherous line of escape toward northern climes. I sent my contribution across the seas, across the world, via mail. A small sound installation piece all laid out in an Australian mail postage box. One of the books in the installation, the English language one, was nicked from the installation site at the Bartlett School of Architecture. The organisers apologised. The French language booklet was eventually returned, with the nasty synthetic piece of curtain I had intended to be hung as part of an imagined installation. The old portable CD player was posted later, as it had been temporarily misplaced. It was somehow important that the CD player was old, or at least somewhat anachronistic technology, near defunct, kind of clunky. As for the installation, it had been a simple exercise, two books, one in the original French and one in translation. The ink was a very deep blue. The covers blank, pale. I had them bound at a specialist book-binding establishment, Whites Law Bindery, Caulfield. The pages were French folded, thick creamy paper with enticing material weight.

Attending the books there was a sound recording of a voice reading the French text. The voice of someone whose early novel, *Lines of Flight*,[7] set in Paris, opened with a meditation on an orange peel. I can still smell it. In any case, I met the novelist, Marion May Campbell whose voice I recorded for the piece much later, and she was so kind. She rode her bicycle over to my place on a hot day, her eyelashes smeared with mascara. With only a little rehearsing, she let me record her voice saying those words, whirlwinds, eddies, and the birds outside, dimly audible. She had a great voice. From the vantage point of the future, I recognize what older women mean to me, acknowledging that I follow their trail-blazing path for a while, until I wander off.

I heard so much news of the event. Undine kept telling me about the amazing Swedes, the group called *FATALE*, a group Julieanna Preston had also been referring to in her PhD research. What arrived was news from an elsewhere where all kinds of creative and

A thin layer of snow covers the ground in Bloomsbury. *FATALE* just arrived from Stockholm together with her especially recruited guide who will escort the company through her garden.[8] Seven rolls of motley coloured oilcloths scheduled to arrive the next day at the Bartlett. Addressee: Peg Rawes. One day to set up the garden in the gallery. In the suitcase: Ten old-fashioned slides; ten mp3-players, loaded with distinct soundtracks; packs of postcards, fourteen motifs; the cardboard model. To be delivered: ten old-fashioned carousel slide projectors, loudspeakers, tables and chairs. Produced by local connoisseurs and printed on site: packs of maps, indicating hospitalities and generosities of place.[9] And, the outfits: specially selected outfits for the scheduled outing in the garden. For Chantal Fatale, a Scandinavian wintery style, reminiscent of cross-country skiing excursions in the 1940's.

For the 2010 conference *Sexuate Subjects: Politics, Poetics and Ethics* at UCL, London, in specific relation to the *Whirlwinds session*, *FATALE* has invited participants to the *Incompatible Modalities Salon* for lunch.[10] The salon aims at offering a break, a space for reflection and a memorable experience, to the conference participants. The Woburn Galleries, a set of roof-lit white cube gallery spaces, is transformed into a conversational landscape garden with ten 'fluttering follies' – each with its different modality of chicks, birds and buildings (*The love nest, La Sybille, The grotto, ...*). (Fig 10.3.1K) Once the participants are settled for lunch, *FATALE* performs a guided tour of the garden. (Fig 10.3.2K) Bringing forth its imagined spatialities, its gendered connotations, and the feminist narratives and figurations it materialises, a critical fiction is momentarily realised:

Chantal Fatale is the expert on eighteenth-century landscape gardens. Chantal is her role. Pascal Fatale knows all about *les folies*.[11] The follies open up to feminine worlds and articulate a geography of recollections. Pascal takes the company to Nathalie Barney's Temple of Friendship, to the childhood garden of pioneer abstractionist Hilma af Klint, to the cackling hen house and at last the outlook on Virginia's lighthouse from Ellen Key's Strand. Resting in the mossy softness of the moist grotto the relations between these points

178 Hélène Frichot, Katja Grillner and Julieanna Preston Feminist Practices: Writing around the kitchen table

It was a gesture of minor proportions: Most airports and roads in the UK were closed due to snowfall and frigid temperatures, University College London students were waging a public protest over recent government decisions to close programmes and increase fees, Luce Irigaray and Elizabeth Grosz were soon to deliver intense keynote lectures and the group FATALE were installing an ambitious interactive installation. *No Fixed Seating* was an inquiry into the politics of movement, a subtle action capable of shifting a field of relations, and a variation verging on the state of mutual transformation that enabled the co-mingling of destruction and creation.

On the day of the symposium, I entered the main lecture hall of Wates House, home to the Bartlett School of Architecture. My passage was marked by an audible siren, a low smooth voice babbling lyrically from an archaic bit of technology sitting out nonchalantly on a table in plain view. The room beyond the curtain featured a field of common institutional chairs arranged in neat rows. I quickly took my cue to claim a place amongst my colleagues. I took no time to unfurl my wet coat and sit with indifference upon a chair cover in thin plastic films infused with golden brown inscriptions. (Fig 10.3.J)

The day waned. The symposium proceeded. Irritated by the rustling sound that the plastic made as I shifted my posture, I tied its excess material around the legs of the chair. I found myself drifting away from the speaker's presentation. My gaze fell upon the plastic draped over the chair in front of me. A tag embedded in a pocket suggested a sitter was meant to register their presence. The slip cover's translucent surface bore a charred aroma that revealed it was a fusion of two layers coupled by the heat of a laser beam inscribing Luce Irigaray's essay "The 'Mechanics' of Fluids". I observed how the marks of the laser enticed rips, rents and tears, and hence gifted a vitality to the injection moulded mass produced chairs. I pondered which part of

Fig 10.3.H Hélène Frichot, 'She speaks as she is not one', sound recording, two bound books and synthetic curtain in cardboard box. Exhibited at Whirlwinds, Sexuate Subjects, Bartlett School of Architecture, 3–5 December, 2010, UCL, UK

Fig 10.3.J Waiting for that moment to begin. Image by Julieanna Preston 2010

critical and performative experiments were possible, where there was still something that could be identified as social consciousness and political awareness, where architecture was not just about built artefact and over-determined program, and where feminist practices were fully supported.

are recalled along with the lingering walk past groups of curious travellers conversing over their pick-nick lunches. Chantal lectures on the particular spatiality of the landscape garden. How *points de folies* are connected through a variety of clever techniques: meandering paths, compelling sightlines, narrative links, topographical adaptations, and a geography of emotional states.[12]

It all happens very fast. Guests arrive. They are assigned to their follies (not all follow orders). They receive their lunch. At the table, they converse (and write their postcards). Everything is in place. It works well. No glitches. Our enthusiastic guide performs according to plan.[13] Pascal and Chantal play their roles. In our company we have the eager listeners and our very own tireless flirt in spotless costume.[14] Do we even sit down for lunch ourselves? Vague memories of slipping in and out of the role. Recognising friends, bits of conversations. Interrupted for the show. It is a garden. I am Chantal. We are not at the Woburn Studios. We are in the garden. We are in the gallery. The guests are all gone. In two hours time, everything has to be erased. Later that evening a lecture will be held in these same rooms. We stop and look up. We take our photo. *The Incompatibles.* From left to right: Thérèse Kristiansson, Brady Burroughs, Meike Schalk, Katja Grillner and Katarina Bonnevier. (Fig 10.3.3K)

With reference to Luce Irigaray, the Whirlwinds session set out to explore productions of spatial modalities of essentially incompatible, alternative kinds.[15] The nomadic subject acts here within the institution, consolidates her house within the city of architecture, while still restlessly moving on, in transition. This house then must be cast in illusion – appear, disappear, reappear – a fragile construction to maintain.[16]

Irigaray's text was pressing between the seat of the chair and my buttock, an irreverent gesture considering the stature of the event. At the same time, I noted how the plastic pairing enabled a posterior movement akin to a shimmy, a wiggle, a hip roving gyration, a local whirlwind. This slippery surface adornment was begging for pelvic movement. What was this perforated plastic sheet promoting let alone protecting? The texture of Irigaray's text offered the only source of friction to such inappropriate behaviour. It became more and more difficult to be attentive to what was occurring at the podium as I contemplated how such movement was editing Luce's words. Certainly, sex was not one and there were more than two lips involved. I turned to the person sitting behind me who I knew to be the artist of the artwork with which I was engaging. I whispered, "I get it."

Fig 10.3.3K The Incompatibles. Photo taken a brief moment after closing the salon

Fig 10.3.2K In the pleasure garden. Touring the Garden of the Incompatible Modalities Salon, Woburn Studios, Dec 3rd 2010. The tour guide is accompanied by two garden experts – Chantal Fatale (garden historian) and Pascale Fatale (folly expert). Photo: Takako Hasegawa

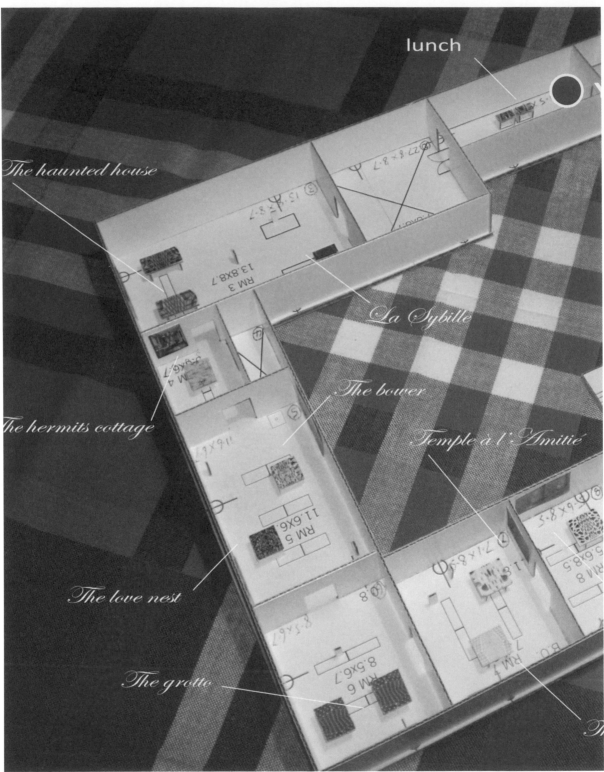

lunch

The haunted house

La Sybille

The bower

The hermits cottage

Temple à l'Amitié

The love nest

The grotto

Fig 10.3.1K Model photo and lay-out presentation of The Garden of the Incompatible
Modalities Salon, Woburn Studios, Dec 3rd 2010. Model and image: Brady Burroughs

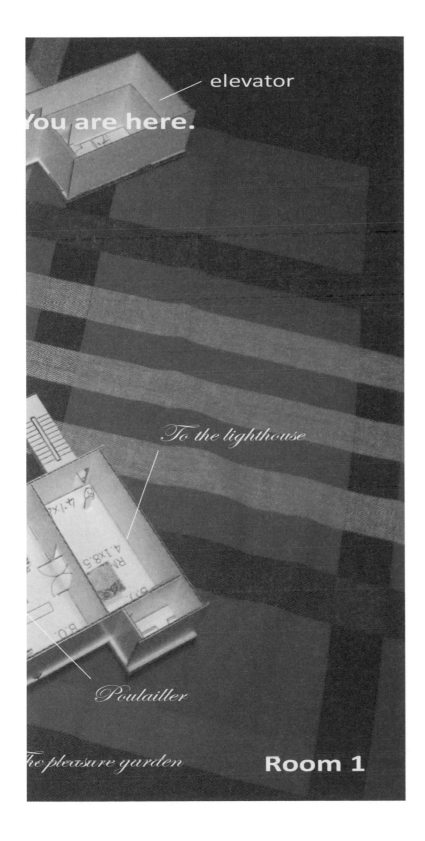

elevator

You are here.

To the lighthouse

Poulailler

The pleasure garden

Room 1

She cried when the flowers were handed out. She was still arriving in looking glass land, the northern, upper-half of the world, in the midst of undertaking a treacherous exercise in becoming-Scandinavian. Formidable distances travelled and great risks undertaken. Here, now, with you all, she thought to herself. It was a warm two days, and there was a feeling of great excitement. They had curated four sets of instructions around four tables covered in garish plastic coated tablecloths, the same ones that had been used for the Sexuate Subjects event at Bartlett in 2010. One table incited exploration of the 140 character constraints of Twitter Web 2.0 technology. Another table was dedicated to collage techniques, a further table demanded the drafting of manifestos. The fourth table asked you to write a site-writing letter, based on what had come to pass already on that very day. She remembers great peals of laughter. Jane Rendell, who had travelled across Europe by train, and Mona Livholts gave wonderful lectures. Tatjana Schneider introduced her collaboratively edited book, *Spatial Agency: Other Ways of Doing Architecture*,[8] which we all received as a further challenge to hegemonic architectural habits. The emphasis was on methodologies joyfully deployed by way of the productive constraints of instructions, with the insistence that it is only through the deployment of constraints that something wild and unexpected may unfurl. A determined argument was also articulated for architecture-writing,[9] as an alternative mode of design practice and even more as a creative feminist practice, making the thinking of other worlds, other places, possible.

Writing from another place, more than four years after the event itself she has to make certain efforts to recall the particularities of the situations, the workshop, the performances, the lectures, the conversations. The few keywords she has written down, sends her to an excursion with the international guests to the Drottningholm Palace Park, to memories of her then fifteen months old toddler daughter, eager to push the pram herself, and to the now 'old' KTH School of Architecture building, still partly in ruins after the 2011 fire.

She was moved to tears when viewing the ruined parts and reflecting in writing on the spaces that had been lost. Those tears were not only triggered by the building, or its loss but also by the association of that fire on May 11th, 2011 to another wholly personal and profoundly sad experience of loss. Particular locations become forever connected to the mood of despair, anger, loss, helplessness that accompanies the personal experience of loss and the ruthlessness of death. She reminds herself, again, that she had plans in 2012, to write an essay on the geography of those locations. This essay remains to be written.

Returning to the workshop, a photograph of a newspaper collage work on the checkered light green incompatible modalities table cloth has stayed strongly with her since. (Fig 10.4.2K) But she did not herself take part in the work on that table. To her rescue comes the collective memory of social media. Tweeting had been incorporated into the workshop, explored as a mode of writing. Still out there to be found (#archwrit) she now revisits the series of tweets:

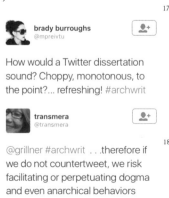

17

brady burroughs
@mpreivtu

How would a Twitter dissertation sound? Choppy, monotonous, to the point?... refreshing! #archwrit

transmera
@transmera

18

@grillner #archwrit . . .therefore if we do not countertweet, we risk facilitating or perpetuating dogma and even anarchical behaviors

Dear H+K,
Missing you heaps, wishing I was there.

j

Fig 10.4.J. Marking and embracing the spot. Image by Julieanna Preston 2010

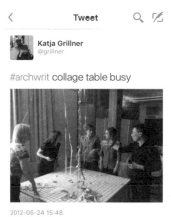

Fig 10.4.1K Tweets from the Architecture Writing Workshop May 24–25th 2012 (#archwrit)

Fig 10.4.2K Textual collage production at the Architecture Writing Workshop convened by Hélène Frichot and Katja Grillner at KTH School of Architecture May 24–25th 2012. Working around this table at the occasion were Jane Rendell, Mona Livholts, Stephen Loo, Undine Selbach and Malin Alenius. Photo: Katja Grillner

She had activated her existing twitter account in the months before preparing for the workshop, trying out, fumbling, but not really getting a grip on the format. "Twitter is a propositional mode of writing, what if there is nothing there ready to be proposed? Or if the news value can well be disputed? Is twitter demanding confidence? Is it creating confidence?"[19] (Fig 10.4.1K)

I remember now. Other tears. My new colleague Hélène had pulled the whole event together. New to Stockholm, to Sweden, to KTH, she had gone at full speed in the midst of the academic year and taken on full course responsibilities as well as setting up this workshop in dialogue with myself who was on partial parental leave. Hélène had done a terrific job. We were proud to be able to gather so many scholars and artists from our shared family of spatial writing friends from Sweden, UK and Australia.[20] I was surprised and moved when handing over the flowers to Hélène. Recognition, appreciation, relief and fatigue?

05. Writing Places Conference: TU Delft, the Netherlands, November 2013

A wilderness will be set out across a table set for tea. Two women, their voices in unison and discord will take their places. They will be introduced by a third voice, which will emerge from the audience as mistress of ceremonies. She will ring a small bell to quiet the room. Before long the two, and then the three voices will become a multiplicity, a collective voice of enunciation, as there will rise up a veritable chorus of voices calling out their vibrant material concerns. The whole performance will be simultaneously scripted and unruly. Flurries of cake crumbs, eddies of flower petals, great storms of tea in a great many tea-cups. It will be a still life that turns out to be disturbingly alive, no *nature morte* here. The table will collapse scales, mix materials, liquids and solids. The two women will be required to prepare for two days in a quaint bed and breakfast a few blocks away from the Delft University of Technology, School of Architecture. It will drizzle persistently from grey, leaden skies. And although they will worry constantly about coming across as a couple of mad old tea ladies, curious biddies who had some-how misunderstood the academic etiquette required by such an event, their experiment in feminist practices of lively materiality will receive respectful applause.

Is it time to return to the I. Or, no? The subjective tone is always troubling her. Why should a reader pay any attention to, or have an interest in the very I, the subject herself. To offer, as in this essay, complementary subjective points of view on a series of interrelated events, is one thing. It weaves a series of situations together temporally, spatially and relationally. But its side-effect, the calling to attention of the biographical I herself, the Katja Grillner that, by invitation from Klaske Havik, attended the Writing Place Conference in Delft to deliver a key-note lecture alongside the key-note by her previous professor and mentor Alberto Pérez-Gómez, remains slightly uncomfortable.

She remembers the feeling of pressure, of last minute concern with the slides, exercises of reading and timing the lecture at the hotel room. Enjoying the presence at the conference of her critical studies colleagues Brady Burroughs, Helen Runting, Hélène Frichot, and her co-author in this essay Julieanna Preston, but also, as always, anguishing whether her lecture would prove worthy of the context: *Fiction and Performance in Architectural Research Inquiries.*[21] She passes in the corridor a messy room set up for (or did the session just conclude?) a tea-party, while settling in (or

Setting the scene
To set the table
Enabling a performative lecture
Tabling Femininities: Two (or more) Voices on Still Life

By Hélène Frichot and Julieanna Preston
with contribution by Helen Runting

a room of modest proportions
a data projector linked to electricity
a webcam connected to a laptop computer

a bank of chairs filled with an audience
a table and two chairs located in front of the room
a projection surface hung behind and above the
table and chairs

a door

a woman
bright red lips
a hand bell

Fig 10.5.1H Julieanna Preston and Hélène Frichot, 'Tabling Femininities:
Two (or more) voices on still life' at Writing Place: Conference on Literary
Methods in Architectural in Research and Design, TU Delft School of
Architecture, 25–27 November 2013, Netherlands Photography by
Andrej Radman

leaving?) the adjacent room where her task is to moderate the session *Scriptive Experiments – Literature as Research Tool*.[22] She is clearly missing out on the tea-party.[23]

In the other room, she is introduced to new compelling imaginaries of the Farnsworth House, to new conceptions of the dead-zone, and to the reception of her PhD-Student, Brady Burroughs', fictional renovations of a Rossi row house.[24] Brady's PhD-dissertation is now, at this moment of writing, the summer of 2016, coming to its final closure. It is definitely promising to add a new distinct layer to the collective assemblage of fictional and performative modes of writing architecture and architectural research. Adding a new chapter to our shared history.

a woman
fuschia hair scarf
a voice
a blue notebook

a crisp white tablecloth
a basket
four royal blue china teacups
four soft blue china saucers
four white china dessert plates
four large white linen serviettes
four metal teaspoons
four pale blue-grey paper place name cards
a clear glass vase

a woman
yellow fingernail polish
a voice
a blue notebook

a robin's-egg blue ceramic teapot
hot water
a bouquet of yellow and red tulips and white daisies
a royal blue ceramic bowl
sugar
a ceramic pitcher
clotted cream
black tea bags
sandwiches, petit fours
apples and oranges

women and a few men
some voices

Esther Anatolitis, Jane Bennett, Jennifer
Bloomer, Rosi Braidotti, Katarina Bonnevier,
Lori Brown, Norman Bryson, Karen Burns,
Brady Burroughs, Hélène Cixous, Justine
Clark, Gilles Deleuze, Rosalyn Diprose,
Elizabeth Diller, Teresa de Lauretis, Catharina
Gabrielsson, Moira Gatens, J.K. Gibson-
Graham, Katja Grillner, Elizabeth Grosz, Félix
Guattari, Donna Haraway, Luce Irigaray, Alice
Jardine, Gail Jones, Leslie Kanes Weisman,
Sandra Kaji O'Grady, Thérèse Kristiansson,
Michèle Le Doeuff, Katie Lloyd Thomas, Alex

Fig 10.5.1J. A tea setting still life (video still).
Image by Julieanna Preston 2013

Fig 10.5.2J. A still life's source of abundance (video still).
Image by Julieanna Preston 2013

Fig 10.5.3J. She prepares the biscuits and cake for serving (video still).
Image by Julieanna Preston 2013

Fig 10.5.4J. Signaling proper tea party serviette behavior.
Image by Andrej Radman 2013

06. Feminist Futures Roundtable: Architecture and Design Centre, Stockholm, Sweden, March 2014

Rather than making an account of the roundtable gathering with which we have decided to conclude, I want to fall back toward a moment when many of these concerns first began to crystallise for me. It was my first introduction to the thinking of French language feminist Luce Irigaray, an encounter which occurred within the second to last design studio I would undertake before graduating with a degree in architecture. Even today I wonder how I survived that rite of passage. Then, as today, the pedagogical space of the design studio was the tumultuous vortex of every architecture student's education. Falling back down through this maelstrom that is the history of my own formation as an architect, it is toward that sheet of time I want to return, imagining that I will be caught and lifted upwards again as though on a great temporal trampoline. The idea,

Forgetfulness. She has a problem with recollection. Her working days are since a long time mostly busy with meetings and different kinds of urgencies that needs solving. E-mailing. Endlessly. Since taking on her present role in 2015 her schedule has become even more tightly controlled. At home, life is as intense. To be present with her young children is the highest priority, a happy one. The events accounted for in this essay takes place over a period of seven years. Over these years their son went from a toddler to a school-boy of eight and their daughter came into their life and became a three-year-old girl. Today they are ten and five. Her outlook on places and spaces is constantly changing through the added layer of experiencing them through her children's discoveries, playful uses and advancing skills. New dimensions are opening up while

Martinis Roe, Doreen Massey, Doina Petrescu,
Peg Rawes, Jane Rendell, Margrit Rowell, Helen
Runting, Meike Schalk, Zoe Sofia, Naomi
Stead, Isabelle Stengers, Nigel Thrift, Sara Vall,
Weisman, Mary Wollstonecraft, Virginia Woolf,
Sarah Whitmore, Iris Marion Young

Fig 10.5.5 I Tea party tasting Image by Andrej Radman 2013

Fig 10.5.2H Julieanna Preston and Hélène Frichot, 'Tabling Femininities:
Two (or more) voices on still life' at Writing Place: Conference on Literary
Methods in Architectural in Research and Design, TU Delft School of
Architecture, 25–27 November 2013, Netherlands Photography by
Andrej Radman

17 May 2014.
Sunrise.

Taking the dog for a walk.

Head first, head down into the full force of the
southerlies.

Kapiti Island brooding in a salt-laden mist.
It dawns on me, pun intended, that at this
very moment you are very likely seated in the
day before, in 16 May, in the Architecture and
Design Centre, mulling, commiserating, debat-
ing, whatever a group of feminists do when they
gather, doing all that stuff beyond the cliff edge
of my horizon, out of view, out of earshot.

Fig 10.6.J A gesture of openness. Image by Tasha Smith 2015

simply, is to go backwards in order to proceed forwards again toward feminist futures because these futures are also what I blindly looked forward to, at a formative age and as a student of architecture.

When I reflect on that time now it seems remarkable in its prescience, as it encapsulates all the difficulties women continue to struggle with in the academy. And yet, back then, by some astonishing feat an architectural design studio which allowed for fluid relays between theory and practice to be explored was run and the theory in question was signed by such names as Luce Irigaray, Elizabeth Diller, Alice Jardine. The studio mistress was Jennifer Hocking. When I look back through the personal archive of my diaries what I find are an array of references, beacons for the purposes of orientation in a thinking that would eventually lead me, although through a series of irrational passages and detours, toward feminist practices. This is the year 1993, and by 2007, fourteen years later, when the first 'kitchen-table' architectural writing event was convened, I had forgotten much of what I had learnt. And now, again, after another nine-year journey (I write, right now, in August 2016), which required relocating to the other side of the world in order to discover a milieu of possibility. What has travelled with me in the form of a black bound sketch book, holding minutely drafted script and spidery drawings, are tales of this other time. A sheet of the past inscribed so neatly with evidence of that other time, from which location I can rebound to this present moment, here, now, with you.

Let me tell you, briefly, how my design project worked in this exceptional studio run by Jennifer Hocking: It was a proposed installation type of intervention, a materialization of Irigaray's critique of Plato's parable of the cave.[10] The intervention sought to confound entry into my former architecture school by overriding the hegemony of optic regimes with haptic relations. Now I see its close resemblance to some of Elizabeth Diller's early experimental work with quasi-technical devices, section cuts (taken seriously as such) and screens.[11] In my scheme I proposed a carousel that stood sentinel outside as supplement to the glazed entry doors of the architecture school. Upon this carousel there was stationed constrained subjects (students perhaps), kept perpetually outside the edifice of architecture, never gaining access to its truth. And what is to be discovered inside, but a screen on which is projected

other dimensions of life are put on hold.[25] There is a sense of waxing and waning as her nomadic subjectivities evolve, of relative appearance and disappearance of positions. She navigates.

Responding to challenges professionally and privately as they occur, her own research and writing is now a thin rill of water occasionally splashing over pebbles and moss in the woods. The water keeps running, but at times the stream is very weak, on the verge of drying out. A lot of energy goes into being present and alert, to contribute in each situation where she finds herself, in seminars, workshops, lectures, round-tables. It proves difficult to afterwards take care, to reflect on, and to nurture those moments that have passed. It makes her uneasy. Living in the present, always moving on.

But her situation is not coincidental. It is a result of choices. Her longing for a more focused, perhaps more stable condition of thought, responds to an ideal that is ultimately not hers. It is one out of many figurations of subjectivities to embody. It is a fiction that, if embraced uncritically, largely fails to respond to current societal conditions and challenges. She has ever only temporarily slipped into that position. She likes it but was never able to stay for long.[26] Rosi Braidotti's account of nomadic subjectivities now holds a deep both personal and political significance for her: "The nomadic subject is a myth, that is to say a political fiction, that allows me to think through and move across established categories and levels of experience: blurring boundaries and burning bridges."[27] This is important, remember this.

The Feminist Futures Round table in May 2014, arranged as a peer-review session by the editors of this book, included Nel Janssens as peer-reviewers. She now remembers a beautiful day in a fine room overlooking the small ship-building wharf and across the water Djurgården. She remembers excited and happy conversations, a supportive atmosphere, yet sharp and critical. (10.6.K) In the corner she discovered an open box that made her curious. It contained a cycling dress and an Olympic medal. That was something to hold in your hands. A real Olympic medal. At this point, she does not remember if it was silver or bronze. It was not gold. A cycling exhibition was currently being installed on the premises.[28] This explained the open box in the corner. She felt part of a trusted group. There was an Olympic medal in the room.

Calling out to you.

Shouting louder.

Throwing my lungs wide open. (Fig 10.6.J)

The wind hurling my greetings over my shoulder, the Tararua's, Aotearoa, the Pacific, the equator, across the earth's surface, the long way around.

From where I am standing, the future is full of vigor.

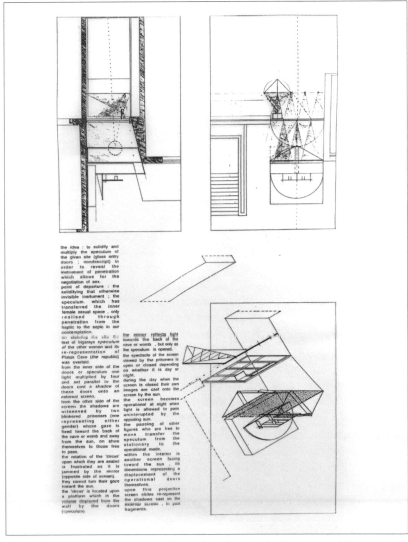

Fig 10.6.1H Hélène Frichot, 'Space for the Negotiation of Sex', sketch, student work undertaken in architectural design studio at the School of Architecture, University of Western Australia 1993

flickering images of their many diverse and animated faces, describing the continuous variation of affective encounter, as the outside, the other, in fact composes the very depths of the discipline, and the possibility of another kind of architecture.

An alternative future was present here all along.

1
See Donna Haraway, 'Situated Knowledges: The Science question in feminisms and the privilege of partial perspective', in *Feminist Studies*, Vol. 14, No. 3, 1988, 575–599.

2
See (architecture.testpattern.com.au),

3
Event convened by Hélène Frichot, Nicole Kalms and Harriet Edquist. Participants included: Esther Anatolitis; Karen Burns; Justine Clark; Katja Grillner; Julieanna Preston; Anna Tweeddale; and others.

4
Harriet Edquist and Laurenne Vaughan must be acknowledged as they supported the event with research funding from Geoplaced Knowledges, RMIT University; Caroline Vains, with her colleague Peter Murphy, also supported the event via SARU, Monash University; the event was further hosted by Workshop, Department of Counterculture (a collaboration between Caroline Vains, Lynda Roberts, Anthony McInneny and the Melbourne Central Management); researchers present included: Esther Anatolitis; Suzie Attiwill; Ammon Beyerle; Lauren Brown (who documented the event with her many photographs); Karen Burns; Justine Clark; Hélène Frichot; James Geurts; Julie Henderson; Katica Pedesic; Christine Phillips; Stephen Loo; Janet McGaw; Katherine Moline; Stanislav Roudavski; Undine Sellbach; Naomi Stead; Sarah Treadwell; Linda Marie Walker; Paul Walker; Phoebe Whitman. Sandra Kaji-O'Grady submitted an abstract on the aphorism, but could not make it.

5
See (archiparlour.org).

6
Jakob von Uexküll, *A Foray into the Worlds of Animals and Humans*, Minneapolis: University of Minnesota Press, 2010.

7
Marion May Campbell, *Lines of Flight*, Fremantle, Australia: Fremantle Arts Centre Press,1985.

8
Nishat Awan, Tatjana Schneider, Jeremy Till, eds, *Spatial Agency: Other Ways of Doing Architecture*, London: Routledge, 2011.

9
'Architecture-writing' is a term introduced by Jane Rendell in *Critical Architecture*, in a section likewise entitled 'Architecture-writing' where she explains that approaches to art-writing had been a point of inspiration, especially suggestive for those writing in the discipline of architecture, where a rethinking of relationships between subjectivity and space is indispensable, and where writing as a practice alongside design practice could be legitimised. Jane Rendell, Jonathan Hill, Murray Fraser, Mark Dorrian (eds.), *Critical Architecture*, London: Routledge, 2007. See also Jane Rendell, 'Architecture-writing' in *The Journal of Architecture*, 2005, Vol. 10, No. 3, 255–264.

10
Luce Irigaray, *Speculum of the Other Woman*, trans. Gillian C. Gill, Ithaca: Cornell University Press, 1985.

11
See, for instance, Elizabeth Diller and Ricardo Scofidio, *Projects 17*, 1989. See www.moma.org/interactives/exhibitions/projects/elizabeth-diller-ricardo-scofidio/

1
Rosi Braidotti *Nomadic Subjects: Embodiment and Sexual Difference in Contemporary Feminist Theory*, New York: Columbia University Press, 1994.

2
FATALE was initiated in September 2007 by Brady Burroughs, Katarina Bonnevier, Katja Grillner, Lena Villner and Meike Schalk, teachers and researchers at the KTH School of Architecture in Stockholm. *FATALE's* establishment of a strong feminist research and education profile at KTH resulted in a new tenure track position that opened at the School of Architecture, with gender theory as a critical studies in architecture specialization. This announcement found it's way to Melbourne, Australia. Hélène Frichot, convenor of the 2007 Architecture + Feminism RMIT round table, arrived as assistant professor to KTH in January 2012. On *FATALE*, see Meike Schalk, Brady Burroughs, Katja Grillner and Katarina Bonnevier "FATALE Critical Studies in Architecture" in *Nordic Journal of Architecture*, No 2, 2011, 90–96.

3
The name *FATALE* is an acronym for Feminist ArchiTecture Analysis Laboratory and Education, or Feminist Architecture Theory Analysis Laboratory and Education.

4
Rosi Braidotti 'Introduction. By way of nomadism' in *Nomadic Subjects* (1994), 1–39 (32).

5
Ibid., 32

6
The formation of *FATALE* was importantly a formation 'within' the institution. I.e. constituted by teachers and researchers at the School of Architecture, KTH, and targeting effects on curriculum building, design studio content etc.

7
Full names of everyone mentioned here: Jane Rendell, Naomi Stead, Linda Walker, Hélène Frichot, Stephen Loo, Undine Sellbach, Karen Burns.

8
Brady Burroughs, Katarina Bonnevier, Katja Grillner, Meike Schalk, as *FATALE*, and Thérèse Kristiansson, as the guide.

9
Kim Trogal and Nishat Awan prepared and produced this material.

10
Sexuate Subjects Irigaray Conference, was organised by UCL and the Bartlett School of Architecture, London, Dec 2010. Main organiser of the conference was Peg Rawes. Session organisers and curators for the Whirlwinds session were Jane Rendell and Ana Arauajo.

11
Katarina Bonnevier performed this role drawing on her own research as published in her PhD-dissertation *Behind Straight Curtains – Towards a Queer Feminist Theory of Architecture,* Stockholm: KTH/AxlBooks 2007 and elsewhere.

12
On spatial and experiential characteristics of the eighteenth century landscape garden see for example Katja Grillner "Experience as Imagined: writing the eighteenth-century landscape garden" in Martin Calder (Ed.) *Experiencing the Garden in the Eighteenth Century*, Bern: Peter Lang 2006, 37–64.

13
Thérèse Kristiansson performed this role.

14
Meike Schalk, Sophie Handler and Brady Burroughs performed these roles.

15
The title 'The Incompatible Modalities Salon' is a reference to Luce

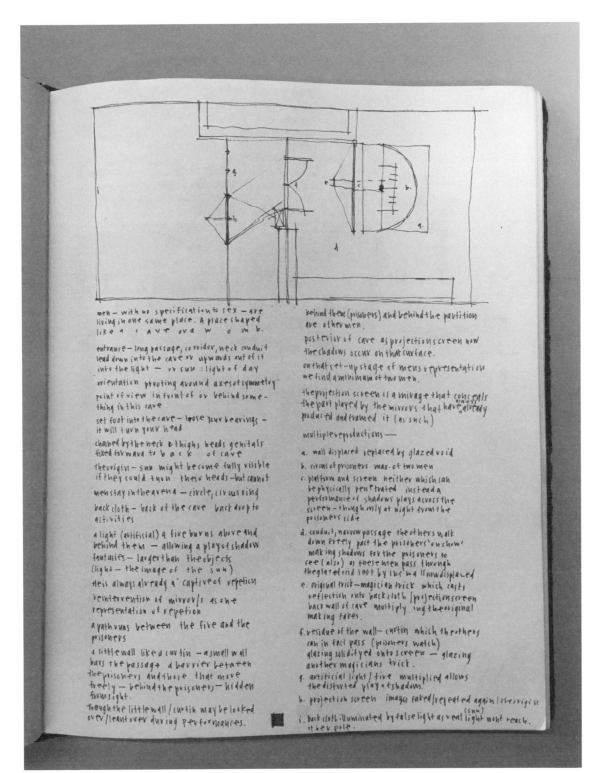

men — with no specification to sex — are
living in one same place. A place shaped
like a c a v e or a w o m b.

entrance — long passage, corridor, neck conduit
lead down into the cave or upwards out of it
into the light — or sun : light of day

orientation pivoting around axes of symmetry
point of view in front of or behind some-
thing in this cave

set foot into the cave — loose your bearings —
it will turn your head

chained by the neck & thighs, heads genitals
fixed forward to b a c k of cave

the origin — sun might become fully visible
if they could turn their heads — but cannot

men stay in the arena — circle, circus ring

back cloth — back of the cave back drop to
activities

a light (artificial) a fire burns above and
behind them — allowing a play of shadow
fantasies — larger than the objects
(light — the image of the sun)

he is always already a captive of repetition

re-intervention of mirror/s as one
representation of repetition

a path runs between the fire and the
prisoners

a little wall like a curtain — a small wall
bars the passage a barrier between
the prisoners and those that move
freely — behind the prisoners — hidden
from sight.

though the little wall / curtain may be looked
over / leant over during performances.

behind them (prisoners) and behind the partition
are other men.

posterior of cave as projection screen now
the shadows occur on that surface.

on that set-up stage of mens representation
we find a minimum of two men

the projection screen is a mirage that conceals
the part played by the mirrors that have already
produced and framed it (as such)

multiple reproductions —

a. wall displaced replaced by glazed void

b. circus of prisoners max. of two men

c. platform and screen neither which can
be physically penetrated instead a
performance of shadows plays across the
screen — though only at night from the
prisoners side

d. conduit, narrow passage the others walk
down freely past the prisoners 'on show'
making shadows for the prisoners to
see (also) as these men pass through
the glazed void lost by the wall now displaced

e. original trick — magician trick which casts
reflection onto back cloth / projection screen
back wall of cave multiplying the original
making fakes.

f. residue of the wall — curtain which the others
can in fact pass (prisoners watch)
glazing solidifyed onto screen — glazing
another magicians trick.

g. artificial light / fire multiplied allows
the distorted play of shadows.

h. projection screen images faked / repeated again as origin

i. back cloth illuminated by false light as real light wont reach.
other pole. (sun)

Fig 10.6.2H Hélène Frichot, 'Space for the Negotiation of Sex', ink
drawing, student work undertaken in architectural design studio at the
School of Architecture, University of Western Australia 1993

Irigaray as quoted for the Whirlwind Session call: "...women diffuse themselves according to modalities scarcely compatible with the framework of the ruling symbolics." Luce Irigaray in "The "Mechanics" of Fluids", *This Sex Which Is Not One*, Ithaca: Cornell University Press, 1985, 106.

16

For further discussion on FATALE's practice and on the Incompatible Modalities Salon see Katja Grillner "Design Research and Critical Transformations", in Murray Fraser (ed.) *Design Research in Architecture*, Dorchester: Ashgate, 2013, 71–94 (77–85)

17

Tweet from brady burroughs (@mpreivtu), #archwrit, 20120524, 13:37

18

Tweet from transmera (@transmera), #archwrit, 20120524, 23:28

19

Series of tweets from Katja Grillner (@grillner), #archwrit, 20120524, 13:25–13:36.

20

Guests and keynote speakers included Mona Livholts, Stephen Loo, Jane Rendell, Tatiana Schneider and Undine Sellbach.

21

Material from the lecture has been partially incorporated into a dialogue piece co-written with Klaske Havik, Susanna Oliveira and Mark Proosten (eds.), *Writingplace: Investigations in Architecture and Literature*, Rotterdam: Nai010 Publishers, 2017. Further a chapter by Katja Grillner in the forthcoming publication Hélène Frichot and Gunnas Sandin (eds.) *After Effects: Theories and Methodologies of Architectural Research* (2017) will be based on the lecture manuscript from the Writingplace conference at TU Delft. November 2013.

22

For full reference to the conference programme see conference website www.bk.tudelft.nl/en/current/agenda/event/detail/conferentie-writingplace/ [accessed July 12th, 2016].

23

The paper by Julieanna Preston and Hélène Frichot *Tabling Femininities: Two (or more Voices) on Still Life* was set up as a tea-party with mistress of ceremonies support from Helen Runting.

24

Papers at this session by Nora Wendl (*Fox/River/House: a Translation*); Gil Mualem Doron (*The "Dead Zone"? "Is that what you call it?"*); and Brady Burroughs (*Renovating Rossi: Stories of anticipation in close encounters of the (un)desirable kind*).

25

For a discussion around the question of experiencing and knowing places through and in relation to a child you are caring for and playing with, see Katja Grillner "A Performative Mode of Writing Place: Out and about the Rosenlund Park, Stockholm 2008–2010" in Mona Livholts (ed.) *Emergent Writing Methodologies in Feminist Studies*, London: Routledge, 2011, 133–147.

26

Katja Grillner, "Fluttering butterflies, a dusty road, and a muddy stone: criticality in distraction" (Haga Park, Stockholm, 2004), in: Jane Rendell et al (eds.), *Critical Architecture*, London: Routledge, 2007, 135–142.

27

Braidotti (1994), 4.

28

Cykel/Bike, exhibition at ArkDes, June 19th-October 5th 2014

11

REHEARSALS – ON THE POLITICS OF LISTENING

**PETRA BAUER
AND SOFIA WIBERG
WITH MARIUS DYBWAD BRANDRUD
AND REBECKA THOR**

The following contribution concerns the project *Rehearsals* where we experimented with different forms of listening. This chapter is divided into four parts which introduce and describe the project from different perspectives:

1. Invitation letter to *Rehearsals*
2. Protocol and reflections on *Rehearsals,* written by the initiators of the project, Petra Bauer and Sofia Wiberg
3. Reflections on Act 2 What do we hear? by Sofia WIberg
4. Reflections from participants in *Rehearsals*. Rebecka Thor interviewed by Marius Dybwad Brandrud.

Rehearsals: Invitation letter
The invitation letter was sent out in the autumn of 2013

Dear xx,

With this letter we would like to invite you to explore listening as a political and ethical approach together with us, within the framework of *Rehearsals – On the Politics of Listening*.

For eight months, between October 2013 and April 2014, we will conduct eight acts at Tensta konsthall,[1] trying out different forms of conversation where articulated language is not the primary tool. We call it acts, but it could also be seen as participatory performances, seminars, or workshops. We will be a group made up of 30 people – with different experiences, ages, professions and local connections – with a joint interest in exploring the terms for political conversations. The overall theme for these conversations will be housing, a topic that concerns us all right now but in different ways.

We, the authors of this letter, have many years of experience as organizers of and participants in both discursive seminars in the art world as well as citizens' dialogues regarding planning processes, activities which we have become increasingly critical towards. We have felt the necessity to question which bodies and perspectives are made possible within a given space and, not least, how these very structures could be altered.

Since the 18th Century, having a voice has, within Western philosophy, political theory and culture been seen as a basic condition of democratic life (Bickford 2004). According to this view, it is the ability to speak freely and to be heard that has made us human and political subjects, something which the philosopher Hannah Arendt (1998) has emphasized. Listening, on the other hand, has, according to the media historian Kate Lacey, been bound up in a cultural hierarchy of the senses that privileges the visual over the auditory and a logocentric frame in which listening is positioned as something passive, as opposed to acts of writing, reading and speaking (Lacey 2013).

Cultural theorist Gayatri Spivak (2002) has questioned on whose terms we are actually being heard. She has written about how oppressed and marginalized groups cannot be heard globally, in the public realm, because they are always being heard on someone else's terms. She argues that if those with privilege and power want to understand the subalterns they have to first become aware of their own conditions and then unlearn their knowledge. Spivak says that we have to learn to un-learn.

With these thoughts as a starting point, it could be considered a radical act to emphasise listening over speaking. This also generates the question whether we, in listening, could generate new forms of community?

Together with you and other participants we wish to explore what a listening practice might involve and what political implications it can have. We have no desire to turn people into better listeners, but to explore what constitutes a *mutual* listening practice. We consider the project an experiment. We also acknowledge that all spaces are conditioned, and when we change the ways in which we interact, new conditions will be set. However, we are not out to find the 'right' way of engaging in conversation – we are more interested in what happens when norms and rules are displaced and re-negotiated.

We hope that you can and want to participate. Each act will last for three and a half hours. You don't have to prepare anything before we meet, but we ask you to commit to attending all the acts. This is what will enable a collective process where we can learn from each other and where we don't need to start fresh each time. In other words, we consider all of the acts to be parts of a whole and not as separate events.

We look forward to hearing from you,

Our best,
Petra & Sofia

Rehearsals: Acts

Act 1: Inauguration: Dance party
31 October, 1.30–4.30pm

Rehearsals – On the Politics of Listening was inaugurated with a dance party at Tensta konsthall. The dance party was only for women and was organised together by Sarah Degerhammar, Tanja Tuurala and the Women's Centre in Tensta-Hjulsta. Degerhammar is a feminist performance artist and active in the artist group TIR and Jordbro Stadsteater. Tuurala works as a choreographer, dancer and teacher and is also active in TIR. The Women's Centre in Tensta-Hjulsta is a meeting place for women. Dance, food and drinks were served.

Act 2: What do we hear?
18 November, 10am–1.30pm

The second act was organised together with Ultra Red, an international group that works at the intersection of sound art and politics. Using pedagogical methods of listening to interrogate social conditions, struggle, and other modes of collective process, Ultra Red's work questions given binary divisions between the aesthetic and the political. Collective listening, dialogue, and reflection are political actions that can both contribute to, and challenge collective organising and relationships. Over the past twenty years, the group has worked within and across a widely distributed network of communities, organising around public housing, health, education, anti-racism and migration.

Act 3: Power, body and space
12 December, 1pm–4pm

The third act was organised together with Carina Listerborn, a professor in urban planning and design, and Ragnhild Claesson, an urban and gender researcher and Ph.D. candidate at Malmö Högskola. Listerborn's research addresses the relationship between power, bodies and space in relation to social sustainable urban development. She focuses on housing issues and how the insertion of gender as an analytical category can create a more sensitive and conscious planning practice. Claesson's research addresses intersectional aspects of cultural heritage in urban development processes in Malmö.

Act 4: Language of gesture
30 January, 10am–1pm

Choreographer and dancer Stina Nyberg led the fourth act. The relationship between sound production and movements is a recurring theme in Nyberg's work. She pays attention to the presence of the body in every sound, music and track. In this fourth act we conversed through movements, using the body and everyday gestures as a medium.

Act 5: Spatial experiences
18 February 1pm–4pm

The fifth act was led by the actor and artist Ellen Nyman. In this act, we used our various experiences of physical, geographical, and mental spaces as starting points, and made visible the knowledge these experiences produce. Attention was paid to the different types of knowledge stemming from migration, language, class, gender and race.

Act 6: Everyday communities
18 March 9.30 am–1pm

The sixth act was organised by the Women's Centre in Tensta-Hjulsta, which is a meeting space for women where women can share experiences, learn Swedish, attend courses, cook food and help each other. It is a place that can be characterised as a woman's everyday community.

Act 7: Terrestrial excursions
29 April, 10am–1pm

This act was led by sound artist Hong-Kai Wang, whose interests involve the question of whether we can create a home beyond a physical space through our memories. During this act, we aimed at remembering together, listening to each other's memories and asking ourselves how we remember in contexts that are characterized by the double processes of leaving and returning, isolation and community, loneliness and friendship.

Act 8: The politics of everyday
20 May, 1.30–4.30pm

Petra Bauer and Sofia Wiberg led the eighth act. We turned our attention to how everyday acts and feelings can be connected to the theme of housing, and how we could understand them in relation to one another's different experiences. For one day, each member of the group recorded their daily activities, which we then shared with one another during the act.

Rehearsals: Protocol

**31 October 2013–27 May 2014,
Tensta konsthall, Stockholm**

Rehearsals consisted of eight attempts to use the act of listening as a political approach. Whilst 'Protocol' gives a voice to the initiators of the project, Petra Bauer and Sofia Wiberg, it is to be noted that the 'we' employed in 'Protocol' often implies perspectives beyond our positions as individuals. We also acknowledge that the other participants have different experiences and perceptions of the acts than the authors do and other stories of *Rehearsals* will be published in the future.

1. Initially, there were a number of questions: How can we create a collective act of listening among people who do not share the same experiences? Can we listen to each other without creating a common understanding? Can we create relationships of solidarity between people by listening to stories, experiences, feelings and perceptions that we ourselves do not necessarily have?

2. After contacting a number of people who were interested in experimenting with the conditions of political conversations, a group of 30 participants was formed, which brought together diverse positions, experiences and interests.[2] We came from different places, spoke different languages, had different opinions and were in different stages in life. Many did not know each other, and since our lives were organised so differently, it is unlikely the group would have met without the context of this project.

3. For about a year, we had been collaborating with Tensta-Hjulsta Women's Centre (KITH),[3] a meeting place where women can share experiences, learn Arabic, English and Swedish, cook, and support each other. The Women's Centre can be described as an everyday community for women.[4] In collaboration with the centre and architect Filippa Stålhane, we constructed a room at Tensta konsthall with tables, lamps, curtains and a rug, and provided slippers for visitors to wear on entry. Everything was mobile, allowing for different spatial configurations depending on the requirements of each act. Sometimes the room was completely empty; sometimes there were only chairs, and at other times there were tables, papers and pens. The room was shaped according to the wishes of the Women's Centre and how they would want a room for learning to look like and be organized. After the project, all the furniture was moved to the Women's Centre and refitted to furnish the designated room.

4. Our common desire was to see if we could create a space where we could engage in the act of mutual listening – meaning a process of collective participation and interaction – but which would take our different positions and experiences as a starting-point. By listening, we do not only refer to spoken words, but rather understand the term as including gestures, feelings, movements, silences and contradictions. In other words, we perceive 'listening' as a process of leaving established structures of knowledge production and dissemination, in order to pay attention to other possibilities and methods.

5. To Hannah Arendt (1958), a prerequisite for the political to come into being is that a measure of unpredictability exists. It is precisely in the space between what is and what might be that there exists the opportunity for new actions and changes of direction. If we attempt to control too much with the purpose of attaining predictable chains of events, we have in effect de-politicized the room and the relationships that may have been shaped through action (Arendt 1970). Put differently: if we learn to listen, we cannot decide in advance what we want to listen to. Listening encompasses unpredictability: to listen, to see, to experience, without making pre-conditioned judgments, interpretations, or analyses. We could say that the act of mutual listening directs us to that which we do not already know: to listen for the unexpected.

6. By creating situations in the acts that differed from how conversation is commonly conducted, we wanted to create a room where the interaction between participants was displaced in different ways:

in tempo, in which parts of our bodies we focused on, in how we spoke to one another, and in how we shared and created mutual experiences. Central to this was the creation of situations that contained a measure of unpredictability. It was here – the points when the choreography for us all changed – that we saw the potential for opening up to something new.

7. Cultural theorist Sara Ahmed (2006) describes the importance of 'getting lost' and losing one's way; it is only then that we are able to find new paths and choreographies. Queer pedagogue Kevin Kumashiro (2002) also emphasises the importance of daring to exist in uncertainty as a prerequisite for making change possible. It is only when one dares to reside in ambivalence and precariousness that one can become aware of one's own behaviour patterns. It is here that an opening up for understanding of previously hidden connections can occur, and new positions can be created (Meyer-Land, 2005). In other words, there is political potential in the uncomfortable – it is by remaining in it that our view of the world can be challenged and changes can be made.

8. Before each act, we had conversations with the invited facilitators in order to brief ourselves as organisers on the subsequent plan of activities. Even though this meant we had prior knowledge of the content of each act, we tried to let go of the desire to control the activity, i.e. to resist our roles as organisers: to not direct what would happen in the room, and thus allow the acts to be open for the unexpected and uncontrollable. We had to keep reminding each other about this challenge, since we were all too often propelled to control the act; to steer it into what we saw as the "right way", based on how we had imagined what would take place. By paying attention to how difficult it was to let go of this desire, we became aware of our own conditions and positions.

9. Each act implied a new situation, with a new set of terms and conditions. However, there were some recurring routines: before every act we sent out an email reminder to the participants, often with questions that we wanted them to consider before

we met. The participants were always invited to take their shoes off and put on white slippers when they entered the room, and it was important that everyone who came felt welcome and seen on arrival. During the act, coffee and a light lunch were served. The food was prepared by the Women's Centre in Tensta-Hjulsta, and the project budget paid for the food, which was free for all the participants. We always started the act with a gathering where everyone introduced themselves by name. We deliberately avoided participants' tendencies to introduce themselves in the context of their professional role, since we wanted to generate relationships that were built on other premises than our professional identities. Finally, we also asked participants to help with interpreting between Arabic, English, Turkish and Swedish.

10. Apart from these prescribed elements, we could not predict what would happen during the acts. Given the diverse experiences and knowledges within the group, there was not *one* habit or method we could fall back on, or utilise when we felt insecure or confused. The participants also interpreted instructions the facilitators of the act gave in different ways. Some felt comfortable, others did not; some felt they understood the purpose of the act, and others felt lost. The different approaches and interpretations generated frustration, but within this uncertainty was a constructive challenging of behaviours and default reactions in which relationships were examined and questioned. There were also instances where participants did not follow instructions despite repeated explanations. We experienced this, in part, as a disturbance; disorder in the structure we wanted to generate. But there was a double movement in this, as the unwillingness to obey formulated a resistance against the set conditions. The ungovernable can be seen as a counterforce to the effective and rational logic that often characterised our attempts of working. An approach in itself, constrained by the wish for much to be accomplished in the few hours we had together. Within this experience, some important questions were articulated: how can we deviate from learned frameworks, approaches, and strategies in working, and instead open up for diversity and unpredictabil-

ity? How can we create a situation where everyone's skills are valued equally?

11. In the beginning, it was evident that there were groups within the group. There was an *us* and *them*, although it was not articulated. Since some participants had more experience with our working methods than others, they began to speak *for* and *about* other participants, rather than reflecting on their own experience of the acts. After a few acts, this began to change. The caution, courtesy, and distance that existed between the participants in the beginning diminished, and more spontaneous interactions took place. We began to relate to each other from a disposition of curiosity rather than duty. Over time, we realised the group had produced common experiences. It materialised when we ate together, when we sat together, when we received common instructions, when we thought together, but also when we misunderstood and became frustrated together. We never aimed at coming to a point where we would share the same opinions, thoughts and feelings, have the same frames of reference, reach a common solution or even understand each other's different experiences. Rather, we were interested in the activities that took place *between* us in the room: how we as participants negotiated with one another, the room, and ourselves, and how this led to changes and shifts in the positions we tended to occupy.

12. During these eight acts, we became aware of the different conditions directing each of our lives. Only then did we fully realise the need to consider, in a very concrete manner, how we might be able to listen in different contexts, and we became convinced that we must continue to explore new common practices, possibly by doing things together. However, this requires hard work: it necessitates a shift in responsibility from marginalized voices to the conventions and practices that shape who and what can be heard (Dreher 2006).

Rehearsals: Reflections on Act 2.
What do we hear?

18 November, 10.00–13.30

The clock is about to strike ten and I position myself just inside the entrance to the room, feeling a bit nervous. Who will turn up? Who won't? Will I be able to let go of the desire for it to become a success? What would even be considered successful in this context? A large drape separates the room from the rest of the exhibition hall. Two people enter. I hug them and say hello. Ask them to take off their jackets. Tell them they can remove their shoes and help themselves to tea or coffee. More people enter. Petra and I take turns greeting them. We make sure every person gets our attention and that we show them how glad we are that they, specifically, are here. The room, which initially contained a large rug, a bookcase, a table and chairs, today holds only, except for the rug, a circle of chairs.

While the participants help themselves to coffee I hand out a paper with questions. For example: Do you host political meetings in your home? Do you greet your neighbours? Do you watch Swedish Idol on Fridays? Do you live far from the store? Do you like to lie in bed and listen to music? Has your rent gone up lately? I tell the participants to go around the room and pose these questions to one another. It is okay to just answer yes or no. At first, I don't have time to ask any questions myself, since I am busy greeting people as they arrive and making sure they know what to do. At 10:15 all thirty participants are present. They have taken off their coats and jackets and put on white slippers. People move about in the room. They don't stick only to people they know from before. Eventually I get to ask a woman a question. I ask her about her favourite room. The conversation is interesting. I like that the questions are fixed. It makes it easy to exchange experiences although many participants are unacquainted with one another. One group has sat down a little to the side. They are not participating in the question posing. I ponder whether to approach them and say something, but decide against it. Different rhythms must be allowed.

Petra asks the participants to take a seat on the chairs we have placed on the rug. We bring out the papers where we have written down what we are going to say word for word and hand them to the people who have been asked to translate. After the introduction we hand over to Ultra Red, who are hosting the act.

Chris, Sabrina and Elliot from Ultra Red ask people to introduce themselves. We have decided ahead of time that we are not going to present ourselves by profession. They tell us about their practice with calm and clear voices. About how the group is made up of a network of people residing in different countries. About having worked in many different places in different constellations and how they see listening as a political method for building up communities and enabling social and political change. That their focus is on how we, by becoming more aware of how we listen, can also make room for more perspectives and experiences.

They describe how the act will be organized. In collaboration with the Women's Centre, they have selected four places in Tensta that we will soon go out and visit. This will happen in the form of an audio walk, where we will be divided into three groups. The participants will remain silent throughout the walk, and focus on listening. The only exception is if a threatening situation should arise. Each participant will also be mindful of the others in the group and adapt their pace to other people's abilities. In each of the four places, the groups will stop for one minute, and record sound clips from that place. After this we will return to Tensta konsthall and share our experiences.

Despite everyone keeping the introductions brief, it takes a long time with all the pauses for translation. There is waiting. Repetition. I notice that I am not used to this slow pace. I start to look around at the participants; some of them look a bit dogged. Maybe a little bored? Is it taking too long? Do the participants feel that the slowness gives room for reflection or is it only time-consuming? I get a little bit stressed, while simultaneously liking that it isn't 'smooth'. The rhythm in the room goes against the rhythm that usually governs things, and can thus be seen as a strategy of opposition against an efficient and productive logic. As everything is being translated, we can only speak with short sentences. This means no one can hold long monologues and take up space through language, but that everyone needs to slow down. The set up simply won't allow anyone taking up too much space through words. My feeling is also that the changed rhythm

creates a sense of gentleness in the room; that we give one another time and space.

I start thinking about our introduction. Was it too impersonal? On the one hand there isn't that much we can say at this stage. It is a joint trial, and even Petra and I don't know where we will end up. But at the same time, perhaps we didn't emphasize enough how this project stems from frustration in our own experiences. How I worked as a process leader for citizens' dialogues for five years in different Swedish municipalities within the framework of planning processes. And how I during this work gradually became more and more critical to which experiences were given the opportunity to take place. How the dialogues were constructed in a way that enabled many people to speak, but where little was heard. The dialogues were rigged in a way where there was a preconceived expectation of what should be listened to. I brought papers with pre-formulated questions that I was to have answered within a short timeframe, which resulted in me cutting conversations, that had started in the room but did not fit my agenda, short. From these experiences my criticism of and frustration with these contexts that I was myself responsible for grew. Rehearsals was an attempt to change the terms. To create a stage where we could meet on other terms. Where we could shift focus from who is speaking to being more attentive to our own ways of listening, and what impact this shift in focus has on what is allowed to be heard.

It is time for the audio walk to begin. We have divided the participants into three groups of ten. But the group arrangements are a little unclear. For a while there is some confusion. Some people disappear to go to the bathroom. Do they know which group they belong to? Are we missing people? Will they be able to find their group on their own? There is no 'leader' in the group, no one to maintain order. At first I attempt to sort things out, but then I decide to let it go. Instead, I, too, go to the bathroom. When I return things seem structured and the first group has taken off. The groups are scheduled to leave at five-minute intervals so as not to get in the way of one another out there. I join the last group.

I notice that I find it both liberating and a bit uncomfortable to walk in silence with people I hardly know. I enjoy not having to think about what to talk about, but at the same time it causes a sense of

displacement or an inbetween space, or even a certain kind of gap. A gap of silence. I ponder whether this feeling of a 'gap' is palpable because we don't know one another or because we aren't allowed to speak. We stop at the first location. Stand still for one minute, recording sound. Then we start walking again. After a while the group starts to split up. I end up at the back, arm-in-arm with a woman who has difficulty walking. Despite the instructions to stick together, some people start to walk faster. We move from group to individuals. I am, however, still constantly aware of other people's presence and rhythm. I think about how much vision governs what we allow ourselves to hear, what we direct our listening towards. My visual impressions are much stronger than the audible ones. I see many things, people, buildings, gazes, clothes, asphalt… My focus wanders to the group. How are they? Are they bored? Are they cold? It is hard to know when everyone is walking around silently in their own world. I notice that I have to fight the urge to be the hostess and make everything nice and agreeable. This is the role I am so used to taking on when arranging citizens' dialogues. In this case it isn't even possible, since we're not allowed to speak, which is both good and frustrating. It is uncomfortable because it doesn't feel 'normal'. I can't act how I am used to acting in this role. It is good because it forces me to act differently. It forces me to make room for something else. I think that is exactly what it takes, constructing certain obstacles and structures to make room for other things, and how we simultaneously feel limited by those structures because we cannot be 'ourselves'. But what is this something else? I realize it frustrates me that I can't grasp what the 'something else' is. That I, when I try to let go of my normal way of doing things, get anxious and start filling the 'gap' with something new. I want instant gratification; I want to know what it is I am leaving room for. At the same time I realize that this is exactly the point of all this: to remain in the confusion without steering back towards 'the usual'. To stop myself from making the pace fit my rhythm and assuming responsibility for creating a 'nice' atmosphere (from my idea of what that is). Instead I try to pay attention to impressions that are already there to be seen and heard, but that I'm not open to if I am set on delivering my own messages and making things happen my way. It is difficult. I think it is a transfer of focus, which takes time and is uncomfortable. Perhaps

this is the reason some people started to walk faster?

The group is walking together again. I become aware of my own body. I am within and outside the group. The internal sounds, thoughts, heartbeats, my steps. Hair rustling. We move calmly and rhythmically, sort of quickly, with determination, and I start to pay attention to the group's movement and internal sounds. We pass by one another, walk side-by-side, walk behind one another, change places. I become more a part of the group again. A cold wind reaches us and I start freezing. I look at the time. We have now been to all four locations. Shouldn't we start to head back soon? We return to the centre of Tensta as one group body. When we approach the art centre the group body spreads out into individual bodies and it feels like a separation, as I climb the stairs at the entrance.

I enter quickly, realizing no one has assumed responsibility for getting lunch ready. Feeling the need to create that nice atmosphere. The familiar. Some people from the Women's Centre help me serve food, since they cooked it. It is pirogi, salad, cookies, coffee.

We sit down in our groups with a large sheet of paper in front of us. We start to jointly map what we have heard, and where. One person from Ultra Red is in each group. We translate between Swedish, English and Arabic. The pen changes hands. Everyone in the group speaks and writes, but I still sense a kind of hierarchy between those who speak both Swedish and English and those who only speak Swedish or Arabic.

When half an hour remains, four people get up and leave. One has a doctor's appointment and another needs to get home. The atmosphere in the room becomes unsettled. The joint concentration is disrupted. I wonder how to relate to this. I want to be able to allow and enjoy different rhythms. That coming and going is okay. But now, not being prepared for it, it bothers me. Is it possible to behave that way in this room? I look around and have a feeling more people are beginning to move restlessly. I decide not to make a big deal out of it, that I should let it be rather than try to compensate and lift the mood. That I can think about it structurally instead. Who in this room has the possibility to decide how to spend their time and be free when it suits them? We continue writing. We write down which places were dominated by female or male voices. Where we heard children.

We gather in the larger group again, in front of our sound mapping papers. We get to reflect on what we have done. Many described how the visual took over. Seeing much more than they heard. And also how the joint silence had been special, and brought on feelings, memories and thoughts. Not many had paid a lot of attention to external sounds. We keep translating, which again means that it isn't possible to speak in long sentences. Participants offer direct comments rather than interpretations. We don't engage in a theoretical discussion about what we were doing, but rather share reflections on the experience. I notice the changed pace again. People I know to generally speak a lot are quiet. While I feel as though their silence gives space to others I also wonder what causes it. Are they quiet because they have nothing to say or because they think they are here to listen to 'the others' in the group? Our attempt was never that some people should become better at listening to 'others', but rather to create a mutual form of listening – for us all to consider how we listen and what we listen to.

At 1:30 pm I intervene and inform the group that it is time to start wrapping up. This despite the fact that we have not managed to do everything we set out to do. Our plan was also to talk about alternative places for listening. While I think it had been good to do so, I feel that it is of greater importance to keep the set timeframe, in order to respect that we all have other commitments as well. Ultra Red instead offers a question for participants to take with them: Did what you heard during the audio walk meet your expectations? If not – what was different or unexpected?

Before Petra and I conclude the day's activities, we remind everyone that those who want to are welcome to write something in their logbooks that everyone had been given in the beginning. We say that it doesn't have to be long analyses; just a few words or sentences are enough to describe how they experienced the day. Or if you'd rather draw, that's fine, too

When everyone has left, Petra photographs the room. Then she and I and Nathalie clear up together.[5] We clean up food crumbs and vacuum. Put the furniture back in its original place. Place the logbooks in a pile.

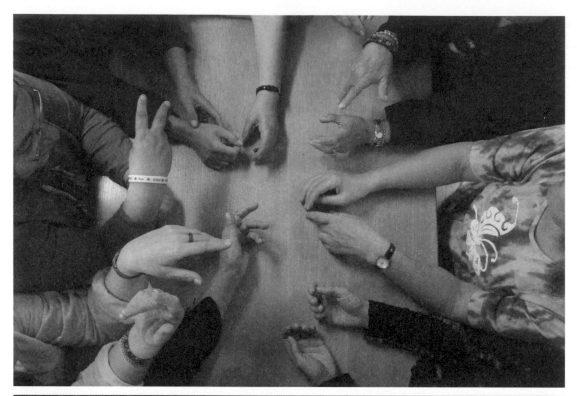

Fig 11.1. Rehearsals. Traces of Act 7 "Terrestrial Excursions", 29 April 2014, Tensta Konsthall
Fig 11.2. Rehearsals. Traces of Act 3 "Power, body and space", 12 December 2013, Tensta Konsthall

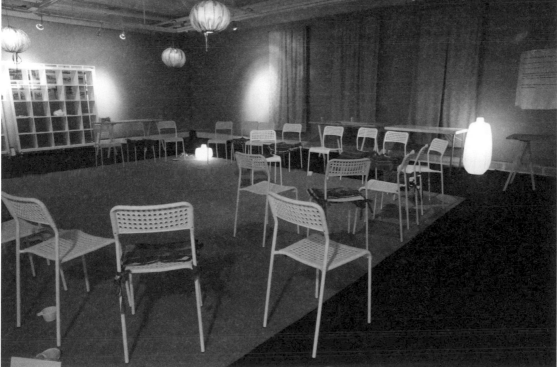

Fig 11.3. Rehearsals. Traces of Act 2 "What do we hear?", 18 November 2013. Tensta Konsthall.

Fig 11.4. Rehearsals. Traces of Act 6 "Everyday Communities", 18 March 2014, Tensta Konsthall

Rehearsals: Reflections from a participant

The last act in the first part of *Rehearsals* took place in May 2014. In June 2014, individual interviews with all thirty participants in the project were conducted.[6] Marius Dybwad Brandrud, who also participated in the project, conducted the interviews. Below is an excerpt from the conversation with Rebecka Thor, one of the participants in the project.

Marius Dybwad Brandrud (MDB): How would you describe *Rehearsals*? That is to say, what was it about for you?

Rebecka Thor (RT): In part, it was about what happens when a group of people who would otherwise never have met are brought together, and for a certain period of time meet regularly in the same room, which was unlike all other situations I'm usually a part of. But foremost, it was about participating in the so called *acts* – which were based on a number of rules formed by the act leaders that we had to comply to – with the purpose of creating situations through which questions were asked about what it means to listen. What does it mean to hear, what politics is at play? Is listening passive or active? Does it mean that an active way of listening is to ask questions? What do we do with what we hear, when we listen? Is the active way to somehow take responsibility for it, to act on it somehow? And if so, how? These are the questions that have stayed with me.

MDB: Before we talk about the acts and the listening, I want to know what you think about the room where the acts took place?

RT: It was a strange room, in many ways. The walls were pink and there were curtains in front of non-existing windows. There was a great number of identical chairs and identical tables, which were moved around, carpets on the floor and embroideries on the walls. When we entered the room we had to take our shoes off and put on slippers. The design of the room and the pink walls announced that it was not an institution, but also not a room in anyone's home. It wasn't a classroom either. The Tensta-Hjulsta Women's Centre had helped decorate the room, and in

a way it was similar to the environment at the centre, and yet not. In a sense, it was a non-existent room, a bubble within a bubble. When you were in the room you couldn't tell whether it was summer or winter, if it was light or dark outside. The room almost functioned as a sort of time capsule. Which was nice on the one hand, because it created an odd neutrality; we were all there on the same terms, because the room was unnatural to all of us. At the same time it was a room in an exhibition hall, where I personally feel at ease, while others might not. In other words, it was a room, which in an interesting way was a sort of in-between space; a room I can't place. An artificial environment, created specifically for this project. When the acts took place, the room was closed to other people, but at other times it was open to an art audience. Did that turn the room into an artwork? But it was empty then, and the absence do tell of something. So, to me the room was a bubble, which was also connected to the whole construction, the framework, the situation and the group. The room was perhaps the ultimate signifier for the construction that materialized in the physical shape of the room.

MDB: What did you feel when you entered the room?

RT: I think I felt a little lost, because it was a room I couldn't read or place. That meant I didn't know what to do with myself. It was a common occurrence when I, or someone else, entered the room, one would go straight to the table where fruit and coffee was set up. Not necessarily because I wanted fruit or coffee, but because it was a place that was easy to hang out at, where one knew what was expected of us. You would go over there, grab some grapes, or a cup of coffee, and then stand there with your cup. It was much easier than standing in the room where maybe some tables and chairs were placed, but one never quite knew if and where one could sit. In short, it wasn't entirely easy to get one's bearings in the room before the act started. On the other hand, we often received specific instructions on how to move in the room eventually, and then it became much more of a tool than anything else.

MDB: What did you feel when you left the room?

RT: I felt like I returned to reality or regular life, in a way. The acts became a different state, which was created in that room, and also existed solely in that room. In part I'm sure that is due to the fact that I rarely participate in something with such a vague purpose, meaning that it isn't meant to lead to a tangible result in the shape of a text, an artwork, a conference, or something like that. There was no clear goal; rather it was something that happened there and then. It has in some ways been hard to explain to outside parties what we were actually doing. In a certain sense it is like saying what happened in the room stayed in the room. Of course, we could talk about, and reflect on, what we had experienced on the way home on the subway, but it was still as if stepping out of the room created a distance to what we had just participated in. The conversations afterwards became something else, not necessarily connected to the shape and content of the act.

MDB: What did this lack of purpose entail for you?

RT: An openness. Since the acts, neither separately nor as a whole, needed to lead to anything – we didn't have to reach a conclusion or achieve a result – events could take place in a more open manner than if there had been a specific goal. Independent of what that goal had been, independent of whether it had been a film, an anthology, a project that was officially part of a research process, or even if we had known that interviews were to be conducted where we were all asked to reflect on the acts and our own parts in them. If I had known that from the start it had probably affected my way of acting in the acts. I had probably reflected much more on the acts while they were taking place. The purposelessness allowed for some type of relaxation or opportunity to be in the moment. It felt strange, since most of what one does is so extremely purpose-driven. I don't think there is any other situation where I can just completely exist in what is happening, without feeling like it has to amount to something. It provided me with a greater freedom to say something a bit rash, or to just be silent…

MDB: If you think back to the different acts, what is the first thing that comes to mind?

RT: The first thing that comes up is the act that was about making our different experiences visible, and what happened in the small group I was in.

MDB: What happened there?

RT: The act leader had divided all the participants into smaller groups and given each group a number of questions to discuss. Some of the questions were about our experiences of being a refugee, or living through a war, which some members of the group had concrete experiences of and could relate to, whereas part of the group had no way of relating whatsoever. In my group a woman briefly told her story about a very brutal flight. When she was finished she began to cry, then silently got up and walked away, and no one went after her. We were incapable of handling the situation that had occurred, which resulted in her story just sort of evaporating. It touched me, and I have thought about both what happened in our group, and also what it means to pose these questions; especially how they are posed, to whom, and by whom. I think this is the event that made the most lasting impression on me, and I'm still not quite sure of what it meant. I'm fully aware that the act leader's purpose with the questions was that we should reflect on how to re-evaluate different types of experiences of, for example, fleeing and experiences of war, and how we can see these experiences as an asset rather than a burden. But the consequence of the act, for me, was that I left with someone else's experience, or rather the account of someone else's experience, while she left in tears. She told the group that she had never spoken of her flight since she came to Sweden. But since she left so suddenly, no one had time to ask her how it affected her or how she was feeling about talking about it. This was problematic and uncomfortable.

One reason is that I am a person who often feels responsible, and in this specific situation I felt responsible for solving the situation in some way, but I couldn't and I didn't know what would have been the right way to do it. I wanted to salvage the social situation to make sure no one was hurt

and nothing went wrong. In our group there was one woman who kept asking the woman who told us about her flight questions, and I felt that I was trying to gloss over her questions and almost silence her to protect the other woman from them. I don't actually think that the woman with the questions was trying to push the other woman, but it was clear that we read the situation very differently. So in that particular woman's story it really felt like something was at stake concerning the terms of speech, and I did feel a certain responsibility for what we heard. There were actually other people in my group with experiences of fleeing, but they spoke of it in an entirely different way. I could, for example, tell of my own family's past and their flight, but it would be in an extremely distanced manner, since it happened two generations ago. For me, the situation raised questions like: how do we handle these types of experiences? Who tells about them, and who has the privilege of just listening? In which way can it be a privilege for me to hear a story that to someone else might be very difficult to tell? What do these two positions mean, and what kind of power structure do they include? But I also ask myself whether it is possible to move beyond this inequality, and if so, how? Can the relationship between speaker and listener be different? And this is in a way what the project, *Rehearsals*, wished to address.

An experience, which is maybe directly opposed to this, is the act that the Tensta-Hjulsta Women's Centre led, where we cooked food at the centre. In a way it was the least directed act, even though the dishes we were making were decided on in advance. There was a much greater sense of community, and the differences between us participants were least obvious. This, in turn, raised the question of how differences are created and how a sense of community can be achieved. Cooking is such a simple thing to do together, and the roles can be overturned in who has knowledge, who has power in a specific situation, and who knows what. It became clear since the act was not dependent on language skills and instead we realised that half the group was terrible at rolling dough.

I also really enjoyed an act that was about how we listen to each other's memories. The act was in three parts, one where two actors read a dialogue written by the act leader about Buddhist burial traditions and views on death. In the second part of the act we were divided into smaller groups and given the assignment to discuss certain issues concerning death, the belief in life after death, and how we relate to our dead. The actors walked around and listened in on our conversations, writing down and compiling fragments of what they heard. In the third part of the act, the actors staged these fragments in front of the whole group, and in that way our own words bounced back at us, but through the actors' bodies and interpretations. This time it felt like everyone in my group could relate to the questions and subjects on equal terms, because everyone had a relationship with death or someone who had died. We had very different experiences and opinions about death, and with that as a starting point we had a very lovely and serious discussion. For me, the act worked very well, with its three different parts, making up an interesting whole.

In my opinion, this act brought up the central question of the project in a constructive and productive way; that is to say, how listening can be a political act or action. This is a very central issue to me; meaning both who gets listened to and who speaks, but also what I hear in that speech. What is actually being said, and what is being said in terms of experience, inflection and emotion? Listening to someone else's story is close to exotification of the other person's story, but in this act it became a mutual conversation without exotification or hierarchies. The purpose shouldn't be to extinguish all differences, of course, or to reach as much similarity as possible, and in that sense what happened in the act concerned with experiences of fleeing had a certain value, in that it brought attention to differences. The question is rather how one gets past that difference, or whether it is possible to do so? If one doesn't, what does that mean? If we only point out that in this room there are vastly different conditions, positions of power and classes,

what happens then? If we conclude that there is privilege and there are those without privilege, and that there is suffering some have experienced which others cannot even imagine – what do we do with that? How do we create a situation where the person who has suffered does not always need to be the one telling and teaching the privileged person about their suffering? How can we rethink that power relation and those stories? How can we listen in a different way? While it is, of course, still important to hear those stories which are rarely told in Sweden. But I still think it is important to avoid a fixed positioning of the speaker and the listener and create a more equal exchange of listening.

MDB: You have related to some of your experiences of listening, but do you feel that you have learned anything new about the practices of listening, and, in that case, what?

RT: I have learned to pose the question what it means to listen as a political act. It is something I haven't considered closely before. Of course I have thought about it, based on some type of basic analysis of power; some people speak and take up space and have the ability to make their voices heard, for example through media and other places where stories are being told. But I haven't thought about it in this direct and concrete way, or in a situation where I was a participant. Many years ago I was involved in making a magazine, *SLUT,*[7] which really was about telling stories that, at the time, couldn't be told anywhere else or had no place anywhere else. But what happened here, in *Rehearsals*, was concerned with something very different; it was more about listening than about storytelling and where the difference between them actually lies. But, again, what is the distinction between hearing and listening? Does the difference lie in how we attend to what we hear? That is, when we act upon what we are hearing, is that when we are listening? Is there a responsibility for what we hear implicit in the act of listening?

2
We contacted people within our network: activists, artists, academics, and civil servants who, in different ways, were interested in exploring ways of conducting political dialogues with a focus on listening.

3
For more information about Tensta-Hjulsta Women's Centre: www.kvinnocentertensta-hjulsta.org

4
The term 'Vardagsgemenskap' translated as 'everyday community,' is based on the research of Lisa Kings' *Till det lokalas försvar: civilsamhället i den urbana periferin*, Lund: Arkiv, 2011.

5
Nathalie Gabrielsson was working as project assistant during *Rehearsals*.

6
The purposes of these interviews were many; we wanted to have access to the participants' experiences of the project to gain insight into the kinds of experiences it had created. Marius Dybwad Brandrud wanted to make a film with the project as its starting point, where the recorded interviews would play a significant role, Sofia would draw on the interview material in her doctoral thesis and finally, we also wanted to use the interview material in contexts such as this book. The interview questions were designed together by Petra Bauer, Sofia Wiberg and Marius Dybwad Brandrud.

7
SLUT was a Swedish feminist and postcolonial journal that was published from 2006 to 2008. *SLUT* engaged in cultural critique from an intersectional perspective and contained both analytical texts and personal stories. More info: sv.wikipedia.org/wiki/Slut_(tidskrift)

1
Rehearsals was also part of an exhibition, Tensta Museum, at Tensta konsthall (Tensta Art Centre), which took place between October 2013 and May 2014. For more information about Tensta konsthall: www.tenstakonsthall.se

PEDAGOGIES

FEMINIST EDUCATION AND FORUM THEATRE, A COLLECTIVE REHEARSAL FOR REALITY

NORA RÄTHZEL

Looking back over the last 40-odd years of my life, I have spent two thirds of that time in educational institutions, studying and teaching at universities. It was during the other 16 years outside academia that I was forced to find different forms of transmitting knowledge, as I was invited to 'coach' people on issues of racism and gender relations: people who were working in public sector administrations, in professional jobs, in churches, but also in universities and schools. One of the most successful methods I employed was Augusto Boal's 'Theatre of the Oppressed', especially the method of Forum Theatre. In the following text, I want to reflect upon its usefulness for a feminist understanding of education as a form of empowering the disempowered.

Re-reading Boal's work a few years ago, when my colleague David Uzzell and I began to think about alternative forms of environmental education (Räthzel and Uzzell, 2009), I was surprised to find concepts in Boal's early writings (1985) that I had learned in the feminist movement: consciousness raising, self-reflexivity, self-empowerment, horizontal collective action.

But there is something more in Boal's approach which I think can be useful for feminist educational practices: the way his method allows us to confront power. This may seem like a strange distinction to make, as challenging power has always been at the heart of the feminist movement. For instance, the three excellent and innovative contributions to this section all talk about ways to overcome power relations and hierarchies. However, the power relations and hierarchies addressed in feminist education are predominantly those 'within': within institutions and organizations, within science as a male-dominated field, or those between group members of an institution.

Perhaps the most powerful slogan of the so-called second-wave feminist movement has been 'the personal is political'. This can be and has been interpreted in a variety of ways. It can mean that personal issues have to be dealt with in the realm of the political as opposed to being seen as issues that should be solved between

individuals. It can also mean that what is perceived as personal is the result of political decisions and societal structures. Different interpretations call for different activities. If the personal is to be raised into the realm of the political, this means for instance campaigning for the right to choice, for legislation against marital rape, against the exploitation of the female body in media representations, etc. While all these campaigns are crucial and have brought about changes that have improved the lives of millions of women, they can be fought and – at least partially – won without referring to the broader system of societal relations of production, political relations, and relations to nature. If personal issues are seen as the result of political systems, they need to be solved by transforming these systems as well.

One of the main theorists to inform the practices that tackle everyday power relations is Michel Foucault. He redefined power as circulating: "Power must be analyzed as something that circulates… And not only do individuals circulate between its threads; they are always in a position of simultaneously undergoing and exercising this power" (Foucault, 1980:98). However, what is often overlooked is Foucault's emphasis that circulating power relations are related to and reproduce relations of domination: domination of power where the actors cannot be reversed, where one part of the 'power-couple' prevails and has to be overcome, not negotiated with (Foucault et al., 1994).

The question then becomes: how do we understand the link between everyday power networks and the broader relations of power which are sustained by these everyday relations? More precisely, how can we avoid reproducing relations of dominance while addressing everyday power relations? Burroughs draws attention to this problem in her chapter in this book section. I think Boal's Theatre of the Oppressed has something to offer in understanding the junction between everyday power relations and structures of dominance.

When I first used Forum Theatre, I was no stranger to the notion of self-empowerment. However, Boal's Forum Theatre does not only enable people to learn from the point of view of their own experiences, nor does it only presume that as human beings, we all have the capacity to understand theories and the societies we live in. Boal's Theatre of the Oppressed offers more than that: it implies action, the articulation of conflicts, and the search for solutions that can be implemented by the 'spect-actors' themselves:

Theatre is a representation and not a reproduction of social reality. Forum-Theatre presents a scene or a play that must necessarily show a situation of oppression that the Protagonist does not know how to fight against, and fails. The spect-actors are invited to replace this Protagonist, and act out – on stage and not from the audience – all possible solutions, ideas, strategies. The other actors improvize the reactions of their characters

facing each new intervention, so as to allow a sincere analysis of the real possibilities of using those suggestions in real life. All spect-actors have the same right to intervene and play their ideas. Forum-Theatre is a collective rehearsal for reality. (Buchleitner, 2010)

The emphasis here is on acting out and finding solutions. I'd like to illustrate the usefulness of the method by describing one instance in which I used it, during a seminar with employees in an office for cultural integration, part of the city council. The employees were a mixed group in terms of ethnicity, age, and gender. My task was to teach them about racism. What they expected was to learn what racism is, how it works and how to address it. But somewhere between the lines was also the hope that such a seminar would help them to work better together to fulfill their task of 'integrating' migrant communities into the host society. I started by asking what they thought the main problems in their work were; the answer was cultural differences within their working group. Gender relations, they replied, weren't a problem at all. Thus, I started with developing the notion of culture theoretically: how we are all immersed in and brought up within different cultures, and how this determines the ways in which we think and act, even when we're convinced that our thoughts and actions are the result of rational thinking. A heated discussion followed, with some arguing that we could liberate ourselves from the cultures we came from and act rationally, with others arguing the opposite. The discussion went on endlessly, with no tangible result. I sensed that there was a gender difference in the argumentation, and so I proposed that we take a break and try something else: all proponents of the 'rational decision' opinion would go and stand in one corner, with those supporting the 'cultural influence' opinion in the other. To everyone's surprise, all of the women stood in the 'cultural influence' corner, and all of the men stood in the 'rational decision' corner.[1] The groups were mixed in terms of ethnic background and generation.

This triggered a discussion about gender relations, specifically the ways in which men are brought up to be different from women across boundaries of national cultures. But more importantly, it also elicited a discussion about gender relations in their department: without prompting, the women started to criticize that the men always talked too much during meetings, were unable to listen, and tried to take the most interesting jobs for themselves. It's doubtful that this would have occurred if I had simply told them that one of the ways in which our thinking is influenced is through the fact that women and men are brought up differently, in all modern nation-states. So why did this simple movement of bodies in space have such a powerful effect? Why did it change the subject people wanted to talk about? Perhaps it was because nobody had tried to convince anybody of anything; instead, the movement of bodies created a reality, something that could be considered as a fact beyond individual belief. What remained to be done was to come to terms with this fact. This physical

demonstration of a difference between what men and women thought, irrespective of their age and ethnic background, was also powerful because it could not be attributed to anybody's 'false consciousness', 'misinterpretations' or 'being biased'. No specific person had voiced an opinion; the whole group had just demonstrated to themselves an issue they did not even know they shared – and likely would not have, if it had only been discussed.

This power of 'reality' (I write reality in quotation marks because we know that reality is always only experienced through our concepts and interpretations) is also what gives Forum Theatre its educational power, its capacity to create convincing knowledge. It is convincing because people produce it themselves, even in opposition to their own ideas and convictions, the things they think they know.

After the surprising outcome the movement of bodies had produced, everyone was much more tuned into doing a Forum Theatre exercise than before, when some of the more knowledge-oriented participants had been quite suspicious of 'playing around', instead of having solid lectures about real knowledge.

After explaining the method, I asked the participants to think of a conflict at their workplace which they wanted to resolve. Feeling much more free to articulate work-related issues, many were able to contribute a story. We created four groups who played out a particular situation. While one group was performing, the others would be the spect-actors, who could change places with one of the actors in order to try to resolve the conflict. However, during the first group's performance, it became apparent that with each change of places, the conflict worsened. At times there was such a level of anger that I feared the situation would get out of hand. After several rounds, I stopped the performance and suggested that we proceed to the next group and to come back to the first one later. But the same thing happened with every group. At the end of the day, everybody was devastated – including me. I had been paid to help these civil servants to solve their problems, but I had only succeeded in making them worse. Aggressions had surfaced that the participants had never experienced at their workplace before. The fact that they were 'only acting' had opened the door for people to complain about each other in a way they would never have dared to do in their usual working relationships. No solution was found for any of the conflicts. I conveyed Boal's message that it was not a problem if no resolution could be reached; we had tried, and that was the main objective, to go through the process. Nobody was really convinced by this soothing message, including myself. I ended the session by pointing out that we still had half a day left tomorrow, and that I was absolutely sure that we would be able to find solutions during the remaining time.

And miraculously, the next day each group re-enacted their conflict with a solution that satisfied everyone: the people who had experienced the conflict, as well as the spect-actors. I don't know if people had sat together in a pub afterwards and thought

things through or if they just thought about it personally at their homes.

I'll use the example of one conflict and its solution to demonstrate how the method enabled a specific understanding of the conflict, which then also enabled its solution. A woman and a man, the first with an immigrant background and the second without, worked in the same office space on the same task. The male colleague complained that the woman was never in the office, that she was always off socializing with people from her immigrant community during working hours instead, pretending that this fell under her job assignment of developing networks with the community and listening to their needs. In turn, the woman complained that her colleague kept griping that he had so much work, working even during the evenings, when in fact this 'work' amounted to attending parties with prominent politicians, eating and drinking.

On the second day, the conflict was resolved in the following way: the woman promised to take her colleague into her community, so he could talk to people, listen to their needs, and experience their ways of life, while the man would take her to the 'parties' so that she could speak to the politicians herself, and experience that politics are indeed made in these kinds of settings. The ease with which this simple solution was reached caused us all to wonder why it had not been possible to do so right away. We began to analyze the situation in terms of the power relations that were represented in the daily conflicts of the two protagonists, but did not have their origin there. It became possible to talk about ethnic and gender relations in society at large, about the images of the 'Other' lying at the bottom of the man's suspicion about what his colleague was doing out there in her community, about the feelings and realities of exclusion that fueled her suspicion about her colleague's work with powerful politicians. We discussed that they had occupied precisely those power vs. powerless positions that society had assigned to them, not only in terms of their ethnicity, but also in terms of their gender. We also discussed that the solution that seemed so simple would perhaps not turn out to be so easy in practice. Anxieties, images of the 'Other', exclusionary practices – in short, societal power relations as they are reproduced in daily personal encounters – are not easily overcome by just getting to know each other.

However, what was appreciated by all participants was that a dynamism of mutual recognition of each other's position as well as a process of self-reflection had been initiated that might enable all employees to approach not only their problems at work, but also the problems they faced within their daily job of 'integration,' in a more productive manner. They could begin to avoid individualizing conflicts: instead of explaining them on the basis of individual traits (she is lazy, he loves parties), they could trace their conflicts back to the societal and institutional contexts (after all, they were working in a state office) within which they had been brought up and were acting.

There are a number of ways in which Forum Theatre facilitated this connection

between everyday power relations and societal structures of domination. First, playing theatre provided emotional freedom, and allowed people to express views they would not have dared to express in an ordinary discussion. Similarly, while these expressions at times produced anxiety, they were not as destructive as they would have been outside of a 'play,' because they did not have to be taken seriously (see Burroughs in this section). Second, the seriousness of the play was equally important, and manifested itself in the inability to create an imaginary solution. Nobody who replaced an actor succeeded in finding a solution that attained consensus, because the other actors would act as the 'reality principle' and prevent that solution from materializing. That is why this method can be described (as Boal did) as a collective rehearsal for reality, the emphasis being on collective and reality. Third, the fact that different people – different members of the collective – did not succeed in finding a solution during the first round took the 'blame' away from specific individuals, and opened the door for discussing the external origins of the conflict, i.e. the societal and institutional context within which the conflict between a few people in a small office could be understood. Forum Theatre sets knowledge free through bodily practices (including the brain) that go beyond mere personal opinions: for instance, the de-individualization of conflicts; the existence of prejudices even when people think they are free of them; the recognition of conflicts and tensions that are difficult to articulate. This knowledge creation, undertaken by the participants themselves, generates the desire for more knowledge, for broader contexts and broader visions. This is where the 'teacher' comes in, and where I departed from the strict Forum Theatre method. Spect-actors and the teacher know different things: the former know their contexts and the difficulties of their daily working life as well as the societies they live in and come from, and the latter know theories that can hopefully provide an explanation for these contexts and provide a framework for future learning and solution-finding. The Boal method can thus complement feminist education practices by providing the possibility to connect internal power relations with relations of dominance in society at large, and practical knowledge with theoretical knowledge, which are both equally indispensable.

1
It was remarkable that the gender division was so distinct, which
helped trigger discussion about that very subject.

12

ARCHITECTURAL FLIRTATIONS, FORMERLY KNOWN AS CRITIQUE

DETHRONING THE SERIOUS TO CLEAR GROUND FOR GENEROUS ARCHITECTURAL CONVERSA-TIONS

BRADY BURROUGHS

In this chapter, I aim to briefly describe and position the key concepts that form the central idea of my recently published dissertation *Architectural Flirtations: A Love Storey*. I explore the terms *architectural*, *flirtations* and *critique*, in relation to ideas about architects and their formation, staked out by architect and theorist, Dana Cuff in her chapter "The Making of an Architect" from 1991.[1] Cuff writes: "The ethos of a profession is born in schools."[2] For me, It's obvious that the effects are lasting! Although written almost 25 years ago, around the time of my own design education, I am struck by the degree to which my masters architecture students still recognize elements of their own education in Cuff's text when reading it together in March 2014.[3] In revisiting the central aspects that contribute to making a culture of architects, what Cuff describes as *enculturation*, "…a process that transforms layperson into architect through the knowledge, experience, and authority gained over the course of a career," with a specific focus on education, I propose an intentional and continuous displacing of what I call *the center*.[4] This strategy, what I call *architectural flirtations*, involves *clearing ground* for more ethical, socially conscious, and generous architectural conversations.

Architectural

Why do I insist on using the word *architectural*? Situated within what feminist, art and architectural theorist Jane Rendell describes, in "Critical Spatial Practices: Setting Out a Feminist Approach to some Modes and what Matters in Architecture," as one of the five thematics of current feminist critical spatial practices – *performativity*, my work is most often a joining of (queer) feminist, literary and architectural disciplines within a theatrical guise, "to explore the 'position' of the writer through the spatial and *material* qualities of the text."[5] I write stories as an architect, about architects, within and around architecture, inspired by architectural encounters and phenomena. At times, I would even claim that I write architecturally, but it is absolutely a creative and an interdisciplinary endeavor. According to Cuff: "Becoming an architect is about becoming an artist, but a peculiar kind of artist who stays within *certain boundaries*… The process of becoming an architect

is one of learning *socially appropriate avenues* for creativity."[6]

I understand Cuff's intention of evoking the figure of *the artist* as an example of an autonomous individual, in order to emphasize the incongruity of architecture's strong identification with and lingering myth of the lone creative (male) genius, in relation to the collective teams necessary to do the actual work. She points to an unresolved conflict between a perceived freedom in the process of design and the more constraining practical aspects of business associated with professional practice.[7] Cuff admits that even most art practices must resolve these very same conflicting roles she is referring to, but states that she uses a *stereotypical artist* in order to get at the way most architects are fostered to see themselves primarily as the *architect-artist*, rather than identifying with their managerial or collaborative roles.[8] Jane Rendell, on the other hand, describes a more complex understanding of artistic practice and collaboration, and focuses specifically on interdisciplinary work that offers "a critical feminist alternative to conventional architectural practice."[9] Nonetheless, could it be these *certain boundaries* and *socially appropriate avenues* necessary in becoming an architect and mentioned by Cuff, designating the limitations of the discipline, that Rendell finds constricting in her desire to expand the field through the use of the term *critical spatial practice*, leaving the term *architectural* behind?

While I empathize and agree with Rendell's call for a more interdisciplinary perspective and expansion of the field of architecture, I wonder if there might be another way to approach the disciplinary limits of architecture, or its *certain boundaries* and *socially appropriate avenues*? My concern is that in giving up the term *architectural*, work done under the epithet *spatial* may be relegated to the margins, leaving the bastion of architecture located firmly at *the center*, unchanged. Since the word *architectural* is directly associated to the discipline I intend to affect, Architecture – with a capital A (to signify a self-perpetuating patriarchal discipline and canonical culture that is in need of change), and because I recognize this inherent association with power, I choose strategically to call any and everything I

do *architectural*. In the conclusion of her text on critical spatial practices, Jane Rendell stresses the continued importance in making explicit references to feminism in order not to "partake in the act of obscuring feminism's political imperative" in an attempt to find "less oppositional ways of being feminist".[10] In a similar manner, I would suggest that "contemporary feminist practitioners interested in architecture" cannot afford to give up the term *architectural*, if the intention is to change it.[11]

Flirtations

Beyond the matter of terminology, I address *serious* issues, specific but perhaps not exclusive, to the architectural discipline and culture (within educational institutions) through *architectural flirtations*. My work focuses primarily on the education and formation of young architects through pedagogical practices that touch upon different areas within the architectural discipline, such as research, pedagogy and professional practice. The term is an adaptation of historian and performance/queer theorist Gavin Butt's notion of *scholarly flirtations*.[12] Both *architectural-* and *scholarly flirtations* seek ways to challenge the seriousness of traditional forms of critical writing through playful experimentation, without worrying so much about possible failure or outcomes; however, *architectural flirtations* extend the scope to include not only critical writing, but also architectural design and pedagogical forms of design education. In the development of queer Campy practices or a mode of working, my aim is to question and find new ways of approaching the habits of an architectural culture, specifically those of criticism and critique within that culture.

Architectural- and *Scholarly flirtations* are similar in their intent to undermine the reproduction of power within *serious* or traditional subjects, and/or approaches to these subjects, through an act of queer scholarship that is purposefully improper and contingent. However, while Butt's *scholarly flirtations* remain concentrated on the study *of* contemporary art and performance, I see possibilities in the flirtatious performative act itself as a mode of *doing*, applicable to the field of architectural design and pedagogy and pertinent to the self-critique of

critical research within the field. More specifically, Butt is interested in the possible knowledge production of these flirtatious experiences and the (other) ways this knowledge may be recounted, while I am perhaps more concerned with what the actual space of contingency can offer, in the very moment this knowledge is being produced. In the performatvie mode, the difference is between talking *about* something or actually *doing* it. It is my attempt to take *seriously*, and develop, the line of questioning Gavin Butt initiates.

In reference to a quotation from psychotherapist and essayist Adam Phillips' book *On Flirtation*, Gavin Butt reminds us: "The fact that people tend to flirt only with serious things – madness, disaster, other people – and the fact that flirting is a pleasure, makes it a relationship, a way of doing things, worth considering."[13] I am interested in this *way of doing things* that contributes to the formation of an architectural discipline in general, but more specifically, in the practices that aim to produce specific architectural cultures. Cuff writes: "…the metamorphosis from layperson to architect tells us much about how the architectural profession sees itself. As a group teaches its prospective members how to belong, the observer grasps the important traits of the culture."[14] The status of culture implies that the "correct" *way of doing things* has become established, hence deemed professional or *serious*, and therefore rarely questioned or even noticed, as a habit from a certain time and place. It occupies *the center*, and its influence extends to all aspects of the culture it represents. These aspects, in turn, assume the habits or norms of a larger culture, according to prevailing social systems and hierarchies of power. Cuff argues: "It is my contention that the social context of a work of architecture is at least as influential as the properties of building materials or the building site."[15] How might *architectural flirtations* provide a re-orientation or displacement of this *center*, and suggest other *ways of doing things*?

In her experimental essay "Notes on 'Camp'" in note form, with the intention of exploring the Camp *sensibility*, cultural-political critic and author Susan Sontag writes: "The whole point of Camp is to dethrone the serious. Camp is playful, anti-serious. More precisely, Camp involves a new, more complex relation to 'the serious.' One can be serious about the frivolous, frivolous about the serious."[16] Gavin Butt suggests that Sontag's text can be seen as a "staging of a provisionality," as if she will at a later stage write a more *serious* scholarly article.[17] Sontag performs the indeterminable quality of Camp- its reluctance to be pinned down or defined in its tension between the serious and the frivolous, by making a list. By refusing the temptation to put forth a full-fledged idea, she retains the tentativeness in a list of points, giving the sense of incompleteness, as if they may be revised, deleted or even added to. It indicates that the statement may perhaps not be taken at face value. There's something else going on here! Immediately, as Butt suggests, the question arises: Should I take this *seriously*, or not? In this way, "Notes on 'Camp'" performs an act of flirtatious writing. I am interested in both the performative flirtatious act, as well as the flirtational intention to shift or re-orientate the habits of a culture, in order to find *a more complex relation to "the serious."*[18]

The strength of other important queer-feminist performative work, such as that of my colleagues Katarina Bonnevier, Thérèse Kristiansson and Mariana Alves, of the Stockholm-based art and architecture collective MYCKET, most directly inspires and influences me as a clear example of shifting the rules of engagement and challenging *the serious* within architectural practice, as well as in architectural scholarship.[19] They make rooms of love (and sex), safe spaces, or what Katarina Bonnevier sometimes refers to as the *kindly disposed room*, most often for and with groups located outside of what is usually considered *the center*. In her account of current feminist spatial practices, Jane Rendell notes the rise of interdisciplinary and practice-led research, where the tendency of contemporary feminist practitioners "…highlights an interest not only in the end product, but in the process of designing itself, pointing to the importance of the dialogue between theory and practice in architecture."[20] This interest in the performative act of research, and the desire to combine practice and theory, is something MYCKET and I share; however, I also see an important distinction between our work, in both the intention and the way change is brought about.

MYCKET's work is direct, it's *in-your-face*, and it

aims (and usually manages) to create temporary utopias or places that allow and encourage other ways of being in the world. One specific example is their Club Scene events, where they reconstruct and reenact historical queer clubs from around the world, experimenting with performance through spaces, scenography, costumes, and bodies. The recurring usage of slogans like "Every Time We Fuck We Win" or "An Army of Lovers Cannot Lose," phrases borrowed from *The Queer Nation Manifesto* and used by MYCKET as both posters and "guerrilla" flyers in several of these events, is one detail that speaks of the very clear urgency in their work.[21] It's voracious, there's an appetite for victory and there are no apologies! MYCKET's work makes space, and although there may be some flirtation involved, I'm not certain that it is ultimately *about* the flirt. Rather, I would suggest that it is closer to seduction, as there is a clear desire for resolve or a "consummation" of the original intention, in order to achieve these utopian places, even if the result is fleeting. To put it in a historical perspective, this work resembles the directness of the post-Stonewall tactics of many queer activist groups, rather than a more subtle, coded, pre-Stonewall campiness that lends itself to flirtation.[22]

Architectural flirtations, on the other hand, make space within acts of anticipation and contingency, regardless of the outcome. In contrast to a more confrontational, *in-your-face* approach, the flirt engages in a playful displacement of *the center*, pulling and pushing it around like the lead in an enticing dance, eventually dissolving the defining edges of *the center* to expand what *the center* might include, or moving them over to make room for new centers.[23] In this way, the space it makes is less defined and more like *clearing ground*. In an article on queering phenomenology, Sara Ahmed describes a similar act of *clearing ground* as she proposes that "…orientation is a matter of how we reside or how we clear space that is familiar."[24] "Orientations are about the directions we take that put some things and not others in our reach."[25] Ahmed borrows a term from queer-feminist literary theorist Teresa de Lauretis, *habit-change*, to describe the queer act of re-orientation in order to bring those things (and people) that were previously unavailable, in a

conventional geneaology, within reach.[26] It is this act of *re-orientating*, or *recentring*, brought about by the flirt that I pose as a possibility for instigating change in the habits of an architectural discipline and culture.

While there are strengths and weaknesses in both of these approaches, depending on the situation, I would suggest that flirtation is perhaps particularly applicable to pedagogical situations. One of its clear advantages is that, although it does make demands, it doesn't exclude what is already in *the center*. In other words, it's not only useful for the "queer kid" (or any position(s) that understands itself as being outside of *the center*) who is perhaps searching for a role model and a place to belong, but also seeks out the future architectural critic, already schooled in the culture of the architectural profession, who may have a direct affect on that very same "queer kid" in a pin-up. However, it is important to remember that the three previously mentioned spheres within an architectural culture or discipline; research, pedagogy, and the profession, each have their own *centers* or habits that are different and that at times may overlap or even displace each other, so *flirtations* must always be situated. Likewise, the position of *the flirt* is subject to the prevailing hierarchies at work within specific situations, so the possibility for and effectiveness of a *flirtation* is also dependent on the intersections of gender, race, sexuality, class… and any combination thereof. Therefore, *flirting* tactics are always uncertain and must be adjusted accordingly.

In her trilogy on teaching, feminist writer, theorist and activist bell hooks describes engaged pedagogical settings, not as so-called "safe spaces" where everyone agrees, but rather as spaces that "know how to cope in situations of risk."[27] And yes, flirtation *is* risky, in its inherent vulnerability in not knowing how things might turn out, as *the center* is always slippery and reluctant to give up its privileges. Butt notes: "Flirtation may be deemed 'weak' by dint of its pleasurable embrace of uncertainty and doubt."[28] However, in these particular instances, I would argue that the *in-your-face* approach is perhaps likely to trigger a complete shutting down-shutting out effect, creating even further distances between what is in *the center* and what is

not. Ahmed makes a similar observation regarding feminist killjoys, "…when you are filled with the content of disagreement, others do not hear the content of your disagreement."[29] In other words, a direct confrontational approach may be perceived as an "attack" and result in the immediate dismissal by those who most need to hear the message. To be clear, situations of *architectural flirtations* are not (only) about everyone having fun and getting along. They are about creating the situations where risk is possible. There's no lack of precision, but rather it is *precisely improper.*

Besides the risks of weakness or failure, there is another type of risk with flirtation, mentioned by Gavin Butt, in relation to gender. In reference to a quotation by sociologist and philosopher Georg Simmel he writes: "[Note: in the context of Simmel's patriarchal heterosexism, *all flirts are women*]."[30] Cuff discusses questions of gender in terms of what she calls *the competitive arena*, established in the three elements shared by most architectural programs, the studio, the crit and the charrette. She describes the "macho" qualities built-in to the charrette forms of working as *endurance tests* where students are expected to "temporarily sacrifice everything for the sake of their projects" and likens the architectural school to a *designer boot camp*.[31] Although students of all genders may (and do) participate in this *competitive arena*, there remain assumptions connected to gender marked situations, such as the masculinity of boot camp, that potentially place the flirt into a stereotypical gender role of the feminine, where the "weak" or uncertain tactics are perceived as inferior or second-rate. In other words, they can be easily dismissed as not being up to par for the demands of a tough and competitive environment. It is therefore important to stress the queer position of the flirt, where gender and desire are not linked in a simplistic binary structure and have *a more complex relation to the serious*. By complicating the gender-desire chain, while retaining the "weak" or uncertain character of the flirt, the reproduction of power is undermined and assumptions or habits around situations deemed *serious* acquire a Campyness, shifting the grunts and elbowing of a boot camp into the songs and choreography of a Broadway musical.

When the American business magazine *Forbes* asked one of my own *flirtatious* role models, former Star Trek actor, Broadway musical director and current LGBTQ activist/social media phenomenon, George Takei, about his approach that combines very serious struggles with what can be seen as frivolous Campy tactics, his answer struck a chord with me. "I think the serenity at the heart of the Buddhist philosophy has allowed me to combat injustice and inequality with a certain level of patient perspective. It's so necessary to engage those who would seek to oppress you, and to extend to them a hand in our common humanity. That's the philosophy I try to maintain on the Facebook page– with a few adorable and irresistible cat pictures, of course."[32] He extends his hand and invites *the center* up for a "dance," but maintains the lead by adding the flirtatious uncertainty of never really knowing what can be taken seriously (through his relentless use of bad puns and cute animal posts online). I would suggest that this particular "dance" doesn't resemble a sexy salsa or a sophisticated tango, rather it's a full-on parodic disco! As architectural critic and author Aaron Betsky writes in his book *Queer Space*: "The space of the disco was one of the most radical environments Western society has created in the last fifty years."[33]

In her "Notes on 'Camp'" Sontag writes: "Camp taste is a kind of love, love for human nature. It relishes, rather than judges, the little triumphs and awkward intensities of 'character.'"[34] It is this shift of ethos from judging to relishing that I am interested in. In her call for an *ethics of love*, bell hooks writes: "Cultures of domination rely on the cultivation of fear as a way to ensure obedience… When we choose to love we choose to move against fear – against alienation and separation. The choice to love is a choice to connect- to find ourselves in the other."[35] *Architectural flirtations* operate in a mode of generosity and connection, rather than the judgement and alienation of critique.

Critique

Pedagogy and practice meet most directly in situations of critique and evaluation. It is one of the central activities of architectural education

where students learn how to be critical through the discussion of their work, with teachers, peers and sometimes practicing architects as guests. These performative practices foster, promote and perpetuate an architectural culture and discipline, as students are educated and sent into practice, continue into academic positions, or even return as teaching faculty. In her chapter on the formation of architects, Cuff writes: "As the terminology indicates, crits are not two-way discussions: for the most part, students are the passive recipients of jurors' opinions. As a ritual, the crit teaches students that their work should be able to stand the test of harsh professional criticism, doled out by those with greater experience. It offers a model of professional behavior, implying that full-fledged architects hold positions that can be challenged only by other full-fledged architects (other jurors) and not by the public, other professionals or clients."[36]

In her work on architectural education, with a specific focus on the design jury, architectural academic Helena Webster provides an accurate and current account of this ritual of critique, mentioned by Cuff above. Webster agrees about the crit's centrality in the *acculturation* of students into architects and finds that the design jury's intention "to support student learning through a reflective dialogue" is for the most part rhetorical, while what it generally does is exact judgement over student work.[37] Through a Foucault-inspired ethnographic study of power in design juries from one British school of architecture, Webster suggests that the asymmetrical construction of power in design juries encourages students to adopt "surface tactics" to appeal to critics' tastes, deterring them from a deeper understanding and reflection over their work. She also notes that the critics perform critique differently according to the students' varying degrees of ability, where those that already possess "architectural identities" are met in more mutual terms, as colleagues, while those that are perceived as "weaker students" are often interrupted and/or dismissed. Webster's work points to many of the same issues and situations that I aim to address with *architectural flirtations*; however, as a leading Bourdieusian scholar within architectural theory, her critique centers on a class-based analysis of *cultural and social capital* as the primary factor in relations of power, leaving oppressive systems of gender, race and sexuality unexplored.[38] This is the point where *architectural flirtations* grab the baton and keep running!

In proposing a shift from critique to conversation, brought about by *architectural flirtations*, my intentions are two-fold:

First, to encourage situations of evaluation where the focus is on reciprocal learning, i.e. everyone involved can potentially learn something. I use the term *conversation*, rather than discussion, which often implies an underlying attempt to persuade through argumentation, as *conversation* evokes a less certain, more informal interaction, allowing flirtations to occur. These flirtatious interactions are a combination of discourse and practice between those involved, as both a discursive act and a way to be in dialogue through *doing*. The crucial part, for me, is the exchange, which requires a mutual acceptance of vulnerability. For instance, in writing or making, if I am *in conversation with* a reference, whether contemporary or historical, neither of us is left unchanged; whereas, a critique of this same reference, doesn't necessarily require any revision on my part. It simply proves a point! The former inhabits a "weak" or vulnerable position, allowing the *conversation with* to re-orientate previous assumptions, while the latter tends to maintain a "strong" position to secure an intended outcome. The same applies to a crit situation, between critic and student. In an *architectural flirtation*, both must be willing to temporarily occupy a "weak" or vulnerable position, where the destination of the conversation is unknown. It is a risky opportunity for generosity, rather than a power struggle. So, the "dance" of *architectural flirtation* is to be *in conversation with*.

And second, to problematize the concept of *critique* or *criticism* and flirt out assumptions perhaps overlooked in the critical architectural project, where I locate my own work. In other words, the fact that a project is critical does not preclude it from falling into habits, such as the practices of *critique* or *criticism,* habits that may undermine the very intentions of being critical in the first place. Butt suggests: "Flirtation might therefore be seen as model for practices of criticism – where it seems

necessary and germane – to decentre the paranoid structures of serious analysis, or indeed to re-inflect them with a flirtatious, and playful, form of knowing."[39] The "dance" of *architectural flirtation* is also *a way of knowing,* where knowledge is not a fixed or certain entity but rather something that is in continual transformation through situating, positioning, questioning, proposing, or… flirting.

Like a conversation, a flirt is dependent on the interaction of more than one part. It isn't a one-way relationship; otherwise the flirt begins to resemble a stalker, and the conversation an interrogation. In his argument for *scholarly flirtations* as a way to fulfil an *ethical imperative* "by transforming, or disrupting, the habitually sober performativity of critical writing," Gavin Butt refers to the work of queer literary theorist Eve Kosofsky Sedgwick and her claim that paranoia has become the standard mode of operation for critical theorists.[40] Sedgwick describes this paranoia as a strong theory, concerned with certainty and knowledge in the form of exposure, as it operates within a negative affective register (e.g. seriousness).[41] You could call it a kind of "critical auto-pilot." She explains that while paranoia may know some things very well, it may simply "[blot] out any sense of the possibility of alternative ways of understanding *or* things to understand."[42] Consider, for a moment, the architectural critic, or even the critical researcher, fostered within the culture of criticism described by Dana Cuff. What is the likelihood that *the critical* tends toward a similar mode of operation, where paranoia guards *the center* of a privileged position?

If *architectural flirtations* are to offer another *way of doing things* where *alternative ways of understanding* are not lost, it is important to point out that the proposed re-orientation or recentring of *the serious* does not preclude the presence of the critical. As Sedgwick notes "…to practice other than paranoid forms of knowing does *not*, in itself, entail a denial of the reality or gravity of enmity or oppression."[43] *Flirtations* complicate things for *the critical* that has fallen into habit, whether in an act of securing its own position or in routinely following practices that it has come to rely on. *Flirtations* take away certainty and open up for vulnerabilities. *Flirts* can take a very clear position, but don't take themselves so *seriously,*

so that this position cannot change. *Flirtations* are short-lived and committed to being uncommitted. *Flirtations* get in the way, functioning almost like critical killjoys, and likely for some, an irritation, as not everyone likes to "dance."

What would a generous architectural conversation look like, if we were to extend a hand to *the serious* culture of architecture and invite it up to a Campy dance in disco form? With one steel point placed precisely on the hip of curiosity, the other arm draws a sweeping arc towards imagination. The weight shifts, as the steel point now moves to rest on the other swaying hip of vulnerability, and the second arm swoops around in a deep curve toward empowerment and stretches upward into an exaggerated power pose.

In a (queer) feminist future, there is an(other) flirtatious architectural culture of conversations. An architectural scholarship that values playfulness, impropriety and uncertainty. An architectural education that encourages generosity, collaboration and exchange. An architectural profession that understands privilege, uses power ethically, and doesn't take itself so damn seriously!

Should YOU take this *seriously*, or not?

Architectural Flirtations in Images

Welcome and registration
The seminar was staged as an open performative event, where I invited everyone to attend an "Architectural Flirt Aid Course." Participants joined me in an afternoon workshop of instruction, practice, and certification in *architectural flirtation*, at a borrowed (and temporarily transformed) architectural office space in Stockholm.

Chocolate fountain centerpiece
Beyond the experimentation with form, language, and content in my own scholarly texts, I work to achieve a performative mode of research in the staging, presentation and conversation around the writing. Here, one such example of *architectural flirtations* and what I call my *queer Campy practices* from a PhD seminar on 28 May 2014.

Certificates
Both the Flirt Aid Kit and the "official" certificate participants receive at the end of the course are Campy, equally silly as they are serious, but the message they carry is not uncritical: Architecture is in critical condition and in dire need of Flirt Aid!

Flirt Aid Kits
Everyone received a white lab coat and a Flirt Aid Kit at the door and was asked to replace their outerwear with this course uniform, to quickly bring everyone into the scene.

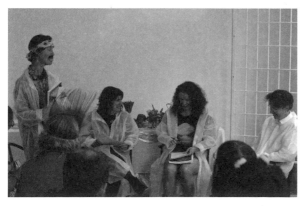

Supervisors, opponent, and PhD candidate
Shifting the roles of a typical research seminar to enact this fictional course, my role as PhD candidate shifted to head instructor, my academic advisors became training supervisors, my "opponent" performed as the special guest affiliate, while my former students and friends who helped guide those attending, became my Flirt Aid staff.

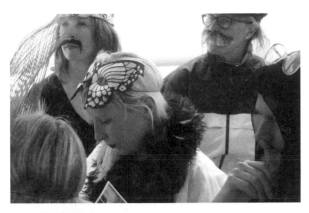

Close-up of seminar audience
To further involve my colleagues in the act of flirtation, I asked them to dress up as different characters that appear throughout my fictional stories, that make up my experimental writing practice, in the costumes I provided.

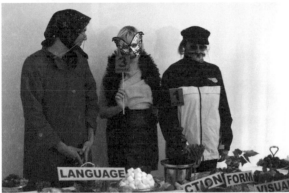

Meeting the characters and constructing the living diagram
The theatrical aspects of the seminar created situations where it was ok to play, even be silly, while still getting *serious* academic work done.

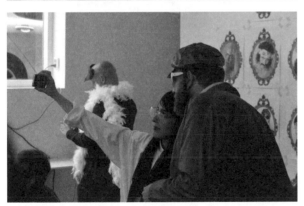

Selfie in exchanged costumes
Throughout the seminar, participants were encouraged to trade costumes at will and explore different positions. I was even surprised at how willing and playful these otherwise *serious* academics were.

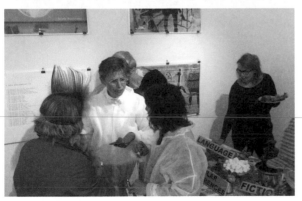

Intermission and exhibition
The brief intermission provided a space for participants to converse informally and to view the small exhibition of visual material, including self-portraits in costume, a manifesto, and early diagrams of the project.

Architectural office before
(photo: Brady Burroughs)
A *habit-change* can be as simple as changing the way a space is arranged, what's in that space, or how it is used. During each phase of the seminar, the room was slightly rearranged to accommodate the mode of activity; presentation, intermission, conversation.

Living diagram
In place of the typical slideshow presentation of my work, together we built a living diagram or a Campy version of the *tableau vivant*, around a copious, kitschy table of snacks and sweets, including the chocolate fountain centerpiece that filled the room with a distinct chocolate aroma.

Office during seminar
I would argue that *other ways of doing things* and *alternative ways of understanding* took place in this transformed architectural office, during the Flirt Aid Course.

Group conversation around the PhD work
At the end of the seminar, rather than opening up for general questions and comments, we made a round to give everyone a chance to say something.

Table of Flirtations: Once the diagram and presentation was complete, we then ate parts of it, as the table also provided refreshments during the short intermission. Again, this constant turning of things on their end, to allow a state of anticipation and uncertainty, helps to perpetuate the atmosphere where *the serious* is constantly countered with the question: "Should I take this *seriously*, or not?"

Special guest affiliate (a.k.a. opponent): My guest, Katie Lloyd Thomas from Newcastle University, played right along with me, giving accounts of her own relationship to flirtation, while the 4–5 written pages of comments I received afterwards had chocolate smudges on them- traces of the flirt.

Certification ceremony with bubbles Certification to practice Architectural Flirt Aid and a toast.

*All photos by Håkan Lindquist (unless otherwise indicated)

1

Cuff, Dana. 1991. "The Making of an Architect." In *Architecture: The Story of Practice*, Cambridge, Massachusetts: MIT Press, 109-154.

2

Ibid., 43.

3

My colleague Anders Bergström also makes the case for the continued relevance of Dana Cuff's text to the current state of architectural education. See Bergström, Anders. 2014. "Architecture And The Rise Of Practice In Education." In *Architectural Theory Review*, 19:1, 10–21.

4

Cuff (1991), 153.

5

Rendell, Jane. 2011. "Critical Spatial Practices: Setting Out a Feminist Approach to some Modes and what Matters in Architecture." In *Feminist Practices: Interdisciplinary Approaches to Women in Architecture*, edited by Lori Brown, Surrey, UK: Ashgate, 37.

6

Cuff (1991), 154.

7

Ibid., 11.

8

Ibid., 40.

9

Rendell (2011), 17–20.

10

Ibid., 39–40.

11

Ibid., 20.

12

Butt, Gavin. 2006. "Scholarly Flirtations." In *A.C.A.D.E.M.Y.*, eds. Angelika Nollert et al., Frankfurt am Main: Revolver Verlag, 187-192.

13

Butt (2006), 189, citing Phillips, Adam. 1994. *On Flirtation: Psychoanalytic Essays on the Uncommitted Life*, Cambridge, Massachusetts: Harvard University Press, xvii.

14

Cuff (1991), 111. I use Cuff's analysis of design education as a reference point to better define the type of pedagogy my work is relating to, a "dominant model," although I am aware that there are exceptions to more traditional pedagogical practices.

15

Ibid., 116.

16

Sontag, Susan. 1986 (1964) "Notes On 'Camp'." In *Against Interpretation*, New York : Anchor Books Doubleday, 288.

17

Butt (2006), 189–190.

18

Sontag 1986 (1964), 188. Thank you to my colleague Catharina Gabrielsson for raising the potential conflict in the use of Camp in work that aspires to question the status quo of architectural culture, with (neoliberal) capitalist-driven models for institutions of higher learning.

19

See mycket.org.

20

Rendell (2011), 20.

21

"The Queer Nation Manifesto" (anonymous) from the New York Gay Pride Day parade 1990. In *Queerfeministisk Agenda* (Queer Feminist Agenda) by Tiina Rosenberg, Atlas: Stockholm, 167-178.

22

The Stonewall uprisings were a series of three nights of violent clashes between the LGBT community and the New York city police, during raids of the Stonewall Inn, after the funeral of the long-time gay icon, Judy Garland. This is often credited as the event that sparked the fight for gay liberation and LGBT rights in the U.S. See Bergman, David. 1993. "Strategic Camp." In *Camp Grounds: Style and Homosexuality*, edited by David Bergman., Amherst: University of Massachusetts Press, 103.

23

Many thanks to Marie-Louise Richards for the conversation (over sushi and a beer in the sunshine) that helped clarify my own thinking around the similarities and differences between my work and MYCKET's!

24

Ahmed, Sara. 2006. "Orientations: Toward a Queer Phenomenology," 543–574. *GLO: A Journal Of Lesbian And Gay Studies*, 12:4, 554.

25

Ahmed (2006), 552.

26

Ibid., 564.

27

hooks, bell. 2010. *Teaching Critical Thinking: Practical Wisdom*, New York and London: Routledge, 87.

28

Butt (2006), 192.

29

Ahmed, Sara. 2014. *Willful Subjects*, Durham: Duke University Press, 154.

30

Butt (2006), 191. (my italics for emphasis)

31

Cuff (1991), 128.

32

Knapp, Alex. "How George Takei Conquered Facebook," *Forbes*, 23 March 2012. (www.forbes.com/sites/alexknapp/2012/03/23/how-george-takei-conquered-facebook/, accessed 28 April 2014)

33

Betsky, Aaron. 1997. *Queer Space: Architecture and Same-Sex Desire*, New York: William Morrow and Company, Inc., 160.

34

Sontag (1986), 291.

35

hooks, bell. 2000. *all about love: new visions*, New York: Harper Perennial, 93.

36

Cuff (1991), 126.

37

Webster, Helena. 2007. "The Analytics of Power: Re-presenting the Design Jury" 21–27. *JAE*, 60:3, 24. Webster's term acculturation can be considered synonymous with the term enculturation used previously by Dana Cuff.

38

Sociologist and philosopher Pierre Bourdieu proposed that in addition to economic capital, factors such as cultural and social capital also govern and determine an individual's chances of success in the world. However, although this analysis begins to take into account important social factors beyond purely economic ones, it fails to consider factors such as gender, race and sexuality by focusing mainly on aspects of class. See: Bourdieu, Pierre. 1986. "The forms of capital." In John G. Richardson *Handbook of Theory and Research for the Sociology of Education*, edited by John G. Richardson, New York: Greenwood, 241-258.

39

Butt (2006), 192.

40

Ibid., 189.

41

Sedgwick, Eve Kosofsky. 2003. "Paranoid Reading and Reparative Reading, or, You're So Paranoid, You Probably Think This Essay Is About You." In *Touching Feeling: Affect, Pedagogy, Performativity*, Durham: Duke University Press. 123–151.

42

Ibid., 131.

43

Ibid., 128.

13

FEMINIST PEDAGOGIES. MAKING TRANSVERSAL AND MUTUAL CONNECTIONS ACROSS DIFFERENCE

KIM TROGAL

This chapter explores what feminist pedagogy can bring to our understandings and construction of futures. Education is often seen as something that prepares the student for a task or role in the future, as a worker, as a professional, or more rarely, as a citizen. But as education is a *reproductive* activity, it concerns not simply the transfer of knowledge between generations, but the active *production of persons and relations* in the here and now. If we want different futures, we will need modes of education to produce them, modes that are open to alteration by those participating.

Feminist pedagogy has particular qualities when it comes to collective learning and how groups work and learn together. Whilst there are many things to say about the need for feminist pedagogy in making different futures, I will focus on some of the tools and approaches of pedagogy as forms of making and reproduction, rather than the subject matter it can be directed towards. In particular, I want to highlight the relevance that feminist pedagogy has for working with groups, and particularly how it might help create more inclusive, transversal and mutual relations.

One of the drivers for my inquiry comes from feminist political ecologists and feminist post colonial theorists, who have shown us that our notions of community are both anthropocentric and otherwise exclusive and hierarchical.[1] Similarly, other critiques have shown that as a reproductive activity, education re-creates social hierarchies and relations of class, race, gender and sexuality. Looking to feminist pedagogies however, there are examples that make different kinds of relations, which are not only less exclusive or hierarchical, but are transformative connections made in recognition of, and active engagement with, difference.

I will bring a few real life examples, two modest and one ambitious, to try to illustrate some aspects of this and to consider how pedagogy as a practice makes different futures in the here and now. The first is the action research projects of Masters students at the Sheffield School of Architecture, UK, which I taught. Following on from that is a small project I initiated with Anna Holder and Julia Udall, called "Elephant in the (class) room." Both projects aimed to raise questions around cultural difference in

peer-assisted learning in the school of architecture. The third, larger, project is a civic pedagogy network called "EcoNomadic School," which organises trans-local, mutual teaching around ecological skills. Through a discussion of these activities I will try to raise some questions around the ways feminist pedagogies can transform relations for feminist futures.

Transversality and Mutuality as Qualities of Feminist Pedagogy

Feminist and radical critiques of education on both the right and the left of the political spectrum, have highlighted the 'hidden curriculum.'[2] This consists of the lessons we learn tacitly in schools and classrooms, the norms and values which are conveyed, as well as the learning of behaviours, rules and relationships. This is what Raymond Williams once called the 'social content' of teaching, which he said is inseparable from its technical content.[3] This social content is part of education's reproductive process, reproducing values, beliefs and norms of a culture, reproducing its social and cultural hierarchies.

Feminist pedagogy, in my experiences of it at least, not only involves the creation of a different 'social content,' with different relationships and norms, but also *a different relationship to the future*. Like critical pedagogy, feminist pedagogies engage with the macro-political, but they also engage with the micro-political aspects of the class, in Janna Grahams' words, the "relational fabric and affective modes of conditioning."[4] They involve the embodied performance of different relations *in the here and now*. But what kinds of relations are performed? What kind of 'social content'? And by whose determination?

One of the best known feminist teachers is bell hooks, who writes of pedagogy as a process that enables and transforms 'habits of being' as well as ideas.[5] One of the habits of being she tries to create in the classroom is a democratic one. For her this involves making space for each and every unique voice in the class.[6] What she describes is not only a collective practice of knowledge construction through dialogue, but also a learning process that constitutes a democratic community or group. This process generates habits of listening and *valuing* other voices,

to seek them out and make space for them.

What is significant in feminist pedagogies is that they always seem to address the question of *who is in the room?* in the first instance. Examples of feminist pedagogy in art and architecture show that careful attention is paid to this question, too. In Suzanne Lacy's work, such as "the roof is on fire" and "CODE 33," she and a team created new contexts for dialogue between young people and members of police force. The project brought together not only young people and police, but also involved teachers, neighbourhood institutions and media.[7] Or, Martha Roslers' "If you lived here," a project that created a public forum for developing collective knowledge, which attempted to intervene in the intertwined process of gentrification and homelessness in New York. The project, through series of symposia, discussions, and exhibitions, gathered activists, neighbourhood associations, artists, photographers, policy makers, planners and academics. It aimed not only to address issues of the production of space in 'uneven development' but also to create a democratic social space through the process.[8] Another well-known example is The Women's School of Planning and Architecture (WSPA),[9] which was a residential summer school (1975–1981) run and financed by women for women. This too engaged participants of diverse ages, experiences and backgrounds, some were architects and planners, some were women active in their neighbourhoods, in local associations or towns' boards. The criteria for participating were not prior qualifications but *interest* in a field of environmental design.[10]

Across these three quite different projects and initiatives, each creates space for dialogue amongst diverse groups. They also demonstrate something of a 'transversal' approach in terms of their processes. Transversality is a psychoanalytic concept, coined and developed by Félix Guattari during his time at La Borde clinic. Working with an understanding that institutions contribute to the creation of certain kinds of subjectivity, Guattari developed this notion to help understand the otherwise closed logics that occur when structures and practices become entrenched.[11] In the psychiatric clinic roles and relations are highly structured, such as the doctor-patient relation or medical staff-service staff

relation. Guattari was asked to develop an "intra-hospital committee: the Patients Club,"[12] in which all staff, both medical and non-medical, participated. Together they undertook tasks that included not only medical work, but also many other activities of cooking cleaning, gardening, social activities and so on. This allowed people to work together on, say a menial task, where normally they would be working together in a clinical situation, with established hierarchies and procedures. As the organisation became more complex, Guattari introduced *la grille* (the grid), a double entry table with rotating times and tasks that engaged everyone there. As Genosko describes:

> [The grid was] the tabular representation upon which the evolving schedule of work rotation in which complex institutional inter-relations affected the psychical economies of actual groups and their members. Guattari set about experimenting with ways to heighten and max-imise institutions 'therapeutic coefficient' by unfixing rigid roles, thawing frozen hierarchies, opening hitherto closed blinkers and modifying the introjection of the local superegoisms and objects.[13]

By changing institutional positions, the roles and relations that had become sedimented in routines became open for redefinition *by those who were participating*. Following Guattari, transversality means opening up otherwise closed logics for re-invention, making new kinds of connections at different levels, and new kinds of subjectivity. As Guattari explains, transversal approaches are neither purely horizontal (e.g. only between patients) nor vertical (in the institutional hierarchies).[14] They do not remove or 'break down' hierarchies or authority, but rather open up possibilities to increase communication, empathy and possible capabilities.

In feminist theory and politics, transversality has been an important way of working with difference *and* equality, moving away from identity politics or assimilation approaches. According to Yuval-Davis, feminist approaches to transversal politics in the Italian autonomist tradition, emphasised two actions to engage constructively with difference. One is 'rooting,' understood as a reflexive understanding of one's own situatedness, and the second is 'shifting',

understood as a movement towards others who are different from the self. A difficult processes, in which these feminists tried to acknowledge the difficulties as well as the gains.[15] Transversality, in Guattari's sense, differs a little from related feminist concepts in epistemology such as 'mobile positioning'[16] and nomadism,[17] where the latter are potentially individual acts of epistemic and affective 'mobility' or shifting. Guattari's notion refers to *transversality in a group*, a quality present in feminist pedagogies. Most importantly, transversal approaches offer an opportunity for those involved *to alter those relations themselves*. It opens up collective agency.

The *Women's School of Planning and Architecture* for example, included not only a very mixed group of women, of diverse ages and experiences, but their aim was to establish a way of organising the school so that those participants could "influence and participate in the evolution and direction of the school."[18] The school had no lectures, but rather core courses were carried out in small groups and some were team-taught: "Emphasis was on the active participation of all members of the group, minimising the role of coordinators as experts or authorities and maximising our roles as information sources and organisers."[19]

As well as creating a participatory, more democratic group in class, they introduced administrative and organisational mechanisms, such as a large calendar of the two weeks, which was put on the wall. Participants could add to the calendar, scheduling events such as field trips, discussions, meetings etc. The calendar could be changed "without having to ask the 'person in charge.'"[20] There is no singular person in charge of events, but a means by which they can be collectively organised.

The *Women's School of Planning and Architecture* also initiated a work/study programme through which about one third of the participants were subsidized. Tuition was waived and in reciprocity, participants had to contribute to other tasks such as videotaping sessions, documenting and recording discussions, photographing events, operating the library or helping with childcare. One of the positive outcomes was that these forms of organisation *altered the composition of the group*, in terms of its hierarchies, dynamics and affective attachments.

Leslie Kanes Weisman, one of the cofounders and organisers, noted that the work/study programme "helped diminish the difference in roles and responsibilities between them (students) and us (organisers and teaching staff)."[21]

The WSPA's emphasis on the diminishing 'of the expert' and positions of authority raise difficult questions, too: how to create positions and roles where differences in knowledge are acknowledged and worked with to mutual benefit? It raises questions about the relation between authority and responsibility; do we need authority at certain moments? Can it be temporary, for instance, as in anarchist practices, where "there is no fixed and constant authority, but a continual exchange of mutual, temporary and, above all, voluntary authority and subordination."[22] In some anarchist cases, leadership or authority should be 'spontaneous,' a concept that Guattari for example would reject, as it can allow for unspoken hierarchies, desires, and egos to dominate. Whilst these questions remain unresolved, a valuable learning situation in the WSPA is not only what can be learnt 'formally' through participating in various tasks together, but also the enabling of changes in perspective to open new subjectivities and understandings. Equally, they create conditions in which questions of expertise and authority can be discussed and worked with.

This transversal approach to making groups or communities is a fundamental aspect of the 'social content' of feminist pedagogies, it is a tool and part of the process that is used irrespective of the topic or subject it is directed towards changing. Importantly, this approach recognises and builds mutuality in the class: *that each person has something to contribute and to teach*. I will consider three examples of feminist pedagogy that I have been involved in, and elaborate on attempts at supporting more transversal and mutual relations, qualities which take equality (we all have the capacity to learn and to teach) as their principle, yet works with difference rather than same-ness.

"Reflections on Architectural Education"

At the Sheffield School of Architecture, the postgraduate module "Reflections on Architectural Education" was co-created by Jeremy Till and Rosie Parnell, with the express aim of bringing a process of critical pedagogy to bear on the educational practices taking place at the school. The module involves readings and discussions around different modes of teaching, knowledge politics, and hierarchies, alongside students' active participation in teaching practice. The final assignment asks students, usually in groups, to design and carry out a piece of participative action research. This is conceived as a teaching innovation, in which they must work with other students (usually students in the undergraduate school) as their participants.

Through discussions, the module generally aims to open up education as a subject of knowledge and inquiry. Importantly, however, it aims to create more variable positions and roles in that students become teachers and researchers, and aims to make connections across the otherwise more stratified structure of the school and educational 'progression.'

In one of the years that I led the module, however, rather than focussing on postgraduate-undergraduate relations, we focussed on a different set of relations, namely relations across cultural differences between different groups of Masters students, specifically a divide that exists between international students and 'home' students from the UK.[23]

Alongside teaching formats common to many courses, like lectures and seminars, architectural education also employs problem-based inquiry and peer-assisted learning in studio-based teaching. In this setting, students must work through design problems through a variety of different tasks and techniques which, generally, involve learning through a process of doing. The archetypical studio in the architecture school context has its own particular culture and its own 'hidden curriculum.' As late as 1997 the feminist critique was one that highlighted the predominantly macho culture of the studio as a social space, its celebration of individual 'genius,' and a milieu that fostered competition amongst individuals.[24] Following feminist critiques, schools like Sheffield have developed collaborative modes of teaching,[25] with a high emphasis on peer-assisted learning. Whilst this might appear to be mutual teaching, it is not always feminist, or quite feminist yet.

As the sociologist Anne Querrien has written about compulsory schooling, not only do institutional structures reproduce societal structures, but they also *create* relations and feelings of competition and jealousy rather than cooperation, "where an atmosphere of cooperation would have pushed everyone upwards."[26] Peer assisted learning, to a certain extent, tries to 'push everyone upwards' through allowing students to learn from each other, but from a feminist perspective there is a problem. Peer assisted learning is defined as the "acquisition of knowledge and skill through *active helping and supporting among status equals or matched companions*" and peers are defined as being "close to each other in age, ability, status, ethnicity and other characteristics."[27] What happens, as is our case in the school of architecture, when the peer is 'other'? International students are, as a group, to varying extents 'othered' through negative stereotyping, exclusion or discrimination.

Whilst there is a general acknowledgement in the school that students have different backgrounds and differing pedagogical experiences, they are not actively sought out or understood. Some staff members are frustrated with others, in whom they find a lack of awareness and interest in the *political context* of where students come from problematic. Others express frustration around a 'hidden curriculum' that exists around implicit assumptions of 'right' ways of doing (concerning graphics and style, for example), and moreover what projects should address and what their values are. For reasons of both language and culture, international students are less vocal in discussions, with some members of staff informally observing that international students performed better when in their own, dedicated, studio group. When taught in group predominated by UK students, worryingly, their performance was not as good.

In the studio context, where peer-assisted learning is important both for students' individual achievement and more importantly, their overall wellbeing, we took these relations and dynamics as our primary concern and point of intervention. In the course, there were five white UK students, one international Asian student, and one white UK teacher (me), and together we discussed the stu-dents' experiences and how they had found working in mixed groups on different projects. In two groups, students then conducted action research, to explore some of the issues they raised and to test if specific modes or interventions can help us relate to one another differently, in less exclusionary, segregated, or judgemental ways.

One pair of students, Joanna Hansford and Abigail Cherry Watts were directly concerned with the idea of 'peer,' the importance of friendship and the impact that these informal networks in studio culture have on learning. Rather than making assumptions, or trying to solve any problems, Joanna and Abi wanted to open up questions with others. Joanna and Abi convened a group of ten students, two groups of friends, five UK students, five international students and set them two design challenges. For the first task, they asked groups to build the longest bridge they could, using only straws and tape. For the second task, they asked groups to use the same materials to build the tallest tower. For the first task, students worked in friendship groups, but in the second, the groups were mixed. Joanna and Abi then asked the students to reflect on differences in ways of working, and consider why the first session had been much more flowing, the second one slower and more formal.[28] Yet they found that when they tried to discuss it, the conversation turned to the task rather than relations. In her final assignment, Joanna wrote:

> During the reflection session the students found it hard to discuss the problems that formal differences, such as their cultural and language backgrounds, have on their learning experiences. They also found it hard to identify why they worked differently with their friends... As a result the students held a more general conversation about the design challenges rather than using the task as a tool for facilitating a deeper discussion.[29]

Joanna and Abi went on to conduct more in depth interviews with other students about cultural differences in learning experiences and started mapping the informal networks across the different programmes. They mapped connections between who was, for example, house sharing, who played football together, and other non-course-related ac-

tivities, and asked students to reflect on how these activities impacted on their learning and their experience of the course. From the interviews, Joanna reached the conclusion that student peer groups were growing narrower, and she highlighted the more subtle opportunities and chance conversations that happens through friendship. Joanna noted that these kinds of relations and opportunities, when students share housing, for example, "strengthened the image of who was considered a peer."[30]

As Jo Freeman wrote in "The Tyranny of Structurelessness," the structures that come with friendship are not neutral and don't come 'naturally.'[31] Joanna and Abi found that friendship is both bridge and boundary, creating barriers, but also creating opportunities. Joanna suggested that we (staff and students) need to create more opportunities through non-assessed work to allow for games of chance, for serendipity and to open up more possibilities for informal connections.

Another group, Liam Ashton, Nicola Dale, Lee Ling-Wei and Neil Michels decided to test the ways we might come to know each other better. They designed and tested 'speed dating' as a teaching tool for peer learning. Convening a group of ten students from across the different courses, they sat a mixed group of five students on one side of the table, and five on the other. After a certain time interval, they moved around the table, to begin their next 'date'. Each date was structured, with the group designing a series of prompts for participants to follow. These prompts were to allow participants to get to know one another and involved varying combinations of speech and drawing (usually aiming to reduce the emphasis on language). The questions they posed included: "draw your project in 1 minute," or "draw where you are from" or "what are your hobbies?"

When reflecting on the events with participants Liam, Nicola, Lee and Neil noted that home (UK) students placed very little value on social questions and learning about their peers in general. UK students associated learning purely with their own work. Whilst the effects of an event like this are difficult to measure, the group did note some changes. In discussions one international student said:

> I think it was helpful, but in the long term. You have some ideas about where he or her from [sic] and maybe you can become friends, so next time you might ask her or him personal questions about his project and you can learn more in the following days I think.[32]

In his assignment Neil wrote:

> Personal connections created between students did seem to break down barriers around what would be acceptable to ask each other in the future. The simple act of creating friendships and connections with peers does seem to aid peer learning. This can often be seen in groups within the school who have had shared 'bonding' experiences such as studio trips whom following the trip are closer and more likely to value each others judgements and knowledge.[33]

Overall, the module is an important yet modest *transversal* tool for the school in that it provides a space to direct attention to the ethics of relations within the school itself. The module helps students take active roles in investigating and reshaping these relations in more mutual ways, creating space for discussion, reflection and action not only amongst those participating directly, but those involved in the students' initiatives. Whilst the module helps open up new possibilities, some have been more lasting changes than others.

Within the course, we aimed to study and create the conditions for mutual teaching whilst working with difference. Whilst we managed to discuss some of the issues around cultural difference, discrimination and exclusion, there was a certain limit. Joanna and Neil both observed in the discussions they held with students, that the conversations quickly become task focussed, focussing for instance, on the efficacy of speed dating as method, or the design of the tower, rather than discussing the relational and ethical implications of working together. This was also the case in the group I taught, when I asked them to reflect on their experience of this project in terms of their own inter-cultural dynamics. In some ways, this is hardly surprising when trying to stay diplomatic to the person sitting next to us. Yet this experience highlights a need for more opportunities like these, in school and in life, as many of us are not equipped to deal with the issues of difference ethically.

The "Elephant in the classroom or the lice on the bald head"[34]

The "Elephant in the Room" is a project I initiated with friends and colleagues Anna Holder and Julia Udall in the School of Architecture at Sheffield. Following discussions we had together with students participating in the education module, we wanted to make an intervention alongside the student's activities, to make for a more equal group, reinforcing mutuality and lessening a distinction between staff and students.

Anna, Julia and myself were concerned that teaching methods rely on cultural understandings or assumptions, which are not always articulated. We felt that whilst an awareness of cultural barriers does exist within the school, they are often unspoken leaving problems unaddressed and preconceptions unchallenged. This is a situation that arises in many situations, and includes hierarchies of gender and class.

We worked with a group of Masters of Urban Design students, the majority of whom originate from East Asia. We organised two informal discussions a 'Working Lunch' and a subsequent 'Teatime discussion'. Both sessions aimed to encourage us all (staff and students) to reflect on our experiences of working with international groups, with our (staff) role simultaneously as both participants and facilitators in the dialogue. We drew out our experiences, literally, and wrote them on a large paper table-cloth to allow a collaborative form of record making across both sessions.

We used the title, Elephant in Room, to signify the presence of a large problem, which everyone can sense, but tries to ignore or avoid mentioning. One student we worked with told us of a similar idiom, used in some parts of China, "the lice on the bald head," something that is in plain sight but would be impolite to draw attention to. Our intention was to make a space in which one could draw attention (politely or otherwise) to different issues and experiences. 'The Elephant' became a tool to initiate conversation, we discussed, "what are the elephants," "whose elephant?" As a metaphor, or figure, it became a way to re-frame the way we thought about problems and our responses.

During the project, the name 'Elephant' drew the attention of other staff members as well as students. It became a focal point for informal discussions about international-domestic dynamics, where small opportunities to discuss issues arose in corridors, kitchens or on the tram. This was an unintended, but welcome effect and reminded us of the importance of language in enabling discussions.

Some of the issues students raised tended to focus on why international students participated less in group discussions. We talked about fears of speaking, of getting the language wrong, of making mistakes. One student spoke of (cultural) associations, between polarised conceptions of good and bad, where saying the wrong thing equated "to being a bad person." Others spoke of qualities of humility, of not questioning the teacher for fear of offending them, for example students did not want to inadvertently imply that the teacher had explained something badly. Often, students did not wish to speak in class, in order to avoid advancing their own ideas before others had the chance to; they wanted to avoid appearing arrogant.

Whilst language barriers were also discussed, (that it takes longer to process the conversation, and consequently you miss opportunities to speak) one student wrote on the table-cloth, that for them it was 60% language, but 40% confidence. Others referred to a 'group bubble' that happens during the teaching-learning process, with one student writing on the table 'be friends first.'

Towards the end of the second session, we asked students if they would be willing to make their own, visual, representations of the issues. The students had freedom to take this in any direction they chose; they might have developed an installation, posters or a performance. Shiwei Li, Yuejiao Wang, Jianyu Hu, Nicos K Taylor and Sharmeng Zhang chose to design and produce a kind of handbook, as a guide for others. Their idea was to produce something that could be distributed amongst other students to help raise discussion, or to help pass on the more implicit learning from their experiences on the Masters course. They used comic strip-like photos, illustrating different situations, and added thought bubbles as a literal way to make some unspoken fears visible.

The final part of the project was our (staff)

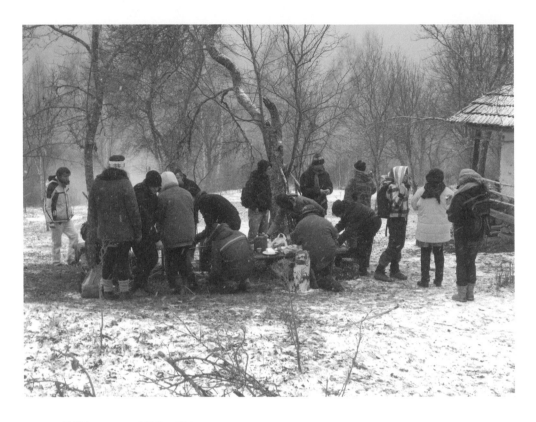

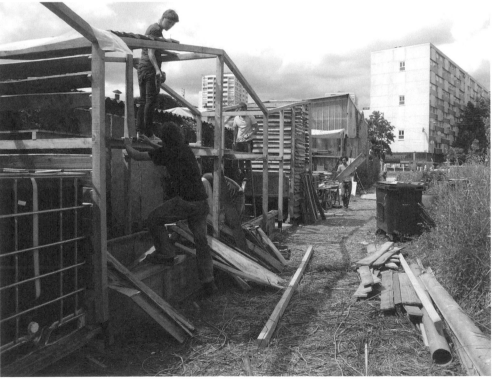

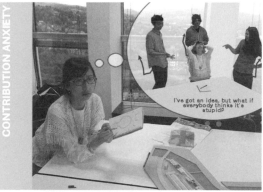

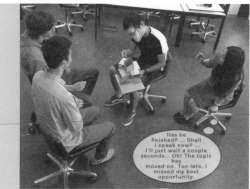

Fig 13.1 One of the workshops organised by FCDL in Brezoi, Romania, included a visit to the Odaie, traditional small holdings in the mountain, which used to supported subsistence lifestyles. Here Theo showed us how to make a quick mountainside lunch for 24 people!

Fig 13.2 'Chantier' at Agrocité, Colombes, Paris. During one of the workshops organised by aaa, the group worked on the ecological constraction of a building that housed composting toilets and composting facilities for the urban agriculture site.

Fig 13.3 Student booklet: Comic-strip images by the students. Image Credits: Shiwei Li, Yuejiao Wang, Jianyu Hu, Nicos K Taylor and Sharmeng Zhang

interpretation and representation of the project, which took the form of a small booklet in which we tried to name the elephants we, and the students, had encountered.

As young members of staff, we were perhaps naïve about the level of discussion we could facilitate around a sensitive subject. The conversations brought up, for example, fears around who the course was, or should be, designed for; who were 'desired' students; what different levels of skills were being taught and so on. It raised questions as to why exclusion might take place, which are not easy conversations.

Worryingly, we found that the student's booklet, whilst helpful to others in providing a guide, is structured around the idea that it is international students (rather than home students or staff) who need to change and learn new skills. Similarly, in the education module, Lee, a Taiwanese student wrote about how Asian students "need to get better" at peer-assisted learning, which of course was not the subject to be addressed from my perspective.

This was a very small and modest project, done quickly with few resources.[35] As such, there are limitations. Primarily it has stayed within the group of Urban Design students and consequently was a 'horizontal' project rather than a project which connects across multiple differences or levels of authority. The differences in the group were not only ones of cultural background and gender, but also age, experience, and authority through our position as staff. One of the bigger lessons of the project has been a certain difficulty around approaches to criticism in the context of both student-tutor's relations and cultural background. Specifically, what we (as staff) sought was a critique *from the students* regarding our pedagogical approaches or performance, as well as a critique for other (home) students. However, the established hierarchy of student-tutor, as well as the difficulties of critiquing your 'host' proved quite difficult to overcome.

Feminist pedagogy as an approach, however, makes it possible to make difficult issues like these the subject of inquiry and action. Both the Reflections module and Elephant project helped students, and us, to understand, elaborate, and construct knowledge around this issue. But more than this,

in each situation, we attempted to construct more mutual relations within the group.

Mutual Teaching in Civic Contexts

EcoNomadic School is a mobile project for teaching civic-ecological skills in which I have been a participant. Whilst I have been less involved in this particular project, it has become an important reference for me as a feminist approach to pedagogy in civic and community contexts. It is particularly important for me as an example of mutual teaching, as at different moments, participants have opportunity to teach something to the others. The positions of teacher and student are variable, with each taking turns. I use the word mutual here, not only to invoke the idea of a more equitable structure, with each doing things for others, but also to underline the feelings of mutuality and friendship that are built up through such a process, of exchange and sharing.

EcoNomadic School was organised by a network of four main European partners: *aaa* (Paris), Agency (Sheffield UK), the Foundation for Local and Community Development (Brezoi, Romania) and My Villages (Germany and the Netherlands). Each partner is engaged in different contexts with different populations, but all concerned with the loss of 'resilient' life practices from, for example, self-sufficiency and subsistence practices, alternative economies, to crafts and more traditional or vernacular skills and knowledge. In areas such as Brezoi, Romania, these skills have been somewhat preserved. In other contexts, particularly in the Parisian suburbs, immigrant populations, who have no means or context to apply them, also hold knowledge and vital skills. The network was concerned with such skills being (often) the feminized and unvalued ones that are no longer passed between generations. The project aimed to set up more mutual conditions for exchange and learning, and to re-build 'resilient memory' in urban contexts. In *aaa*'s words, EcoNomadic School aimed to "create the conditions for a growing number of citizens from different social and cultural backgrounds to take part and learn how to get involved in finding resilient solutions, and contributing to realisations in their own life contexts."[36]

Over the course of a year and a half, each of the

partners organised and hosted events for the others, which usually included a range of activities such as: visits, watching films, holding talks, inviting guests, holding workshops, learning by doing things such as building composting toilets. The events were based around the hosts' interests and activities, and some examples include subjects of urban agriculture, ecological building, rural women's domestic economies and activities, or revalorisation of traditional crafts.

Invitations for each event were extended beyond the immediacy of the four partners and into their wider local and professional networks. What I found significant was the way the workshops brought together a different group of people each time, making different contexts for learning. They always brought together an impressive mix of people. One workshop, for example, included: farmers, housewives, pensioners, residents of a Parisian housing estate, German sociologists, a historian/curator, women with training in household economy, women with training in the use of 'wild herbs', Romanian women, who to large extent actually practice subsistence households, Dutch community activists, French translators, a French politician, two product designers, artists, and me. The groups, different in composition each time, had a "variable geometry" to borrow *aaa's* expression[37]. In one context participants are 'teachers' or experts, yet in another they participate as student, and roles are reversed. These projects demand a repositioning of the self in relation to others, putting oneself in different roles and contexts. In some ways this goes further than sharing tasks, because not only can you learn about others' situations, you come to learn *how it is they know what they know*, as well as learning the skill and increasing your own capacity.

Projects like EcoNomadic School thus bring something of a transversal approach. In bringing together different constellations of people: community activists, community growers, and local residents into relation with those in academia, in art. It is not simply a 'bridge' between the civic realm and academia/ arts institutions, but rather aims to produce mutual relations.

One of the important questions this project highlights for me, is that the kinds of knowledge we need for resilient, ecological futures are not so easily learnt. They are often experiential, practical and tacit and cannot be so easily transferred. One of the difficulties is, of course, that it takes time to learn different techniques. Everyday skills, like gardening or cooking, are not always simple, and whilst YouTube videos can be helpful (for knitting skills, cooking and so on) the difference here is *the collective activity*. As Anne Querrien writes:

> The classroom is made up of habits, of experiences, of smells, of sounds. This is very different from the virtual community of, say, the 'users' of a book, or of the same game... The modern classroom is a milieu in which students develop, either in a good way or bad way, methods of interaction with his or her classmates.[38]

Education is not an individual endeavour and what EcoNomadic School has emphasised for me, was the importance of mutuality and creating a *space/time* for this. All the workshops happened in civic rather than institutional contexts: in polytunnels on growing sites, in local cafes, in hostels, in museums, in local markets, in church halls. This physical aspect of making a group and (its mobile) spaces is an important part of the process, which deserves more attention.

Making 'Partial Visions' of the Future

These examples of feminist pedagogies are, to differing degrees, transversal and mutual practices. In terms of the future, unlike other approaches in architecture and planning, they do not set out a vision, but try to give tools to those participating, and make something which is more like a 'partial vision' to borrow Kathi Weeks' expression.[39] 'Partial visions' are "fragments or glimpses of something different that do not presume to add up to a blueprint of an already named future, with a preconceived content."[40] In a similar vein, David Harvey has said "We need to create the poetry of our own future... Marx was quite right when he said that you cannot change society except by taking elements of the future which are already there and using them creatively to create the future."[41]

These three pedagogical projects, Reflections on Architectural Education, Elephant in the Room and EcoNomadic School, do not aim to set out a

vision of a future which is 'out there' in some time to come, but are however, *future-oriented*. EcoNomadic School in particular, is concerned with the teaching of sustainable life-practices, and all three teach an important part of life-practice by make contexts for creating new roles and undertaking mutual learning. In their transversal approaches, they open up not only possibilities for increased communication and empathy across difference, but increased agency and capacity, by creating the conditions in which we can become something we would not have been before – such as a teacher – or, by undertaking a new task.

These projects, and feminist pedagogies more generally, allow us to become acquainted with new practices and habits of being, whilst at the same time reminding us of the difficulties in getting there. The first two projects, in particular, highlight something of the difficulties in recognizing, understanding, and working with difference. In both cases, the authority that comes with culture, experience and position was not easily undone or even easily discussed together. In this respect, time is quite important. Returning to ideas of anarchist forms of organising and working with authority, Colin Ward emphasizes the long term engagement and dedication needed (and also faith in the process), noting it took groups working with these notions many months to become settled with them. bell hooks, in her reflections, also describes sustained, on-going processes with classes, through which collective knowledge is built and new habits made. These three projects are quite fleeting, even EcoNomadic School, which, although it spanned 18 months, always moved location, taking place with different groups each time.

These moments and experiences are valuable steps towards different futures. For me they point to qualities of a feminist future we might want, in which we can work across differences, with mutual respect, in self-organised and self-managed ways. They also help us create tools for change in the here and now. Whilst these three projects might be time constrained, by taking part in them participants (including myself) have more capacity and knowledge to reproduce those conditions elsewhere. Feminist pedagogies like these ones, are both the

'partial vision' and the *means* for change; they are a 'vision' and 'practice in the here and now' of learning mutually, *across difference.*

1
Val Plumwood, *Feminism and the Mastery of Nature*, (London: Routledge, 1993) and Val Plumwood, Environmental Culture: The Ecological Crisis of Reason (London: Routledge, 2001)
2
From different political perspectives, see for example: Henry Giroux, The Corporation, (1983); *The Hidden Curriculum and Moral Education* (Berkeley, California: McCutchan Publishing Corporation, 1983.); Ivan Illich, Deschooling Society (London: Marion Boyars, 1971); John Taylor Gatto *Dumbing Us Down. The Hidden Curriculum of Compulsory Schooling* (Gabriola Island, Canada: New Society Publishers, 2005 [reprint of 1992 edition]); John Holt *How Children Learn*, (London: Penguin, 1991); bell hooks, *Teaching to Transgress: Education as the Practice of Freedom* (London: Routledge, 1994). In the field of Architecture especially, see Sherry Ahrentzen and Kathryn H. Anthony, "Sex, Stars, and Studios: A Look at Gendered Educational Practices in Architecture," *Journal of Architectural Education* (1984-) 47, no. 1(1993), p. 11–29
3
Raymond Williams, *The Long Revolution*. Reprint (Cardigan: Parthian Books, 2011) p. 154
4
Janna Graham, "Between a Pedagogical Turn and a Hard Place: Thinking with Conditions," in *Curating and the Educational Turn*, ed. Paul O'Neill and Mick Wilson, Occasional Table Critical Series (London: Open Editions, 2010), 124–139, p. 137
5
bell hooks, *Teaching to Transgress: Education as the Practice of Freedom* (London: Routledge, 1994) p. 53
6
Ibid.
7
Suzanne Lacy, *Leaving Art. Writings on Performance, Politics and Publics*, 1974–2007 (Durham and London: Duke University Press, 2010)
8
For more information on this project, see Martha Rosler and Brian Wallis (ed.), *If You Lived Here: The City in Art, Theory and Social Activism*. Reprint. (New York: The New Press, 1999)
9
WSPA was founded by Katrin Adam, Ellen Perry Berkeley, Noel Phyllis Birkby, Bobbie Sue Hood, Marie Kennedy, Joan Forrester Sprague and Leslie Kanes Weisman. For more information, see Leslie Kanes Weisman and Noel Phyllis Birkby, "The Women's School of Planning and Architecture," in Charlotte Bunch and Sandra Pollack (eds.) *Learning Our Way. Essays in Feminist Education*, (Trumansburg, NY: Crossing Press, 1983), p. 224–245
10
Ibid. p. 238
11
For more details, see especially Gary Genosko, Félix Guattari a Critical Introduction. 1st Pluto Press ed. (London: Pluto Press, 2009)
12
Félix Guattari, Chaosophy: Texts and Interviews 1972–1977, Semiotext(e) Foreign Agents Series (Los Angeles, CA: Semiotext(e), 2009) p.177–178
13
Gary Genosko, Félix Guattari a Critical Introduction. 1st Pluto Press ed. (London: Pluto Press, 2009) p. 29–30
14
Félix Guattari, *Molecular Revolution: Psychiatry and Politics*

(Harmondsworth, Middlesex: Penguin Books, 1984) p. 17–18

15

Nira Yuval-Davis, "What is 'Transversal Politics'?" *soundings issue* 12, summer 1999. Many thanks to Nora Räthzel for drawing my attention to this and for her discussion on the 'problem' of authority.

16

See for example feminist work on standpoint epistemology, and multiple standpoints, Sandra Harding, "Rethinking Standpoint Epistemology: What Is Strong Objectivity?" in *The Feminist Standpoint Theory Reader: Intellectual and Political Controversies*, ed. Sandra Harding (London: Routledge, 2004), p. 127–140

17

Or the discussion of the Politics of Location and Nomadism in Rosi Braidotti, *Nomadic Subjects: Embodiment and Sexual Difference in Contemporary Feminist Theory* (New York: Columbia University Press, 1994) p. 268–269

18

Leslie Kanes Weisman and Noel Phyllis Birkby, "The Women's School of Planning and Architecture," in *Learning Our Way. Essays in Feminist Education*, ed. Charlotte Bunch and Sandra Pollack (Trumansburg, NY: Crossing Press, 1983), p. 228

19

Ibid. p. 224–245

20

"'Educator, Activist, Politician.' Leslie Kanes Weisman in Conversation with Cristina Cerulli and Florian Kossak," *Field* 3, no. 1 (2009): 7–20 p. 10

21

Leslie Kanes Weisman, "A Feminist Experiment. Learning from WSPA, Then and Now," in *Architecture. A Place for Women*, ed. Ellen Perry Berkeley and Matilda McQuaid (Washington; London: Smithsonian Institution Press, 1989) p. 132

22

Mikhail Bakunin quoted in Colin Ward, *Anarchy in Action*, (London: Freedom Press, 1973) p. 39

23

To explain the context at Sheffield and across the UK more widely since the late 1990s, there are increasing numbers of international students particularly from East Asian regions (China, Thailand, Singapore, Malaysia, Hong Kong etc.), as well as some from the Indian subcontinent and the Middle East. In the case of Sheffield, these students are primarily on one year taught specialist Masters programmes: in Architectural Design, Urban Design, Digital Design, Sustainable Architecture, and, Conservation and Regeneration. These programmes are taught alongside a two-year Masters in Architecture, the only Masters to be accredited by the professional body, the RIBA. This course, in contrast, has predominantly (white) UK students enrolled. Whilst the courses are separate, they share studio teaching and work on the same topics and projects, often in groups.

24

Linda N. Groat and Sherry B. Ahrentzen, "Voices for Change in Architectural Education: Seven Facets of Transformation from the Perspectives of Faculty Women," *Journal of Architectural Education* (1984-) 50, no. 4 (May 1, 1997), p. 271–285

25

Examples include, 'live projects' where students work collaboratively in a team for a client, 'competing against a problem' rather than each other. In the first year of the BA course, the staff convenes a project called Matter Reality, where students must work together to design and build an installation in a public space. They must mutually agree on roles in the group if it is to succeed, and organize all aspects of the process, such as sourcing materials, as well as design and construction. For Live projects see: www.liveprojects.org
For a feminist discussion of competing against tasks see: "The Secret Between Us" by Laura Tracy quoted by Sherry Ahrentzen and Kathryn

H. Anthony, "Sex, Stars, and Studios: A Look at Gendered Educational Practices in Architecture," *Journal of Architectural Education* (1984-) 47, no. 1 (1993), p. 11–29

26

Anne Querrien, "Mutual Schools" in Binna Choi and Axel Wieder (eds.), *Generous Structures*. Casco Issues XII (Berlin: Sternberg Press, 2011) p. 166

27

Keith Topping and Stewart Ehly (eds.), *Peer-Assisted Learning*, (London: Routledge, 1998) 1–24, p. 1

28

Differences that Abi and Joanna observed were that during the first task, the conversations were faster, more casual, with others interrupting more freely and more than one conversation happening at a time. In this situation ideas and design happened simultaneously. In mixed groups the decision-making was slower and more formal, with students taking turns in offering opinions and ideas. Joanna and Abi found that the second exercise was more task focussed.

29

Joanna Hansford "Mapping informal networks within the MArch and MAAD courses. How can we facilitate peer-to-peer learning across cultural boundaries within Sheffield School of Architecture?" Unpublished MArch essay, University of Sheffield, 2013, p. 7

30

Ibid. p. 12

31

Freeman, Jo. "The Tyranny of Structurelessness," 1972. www.jofreeman.com/joreen/tyranny.htm. [Accessed 15.03.2012]

32

Student quoted by Neil Michels, in Neil Michels "Can project 'speed dating' encourage peer to peer learning between home and international students?" Unpublished MArch essay, University of Sheffield, 2013, p. 7

33

Ibid. p. 10

34

This section of the text is based on our co-authored report: Anna Holder, Kim Trogal and Julia Udall. *Seven Elephants. Visualising and Challenging Barriers to Domestic-International Student Integration at the Sheffield School of Architecture*. Sheffield, 2013

35

Anna and Julia made a successful application to the University's Learning and Teaching fund to pay for one day of our time, to pay the students for a few hours of their time and to pay for a small amount of printing.

36

For more information, please also see: www.rhyzom.net/nomadicschool/

37

atelier d'architecture autogérée (aaa): www.urbantactics.org/collective/collective.html [accessed 13.05.2015]

38

Anne Querrien, "Mutual Schools" in Binna Choi and Axel Wieder (eds.), *Generous Structures*. Casco Issues XII (Berlin: Sternberg Press, 2011) p. 164

39

Kathi Weeks, *The Problem with Work: Feminism, Marxism, Antiwork Politics, and Postwork Imaginaries* (Durham NC: Duke University Press, 2012).

40

Ibid. p. 30

41

David Harvey "Seventeen Contradictions and the End of Capitalism" lecture at Central Saint Martins, University of the Arts, London, 7th June 2013

14

URBAN CARING: FOSTERING RELATIONSHIPS, FOREGROUNDING DIVERSITY AND BUILDING SUBSISTENCE ECONOMIES

SARA BROLUND DE CARVALHO AND ANJA LINNA

Fig 14.1 The weaving association "Hantverkstan" (The handicraft workshop)

"Maybe we take care of each other. Many here have had worries, relatives that died and things like that. We can come here and cry, and there is nothing strange about that. This place is caring and warm. It doesn't have to be less of a place just because there are no men here; regardless, this place works very well."[1]

The setting is the Stockholm suburb Bagarmossen, built mainly in the 1950s and inspired by the neighbourhood unit concept.[2] Apartment buildings, mostly three stories tall, are oriented along narrow, circular streets with pedestrian walkways connecting them to the community centre with a library, shops and subway station. A very unique feature of the apartment buildings is that most of them contain relatively hidden semi-subterranean rental spaces, which were originally designed as common spaces for the inhabitants to meet and socialize in.

In the 1950s, each housing block had their own common spaces that were accessible for the tenants of that same block. The large number of non-residential spaces in the housing blocks was part of the city´s planning ideal at the time: to create a sense of fellowship and community.[3] Today, these spaces are subleased, despite being not very suitable for commercial use due to their relatively small size, lack of visibility and non-existent shop front windows. Consequently, there is an exceptionally high amount of small associations and cooperatives renting these semi-subterranean spaces in Bagarmossen today, organisations, which are mostly run by and for women.

Our exploration in forms of 'urban caring' is a pedagogical project where we, from our respective

Fig 14.2 The semi-subterranean rental spaces in Bagarmossen, a suburb of Stockholm

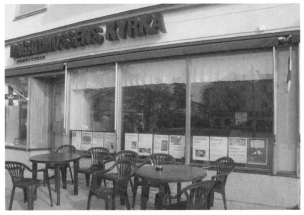

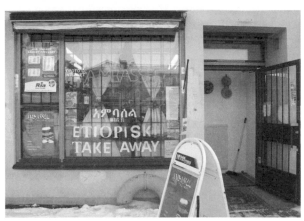

standpoints of an architect/filmmaker and an architect/musician, started speculating on methods of collecting knowledge about a site, which was not predetermined by generalizing assumptions. We retrieved and documented our findings through a timeline mapping of the semi-subterranean 'care' spaces we found in Bagarmossen, as well as through making a film. Our film *Underground Urban Caretaking*[4] depicts the activities and people that use the spaces in Bagarmossen today, not through conventional interview, but rather through dialogue and personal engagement. The film portrays hands, filmed close-up, accompanied by stories from several non-profit associations and small-scale businesses, such as the handicraft associations *Hantverkstan* and *Knut*, the feminist tattoo collective *Skäggiga damen,* and a drumming studio for girls called Rhythm Works, who all occupy and activate the semi-subterranean spaces in Bagarmossen (Figs. 14.2–5). Their stories bring up concerns about relations, caring for difference, and the recognition of the importance of subsistence economies and self-management.

Inspired by feminist architects before us, such as Matrix and the founders of the Women's Design Service in Great Britain in the 1970s, as well as contemporary architecture/art practice muf, we question norms and power relations in architecture, as well as pay attention to the unseen and seemingly trivial. Instead of abstracting reality according to dominant power structures, our feminist approach deals with the 'messiness' of the world, and the political, social and bodily aspects of places. In other words, feminist strategies allow us to value the everyday and the personal as an important basis for knowledge in architecture.

The embodied and lived experience is often forgotten or even explicitly put aside in favour of a more theoretical, or rather technical framework, where the quantifiable is treated as reliable while all other observations become curiosities or mere indicators. What we wanted to do is to focus on everyday and personal aspects of places, and find the stories that are usually overlooked but crucial for the survival of communities, and ways of representing them.

An Ethics of Care

The ethics of care focus on qualities and values such as interdependence, responsibility, empathy, respect and solidarity. In the 1980s, feminist ethicist and psychologist Carol Gilligan introduced care as an attached way of human connection, requiring listening and an understanding of differences and needs, in contrast to what she perceived as male ethics of justice and hierarchies.[5] More recently, architect, researcher and educator Kim Trogal has elaborated on care as an ethical and relational way of acting in contemporary spatial practices.[6] Like Trogal, we see a strong potential in a feminist understanding of *care*: it can help us to discover marginalized or even despised urban activities and the spaces where they take place, as well as their importance as the base of a resilient community.

We argue that the concept known as 'feminist ethics of care'[7] allows us to transgress our roles as architects. As Trogal points out, the ethics of care emerge from real life practices and can offer a new kind of urban category: an analytical framework for a specific form of fieldwork. We ask ourselves: what if we, as architects, recognize and utilize care-focused values such as sensitivity, compassion and feeling in our work? Taking this ethical attitude as a point of departure, we have developed a set of methods and practices for fieldwork, which include historical mapping, enactment, film and conversation.

Fig 14.3 The handicraft association "Knut"

A Brief History of Social and Common Spaces
Spatial, economical and political aspects

How have these rooms looked like in Sweden,
and more specifically Bagarmossen, throughout history?

BAGARMOSSEN/ STOCKHOLM

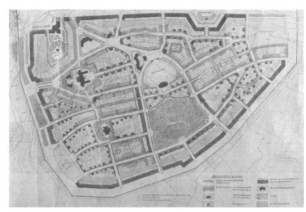

1907. Plan drawing of Enskede trädgårdsstad (garden city), Stockholm

1890 1893. Malmö Folkets park – the first People´s park in Sweden. **1900** 1910

SWEDEN

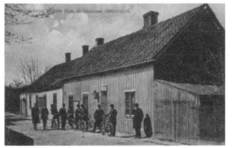

1890. Folkets Hus in Kristianstad, Skåne, was the first community center built by the workers movement in Sweden (Postcard from 1914) www.fhp.nu/Hem/Om-oss/

1907. Folkets Hus in Fågelviken, Härnäset, Bohuslän, Southwestern Sweden.

Arbetarrörelsen och Folkets hus
The Swedish worker's movement, "arbetarrörelsen", played an important role in the establishment of indoor, and outdoor, public space open for the working class. In late 19th Century the first "Folkets hus" (the people's houses) were built in the outskirts of the cities, with fear of riots. During the 20th Century they were built in central locations. These gathering spaces for the worker's movement, outdoors in Folkets Park (the people's parks) became common throughout Sweden

Fostering Relationships

"I always think of the people that live here when I'm around. I've developed a relationship to many of the buildings, to many addresses, and to the history. Many of them have lived in the same place for a long time, they moved in when it was newly built."[8]

Fig 14.4 The drumming studio for girls "Rhythm Works"

Our background – not only in architecture, but also in art, music and film – often pushes us in a more playful direction. Dealing with the complex social urban fabric, we would argue, presupposes a certain level of openness and maybe even some form of 'ad-hoc strategy'.

The personal key to our mapping of Bagarmossen was the traditionally female gatherings around the practice of handicraft, handwork and bodily practices primarily using the hand. The hand often plays an important role in actions of caring – for example, in Swedish, *ta hand om* means to take care of – and so the hand symbolizes a care-full approach. Practices of handicraft and various forms of 'hand work' became a key to conversation and dialogue in our urban mapping.

As the social interactions of traditionally female handicraft groups – such as informal knitting, crochet and sewing gatherings, but also the feminist tattoo studio and the drumming workshop for girls – show us, occupying one's hands can be a way to create an informal and trusted interaction between people. An important aspect in this is time, which helped to build relationships over several visits, long conversations and our engagement in different activities, such as taking part in a drumming class at Rhythm Works. These practices have informed our method 'to talk through the work of the hands', which became the basis for the film we made.

Foregrounding Diversity

"…and then she brought her… I think it was her brother, a relative, a guy. But wasn't it supposed to be for women only, was my question. But he is so kind! She said. And then men started to come along. Neighbours come, drum enthusiasts from here and there, sometimes people who don't know left from right and don't know anything, sometimes real professionals come. And then I put together a drum ensemble according to the current conditions."[9]

Fig 14.5 The feminist tattoo collective "Skäggiga damen" (The bearded lady)

The focus on dialogue and hands allowed us to first discover and eventually, through moving images, convey how practices of caretaking are important as social and political forums for learning, exchange of ideas and support. These activities are all crucial for the development of sustainable social communities, but seldom acknowledged.

Practices of handwork have historically not been visible in the public sphere and have mostly been restricted to private homes, which in many ways is symptomatic of how women's activities have been (and to some extent still are) overlooked in public space. As Swedish urban and gender researcher Carina Listerborn points out, both feminist critique

The neighbourhood unit

The neighbourhood unit planning in Sweden developed from a critique on the rational, functionalist way of building of the 1930s. The aim was to create physical conditions that would enable the emergence of a community.

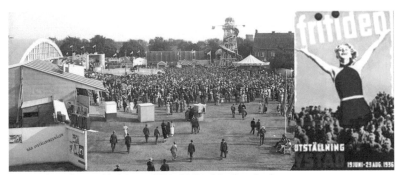

The neighbourhood unit idea tried to create/re-create a fellowship and community that was believed to exist in the countryside.

The sociologist Clarence Perry's ideas were an important influence. Diagram of Perry's neighbourhood unit, published in the New York Regional Survey, Vol 7. 1929

1946, poster urging people to not move to Stockholm - 21 000 are looking for housing "in vain". As well as after WW1.

| 1920 | 1930 | 1940 |

1936. Fritidsutställningen (the leisure exhibition) in Ystad, Southern Sweden

Torö "bygdegård", Nynäshamn, founded in 1944.

Leisure

"In Sweden in the 1930s, leisure was not a word in common use, particularly amongst blue collar workers and their wives who had little or no spare time. When industrialisation swept over Sweden and the factories organised fixed working hours and legislated holidays and other social reforms were introduced, the working class suddenly had time to spare – this had to be well spent! That was the key to the exhibition in Ystad."
text from Ystad city webpage, www.ystad.se/ystadweb.nsf/AllDocuments/650911EC08BB6C5CC125713F0035AB40, 2012-05-22

Bygdegårdsrörelsen

The bygdegård movement, was a movement of building community spaces specifically in the countryside and smaller villages in Sweden. The civil movement of rural Sweden grew in early 20th Century and during a period of 25 years about 400 "bygdegårdar", houses for meetings and activities, were built.

and post-colonial theory reveal an existing generic blindness towards certain citizens, because of ethnicity, gender, class and sexuality.[10] Through new methods for mapping and knowledge-making, we can transgress the boundaries of this narrow focus.

Building Subsistence Economies

"We make our decisions together and we don't want to go behind anyone´s back. It wouldn't work any other way. Now everyone is equally responsible, which is both good and bad, but mostly good. And you earn so much more. We've learned so much about economy and other things. It's such an amazing feeling, that we can manage this on our own. We don't need anyone pushing us around. What the heck, we'll do it ourselves instead! And do it the way we want, and avoid the humiliation of trying to get into that environment. And instead own ourselves the place we want to go to."[11]

As in architecture, activities and actions concerned with *care* are often undervalued in our capitalism-dominated economic system. Care-work or reproductive work is poorly paid, even though it is fundamental for maintaining communities and forms the base for all gainful employment. Feminist economists such as J.K. Gibson-Graham have added the notion of diversity to the often commodity-focused economies of today, developing alternative economic models constituting society. Apart from production and wage labour, these models include reproduction and other diverse economic activities.[12]

Maria Mies speaks of a 'subsistence perspective' as a new way of looking at economy. In contrast to commodity production, where the goal is to produce a commodity that is bought and sold, the goal of subsistence production is the direct satisfaction of human needs. Hence, it is a direct production and reproduction of life, a "life production".[13] Most importantly, subsistence economics include the possibility to maintain oneself, be independent and make one's own decisions.

Traditional economics overlook the small-scale activities of communities and dismiss their value. Therefore, to perform urban care work, we need new, inclusive models. To question mainstream notions of economy, and to acknowledge a diversity of 'life-producing' economies, requires in turn new forms of data collection and new architectural strategies. We argue that free-of-charge or affordable spaces are indispensable for inclusive community activities to develop.

Developing A Personal Feminist Practice Of Care

So how can we use our new knowledge about the care-full, small-scale activities of the here and now to develop an architectural strategy of caring for the future? How can we promote the need for spaces where social, non-commercial and micro-commercial activities can take care of people's collective, political and creative needs, longings and desires? What stories of a place can these practices tell?

The up close and personal look at the details of social practices through the metaphor of the hand generated a broader understanding of the spatial needs for social and community building.[14] It also led us to discover the importance of Bagarmossen's many relatively cheap, but almost invisible, rental basements. Were it not for their existence, the care-full activities we have foregrounded in this chapter would not flourish. There is a sense of caring in the design and layout of the buildings in Bagarmossen built during the 1950s. Providing a common space that is flexible, accessible and free of cost or affordable to rent means that meeting, talking, creating, partying etc. are all recognized as crucial activities that belong to and take care of a community.

Today, these spaces are legally designated as non-residential or commercial spaces, allowing the main municipal landlords in Bagarmossen to rent them out. Even though the semi-subterranean spaces are no longer free to use for tenants, their rent has remained relatively low due to their lack of suitability as conventional shops.

Common and social spaces like these have disappeared from contemporary housing typologies, where a commercial space on the ground floor at best serves as an alibi for social sustainability in urban plans. But community-building, which is crucial for our diversified societies in respect to social, political and civic development, needs time and

1953-1955

Stockholmshem's 553 rental apartments from the time consist of **30 080 m2 accomodation and 8 136 m2 common and commercial space** (sv: lokaler) and 134 garages.

21,3 % non-residential space

30 % of Stockholmshem apartment stock in Bagarmossen

Bagarmossen is planned, influenced by the idea of the neighborhood unit.

Statistics from Stockholmshem, "Bagarmossen", text by Klas Schönning. BOOM-gruppen, KTH Arkitektur, commissioned by Stockholmshem, 1997, p. 51.

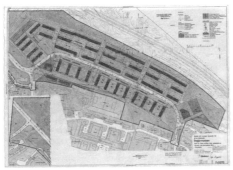

1971-1973

Stockholmshem's 1 134 rental apartments from the time consist of **81 176 m2 accomodation and 1 855 m2 common and commercial space** (sv: lokaler) and 1001 garages.

2,2 % non-residential space

62 % of Stockholmshem apartment stock in Bagarmossen

Bagarmossen gets a big addition to its building stock when apartment buildings are built at Byälvsvägen as part of the Million Program. Masterplan from Stockholms stadsbyggnadskontor (city planning office), stadsplaneavdelningen (city plan department) 20 mars 1969 (Pl.6978).

1950 **1960** **1970** **1980**

Årsta square, planned in 1943, finished in 1953.

1972 Byälvsvägen, Million Program housing. Common space used by the tenant's association.

1950s. The first "bostadsrättsförening" (co-op housing) built in Bagarmossen. The display-window-like space was planned as a meeting space for the inhabitants and is still used as one.

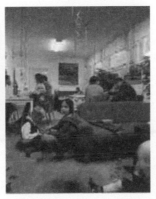

Shared neighbourhood space in a basement in a 1950s house in Bagarmossen. Photo: Nino Monastra, Stockholmshem, "Bagarmossen", 1997.

Two ground floor locations in Bagarmossen show the difference between the visual retail space and the more hidden common space in the 1950's building fabric.

spaces to flourish. Therefore, in our view, we have to reconsider the role of both common and collective surfaces, as well as cheap-to-rent spaces for urban practices of care; we must defend their existence, and plan for more common spaces in the future.

A feminist ethics of care can help us – and other spatial practitioners – to go from a generic blindness to a growing ability to interact, through the development of sensitivity to the small gestures and activities of urban caretaking, which may not stand out at first glance, but regardless make a crucial difference in everyday life. Techniques of mapping help us find and foreground small-scale and micro activities as important 'caretakers' of our urban environments, necessary for building resilient communities. We argue for an unconstrained search and a somewhat obsessive attention to detail in order to find what is not obvious or easily seen from a planner's perspective, in order to be able to envision and create more care-oriented urban futures.

1
Quote translated from Swedish by the authors, from *Underground Urban Caretaking*, 2012. [Film]. Dir. Sara Brolund de Carvalho and Anja Linna. Stockholm.

2
Clarence Perry introduces this concept of the self-contained neighbourhood unit in North America in the late 1920's as an American version of the garden city. Narrow streets with apartment buildings, shops and services would surround a community centre with a school. The neighbourhood unit concept initially had a strong focus on pedestrian safety, but came to additionally include aspects of social structures and community-building connected to physical design principles. See Clarence Perry, "The Neighborhood Unit" in *The Urban Design Reader,* edited by Michael Larice and Elisabeth MacDonald. London and New York: Routledge, 2007, pp 54–65.

3
BOOM-group (KTH Arkitektur/Stockholmshem) *Bagarmossen*, Berlings, Arlöv 1997, pp 16–17.

4
Our film *Underground Urban Caretaking* was initiated through a project we started in the Critical Studies Design Studio at KTH School of Architecture in Stockholm, led by Meike Schalk, Linda Lindstrand and Sara Vall. The task was to develop experimental forms and methods of mapping, and to question conventional architectural methods that privilege seemingly objective data over personal experience in site analysis and research. As architects, we wanted to find new tools to gather and create knowledge, and to transgress the boundaries of what is valued as important in architectural projects. In making a short film, our intention was to unearth social knowledge that is usually not considered in planning and building processes.

5
Carol Gilligan, "Moral Orientation and Moral Development", in *Women and Moral Theory*, edited by Eva Feder Kittay and Diana T. Meyers. Totowa, NJ: Roman & Littlefield, 1987, pp 19–32.

6
See Kim Trogal, *Caring for Space. Ethical Agencies in Contemporary Spatial Practice.* PhD Architecture, University of Sheffield, October 2012.

7
This concept was introduced by Carol Gilligan and Nel Noddings. Carol Gilligan, *In a different voice: psychological theory and women's development* (Cambridge, Massachusetts: Harvard University Press, 1982) and Nel Noddings, *Caring: A Feminine Approach to Ethics and Moral Education* (Berkeley, University of California Press, 1984).

8
Quote translated from Swedish by the authors, from *Underground Urban Caretaking*, 2012.[Film]. Dir. Sara Brolund de Carvalho and Anja Linna. Stockholm.

9
Quote, translated from Swedish by the authors from *Underground Urban Caretaking*, 2012. [Film]. Dir. Sara Brolund de Carvalho and Anja Linna. Stockholm.

10
Carina Listerborn, "Who speaks? And who listens? The relationship between planners and women's participation in local planning in a multicultural urban environment", in *GeoJournal*, September 2007, Volume 70, Issue 1, pp 61–74.

11
Quote translated from Swedish by the authors, from *Underground Urban Caretaking*, 2012. [Film]. Dir. Sara Brolund de Carvalho and Anja Linna. Stockholm.

12
See for example Jenny Cameron and Katherine Gibson "ABCD Meets DEF: Using Asset Based Community Development to Build Economic Diversity", paper presented at the Asset Based Community Development Conference, The University of Newcastle, 3–5 December 2008.

13
Maria Mies, *The Subsistence Perspective*, Transcription of a video by O. Ressler, recorded in Cologne, Germany, 26 min., 2005, translated by Lisa Rosenblatt. See republicart.net/disc/aeas/mies01_en.htm, (accessed August 16, 2016).

14
In this we are inspired by the work of muf architecture/art and their focus on the detail as a key to successful, emancipatory projects. In This is What We Do – A Muf Manual, Katherine Schonfield describes how to move from the close-up to the bigger picture and then back to the particular, as a method for critical spatial practice. See Katherine Schonfield "Premature Gratification and Other Pleasures", in muf, This is What We Do – A Muf Manual. London: Ellipsis, 2000, pp 14–23.

1990-1991

Stockholmshem's 145 rental apartments from the time consist of **12 508 m2 accommodation and 3 816 m2 common and commercial space** (sv: lokaler) and 49 garages.

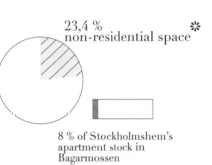

23,4 % non-residential space ✳

8 % of Stockholmshem's apartment stock in Bagarmossen

✳Comment: The big grocery store Konsum is located in Stockholmshem's apartment blocks from the 1990s, taking up a significant percentage of the above non-residential space.

1990 2000 2010

Former common space for the inhabitants of a bostadsrättsförening (co-op).

2009. Newly built housing block "Näringsministern" in Bagarmossen lacking commonspaces

PROJECTIONS

PROLOGUE
THE WAITING ROOM

HELEN RUNTING

In the bleachers

Anticipation travels quickly through the bleachers In a stadium of supporters before the teams take the field or in a theatre before the curtains are raised. Taking root in the midst of audiences, anticipation precedes the staking out of definitive positions on the play to come, marking a moment of expectation wherein crowds await imminent action and familiar modes of address (the whistle being blown, the lights being lowered, the game beginning, the first note, the first word). Operating *affectively* through a register that is intersubjective, pre-personal, and precognitive, anticipation is a visceral force that moves us to action.[1] In a state of anticipation, we actively *await* something that has not yet materialized but that we believe will. Anticipation is, in this sense, always "not yet" and never just "not"—it precludes negation and to some extent also critique. Just as "a critical kiss is a bite, not a kiss,"[2] critical anticipation is in definition closer to apprehension, or even dread.

Like desire itself, anticipation does not express a lack, but rather a promise: "Not yet, but soon," it murmurs in our ears, "good things come to those who wait." And like all promises, the commitment inherent in anticipation can, of course, be broken: that which was anticipated can fail to materialize, be indefinitely withheld, or can arrive in a form so unfamiliar that it is in fact not what we were waiting for but rather something entirely different. Similarly, at the point when the thing we await finally appears, it can sometimes seem "only natural," precisely because it manages to meet our expectations. In this sense, anticipation moves us by promising us the world, but it does so by fixing that world to what we expect and recognize, and normalizing it after the fact.

Postcritical, precognitive, and "fuzzy" by virtue of the lack of any guarantees, anticipation is a state that can be lingered in. The sensation that anything might be possible is a pleasurable one, the notion that a future is under construction—and thus to some extent open—is deeply attractive. For urban planners (my own discipline) and feminists alike, anticipation is a thus a cocktail that is hard to refuse: at the very limit of the "not yet, but soon," we encounter the rare and intoxicating sense that a new world might indeed be possible. It is at this limit that I would like to position the four chapters that compose this section of the book: as acts of anticipation, they await

future states that deviate dramatically from a patriarchal present. Like all good hosts, these authors (and the activists and thinkers they cite and discuss) pull us into a space which invites, which longs for, and which produces a space of convivial reception for future (structural) change. In each of the four chapters in this section—whether we turn to Helena Mattsson's exploration of the construction of new architectures and of new archives; or Ramia Mazé and Josefin Wangel's reflections on the distributions of resources and the solidification of norms they are accompanied by; or Karin Bradley, Ulrika Gunnarsson Östling, and Meike Schalk's critical reformulation of regulatory environments; or Sophie Handler's reframing of the transformation of the body over time—an act of anticipation is present. Whether the bodies-minds doing the practicing are the authors themselves, or other collectives (like KBF or BiG, as discussed by Mattsson), what becomes clear is that the production of anticipation is *hard work*. It is practiced in the flesh. Feminist scholars have long reminded us of the importance of highlighting unwaged and obscured domestic labor, of recording and describing it, of using the weight of theory in its instrumental modes to lend weight to its valorization. In the spirit of that call, I propose that we might turn our attention to the work of waiting, to consider its projective potential in ushering into being new worlds.

Containing our enthusiasm

In cities like Stockholm, we spend much of our lives immersed in atmospheres that are fine-tuned to the solicitation of communication and exchange, and the shaping of our expectations. In our dealings with institutions and with each other, we are enclosed in affective fogs that produce within us expectations of "the coming play." From the tasteful blonde wood and porthole windows that run throughout Arlanda Airport to the corporate lobbies of Stockholm Waterfront, and from the cheerful, domestic interiors of State health care centers across Sweden to the endless interior of the epic new Mall of Scandinavia in Solna, spaces of waiting curate our expectations, shaping our longings, and naturalizing events in advance. The artful curation of our "reception" of possible futures occurs everywhere under semiocapitalism. As architect Hannes Frykholm suggests through his sumptuous interior montages, our lobbies in fact actively lobby us right back, framing the experience of our place within capitalism just as they frame the spaces which lie behind and beyond them.[3]

Whilst the theorization of "semiocapitalism" has a number of roots, the version most recently popularized via the work of Italians Maurizio Lazzarato and Franco 'Bifo' Berardi takes its point of departure in the theory of Gilles Deleuze and Felix Guattari.[4] The term acknowledges the role that semiotic operations play in the production of subjectivity in the twenty-first century: both Lazzarato and Berardi emphasize the doubled nature of this production, which occurs on one hand through the produc-

tion of meaning (so-called "signifying semiotics"), and on the other hand through the projection of visceral "asignifying semiotics." This latter category of sign can be thought of in terms of "sign machines," which "operate 'prior' and 'next' to significa- tion, producing a 'sense without meaning,' an 'operational sense.' Their operations are diagrammatic insofar as the subject, consciousness, and representation remain in the background."[5] Anticipation, I would advocate, fits neatly into this latter category, operating on us alongside conscious thought and in advance of more traditional modes of communication (the play, the game, the dance, the battle, the date). Lazzarato argues that capitalism fights to control these asignifying semiotic apparatus- es with the aim of depoliticizing, depersonalizing, and ultimately integrating workers into broader, precarious assemblages that are available to opportunistic exploitation.

The curation of reception through the production of anticipation is thus not only an important facet of contemporary representative democracy, with its swarms of spin doctors, lobbyists, and opinion polls, but also of contemporary capitalism itself, wherein our expectations regarding the future are increasingly treated as a resource to be mined in the present. We are, on one hand, bombarded with invitations to voice our opinions on everything from the service rendered by our ride-sharing service driver to the performance of our employer, or the usability of a website we regularly use. These invitations to judge and rate normalize our experiences after the fact—the injunction to constantly compare what happened to what we anticipated—produces a kind of retroactive anticipation for a present we had no hand in making. On the other hand, the future is often delivered to us in a tonal register predicated as much on dread as on anticipation: neoliberal austerity agendas push us to await the worst, and to mindfully enjoy the present moment rather than engaging in the folly of utopi- an projection.

A transportable mold

If in some moments anticipation is able to stir the bodies-minds of groups, of whole social worlds, into motion, we must acknowledge that it does so in a particular direc- tion. *It is in the capacity to determine the direction of a general and diffuse anticipation— to defend its capacity for "projection"*—that, I would argue, we can locate the pos- sibility of a progressive politics. It strikes me that it is precisely this utopian task that contemporary feminism must respond to. Might, I wonder, we view the production of projective anticipation for a feminist future in terms of the production of a kind of architecture—a "waiting room," perhaps, or a lobby—which welcomes certain "prefer- able" futures and reveals other developments as in fact constituting broken promises and betrayals?

Such a space might be conceived of in terms of a "chora," a concept that, drawing

on the Platonic notion of a space which would mediate between the pure world of forms and the imperfect world of objects, Elizabeth Grosz has described as the "receptacle or nurse that brings matter into being, without being material; it nurtures the idea into its material form, without being ideal."[6] Chora constitutes an important concept in the place between philosophy and architecture (for instance in the work of Jacques Derrida), and in discussions of the links between language and subjects (for instance, through the writings of Julia Kristeva). It is, however, the work of philosopher Luce Irigaray that is most pertinent to the present discussion. Irigaray highlights the violent suppression that underscores our philosophical understandings of chora, wherein the maternal-feminine is assigned to the uterine, to place, and thus "serves as an envelope, a container, the starting point from which man limits his things."[7] Whilst woman is put in place (and not a place of her choosing) in this schema, Irigaray also reminds us that woman is "able to move within place as place,"[8] because rather than matter or form, the "place" that is chora—that hosts the processes that bring matter and form into being—can be thought in terms of a "vessel." A vessel can be a cup or a jug—a "container technology," to use Zoe Sofia's productive terminology[9]—but it can also be a sailing boat or an ocean liner. It is thus in seafaring terms that we might best conceive of this odd ability to "move within place as place." Chora, therefore, emerges as doubled, as both limit and vessel, a kind of "transportable mold," wherein the container and the contained are set in a co-constitutive relation, wherein *both can move*, together.

Architect and theorist Katie Lloyd Thomas recounts the way in which Gilbert Simondon reconceives of the mold as "a limit condition to an energetic transformation, rather than the imposition of form on a passive clay,"[10] reminding us that in fact clay should be thought in terms of its own singularities and implicit forms. In the same spirit, we must be clear that the act of anticipation cuts both ways: far from a passive act performed by an impartial crowd, at its limit, anticipation can shape both the direction of things to come and those who it envelops, and do so simultaneously. The home team often wins for this reason: the roar of their supporters can feel like it contains everyone, as it echoes deafeningly through the stands.

Projective anticipation

Whether our feminist future involves the production of new architectures, new archives, new knowledges, new practices, or the production of an entirely new world, a task exists in preparing the crowds in the bleachers for the unfamiliar modes of address to come. *The capacity to projectively bring into being another world might, I suggest, ultimately lie in the crafting of the conditions of its reception.* Learning from the restless operations of semiocapitalism, which "sets its sights on individuals in

their entirety, watching over them from morning to night, in their homes and in their beds, as lovers and as dreamers, in sickness and in health,"[11] we too might turn to the production of atmospheres heavy with transformative affects and productive stimuli. Spaces of feminist anticipation—that is, spaces geared to the production of longing for a different society—will need to enclose, collect, recruit, affect, move, rouse, calm, forbid, exclude, and excite simultaneously, and in advance of the main play. They will need to move us, and we will need to move with them.

This is a design task that is far from "postcritical."

1
Gregory J. Seigworth and Melissa Gregg, "An Inventory of Shimmers," *The Affect Theory Reader*, eds. Gregory J. Seigworth and Melissa Gregg (Durham: Duke University Press, 2010), 1–25.
2
Sylvia Lavin, *Kissing Architecture* (New Jersey: Princeton University Press, 2011), 14.
3
See for instance Hannes Frykholm, "Sweating the Small Stuff: A Micro-Scopic Analysis of the Real Estate Lobby," *LO-RES* 2 (forthcoming, 2016).
4
See Maurizio Lazzarato, *Signs and Machines: Capitalism and the Production of Subjectivity* (Los Angeles: Semiotexte, 2014); Franco 'Bifo' Berardi, *After the Future* (Edinburgh: AK Press, 2011); Gilles Deleuze and Félix Guattari, *Anti-Oedipus: Capitalism and Schizophrenia* (New York: Penguin Classics, 2009).
5
Lazzarato (2014), 41.
6
Elizabeth Grosz. *Architecture from the Outside: Essays on Virtual and Real Space*. (Cambridge, Mass.: MIT Press, 2001), 91.
7
Luce Irigaray. *An Ethics of Sexual Difference* (London: Continuum, 2004[1993]), 10.
8
Ibid., 35.
9
Zoë Sofia, "Container Technologies," *Hypatia* 15, no. 2 (2000), 182–200.
10
Katie Lloyd Thomas, "Going into the Mould: Materials and Process in the Architectural Specification," *Radical Philosophy* 144 (July/August 2007), 21.
11
Joseph Vogl, *The Specter of Capitalism* (Stanford, CA: Stanford University Press, 2015), 99.

15

FUTURE (IM)PERFECT: EXPLORING TIME, BECOMING AND DIFFERENCE IN DESIGN AND FUTURES STUDIES

**RAMIA MAZÉ
AND JOSEFIN WANGEL**

Through critically exploring intersections between futures studies and design, this essay seeks ways of approaching 'the future' in order to open for a variety of futures. We, the essay authors, first met at the Stockholm Futures Conference where we encountered normative paradigms that we want to question or change.[1] One of us, Josefin, comes from a professional and research practice in futures studies, and the other, Ramia, comes from a professional and research practice in design. At the conference, Teodore Gordon, a pioneer of early futures studies, spoke of the history of futures studies in the US during the post-war 'Atomic Era' and 'Space Age' premised on technocentric and positivist logics. Such futures studies have tended to imagine the future as technological and material only, portraying the future as a discrete and definite location, even a singular ('the' future), which might be arrived at through linear transition pathways along which the development of particular technologies as the privileged baseline for plotting human, cultural and societal 'progress' (if social factors are considered at all, e.g. Wangel 2011).

Such futures studies approaches are increasingly allied with design, we both argued at the conference. With the rise of more participatory, interactive and 'grounded' forms of governance, social and spatial planning (cf. Raco 2007; Julier 2011), design has become a powerful discipline charged with visualizing such futures in accessible, popular and persuasive forms (e.g. in Pipkin 2006; Vergragt 2010; Ilstedt and Wangel 2013). Through constructing abstract concepts (such as 'sustainability') in forms available for empirical (i.e. bodily) experience, the imagery and materiality of futures studies and design is powerful, shaping market demand, public opinion and cultural imaginaries (Dilnot 2015). As such future visions, along with their norms and priorities, shape both policy planning and our everyday cultures, there is much at stake in our professional disciplines of futures studies and design, as well as for us all, personally, in our everyday lives. Thus, we find the need to explore how 'the' (or other notions of) future and how design artifacts take part in (re)producing or countering social norms, practices and structures.

Ruth Levitas (2013) articulates three interrelated

ways of analyzing and constructing images of the future: *archaeologically*, which entails examining the ideological or discursive elements on which 'the' future is premised (for example, economic growth or individual wellbeing); *ontologically*, which involves declaring basic understandings of concepts such as human nature and time, and; *architecturally*, in which constructing alternate futures is in focus. Also relevant in our respective fields, these three ways are useful here for framing our critical exploration of intersections between futures studies and design.

In an archaeological light, for example, we can examine designed images of the future as prefiguring larger ideological programs or macro-scaled endeavors to re-design entire societies (Jameson 2005). Such images may include those well-known but unrealized, such as William Morris' 1890s socialist utopia *"News from Nowhere"* (see Mattsson and Zetterlund 2011) or those like Sweden's 1960–70s Million Program of housing that, in becoming reality, have become so normalized that their ideological or utopian aspects are hard to identify, but which, through re-examination, can also become re-politicized (see Bradley and Hedrén 2014; Hedlund and Perman 2012). Examining such examples, we can query not only the forms and functions but the worldviews on which they are premised, including for whom they are targeted, for whose benefit and for what socio-economic purposes. Examination can be of macro-scale societal implications, as in the case of futures studies scenarios that tend to be policy-oriented in outlook, or micro-scale, as design examples tend to focus on human-artifact relationships. Our main focus here is an increasing number of contemporary design-oriented future scenarios that bridge the macro and the micro, and which require critical examination concerning the societal narratives implied.

In this essay, we also take apart and piece back together some of the ontological concepts at stake in our work, revisiting turning points in our understandings and practices. What do we mean, for example, by 'the future' and 'time'? Countering universalizing narratives of time and 'the' future is one of the critical moves of feminist and post-colonial theory (see e.g. Harding 2008). Our question

is premised on Barbara Adam's challenge to modern conceptualizations of time as a linear commodity, regulated through industrial clock-time (Adam 2008), the future as simultaneously non-present and yet ultimately controllable, something to be colonized by those with power and resources. Through a feminist critique of this Modern (and essentially masculine) way of understanding time and futurity, we seek to open up for a plurality of understandings of time, temporality and futures. Challenging assumptions of determinism and control, we argue that the future is something that is always becoming, interwoven with the complex dynamics of human biological, socio-cultural, economic-political, bio-geo-chemical and astronomical formations. At different paces and in different ways, bodies, and places, the future is constantly turning into the present.

This leads us to a third exploration: that is, how different conceptions of the future may open up for different ways of conceptualizing and constructing everyday practices in the present. Without surrendering to im-possibilities (deterministic path-dependency toward 'the' future) or to supra-possibilities (in which everything is possible and there are no relevant limits), there may be other possibilities to conceptualize the relation between *present futures* and *future presents* (Adam and Groves 2007). Perhaps, to recall Levitas, this can include the construction of "prefigurative or interstitial utopias, places where a better life can be built even in the face of the dominance of [hegemonic ideologies]" (2013: 165). This might also recall her architectural mode of inquiry, but, for us, here, this includes a wider notion of conceptualization and construction that includes our everyday professional practices and personal practices. Considering the 'becomingness' that we articulate here, we explore the indeterminate interface between the present and the future, how our everyday practices, our material cultures and techniques endure or change, in different rhythms and ways, in a range of temporalities as diverse as ourselves.

Ultimately, ours is an exploration of some of the ways in which design and futures studies can be critical practices, and we, critical practitioners. Feminist, postcolonial, and environmental theories

Workshop guidance

Step 1, 10 minutes (on your own)

- Map your present and yourself within your social networks (as it exists today).
- Who makes up your social context and practices?

Step 2, 10 minutes (on your own)

Time-travel! You wake up in the future developed in Workshop part 1. What is the first thing you do? What are the first things you would like to do differently, who would you like to encounter? What is it that makes you understand that you are in another time? What happens next...

Step 3, 20 minutes (in groups)

- Meet one another in your future(s)
- Discuss your social network and time travel in terms of these questions:
- Who's future is it? Who creates/benefits from the future?
- Who is un/under/over-represented? Who is missing from the future?

Fig 15.1 Image created by a group in the workshop. The upper part of the poster shows how the participants see society today, and the lower part represents how they envision a desirable future.

are normative social theories, they are not neutral. In naming and framing phenomena and examples through such theories, we take something as an issue in ways that may destabilize the status quo or hegemonic understanding. By critical practice, we mean both critique 'outside-in', i.e. using critical theories to critically reflect on and develop the practices (including ideological and ontological implications) of design and futures studies, and critique 'inside-out' (see Mazé and Redström 2009). Critique from the inside, or criticism from within

(Mazé 2007), takes place here through anecdotal accounts of our everyday personal and professional practices, through which we reflect and examine larger societal phenomena (including ideological and ontological dimensions).

This essay stems from a class that we organized as part of the course Feminist Futures,[2] in which we opened up some of our conceptual questions in lecture form but also interwove professional and personal anecdotes as well as workshop activities to engage participants' perspectives (Fig 15.1). Here, inspired by feminist creative and research writing practices (Grillner 2005; Livholts and Tamboukou 2015), we expand an approach from our class session to mix our different voices, our professional and personal experiences, and multiple forms of expression. We unfold some of the turning points in our own practices, concluding with some thoughts on claims of determinism and of authority by planning, architecture and design in the shaping of futures.

In the Future When All is Well (or Goes to Hell)

The future, in our respective fields, tends to be posited as just that: 'the' future, a singular and separate reality, which might be arrived at through logical and linear pathways, seemingly free of judgment. However, such framings of 'the' future are far from neutral.

Such visions of 'the' future can be reproduced by design with deep and lasting effects on social practices and structures in the present, an example of which is the influence of the design manifesto *acceptera* within the ideological and socio-material construction of the Swedish welfare state (Mattson and Wallenstein 2010). *acceptera* is the first manifesto of Swedish Modern design (Åhrén et al. 2008 [1931]). Distributed by the publishing arm of the Social Democratic party, it is explicitly also political propaganda, evoking in text, image and form a modern or future 'A-Europe', "...the society we are building for", and 'B-Europe', or "Sweden-then": fragmented spatially and socially, but also temporally. Differences in values, cultures, families and customs are portrayed as regressive and stuck across multiple past centuries (Mattson and Wallenstein 2010), similar to how contemporary 'development' narratives are constructed based on a representa-

'ARK-INC'
by Jon Ardern and Benedict Singleton (UK) 2006

Critical service design in response to climate change scenarios.
'ARK-INC' combines strategies of art, design and research to re-
spond to extreme, but plausible, political, technological, and envi-
ronmental scenarios of the near future. 'ARK-INC' is a fictional
investment company. Instead of investigating in a tomorrow
that is much like today, it prepares its fee-paying members for a
future where natural resources are diminished, violent weather
part of everyday life, and social unrest widespread. The design of
'guerrilla infrastructure' communication systems, services that
enable practical and psychological adjustment to extreme situ-
ations, and domestic products for a 'post-Crash' world. Within
a new organizational idiom, combining features of a corpora-
tion, a social movement, a government, and a cult, design par-
takes in the branding of the apocalypse. "By shifting terms like
'sustainability', 'empowerment', 'community' away from their
often-assumed connotations of democracy and inclusiveness,"
argue 'ARK-INC's creators, "the project gestures towards, and
encourages debate about, the latent assumptions beneath the pro-
motion of 'responsible' practices of design."

LINKS
→ ark-inc.info
→ jonardern.com/projects/ark-inc/index.html

Photo: 'ARK-INC'

Fig 15.2 Facsimile from Ericson and Mazé 2011: 160–161.

tion of certain practices as 'primitive' or demoralized
(see e.g. see Wald 2008, on 'outbreak narratives'
in which disease and epidemics are described as a
result of particular cultures). A-Europe is premised
on a standardized society, allowing for industrializa-
tion at all levels, from that of large-scale communi-
cations networks to the micro and minor practices
of local farming, leisure activities and domestic
work. *acceptera* is a manifesto for development in
a predetermined direction, created on the basis
of a modern understanding of time, progress and
linear causality, a specific arrow of time premised on
industrial technologies and industrial design, leading
to a particular and singular societal future.

These singular and technocentric futures still
permeate our fields as well as other fields of research
and practice. This is perpetuated by research para-
digms premised on positivist ideas of cause-effect
chains and prognoses that advocate 'evidence-based
planning and design', or future projection based on
those things that can be known through measure-

ment and aggregation (Adam 2008). Other things,
such as social and cultural practices, psychological
and biophysical forces, and socio-ecological pheno-
mena, however, are less amenable to measurement
and prediction, except within the most experimen-
tally contained and limited contexts. This, in addition
to other underlying logics and assumptions in such
approaches, may partly explain why 'probable',
'possible' and 'preferable' future logics alike are
largely devoid of explicit explorations of the social
(Wangel 2011). Further, as Ulrika Gunnarsson-Östling
(2011) has established, futures studies images
and activities are largely devoid of women and
Non-Westerners as well as feminist issues or issues
of particular relevance to women. Through this
construction of silences, i.e. through not elaborating
on social or gendered preconditions or consequen-
ces of the suggested technological development,
both technologies and the entire image of the future
can be constructed as dis-embodied and free from
norms and values. However, just because the social is

not spelled out it is still there, we just have to look for it in between the lines of the technological development narratives. Making such a critical reading of even 'radical' futures studies, i.e. backcasting studies for sustainable development, shows that the social side of society is assumed to go on more or less according to business as usual (Wangel 2011). This also means that the critical potential of these images of the future is severely restricted since the critique can only take place through incremental alterations of the status-quo.

Such logics are also manifest in design as it intersects with futures studies. One contemporary example of the problem of not addressing the social is the 'One Tonne Life/Villa Bright Living' project, in which the overarching objective was to explore low-carbon living. The project is clearly premised on the idea of that a 'good' (or perhaps even decent) life which, even in a low-carbon future, includes living in a single-family house and owning a car. Indeed, since the companies running the project include one car manufacturer (Volvo) and one villa manufacturer (A-hus) this might not come as a surprise. The project was also premised on an understanding of a family as two adults (one man and one woman) with two children (one girl and one boy). On close examination, the family represents more or less every privileged way of being there is in (Swedish) mainstream society: they are white (and with Swedish names), middle-class, and seemingly cis-gendered and able-bodied. In this way, the One Tonne Life comes across as a continuation of the futuristic imaginaries from the post-war era, in which technological progress is premised on a norm-fixed social system. This, and other examples of increasingly widespread design 'foresight' (e.g. the influential project by Philips Design, *Visions of the Future*, see Baxter 1996) are 'preferable' futures privileging technological progress while merely reproducing or reinforcing social norms.

Such norms may be problematized within contemporary genres of 'speculative design' and its 'design fictions', self-consciously positioned in relation to sci-fi (Sterling 2009). Ben Singleton and Jon Ardern (2008), for example, developed 'ARK-INC' framed as a service design offer targeted at the select and economically privileged few within a future

society possessing the foresight to invest in financial and technical services in order to ensure their survival in a future climate crisis. Crisis preparedness training locations featured in fictional marketing campaigns include Chernobyl, thus blending history and the future in order to color that future through a popular trope of nuclear disaster brought on by the paranoia of a socio-political elite. In providing elaborate economic and technological defenses for the financially-elite 1% of the population in times of socio-ecological uncertainty, the project cynically exaggerates the elite clientele often served by design. ARK-INC's 'noir' future can be argued as a critique of prevalent normative visions of the future and how they are served by design.

Some speculative design projects may be understood as a kind of 'criticism from within' (Mazé 2007) a future predicted or preferred by science or policy. For example, some projects extrapolate a particular technological or biotechnological future from laboratory science, drawing attention (more or less intentionally) to underlying values and ethical dimensions by elaborating possible futures including unforeseen or deviant social, psychological and ecological effects. Assuming underlying values and norms, other projects, such as 'United Micro Kingdoms' by Anthony Dunne and Fiona Raby (2014), draw these out by juxtaposing potential differences and conflicts within the future among political ideologies, belief systems, and ideas about nature.

Within our own work, the 'Switch! Energy Futures' project (Mazé, Messeter, Thwaites and Önal 2013) elaborated 'superfictive' scenarios of alternative energy futures in order to draw out differences among and consequences of socio-economic and sustainability paradigms within contemporary policy (cf. Mazé 2016). Each 'superfiction' materializes tropes that can be traced within contemporary sustainable development and scenarios of energy futures. While one evokes a technological silver bullet or typically 'eco-modernist' trope, another raises issues of eco-disobedience and environmental justice, another articulates new forms of communal solidarity congruent with a 'de-growth' trope, while still another evokes increased individuation, austerity and separatism. The content of each 'possible future' varies: along with implied costs, benefits, exclusions

and beneficiaries, each is carefully crafted from a first-person standpoint in order to humanize possible experiences, worldviews and realities that are nevertheless very different. Since we were interested in opening up, rather than resolving or closing the future, each superfiction is designed so that further qualities emerge in juxtaposition when enacted in present-day participatory events involving stakeholders in debating possible future techno-social narratives. Thus, our intention in this project was to stimulate debate and change in the present concerning both the macro-ideologies and the micro-experiences underpinning possible energy futures.

Ours was a choice in contrast to most speculative design, which typically operates through the channels of the art world (ending in galleries, for example) and cultural media (occasionally featured on the culture pages of *The Financial Times*). Futures studies and design fictions can be (and claim to be) powerful: persuasive visions stir markets, politics and public debate alike. For the most part, however, design engaging with foresight or speculation on the future merely reproduces and perpetuates the economic and technological values already privileged within mainstream futures studies (see e.g. Prado and Oliviera 2014). While some design fictions appear technologically or ecologically radical, the extent to which they critique normative modernist and Western paradigms may lie in whether (or how) it is possible to imagine differences within or alternatives to a present society and its socio-economic, gender and other social structures. Here, we have drawn out some suggestive examples in this respect; however, while the content of these design fictions may query social practices and structures, a further question is whether or how such 'criticism from within' science and policy paradigms, typically confined to artistic and cultural venues, can actually counter or change such paradigms. An interesting instance of this dilemma is when those behind ARK-INC received a telephone call from the US Pentagon (Singleton 2009), offering a powerful and concrete potential to realize a future cynically portrayed. (Fig 15.2)

Telling Time (Josefin)

It was not until I started writing the cover essay of my dissertation that I became aware of my hitherto rather unreflected understanding of time. My thesis dealt with futures studies, and the concept of time suddenly surfaced from my unconscious as I realized that I actually did not know what constituted the future. Of course, I was familiar with the future, but in an intuitive and unarticulated way.

To understand the future, I needed to understand time. Or at least, so I thought. What did I know about time? How did I know time? From science classes in high school and at university, I knew time as a variable in equations. In physics, chemistry and biology, time was an essential component of speed, the half-life of radioactive substances and the population dynamics of fish. Time also came into play as geological eras and the loops of collapse and reorganization of systems ecology.

But I also knew that time was more. This knowledge, however, was not knowledge in the scientific sense but based on experience and bodily memories. I knew regret, hope, desire and fear. I knew waiting and achieving. And I knew longing and missing, and I knew that the difference between these was not as much a matter of the feeling as such, as in its temporal direction. When *Time* manifested in my mind, I was sitting at my kitchen table, where I spent what seemed like endless hours writing, hours that sometimes sped by and that, at other times, crawled slowly second by second.

– How come you never noticed me before? *Time said.*

– I'm sorry, I don't have time to discuss you right now, I need to understand the future.

– Sorry, Future is not here at the moment.

– I know that the future is not here now, then it would not be the future, right, but that's what I need to know about.

– I am Future too, you know.

– I know that! I know that you are the future, the present and the past. Or that the future, the present and the past are all part of you. What

I'm trying to understand is what the difference is between the part of you that is the future and the parts of you that are the present and the past. *Perhaps, I thought, I could just skip this entire discussion. No other futures studies thesis I had read had discussed the concept of the future with any depth.*

– Ok. I'll act as if I was one of these three parts of me that you mentioned, and you need to figure out which of them I am. Ok?

– Ok, *I said, taking a minute to think*. Have you happened?

– No, *Time replied*.

– Then you're Future!

– No, you can't make that conclusion. All things that have not happened are not Future. Some of the things that have not happened are Past. You see? Remember last year when you didn't get that project funded?

– Oh. So the future is that which has not happened yet. Not that which has not happened. But since the future does not exist in any prede-termined way but only as a mental construct…

– Mental construct? How do you know that?!

– How do I know that? Well, I suppose I just know it? Otherwise, the kind of futures studies I do wouldn't make much sense…

– So you are making conclusions about the existence of the future based on what fits your methods?

– But this is what everyone does, *I replied, knowing that this was not at all a good argument.*

It was not until I started querying (and indeed, queering) Time that I realizing how deeply embedded my understanding of the future was in unreflected norms. I knew that there were other ways to understand the future, such as believing in fate or other types of determinisms, but since I had not been able, or willing, to see these other ways as equally valid starting points, I had not seen the need to articulate my view on the future. I had fallen into the classic trap of priv-ileging the norm – that is, how things are usually assumed or expressed in my discipline – rather than explaining or arguing for my view. Having spent many years fighting and trying to uncover other norms, I should have known better. In the

end, I formulated my understanding of the future as follows (Wangel, 2012: 31):

In its most basic sense, the future is one of three time modalities, the past and the present being the other two. The future is not what has or has not happened. Unlike the present and the past, the future is that which has or has not happened yet. The future is the time modality for what may and may not happen. It is the abode of expectations, desire, hope and fear. Once real-ised, the future is no longer future but has shifted modality to the present or the past. This places the future beyond the scope of observational descriptions. According to this secular Western philosophy, the future is a subjective and/or social construct, existing only in our imagination.

I still agree with this understanding, with one exception: I do not believe that the future exists only as a mental construct. The future, as in that which comes after now, does not only depend on human imagination. If that was true, then everything would come to a halt were there no humans. Trees would no longer grow, winds would stop blowing – time (as I know it) would cease to be.

Growing, blowing and becoming are thus more than human dynamics. Our bodies transform as time passes (or as our bodily transformations mark time), but there are also transformations that involve intentional acts, whether conscious or subconscious. Indeed, even acts of non-transformation – of staying fit, staying healthy, staying alive – depend on intentional actions. Perhaps we can understand this as human becoming and our intentions to-wards transformation or non-transformation have been theorized not least in feminist discourse (cf. Jones 2010 [1981]; Haraway 1991; Grosz 1994). I can imagine other times, other realities, other 'I's, for example. Becoming as an intentional act always involves time, and not only futures but the present and past as well. My futures, and my understandings of the future are always shaped by my experience. And when I embark on transformation, it is not really some distinct and separate reality called 'the' future that I want to change, but rather (and closer to my practices in everyday life) the as yet unrealized

present(s) to come.

On reflection, dividing time into the categories of past, present and future assumes that time is linear. Linearity and these three categories, a tripartite ontology, can itself be queried as part of historically – and culturally – specific world-views (e.g. Adam and Groves 2007; Grosz 1999; Inayatullah 1990). If one supposes (as is common in some cultures) that time is not linear but circular, then concepts of past and future lose relevance, and there remains only the present and the non-present. However, even within a tripartite ontology of time, we can question causality and connections between the three categories. Politicizing Modern, Western, linear time, Adam (1998) highlights the complicity of clock time with the logics of industrial capitalism. She queries this as an abstract(ed) construct, at odds with complex, cyclical, interrelated, contextual and embodied cosmic, ecological and biological rhythms. Yet, it is industrial time that governs our lives, in which biopolitical time can be subsumed, as we are disciplined to suppress biorhythms reflecting seasonal daylight and hormonal cycles that affect some of us more than others.

Something – perhaps some of me and others – gets lost in the modernist paradigms underpinning many futures studies. The structural conception of diachronic or a synchronic time, of a/state b/progression billiard-ball theories of change that isolate progression along a causal line, can be understood as just one way of telling time, among others. Some contemporary philosophies counter such master narratives, for example, conceiving of time as a torrent of sheer 'becoming', "a stream into which," paraphrasing Cratylus, "one cannot even step once" (see Jameson 2005). Time and futures today seem to involve jousting between facts and constructs, universal claims or sheer relativity. Jousting indefinitely, we can also look to our own everyday social practices, in which ideals, artifacts and knowledge intersect in ordinary embodied and situated acts. It is in such practices that we can be critical, intentional and active, that we can participate in the science / fiction / fact of how 'the' future comes into being.

Fig 15.3 Wangel 2012. The photograph on the cover of my dissertation is taken by Lars Epstein, photographer and journalist, during the "the battle of the elmes" (Almstriden) in Stockholm, May 1971.

As part of the reconstruction of central Stockholm and the development of the underground metro, the City of Stockholm, backed by the Swedish government, had decided that thirteen old elm trees and a café in the park Kungsträdgården would be removed to make room for a metro exit. The battle over the elms was the culmination of a long period of increasing citizen criticism of approaches to the reconstruction of central Stockholm. The elm battle engaged people from a variety of backgrounds and developed into a matter of principle concerning citizen participation in urban planning and local democracy – i.e. the making of futures. Activists won the battle, the metro exit was re-located, and today some of the elm trees are still standing.

There are two reasons why I wanted a photo of the elm-tree battle on the front of my thesis. First I wanted the title of the thesis *Making Futures* to be represented by 'ordinary' people rather than planners, architects, politicians, and other urban decision-makers. Secondly, and related to this, I also wanted to show that future-making is by necessity a process involving conflict over what (whose) future to aim for, and how to get there.

Dating Practices (Ramia)

This wallpaper is from the 1930s. Of course, that's only the bare fact, data printed on the auction website (Fig 15.4b). In 2010, I bought my first apartment, in Sweden, far from where I grew up in a particular context within the United States, from my previous experiences, norms and things. In this new place, making a home, becoming in other ways than I could have foreseen, I began to restore my apartment. It

Fig 15.4a Testing samples of 1930s wallpaper

Fig 15.4b Wallpaper as featured in real estate listing

proved impossible to remove the fiber wallpaper pervasive in Sweden during the '80s and the techno-tropical 'feature wallpaper' installed by a previous owner. I hired a carpenter to plaster over everything. Thus, my walls restore a particular, preferred past layered on top of others subsequently preferred by other people. I searched into Swedish design history, registering myself in online archives from the 1930 Stockholm Exhibition, among others suggested by design historian Christina Zetterlund.

I telephoned a company near Göteborg that still produces its wallpapers from previous centuries but with modern techniques. I met a woman nearby who reproduces antique wallpapers with handicraft skills. I tacked up samples on my walls from different places and times, I scanned sample patterns into Photoshop and simulated possible interiors. Eventually, I decided on one.

I bought the last 12 rolls of the wallpaper in existence. It was produced with the industrial techniques of its time, blotched with imperfections and on a thin paper, not yet today's robust, identical and impervious products. Its pattern is abstract, recalling the Stockholm Exhibition, with a hint of the Orientalism in vogue. There is also reference to a history of floral motifs in the Swedish and European decorative arts, which I recognized from the archives. It is, in fact, the 1930s; more than that, in technique and pattern, it is a particular version of the Modern, one laden with specific traces of previous eras and idealized futures.

When it came to installing the wallpaper, I encountered further temporal dilemmas. My carpenter had no idea how to treat the wall or the paper in the right way. Searching for renovation firms, I had long conversations about past technical and material cultures in Sweden. I found someone who agreed to do the job, but only because he was able to consult the oldest employee in his firm. The paper, though rare, cost much less than today's wallpapers, but the specialized carpenter charged three times as much as an ordinary one. In that moment, I perhaps experienced the postmodern 'immaterial'

economy, in which knowledge is more highly valued than material commodities.

My wallpaper thus cannot be unambiguously dated. It's the most recent surface, though maybe the oldest paper, on walls transformed many times. Its techniques and pattern are of its time, and its particular histories and desired futures. The wallpaper is a complex socio-material construction: an extinct vintage that I prefer today, techniques and patterns laden with other times and regimes of knowledge, norms and skill. It endured in, and perhaps because of, the immaterial 'knowledge economy' involved in my renovation, and perhaps most enduring, in a brochure image that was part of real estate services when I sold my apartment, an image part of the paid professional 'styling' of the realtor targeting consumers of the trendy Södermalm lifestyle (Fig 15.4b).

Along the way, I became entangled in this complex temporal (re)construction – not just a catalog date. This '1930' assembles around it a complex web of histories and ideals, technologies and aesthetics, knowledge and practices of many people. Thus excavated, even a minor practice of home-renovation is far from trivial. Further, I was transformed, renovating shaped my own becoming, then, now, entangled in these specific socio-material and temporal forms, and this home in Stockholm, and my act of (re)constructing a preferred future for myself, at least for some time.

I also encountered time in my dissertation (Mazé 2007), specifically in the problematics of design beyond the real-time and human-scale. As I design smart textiles, electronic products and interactive environments, I engage with computational materials operating at speeds faster and scales smaller than can be directly grasped by the human senses, whether those of designers or users. Simultaneously, in practices of design and of use, such artifacts transform how I, and we, think, act and relate, thereby affecting longer – and larger – scales of social change and futurity. My doctoral thesis was also separated into three temporal registers, with the table of contents revealing a structure literally

separating micro and macro spatial-temporal scales with the real-time human-scale in between. Of course, this separation is a construct, just as '1930' is only one way of telling time. Micro-, human- and macro-scales of time coexist and intermingle in practice, just as pasts and futures fold into the fleeting present.

It is precisely such practices that give form to the future – social and material practices happen, take form and persist, thereby shaping the future even as it slips by the second into the past. My future home, and evolving past, continually take form through my practices of renovating in the present. Ways of doing everyday practices such as renovating, like mine above, as well as others such as cooking and bathing (see de Jong and Mazé 2016; Scott et al. 2012) travelling and gardening (Spaargaren et al. 2006) become naturalized into bodily action and daily habit. Practices become normalized as routines that embody the values and morals of family, work, community, cultural and social life. Thus, practices endure, happening in the present but also shaping futures through simultaneously solid and enduring, and leaking and fluid (Olofsson 2016; Tuana 2010), material forms, ideals (such aspiration for '1930') and knowledges (such as my design historical knowledge and that of my carpenter and real estate agent).

Embedded in such mundane practices is another form of power than that circulating through our professional practices in futures studies and design. We all do such everyday practices: they occupy/constitute our time, they transform our bodies, families, material cultures, economies, lifestyles and societies. While practices can take hold of us – for example, as renovating engaged me in a design culture, social network and lifestyle category – we continually negotiate in practice. Performing practices takes effort and is therefore purposeful (Shove et al. 2007): what I negotiate moment-by-moment is oriented toward particular ideas about my future, whether maintenance of the status quo or visions of how things might be different.

Circling back to the future

Even if practices are instantiated and may be recounted in terms of individual experience, as we have done here, they are also wider and longer-term socio-culturally and geographically variegated phenomena. These accounts of writing a thesis and renovating a home are only two possible variations: there are an infinite variety of other possible ideals, knowledges and material conditions that shape our and others' practices. Gert Spaargaren (et al. 2006) locates practices in between the micro-scale of individual actors and the macro-scale systems and structures, phenomena not easily measured or amenable to prediction. Practices are conditioned by many actors and groups, with local as well as societal implications, and they are sedimented (or resisted) within habits and families, generations and cultures; they influence and are influenced by institutions, infrastructures, policies and our own professions.

It is this 'in between' that Spaargaren refers where our professions have power, for example in (re)telling history, shaping cultural imaginaries and speculating on the future. This power is a 'soft' or 'symbolic' type of power, not necessarily amenable to measurement, prediction, nor linear and causal explanations. Nevertheless, it is always laden with normative assumptions, it speaks for and from particular points of view, in selecting or preferring one future over another (see e.g. Mattsson and Wallenstein 2010; Ehrnberger et al. 2012). Soft power acts through subtle punishments and rewards, persuading us of what is 'right', 'natural' and 'normal' to be, to do and desire (Bourdieu 1999 [1998]).

In this respect, a critical and feminist design and futures studies practice can be understood to aim at de-naturalization (and thus, re-politicization) through re-narrating the familiar in un-known and unexpected ways (also see Eckstein 2003; Merrick 2003). As Veronica Hollinger points out, "one crucial facet of the feminist project is the "telling of new stories that were previously invisible, untold, unspoken (and so unthinkable, unimaginable, 'impossible')" (2003: 128). This type of 'soft power' is of course not unique to our fields. For example, movies provide a social context for technology, a kind of 'diegetic prototype', making persuasive arguments about the functionality and benefits of specific technologies to the audience (Kirby 2009). Central to the film industry is the active participation of scientists and engineers with vested interests in creating interest in, accept-

ance of and demand for their inventions through technoscience 'product placements'.

The role of filmmakers in this context is not unlike that of designers in *Vision of the Future* and many other projects. Speculative design and design fiction can also reproduce 'technology push' or 'market desire', intentionally or not. Some such projects deconstruct associated norms, taking advantage of the (rarefied) milieu of art galleries and the cultural sphere to establish some 'critical distance' to the market forces and industry clients that circumscribe other designers. These may, however, not go as far politically or aesthetically as e.g. Ursula Le Guin, Octavia Butler and other feminist, queer and in other ways critical science fiction writers in elaborating alternative worlds and world orders (for an overview see any of the several feminist and queer sci-fi anthologies, e.g. Vandermeer and Vandermeer 2015, Notkin and the Secret Feminist Cabal 1998, Barr 1981, and Sargent 1975).

However, it is not only in fiction, but in the most ordinary practices of everyday life that norms surface in ways that are not soft at all (Fig 15.5). For us professionally, accounting for everyday practices is a way of philosophical jousting between facts or constructs, universal claims or sheer relativity. Such an approach can also account for time in the ontological sense that we explore here since time may be understood in terms of historical, cultural and ideological differences. This can also avoid the empirical shortcomings of predictions since, as we emphasize here, knowledge can be understood as always situated, partial and normative. For us, personally, insisting on excavating and recounting our own everyday practices, our agency and transformation complicates the possibility of any singular grand narrative, an objective or culture-free perspective.

My personal struggles with dress codes (norms) for female academics was cast in a new, politicized light when I stumbled over a blog post one day describing how these codes are "simply a reflection of the wider policing of women's bodies in other professional contexts in western society" (Stavrakopoulou 2014). I could now pinpoint and shift my sense of trepidation and inhibition, internalized as shame, in not follow-

ing 'the' norm. Suddenly, it felt easier to dress the way I wanted to. And to defend the rights of others to do the same. This outside intervention into my everyday reminded me again that, paraphrasing Simone de Beauvoir, you are not born a feminist, you become one, as well as that being (a) feminist is a continuous process.

This performative aspect of feminism was also highlighted several times during the course Feminist Futures. One example that I recall clearly is when the New Beauty Council (NBC), as preparation for one of the course meetings, asked all participants to bring a garment or a piece of accessories we love but that we would feel uncomfortable wearing in public. I immediately came to think of a dress that I had inherited from my great aunt. The dress was bright yellow and had a discrete checkered pattern in green and white, and it was way too large for me. But I loved it. I also came to think of my son and how he continued wearing his beloved Hello Kitty t-shirt, even when his classmates questioned him for this, and for his long hair.

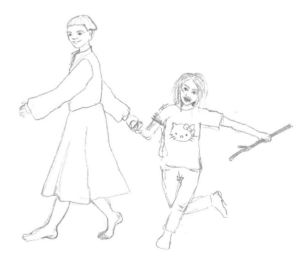

Fig 15.5 A picture and story by Josefin Wangel from one of the other Feminist Futures course sessions arranged by the New Beauty Council.

"We walk freely, joyfully moving. I wear the dress my great aunt made, right in every way, but size, color, style. But I walk freely, the matters of taste doesn't matter here. My son in his long hair and Hello Kitty t-shirt, right in his own right, right in every way, but ideas of how boys behave. But he walks freely, the matters of gender doesn't matter here. We walk freely, joyful."

Countering universalizing narratives of time and 'the' future is one of the critical moves of feminist and postcolonial theory. Sandra Harding (2008) demonstrates how such theories expose and challenge a spectre of "the Modern rational man" tacit within the sciences (also see Merrick 2003; Strengers 2014), a hegemony of grand narrative that presumes a universally valid history and culture-free prediction of the future. Harding argues that so-called 'modern' images, artifacts and knowledges are, in fact, spread in different ways to different people and places, intermingled with local practices in ways that cannot be privileged or separated without analysis of the power dimensions and politics of privileging one reality over another. For us, this means that we must continually interrogate time and notions of 'the' future, rather than presuming and reproducing norms embedded in the sciences, our professions, and indeed ourselves.

Determinisms and standpoints

Our encounter at the Stockholm Futures Conference and our reflections and collaborations since then continue to influence how we approach our professions in futures studies and design. We are more circumspect about the power, norms and determinisms underpinning our fields.

Design, like film, can have profound effects on market demand, public opinions and cultural imaginaries. Unlike film, it also enters deeply into everyday life practices, literally and materially touching and disciplining us through all of our senses: once, repeatedly and many times, (re)forming our bodies, habits, environments and relations. Aligned with a Latourian concern for the 'missing masses' in much technology and consumption studies, Elizabeth Shove and colleagues (2007) examine the material cultures of practice, in which artifacts carry meanings, have agency, and act as resources for the construction of individual and collective identities. Beyond the study of individuals as carriers of semiotic meaning, she pays attention to the relations among the 'complexes of stuff' comprising everyday life. Practices, becomings, are shaped by materialities and technologies, which may be given form by planning, policymaking, architecture and design. The power of design lies in deeply entering into everyday practices, including both those mainstream design artifacts intended both for mass consumption as well as speculative design intended for 'mass communication' (Dunne and Raby 2009) through other modes of consumption.

Nevertheless, design does not fully determine everyday practices. Images and artifacts are also negotiated in socio-material practices, reflection, resistance and agency, and have a part in how the future, or alternative futures, come into being. In order to account for and to allow such agency, we must challenge the reduction of everyday socio-material practices to grand or data-driven narratives, attend to heterogeneity and seek out not only continuity but discontinuities. As Ben Highmore articulates (2002), social practices cannot be reduced to macro- and slow-moving formulations that might be generalized in terms of culture, gender or geography, they are localized in materials, bodies and situations through which they are continually performed, reproduced and renegotiated. The ways in which socio-material practices co-evolve, making futures, becomes important to understand as situated, multiple and different. In this way, we can not only examine the conceptualization and construction of images of the future, but we must also critically examine how images, artifacts and knowledges spread in different ways to different people and places (Harding 2008).

Futures studies and design can thus question and counter a legacy of Western scientific 'grand' and 'universal' claims. Indeed, norms of practice, for example concerning decoration, hygiene and care, can be understood as highly gendered, cultural and racialized (Fallan 2012). Designs and policies for certain 'sustainable' renovation practices in the modernist Modern Program housing areas in Stockholm disadvantage certain socio-cultural groups and types of families (Hedlund and Perman 2012). Our respective work concerning planning and design for energy consumption argues that there is no universal 'good', 'proper' or 'sustainable' practice; rather, there are diverse practices that must be understood and valued in terms of how they are situated socially, culturally, historically and ecologi-

cally (Jonsson et al. 2011; Mazé 2013).

Futures studies, by articulating that there are not only predicted and possible but also 'preferable' futures, makes an important distinction for us. Moreover, we acknowledge the importance of material representations of preferable futures, as these, "no matter how imperfect or implausible, …allow us to become emotionally and corporeally invested in the promise of a better future" (Vrasti 2012). The 'preferable', if dealt with through critical practice, implies a selection, judgment and prioritization; it implies a human subject, or subjectivity, an intentionality, a standpoint, situated and positioned in a particular background knowledge, cultural context and historical moment. 'Who' comes into focus, both as the subjective makers of and as the envisioned subjects in such futures. We can ask, for example, who prefers what, for whom? Predicted or possible futures might refer to seemingly 'objective' data (and even data is, of course, more or less socially-influenced and -constructed (see e.g. Mauthner and Doucet 2003; Finlay 2002), but preferring one future over another is, explicitly, a social and even a political practice.

Futures can be understood as an everyday practice, made by professionals who are circumscribed by systems and structures reproducing the ideals, knowledges and material realities of individuals – but who must also take responsibility for their assumptions, agency and power. We are privileged in our professional roles and social positions, and as critical practitioners, we acknowledge the power dimensions and politics in how we select, prefer and privilege one reality over another. Indeed, as critical practitioners we work from the 'outside in' and 'inside out' to bring new social-critical and feminist theories to destabilize the status-quo of prevalent ideologies and ontologies embedded in the context of design futures, and we also work through our professional and personal practices to explore and live through alternative ideologies and ontologies. Inevitably, futures studies and design are embedded with preferences, subjectivities and normativities. However, futures studies and design can also be plural, positioned, and explicit about preferences, subjectivities and normatives, allowing other forms of agency, participation and practice. At the

Stockholm Futures Conference, 'prospective-action research', 'cultural-interpretive' and 'critical-post-modern' practitioners spoke (cf. Gidley et al. 2009; Adam 2008) alongside the technocentric, Modern and masculine orientations that still dominate futures studies and design foresight – we could say, "even in the face of the dominance of [hegemonic ideologies]" (Levitas 2013: 165). We position our work as part of this critical turn in futures and design practice, professionally as well as personally, towards the kinds of futures this may bring into being.

References

Among colleagues in a common project some time ago, we found ourselves discussing how design history and theory seem to be disproportionately dominated by male authors. I was writing at the time about how climate change disproportionately affects certain peoples, genders and parts of the world, and how design can reproduce such inequalities (Mazé 2013). Further scrutinizing the references in my article, I found my own citation practices dominated by white, Western, male authors. It is apparently, normal to cite female authors less frequently than males (Larivière et al. 2013), and I was reproducing a practice that contributes to systematically discriminate and exclude female academics, like myself, from advancing within academia (Savonick and Davidson 2016). I decided, equally systematically, to analyze and rectify my reference list. This involved quantitative counting but also set me off on a qualitative journey to engage with other authors, from many backgrounds and parts of the world. In the process, I encountered a wealth of examples, issues and approaches that I have only begun to explore, but which have fundamentally transformed my research content. My critical citational practice (cf. Ahmed 2012) has transformed my ideals, knowledges and the basic materiality of my everyday practice as an academic.

1
The Stockholm Futures Conference was themed 'Our Future in the Making' and was held on November 18–19, 2010, organized by the Swedish Institute for Futures Studies, the CESC Centre for Sustainable Communications and the FMS Environmental Strategies Research department at KTH Royal Institute of Technology. The positioning text for the conference articulated: "Particularly, we want to ask the question of the role and relevance of futures studies for making our future, for imagining alternative paths of development and helping us see the consequences and impacts of decisions taken today." Invited speakers included ourselves and many key scholars from across different eras, geographies and epistemologies of futures studies, including Teodore Gordon, Barbara Adam, Jennifer Gidley, Jaco Quist, and others referred to in this essay.

2
Our lecture and workshop was 'Scenarios for Sustainable Futures' on Sept 28, 2011. Ours was a one class session within the Feminist Futures course at the The School of Architecture and Built Environment, KTH Royal Institute of Technology, in collaboration with WISP (Women in Swedish Performing Arts).

16

SHIFTING GENDER AND ACTING OUT HISTORY: IS THERE A SWEDISH POSTMODERN-FEMINIST ARCHITECTURE?

HELENA MATTSSON

History is written in order to frame new historical facts, and consequently is a way of setting up a historical scene with actors, objects and events. It is the choice of the historian to construct perspectives, to position oneself in relation to the material and to decide the temporal and spatial locus of investigation – all these decisions make up the historical framework determining the interpretations. As a historian, the construction starts by taking stock of the source material: whose voices are expressed, which archives could be used, and maybe the most important reflection, which archives must be constructed? In this article, I will revisit postmodernism in architectural historiography, a period that to a large extent has been interpreted through limited source material, both internationally and in the local Swedish context. My aim is to establish a somewhat reorganized historical setting that establishes new relations between actors and events, and to connect the 1980s with the present.

The so-called postmodern shift that emerged in the 1970s is largely understood as a critique of modernism. The narrative is described through a few canonical texts, which consequently excludes a variety of other postmodern 'histories'. Through shifting perspectives and the construction of new archives, I propose an interpretation of the period that alters the most common understandings of postmodernism as a negation. Even though writers have emphasized that new strategies of 'political reorganisation' and actions by counter-movements like ARAU in Brussels (Atelier de Reserche et d'Action Urbaine) and ARC in London (Architect's Revolutionary Council) are crucial for the postmodern formation, they are basically formulated as critique. For instance, the architect Charles Jencks stressed in his canonical text *The Rise of Post-Modern Architecture* that "the next move (…) might be to incorporate itself [the counter-movement] as a necessary process to any large urban renewal."[1] The famous example of political reorganisation mentioned by Jencks is the Byker Wall project, designed by the architect Ralph Erskine.

This chapter will examine another understanding of political reorganisation by investigating the feminist architecture that took form during this period, unfortunately neglected by Jencks and most other historians.[2] However, the aim is not to engage in

polemics with earlier historiographers, but rather to outline narratives that can open for new beginnings in the interpretation of postmodernism through looking into feminist architecture. When written sources have been scarce, this research has drawn from oral history, meetings and private archives. This also raises questions about the content of 'official history' and what is saved in the archives, and how we as historians and researchers deal with the gaps and voids in such archives.

This overview highlights strategies and concepts formulated by women's liberation movements, starting in the 1970s and developing throughout the 1980s, covering a period that is often referred to as postmodern. Focusing less on the formal characteristics of buildings, these practices rethought the foundation of architecture based on patriarchal structures framing production as well as design. The discourse of women's liberation, as well as other emancipatory movements, had a major impact on the postmodern movement at large, and it is remarkable that this side of postmodernism is still poorly formulated in relation to architectural history.

Gendered postmodernism

It is often said that the term 'postmodernism' was first used, and perhaps even invented, in the field of architecture. Though this might not be completely correct, it was in fact through architecture that the term became famous, becoming popularized to the extent that it formed an 'ism'.[3] As pointed out earlier, the so-called postmodern shift in architecture was constructed through canonical works made by a limited group of theoreticians and practitioners who were (not surprisingly) mainly men. According to the art historians Mark Crinson and Claire Zimmerman, the most important works creating the canon are buildings from Robert Venturi's *Vanna Venturi's House* (1962–64) to James Stirling's *Neue Staatsgalerie* (1983). The books they list are: Venturi's *Complexity and Contradiction in Architecture* (1966); Venturi, Denise Scott Brown and Steven Izenour's *Learning from Las Vegas* (1972); Aldo Rossi's *L'Architettura della Cittá* (1966); Colin Rowe and Fred Koetter's *Collage City* (1978), and George Baird and Charles Jenck's *Meaning in Architecture* (1969).[4] Even though

one of the most important objectives of the postmodern discourse was to deconstruct the universal narrative of modernism through situated micro-histories, the result was a uniform idea, though with some deviations, of what postmodern architecture was and had been. Although political aspects were already stressed in the formation of the movement as pointed out earlier, postmodernism was (and still is) to a large extent understood in terms of formal expressions, pastiches and ironic play with style and historical elements.

Broadening the perspective by looking into the early discussions on postmodernism and feminism sheds some light on the theoretical framework that has inspired this article. The interactions and overlaps between feminism and postmodernism are tricky to trace and contain multiple contradictions. On the one hand, 1960s feminist theories, together with racial and postcolonial discourses, have been crucial for the development of postmodernism; on the other hand, the understanding of postmodernism is coloured by a male interpretative prerogative. Parallel to the formation of a 'postmodern feminism' at the end of the 1980s, one finds a vociferous critique of postmodernism and poststructuralism from several feminists.[5] As pointed out by the literary scholar Linda Hutcheon and cultural theorist Teresa L. Ebert, an understanding of postmodernism as conservative and apolitical, formed by a gender imbalance, led to a situation where many feminists withdrew from the postmodern discourse in fear of trivializing their own feminist work.[6]

Obviously, many different interpretations of postmodernism were in play at the same time, and several writers argued for a more nuanced view of its relationship to feminism. Nancy Fraser and Linda Nicholson asserted that postmodernism offered sophisticated criticism of foundationalism and essentialism, while feminism offered "robust conceptions of social criticism", and that an overlap between these two perspectives would strengthen both strains.[7] Teresa L. Elbert proposed two trajectories of postmodernism: "ludic postmodernism" presents reality as a theatre for playful images, while "resistance postmodernism" understands the relation between word and world, representation and reality, as the effect of social struggles, and therefore necessitates

a materialist political practice.[8] According to Elbert, the focus on ludic postmodernism had framed the feminist critique of postmodernism in an unproductive way. Postmodernism as a 'movement of resistance' stemming from minority and activist groups forming new political constellations – like feminism, environmentalism, and non-Western perspectives – is also articulated by the literary scholar Andreas Huyssen.[9] Furthermore, Hutcheon stresses that postmodernism *is* political but with obvious limitations: it challenges the dominant discourse, and thereby also reproduces it.[10] She framed postmodernism in *The Politics of Postmodernism* (1989) as a theory that deconstructs without constructing anything new, and thus lacks a proposition of agency, "a positive action on a social level".[11] Using these early formulations of postmodernism and feminism – Elbert's "resistance postmodernism" and "ludic postmodernism", Fraser's and Nicholson's "robust conceptions of social criticism", Hutcheon's "positive action on a social level" – as points of departure will open for a new interpretation of a Swedish postmodern-feminist architecture.

My purpose here is not to focus on the 'postmodern shift' as critique, but rather on that which was constructed. The feminist movements in architecture that I will present never called themselves postmodern. Since everyone at that time avoided the label, one could say that there never existed a truly postmodern Swedish architecture; however, another interpretation could be to define the rich variations of expression in Swedish architecture as postmodern, including a critique of modernism as well as propositional ideas for the future. Focusing on feminist practices and discourses in this major societal transformation implicates a framing of 'the postmodern' not as deconstructions of former ideas, but rather as constructions of new ones. Importantly, this discourse was concerned less with the formal characteristics of buildings than with forces related to production, finance and power structures regulating the conditions of architecture.

Fig 16.1 Book cover, Edmund Dahlström, (ed.) *The Changing Roles of Men & Women* (1967)

Moving into the midst

A radical research report that introduced the concept of gender roles in a Nordic context, *The Changing Roles of Men & Women*, was published in 1967, with a cover depicting a female construction worker (Fig 1).[12] This popularised a new imagery of the liberated Swedish woman who had transgressed traditional gender roles, and it was widely exported abroad. The image was theatrically staged, showing a young woman as a construction worker (posing as a construction worker?) – the most male dominated profession of all. The image draws upon the sexy, soft and natural imagery of the Swedish woman, an image that had become exported, for example, by the main character in Ingmar Bergman's *Summer with Monika* (1953). As pointed out by Yvonne Hirdman, the image communicates the duality of the traditional male and female metaphors: a beautiful and fragile woman working with her bare hands and a smile on her face. As Hirdman wondered, "who could take this happy wench seriously?"[13]

Even if the caption tells us that the picture is showing one of the few women actually trained as a construction worker, it also explicitly states that "explosives must be handled with care."14 While the 1990s may have been the first time it was possible to

portray a woman in a traditionally male role without a smile on her face, the period of change when new gender relations were taking form really began in the 1980s. Looking specifically into the sphere of architecture (ranging from planning, design and policy making, to built structures) it is clear that new sensibilities, emerging from the feminist field, were taking form during the late 1970s and the early 1980s, and resulted in shifts affecting power relations, economic and social conditions, as well as the role of architecture in society at large.

In the wake of the 1968 movement, *Sveriges Civilingenjörsförbund* (Swedish Association of Graduate Engineers) established an equality council in 1970 which analysed women's situation in the engineering profession, which existed until its shutdown in the late 1970s. The discussions on women's professional situation moved from the professional organizations to women's liberation movements like *Fredrika Bremer Förbundet*, which organized a thematic week around women and technology entitled 'Technology in the Home' 1979 at Stockholm's *Tekniska museet* (The National Museum of Science and Technology).

1979 was a crucial year in Swedish feminist architectural history. A new professional association, *Nordiska kvinnors bygg- och planforum* (Nordic Women's Building and Planning Forum), was set up to work with questions on the women's role in the building sector. This new association was a conglomeration of three Nordic subgroups: the Danish *Kvinder i byggsektorn* (Women in Building Business), the Norwegian *Kvinnopolitiskt planforum* (Planning Forum of Women Politics), and the Swedish *Bo i Gemenskap* (Living Together). They organized an important conference in Kungälv during 7–8 September in 1979, which paved the way for in-depth discussion (as well as real change) regarding the role of women in Swedish architecture. In 1980, a feminist platform would subsequently take shape in Sweden: though occurring through different productive environments, it was unified in the shift from deconstruction and critique to construction and vision.

I will consider two different matrices here, addressing topics more or less neglected in the architectural discourse of that time. The first is is the loose group *Bo i Gemenskap*, BiG, that worked with

the habitat as a potential place for emancipation from traditional gender roles. The second is *Kvinnors Byggforum* [Women's Building Forum], or KBF, which was an organized association promoting women's roles in the construction industry: as architects, project leaders, builders and so forth. Besides these, there were many other initiatives like the research project Det nya vardagslivet [The new everyday life][15] or *Föreningen Sveriges Kvinnliga arkitekter ATHENA* [The Association of Sweden's Women Architects ATHENA], founded in 1986.

Postmodern-feminist architecture

As early as the 1930s, Swedish intellectuals such as Alva Myrdal supported collective housing. Myrdal collaborated with the architect Sven Markelius in planning and building iconic collective housing in Stockholm. This 'first wave' of collective apartment buildings was based on a division of labour, meaning that employed people (often women) provided services for the residents, such as cooking, cleaning and childcare. On the one hand, it enabled a restructuring of traditional gender roles for the people living in the building; on the other, it supported a class and gender differentiation for those working in the building. Ultimately, property developers and real estate companies would withdraw from the collective housing market in the mid-1970s.

During the financial crisis, which coincided with the collapse of the collective housing movement in the 1970s, a group of women architects, writers and intellectuals met to discuss new possibilities for organizing collective forms of living. They developed strategies for rethinking the house and the home; they defined new areas of research and initiated seminars at Swedish universities. This resulted in the formation of the project/group *Bo i Gemenskap*, BiG. Their activities were aiming to move beyond analysing the structures and formulating critique, instead, the main goal was to imagine a new reality; what they called "utopia in reality".[16] They defined and investigated a 'level' of reality where things were made together, collectively, in what later became labelled as the 'middle level' (*mellannivån*).[17]

BiG developed a strategy labelled 'practical activism', where they constructed models for the

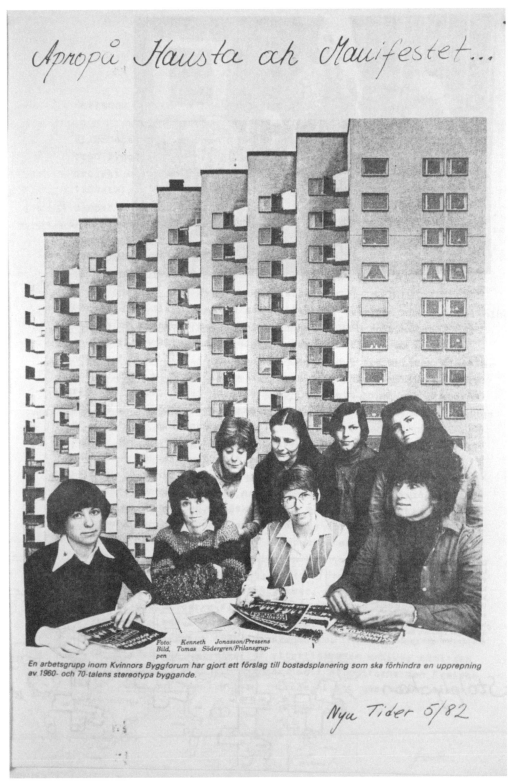

Apropå, Hausta och Manifestet...

Foto: Kenneth Jonasson/Pressens Bild, Tomas Södergren/Frilansgruppen

En arbetsgrupp inom Kvinnors Byggforum har gjort ett förslag till bostadsplanering som ska förhindra en upprepning av 1960- och 70-talens stereotypa byggande.

Nya Tider 5/82

Fig 16.2 A working group in KBF that made a proposal for a renewal project, *Nya Tider*, No. 5, 1982

future habitat.[18] Their work demonstrates a new attitude towards activism and feminist strategies in the field of architecture, moving from a critique of power structures to real changes *within* these power structures. Through their positions as writers for widely circulated magazines and newspapers, and as occupants of central positions in the Swedish Association of Public Housing Companies as well as in the Swedish Association of Architects, they had the capability to change reality. BiG managed to launch the idea of a 'second wave' of collective housing, based on labour distribution between inhabitants rather than earlier distinction between employees and inhabitants. This was more attractive for the developers, with whom they worked closely, and in the 1990s almost fifty collective houses were built.

In the same year that the crucial Kungälv conference took place, 17 women working in the building sector as architects and engineers met in Stockholm under the name *Kvinnors Byggforum*, KBF.[19] Inspired by the UIA (*Union Internationale des Architectes*) meeting in Mexico City 1979, where UIFA (*Union Internationale des Femmes Architectes*) discussed questions of equality and feminist aspects of planning and housing, an association was formally constituted in 1980. At this time, women's associations for architects were being founded around the world, with the issue of 'hidden discrimination' on the agenda.[20] This was an international trend during the late 1970s, and this message was disseminated worldwide.

If BiG was working with practical activism to reformulate the habitat as an emancipatory space and platform for new opportunities, KBF wanted to change the structures in the building sector: women should be equally represented in decision-making bodies; women should be active as project managers, builders and developers; women's studies in architecture should be included in the educational content and take place in public debate. Feminism was seen as a revolutionary power in the field of architecture and planning during this period: not just in regards to equality between men and women, but in its implications of new perspectives on technology, planning, and the built environment at large – a struggle that acquired its own symbol.

The work that started at the conference in

Kungälv, where hundreds of women formulated their visions for a future society, continued in different working groups, all with specific tasks such as reviewing the proposal for a new planning and building law, analysing new loan regulations, putting together a program for women's studies in architecture and writing a handbook on planning for women.[21] Like BiG, KBF became an expression of how feminist activism had moved from a critical approach to a constructive position, trying to change reality and to enter into existing power structures.

Fig 16.3 The symbol for KBF on a pamphlet from 1985

1980: The summer of postmodernism

1980 was the year of postmodernism in architecture. Internationally the movement was manifested through the 1st Venice Architecture Biennale, *La presenza del passato* (The Presence of the Past); in Sweden, a range of exhibitions were organised that discussed modernism in light of the 50th anniversary of the Stockholm Exhibition in 1930. As in Venice, the term 'postmodernism' was avoided in the Swedish context, but the reappearing message was a critique of rational, large-scale industrially-built housing programs associated with modernist housing areas, and the lack of small scale, individual-

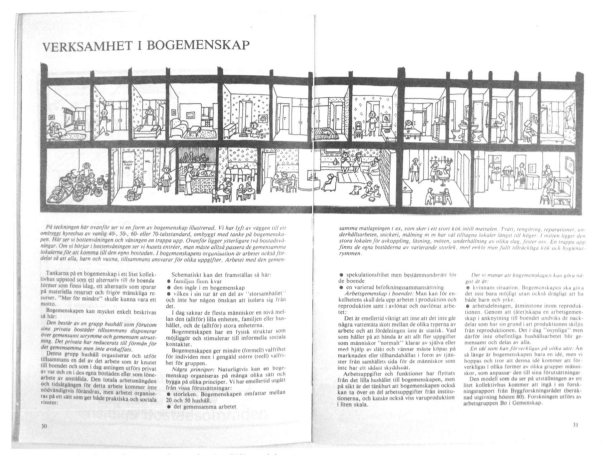

Fig 16.4 A spread in the Boplats 80 catalogue showing BiG's model

ized typologies, democratic planning processes and women's perspectives pointing towards new values in architecture.

In Stockholm, one of the largest manifestations in 1980 was the exhibition *Boplats 80*, which was supposed to be a follow-up of the Stockholm Exhibition. It took place in a tent structure designed by Ralph Erskine in the central city park *Kungsträdgården*, organized by the Swedish Association of Architects. Many organizations were invited to comment on the 1980s habitat, among them were BiG and KBF. "The freshest ideas come from the women" was a headline in *Aftonbladet*, one of the largest Swedish newspapers.[22]

In the exhibition, a model of a refurbished modernistic slab structure from the 1940s made by BiG showed an alternative collective living in an old building. This expressed the possibilities of alteration as an alternative to demolition. The model was carefully furnished like a dollhouse, showing the common spaces like workshops, laundry, common living rooms, kitchens and dining areas. They presented this as an idea which could be realized through different strategies and exhibited it as a work in progress. A crucial idea presented in both model and text was the general lack of a level between the small-scale family and the large-scale society, 'the middle level'.

At the same exhibition, KBF worked in full-scale to create an environment for the visitors to move through. This was a way to counteract the abstraction of the (male) text-and-image exhibits hanging flat on the wall. They had built an entrance and a hallway: collective, in-between spaces they claimed were often neglected or treated by routine. KBF also suggested rough areas where one could paint, do crafts, and repair things in contemporary apartments. Like BiG, KBF invented new spaces and new

uses in the living spaces of the 1980s apartments, and both groups encouraged individuals to control the organisation of their own space.

Fig 16.5 Drawing showing a workshop in a private apartment. KBF's pamphlet Boplats 80

Concluding remarks and 'moving into the midst

Gunilla Lundahl, a journalist writing on architecture and feminism who was one of the participants in BiG, describes the postmodern period as marked by contradictions: it was political and apolitical at the same time.[23] The Swedish financial crisis at the end of the 1970s changed everything. Suddenly, it was not possible to be critical anymore; no one could afford solidarity in the same way as in the early 1970s. Volunteer work disappeared from the agenda, state support for culture was cut to almost zero and the museum sector was closed to politically progressive actions. Instead, it was pleasure and enjoyment that became the new source of invention.

This backdrop is crucial for understanding the paths taken by the feminists in the 1980s. It was through direct action and professional positioning, the enjoyment of building full-scale models and making handbooks for immediate impact, and through playing with dollhouse models and starting associations that it was possible to act. It was essential to be professional and to act in the midst of things. It "…was more fun to develop new concrete strategies for how to live in the future than to

discuss and critique the discriminating structures".[24] Interestingly, one can notice that the way taken by these women were a combination of the two trajectories of postmodernism described by Teresa L. Ebert – the ludic and the resistance. As one of the practices of several feminisms and postmodernisms, this strategy was rather constituted on 'a ludic resistance'.

Among others, the feminist and political theorist Nancy Fraser suggests that new relations between forces protecting society from the market and forces set free by commodification and a deregulated market must be made. Fraser understands this ambition as a political project, which she calls emancipation, that started in the post-war years.[25] For sure, this is a path already travelled by the women architects of the 1980s – though a neglected path of postmodernism – it still has a lot to teach us even today. From a women's perspective, the postmodern period could be described as a shift from critique to action and from deconstruction to construction. In the 1980s, the feminist activists in the field of architecture left the streets and entered into the midst of power structures, where they exercised their 'practical activism'.

I conclude here by discussing the potential impact of constructing events, facts and historical consciousness – and to frame this historiographical exposé in the present. The account I have given here was actually precipitated by a coincidence (as perhaps most histories are): my historical project at the time involved looking into the records of Swedish 1980s architecture concerning connections between the postmodern movement and major social transformations marked by deregulations and marketizations. In the process, the importance of the feminist movement as one of the most obvious and strongest manifestations during the period clearly emerged. However, almost no contemporary research had been done on the topic, and historical records were not to be found in the archives. Consequently, an archive had to be constructed.[26] Through contacts with KBF, who are still active,[27] I learned that the archive of the Swedish Architecture and Design Centre in Stockholm was not willing to accept their material, consisting of drawings, photos, letters, manifestos and protocols. For that reason,

the members had decided to make selections and throw away old material; a crucial historic material memory, difficult to reconstruct (if even possible), was on the verge of disappearing. But together, we managed to collect and preserve the material, which today exists as a small but crucial archive in my office space, with binders, photos and file folders.[28] Underscoring the connection between the postmodern movement and the feminist movement, the material happened to end up on the shelf just above the archival material from one of the leading architectural critics, displaying the canonical magazines forming the postmodern movement. Consequently, when I raised my gaze to look at the shelf above, the spatial organization of the material prompted the realization of what had to be done in terms of historical inquiries and theoretical interpretations. For all of us trying to understand and contextualize postmodern architecture, a critical task is the need for *shifting gender*.

On March 7 2015, the day before Women's Day, the KBF held a pep-talk evening and invited me to speak on their history. This event demonstrated how important and explosive history can be, even if KBF nowadays deal with a broader gender perspective than in the 80s, covering the issues relating to the whole LGBTQI spectra. The space was filled with people, from new members to founders of the organization; the exhibition of pictures of their own archival material created a powerful historical consciousness of finding new strategies for 'moving into the midst'. This way of 'acting out history', where founders together with new members could discuss and relate to pictures shown and react to readings of old manifestos, created unplanned connections over time, where central issues for the young LGBTQI -generation overlap with the struggles of the 1980s feminist movement. The event pointed towards the core of something important: a common struggle over time, driven by desire and 'ludic resistance', continuously active in the construction of a feminist future.

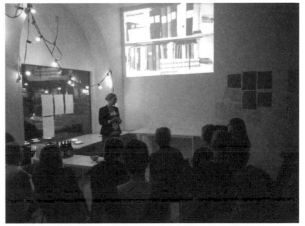

Fig 16.6 Me speaking the day before Women's Day at the KBF

1
Charles Jencks, "The Rise of Post Modern Architecture", *Architectural Association Quarterly* 7, no. 4, 1975, p.7.

2
Parts of this article have previously been published as "Revisiting Swedish Postmodernism: Gendered Architecture and Other Stories", *Journal of Art History*, 85:1, 2016, pp. 109–125. I want to thank members from the Kvinnnors Byggforum, KBF, among them Frida Brolund, Tatjana Joksimovic and Ulla-Liza Blom, without whose support this research would have been impossible.

3
The painter John Watkins Chapman speaks of "a postmodern style in painting" in the 1870s; the historian Arnold Toynbee sees the end of "the modern" in the 1930; Irving Howe used the term in his essay "Mass Society and Postmodern Fiction"; Charles Olson together with artists and poets from Black Mountain College use it against Formalist poets. In the late 1960s and early 1970 the term started to signify a distinct development in American culture in the writings of Leslie Fiedler, Dick Hebdidge, and Ihab Hassan.

4
Mark Crinson and Claire Zimmerman (eds.), *Neo-avant-garde and Postmodern. Postwar architecture in Britain and beyond* (New Haven, Yale University Press, 2010) p. 20. Other canonical texts to mention are Charles Jencks, "The Rise of Post-Modern Architecture", *AA Quarterly* 7 no. 4, 1975 pp. 3–14; *The Language of Postmodernism* (New York: Rizzoli, 1981), Robert Stern, "Gray Architecture as Post-Modernism, or, Up and Down from Orthodoxy", *L'Architecture d'aujourd'hui* 186, 1976, pp. 169–171; Manfredo Tafuri, "The Ashes of Jefferson", *The Sphere and the Labyrinth: Avant-gardes and Architecture from Piranesi to the 1970s* (Cambr. Mass., MIT Press, 1987), pp. 291–303. Events that became symbolic to the rhetoric of the critique of modernism were the demolition of the Pruitt-Igoe public housing project in St. Louis (1972) and the collapse of the Ronan Point apartment tower in London (1968).

5
For the formation of a postmodern feminism see for example Nancy Fraser and Linda Nicholson, "Social Criticism without Philosophy: An Encounter between Feminism and Postmodernism", *Theory, Culture & Society*, Vol. 5 (1988), pp. 373–394; Judith Butler, *Gender Trouble: Feminism and the subversion of identity* (New York: Routledge, 1990); Donna Haraway, "A manifesto for Cyborgs: Science, technology, and socialist feminism in the 1980s", *Australian feminist studies*, no. 4, 1987, pp. 1–42. For a critique of postmodernism see for example Linda Alcoff, "Cultural Feminism versus Poststructuralism: The Identity Crises in

Feminist Theory", *Signs* 13, no. 3, 1988, pp. 417–418 and Susan Bordo, "Feminism, Postmodernism and Gender-Skepticism" in Linda Nicholson (ed.) *Feminism/Postmodernism* (New York: Routledge, 1990), pp. 133–156.

6
Kathleen O'Grady, "Theorizing Feminism and Postmodernity: A conversation with Linda Hutcheon", *Rampike*, Vol. 9, No. 2, 1998, pp. 20–22. Teresa L Ebert, "The 'Difference' of Postmodern Feminism," *College English*, Vol. 53, No. 8 (Dec., 1991), pp. 886–904. This is also formulated in relation to architecture and space in Jane Rendell, Barabara Penner and Ian Border (eds.), *Gender, Space, Architecture: An interdisciplinary introduction* (London: Routledge, 2000), and see, for example, Rosalyn Deutsche's chapter "Men in Space", pp. 165–202.

7
Nancy Fraser and Linda Nicholson (1988), p. 374.

8
Teresa L Ebert (1991), p. 887.

9
Andreas Huyssen, *After the Great Divide: Modernism, Mass Culture, and Postmodernism* (Bloomington: Indiana University Press, 1986).

10
Kathleen O'Grady (1998), pp. 20–22.

11
Linda Hutcheon, *Politics of postmodernism* (London: Routledge, 1989), p. 22.

12
Edmund Dahlström (ed.), *The Changing Roles of Men & Women* (London: Gerald Duckworth, 1967).

13
Yvonne Hirdman, *Vad bör göras: Jämställdhet och politik under femtio år* (Stockholm: Ordfront, 2014), p. 21.

14
The expression was used by Gunnar Myrdal in *An American Dilemma* (1944) describing the relation between black and white groups in the US, and was picked up by Hirdman (2014) in relation to the history of gender equality, p.11.

15
The project included researchers from several Nordic countries: from Denmark Birthe Bech Jørgensen, Tarja Cronberg, Hedvig Vestergaard; from Norway Sigrun Kaul, Anne Saeterdal; from Finland Liisa Horelli, Kirsti Vepsä; from Sweden Ingela Blomberg, Birgit Krantz and Inga-Lisa Sangregorio. For more information on the project see Birgit Krantz, "Kvinnovisioner om ett nytt vardagsliv". *Tidskrift för genusvetenskap*, No. 2, 1991, p. 43–53.

16
Interview with Gunilla Lundahl, Stockholm, October 20, 2014.

17
Birgit Krantz (1991), p. 49.

18
Interview with Gunilla Lundahl, Stockholm, October 20, 2014.

19
Cecilia Philipson, Kvinnors erfarenheter ska tas tillvara!, *AT*, No. 16, 1979, p. 13.

20
Charlotte Rapp, "Kvinnliga arkitektmöten på gång", *Arkitekten*, No. 5, 1979, p. 7.

21
Amelie Tham, "Med boendet och hemarbetet som aktionsbas". *Arbetaren*, No. 12, March, 1980, p. 20.

22
Lennart Arnstad, "Kvinnorna har de friskaste idéerna", *Aftonbladet*, May 23, 1980.

23
Interview with Gunilla Lundahl, October 20, 2014.

24
Ibid.

25
Nancy Fraser, "A Triple Movement? Parsing the Politics of Crisis after Polany" *New Left Review*, No. 81, 2013, p. 128.

26
KBF and BiG are mentioned in earlier research but no in-depth study has been made, see for example Carina Listerborn, *Trygg stad: diskurser om kvinnors rädsla i forskning, policyutveckling och lokal praktik* (Göteborg: Chalmers tekniska högskola, 2002) and Helena Werner, *Kvinnliga arkitekter. Om byggpionjärer och debatterna kring kvinnlig yrkesutövning i Sverige*. Göteborg: Acta Universitatis Gothoburensis, 2006).

27
See www.kvinnorsbyggforum.org

28
Special thanks to Frida Boström (KBF board member at that time) who organized this.

FUTURIST FEMINIST POLITICAL ECOLOGY – REWRITING STOCKHOLM'S VISION 2030

KARIN BRADLEY,
ULRIKA GUNNARSSON-ÖSTLING
AND MEIKE SCHALK
WITH JENNY ANDREASSON

Despite increased environmental awareness as manifested in plans and policies for sustainable development, new ecotechnology and ecolabelling of products, the trajectory of increasing resource use and global emissions of greenhouse gases has not been curbed (WWF 2014). Rather, the strategies for greening cities in the wealthy global North have at times displaced socioenvironmental problems to the hinterlands and/or to distant peoples and territories. As Swyngedouw (2007, p. 36) has phrased it, there is an urgent need for "foregrounding and naming alternative socioenvironmental futures", in plural. We argue that taking a feminist environmental perspective is productive in rethinking the dominant development path, i.e. seeing that the domination of other genders and species are interlinked and calling for systemic change. In this chapter, we develop an analytical framework that can be used in urban development practices and in formulations of city visions that strive for more environmentally just feminist futures. By cross-reading feminist political ecology and ecofeminist literature with feminist economic geographers such as J.K. Gibson-Graham and peak-oil strategists such as Sharon Astyk, we develop a *futurist feminist political ecology perspective*. With this framework, we read and rewrite the City of Stockholm vision for the year 2030 and discuss it with citizen groups and city officials. Through fictional stories and images of the future, we show how alternative analytical frameworks such as ours can be used in urban visioning and strategy making towards more environmentally just futures.

In spite of years of environmental alarms and international, national and local programs for *sustainable development,* there is still much more to be done in order to safeguard an environmentally just development. Even countries claiming to have achieved 'green growth' and a position at the forefront of sustainability, like Sweden, have actually raised greenhouse gas emissions in the last decade.[1] Low-income nations, and more specifically low-income groups, are generally the most vulnerable to the consequences of climate change, while having the least impact on its causes (Agyeman et al. 2003, Schlosberg 2013). As has been illustrated by environmental justice research, there are recurrent patterns of injustices between territories, socioeconomic

groups, ethnicities and genders in terms of access to environmental resources, as well as exposure to environmental risks (e.g. Low and Gleeson 1997, Bullard 2000, Agyeman et al. 2003, Walker 2011, Schlosberg 2013).

At a time when international and national institutions have had difficulties handling climate change, expectations have been placed increasingly on the local or city level to take the lead in sustainability politics (Raco 2007). In the field of sustainable urban development in the global North, efforts have been made to transform the technical infrastructure and built environment: green roofs, new light-rail trams, densification schemes, bike lanes, energy-efficient building materials and environmental rating systems (Farr 2008, Nijkamp and Perrels 2009, Wheeler and Beatley 2009). These types of initiatives are often regarded not only as beneficial for the environment, but also good for the city's attractiveness, global competitiveness and economic growth. In this way, potential conflicts between ecological sustainability and other societal goals, such as economic growth, are generally not foregrounded. However, as Keil (2007, p. 56) argues, these types of strategies for greening cities "…cannot reach deeply enough to fundamentally redirect the destructive dynamics of today's urbanism". Moreover, in the 'smart growth' and 'sustainable urbanism' strands of research and related best practice, there is little critique of the overall unsustainable socioeconomic structures in which these practices are imbedded (Keil 2007, Swyngedouw 2007, Bradley et al. 2013).

What is needed to bring climate change under control is a profound transition of the dominant socioeconomic order – a redirection of the over-consumption by the few at the expense of other peoples and territories (Worldwatch Institute 2012). The often-used conceptualizations of sustainable development as a Venn diagram, searching for ecological, social and economic dimensions in balance, seems of little help on the path towards a more profound transition. What conceptualizations might be more useful, then? There are several alternative perspectives and traditions to draw from which demand radical systemic change, including deep ecology, ecofeminism, environmental justice and political ecology. Our primary intention is not to add

to the societal critique, but rather to illustrate how futures can be imagined and articulated differently. As Bergman et al. (2014, p. 67) point out, describing varied futures "…could be a way of making temporal knowledge production more tangible and engaging, as well as a way of intensifying the debate about the future in politics and planning". We are therefore inspired by the academic field of futures studies, which provide stories/images about the future coupled with an analysis of how those prospective futures relate to the current state (Svenfelt and Höjer 2012).

We build our analytical framework on feminist political ecological (Rocheleau et al. 1996, Elmhirst 2011) and ecofeminist perspectives (Mies et al. 2014, Warren 2000). We then translate these theoretical approaches to a more practice-oriented framework with the use of peak-oil strategist Sharon Astyk's handbook (2008) and tactics and strategies developed by the feminist economic geographers J.K. Gibson-Graham (1996, 2006, 2011).

In order to illustrate how this framework can be used, we apply it to the case of the city of Stockholm, where we live and work. Stockholm is also a city that is often referred to as being in the forefront of the sustainability metrics league; in 2010, the city received the EU Green Capital award for its achievements. However, Stockholm's current urban development and official strategies have been criticized for glossing over social divides, as well as disregarding environmental effects outside its administrative boundaries (Rader Olsson and Metzger 2013, Bradley et al. 2013). In this way, Stockholm is an interesting case for exploring socially and environmentally more radical futures.

Here, we analyse Stockholm's official vision for the year 2030, highlighting the vision's theoretical and normative underpinnings. We then rewrite and reillustrate the vision. In doing so, we aim to demonstrate how a different set of theoretical and normative perspectives can give rise to quite different goals, strategies and images of the future. This clarifies that there is no singular future, but many different ways of imagining the future. In order to get feedback on our alternative vision, and to test and develop this revisioning exercise, we organized three meetings in November 2014 with stakeholder

groups involved in urban development in relation to environmental and/or gender concerns: (1) eight persons engaged in feminist and women's perspectives on the built environment from Kvinnors Byggforum (Women's Building Forum); (2) three persons engaged in activism around environmental justice and alternative urban development, members of Alternativ stad (Alternative City) and Jordens Vänner (Friends of the Earth); and (3) three officials at the Executive Office of the City of Stockholm, who are responsible for leading the process of updating the *Vision 2030*. Prior to the meetings, the participants had received and read our alternative vision. At the meetings, we made a short presentation of the official vision, the alternative vision and our theoretical framework, and then opened up for a discussion on the content, the role of alternative visions and finally methodologies on how to generate and use these visions.

The intention is that a contesting revisioning exercise, in this case grounded in our different disciplinary backgrounds, namely urban planning (Bradley), futures studies (Gunnarsson-Östling), and architecture (Schalk), can stimulate other groups – citizens, activists, professionals, etc. – to spell out their perspectives and visions of the future city. Taken together, a multitude of contrasting visions can form the basis for a more transparent public discussion about desired futures. Thus, it is a way of questioning the consensus ideal so common in planning and governance (Mouffe 2005).

From ecological modernization to futurist feminist political ecology

There are varied and competing discourses of sustainable development. A dominant interpretation has come to be that of *ecological modernization,* implying a belief that continued economic growth is compatible – and sometimes necessary – for benign environmental development (Spaargaren and Mol 1992, Hajer 1995, Fisher and Freudenberg 2001). Environmental aspects and gender are to be 'integrated' into the development without challenging the overall model. New technology paired with smart economic incentives is often seen as the solution, through the advancement of electric cars, water-saving toilets and ecological products (Hobson 2006). From this ecological modernization perspective, environmental issues are generally presented as if they concerned everybody the same way. Questions of who/what causes or are affected by environmental problems are seldom highlighted, nor are questions of who will be able to access and afford the new ecotechnology, or whose needs and desires are prioritized in the strategies and technologies for green growth.

Using a political ecology perspective in the field of sustainable urban development entails highlighting how planning strategies affect different societal groups and nonhuman entities. It could also mean exploring questions such as: does environmental improvement in one place have disadvantageous effects elsewhere? Regarding sustainability assessments and plans: which actors or effects are included and which are excluded? How do the resource flows to and from a city affect groups and territories? How could societal structures be reconstructed so as to promote more just relations between groups of people, territories and species (see e.g. Swyngedouw and Heynen 2003, Heynen et al. 2004, Keil 2007, Pincetl 2007, Robbins 2012)? In short, the interest of feminist political ecology research is concerned with access to and control of environmental resources, with gender as its focus – though interacting with categories such as class, ethnicity and culture (Rocheleau et al. 1996). It also means focusing on women's knowledge, gendered ways of handling ecological change, the value of local knowledge and women's socioenvironmental struggles. Rocheleau et al. (1996) in particular recognize power relations in decision-making about the environment, and question the presumption of technological progress and domination of nature. They also recognize the relationship between gender, knowledge, environment and development and address gendered structures in the economic system, including analysis of the household. This approach resembles ecofeminist discourse of the late 1980s and 1990s (Merchant 1989, 1996, Plumwood 1993, Salleh 1997).

Since Rocheleau gathered political ecologists to extend their analysis to gender in the early 1990s, much has happened in the field of feminism and

gender studies (Rocheleau et al. 1996). Poststructuralist and performative approaches to gender, power and subjectivity have developed and gained strength in the 2000s (Butler 2004, Radcliffe 2006, Elmhirst and Resurreccion 2008), questioning the essentialist view of womanhood and bringing forward a more decentred subject and gender based on several interacting and changing subjectivities: class, ethnicity, sexuality, place and, more recently, 'more-than-human' approaches (Bennett 2010). Elmhirst (2011) calls for *new feminist political ecologies* extending from a decentred subject and poststructuralist power analysis and has gathered examples of such analysis of fishery, water management and forestry. This new feminist political ecology has primarily been used for critical analysis of the existing order (e.g. Truelove 2011, Sultana 2011), rather than being applied for exploring alternative futures.

In this chapter, we attempt to explore what a *futurist* feminist political ecology framework could mean. The ambition is to contribute a futurist and strategic angle to feminist political ecology and illustrate how it could be used to envision another future. Building on Elmhirst (2011), the ecofeminists Mies et al. (2014) and the feminist futures studies scholar Milojevic (1999), we view a feminist approach not only as concerning the roles of men and women, but also as questioning other divisions and hierarchies, i.e. nature-culture, developed-developing world, capitalism-socialism, etc. Milojevic (2008, p. 330) has also highlighted the exclusion of women in futures studies, viewing the general exclusion of women from professional activity as one cause, but also highlighting the fields' hypertechnological and scientific orientation and focus on economics, international politics and the impact of new technologies as other important contributing factors. Despite this, Milojevic (2008) argues that feminists would benefit from futures studies tools and methods when articulating feminist projects for the future. Drawing on the perspectives of Mies et al. (2014), Hurley (2008)[2] and Warren (2000), a futurist feminist political ecology perspective entails for us an imagination of another world-order, beyond the economic growth paradigm, freed from the complex of patriarchy-capitalism-militarism-colonialism. Mies et al. (2014) calls this a subsistence perspective: a system where the

creation and quality of life is placed in the centre, where production is synchronized with needs of consumption (rather than focusing on profit and growth) – a society entailing decentralized and local economies and bureaucracies, and life characterised by equity between genders as well as between different societal groups, territories, species and generations.

Translating theories into practical strategies for alternative futures

With the theoretical framework and visions of the future outlined here, what could this mean in more practical terms? How could the framework be used to inform alternative practice-oriented visions and strategies in the field of urban planning? Here, we find the writings of feminist action researchers Gibson-Graham on micro-practices useful, as well as peak-oil strategist Astyk's focus on the household economy.

Under the pen name J.K. Gibson-Graham (1996, 2006, 2011), Julie Graham and Katherine Gibson have conceptualized what they describe as postcapitalist economies and relations. For them, just like Mies et al. (2014), capitalist hegemony is an entanglement of oppressive relations that play out in terms of gender, class, cultures and species. They illustrate the diversity of the economy by highlighting community economies and microscale noncapitalist economies that are continually practiced in nations that, on the macrolevel, are termed capitalist economies. *Postcapitalism* summarizes practices that exist in parallel: sometimes articulated as critiques and struggles *against* mainstream capitalism, and sometimes economies that simply supplement the dominant capitalist economy. Hence, the *post* prefix is not necessarily meant to denote a point in time.

Gibson-Graham (2006) argue for the importance of highlighting, understanding and naming non/post-capitalist economies, in order to acknowledge their existence and future possibilities. In their community action research, the duo has worked with 'skills and asset mapping' in order to make visible the skills, assets and functions that exist outside the formalized market. Such simple mapping exercises can contribute to "…an expansive

vision of what is possible" (ibid., p. xxxvi). In their mapping exercises, Gibson-Graham (2011) highlight examples of economic activity that are socially and environmentally beneficial, including cooperatives providing green laundry services, renewable energy, community-supported agriculture and experiments with alternative currencies that account for environmental impact.

With the contemporary backdrop of peak oil, or 'peak everything', and the difficulties nation states and supranational institutions face in handling climate change and fossil-fuel dependency, several researchers and activists have published books on how to act locally, addressing local civil-society communities as well as local governments and policy makers (Astyk 2008, Murphy 2008, Heinberg and Lerch 2010, Hopkins 2012). One such researcher and activist is Sharon Astyk. In her book *Depletion and Abundance – Life on the New Home Front* (2008), she outlines a present and future of decline (in economic and fossil-fuel terms) and explores what this decline, or postpeak era, might mean in terms of work, use of time, housing, cooperation and the remaking of social relations. She argues, "We are past the time at which we could hope to go on more or less as we have. For good or ill – and probably some of both – we have to make real changes in our lives. Most of us living in rich nations are going to have to learn to live simpler lives, using much less energy" (2008, p. 3).

In line with this, Astyk (2008) argues against high-tech solutions requiring distant materials, which serve to ensure that the affluent people of the world can continue to consume energy and products at the current levels, and instead presses for the need to find ways of using *less* resources while simultaneously assuring quality of life. These ways include low-tech solutions, products and infrastructures that are easy to construct and repair with local skills, and that are built with local and recyclable materials.

Both Astyk (2008) and Gibson-Graham with Cameron and Healy, in *Take Back the Economy* (2013) write in a handbook style, with concrete suggestions of what can be done from the perspective of a household. Astyk calls it "coming together on the home front" (2008, p. 33), in reference to creating socially and ecologically resilient communities which can then serve as a platform for working for political

and structural change. The primary question investigated by these works is how life in existing suburbs, settlements or towns can become more resilient. The focus is primarily on changing socioeconomic relations: localizing the circuits of production and consumption, downshifting, sharing goods and services and *reskilling* – rediscovering basic skills for resource management such as cultivation, construction and crafts (Astyk 2008, Murphy 2008, Hopkins 2012). Astyk (2008, p. 156) argues that, in a world of higher oil and food prices, productive land will be more valuable, and hence green space and the space between buildings will be seen as valuable assets. She points out that the current industrial and globalized production of food relies on cheap oil and phosphorus, and when these resources become more expensive, more human physical energy will be needed for food production. Decentralized systems for energy provision, food supply and waste and water systems are brought forward – systems in which households can be both consumers and producers, and hence less reliant on e.g. a central power provider or corporate food chains. This does not necessarily mean becoming self-reliant on food and energy, but rather that households can build closer ties with the producers of food and energy, for instance through joining wind-power cooperatives, community-supported agriculture or some form of schemes whereby households own shares in local farms or subscribe to their products. In line with Gibson-Graham's emphasis on noncapitalist economies, community spaces come to play an important role (Hopkins 2012, Astyk 2008). Assuring that there are good quality, accessible community spaces is important for the social life and organization of the neighborhood, but also for the cultivation of socioeconomic exchange, micro-businesses and support systems.

Gibson-Graham, Astyk and their affiliates are situated in different fields and have differently situated points of departure, yet there is a common focus on practical change on a local level, highlighting the roles of the household, civil society and agents and relations beyond the formal capitalist economy. In a feminist political ecology approach, there is a clear normative position, striving for a more equitable society across gender, class, territories and species.

The Stockholm *Vision 2030*

The future vision of the City of Stockholm is entitled *Vision 2030* and is presented in a booklet with the subtitle *A guide to the future*.[3] It has been developed by the Executive Office of the City of Stockholm after "dialogue with spokesmen for the City itself, with representatives of trade and industry, with schools and universities, as well as other public authorities" (p. 1).[4] It was adopted by the city council in 2007. Stockholm's *Vision 2030* still constitutes the framework and direction for the city's visioning work, and it is this version that will be analyzed here. All public bodies under the City of Stockholm are obliged to work for a realization of the envisioned future.[5]

Drawing questions from our futurist feminist political ecology perspective, this section will briefly describe the vision by asking, how are the overarching goals phrased? What types of lives and social relations are envisioned? What notions of production, consumption and exchange are put forward? And how does this translate to the built environment: housing, the use of space and infrastructure? How does the vision relate to equity in relation to gender, distant regions and peoples and the nonhuman world? Who is it written for?

The vision is to achieve "a world-class Stockholm" (p. 1), and the goals are phrased in terms of "sustainable growth and development". It envisions Stockholm as "a magnet for researchers, innovators and entrepreneurs" and "the green capital of the world" (p. 1). The vision is based on the assumption that the City of Stockholm will continue to grow from 809,000 residents in 2008 to 1,000,000 by 2030. Therefore, the vision is centred on how to expand infrastructure, housing, workplaces, schools and public services.

It includes three themes for Stockholm's future development: (1) "Versatile and full of experiences", (2) "Innovation and growth", and (3) "Citizens' Stockholm". Through images, texts and short interviews with three children, stories of the future tell what it is like to live, work and visit the city in 2030. In these stories, residents and visitors are attracted to Stockholm's rich culture, entertainment, nature and waterways. Stockholm is envisioned as having "a world-class business climate", in which "international

high-technology companies work side by side with small spin-offs in the service sector" (p. 4). In this vision, Stockholm has a low municipal tax, as well as "the world's best IT infrastructure and a reliable energy supply system" (p. 4). Moreover, Stockholm is described as northern Europe's financial capital as well as "Europe's top growth region" (p. 6).

Fig 17.1 Excerpt from the official *Vision 2030* of Stockholm. Courtesy of the City of Stockholm.

We learn in *Vision 2030* that "competition among cities and regions is increasing, which makes marketing and profiling increasingly important" (p. 15), and that Stockholm in 2030 has succeeded in this global competition. In this future, the city has a knowledge-based high-tech and creative labour market successfully producing for an export market (p. 8).

In this discourse on cities in global competition, it is the highly skilled, educated and entrepreneurial residents that are desired – not caretakers, repairers or manufacturers. The role of planning in this envisioned future hence becomes ensuring that the city attracts the 'right' people and firms. It is furthermore stated that "It is important for the City to develop spectacular, momentous projects in conjunction with other players. These projects will make the vision clear and become symbols of the Stockholm of the future" (p. 16).

The vision ends with a map pointing out such momentous projects and expanded infrastructure that have supposedly been realized by 2030. These include two major shopping centres, three new

major roads, an expanded airport, internationally profiled conference and hotel facilities, new tramways and extensive new housing development that expands the compact city outwards.

In terms of environmental issues, the vision includes a short paragraph stating that "innovations have resolved many environmental problems, and the city is well on the way to achieving its goal of being fossil fuel-free by 2050" (p. 9). Stockholmers have reduced their energy consumption, drive clean vehicles, bike or use public transportation and the construction companies use environmentally sound methods and materials in all new buildings. The vision could be understood as grounded in an ecological modernization perspective – a belief that technical solutions will solve environmental problems and that continued economic growth goes hand in hand with benign environmental development. However, this vision of being fossil fuel-free does not take into account the emissions or socioenvironmental impact arising from Stockholmers' consumption of goods and use of transportation originating from beyond municipal boundaries (Bradley et al. 2013). Green areas are briefly mentioned as sites for recreation, particularly for visitors; their role in the eco-system, as habitats or as productive land is not mentioned. As for equity, there are efforts to improve "local democracy and equality among citizens", and in 2030, "no one faces discrimination because of gender, origin, age or social status" (p. 12). Apart from this, there is no further mention of equity or responsibility in relation to the lives of distant regions and peoples, future generations or the nonhuman world.

The target group of the vision – and the people who are to realize it – are professionals, the City's employees, the business community and "other public players" (p. 2). Citizens or civil society appear to have little or no role in realizing the vision.

Rewriting Stockholm's *Vision 2030*

From a futurist feminist political ecology perspective, then, how would a future vision for a city like Stockholm be formulated? Drawing from the previous theoretical section, we argue that such a framework could entail the following:

Working for greater equity *within* the city in terms of access to good living environments, fair resource use and influence on decision-making across gender, class and ethnicity.

Finding forms of production and consumption through which the lives of the city's residents do not negatively affect distant peoples or territories.

Highlighting resource flows and inter-dependencies and accounting for the social and environmental costs of production, consumption and transportation. Accounting for these 'invisible' costs means acknowledging support structures, unpaid work and socioenvironmental aspects of the economy in which women are often involved. Accounting for local and distant socioenvironmental costs are likely to push for more circular and localized economies.

Acknowledging postcapitalist relations and forms of exchange that are the foundation of the formalized wage economy, again a sector where women and marginalized groups are highly present. This includes seeing the role of common space for noncommercial forms of exchange, socializing and organizing.

Using local lay knowledge, the perspectives of all genders and ages and foregrounding the roles of households and everyday micropractices.

Based on this, we have formulated a set of goals for the city of Stockholm (see Table 1). In the official *Vision 2030*, detailed goals are not spelled out, but are instead phrased in general terms like "a top growth region" and "a world class city". Little is said about the responsibility of different societal actors, and nothing about the role of civil society. In order to facilitate a transparent public discussion about desired futures, it is important to spell out goals, strategies and roles, not only of institutions but also of civil society. For these goals to materialize there must be institutional, political and legal change, sometimes beyond the city level. Some of these institutional changes will be noted, but most

Table 1: Goals, strategies and practices for a more environmentally just Stockholm

MACRO GOALS FOR THE CITY	INSTITUTIONAL STRATEGIES for local, regional, national and supranational institutions	MICRO PRACTICES of civil society
A diverse and localized economy	Include social and environmental costs of products, services and transportation through taxation	Develop existing postcapitalist economies, such as sharing, bartering and cooperatives
	Ensure that the region has complementary primary, secondary and tertiary sectors	Start a local exchange trading scheme, such as a time bank or local currency
	Shift higher salaries into less working hours	
	Provide infrastructure for sharing vehicles, spaces, machines and other idle resources	
A circular economy	Introduce schemes for individual emissions quotas ensuring fair environmental space for all	Lower the level of resource-intensive private consumption
	Make producers take on the costs of repair and maintenance	Produce and consume local goods
	Provide facilities and incentives for local ecocycling of water and waste	Reuse, share, swap and trade goods
		Recycle and compost what you cannot reuse, retrofit, swap or trade
		Use and develop common spaces for shared facilities
A local food system with biodiversity	Activate land-use planning to provide qualitative green space for recreation, biodiversity and food production	Cultivate gardens and empty lots
	Facilitate for local farmers to sell their goods in standard food stores	Join a local garden club or a community-supported agriculture in the region
	Allow chickens and other household animals in urban and suburban areas	Start a food cooperative
		Keep productive animals in yards and gardens – bees, hens...
Robust technical infrastructure	Ensure that energy, waste and water systems are robust and can be repaired with local skills and materials	Complement high-tech with low-tech facilities that can be easily repaired with local skills and materials
	Facilitate for communities to construct local water and waste systems, nested into a larger system	

Renewable and local energy provision	Provide grids where households and other entities can be both producers and consumers of energy	Set up individual or collective facilities for local renewable energy provision (solar, wind, hydro, biogas...)
	Allow public institutions like schools and public housing organizations to be producers of energy	Buy renewable energy but also find practices that lower energy use
Affordable retrofitted housing for all	Assure that there are different forms of affordable housing – such as nonprofit rental, self-owned cooperatives, cohousing	Try ways of living together with others
		Eco-retrofit existing buildings
	Facilitate for a wide array of builders and nonprofit cobuilding groups	Use local and recyclable materials
	Develop new areas gradually	Consider developing semipublic space at home or in the neighbourhood – a small work space, a guest apartment, a social space, a common garden – making home interlinked with the public sphere
Coproducing a fair society	Facilitate democratic cocreation of society and the built environment	Get organized. Engage in politics.
	Ensure that there are good common spaces for noncommercial activities	Alternate intellectual, political and practical work in seasons or phase in life
	Use local lay knowledge, the perspectives of all genders, young and elderly	Develop and use local space for social organizing, cocreation of goods, education
Fair accessibility	Map the purposes of transport in the region and minimize the need for undesired transport and facilitate for the desired	Live and work nearby
		Use local services
		Care for your neighbourhood
	Ensure that basic services can be found locally (schools, kindergartens, health-care centres...)	Forget international mass tourism and instead go abroad to do something meaningful for a longer period of time
	Facilitate for local work and neighborhood job hubs	
	Facilitate for nonmotorized forms of transport (develop rail, bike and pedestrian systems)	
	Ensure that living environments are enjoyable year-round	

attention will be directed to the ways micropractices at the local level could alter life and simultaneously influence and prepare the ground for institutional and macropolitical change.

The aim is not to formulate a new singular vision, but rather to show how futures can be imagined and articulated quite differently, depending on point-of-departure perspectives and goals. By spelling out an alternative vision and its theoretical and normative basis, it can be confronted, discussed and hopefully inspiring other actors/interest groups/inhabitants etc. to spell out their normative goals and desired futures. Transforming the goals, strategies and practices described in Table 1 into a city vision raised questions of how key words, themes, images, stories and maps of the future could be (re)formulated. What practices are to be foregrounded and named? Using the same booklet format as the official vision, we rewrote and redesigned the cover page and preface, transformed the three themes with interviews into discussions between fictional characters, and finally redrew the map of new developments. The whole booklet entitled *Stockholm 2030 – Another guide to the future* can be found at the end of this chapter.

How a just city differs from a world-class city

So, how does our alternative vision differ from the official vision? The official vision is 'a world-class Stockholm', based on the idea that cities compete in a global arena for investments, residents and visitors. Our vision is an attempt to let a vision proceed from a theoretical basis and is formulated in terms of 'towards a just Stockholm'. We emphasize equality in a broad sense, across social groups, genders, territories and species.

Instead of focusing on how to attract the right firms and people – entrepreneurs, researchers and innovators – our starting point is how to attain good and responsible quality of life from an everyday resident perspective. Feminist approaches, such as that of Gibson-Graham, have inspired us to foreground existing and possible everyday ways of living, producing and reproducing. The official vision is made by and for 'the big players', giving them a central role in decision making and the construction of the future city. Our alternative vision is primarily directed towards civil society, communities and households. In this future, inhabitants alternate intellectual, practical and political work in a way that has democratized decision making. Urban space is not only shaped by professionals and the big players but coproduced through the active involvement of citizens.

In the official vision, Stockholm is envisioned as fossil-fuel free by 2050, without accounting for effects outside its administrative boundaries. Hence, technical solutions – clean vehicles and energy-efficient buildings – are perceived as being sufficient to bring about this change. The vision we present has a relational perspective, emphasizing the responsibility of the effects of Stockholmers' consumption, travel and trade on distant peoples and territories and the nonhuman world. In practical terms, this means that Stockholmers by 2030 have drastically reduced their ecological footprint. In the vision we describe this has been enabled due to a UN Treaty in 2027 issuing individual resource entitlements for a fair share of environmental space. The alternative vision then pictures what less resource-intensive ways of living, producing and consuming might look like.

In line with peak-oil strategist Astyk, we have developed a story of the future in which Stockholmers consume less overall, as well as increasingly utilizing local resources. In this vision, production of basic goods such as food, clothing and utilities has been progressively localized. In the official vision, it is international high-tech companies in information technology, the life sciences, clean tech and finance that are highlighted. We have instead portrayed a future in which residents alternate intellectual work with cultivation, manufacturing and use of low- and high-tech methods. The social hierarchies that currently exist based on what is considered a high-skilled or low-skilled work, or a male/female work, have vanished. The official vision briefly presents Stockholm's greenery and waterways as sites for recreation, particularly for visitors. In the official map of planned developments, none of the 22 projects deal with developing the city's green or blue spaces. Starting out from the theoretical framework developed for our alternative vision, we see the greenery and waterways as sites for food production but also as homes for plants and animals, all playing

important roles in the ecosystem.

In the official vision, the emphasis is on the citizen's role as *consumer* of culture, services, goods, greenery, open space and energy. In the alternative vision, we try to depict a future in which the residents are also *producers* of these entities. The notion of 40 hours of salary work for an international high-tech corporation followed by time for recreation, travel and consumption has been changed into lives in which citizens are both producers *and* consumers of goods, culture and energy; hence, 'work' and 'free time' are distributed differently. In this future, the amount of working hours in formal salary jobs has decreased, whereas forms of social and reproductive work, or postcapitalist relations, have become more recognized and well-organized. In this way, the social and reproductive work (in which women often have a larger role) has become upgraded, paving the way for a more gender-equal society. In line with Gibson-Graham's emphasis on the importance of postcapitalist relations, we have described and mapped such relations – many of which flourish already today, though they are seldom acknowledged in official documents. These include caring for elderly and children, political and social organizing, bartering and sharing of goods and resources and other forms of support systems outside the formal economy. In the alternative vision future, 'homes' have opened: some becoming live-work collectives, with others including shared spaces for socializing, organizing or producing.

Concluding discussion: Working with alternative visions

What difficulties did we encounter in the making of this alternative vision? And what were the reactions that we received at the stakeholder meetings? Our intent was to create a normative image of the future marked by environmental justice across genders, social groups, territories and species. Our ambition has not been to say *how* this might happen. Nevertheless, the vision may be interpreted as downplaying the path dependency of current socio-economic and environmental development. Perhaps we should have considered scenarios as where European and national policies of migration have opened to allow more refugees and people seeking a better life to come to cities like Stockholm. In such a scenario, Stockholm might have grown immensely. Or, we could have assumed that the Gulf Stream might have changed direction so that Stockholm became an arctic zone, and that large parts of the population would have left the city. In the rewriting of the vision, we have explored internal factors and assumed that the world around Stockholm has somehow developed in an environmentally just direction, enabling people to find agreeable living conditions all around the world. However, an in-depth discussion of how to relate to external factors, desirable as well as undesirable, would be relevant to develop in future research.

The development of Stockholm is also largely dependent on development in the greater region and nation. Currently there is a large influx of people to Stockholm, motivated by the search for work and a better life as a result of the politics emphasizing big cities as the 'growth engines' of the country. In our alternative future, we have not taken a continued urbanization for granted. Starting out from our theoretical framework, we have instead imagined a movement towards decentralization where people are able to find good lives in towns and settlements across the country.

For a vision to be credible, it is important to show how it relates to desired goals as well as possible undesired side effects. How can we assess the social and environmental impacts of this vision, locally and globally? This is beyond the scope of this chapter, but for future work, it would be worthwhile to explore assessment methods that consider production *and* consumption beyond administrative boundaries[6] as well as effects on the welfare system and people's wellbeing.

In order to get feedback on the alternative vision, we arranged three stakeholder meetings. The reactions we received at these meetings ranged from that the alternative vision was too utopian (according to a representative from the City of Stockholm), to that it was not radical enough and could have gone even further to portray a post-capitalist economy (according to representatives of *Kvinnors Byggforum* (Women's Building Forum)). A common reflection was that this type of exercise

– discussing an image of a normative, fairly distant future – can help us to see beyond current structures and actually put another society into words. There were also several comments and suggestions for how to develop the vision: for instance, that it should encompass the whole region of Stockholm rather than just the City of Stockholm, particularly important when discussing food supply systems; that the potential for public transport on the waterways could be developed; and that the issue of health care should be dealt with. In particular, how the envisioned co-production of society is going to work for disabled, sick and old people was a crucial question.

At the stakeholder meetings, we also discussed ideas of how the format and function of alternative visions could be developed. All of the three groups expressed that alternative visions like the one presented here are useful as bases for discussions about values and desired futures. Suggestions came up to arrange vision workshops with different citizen organizations as well as political parties so that a set of multiple visions for the same city could be developed and contrasted. Another idea was to develop an online template that could help other groups to develop their own visions. It was pointed out that citizen groups tend to criticize urban planning proposals, but seldom devote time to envision and argue for alternative developments. Here, methods and exercises for developing alternative visions clearly have a role to play.

With this chapter, we hope to contribute to the work on how to navigate urban planning and vision making towards more environmentally just futures. We have argued that a futurist feminist political ecology framework is useful for this purpose, and illustrated how such a framework can be used to work out concrete goals, strategies and images of everyday practices for the future. Our alternative vision is of course simplified – developed by a small group, departing from a specific normative framework – and is therefore not to be understood as something to be implemented. Rather, the intent is for it to spark discussion about desired futures, triggering others to articulate their opinions, critiques and alternatives. In this way, it can also serve as a basis for discussing the current way of living, planning and doing politics, in Stockholm and elsewhere.

Acknowledgement

This work was supported by the Strong Research Environment *Architecture in Effect: Rethinking the Social* funded by The Swedish Research Council Formas as Grant 2011–74. We are grateful for valuable comments from the participants at the 5th Nordic Geographers' Meeting, the session on *Place, economy and sustainability* in Reykjavik 11–14 June 2013 and the participants at the symposium *Rethinking the Social in Architecture* in Umeå, 6–8 February 2013. We have also benefited from insightful comments from Ramia Mazé. Special thanks to Alternativ stad (Alternative City), Jordens Vänner (Friends of the Earth), Kvinnors Byggforum (Women's Building Forum), and Stockholm Stad (Stockholm City) for participating in, and responding with constructive critique to, our workshops on *Stockholm 2030 – Another guide to the future*.

1
To the United Nations Framework Convention on Climate Change (UNFCCC), Sweden and other countries report emission levels based on what is being emitted *within* national boundaries. However, if emissions arising from consumption by Swedes of products produced *outside* national boundaries are accounted for, the figures are quite different. When total consumption is accounted for, Sweden has not lowered greenhouse gas emissions by 13% but in fact raised them by 9% between 2000 and 2008 (Naturvårdsverket 2012, p. 7–9). This is mainly because consumption levels have risen, and goods are to a large extent imported.
2
Hurley calls for images of the future that can form resistance to the hegemonic images of e.g. Hollywood films.
3
An English version of the vision is printed but no longer available on the Internet. The booklet is not paginated; however, in order for the reader to easily locate the quotes referred to, we have added page numbers.
4
www.stockholm.se/OmStockholm/Vision/, accessed July 17, 2016.
5
Stockholm City's visioning work began in 2004 under the government of a coalition of conservative parties, and was revised under a new government, which, since 2014, consists of the Social Democratic party, the Green party, the Left party and the Feminist Initiative party. By the time of concluding this chapter, there is an updated version, *Vision 2040* on the Internet, with the title: "A City for All", but Stockholm's *Vision 2030* still constitutes the major framework and direction for the city's visioning work and it is this version that is analyzed here.
6
One such tool is REAP: Resources and Energy Analysis Programme developed by Stockholm Environment Institute, see www.sei-international.org/reap, accessed 7 November 2013.

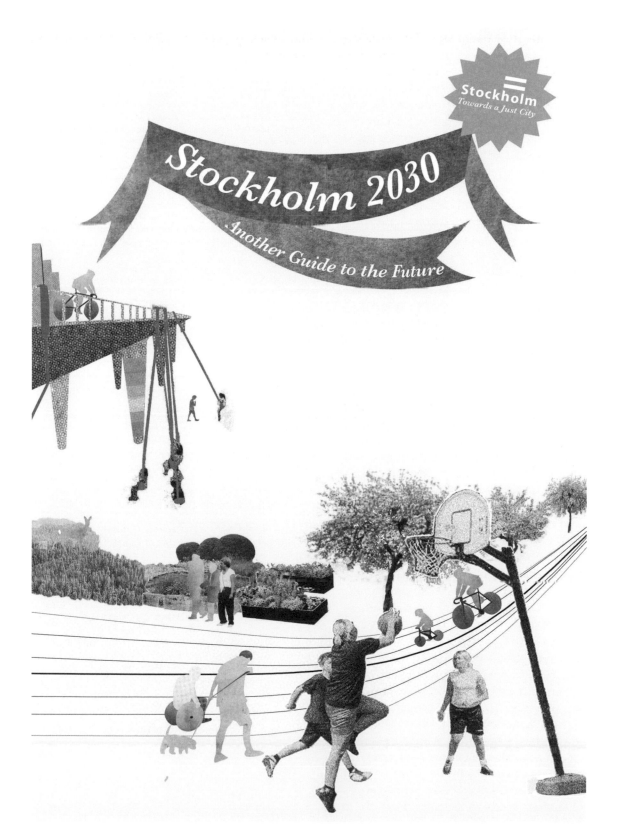

Towards a Just Stockholm

As of late 2013, Stockholm is one of the fastest growing cities in Europe, and the region is expected to house half a million more residents by 2030. In 2010 the city received the EU Green Capital award amid claims of being at the forefront of the international sustainability league. At the same time, figures show the per capita ecological footprint to be three times greater than if resources were divided in a fair and sustainable way. Politicians and planners are not sure what to do about this, or how to handle it, or, we may add, how long they can describe the city as "green" when the patterns of resource use go in the opposite direction.

Like many other Scandinavian regions, Stockholm is known for good and equal housing and living standards for all. However, this image is cracking as socioeconomic and ethnic segregation increases. Public participation is requested, but the planning of the city is considered largely to be a task for "the big players" and their public-private consortia, not for citizens.

The shadow version of Stockholm's official vision presented here envisions a future marked by more just use of resources across social groups, genders, territories and species. The ambition of this vision is not to describe one future desired by all but rather to illustrate how futures can be imagined and articulated differently, based on varied perspectives and values. There could – and should – be a multitude of articulated visions for a city so that different values, goals and strategies can be confronted. We hope that these snapshots of the future will encourage you to share yours.

Welcome to another future!

Karin Bradley, Ulrika Gunnarsson-Östling, Meike Schalk and Jenny Andreasson

Stockholm, 8 November 2013

3

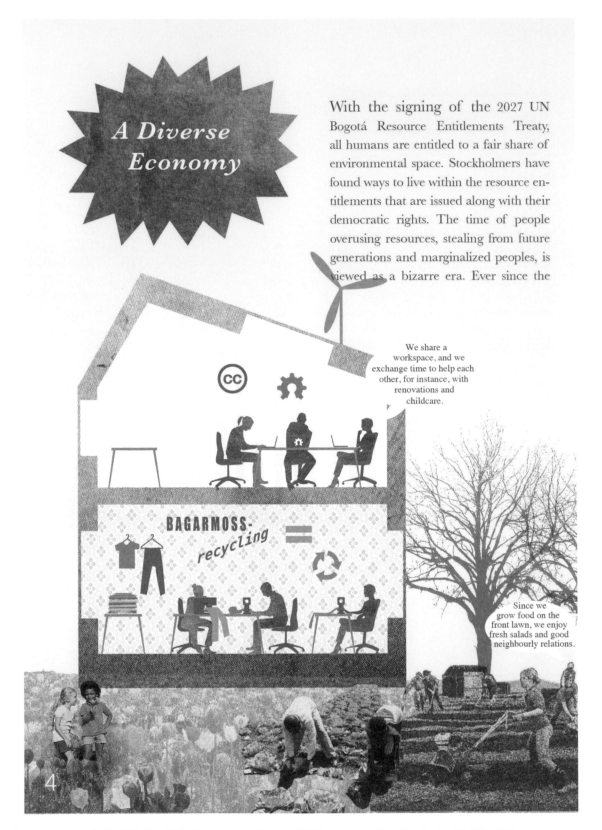

A Diverse Economy

With the signing of the 2027 UN Bogotá Resource Entitlements Treaty, all humans are entitled to a fair share of environmental space. Stockholmers have found ways to live within the resource entitlements that are issued along with their democratic rights. The time of people overusing resources, stealing from future generations and marginalized peoples, is viewed as a bizarre era. Ever since the

We share a workspace, and we exchange time to help each other, for instance, with renovations and childcare.

BAGARMOSS-
recycling

Since we grow food on the front lawn, we enjoy fresh salads and good neighbourly relations.

4

environmental and social costs of production and transportation have been adequately accounted for, the production of basic goods, such as food, clothing and utilities, have been localized.

Basic goods are traded through the local currency, the Stockholm krona, or exchanged in time banks and swapping systems. Specialized goods, such as medical equipment, are traded in the Tellus global peer-to-peer currency.

Stockholmers in 2030 live on less resources than they did in the 2010s. They travel and consume goods in wiser ways and enjoy a great quality of life in terms of meaningful and varied work, belonging, good local food, greater freedom in car-free environments where children walk and play outside.

We open our home to the public sometimes with concerts, exhibitions, and even political debates, which has contributed to a lively community.

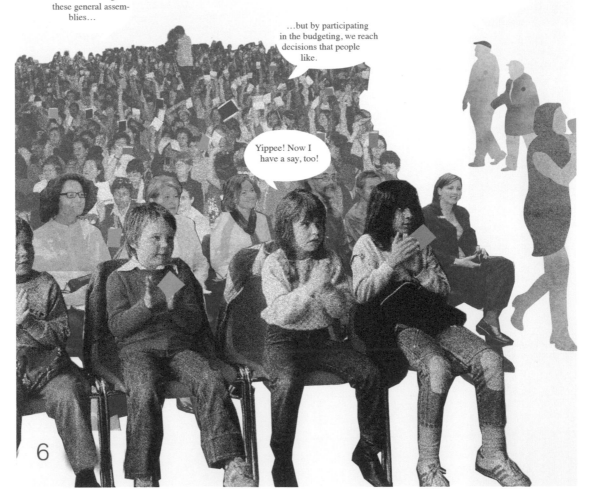

Now, in 2030, local social enterprises and cooperatives are flourishing. Most citizens alternate intellectual work, practical work and political work. Universities award double degrees and have developed production/cultivation labs on campus. Low-tech and high-tech hardware and software are produced through open-source models. The municipality facilitates housing construction and retrofitting by cobuilding in nonprofit cooperatives. Citizens collectively own and manage housing and often own a share in a local workshop or farm. All people engage in forming society and are met with equal respect. The era of some groups dominating and setting the social norms is history.

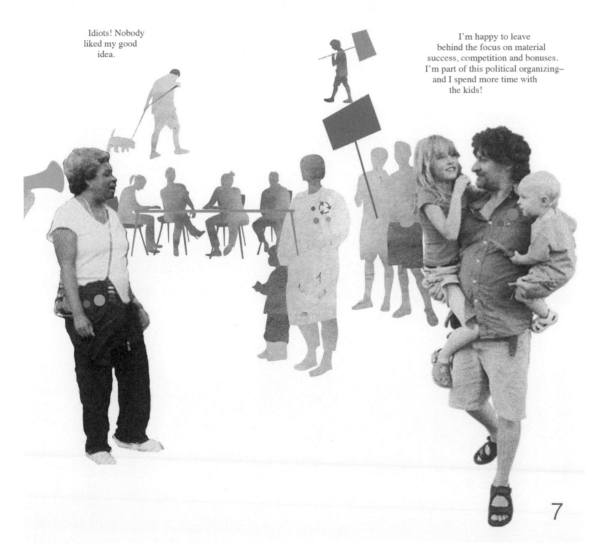

Idiots! Nobody liked my good idea.

I'm happy to leave behind the focus on material success, competition and bonuses. I'm part of this political organizing— and I spend more time with the kids!

7

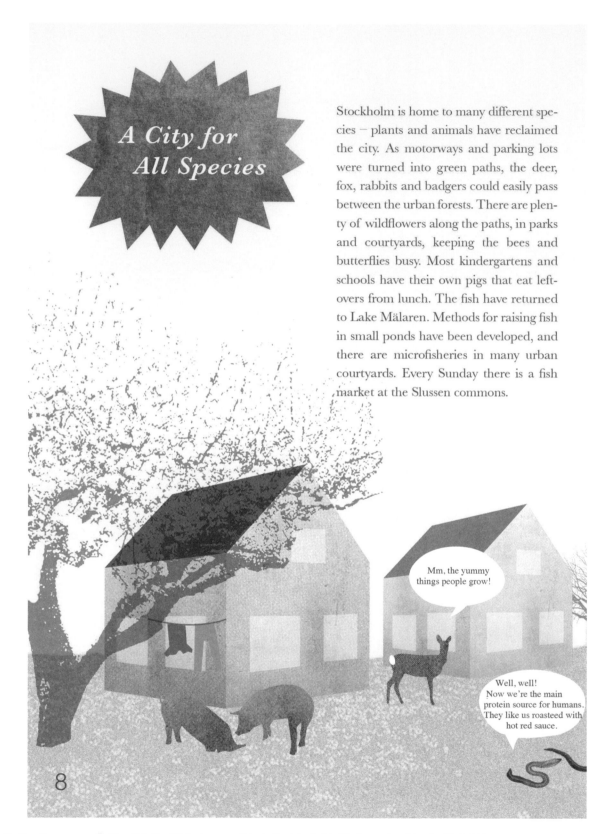

A City for All Species

Stockholm is home to many different species – plants and animals have reclaimed the city. As motorways and parking lots were turned into green paths, the deer, fox, rabbits and badgers could easily pass between the urban forests. There are plenty of wildflowers along the paths, in parks and courtyards, keeping the bees and butterflies busy. Most kindergartens and schools have their own pigs that eat leftovers from lunch. The fish have returned to Lake Mälaren. Methods for raising fish in small ponds have been developed, and there are microfisheries in many urban courtyards. Every Sunday there is a fish market at the Slussen commons.

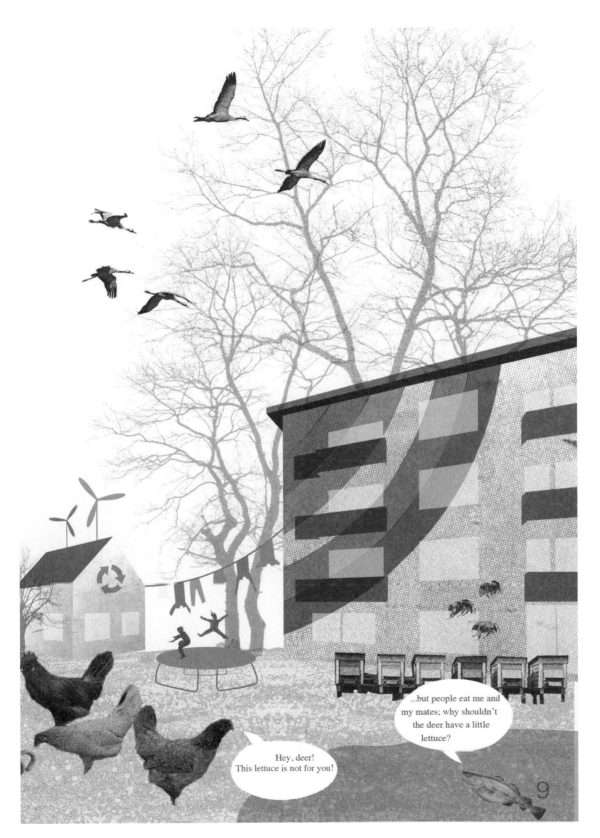

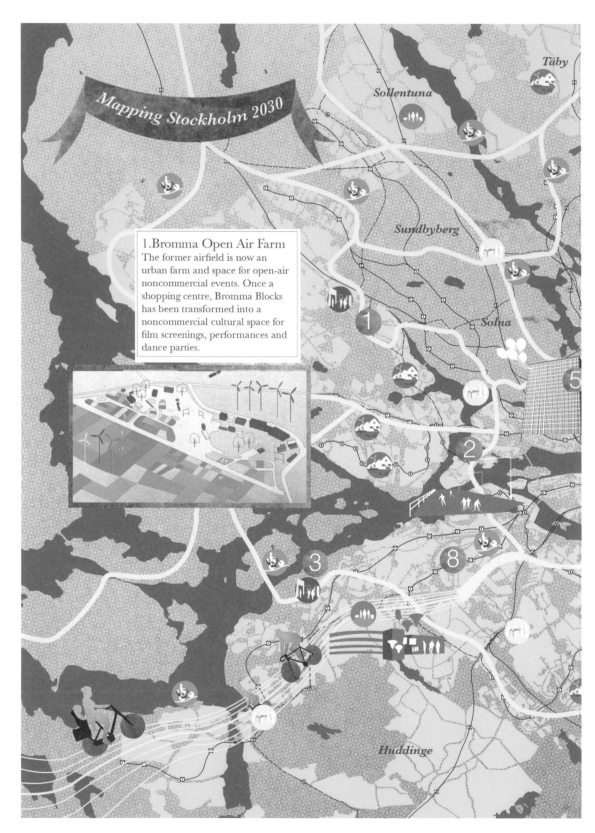

1.Bromma Open Air Farm
The former airfield is now an urban farm and space for open-air noncommercial events. Once a shopping centre, Bromma Blocks has been transformed into a noncommercial cultural space for film screenings, performances and dance parties.

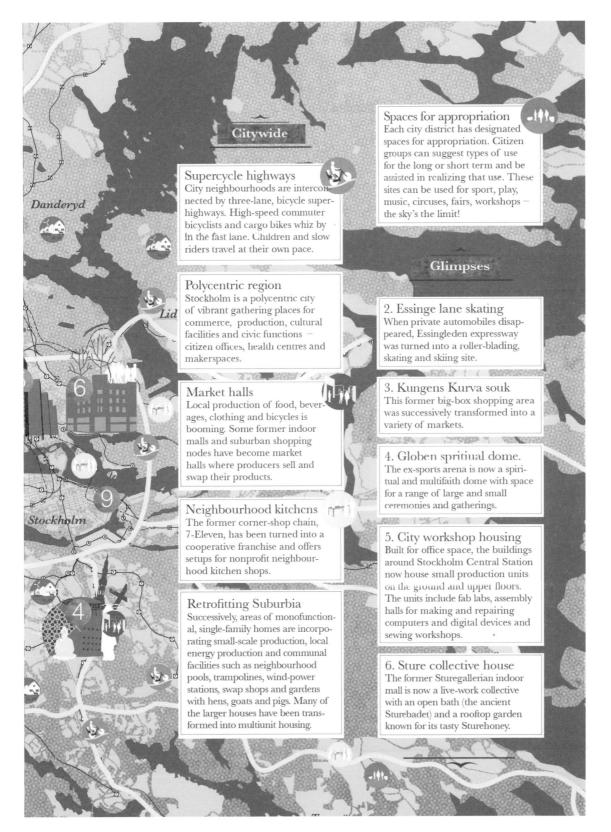

Supercycle highways

City neighbourhoods are interconnected by three-lane, bicycle super-highways. High-speed commuter bicyclists and cargo bikes whiz by in the fast lane. Children and slow riders travel at their own pace.

Polycentric region

Stockholm is a polycentric city of vibrant gathering places for commerce, production, cultural facilities and civic functions – citizen offices, health centres and makerspaces.

Market halls

Local production of food, beverages, clothing and bicycles is booming. Some former indoor malls and suburban shopping nodes have become market halls where producers sell and swap their products.

Neighbourhood kitchens

The former corner-shop chain, 7-Eleven, has been turned into a cooperative franchise and offers setups for nonprofit neighbourhood kitchen shops.

Retrofitting Suburbia

Successively, areas of monofunctional, single-family homes are incorporating small-scale production, local energy production and communal facilities such as neighbourhood pools, trampolines, wind-power stations, swap shops and gardens with hens, goats and pigs. Many of the larger houses have been transformed into multiunit housing.

Spaces for appropriation

Each city district has designated spaces for appropriation. Citizen groups can suggest types of use for the long or short term and be assisted in realizing that use. These sites can be used for sport, play, music, circuses, fairs, workshops – the sky's the limit!

2. Essinge lane skating

When private automobiles disappeared, Essingleden expressway was turned into a roller-blading, skating and skiing site.

3. Kungens Kurva souk

This former big-box shopping area was successively transformed into a variety of markets.

4. Globen spritiual dome.

The ex-sports arena is now a spiritual and multifaith dome with space for a range of large and small ceremonies and gatherings.

5. City workshop housing

Built for office space, the buildings around Stockholm Central Station now house small production units on the ground and upper floors. The units include fab labs, assembly halls for making and repairing computers and digital devices and sewing workshops.

6. Sture collective house

The former Sturegallerian indoor mall is now a live-work collective with an open bath (the ancient Sturebadet) and a rooftop garden known for its tasty Sturehoney.

Danderyd

Lid

Stockholm

Getting there

Macro goals for the city	A diverse and localized economy	A circular economy
Institutional strategies for local, regional, national and supranational institutions	Include social and environmental costs of products, services and transportation through taxation Ensure that the region has complementary primary, secondary and tertiary sectors Shift higher salaries into less working hours Provide infrastructure for sharing vehicles, spaces, machines and other idle resources	Introduce schemes for individual emissions quotas ensuring fair environmental space for all Make producers take on the costs of repair and maintenance Provide facilities and incentives for local ecocycling of water and waste
Micro strategies of civil society	Develop existing postcapitalist economies, such as sharing, bartering and cooperatives Start a local exchange trading scheme, such as a time bank or local currency	Lower the level of resource-intensive private consumption Produce and consume local goods Reuse, share, swap and trade goods Recycle and compost what you cannot reuse, retrofit, swap or trade Use and develop common spaces for shared facilities

12

A local food system with biodiversity

Activate land-use planning to provide qualitative green space for recreation, biodiversity and food production

Facilitate for local farmers to sell their goods in standard food stores

Allow chickens and other household animals in urban and suburban areas

Cultivate gardens and empty lots

Join a local garden club or community-supported agriculture in the region

Start a food cooperative

Keep productive animals in yards and gardens – bees, hens…

Robust technical infrastructure

Ensure that energy, waste and water systems are robust and can be repaired with local skills and materials

Facilitate for communities to construct local water and waste systems, nested into a larger system

Complement high-tech with low-tech facilities that can be easily repaired with local skills and materials

13

Macro goals for the city	Renewable and local energy provision	Affordable retrofitted housing for all
Institutional strategies for local, regional, national and supranational institutions	Provide grids where households and other entities can be both producers and consumers of energy Allow public institutions like schools and public housing organizations to be producers of energy	Assure that there are different forms of affordable housing – such as non-profit rental, self-owned cooperatives, cohousing Facilitate for a wide array of builders and nonprofit cobuilding groups Develop new areas gradually
Micro strategies of civil society	Set up individual or collective facilities for local renewable energy provision (solar, wind, hydro, biogas…) Buy renewable energy but also find practices that lower energy use	Try ways of living together with others Ecoretrofit existing buildings Use local and recyclable materials Consider developing semipublic space at home or in the neighbourhood – a small work space, a guest apartment, a social space, a common garden – making home interlinked with the public sphere

14

Coproducing a fair society

Facilitate democratic cocreation of society and the built environment

Ensure that there are good common spaces for noncommercial activities

Get organized. Engage in politics.

Alternate intellectual, political and practical work in seasons or phase in life

Develop and use local space for social organizing, cocreation of goods, education

Fair accessibility

Map the purposes of transport in the region and minimize the need for undesired transport and facilitate for the desired

Ensure that basic services can be found locally (schools, kindergartens, health-care centres...)

Facilitate for local work and neighbourhood job hubs

Facilitate for nonmotorized forms of transport (develop rail, bike and pedestrian systems)

Ensure that living environments are enjoyable year-round

Live and work nearby

Use local services

Care for your neighborhood so you want to stay

Forget mass tourism and instead go abroad to do something meaningful for a longer period of time

15

18

AGEING, INVISIBILITY AND THE POSSIBILITIES OF TEXTUAL PLAY

SOPHIE HANDLER

The idea of ageing is still, in many ways, marginal within contemporary western culture. 'Older people' are often constructed as an overlooked, invisible Other: an Other that tends not to hold a firm place within the public imagination – nor in the public realm. The physical presence of older people in public space is often ignored, slightly felt, their relationship to that public realm minimised and neglected.[1] Indeed, the whole discourse around ageing is itself repeatedly marginalised – often in spatial terms. Discussions around ageing are more easily 'contained' within age-segregated settings (sheltered housing complexes, retirement homes etc.,) to the point where the subject of ageing itself becomes ghettoised: set apart from the life of the public realm.

Over the last ten years, however, engagement with the spatial dynamics of ageing has started to shift with the changing demographic profile of cities as cities have begun 'ageing' and expanding, simultaneously. In response, a growing number of social scientists, policymakers and politicians have started to grapple with these trends using research, public policy and the development of targeted, age-specific urban programmes to respond to the double dynamics of ageing and urbanisation.[2] And yet within the field of spatial practice interest in the ageing population – in ageing at all – has been limited, at best marginalised to a certain terrain of design practice. Here, in the narrow field of spatial practice on ageing, design methodologies have focused mainly on processes of object-based production, physical adaptations to the environment, devising 'solutions' to body-related issues primarily, working within a problem-solving tradition of design practice that is often framed under the untroubled terminology of 'inclusive design'.[3] This problem-solving design approach is, not insignificantly, an approach that mirrors the biomedicalised language around older age: dominated by the health and social care sector discourse of preventative interventions where to talk about ageing is reduced to the problematised individual body.

But what if the language around ageing were altered? And the premise of these orthodox design approaches were challenged? Would this open up a space for thinking about older people's relationships

to urban environments in different ways?

The following annotated text-image essay explores how disrupting and altering the language around ageing is one way of not just challenging the representational politics of ageing but a way into generating alternative spatial practices too. Drawing on the work of Ageing Facilities (an informal age-focused research platform) this essay suggests different ways in which the production of differently sited forms of writing around ageing can start to unsettle orthodox narratives and methodologies around age-related urban practice and offer constructive-critical alternatives instead.[4]

The sample of texts illustrated in the pages overleaf show how writing about ageing in different ways can lead into other ways of talking and practicing around the spatial dynamics of ageing. They are texts that build on a rich tradition of feminist textual experimentation, from the writing practices of Hélène Cixous' ecriture feminine to Jane Rendell's notion of site-writing through to the creative play deployed in conceptual art practice.[5] The form that these texts assume is varied: counter-narratives, participative textual constructions, fantasy spatial propositions, subverted definitions of terms, word games. Playful-constructive in their tone, these are texts that start to offer a critically reflective space through which to explore new spatial relationships, conditions and dynamics around ageing.

In different ways, these are pieces of writing that actively engage with older people's marginalised relationships to urban space – relationships that would otherwise go overlooked. They are texts that make space for feeling and fantasy and spatial propositions too – permitting the kind of prospective identification with place that is so often lacking in discussions around ageing, undermining the way in which ageing is all too often tied to a nostalgic, retrospective attachment to place.[6]

These are pieces of writing that start to build a participative space of storytelling through its inter-textual play opening up a public space of critical and reflective discourse around ageing across 'urban' professions and disciplines. In mixing the language and familiar frames of references of different professions and disciplines there is a way of bringing discourses into conversation with one another: social science and local government policymaking with design, creative and urban arts practices.

There is, as these pieces of writing try to show, an attempt to introduce a 'different voice', tone and temper into the instrumental, body-bound narrative around ageing. They bring in what is so often left out of accounts of ageing – the hidden emotional geographies of ageing. Moreover, as texts, they encourage other kinds of reading and conversation around the subject of ageing, moving the debate around ageing beyond an instrumental project/ problem-solving task.

In the feminist figuration of this practice, it is the persona of the 'urban curatrix' that instigates this textual practice, a figure who combines the persona of the 'urban curator' (a 'mediator between actors, forces, processes and narratives')[7] with the caring motivations that, arguably, implicitly underpin curatorial practice. Linked, via its etymological roots in care, to the care-focused feminist theories of Carol Gilligan, Joan Tronto and others, curating here becomes a self-consciously caring practice. And it is through this 'caring' figure of the urban curatrix – through the notion of a care-praxis – that these feminist writing tactics (what Gilligan's idea of 'narrative nuance' might well refer to)[8] are adopted as part of a broader set of caring practices around ageing: using dialogical constructions, counter-narratives, (semi-) fictional stories, as ways of exploring, being attentive to and responsive to the alternative spatial possibilities of ageing.[9]

The following pages are intended as immersive snapshots of this textual practice – and to suggest a range of forms, formats and sites of critical textual production. They include: a large print psycho-geographic novel on ageing, a series of endnotes and fantasy spatial propositions (that 'conclude' the storyline of that fictional novel), a dictionary of age-related words (for public display) and an age-focused adaptation of a popular word game (for personal use).[10]

SLIDE 1
A large print psychogeographic novel on ageing

Produced in 2006, The Fluid Pavement is a Large Print psychogeographic novel on ageing: a semi-fictional story that explores how relationships to public space start to alter over time, in different ways, with age. Introducing stories more usually hidden within stock narratives around ageing (more ordinarily focused on ageing as a condition of mounting need, dependency and loss) the semi-fictional space of this story makes room for a series of counter-narratives on ageing: drawing out what is overlooked, unspoken, half-said; exploring those longings and frustrations that define people's relationships to urban space; mapping out those everyday urban tactics and creative practices of growing old in a particular kind of place; replaying the often hidden emotional geographies of older age. Told through the double voice of two differently ageing narrators, it is the split authorial personality of the novel that allows this storyline to navigate the dominant and counter-narratives of ageing: its unspoken complexities and contradictions, its spatial possibilities and taboos as each voice, differently, starts to replay and move beyond the stock stereotypings of the ageing subject. Set – and re-housed – in the public realm, this is a story that explicitly opens up the geography of ageing. It is a story that exposes people's neglected relationships to public space, it makes these hidden relationships more visible and it confronts the spatial marginalisation of interest in ageing – directly. Produced in a fully accessible large print format and returned to its readership of housebound pensioners (the book is now circulating in a mobile library in east London) the story finds itself back in the landscape out of which it emerged with the subjects of the story itself becoming its active, critical readers in turn.

Or are small markers enough (to remember things by)?

I notice, with some concern, that Sophie's preoccupations are taking on a melancholic turn again. She has taken to listening to Rod Stewart's "I am sailing", when at home, humming the chorus line over and over ("Can you hear me? Can you hear me? Thro the dark night, far away …"). She has borrowed the tape from Mary via me (having heard that this is what Mary wants played at her own funeral). She says she is just following up on Mary's preferences (testing them out for herself). I suggest this is somewhat morbid, turning her living room into a waiting room for death, as if this is all growing old meant to her.

Sitting it out.

Although by my next visit I notice her morbid preoccupations have

78

taken on a more intellectual turn. The singing has stopped. It seems now she is toying with the idea that ageing is the inevitable confrontation of the painful dilemma of permanency and impermanency, a playing out of losses and durability in concrete, physical space … the need for tangible markers in space to outlast disappearance and death (it is the anxiety of invisibility again, she tells me, articulated as the desire for incorporation into that which surrounds you). I think of the bush in Plashet Park ("a frame for posterity"). Sophie thinks of putting up a memorial plaque on Zina's bench ("to register our passing presence", she says).

The following day we resolve to catalogue the losses and emptiness in Newham. Missing pubs that have closed down. A street that's gone. (The street that was Alice Road). We travel

79

SLIDE 2
160 endnotes to a semi-fictional novel

There are 160 endnotes included in the annotated small print edition of The Fluid Pavement. These endnotes account for the participative construction of The Fluid Pavement as a half-fiction told through stories gathered via a series of 'ordinary encounters' with older people, the by-product of an 8-month long pseudo-ethnographic research process of wandering across an east London borough 'exploring the spatiality of ageing.' Each endnote replays that pseudo-ethnographic trail of the story's construction: following the housebound library service through hospital wards, sheltered housing complexes, pairing up with Edith on her shopping trip (down to Rathbone Market), signing up for Barry's weekly tea dance classes in Canning Town (returning to the class week after week), visiting the borough's designated warm zones (for the over-50s) in winter, sitting with Zina on her bench in the park. Each of the 160 references accounts for each constructed moment within the novel, tied to a time, place, a particular encounter in an alternative referencing system of relational documentation. They account for the minutiae of close encounters (within a research process) while grounding the fiction of the novel in its constructed time and space (drawing the fictionality of the novel into its ordinary reality). But they also provide an extension to the fiction of the novel: with added room for speculation and wandering thoughts ('how do you lighten the mood of narratives that insist on returning to relive the past?' p.95).

#8

The Pensioner-Twinned Tree*

*A Public Provision to
Twin Trees in the Borough
with Pensioners across Newham*

Pensioners across the borough are matched up with trees of a similar* (or same) age that are then planted in a park of the pensioner's choice. These ready-matured trees (once allocated) appear overnight across the parks of Newham to give a quick-fix impression of a borough in full maturity. The public landscape of the borough is transformed instantly through these Pensioner-Twinned Trees, providing an image of the borough that corresponds to an older way of seeing things.

* Currently available:
London Plane, *Platanus Acerifolia*, 140 cm girth,
12m high, 6m spread, approx. 55 years old
Silver Maple, *Acer Saccharinum*, 110 cm girth,
13m high, 7m spread, approx. 55 years old

** developed out of page 80*

118

119

#9

A Last Dance in the Park*

*An Illicit Tea Dance
in the Park After-Hours*

A Last Dance in the Park is a one-off, unauthorised event: a tea dance in the park after dark. The event is both a historic re-enactment of a lost tradition – dancing in the park on a Saturday afternoon – as well as an illicit flash-mob act of unsanctioned congregation in the park after closing time. With a dress-code of fluorescent-enhanced period (minimum) 1950s dress, *A Last Dance in the Park* combines irreverent misbehaviour with old-style conformity to tradition. For one night the deadening weight of preservation and tradition is provided with a bit of light relief, as historic re-enactment becomes an opportunity for pensioners to lay claim to the public realm *en masse* by night.

** developed out of pages 94 & 95*

120

121

SLIDE 3
Ten spatial propositions as fantasy 'conclusion' to a semi-fictional novel

The semi-fiction of The Fluid Pavement concludes with ten fantasy propositions. These playful extensions drawn out of the storyline of the book offer up other ways of laying claim to the public realm 'even in older age' (fluidified pavements for recovered ease of movement, 'pensioner'-twinned trees to recover an age-equivalent sense of space). These spatial propositions 'from the sublime to the absurd' offer alternative images of ageing that move beyond the problem-solving brief of age-inclusive design practice (where ageing is understood as an instrumentalised problem to be solved) and beyond the retrospective focus of creative urban practice around ageing too (where older people are tied, through memory and reminiscence, to places as-they-were to the exclusion of places as they are experienced now or as they might be). These other-worldly fantasy propositions take on their own real-world presence as they become in turn, the basis for a series of acted-out interventions in the public realm: the fictional components of the story that turned into realised briefs, two, three years on (Civil Twilight, the Resistant Sitting project, Audio Aid).

SLIDE 4
An alternative dictionary of age-related words (for public display)

This dictionary of age-related words (for public display) is a dictionary that unsettles as much as it starts to define key terms on ageing (aged, old, over the hill). From the infra-ordinary to specialist language on ageing, these definition of terms trace the etymological roots and the often unacknowledged spatial implications of how we talk about ageing – the implied invisibility of now being 'over-the-hill' as being somehow beyond a horizon of visibility. Displayed as a series of sample spreads 'as if' drawn from the pages of a conventional dictionary these redefined terms mounted for display aim to create a public space of communication around the meanings of older age. Unsettling the unproblematised discourse on ageing each definition unpicks the loaded meanings behind each term, a prop for conversation, reflection and debate. This alternative dictionary was exhibited under the title 'Sticks and Stones may Break my Bones' at the William Road Gallery, London in January 2012.

121 *Like the story of the bomb on South Molton Street,* for instance. A story that must have been told to me by others and then by others 5 times or more. "The whole front of the house came down like a white sheet." (From a conversation with Ivy at the Ascension Church Lunch Club, Custom House, London, E16: 24th November, 2005 and then again, for the following 3 weeks). Memories of places are marked out by incidents that repeat themselves as they are relived in storytelling, over and again.

122 *It is the steadying effects of familiar narratives* (and memories). Stories that provide a way of reconnecting to places within a broader environment that is changing fast beyond recognition. Fixing places in words becomes a way of making a place remain as it is (in the mind at least).

123 *It is the unsettling effect of listening to the past being retold in repetition.* As if there were some sort of compulsion to repeat old stories, as if older people themselves assume that this is all that others are interested in, in their stories of the past. (Is this assumption fuelled by the work of reminiscence clubs that provide a guaranteed time slot, once a week to travel backwards in time, turning the clock back as if the principle knowledge, expertise and value of older people lay only in the past?)

124 *The first turn in the road after the station,* if you're heading north on Manor Park Road, London.

125 *Unlike the changing layout of Selfridges. (See note 119).*

126 *As certain places have a way of triggering running commentaries of them.*

127 *Like increasing your pace to catch up with a familiar face* (shopping with Edie, for instance, in Rathbone Market – on the 10th March, 2006 – we increase our pace to catch up with a familiar face: "It's nice to see old faces," she says. "Isn't it?"). Now the same comforts of social recognition repeat themselves in Edie's bend in the road. The recognition of an old, favourite place ends up feeling like recognising an old face. (Places turn out to be socially comforting too).

128 *On North Street, Plaistow, London, E13.*

129 *The recently completed Gate, for instance* (on Woodgrange Road, in Forest Gate, London, E7). Or the Beckton Globe "purpose built and state of the art", (on Kingsford Way, Beckton, London E6). Or the new library that's been promised (for North Woolwich).

130 From a conversation with Joan (at the Ascension Church Lunch Club, Custom House, London, E16: 15th December 2005).

131 *"Mrs. B. we've kept your book for you."* (From a conversation with Pat in Plaistow Library, Plaistow, London, E13: 13th October, 2005). "This is what old people come in to hear. They don't come in so much for books. They come in to be recognised as a valued member of the community. To know that people have been thinking of them. (Now there's only one person at the counter. Most of it's self-service now)." The trajectory from the past to the present is made to read as a loss of community values: everything now reduced to the level of diminished social contact. Remote care like Telecare, *(see note 45).* "It's all help-yourself, D.I.Y. in the libraries now …").

132 *The library dates from 1903.* (It's 203 years old).

133 *Redbrick-solidities and old securities.* "We need to turn the clock back," the librarian says (in a conversation in the Library, Plaistow, London, E13: 13th October, 2005). Does that mean turning the clock back now to 1903? Or maybe not. *(See note 135).*

134 *The dancing classes start on 7th November 2005* at the St. John's Community Centre, North Woolwich, London, E16. Research takes on the form of partnered discussion-while-dancing (paced to a partner's step) as thoughts let slip, by the way. I go dancing, like everyone else, every Monday for 6 weeks. (It is the immersive method of conducting research).

135 *How do you lighten the mood of narratives that insist on returning to relive the past?* Can stories that insist on "turning the clock back" ever turn into narratives that look forward into a changing world? To 2012. (As opposed to facing backwards with longings still for 1903).

136 *The Christmas Special* (at the St. John's Community Centre Pensioners' Ballroom Dance Club, North Woolwich, London, E16: 7th December, 2005) in the presence of the Mayor, Sir Robin Wales.

137 *Built to the dimensions of 25,000 pensioners squared.*

138 *The tea dance sessions have continued* (supported by LBN's Festivals and Celebrations Department). There were (not unfounded) fears that the sessions would be axed. *(See note 139 below).*

139 *Which is in large measure dependent on a commitment to funding that is not always sustained.* Consider, for instance, Mrs. P's self-initiated sit-down exercise clubs in Silvertown, which were funded by Age Concern for a year or so – and then the funding was abruptly cut. More recently, (according to local rumour, at least) the line item for financing

94

95

a certain age (of) *adj*. **1** of indefinite age (literally). **2** *n*. an older person. Ambiguous allusion to a subject's precise number of lived years (obfuscation). Often used in social situations to softening effect in indirect allusion to older age [PSCYH. MECH: DENIAL] *tone*: EUPHEMISTIC.

advanced in age *adj*. to be beyond others in age. Marking out time through metaphor of distance [SPATIAL] with subtle clinical [MED.] overtones (alluding to medical conditions in a last, often terminal phase - eg. 'advanced dementia'). Also used in following variations: **advanced years (of), advanced old age** and as a term of inexorable progression, as in: *adv*. **advancing years**. *tone*: OMINOUS though literally: PROGRESSIVE.

aged *adj*. **1** in a condition of agedness. Having lived almost to, or beyond the usual time allotted to a given species of being (approaching a terminal point of limit). **2** *n*. a fixed assignation for older age [CONDITION: PASSIVE] *pl.* **the aged**. **3** *adj*. ripeness, in vinology meaning: brought to a desired state of fullness of flavour. Also applied to literary effect: **aged youth** *literary* as in Goethe's *The Man of Fifty* [1829] (both romantic and infantilising). *tone*: DEFINITIVE.

ageful *adj*. **1** literally, full of age - ie. plentiful and generous (the opposite of ageless). Rhymes with plentiful: eg. 'there was an ageful wisdom in her eyes' *tone*: RELENTLESSLY POSITIVE. **2** *n*. a legal desingation to define a condition of maturity in face of the law (in UK to be 18 years and above). **3** *adj*. (*Amer.*) geriatric. An Americanism used to avoid the objectifying and/or direct naming of the old as old. *tone*: P.C. (POLITICALLY CORRECT).

ageing *adv*. **1** in the process of growing old. A universal concept (technically begins in embryonic state also known as 'cell death' ie. ageing as a continuous process of biological death). **2** *adj*. also refers to dillapidated objects, things and buildings, eg. 'ageing sports facilities'. Also used as **3** *n. pl.* **ageing (the)** to designate the elderly (as collective social structure). [USAGE: ACADEMIC] Coined by American gerontologists to avoid the objectifying and/or direct naming of the old as old. *tone*: P.C. (POLITICALLY CORRECT).

ancient *adj*. **1** of or relating to times long gone past (as in 'ancient Egypt'). Frequently applied to physical structures, ruins and monuments (often with preservation orders attached). Carries positive connotations of venerability. **2** *n*. (*inf*) an old person. Carries negative connotations of crumbling states of ruin (mental and/or bodily). *tone*: DEROGATORY, SELF-DEPRECATING also, on occasion, MILDLY AFFECTIONATE.

anile *adj*. **1** to be in a state of **anility** ie. to be like a feeble old woman [from the Latin *L. anus* meaning woman]. **2** *adj*. aged through implied senility [GENDERED: FEMALE]. Associates with dementia and so, by extension, with ageing. *tone*: OFFENSIVE.

autumn of life (in the) *adj. & n*. to be old. A metaphoric allusion to that transitional period between summer and winter characterised by loss of fertility, warmth and the shedding of leaves. Applied to the natural progression of a human lifecourse into older age (precedes the cold winter of death). [SEMIOLOGICAL EFFECT: NATURALISING]. *tone*: EUPHEMISTIC / NOSTALGIC.

biddy *n*. (*inf*.) **1** a hen, a fowl. **2** *n*. (*inf*.) an old woman, especially a garrulous one [GENDERED: FEMALE] *tone*: DEROGATORY, SELF-DEPRECATING also, on occasion, MILDLY AFFECTIONATE.

bluehair *n*. (*inf*.) an old woman, derived from the blue dye rinse used to cover grey hairs. See also **blue rinse** as in 'part of the blue rinse brigade'. *tone*: DEROGATORY

centenarian *n*. (*tech*.) someone who is 100 years old or older [from the Latin *L. centenarius* meaning of a hundred]. A strictly quantitative definition of age based on numeric calculation. *tone*: MILDLY CALCULATING.

chair-days (in my/your/one's) *n*. (*obsolete*) **1** older age as a period of time. Alludes to days spent sitting in chairs owing to lack of mobility. [CONDITION: PASSIVE]. Historically specific term [16TH CENTURY] used before the advent of hip replacements, as in 'In thy reverence and thy chair-days, thus/To die in ruffian battle?' Shakespeare: 2 Henry VI, Act V, Scene II]. Connotations of spatial confinement (see seamless conjugation of chair-bound with housebound). *tone*: RESTRICTIVE.

crinkly *adv*. **1** an uneven surface by virtue of having wrinkles or a rippling texture (informal). **2** *n*. (*inf*) an old person as in someone with wrinkles. An insult (often overheard in youth speak). See also **wrinkly**. *tone*: OFFENSIVE.

crumbly *adj*. **1** with a tendency to disintegrate and fragment *adv* **2** *n*. (*inf*) an old person, presumably about to disintegrate. An insult (often overheard in youth speak). *tone*: OFFENSIVE.

declining years (in my/your/one's) *adv*. to be in older age. Associated with a downward trend and/or with diminishing scale [SPATIAL]. Also implies a process of gradual deterorioration and degradation. *tone*: DEPRESSING.

decrepit *adj*. **1** in poor condition, worn out by hard and long use, often dilapidated and no longer working

tone: MORBID. [SEMIOLOGICAL OPERATION: OVERLY LITERAL].

longer living *adv. Amer* having considerable duration in time, extending beyond normal or moderate limits *tone:* EUPHEMISTIC.

mature *adj.* **1** complete in natural growth or development, as in plant and animal forms (eg. a mature rose bush, ripe as fruit, or fully aged cheese or wine) **2** fully developed in body or mind (as in 'he is mature for his age') **2** to be old, as in *The Mature Times* (a publication for older adults). *tone:* VAGUELY RESPECTFUL.

more advanced in years *adj.* **1** literally meaning having more years **2** *(euphm)* a designation of old in the more positive, progressive terms of advance, advancement and advancing. *tone:* EUPHEMISTIC.

nonagenarian *Tech* a person in his/her nineties, of the age of 90 years, or between 90 and 100 years old. [from the Latin *L. nōnāgēnāri(us)* as in containing ninety, consisting of ninety].

not young *adj.* an emphatic antonym for not being in the first or early stage of life or growth (not having the appearance, freshness, vigor, or other qualities of youth).

OAP *n.* stands for 'Old Age Pensioner' or a person who receives or lives on a pension, *(increasingly obsolete)*. *tone:* DEROGATORY.

octogenarian *Tech* person in his/her eighties, a person who is between 80 and 90 years old [from the Latin *L. octōgēnāri(us)* comprising eighty, eighty years old].

of pensionable age *Tech* a person of statutory age (sixty/sixty-five plus) eligble to receive or lives on a pension.

of retirement age *Tech* a person of statutory age eligble to retire from work sixty/sixty-five plus

old emphatic obsolete, no longer in general use; fallen into disuse, effaced by wearing down or away. of or pertaining to the latter part of the life or term of existence of a person or thing; far advanced in the years of one's or its life

old age (in) *n.* the latter years of somebody's life lived out to its full term.

old codger *(inf)* joan lunch club 21.05.2009 context "this is the old codger's table" an eccentric man, esp. one who is old. *tone:* MILD AFFECTION OR DERISON [from *cadger* a person who begs or gets by by begging].

older **1** literally more old than old between old and oldest (relative term, degrees of comparison - between adjective and superlative is the comparative - in the sequence old, older, oldest) a softening comparison in generational sequence from young to old. *tone:* EUPHEMISTIC.

older people *n.* a collective designation for the elderly.

tone: GENERAL.

old fogey an excessively conservative or old-fashioned person, esp. one who is intellectually dull (usually prec. by old). *tone:* DEROGATORY.

oldie *(inf) noun* Informal an old person or thing, songs: a song that was formerly popular see also **golden oldies,** something old or long-established, esp a hit record or song that has remained popular or is enjoying a revival oldish *adj* somewhat elderly. non-committal/vague/ambiguous

oldster *n.* an old or elderly person [SLANG] (modelled on 'hipster' and 'youngster').

old-timer *(inf)* **1** a person who has been in a certain place, occupation, etc., for a long time **2** *Amer* an old person.

on the way out *v.* **1** literally, en route to an exit [SPATIAL]. **2** on the way out of life, or old. *tone:* EUPHEMISTIC.

one foot in the grave (with) *(proverbial)* half-buried, modelled on toe dipped in water. *tone:* BLACK HUMOUR.

over-fifties *n.* chronological category of those 50 plus (institutional definition for elder groups favoured by local authorities).

over-the-hill *n.* **1** the state of being literally beyond a horizon of visibility [SPATIAL] **2** far along in life; old. past the peak of one's youthful vigor and freshness. [PSCYH. MECH: DISTANCING] *tone:* EUPHEMISTIC.

past it *adj.* **1** No longer current [TEMPORAL] **2** gone by [SPATIAL] **3** redundant. (May be, as it rhymes with, confused with 'lost it').

past (my/your/one's) prime *adj.* the state of being past the principal, active phase of life (see Johnny Mercer's lyrics for Li'l Abner - The Musical, 1956, 'I'm past my prime/What a shame/And I'm losin' time'). *tone:* REGRET. *gendered:* FEMALE. Relates to being left on-the-shelf [SPATIAL].

pensioner *n. Tech* the beneficiary of a pension fund, one who is dependent on the bounty of another.

retired *n. Tech* withdrawal from one's occupation, business, or office/someone who has retired from active working...Withdrawn; secluded. see also variations **retired person** (3rd person neutral) **retiree** business/Industrial Relations & HR Terms) Chiefly US a person who has retired from work

second childhood (in my/your/one's) *n.* **1** the state of being in chidlhood again (with implied regression) [EFFECT: INFANTILISING] **2** the state of being in

SLIDE 5
An age-focused adaptation of a popular word game (for personal use)

'Jargon bingo' is an informal word game used in meetings to quietly log and undermine age-specific neologisms (questionable, quizzical turns of phrase, difficult for those outside a specialist discourse to understand). Here, in the age-focused adaptation of this linguistic game, words and expressions typically used by those working in the specialist field of age-related policy are set out as a trail of terms for others to quietly follow. From 'person-centred' to 'product', the idioms of 'age-inclusive discourse' appear as a matrix of expressions from across the fields of public health, social policy, local government and urban design. Turns of phrase that would otherwise never meet are set side-by-side, and, through their own set of footnotes, put into their literal context: their meanings demystified (in part), their context disclosed (overheard in the context of a public health seminar)[11] logging the disparate locations of their encounters.

protective function[1] mainstreaming[2] person-centred[3] mitigation[4]

wellbeing[5] social return on investment[6] product[7] supportive function[8]

future-proofing[9] whole lifecourse approach[10] whole-system[11] efficiency savings[12]

rightsize[13] upstream[14] high wellbeing environment[15] under-occupancy[16]

downsizing[17] prevention[18] evidence-based[19] age-proofing[20]

1. Factors within an environment or personality that make it less likely for someone to experience a given problem. Appears both technical (in function) and, ostensibly, caring/paternalistic (carries implications for/pressure to enact **behaviour change**). Closely related to **prevention**. Context: PUBLIC HEALTH [ICUH | 06.03.14]. 2. *Active verb* taken to mean 'normalising' new or marginal ideas and practices within a cultural mainstream. Or, put differently, the act of reframing prevalent attitudes, values, and practices to the point where 'other' ideas become common/accepted values and practice: as in 'mainstreaming ageing'. Etymology: derives from 'management speak' Context: LOCAL GOVERNMENT. [AFM050G-MCC | 23.03.13]. 3. Literally, focused on the person. Could be understood as humanising – in its personalising focus (the opposite of objectification - i.e. subject-focused) or, conversely, as de-humanising in its implied denial of inter-dependency. Used as a *compound adjective*. Context: PUBLIC HEALTH [WHO-ALC | 01.10.15]. 4. Literally, the action of reducing the severity, seriousness, or painfulness of something. More commonly understood as, simply: damage limitation. Closely related to **prevention**. Context: PUBLIC POLICY [WHO-CHD | 30.08.12]. 5. Literally, the state of being comfortable, healthy, or happy. (A merged *compound adjective* - formerly 'well-being'). Derives from positive psychology movement and self-management principles. Increasingly, used as a basis for measurement. Context: PUBLIC POLICY [IDGO-TOO | 26.04.12]. 6. An analytic tool for measuring and accounting for 'value'-(for-money) that acknowledges the social as well as economic value of things. As in, 'the benefits of very sheltered housing has led to an overall reduction in the need for care of 63 hours a year for those who would otherwise have been in their previous home, with a cost saving of approximately £1,300.' See Bield, Hanover & Trust Housing Associations and Envoy Partnership, *Striking the Right Balance: A Social Return on Investment (SROI) of Very Sheltered Housing* (Housing Lin: 2013) Context: LOCAL GOVERNMENT. [UKNAFC | 27.09.12]. 7. Literally, something made to be sold. More broadly, may be a service, 'offer', or publication provided for free. Used to suggest the concrete goods of less tangible services? Implies solidity. Object-focused. Context: LOCAL GOVERNMENT [AFM-MCC | 11.09.2015]. 8. The transformation or modification of human behaviour. More broadly, meaning, strategies and interventions that focus on changing people's behaviour (as in 'nudging' or designing a 'choice architecture'). Context: PUBLIC POLICY [EMC4HNC | 17.10.13] 9. The process of anticipating what will happen in the future and developing methods to minimise the shock effects of those future events. Related to **mitigation**. Etymology: used in electronics, industrial design, increasingly, used in relation to building design, primarily, as in: 'the future proofing' of 'Lifetime Homes'. Carries an implied guarantee. Used as a *compound adjective*. Context: DESIGN. [MDAG | 03.06.2015] 10. A particular temporal and social perspective that involves thinking across a cohort's lifecourse (and its dynamic social context). Usage: 'a whole lifecourse approach to positive ageing'. Context: PUBLIC POLICY [GGAHA-DGE-EU | 04.06.12]. 11. An approach that involves identifying the different components of, and the characteristics of the links within a system. Used as a way of encouraging integration and participation across all levels of policy and practice. *Compound adjective*. Context: PUBLIC POLICY [ILC-UK/AGEUK | 08.05.14]. 12. Saving through efficiency. Neutral/euphemistic in tone. Another way of saying: cuts in funding. Context: LOCAL GOVERNMENT [AFCLE-ARC/CU | 17.01.13] 13. Literally meaning to convert (something) to an appropriate or optimum size. Corrective. Merged *compound adjective*. Context: DESIGN. 14. Literally, meaning close to the source. Used as an *active verb* ('to upstream') to describe tackling problems before they come to a head. (e.g. focusing on the 'social determinants' of health). Related to **prevention**. Context: PUBLIC HEALTH [FPH-UK | 04.07.2013]. 15. An environment that promotes positive wellbeing. Implies environmental determinism. Context: DESIGN. 16. The state of not being occupied to the expected or advertised capacity (as in hotel or hospital accommodation), or, when referring to home dwellings, occupancy of a building by fewer people than it could reasonably house. Implies, as with **rightsize**, an ideal size ratio. *Compound adjective*. Context: PUBLIC POLICY [HLIN-ECHAC | 18.02.14]. 17. Making something smaller, to minimise. Originally used within organisational management to describe the shedding of staff within a corporation. Increasingly, used to describe the process of downsizing in retirement. Related to **rightsize** and **under-occupancy** with an implied pressure to encourage movement (down, into smaller spaces). Context: PUBLIC POLICY [LNW2-GLA | 06.07.12]. 18. The action of stopping something from happening or arising. Used as an *active verb* to mean interventions that occur before the initial onset of a certain condition. Related to **upstream**. Context: PUBLIC HEALTH. 19. *Compound adjective* literally, meaning: founded on evidence. Implies solid certainty. Often used in conjunction with 'research shows'. Context: PUBLIC POLICY | LOCAL GOVERNMENT. [EUINNOVET/APU | 24.09.15] 20. A *compound adjective* similar to **future-proofing**, as in anticipating what will happen in older age and developing methods to minimise the shock effects of those future events. Related to **mitigation**. Example usage: 'age-proofing universal services'. Carries an implied guarantee. Context: LOCAL GOVERNMENT | DESIGN. [RIBA/FCC | 14.04.14]

Afterword

Ageing, it can be said, bears many of those same burdens that feminists have long been grappling with: the experience of marginalisation and invisibility, the focused preoccupation on the (differently objectified) body. Ageing, within design practice though, with its instrumental focus on the ageing body, is rarely addressed in these terms. Feminist approaches to thinking about older age, however, offer new ways of addressing these silenced issues around ageing and marginalisation, invisibility and objectification – suggesting alternative ways of imagining and constructing older people's possible relationships to space – here, through experimental writing. From dialogic constructions to fictional criticism these forms of writing make space for the development of a critically more reflective and situated practice around the subject of ageing.

There is a strange temporal dynamic, though, to the subject of ageing that situates this practice differently to other marginal subjects. The temporal distortions of this subject are hinted at in what Simone de Beauvoir called 'prospective identification'[12] – the contorted process of imagining forward into an unimaginable future of older age, a subject position we, paradoxically, expect to grow into over time, with age. But those distortions carry, a critical potential too as feminist writing offers a constructive-creative space in which to explore these shifting temporal positions around the subject(s) of ageing: imagining forward into unimagineable futures; thinking forward into older age from a position of relative (passing) youth; exploring the shifting subject position of the critic-practitioner and her care-praxis (curatrix) in relation to its 'cared-for' subject over the lifecourse of a practice – as a figure working/writing, variously on/with/ by/from/for – eventually as – its own subject(s).

1
Ageing, Creativity and the Public Realm, Public Wisdom, Symposium 2015, Cubitt Education, London).
2
See for instance, C. Phillipson, 'Developing age-friendly communities: New approaches to growing old in urban communities' in Richard A. Settersten Jr. and Jaqueline L. Angel, *Handbook of the Sociology of Aging* (New York: Springer, 2011).
3
See Sophie Handler, *An Alternative Age-friendly Handbook* (Manchester:
the University of Manchester Library, 2014) also Jos Boys, *Doing Disability Differently: An alternative handbook on architecture, dis/ability and designing for everyday life* (London: Routledge, 2014).
4
www.ageing-facilities.net
5
See for instance, Hélène Cixous, 'The Laugh of the Medusa' trans. Keith Cohen and Paula Cohen, *Signs* 1, no. 4 (1976), pp. 875–93, bell hooks, *Wounds of Passion: A Writing Life* (New York: Holt Paperbacks, 1999). Julia Kristeva, 'Institutional Interdisciplinarity in Theory and in Practice' in *The Anxiety of Interdisciplinarity: De-, Dis, Ex-,* ed. by Alex Coles and Alexia Defert, vol. 2 (London: Blackdog Press, 1998), pp. 3–21, p. 18, Jane Rendell, *Site-writing: the Architecture of Art Criticism* (London: IB Tauris, 2010) or Peter Osborne, 'Conceptual Art and/ as Philosophy,' in John Bird and Michael Newman eds., *Rewriting Conceptual Art,* (London: Reaktion Books Ltd., 1999).
6
Sophie Handler, 'Active Ageing: Creative Interventions in Urban Regeneration' chapter 9 in Myrna Margulies Breitbart ed., *Creative Economies in Post-Industrial Cities: Manufacturing a (Different) Scene* (Surrey/Burlington VT: Ashgate, 2013) and Sophie Handler, 'Ageing, Care and Contemporary Spatial Practice' in Charlotte Bates, Rob Imrie, and Kim Kullman eds., *Design as caring in an urban world* (Wiley: forthcoming 2016).
7
Meike Schalk, 'Urban Curating: A Practice of Greater Connectedness' in Doina Petrescu, *Altering Practices. Feminist Politics and Poetics of Space* (London and New York: Routledge, 2007), p. 161.
8
See Virginia Held, *The Ethics of Care: Personal, Political, and Global* (Oxford: Oxford University Press, 2006), p. 15.
9
Handler, forthcoming 2016.
10
Sophie Handler, *The Fluid Pavement and Other Stories on Growing Old in Newham* (London, RIBA: 2006); 'Sticks and Stones May Break My Bones' William Road Gallery, London (January 2011).
11
'Age-friendly cities and healthy cities: reshaping the urban environment', *11th International Conference on Urban Health*, University of Manchester (6th March 2014).
12
Kathleen Woodward, *Aging and Its Discontents: Freud and Other Fictions*, (Indiana University Press: Bloomington and Indianapolis, 1991), p. 13.

OLD AND NEW RADICALISMS: A SHARED VISION, THROUGH THE LOOKING GLASS

DESPINA STRATIGAKOS

A century ago, an extraordinary phenomenon unfolded in imperial Berlin: through architecture and words, women began to claim the city's streets and spaces for themselves, shaping a new form of urban experience responsive to their needs and identities. The creation of this alternative "women's Berlin" was largely a bourgeois response to the industrial metropolis and the challenges it posed to traditional family patterns and gender roles. While male critics of Berlin's rapid development decried the loss of familiar places and routines, some women glimpsed their freedom in these dislocations. In the city's alienating potential—the unmooring of the individual from traditional social ties—bourgeois women saw an opportunity for the creation of new communities of women self-consciously engaging with and contributing to the metropolis. By pooling their resources, these urban female collectives succeeded in building a visible network of women's spaces—from residences to restaurants, schools and exhibition halls—to accommodate changing patterns of life and work. In the process, they both mastered the rules of the masculine public realm and challenged its foundations by exploring and asserting a different way of being.[1]

When, during the imperial period, female traders were banned from the floor of Berlin's stock exchange (along with "idiots, bankrupts, criminals, and persons afflicted with contagious diseases"), a newly founded women's bank insisted that its representatives be admitted. Similarly, police harassment of "public" women, including those who dared to walk the streets alone, prompted women to assert their right to be visible. In 1912, the German Lyceum Club organized a monumental exhibition on women's contributions to the nation, held in the Zoological Garden Exhibition Building, a highly visible and trafficked location. These are but a few examples of how women

challenged the boundaries of the public sphere by brazenly stepping onto male turf. At the same time, such exclusions also prompted women's organizations to create separate professional and social spaces that paralleled, and often physically approached, those of men. The German Lyceum Club, which sought new professional opportunities for women, located its headquarters in the immediate vicinity of Berlin's political and economic centers.[2] This position of radical adjacency emerged partly out of necessity, since women had no official entry into these arenas. But it was also strategic, in that women did not want simply to be admitted into the centers of power as they existed, but rather aimed to skew them—shift them off balance—with a fundamentally new vision of a more egalitarian and just society.

The Stockholm *Feminist Futures* participants share a legacy with these past radicals (even if women in imperial Berlin did not always claim that moniker), who sought to undermine the status quo through the insistent presence and intervention of politically self-aware women. The century that separates these groups has witnessed both great strides forward in improving the status of women in the Western world, as well as severe retrenchment and even, some contend, failure. Moving forward in this context requires an honest examination of past strategies that have not proven effective as well as a willingness to reconsider the value of some that may have been prematurely abandoned by others. Audrey Lorde famously insisted that "the master's tools will never dismantle the master's house," but it is worth considering whether those tools, held at a different angle and in different hands, might do a good deal of damage.[3] As Leonard Cohen writes, it is through the cracks that "the light gets in."[4]

In 1913, the publication of a women's guidebook, *Was die Frau von Berlin wissen muß* (What a Woman Must Know about Berlin), marked a profound transformation in the relationship between women and their urban environment. The guide, intended for the city's long-term residents as well as newcomers, was authored by women prominent in their fields and addressed a largely middle-class audience. Twenty-five essays, on topics ranging from high culture to social issues, explored various dimensions of city life from the perspective of what a woman should know. The book portrayed women—in their roles as students, professionals, members of women's organizations, and contributors to social welfare programs—as vital actors in the urban scene. This represented something new in advice literature for middle-class women. Whereas traditional instructional manuals focused on religion and the domestic sphere, the Berlin guidebook defined women in a secular, public relationship to the city. Rather than inviting women to take their place as mistress of the house, as did traditional advice books, the guidebook suggested a turning toward the city as the new realm of women's activity. There was no longer one exclusive site for women's activity (the home), but a network of sites spanning the city.[5]

The empowering strategy of adopting and subverting conventional narrative tropes

also informs *Stockholm 2030: Another Guide to the Future*, authored by Karin Bradley, Ulrika Gunnarsson-Östling, Meike Schalk, and Jenny Andreasson.[6] Writing from the standpoints of their expertise in planning research, future studies theory, and architecture, respectively, the contributors re-read *Vision Stockholm 2030*—the 2007 document produced by the City of Stockholm that laid out its strategies to cope with the city's projected growth over the next decades—from the perspective of feminist political ecology. *Stockholm 2030: Another Guide to the Future* plays on this and other master plans issued by politicians, planners, and corporate partners that inform residents of the happy future selected for them. Such documents typically offer a palliative approach that rarely addresses the fundamental underlying issues of urban distress, such as the chronic shortage of affordable housing or the shortsighted management of waste and pollution. *Stockholm 2030* aims, by contrast, to be a "shadow version of Stockholm's official vision," a political provocation, using a traditional declarative form to give voice to citizens typically left out of the decision-making process and to imagine a future driven by the desire for a truly egalitarian and ecologically sustainable built environment.

Mirroring the strategies employed in *What a Woman Must Know about Berlin*, the creators of *Stockholm 2030* assemble their future vision partly on the basis of progressive aspects of urban design or organization that have already been implemented, but in an isolated or piecemeal manner. The 1913 women's guidebook, for example, encouraged its readers to expand their horizons by mapping out existing new opportunities, such as the Women's Apartment Cooperative, devoted to designing and building residences for female professionals, or the Wannsee Ladies' Rowing Club, founded because the older Berlin Rowing Club refused to admit women. Similarly, *Stockholm 2030* lays out a future that includes practices that are increasingly familiar today, such as urban farming and shared vehicles. The power of both of these documents, one from 1913, the other composed exactly one hundred years later, comes from the impact of gathering such elements into a whole picture—specifically, the space of imagination that they create for the reader to envision not only a new city, but, more importantly, a new way of being.

In 1913, the optimism shaping *What a Woman Must Know about Berlin* spoke to the growing strength of the women's movement and to the slow, but steady advances made in women's education, economic participation, and social involvement. A century later, the authors of *Stockholm 2030* are certainly aware of all that has not happened in the fight for social justice. Nonetheless, they adopt the hope and optimism of earlier feminist narratives as a consciously radical tactic that seeks to inspire in the face of disappointment and cynicism and to raise the bar of our political expectations. Even an older work such as *What a Woman Must Know about Berlin* still has the power to inspire and to make us ask "why not?" in our search for better alternatives to the status quo.

Like the authors of *Stockholm 2030*, the contributors to *What a Woman Must Know about Berlin* placed tremendous emphasis on community as the foundation for social change and agency. In advocating an active role for women in the metropolis, *What a Woman Must Know about Berlin* did not expect an individual to evolve on her own, but rather to develop herself within and act together with a community of peers. After the turn of the twentieth century, various institutions arose in Berlin to respond to the need for new kinds of gender-based communities. In the place of traditional family bonds, they offered *Frauengeselligkeit*, the good company of women. This represented much more than companionship; it was about cultivating the self within a same-sex setting that fostered intellectual agency and social commitment. At the same time, these institutions also addressed the desire for a more gender-responsive built environment. Against the patterns and spaces of the old patriarchal home, these new communities helped shape a way of living in the city as modern women.

Women's clubs in Berlin, the most famous of which was the German Lyceum Club founded in 1905, represent one such example. The Lyceum Club, an international organization first established in London, catered to educated, middle-class women. The idea originated as a response to the excitement and pathos of the "modern girl," who lived independently and supported herself through a profession. The club presented itself as a labor union for female "brain workers"—a broad category including artists, scholars, and writers—that aggressively pursued international markets for their creative work. Promoting a form of gendered free trade, the club promised its members new opportunities to sell their work abroad and at home. To this end, a specially staffed bureau assisted members in their various occupations. The point was not only to promote members' work but also, by rigorous means of selection, to improve its professional caliber.[7]

Additionally, the Lyceum Club understood its mission as providing a home for the increasing number of single women living on their own in large cities and integrating these individuals into a nurturing, female collective. The clubhouse was seen to embody these corporative and restorative functions and to physically symbolize this new feminine entity in the urban landscape. In London and Berlin, the monumental clubhouses established by their respective Lyceum Clubs were modelled on prestigious men's clubs. Their impressive architecture and interior spaces were considered a means to level the playing field for women in competition with men. Single career women, typically living on minimal salaries and barely able to afford to rent a furnished room, found in the clubhouse "a substantial and dignified *milieu* where women could meet editors and other employers and discuss matters as men did in their professional clubs: above all, in surroundings that did not suggest poverty."[8] Moreover, by recalling men's spaces, the clubhouse was meant to put male visitors at ease and encourage them to see women as their equals and colleagues.

This radical act of mimicry recalls the subversive actions of Stockholm's New Beauty Council, a queer feminist collaborative that insinuates itself into corporate boardrooms and onto the committees of public authorities. The artist-founders, Annika Enqvist, Thérèse Kristiansson and Kristoffer Svenberg, engage the conflictual nature of public space through various aesthetic lenses, such as taste, in order to bring to the fore competing ideals and to provide a forum for such values to be aired and debated.[9] The name that Enqvist, Kristiansson and Svenberg chose for their collaborative mimics that of an official organization, which has led to invitations to partner with authorities such as the city planning office and the Swedish cultural ministry. In this way, a door has opened that otherwise might have remained shut. Having thus gained entry into the halls of power, the New Beauty Council's long-term success depends, however, on building trust with these institutional partners. Enqvist, Kristiansson and Svenberg write that "they work from within but address the world outside."[10]

For the members of the Lyceum Club in imperial Berlin, being able to function in boardrooms or on public committees entailed learning a new language and mode of speaking. Members were encouraged to practice public speaking, and prominent male writers and politicians were also invited to give lectures so that women could develop the intellectual habits and modes of discourse that they felt were needed to operate in the masculine public realm.

While the Lyceum Club thus sought to broach the divide between male and female spheres, the club's founders were also aware of the chasms that existed among women themselves and even among its own members. The membership of the Lyceum Club mingled middle and upper-class individuals, a significant act in a title-conscious, monarchical society. Working-class women could not afford the club's fees, and, in any case, were not recruited. Nonetheless, the social and economic disparities that existed among club members were real and significant. To these must also be added differences in religious backgrounds, since membership was open to all faiths. The Lyceum Club believed that through common space and a shared mission, it could foster an esprit de corps among its members despite such differences, promoting a sense of a feminine collectivity in the city. As noted earlier, the clubhouse itself stood as a symbol of this gathering, protective function.

Rehearsal—On the Politics of Listening, initiated by artist Petra Bauer and political scientist Sofia Wiberg, takes up the legacy of the Lyceum Club members' desire to be heard and to forge bonds across social and cultural divides, but does so with a great deal of critical distance.[11] In Bauer's and Wiberg's formulation, it is listening that becomes the vehicle for transcending one's own boundaries and developing an extended field of agency. As at the Lyceum Club, shared space is critical to this process of coming together. The project unfolded over several months in workshops that took place in the Tensta konsthall (Tensta Contemporary Art Center), in a room specifically

designed to communicate a familiar domestic setting. Whereas for the members of the Lyceum Club, talking became a vehicle to assume a subject position, Bauer and Wiberg used empathetic listening to explore more fully what it means to be a subject in contemporary Swedish society. Rather than try to sweep away profound cultural, social, and economic differences, Bauer and Wiberg sought to understand their mechanisms and how inner walls are erected that divide us from other people. Moreover, the program, which used not only listening, but also gestures and music, harnessed the power of discomfort in a productive manner to explore where those inner walls lie and to confront our habitual ways of listening or, more often, not listening.

The shift in balance that Bauer and Wiberg seek in comparison to that pursued by the Lyceum Club founders is reflected in their different locations. The Lyceum Clubhouse was located at the center of Berlin's male power networks, whether commercial or political, upon which it deliberately encroached. Tensta konsthall is, by contrast, in the northwest part of Stockholm, in the suburb of Tensta, which houses a largely immigrant population. Poverty and segregation are pressing issues. This shift in location acknowledges the power imbalances in subject relations between the population at the city's center and those literally on the margins. It also signals the desire of many feminists today to move beyond the class and ethnic boundaries that too often restricted the scope of women's organizations in the past.

The radical projects begun by feminists over a century ago are by no means complete or irrelevant; in many cases, their lessons remain meaningful for our contemporary world. The opportunities they recognized in the gaps of frayed social norms, in occupying radical adjacencies, in the insistence on visibility, in the strength of consciously formed communities, and in confronting the language of power remain as relevant now as they did then. At the same time, and as these three recent projects demonstrate, feminist efforts today are imbued with a criticality and self-awareness that make it impossible to simply continue where others left off. Certainties about the boundaries of power, definitions of the self in relation to community, and the fixity of subject positions have blurred, compelling us to explore the feminist projects of the past and imagine those of the future through new angles and perceptions.

1
My discussion of women's urban history in Berlin is based on Despina Stratigakos, *A Women's Berlin: Building the Modern City* (Minneapolis: University of Minnesota Press, 2008).
2
Ibid., 6, 14, 17–51, 97–136.
3
Audrey Lorde, "The Master's Tools Will Never Dismantle the Master's House," *Sister Outsider: Essays and Speeches* (Berkeley: Crossing Press, 1984, 2007), 112.
4
Leonard Cohen, lyrics to "Anthem" on *The Future* album (Columbia Records, 1992).

5

Was die Frau von Berlin wissen muß: Ein praktisches Frauenbuch für Einheimische und Fremde (Berlin and Leipzig: Loesdau, 1913). For a deeper discussion of the guidebook, see Stratigakos, *A Women's Berlin*, 1–16.

6

See Karin Bradley, Ulrika Gunnarsson-Östling and Meike Schalk with Jenny Andreasson, chapter 17: "Futurist Feminist Political Ecology – Rewriting Stockholm's *Vision 2030*" in the theme section "Projections."

7

Stratigakos, *A Women's Berlin*, 17–51.

8

Constance Smedley, *Crusaders* (London: Duckworth, 1929), 54–56.

9

See Macarena Dusant with the New Beauty Council, chapter 7: "Artistic Strategies, Masked Explorations and Embodied Displacements" in the theme section "Activisms."

10

NBC (2009) "Artistic methods as a tool for Feminist Futures – a manifesto combined with an analysis of the role of a queer feminist collaborative art project (The New Beauty Council, NBC) in a European educational partnership (UniGrowCity)," flyer.

11

See Petra Bauer and Sofia Wiberg with Marius Dybwad Brandrud and Rebecka Thor, chapter 11: *"Rehearsals* – On the politics of listening", in the theme section "Dialogues."

CONTRIBUTORS

Mariana Alves Silva, co-founder of *MYCKET*, works as a designer with a background as a cabinetmaker. Central in her work is to identify parallels between cultural expression and power structures thereby exposing the underlying values which are hidden within aesthetics. Her practice results in built and re-built objects, spaces and environments, teaching and lecturing, writing and graphical representations, usually in collective processes and always with an intersectional perspective. www.mycket.org

Jenny Andreasson is an architect and urban planner at the Uppsala City Planning Office. She graduated from the School of Architecture and Built Environment at KTH Stockholm, within the Critical Studies Design Studio. She is interested in accessibility to public and urban space, more specifically how feminist and critical theory can contribute to urban planning processes in producing just, permissive and inclusive cities. In her Master's thesis from KTH she investigated questions of taste and hierarchies in urban and rural form.

Nishat Awan is a Lecturer in Architecture at the University of Sheffield. Her research focuses on spatial explorations of migration, borders and diasporas. Her recent book, *Diasporic Agencies* (Ashgate, 2016) addresses the neglected subject of how architecture and urban design can respond to the consequences of increasing migration. She is also interested in alternative modes of architectural practice and creative research methodologies, issues that were addressed in the co-authored book *Spatial Agency* (with Tatjana Schneider and Jeremy Till) and the co-edited book *Trans-Local-Act* (with Doina Petrescu and Constatin Petcou).

Katarina Bonnevier, architect, artist, researcher and co-founder of *MYCKET*, currently located at the Swedish Architecture and Design Centre ArkDes. Her practice revolves around relations of architecture, aesthetics and power, especially from gender perspectives. She is frequently lecturing, exhibiting and participating in public programs within the fields of art, architecture, and urban planning. She was the production designer for the movie *Flickan, Mamman och Demonerna* (The Girl, the Mother and the

Demons) by Suzanne Osten, 2016, and the host of award winning radio show *Fasad*, SR, 2013. She has taught at KTH-Arkitektur, Konstfack, Copenhagen Art Academy etc. *Behind Straight Curtains: Towards a Queer Feminist Theory of Architecture* (Axl Books, 2007) is her PhD dissertation. www.mycket.org

Karin Bradley is Associate Professor of Urban and Regional Studies at KTH Royal Institute of Technology, Stockholm. Her research concerns environmental justice, alternative economies and utopian thought. Her doctoral dissertation was entitled *Just Environments: Politicising Sustainable Urban Development* (2009), she co-edited the book *Green Utopianism: Politics, Perspectives and Micro-practices* (Routledge, 2014) and she is currently working with a long-term research project, called "Urban sharing", dealing with sharing economies.

Sara Brolund de Carvalho is an architect, artist and teacher based in Copenhagen. Her ongoing independent research revolves around the relation between accessibility to public meeting spaces and the growth of urban grassroots movements. Currently, she is working with the art/architecture research project, not-for-profit organization and research group *Action Archive* together with architects and researchers Helena Mattsson and Meike Schalk. She is also collaborating with architect Anja Linna in the project "Our common spaces".

Brady Burroughs is a design studio teacher and researcher in Critical Studies in Architecture at the School of Architecture and Built Environment, KTH, Stockholm, Sweden. An 'architectural pulp fiction', Brady's forthcoming dissertation, *Architectural Flirtations: A Love Storey,* focuses on design education in intersections of gender, race and sexuality. Brady explores the critical potential of the improper and unserious to unsettle habitual modes of criticism and question privilege and ethics in the architectural discipline.

Ragnhild Claesson is a researcher at the department of Urban Studies, Malmö University. She is currently working with her doctoral thesis *Social Aspects of Cultural Heritage in Urban Development and*

Placemaking Processes in Malmö where she critically explores how notions of cultural heritage, cultural diversity and gender may be incorporated in urban planning processes. Claesson also works at The Institute for Studies in Malmö's History – a research institute at Malmö University.

Yvonne P. Doderer, educated as an architect with a Doctorate in Political Science, runs the Office for Transdisciplinary Research and Cultural Production in Stuttgart (Germany) and is Professor for Gender and Cultural Studies at the University of Applied Sciences in Düsseldorf (Germany). Her work as a cultural producer, artist and author focuses on the linkages of urban/spatial theories, activism, gender/queer studies and contemporary art. The starting point for her work is the questioning of (urban) space not only as physical but also as social, political and gendered spaces. She has participated in various international contemporary art exhibitions, has published several books and has contributed to numerous scientific publications, exhibition catalogues and art magazines.

Macarena Dusant is an art historian and independent writer, working within the field of art and exhibition production since 2009. Her main areas of focus are power structures, the notion of the public realm and mechanisms of exclusion within contemporary art. Dusant is currently finishing her studies in Art History at Södertörn University with her master's thesis: *Power relations and discourses that create meaning. Three case studies of site-specific art projects in Sweden,* where she looks at site specific art projects in socioeconomically underprivileged areas. She is a co-founder of *IDA* (Institute for Diaspora and Decolonization), which investigates knowledge production and knowledge formations within contemporary Swedish art. She is currently working on the book *The art of participating,* on the conditions of newly arrived immigrant artists.

Annika Enqvist is a curator working with aesthetic theory, craft, design, socially engaged architecture and urban issues. Annika co-founded *The New Beauty Council* (NBC), a collaboratory art practice and the European urban gardening net-

work *UniGrowCity*. She is the curator of "Knitting House;" shown in the exhibition "Textila underverk", Marabouparken (2016) and Reykjavik Art Museum (2012) and "Decolonizing Architecture Rehab Camp", Barnens Ö (2011). For Svensk Form (2000–2007) she curated shows at The National Museum of Singapore, Powerhouse Museum (Sydney), Thailand Creative & Design Center (Bangkok), Museum für Gestaltung (Zürich) and Experimentadesign05 (Lissabon).

Maryam Fanni is a graphic designer who graduated from Konstfack College of Arts, Crafts and Design in 2013 with a degree project on the signage system and gentrification processes in her neighbourhood Hökarängen in Stockholm. Her writing and design practice is often collective, locally engaged and relates to public space and visual culture. She is member of the group Söderorts Institut För Andra Visioner (SIFAV) [Southern Districts' Institute For Other Visions]. She is the graphic designer of *Feminist Futures of Spatial Practice*.

Liza Fior is one of the founding partners of muf architecture/art. The work of the practice negotiates between the built and social fabric, between public and private through urban design, streetscapes and landscapes, buildings and strategies; unsolicited research continues to be entwined into every project. Awards for muf projects include the 2008 European Prize for Public Space for a new 'town square' for Barking, East London. Liza is co-author of *This is What We Do: a muf manual*. Since 1994 muf architecture/art has established a reputation for pioneering innovative projects that address the social, spatial and economic infrastructures of the public realm. muf authored "Villa Frankenstein", the British Pavilion at the Venice Biennale in 2010, which took Ruskin and Venice itself as a means to examine through the installation "Stadium of Close Looking" how detail can inform strategy. This was the beginning of the collaboration with Jane da Mosto and subsequent work gave rise to *We are here Venice*. www.muf.co.uk

Hélène Frichot is Associate Professor in Critical Studies in Architecture, KTH School of Architecture in Stockholm. Hélène is also an Adjunct Professor in the School of Architecture and Design RMIT University, Melbourne, Australia, where she co-curated the Architecture+Philosophy public lecture series between 2005–2014 (architecture.testpattern.com.au). Hélène's research examines the transdisciplinary field between architecture and philosophy, while her first discipline is architecture, she holds a PhD in philosophy from the University of Sydney (2004). She considers architecture-writing to be her mode of creative and critical practice. Recent publications include: co-edited with Catharina Gabrielsson and Jonathan Metzger, *Deleuze and the City* (Edinburgh University Press, 2016) and co-edited with Elizabeth Grierson, Harriet Edquist, *De-Signing Design: Cartographies of Theory and Practice* (Lexington Books, 2015).

Katja Grillner is an architect and critic based in Stockholm, Sweden. She is the Professor of Critical Studies in Architecture and currently serves, since 2015, as the Dean of Faculty at the KTH Royal Institute of Technology. Grillner was the director of Architecture in Effect (2011–2015) and co-founded the feminist architecture group *FATALE* (Feminism Architecture Theory Analysis Laboratory Education together with Katarina Bonnevier, Brady Burroughs, Meike Schalk and Lena Villner, 2007–2012). Her research on architecture and landscape combines theoretical, historical and literary strategies for spatial exploration. Among her book publications are her PhD-dissertation *Ramble, linger and gaze – philosophical dialogues in the landscape garden* (Stockholm: KTH 2000), as main-editor *01-AKAD – Experimental Research in Architecture and Design* (Stockholm: AxlBooks, 2005), and, as co-editor, *Architecture and Authorship* (London: Black Dog, 2007).

Ulrika Gunnarsson-Östling holds a PhD in Planning and Decision Analysis and works as a researcher at KTH, the Department of Sustainable Development, Environmental Science and Engineering. Her research is directed towards long-term planning and often emanates from an environmental justice perspective or a gender perspective, both of which involves looking at environmental issues

from a power perspective. Publications include Bergman, H., Engwall, K., Gunnarsson-Östling, U. and Johannesson, L. (2014) "What about the future? The troubled relationship between futures and feminism". *NORA – Nordic Journal of Feminist and Gender Research* and Gunnarsson-Östling, U. (2011) "Gender in Futures: A Study of Gender and Feminist Papers Published in Futures", 1969–2009". *Futures*, Volume 43, Issue 9.

Sophie Handler works at the intersection of social policy, urban theory and creative practice. She has worked with the feminist practices muf architecture/art and atelier d'architecture autogérée (aaa) in Paris, holds a practice-led PhD from the Bartlett, UCL, on alternative spatial practices in older age and has spent the last ten years exploring the spatial politics of ageing through creative writing, participative urban interventions, research and policy development. She is author of *The Fluid Pavement* (a large print psychogeographic novel on ageing), An Alternative Age-friendly Handbook and is chair of the RIBA working group on Research and Ageing. Her practice-based work operates under the platform Ageing Facilities.

Nel Janssens holds a MSc and PhD in architecture and spatial planning. She is Associate Professor at the Faculty of Architecture, KU Leuven, Campus Sint-Lucas and affiliated with the Department of Architecture, Chalmers University of Technology, Gothenburg. Her research interest is directed at the link between critical theory and research by design, focussing on projective research and theory-through-design. Recent publications include the book *Transdisciplinary Knowledge Production in Architecture and Urbanism: Towards Hybrid Modes of Inquiry*, co-edited with Isabelle Doucet and published by Springer 2011 and *Perspectives on Research Assessment in Architecture and the Arts: Discussing Doctorateness*, co-edited with Halina Dunin-Woyseth and Fredrik Nilsson (Routledge, forthcoming 2017).

Elke Krasny is a curator, cultural theorist, urban researcher and writer, Professor of Art and Education at the Academy of Fine Arts Vienna; 2012 Visiting Scholar at the Canadian Centre for Architecture in Montréal; 2011 Visiting Curator at the Hongkong Community Museum Project. She holds a PhD in Fine Arts from the University of Reading (2015). Curatorial works include *On the Art of Housekeeping and Budgeting in the 21st Century*, co-curated with Regina Bittner; *Suzanne Lacy's International Dinner Party in Feminist Curatorial Thought* and *Hands-On Urbanism 1850–2012: The Right to Green*. She is co-editor of the 2013 volume *Women's Museum. Curatorial Politics in Feminism, Education, History, and Art*.

Thérèse Kristiansson's practice grows through various forms of collaborations and exists at the crossroads between performance art, body politics, carnival, architecture, urban planning and queer & intersectional theory. She is co-founding member of the art, design & architecture collaboration *MYCKET;* the feminist art duo *Die bösen Mösen*; the former collaborative art project *The New Beauty Council* (NBC); co-initiator of the international urban food justice network *UniGrowCity* and teaches and lectures at various institutions as part of her practice. www.mycket.org

Anja Linna is an architect, urban planner and musician based in Malmö. Her research interests lie in finding new forms of engaged spatial practice, which is inclusive and participatory. Linna collaborates with Sara Brolund de Carvalho in the project "Our common spaces". The project uses feminism and art practice to explore the social importance of common and collective spaces in cities, and in doing so, seeks to widen the roles of architects and planners.

Nina Lykke, Professor Emerita in Gender Studies, Linköping University, Sweden, is co-director of GEXcel International Collegium for Advanced Transdisciplinary Gender Studies as well as the scientific director of the Swedish-International Research School, InterGender. She has published extensively within the areas of feminist theory, intersectionality studies, feminist cultural studies, and feminist technoscience studies, including *Between Monsters, Goddesses and Cyborgs* (1996, with Rosi Braidotti), *Cosmodolphins* (2000, with Mette Bryld), *Bits of Life* (2008, with Anneke Smelik), *Feminist Studies*

(2010), and *Writing Academic Texts Differently* (2014). Her current research is a queer feminist, autophenomenographic, and poetic exploration of cancer cultures, death, and mourning.

Hedvig Marano has worked as a translator and proof-reader since 2005. A great deal of her work has consisted of screenplays, fiction, and commercial texts, but for the past few years she has found herself with an increasing number of academic assignments. Her own academic background includes gender studies, museum pedagogy, history of ideas. She holds a B.A. in Film Studies and an M.A. in English, both at Stockholm University. She particularly enjoys working with intersectional perspectives, inclusive language and the many nuances of translation and maintained connotations. Marano was one of the copy-editor's of *Feminist Futures of Spatial Practice*.

Helena Mattsson is an Associate professor in History and Theory of Architecture at the KTH School of Architecture. Her research focuses on 'contemporary architectural history', welfare state studies and the historiography of modernism. Mattsson is currently working on the project "The Architecture of Deregulations: Politics and Postmodernism in Swedish Building 1975–1995" (together with Catharina Gabrielsson) and runs the group *Action Archive* (with Meike Schalk and Sara Brolund de Carvalho). Mattsson is also an editor for the culture periodical *SITE*, and a member of the *Journal of Architecture's* editorial board.

Ramia Mazé is Professor of New Frontiers in Design at Aalto University in Finland. She is also co-editor of the journal *Design Issues*. Previously in Sweden, she worked at Konstfack College of Arts Crafts and Design, at KTH Royal Institute of Technology, at the national PhD school Designfakulteten, and at the Interactive Institute. A designer and architect by training, her PhD is in interaction design. She has led, published and exhibited widely through major interdisciplinary and international practice-based design research projects, most recently in the areas of social innovation, sustainable design and design activism. She specializes in participatory, critical and politically-engaged design practices.

Linda McAllister has been working as a proofreader and translator since 2012, primarily in the areas of art, film, gender theory and performativity. She is currently studying for her M.A. in Translation at the University College of London. Her academic background is in aesthetics, art theory and philosophy with a B.A. in Aesthetics from Södertörn University College. McAllister was one of the copy-editor's of *Feminist Futures of Spatial Practice*.

Irene Molina is Professor in Human Geography, in the specialty of Settlements and Built Environments. Her main research areas are urban and housing studies, segregation, housing policy, social sustainability in urban development, power relations and the intersections of race, class and gender. Molina is a member of CRUSH, the Critical Urban Sustainability Hub, a radical research platform targeting the housing question. Latest publications include: CRUSH (2016), *13 myter om bostadsfrågan* [13 myths of the housing question], Stockholm: Document Press and Karin Grundström & Irene Molina, "From Folkhem to Life-style housing in Sweden: Segregation and urban form, 1930's 2010's", *International Journal of Housing Policy*, volume 16, nr.3. 2016.

Ruth Morrow is Professor of Architecture at Queen's University Belfast. Her work centres on the interconnections between people, place and creativity, ranging across design pedagogy, urban activism and material development underpinned by an ethos of inclusion, design excellence and collaboration. She is co-founder of Tactility Factory (www.tactility-factory.com) an award-winning company combining concrete and textile technologies to make unique surfaces. Ruth also co-curates projects with the artist collective, PS2 (www.pssquared.org) interacting with communities in Northern Ireland's post-conflict context. She is co-editor of *The Gendered Profession* (London: RIBA publishers, 2016) and *Peripheries in Architecture* (London / New York: Taylor and Francis, 2012).

Jane da Mosto, is the co-founder and Executive Director of *We are here Venice*. She is an environmen-

tal scientist (MA, Oxford University, M. Phil. Imperial College London) with international experience as a consultant on sustainable development, climate change and wetland ecology. Since 2012 she has been fully engaged in trying to change the future of Venice for Venetians as co-founder of *We are here Venice* (wearebherevenice.org), an NGO that focuses on using the best available academic research and methodologies to characterise the challenges for Venice while also drawing upon grassroots networks to source more accurate and relevant information on the city and lagoon and disseminate distilled findings and results.

MYCKET is a collaboration between designer Mariana Alves Silva, and the architects and artists Katarina Bonnevier and Thérèse Kristiansson. Together they seek to research and transform how aesthetic expressions affect human activities from intersectional perspectives, such as anti-racist and queer-feminist, a practice informed by the theatrical, the carnivalesque and the activist. In January 2014 *MYCKET* embarked on a three-year artistic research project financed by The Swedish Research Council called "The Club Scene" at the Architecture and Design Center, Sweden. Recent works include "Drömmarnas teater" [The Theater of Dreams], ArkDes 2016–17; "Luftslott – när vi bygger den stad vi vill leva I" [Castle in the air – when we build the city we want to live in], Norrtälje Konsthall, 2016; "Playan", public city beach, Göteborgs stad/Älvstranden utveckling, 2014; "Helena", mobile architecture for Kvalitetsteatern, 2014: "Exclude me in", Göteborg International Biennial for Contemporary Art, 2013. www.mycket.org

Doina Petrescu is Professor of Architecture and Design Activism at the School of Architecture, University of Sheffield. Her research focuses on three main strands: gender, resilience and participation in architecture, all with a strong international dimension. She is also co-founder of atelier d'architecture autogérée (aaa), an award winning collective practice conducting research-actions in Paris, which engage citizens in processes of reclaiming and resiliently transforming the city. Her edited publications include: *The Social (Re)Production of*

Architecture (2016, with Kim Trogal), *Trans – Local – Act: Cultural practices within and across* (aaa-peprav 2010, with Constantin Petcou and Nishat Awan), *Agency: Working with Uncertain Architectures* (2009, with *Agency*), *Altering Practices: Feminist Politics and Poetics of Space* (2007), *Urban Act: handbook for alternative practice* (with aaa-peprav, 2007) and *Architecture and Participation* (2005, with Peter Blundell Jones and Jeremy Till).

Julieanna Preston is a Professor of Spatial Practice at the College of Creative Arts, Massey University, Wellington, New Zealand. Her research draws primarily on the disciplines of architecture, art and philosophy and her background in interior design, building construction, landscape gardening, material processes and performance writing. Julieanna has delivered live art performances and lectured in the United States, UK, Sweden, Australia, Scotland, The Netherlands, Canada and New Zealand. She received a Bachelor of Architecture from Virginia Tech (1983), Master of Architecture from Cranbrook Academy of Art (1990) and a PhD through creative practice from RMIT (2013). Her recent monograph *Performing Matter: Interior surface and feminist actions* (AADR 2014) features creative works and intellectual scholarship from 2008–2012. See www.julieannapreston.space for an introduction to her latest suite of works and publications.

Evan Reed is a molecular biologist and medical student at Karolinska Institutet in Stockholm. Born and raised in America, he moved to Stockholm in 2009, where he has also worked as a translator from Swedish to English, primarily within arts and film. Reed was one of the copy-editors of *Feminist Futures of Spatial Practice*.

Rehearsals
Rehearsals experimented with different forms of listening. *Rehearsals* include:

Petra Bauer
I am a white woman who lives in the centre of Stockholm, and the daughter of two European immigrants with working class backgrounds. My mother and father left their countries for a place

where they could not speak the language, had no friends or family, and no network, but with the hope to build a new life together. Still, to this day, my mother often says that she is happy that her two children made it, despite the fact they are the children of two immigrants. I, on the other hand, am often frustrated that I learned to adapt and change, instead of resisting and demanding other conditions.

Marius Dybwad Brandrud
I am in most situations defined as a priviliged white male and used to being listened to. I am longing to learn how to listen.

Rebecka Thor
I grew up wanting to be a blond male. In the middle class suburban setting I and a few adopted kids where the ones with dark hair – today in a similar, but more urban, setting I am raising two blonde kids, knowing that they will not know what I know about being assumed not to belong. Shaped by a conflictual class background, by a father who believed in the revolution, by an intellectual mother and a Jewish immigrant grandmother, I believe in a future of radical solidarity.

Sofia Wiberg
I am a white middle class woman living with my two children in central Stockholm. I grew up in a left-wing politically active environment where it was more important to express radical and definite stand points rather than give space for listening. This often silenced me, which affects me in some settings to this day. A key issue in my life is therefore how political change can be possible beyond the well articulated words.

Helen Runting is an urban planner and urban designer, and a PhD student within the research group Critical Studies in Architecture at the KTH School of Architecture in Stockholm. Her research operates across the fields of architectural theory, political economy, and critical theory, addressing the co-production of images and subjectivities through the practices of architectural design, urban planning policymaking, and marketing. Her PhD project focuses on issues of biopolitical discipline and control, real estate and property relations, and the aesthetics of neoliberalism. Helen is a founding co-editor of the architecture journal *LO-RES*, and a member of the practice Svensk Standard.

Nora Räthzel, Professor Emerita, is a sociologist at the Department of Sociology, Umeå University. Her research is on the relationship between work and nature, investigating the environmental policies of trade unions and environmental practices at the workplace in the context of class, gender, and ethnic relationships. She has also researched the everyday working lives in transnational corporations. Her latest publications include: *Trade Unions in the Green Economy. Working for the Environment*, Routledge/Earthscan, 2013 (with David Uzzell) and *Transnational Corporations from the Standpoint of Workers*, Palgrave/Macmillan, 2014 (with Diana Mulinari and Aina Tollefsen). For further readings see: www.researchgate.net/profile/Nora_Raethzel

Meike Schalk is an architect and Associate Professor in Urban Design and Urban Theory at the KTH School of Architecture in Stockholm. She is director of the Strong Research Environment, "Architecture in Effect: Rethinking the Social", since 2015. Her research on architecture and urban issues combines critical inquiry into questions of sustainability, democracy and critical participation in planning, and practice-led research. Schalk was co-founder of the feminist architecture teaching and research group *FATALE* and she is part of the group *Action Archive* (with Helena Mattsson and Sara Brolund de Carvalho). Schalk is also an editor for the culture periodical *SITE*.

Despina Stratigakos is Professor of Architecture at the University at Buffalo. She is the author of three books that explore the intersections of architecture and power. *Where Are the Women Architects?* (2016), exposes the professional and cultural challenges facing women in architecture. *Hitler at Home* (2015) investigates the architectural and ideological construction of the Führer's domesticity. Her first book, *A Women's Berlin: Building the Modern City* (2008),

traced the history of a forgotten female metropolis and won the German Studies Association DAAD Book Prize and the Milka Bliznakov Prize. Stratigakos also writes about diversity issues in architecture for the broader media.

Kristoffer Svenberg is an artist. He has a master in fine arts from Konstfack University, Stockholm and a bachelor from the School of Photography at Gothenburg University. Kristoffer is co-founder of *The New Beauty Council* and has been active in architecture and city planning discourses in relation to art for many years. Since 2013 he has been leading the art project "Mallrats Stockholm" and "Mallrats Göteborg – Mallra Linjen" in collaboration with different art institutions such as Göteborgs Konsthall and Moderna Museet. At the moment Kristoffer is head of the young adults program at Moderna Museet in Stockholm.

The New Beauty Council (NBC) was an art project and collaborative initiative between 2007–2014 founded by Annika Enqvist, Kristoffer Svenberg, Anna Kharkina and Thérèse Kristiansson. The NBC explored in which ways architecture is charged with authority, as a stage of built situations, both serving and suppressing our actions and ways of relating. Through conversations and staged situations NBC investigated how concepts of the public are constituted and how beauty and ugliness can be (re-) defined. Using the idea of the carnivalesque as a method, NBC engaged with organizations and institutions, which shape and interpret cities, to search for multiple perceptions. NBC's acts and events blurred the boundaries between the personal and the political. NBC won the *SA-prize* for 'valuable contribution to the public discussion on architecture' by the Swedish Association of Architects in 2009.

Kim Trogal is a Lecturer in Architectural History and Theory at the Canterbury School of Architecture, University of the Creative Arts. Previously, she held the position of a Postdoctoral Researcher at Central Saint Martins, University of the Arts London (2014–16). She completed her architectural studies at the University of Sheffield, including a PhD in Architecture (2012) for which she was awarded the RIBA LKE Ozolins Studentship. Kim is co-editor, with Professor Doina Petrescu, of the book *The Social (Re) Production of Architecture* (2017). She was research assistant to the Building Local Resilience Research Platform at the University of Sheffield (2012–15), exploring issues of local social and ecological resilience. Kim's research examines the intersections of ethics and economies in spatial practice from feminist perspectives.

Josefin Wangel is Associate Professor in Sustainable Urban Development at KTH Royal Institute of Technology. Her doctoral thesis *Making Futures* (2012) explores futures studies as a tool for sustainable urban development and identifies several shortcomings related to the omission of the question of *who benefits* from the futures developed. Her current work includes several projects seeking to further a critical practice in futures studies, planning and design, mainly carried out in collaboration with designers and architects.

REFERENCES

Adam, Barbara (1998), *Timescapes of Modernity*, London: Routledge.

Adam, Barbara, ed. (2008), 'Future Matters: Futures Known, Created and Minded', special issue of *Twenty-First Century Society: Journal of the Academy of Social Sciences*, 3 (2): 111–116.

Adam, Barbara, and Groves, Chris (2007), *Future Matters: Action, Knowledge, Ethics*, NL: Brill.

Adrift in the Circuits of Women's Precarious Lives (2003), [Film] Dir. Precarias a la Deriva, Madrid. Available online: www.youtube.com/watch?v=WCFsKJrKH9c (accessed 19 February 2017).

'Age-friendly Cities and Healthy Cities: Reshaping the Urban Environment' (2014), [Conference session] *11th International Conference on Urban Health*, University of Manchester, UK.

Aging Facilities. Available online: www.ageing-facilities.net (accessed 24 February 2017).

Agrest, Diana, Conway, Patricia, and Kanes Weisman, Leslie, eds (1996), *The Sex of Architecture*, New York: Harry N. Abrams.

Agyeman, Julian, Bullard, Robert D., and Evans, Bill (2003), *Just Sustainabilities – Development in an Unequal World*, Cambridge, MA: MIT Press.

Ahmed, Sara (2006), 'Orientations – Toward a Queer Phenomenology', *GLQ*, 12 (4): 543–574.

Ahmed, Sara (2012), *On Being Included: Racism and Diversity in Institutional Life*, Durham, NC: Duke University Press.

Ahmed, Sara (2014), *Willful Subjects*, Durham, NC: Duke University Press.

Åhrén, Uno, Asplund, Gunnar, Gahn, Wolter, Markelius, Sven, Paulsson, Gregor, and Sundahl, Eskil ([1931] 2008), 'acceptera', reprinted in Lucy Creagh, Helena Kåberg and Barbara Miller Lane (eds), *Modern Swedish Design: Three Founding Texts*, 140–347, New York: Museum of Modern Art.

Ahrentzen, Sherry, and Anthony, Kathryn H. (1993), 'Sex, Stars, and Studios: A Look at Gendered Educational Practices in Architecture', *Journal of Architectural Education*, 47 (1): 11–29.

Alaimo, Stacy, and Hekman, Susan (2008), 'Introduction: Emerging Models of Materiality in Feminist Theory', in Stacy Alaimo and Susan Hekman (eds), *Material Feminisms*, 1–22, Bloomington, IN: Indiana University Press.

Alcoff, Linda (1988), 'Cultural Feminism versus Poststructuralism: The Identity Crises in Feminist Theory', *Signs: Journal of Women in Culture and Society*, 13 (3): 417–418.

Anderson, Benedict ([1983] 1991), *Imagined Communities: Reflections on the Origin and Spread of Nationalism*, London: Verso.

Architecture+Philosophy. Available online: www.architecture.testpattern.com.au (accessed 22 January 2017).

Arendt, Hannah ([1958] 1998), *The Human Condition*, Chicago: University of Chicago Press.

Arendt, Hannah (1970), *On Violence*, London: Harcourt Brace.

Arnstad, Lennart (1980), 'Kvinnorna har de Friskaste Idéerna', *Aftonbladet*, 23 May.

Arora-Jonsson, Seema (2013), *Gender, Development and Environmental Governance: Theorizing Connections*, London: Routledge.

Arora, Ashish (1995), 'Licensing Tacit Knowledge: Intellectual Property Rights and the Market for Know-How' in *Economics of Innovation and New Technology* 4 (1): 41–60.

Astyk, Sharon (2008), *Depletion and Abundance: Life on the New Home Front*, Gabriola Island, CA: New Society Publishers.

atelier d'architecture autogérée. Available online: www.urbantactics. org/collective/collective.html (accessed 13 May 2015).

Awan, Nishat, Schneider, Tatjana, and Till, Jeremy, eds (2011), *Spatial Agency: Other Ways of Doing Architecture*, London: Routledge.

Badiou, Alain (2011), *Being and Event*, trans. Oliver Feltham, London: Continuum.

Bakhtin, Mikhael ([1941] 1993), *Rabelais and His World*, trans. Hélène Iswolsky, Bloomington, IN: Indiana University Press.

Barad, Karen (1998), 'Getting Real: Technoscientific Practices and the Materialization of Reality', *differences: A Journal of Feminist Cultural Studies*, 10 (2): 87–128.

Barad, Karen (2007), *Meeting the Universe Halfway: Quantum Physics and the Entanglement of Matter and Meaning*, Durham, NC: Duke University Press.

Barad, Karen (2014), 'Re-membering the Future, Re(con)figuring the Past: Temporality, Materiality, and Justice-to-Come', *Feminist Theory Workshop Keynote*, Duke University. Available online: www.youtube. com/watch?v=cS7szDFwXyg&feature=youtube_qdata_player> (accessed 17 March 2015).

Barenthin Lindbland, Tobias, and Jacobson, Malcolm, eds (2006), *Overground 2*, Stockholm: Dokument Press.

Barr, Marleen, ed. (1981), *Future Females: A Critical Anthology*, Bowling Green, OH: Bowling Green State University Popular Press.

Baxter, Andrew, ed. (1996), *Vision of the Future*, Bliaricum, NL: V+K Publishing.

Bennett, Jane (2010), *Vibrant Matter: A Political Ecology of Things*, Durham, NC: Duke University Press.

Berardi, Franco 'Bifo' (2011), *After the Future*, Edinburgh: AK Press.

Berardi, Franco 'Bifo' (2012), *The Uprising. On Poetry and Finance*, Los Angeles: Semiotext(e).

Bergman, Helena, Engwall, Kristina, Gunnarsson-Östling, Ulrika, and Johannesson, Livia (2014), 'What about the Future? The Troubled Relationship between Futures and Feminism', *NORA – Nordic Journal of Feminist and Gender Research*, 22 (1): 63–69.

Bergström, Anders (2014), 'Architecture and the Rise of Practice in Education', *Architectural Theory Review*, 19 (1): 10–21.

Betsky, Aaron (1997), *Queer Space: Architecture and Same-Sex Desire*, New York: William Morrow and Company.

Birch, Elisa R., Lee, Ann, and Miller, Paul W. (2009), *Household Divisions of Labour: Teamwork, Gender and Time*, Basingstoke, UK: Palgrave Macmillan.

Bickford, Susan (1996), *The Dissonance of Democracy: Listening, Conflict, and Citizenship*, Ithaca, NY: Cornell University Press.

Boal, Augusto (1985), *Theatre of the Oppressed*, Theatre Communications Group, New York.

Bonnevier, Katarina (2007), *Behind Straight Curtains: Towards a Queer Feminist Theory of Architecture*, Stockholm: Axl Books.

BOOM-group (1997), KTH Royal Institute of Technology, School of Architecture/Stockholmshem, *Bagarmossen*, Berlings, Arlöv, SE. Available online: stockholmskallan.stockholm.se/PostFiles/SMF/SD/ SSMB_0007883_01_ocr.pdf (accessed 22 January 2017).

Bordo, Susan (1990), 'Feminism, Postmodernism and Gender-Skepticism', in Linda Nicholson (ed.), *Feminism/Postmodernism*, 133–156, London: Routledge.

Bourdieu, Pierre (1986), 'The Forms of Capital', in John Richardson (ed.), *Handbook of Theory and Research for the Sociology of Education*, 241–258, New York: Greenwood.

Bourdieu, Pierre ([1998] 1999), *Den Manliga Dominansen* (Masculine Domination), trans. Boel Englund, Gothenburg, SE: Daidalos.

Bourriaud, Nicolas ([1998] 2002), *Relational Aesthetics*, trans. Simon Pleasance and Fronza Woods, Paris: Les Presse Du Reel.

Boutelle Holmes, Sara (1981), 'Women's Networks: Julia Morgan and Her Clients', *Heresies #11, Making Room – Women and Architecture*, 3 (3): 91–94.

Boutelle Holmes, Sara (1988), *Julia Morgan, Architect*, New York: Abbeville Press.

Boys, Jos (2014), *Doing Disability Differently: An Alternative Handbook on Architecture, Dis/Ability and Designing for Everyday Life*, London: Routledge.

Bradley, Karin, and Hedrén, Johan (2014), 'Utopian Thought in the Making of Green Futures', in Karin Bradley and Johan Hedrén (eds), *Green Utopianism: Perspectives, Politics and Micro-Practices*, 1–22, London: Routledge.

Bradley, Karin, Hult, Anna, and Cars, Göran (2013), 'From Eco-modernizing to Political Ecologizing: Future Challenges for the Green Capital', in Jonathan Metzger and Amy Rader Olsson (eds), *Sustainable Stockholm – Exploring Urban Sustainability in Europe's Greenest City*, 168–194, London: Routledge.

Brah, Avtar (1992), 'Difference, Diversity and Differentiation', in James Donald and Ali Rattansi (eds), *'Race', Culture and Difference*, 126–145, London: Sage.

Brah, Avtar (2006), *Cartographies of Diaspora – Contesting Identities*, London: Taylor and Francis.

Braidotti, Rosi (1994), 'Introduction', in *Nomadic Subjects: Embodiment and Sexual Difference in Contemporary Feminist Theory*, 3–20, New York: Columbia University Press.

Braidotti, Rosi (1994), 'By Way of Nomadism', in *Nomadic Subjects: Embodiment and Sexual Difference in Contemporary Feminist Theory*, 21–68, New York: Columbia University Press.

Braidotti, Rosi (1994), *Nomadic Subjects: Embodiment and Sexual Difference in Contemporary Feminist Theory*, New York: Columbia University Press.

Bromseth, Jannet, and Darj, Frida, eds (2010), *Normkritisk Pedagogik: Makt, Lärande och Strategier för Förändring* (Norm Critical Pedagogy: Power, Learning and Strategies for Change), Uppsala, SE: Uppsala University.

Brown, Lori A. (2011), *Feminist Practices: Interdisciplinary Approaches to Women in Architecture*, Farnham, UK: Ashgate.

Bryson, Valerie (2007), *Gender and the Politics of Time: Feminist Theory and Contemporary Debates*, Bristol, UK: Policy Press.

Buchleitner, Katya (2010), *Glimpses of Freedom: The Art and Soul of Theatre of the Oppressed in Prison*, Münster: LIT Verlag.

Bullard, Robert D. (2000), *Dumping in Dixie – Race, Class and Environmental Quality*, Atlanta, GA: Westview Press.

Butler, Judith (1990), *Gender Trouble: Feminism and the Subversion of Identity*, London: Routledge.

Butler, Judith (1993), *Bodies That Matter: On the Discursive Limits of 'Sex'*, London: Routledge.

Butler, Judith (2004), *Undoing Gender*, London: Routledge.

Butler, Judith (2009), 'Introduction: Precarious Life, Grievable Life', in *Frames of War: When is Live Grievable?*, 1–32, London: Verso.

Butler, Judith (2011), 'Bodies in Alliance and the Politics of the Street', *transversal – EIPCP Multilingual Web Journal #occupy and assemble*. Available online: www.eipcp.net/transversal/1011/butler/en (accessed 29 May 2015).

Butler, Judith, and Athanasiou, Athena (2013), *Dispossession: The Performative in the Political*, Cambridge, UK: Polity Press.

Butt, Gavin (2006), 'Scholarly Flirtations', in Angelika Nollert, Irit Rogoff, Bart de Baere, Yilmaz Dziewior, Charles Esche, Kerstin Nieman and Dieter Roelstraete (eds), *A.C.A.D.E.M.Y.*, 187–192, Frankfurt: Revolver Verlag.

Cameron, Jenny, and Gibson, Katherine (2008), 'ABCD Meets DEF: Using Asset Based Community Development to Build Economic Diversity', in *Proceedings of Asset Based Community Development Conference*, Newcastle, UK. Available online: www.abcdinstitute.org/docs/ FigTreePaper.pdf (accessed 22 January 2017).

Campbell, Marion May (1985), *Lines of Flight*, Fremantle: Fremantle Arts Centre Press.

Centre for Excellence in Universal Design. Available online: universaldesign.ie (accessed 24 February 2017).

Cerulli, Cristina, and Kossak, Florian in conversation with Weisman, Leslie Kanes (2009), 'Educator, Activist, Politician', *Field*, 3 (1): 7–20.

Chadwick, Whitney (2012), *Woman, Art, and Society*, London: Thames & Hudson.

Chakrabarty, Dipesh (2000), *Provincializing Europe: Postcolonial Thought and Historical Difference*, Princeton, NJ: Princeton University Press.

Christie, Maria Elisa (2006), 'Kitchenspace: Gendered Territory in Central Mexico', *Gender, Place and Culture*, 13 (6): 653–661.

City of Stockholm, 'Hon är Stockholms Kärleksgeneral' (She is Stockholm's Love General). Available online: www.mynewsdesk. com/se/stockholms_stad/pressreleases/hon-aer-stockholms- kaerleksgeneral-392319 (accessed 30 April 2016).

Cixous, Hélène (1976), 'The Laugh of the Medusa', trans. Keith Cohen and Paula Cohen, *Signs: Journal of Women in Culture and Society*, 1 (4): 875–93.

Cockburn, Cynthia (1983), *Brothers: Male Dominance and Technical Change*, London: Pluto Press.

Cohen, Leonard (1992), 'Anthem', [Song] *The Future* album, Columbia Records.

Collins, Patricia (2012), *On Intellectual Activism*, Philadelphia: Temple University Press.

Cooper, Davina (2014), *Everyday Utopias: The Conceptual Life of Promising Spaces*, Durham, NC: Duke University Press.

Corner, James (1999), 'The Agency of Mapping', in Denis E. Cosgrove (ed.), *Mappings*, 214–253, London: Reaktion Books.

Crary, Jonathan (2014), *24/7: Late Capitalism and the Ends of Sleep*, London: Verso.

Crenshaw, Kimberlé (1991), 'Mapping the Margins: Intersectionality, Identity Politics, and Violence Against Women of Color', *Stanford Law Review*, 43 (6): 1241–1299.

Crinson, Mark, and Zimmerman, Claire, eds (2010), *Neo-Avant-Garde and Postmodern. Postwar Architecture in Britain and Beyond*, New Haven, CT: Yale University Press.

CRUSH (2016), *13 Myter om Bostadsfrågan* (13 Myths About the Housing Question), Stockholm: Dokument Press.

Cuff, Dana (1991), *Architecture: The Story of Practice*, Cambridge, MA: MIT Press.

Cuff, Dana (1991), 'The Making of an Architect', in *Architecture: The Story of Practice*, 109–154, Cambridge, MA: MIT Press.

Curman, Sofia (2008), 'Stockholm Vill Bli Stad i Världsklass' (Stockholm Wants to Be a World-Class City), *Dagens Nyheter*, 4 November 2008. Available online: www.dn.se/kultur-noje/stockholm-vill-bli-stad-i- varldsklass (accessed 28 July 2016).

Dahlström, Edmund, ed. (1967), *The Changing Roles of Men and Women*, London: Gerald Duckworth.

De Angelis, Massimo, and Stavrides, Stavros (2010), 'Beyond Markets or States: Commoning as Collective Practice (an interview)', *An Arkitektur*, 23. Reprinted 'On the Commons: A Public Interview', *e-flux Journal*, #17. Available online: www.e-flux.com/journal/17/67351/on-the-commons-a-public-interview-with-massimo-de-angelis-and-stavros-stavrides.

de Jong, Annelise, and Mazé, Ramia (2016), 'How About Dinner? Concepts and Methods in Designing for Sustainable Lifestyles', in Jonathan Chapman (ed.), *The Routledge Handbook of Sustainable Product Design*, 423–443, London: Routledge.

Deleuze, Gilles, and Guattari, Félix (2009), *Anti-Oedipus: Capitalism and Schizophrenia*, trans. Robert Hurley, Mark Seem and Helen R. Lane, New York: Penguin Classics.

de los Reyes, Paulina, Molina, Irene, and Mulinari, Diana (2002), *Maktens (O)lika Förklädnader: Kön, Klass och Etnicitet i det Postkoloniala Sverige* (Same/Different Disguises of Power: Gender, Class and Ethnicity in Postcolonial Sweden), Stockholm: Atlas.

Dent, Mike, and Whitehead, Stephen (2002), 'Introduction: Configuring the "New" Professional', in Mike Dent and Stephen Whitehead (eds), *Managing Professional Identities: Knowledge, Performativity and the 'New' Professional*, 1–18, London: Routledge.

Deutsche, Rosalyn (1986), 'Men in Space', in *Evictions: Art and Spatial Politics*, 195–202, Cambridge, MA: MIT Press.

Diller, Elizabeth, and Scofidio Ricardo (1989), 'Projects 17'. Available online: www.moma.org/interactives/exhibitions/projects/elizabeth-diller-ricardo-scofidio (accessed 6 February 2017).

Dilnot, Clive (2015), 'History, Design, Futures', in Tony Fry, Clive Dilnot and Susan Stewart (eds) *Design and the Question of History*, 131–243, London: Bloomsbury.

Design Buildings Wiki, 'Inclusive Design'. Available online: www.designingbuildings.co.uk/wiki/Inclusive_design (accessed 24 February 2017).

Doderer, Yvonne P., and Württembergischer Kunstverein Stuttgart, eds (2013), *Rote Rosen statt Zerstörung: Frauen im Widerstand gegen Stuttgart 21* (Red Roses Instead of Destruction. Women in Resistance to *Stuttgart 21*), Stuttgart: Württembergischer Kunstverein Stuttgart.

Dreher, Tanja (2006), 'Listening Across Difference: Media and Multiculturalism Beyond the Politics of Voice', *Continuum: Journal of Media and Cultural Studies*, 23 (4): 445–458.

Dunne, Anthony, and Raby, Fiona (2009), [Film] *Objectified* documentary, Dir. Gary Huswit, US.

Dunne, Anthony, and Raby, Fiona (2014), 'United Micro Kingdoms', in Zoë Ryan and Meredith Carruthers (eds), *The Future is Not What it Used to Be: 2nd Istanbul Design Biennial*, 269–273, Ostfildern, DE: Hatje Cantz Verlag.

Ebert, Teresa L. (1991), 'The "Difference" of Postmodern Feminism', *College English*, 53 (8): 886–904.

Eckstein, Barbara (2003), 'Making Space: Stories in the Practice of Planning', in Barbara Eckstein and James Throgmorton (eds), *Story and Sustainability: Planning Practice and Possibility for American Cities*, 13–28, Cambridge, MA: MIT Press.

Edelkoort, Li (2012), 'Super-Technology is Going to Ask for Super Tactility – Li Edelkoort at Dezeen Live', 28 December. Available online: www.dezeen.com/2012/12/28/super-technology-is-going-to-ask-for-super-tactility-li-edelkoort-at-dezeen-live (accessed 7 July 2016).

Ehrnberger, Karin, Räsänen, Minna, and Ilstedt, Sara (2012), 'Visualising Gender Norms in Design: Meet the Mega Hurricane Mixer and the Drill Dolphia', *International Journal of Design*, 6 (3): 85–98.

Ellialtı, Tuğçe (2014), '"Resist with Tenacity, Not with Swear Words", Feminist Interventions in the Gezi Park Protests', *CritCom*, 8 January. Available online: councilforeuropeanstudies.org/critcom/resist-with-tenacity-not-with-swear-words-feminist-interventions-in-the-gezi-park-protests (accessed 23 July 2016).

Elmhirst, Rebecca (2011), 'Introducing New Feminist Political Ecologies', *Geoforum*, 42 (2): 129–132.

Elmhirst, Rebecca, and Resurreccion, Bernadette P. (2008), 'Gender, Environment and Natural Resource Management: New Dimensions, New Debates' in Bernadette P. Resurreccion and Rebecca Elmhirst (eds), *Gender and Natural Resource Management: Livelihoods, Mobility and Interventions*, 3–22, London: Earthscan.

Ericson, Magnus, and Mazé, Ramia, eds (2011), *DESIGN ACT Socially and Politically Engaged Design Today*, Berlin: Sternberg Press/ Iaspis.

Fallan, Kjetil, ed. (2012), *Scandinavian Design: Alternative Histories*, London: Berg.

Farr, Douglas (2008), *Sustainable Urbanism – Urban Design with Nature*, Hoboken, NJ: John Wiley.

FATALE (Feminist ArchiTecture Analysis Laboratory and Education, or Feminist Architecture Theory Analysis Laboratory and Education) (2007). Available online: fatalearchitecture.blogspot.se (accessed 11 February 2017).

Finlay, Linda (2002), '"Outing" the Researcher: The Provenance, Process, and Practice of Reflexivity', *Qualitative Health Research*, 12 (4): 531–54.

Fisher, Dana R., and Freudenburg, William R. (2001), 'Ecological Modernization and its Critics: Assessing the Past and Looking Toward the Future', *Society and Natural Resources*, 14 (8): 701–709.

Fortmann, Louise, ed. (2008), *Participatory Research in Conservation and Rural Livelihoods: Doing Science Together*, Hoboken, NJ: Wiley-Blackwell.

Forty, Adrian (2012), *Concrete and Culture: A Material History*, London: Reaktion Books.

Foucault, Michel and Colin Gordon, ed. (1980), *Power/Knowledge: Selected Interviews and Other Writings, 1972–1977*, trans. Colin Gordon, Leo Marshall, John Mepham and Kate Soper, New York: Pantheon Books.

Foucault, Michel, and Faubion, James D., ed. (1994), *The Essential Works of Michel Foucault, 1954–1984*, trans. Robert Hurley and others, New York: New Press.

Fowler, Bridget, and Wilson, Fiona (2004), 'Women Architects and Their Discontents', *Sociology*, 38 (1): 101–119.

Fraser, Nancy (2013), 'A Triple Movement? Parsing the Politics of Crisis after Polanyi', *New Left Review*, 81: 119–132.

Fraser, Nancy, and Nicholson, Linda (1988), 'Social Criticism without Philosophy: An Encounter between Feminism and Postmodernism', *Theory, Culture & Society*, 5: 373–394.

Frederici, Silvia (2012), *Revolution at Point Zero: Housework, Reproduction, and Feminist Struggle*, Oakland: PM Press.

Freeman, Jo (1971), *The Tyranny of Structurelessness*. Available online: www.jofreeman.com/joreen/tyranny.htm (accessed 15 March 2012).
Fried, Barbara (1979), 'Boys will be Boys will be Boys: The Language of Sex and Gender', in Ruth Hubbard, Mary S. Hannifin and Barbara Fried (eds), *Women Look at Biology Looking at Women: A Collection of Feminist Critiques*, 37–59, Cambridge MA: Schenkman.

Frykholm, Hannes (2017), 'Sweating the Small Stuff: A Micro-Scopic Analysis of the Real Estate Lobby', *LO-RES*, 2.

Gabrielsson, Catharina (2007), 'Snyggt och Tryggt' (Neat and Safe), *Dagens Nyheter*, 17 October. Available online: www.dn.se/kultur-noje/kulturdebatt/snyggt-och-tryggt/ (accessed 30 April 2016).

Genosko, Gary (2009), *Félix Guattari: A Critical Introduction*, London: Pluto Press.

Gibson-Graham, J.K. (1996), *The End of Capitalism (As We Knew It): A Feminist Critique of Political Economy*, Oxford, UK: Blackwell.

Gibson-Graham, J.K. (2006), *A Postcapitalist Politics*, Minneapolis, MN: University of Minnesota Press.

Gibson-Graham, J.K. (2008), 'Diverse Economies: Performative Practices for "Other Worlds"', *Progress in Human Geography*, 32 (5): 613–32.

Gibson-Graham, J.K. (2011), 'A Feminist Project of Belonging for the Anthropocene', *Gender, Place and Culture*, 18 (1): 1–21.

Gibson-Graham, J.K., and Roelvink, Gerda (2009), 'Social Innovation for Community Economies', in Diana MacCallum, Frank Moulaert, Jean Hillier and Serena V. Haddock (eds), *Social Innovation and Territorial Development*, 25–38, Farnham, UK: Ashgate.

Gibson-Graham, J.K., Cameron, Jenny, and Healy, Stephen (2013), *Take Back the Economy: An Ethical Guide for Transforming our Communities*, Minneapolis, MN: University of Minnesota Press.

Giddens, Anthony (1987), *Social Theory and Modern Sociology*, Cambridge, UK: Polity Press.

Gidley, Jennifer, Fien, John, Smith, Jodi-Anne, Thomsen, Dana, and Smith, Timothy (2009), 'Participatory Futures Methods', *Environmental Policy and Governance*, 19 (6): 427–440.

Gilligan, Carol (1982), *In a Different Voice: Psychological Theory and Women's Development*, Cambridge, MA: Harvard University Press.

Gilligan, Carol (1987), 'Moral Orientation and Moral Development', in Eva Feder Kittay and Diana T. Meyers (eds), *Women and Moral Theory*, 19–32, Totowa, NJ: Rowman & Littlefield.

Gilman, Charlotte Perkins, and Bauer, Dale M. (ed.) ([1892] 1998), *Charlotte Perkins Gilman: The Yellow Wallpaper*, Boston: Bedford Books.

Giroux, Henry (1971), *The Hidden Curriculum and Moral Education*, Berkeley, California: McCutchan Publishing.

Glass, Michael R. (2014), '"Becoming a Thriving Region": Performative Visions, Imaginative Geographies, and the Power of 32', in Michael R. Glass and Reuben Rose-Redwood (eds), *Performativity, Politics, and the Production of Social Space*, 202–225, London: Routledge.

Glass, Michael R., and Rose-Redwood, Reuben, eds (2014), 'Introduction: Geographies of Performativity', in *Performativity, Politics, and the Production of Social Space*, 1–36, London: Routledge.

Glick Schiller, Nina, and Çağlar, Ayşe, eds (2011), *Locating Migration: Rescaling Cities and Migrants*, Ithaca: Cornell University Press.

GIA Global Industry Analysts (2010), 'Global Ready-Mix Concrete Market to Reach $105.2 Billion by 2015, According to New Report by Global Industry Analists, Inc.', 29 March. Available online: www.prweb.com/releases/ready_mix_concrete/cement/prweb3747364.htm (accessed 7 July 2016).

Graham, Janna (2010), 'Between a Pedagogical Turn and a Hard Place: Thinking with Conditions', in Paul O'Neill and Mick Wilson (eds), *Curating and the Educational Turn*, Occasional Table Critical Series, 124–139, London: Open Editions.

Grillner, Katja (2005), 'Introduction, Writing Architecture', in Katja Grillner, Per Glembrandt, and Sven-Olov Wallenstein (eds), *01 AKAD Beginnings: Experimental Research in Architecture and Design*, 64–101, Stockholm: Axl Books.

Grillner, Katja (2006), 'Experience as Imagined: Writing the Eighteenth-Century Landscape Garden', in Martin Calder (ed.), *Experiencing the Garden in the Eighteenth Century*, 37–64, Bern, CH: Peter Lang.

Grillner, Katja (2007), 'Fluttering Butterflies, a Dusty Road, and a Muddy Stone: Criticality in Distraction (Haga Park, Stockholm, 2004)', in Jane Rendell, Jonathan Hill, Murray Fraser and Mark Dorrian (eds), *Critical Architecture*, 135–142, London: Routledge.

Grillner, Katja (2011), 'A Performative Mode of Writing Place: Out and About the Rosenlund Park, Stockholm 2008–2010', in Mona Livholts (ed.), *Emergent Writing Methodologies in Feminist Studies*, 133–147, London: Routledge.

Grillner, Katja (2013), 'Design Research and Critical Transformations', in Murray Fraser (ed.), *Design Research in Architecture*, 71–94, Farnham UK: Ashgate.

Grillner, Katja, and Havik, Klaske (2017), 'Writing as a Mode of Architectural Investigation: Between Sites and Stories, Between Texts and Times. A Dialogue', in Klaske Havik, Susana Oliveira and Mark Proosten (eds), *Writingplace: Investigations in Architecture and Literature*, Rotterdam: Nai010 Publishers.

Groat, Linda N., and Ahrentzen, Sherry B. (1997), 'Voices for Change in Architectural Education: Seven Facets of Transformation from the Perspectives of Faculty Women', *Journal of Architectural Education*, 50 (5): 271–285.

Grosz, Elizabeth (1994), *Volatile Bodies: Toward a Corporeal Feminism*, Bloomington, IN: Indiana University Press.

Grosz, Elizabeth (1995), *Space, Time and Perversion: Essays on the Politics of Bodies*, London: Routledge.

Grosz, Elizabeth, ed. (1999), *Becomings: Explorations in Time, Memory and Futures*, Ithaca, NY: Cornell University Press.

Grosz, Elizabeth (2001), *Architecture From the Outside: Essays on Virtual and Real Space*, Cambridge, MA: MIT Press.

Grosz, Elizabeth (2001). 'Embodied Utopias: The Time of Architecture', *Architecture from the Outside: Essays on Virtual and Real Space*, Cambridge, Massachusetts: MIT Press, 131–150.

Grosz, Elizabeth (2010), 'Feminism, Materialism, and Freedom', in Diana Cole and Samantha Frost (eds), *New Materialisms: Ontology, Agency, and Politics*, 139–157, Durham, NC: Duke University Press.

Guattari, Félix (1984), *Molecular Revolution: Psychiatry and Politics*, trans. Rosemary Sheed, Harmondsworth, UK: Penguin Books.

Guattari, Félix (2009), *Chaosophy: Texts and Interviews 1972–1977*, Los Angeles: Semiotext(e).

Gunnarsson-Östling, Ulrika (2011), 'Gender in Futures: A Study of Gender and Feminist Papers Published in Futures, 1969–2009', *Futures*, 43 (9): 1029–1039.

Habermas, Jürgen (1968), *Technik und Wissenschaft als 'Ideologie'* (Technology and Science as 'Ideology'), Frankfurt: Suhrkamp Verlag.

Habermas, Jürgen (1983), 'Ziviler Ungehorsam – Testfall für den Demokratischen Rechtsstaat' (Civil Disobedience – Test Case for the Democratic State), in Peter Glotz (ed.), *Ziviler Ungehorsam im Rechtsstaat*, 29–53, Frankfurt: Suhrkamp Verlag.

Hajer, Maarten A. (1995), *The Politics of Environmental Discourse: Ecological Modernization and the Policy Process*, Oxford, UK: Clarendon Press.

Handler, Sophie (2006), *The Fluid Pavement and Other Stories on Growing Old in Newham*, London: RIBA.

Handler, Sophie (2011), [exhibition] 'Sticks and Stones May Break My Bones', William Road Gallery, London.

Handler, Sophie (2013), 'Active Ageing: Creative Interventions in Urban Regeneration', in Myrna Margulies Breitbart (ed.), *Creative Economies in Post-Industrial Cities: Manufacturing a (Different) Scene*, 235–260, Farnham, UK: Ashgate.

Handler, Sophie (2014), *An Alternative Age-Friendly Handbook*, Manchester, UK: University of Manchester Library.

Handler, Sophie (2016), 'Ageing, Care and Contemporary Spatial Practice', in Charlotte Bates, Rob Imrie and Kim Kullman (eds), *Care and Design: Bodies, Buildings, Cities*, 178–197, Chichester, UK: John Wiley & Sons.

Haraway, Donna (1987), 'A Manifesto for Cyborgs: Science, Technology, and Socialist Feminism in the 1980s', *Australian Feminist Studies*, 4: 1–42.

Haraway, Donna (1988), 'Situated Knowledges: The Science Question in Feminism and the Privilege of Partial Perspective', *Feminist Studies*, 14 (3): 575–599.

Haraway, Donna (1991), *Simians, Cyborgs and Women: The Reinvention of Nature*, London: Free Association Books.

Haraway, Donna (1997), *Modest_Witness@Second_Millenium. FemaleMan©_Meets_OncoMouse™: Feminism and Technoscience*, London: Routledge.

Harding, Sandra (2004), 'Rethinking Standpoint Epistemology: What Is Strong Objectivity?', in Sandra Harding (ed.), *The Feminist Standpoint Theory Reader: Intellectual and Political Controversies*, 127–140, London: Routledge.

Harding, Sandra, ed. (2004), *The Feminist Standpoint Theory Reader: Intellectual and Political Controversies*, London: Routledge.

Harding, Sandra (2008), *Sciences from Below: Feminism, Postcolonialities, and Modernities*, Durham, NC: Duke University Press.

Harley, J. B (1988), 'Maps, Knowledge and Power', in Denis Cosgrove and Stephen Daniels (eds), *The Iconography of Landscape: Essays on the Symbolic Representation. Design and Use of Past Environments*, 277–312, Cambridge, UK: Cambridge University Press.

Hartsock, Nancy ([1983] 2003), 'The Feminist Standpoint: Developing the Ground for a Specifically Feminist Historical Materialism', in Sandra Harding (ed.), *The Feminist Standpoint Theory Reader: Intellectual and Political Controversies*, 35–54, London: Routledge.

Harvey, David (1989), *The Urban Experience*, Baltimore, MD: John Hopkins University Press.

Harvey, David (2013), [Lecture] 'Seventeen Contradictions and the End of Capitalism', University of the Arts London, 25 June.

Hedlund, Gun, and Perman, Karin (2012), 'The Heating, Especially Warm Water, is Exceptionally High in this Area...', in *Proceedings of the Nordic Conference on Consumer Research*, Gothenburg, Sweden.

Heinberg, Richard, and Lerch, Daniel (2010), *The Post-Carbon Reader: Managing the 21st Century's Sustainability Crises*, Healdsburg, CA: Watershed Media.

Hekman, Susan J. (1990), *Gender and Knowledge: Elements of a Postmodern Feminism*, Oxford, UK: Polity.

Hekman, Susan (2008), 'Constructing the Ballast: An Ontology for Feminism', in Stacy Alaimo and Susan Hekman (eds), *Material Feminisms*, 85–119, Bloomington, IN: Indiana University Press.

Held, Virginia (2006), *The Ethics of Care: Personal, Political, and Global*, Oxford, UK: Oxford University Press.

Henke, Lutz (2014), 'Why We Painted Over Berlin's Most Famous Graffiti', *The Guardian*, 19 December. Available online: www.theguardian.com/commentisfree/2014/dec/19/why-we-painted-over-berlin-graffiti-kreuzberg-murals (accessed 28 July 2016).

Heynen, Nikolas C., Kaika, Maria, and Swyngedouw, Erik (2004), *In the Nature of Cities: Urban Political Ecology and the Politics of Urban Metabolism*, London: Routledge.

Highmore, Ben (2002), *Everyday Life and Cultural Theory*, London: Routledge.

Hill Collins, Patricia (1990), *Black Feminist Thought: Knowledge, Consciousness, and the Politics of Empowerment*, London: Routledge.

Hirdman, Yvonne (2014), *Vad Bör Göras: Jämställdhet och Politik under Femtio År* (What Should Be Done: Gender and Politics in Fifty Years), Stockholm: Ordfront.

History As We Know It (2013), [Film] Dir. Karnevalsföreningen, Britt-Inger Hallongren, Lars Printzen, MYCKET (Mariana Alves Silva, Katarina Bonnevier, Thérèse Kristiansson), The New Beauty Council, Maja Gunn, Marie Carlsson, AnarKrew, and Fotohögskolan Göteborgs Universitet, Sweden. Available online: www.youtube.com/watch?v=VZ-QFqT2azl (accessed 10 February 2017).

Hobsbawm, Eric (1983), 'Introduction: Inventing Tradition', in Eric Hobsbawm and Terence O. Ranger (eds), *The Invention of Tradition*, 1–14, Cambridge, UK: Cambridge University Press.

Hobson, Kersty, (2006), 'Bins, Bulbs, and Shower Timers: On the 'Techno-Ethics' of Sustainable Living', *Ethics, Place and Environment: A Journal of Philosophy and Geography*, 9 (3): 317–336.

Hochschild, Arlie, and Machung, Anne ([1989] 2012), *The Second Shift: Working Families and the Revolution at Home*, New York: Penguin Books.

Holago, Ceylan, and Kasapi, Rani (2011), 'Policy Strider mot Yttrandefriheten' (Policy at Odds with Freedom of Speech), *Svenska Dagbladet*. Available online: www.svd.se/policy-strider-mot-yttrandefriheten (accessed 30 April 2016).

Holl, Steven, Pallasmaa, Juhani, and Pérez Gómez, Alberto (1994), *Questions of Perception: Phenomenology of Architecture*, Tokyo: A & U Publishing.

Holland-Cunz, Barbara (2006), 'Vielleicht wird Feminismus wieder schick' (Perhaps Feminism Will Recur)', *TAZ*, 25 November.

Hollevoet, Christel (1992), 'Wandering in the City: From Flânerie to Dérive and After: The Cognitive Mapping of Urban Space', in Christel Hollevoet, Karen Jones and Timothy Nye (eds), *The Power of the City, The City of Power*, 25–55, New York: Whitney Museum of American Art.

Hollinger, Veronica (2013), 'Feminist Theory and Science Fiction', in Edward James and Farah Mendlesohn (eds), *The Cambridge Companion to Science Fiction*, 125–136, Cambridge, UK: Cambridge University Press.

Holt, John (1991), *How Children Learn*, London: Penguin.

hooks, bell (1984), *Feminist Theory: From Margin to Center*, London: Pluto Press.

hooks, bell ([1984] 2000), 'Preface to the Second Edition Seeing the Light: Visionary Feminism', in *Feminist Theory: From Margin to Center*, x–xv, Cambridge, MA: South End Press.

hooks, bell ([1989] 2000), 'Choosing the Margins as a Space of Radical Openness', in Jane Rendell, Barbara Penner and Ian Borden (eds), *Gender Space Architecture, An Interdisciplinary Introduction*, 203–209, London: Routledge.

hooks, bell (1994), *Teaching to Transgress: Education as the Practice of Freedom*, London: Routledge.

hooks, bell (1999), *Wounds of Passion: A Writing Life*, New York: Holt Paperbacks.

hooks, bell (2000), *All About Love: New Visions*, New York: Harper Perennial.

hooks, bell (2010), *Teaching Critical Thinking: Practical Wisdom*, London: Routledge.

Hopkins, Patrick D. (1998), *Sexmachine: Readings in Culture, Gender, and Technology*, Bloomington, IN: Indiana University Press.

Hopkins, Rob (2012), *The Transition Companion: Making Your Community More Resilient in Uncertain Times*, White River Junction, VT: Chelsea Green Publishing Company.

Hurley, Karen (2008), 'Is That a Future We Want?: An Ecofeminist Exploration of Images of the Future in Contemporary Film', *Futures*, 40: 346–359.

Hutcheon, Linda (1989), *Politics of Postmodernism*, London: Routledge.

Huyssen, Andreas (1986), *After the Great Divide: Modernism, Mass Culture, and Postmodernism*, Bloomington, IN: Indiana University Press.

Illich, Ivan (1971), *Deschooling Society*, London: Marion Boyars.

Ilstedt, Sara, and Wangel, Josefin (2013), 'Designing Sustainable Futures', in *Proceedings of the Nordic Design Research Conference*, Copenhagen, Denmark.

Inayatullah, Sohail (1990), 'Deconstructing and Reconstructing the Future: Predictive, Cultural and Critical Epistemologies', *Futures*, 22: 115–14.

Ingrassia, Franco, and Holdren, Nate (2006), 'Precarias a la Deriva: A Very Careful Strike – Four Hypothesis', *The Commoner*, 11: 33–45. Available online: www.commoner.org.uk/11deriva.pdf (accessed 19 February 2017).

Institute for Human Centred Design. Available online: www.humancentereddesign.org (accessed 24 February 2017).

Irigaray, Luce ([1984] 1993, 2004), *An Ethics of Sexual Difference*, trans. Carolyn Burke and Gillian C. Gill, London: Continuum.

Irigaray, Luce (1985), *Speculum of the Other Woman*, trans. Gillian C. Gill, Ithaca, NY: Cornell University Press.

Irigaray, Luce (1985), 'The "Mechanics" of Fluids', in *This Sex Which Is Not One*, trans. Catherine Porter with Carolyn Burke, 106–118, Ithaca, NY: Cornell University Press.

Irigaray, Luce (2004), *Key Writings*, New York: Continuum.

Jameson, Fredric (2005), *Archaeologies of the Future*, London: Verso.

Janssens, Nel (2012), 'Utopia-Driven Projective Research: A Design Approach to Explore the Theory and Practice of Meta-Urbanism', PhD diss., Chalmers University of Technology, Sweden.

Janssens, Nel, and de Zeeuw, Gerard (2017), 'Non-Observational Research: A Possible Future Route for Knowledge Acquisition in Architecture and the Arts', in Fredrik Nilsson, Halina Dunin-Woyseth and Nel Janssens (eds), *Perspectives on Research Assessment in Architecture and the Arts: Discussing Doctorateness*, 147–158, London: Routledge.

Jencks, Charles (1975), 'The Rise of Post Modern Architecture', *Architectural Association Quarterly*, 7 (4): 3–14.

Jencks, Charles (1981), *The Language of Postmodernism*, New York: Rizzoli.

Johnson, Deborah G. (2010), 'Sorting out the Question of Feminist Technology', in Linda L. Layne, Shara L. Vostral and Kate Boyer (eds), *Feminist Technology (Women Gender and Technology)*, 36–54, Chicago, IL: University of Illinois Press.

Jones, Amelia (1996), *Sexual Politics: Judy Chicago's Dinner Party in Feminist Art History*, Berkeley, CA: University of California Press.

Jones, Anne Rosalind ([1981] 2010),'Writing the Body: Toward an Understanding of l'Écriture Féminine', in Robyn Warhol and Diana Price Herndl (eds), *Feminisms: An Anthology of Literary Theory and Criticism*, 370–383, New Brunswick, NJ: Rutgers University Press.

Jonsson, Daniel, Gustafsson, Stina, Wangel, Josefin, Höjer, Mattias, Lundqvist, Per, and Svane, Örjan (2011), 'Energy at Your Service: Highlighting Energy Usage Systems in the Context of Energy Efficiency Analysis', *Energy Efficiency*, 4 (3): 355–369.

Julier, Guy (2011), 'Political Economies of Design Activism and the Public Sector', in *Proceedings of the Nordic Design Research Conference*, Helsinki, Finland.

Katz, Cindi (2001), 'On the Grounds of Globalization: A Topography for Feminist Political Engagement', *Signs: Journal of Women in Culture and Society*, 26: 1213–1234.

Keil, Roger (2007), 'Sustaining Modernity, Modernizing Nature: The Environmental Crisis and the Survival of Capitalism', in Rob Krueger and David Gibbs (eds), *The Sustainable Development Paradox: Urban Political Economy in the United States and Europe*, 41–65, London: Guilford Press.

Kemper, Andreas (2012), *Die Maskulisten: Organisierter Antifeminismus im deutschsprachigen Raum* (The Masculists: Organized Antifeminism in the German-Speaking Area), Münster, DE: Unrast-Verlag.

Kester, Grant H. (2004), *Conversation Pieces: Community and Communication in Modern Art*, Berkeley, CA: University of California Press.

Kimvall, Jacob (2014), *The G-Word: Virtuosity and Violation, Negotiating and Transforming Graffiti*, Stockholm: Dokument Press.

Kings, Lisa (2011), *Till det Lokalas Försvar: Civilsamhället i den Urbana Periferin* (To the Local's Defense: Civil Society in the Urban Periphery), Lund, SE: Arkiv.

Kirby, David (2009), 'The Future is Now: Diegetic Prototypes and the Role of Popular Films in Generating Real-World Technological Development', *Social Studies of Science*, 40 (1): 41–70.

Klein, Gary, Moon, Brian, and Hoffman, Robert R. (2006), 'Making Sense of Sensemaking 1: Alternative Perspectives', *IEEE Intelligent Systems*, 21 (4): 70–73.

Knapp, Alex (2012), 'How George Takei Conquered Facebook', *Forbes*, 23 March. Available online: www.forbes.com/sites/alexknapp/2012/03/23/how-george-takei-conquered-facebook (accessed 28 April 2014).

Krantz, Brigit (1991), 'Kvinnovisioner Om ett Nytt Vardagsliv', *Tidskrift för genusvetenskap*, 2: 43–53.

Krasny, Elke, ed. (2014), *The Right to Green: Hands-On Urbanism* 1850–2012, Hong Kong: MCCM Creations.

Kristeva, Julia (1998), 'Institutional Interdisciplinarity in Theory and Practice: An Interview', in Alex Coles and Alexia Defert (eds), *De-, Dis-, Ex-, Vol. 2: The Anxiety of Interdisciplinarity*, 3–21, London: Black Dog.

Kumashiro, Kevin (2002), *Troubling Education – Queer Activism and Anti-Oppressive Pedagogy*, London: Routledge Falmer.

Kvinnorsbyggforum (Women's Building Forum). Available online: www.kvinnorsbyggforum.org (accessed 10 February 2017).

Lacey, Kate (2013), *Listening Publics, The Politics and Experience of Listening in the Media Age*, Cambridge, UK: Polity Press.

Lacy, Suzanne (2010), *Leaving Art: Writings on Performance, Politics and Publics*, 1974–2007, Durham, NC: Duke University Press.

Larivière, Vincent, Ni, Chaogun, Gingras, Yves, Cronin, Blaise, and Sugimoto, Cassidy (2013), 'Bibliometrics: Global Gender Disparities in Science', *Nature*, 504 (7079): 211–213.

Lather, Patti (2001), 'Postbook: Working in the Ruins of Feminist Ethnography', *Signs: Journal of Women in Culture and Society*, 27 (1): 199–227.

Latour, Bruno (2005), *Reassembling the Social: An Introduction to Actor Network Theory*, Oxford, UK: Oxford University Press.

Lavin, Sylvia (2011), *Kissing Architecture*, Princeton, NJ: Princeton University Press.

Layne, Linda L., Vostral, Shara L., and Boyer, Kate, eds. (2010), *Feminist Technology (Women, Gender and Technology)*, Chicago, IL: University of Illinois Press.

Lazzarato, Maurizio (2014), *Signs and Machines: Capitalism and the Production of Subjectivity*, Los Angeles: Semiotexte.

Lefebvre, Henri ([1974] 1991), *The Production of Space*, trans. Donald Nicholson-Smith, Oxford, UK: Blackwell.

Levin, David Michael, ed. (1993), *Modernity and the Hegemony of Vision*, Berkeley, CA: University of California Press.

Levitas, Ruth (2013), *Utopia as Method: The Imaginary Reconstitution of Society*, London: Palgrave Macmillan.

Lewis, Gail (2000), *'Race', Gender, Social Welfare: Encounters in a Postcolonial Society*, Cambridge, UK: Polity Press.

Lewis, Gail (2004), *Citizenship: Personal Lives and Social Policy*, Bristol, UK: Policy Press with the Open University.

Listerborn, Carina (2002), *Trygg Stad: Diskurser om Kvinnors Rädsla i Forskning, Policyutveckling och Lokal Praktik.* (Safe City: Discourses on Women's Fear in Research, Policy Development and Local Practice), PhD diss., Chalmers University of Technology, Sweden.

Listerborn, Carina (2007), 'Kroppen som Situation – om Kön, Makt och Rum. Del 1: Begreppsutveckling', *Rapporter och Notiser* nr. 168, Lund, SE: Kulturgeografiska institutionen, Lunds universitet.

Listerborn, Carina (2007), 'Who Speaks? And Who Listens? The Relationship Between Planners and Women's Participation in Local Planning in a Multi-Cultural Urban Environment', *GeoJournal*, 70 (1): 61–74.

Listerborn, Carina (2013), 'Suburban Women and the "Glocalisation" of the Everyday Life: Gender and Glocalities in Underpriviliged Areas in Sweden', in *Gender, Place, Culture*, 20 (3): 290–312.

Listerborn, Carina, Grundström, Karin, Claesson, Ragnhild, Delshammar, Tim, Johansson, Magnus, and Parker, Peter, eds (2014), *Strategier för att Hela en Delad Stad* (Strategies to Heal a Fragmented City), Malmö, SE: Malmö University Press MAPIUS.

Live Projects. Available online: www.liveprojects.org (accessed 10 February 2017).

Livholts, Mona, and Tamboukou, Maria (2015), *Discourse and Narrative Methods*, London: Sage.

Lloyd Thomas, Katie (2007), 'Going into the Mould: Materials and Process in the Architectural Specification', *Radical Philosophy*, 144.

Lorde, Audrey ([1984] 2007), 'The Master's Tools Will Never Dismantle the Master's House', in *Sister Outsider: Essays and Speeches*, 110–113, Berkeley, CA: Crossing Press.

Lorey, Isabell (2015), *State of Insecurity: Government of the Precarious*, trans. Aileen Derieg, London: Verso.

Low, Nicholas P., and Gleeson, Brendan J. (1997), 'Justice in and to the Environment: Ethical Uncertainties and Political Practices', *Environment and Planning A*, 29 (1): 21–42.

Lundstedt, Anna (2005), 'Vit Governmentalitet: "Invandrarkvinnor" och Textilhantverk – en Diskursanalys' (White Governmentality: 'Immigrant Women' and Textile Handicraft – a Discourse Analysis), PhD diss., University of Gothenburg, Sweden. Available online: nile.lub.lu.se/arbarch/aio/2005/aio2005_14.pdf (accessed 11 February 2017).

Mackenzie, Donald, and Wajcman, Judy, eds (1985), *The Social Shaping of Technology: How the Refrigerator Got Its Hum*, Milton Keynes, UK: Open University Press.

Malmö City (2009), *Sustainable Transformation Malmö – Focus Rosengård*, Application to the European Regional Development Fund, Malmö: Malmö City.

Malmö City (2010), *Rosengårdsstråket* (The Rosengård Path), Planning Programme, Malmö: Malmö City, Road Office.

Malmö City (2014), *Comprehensive Plan for Malmö*, Malmö: Malmö City.

Massey, Doreen (1993), 'Power-Geometry and a Progressive Sense of Place', in John Bird, Barry Curtis, Tim Putnam and Lisa Tickner (eds), *Mapping the Futures: Local Cultures, Global Change*, 60–70, London: Routledge.

Massey, Doreen (1994), 'A Global Sense of Place', in Doreen Massey (ed.), *Space, Place and Gender*, 146–156, Cambridge, UK: Polity Press.

Massey, Doreen (2005), *For Space*, London: Sage.

Matrix (1984), *Making Space: Women and the Man-Made Environment*, London: Pluto Press.

Mattsson, Helena (2016), 'Revisiting Swedish Postmodernism: Gendered Architecture and Other Stories', *Journal of Art History*, 85 (1): 109–125.

Mattsson, Helena, and Wallenstein, Sven-Olov (2010), *Swedish Modernism: Architecture, Consumption and the Welfare State*, London: Black Dog.

Mattsson, Helena, and Zetterlund, Christina (2011), 'Historical Perspectives', in Magnus Ericson and Ramia Mazé (eds), *DESIGN ACT*, 47–82, Berlin: Sternberg Press/ Iaspis.

Mauthner, Natasha, and Doucet, Andrea (2003), 'Reflexive Accounts and Accounts of Reflexivity in Qualitative Data Analysis', *Sociology*, 37 (3): 413–431.

Mazé, Ramia (2007), *Occupying Time: Design, Technology, and the Form of Interaction*, Stockholm: Axl Books.

Mazé, Ramia (2013), 'Who is Sustainable? Querying the Politics of Sustainable Design Practices', in Ramia Mazé, Lisa Olausson, Matilda Plöjel, Johan Redström and Christina Zetterlund (eds), *Share This Book*, 83–122, Stockholm: Axl Books.

Mazé, Ramia (2016), 'Design and the Future: Temporal Politics of "Making a Difference"', in Rachel Charlotte Smith, Kasper Tang Vangkilde, Mette Gislev Kjaersgaard, Ton Otto, Joachim Halse and Thomas Binder (eds), *Design Anthropological Futures*, 37–54, London: Bloomsbury.

Mazé, Ramia, and Redström, Johan (2009), 'Difficult Forms: Critical Practices of Design and Research', *Research Design Journal*, 1 (1): 28–39.

Mazé, Ramia, Messager, Aude, Thwaites, Thomas, and Önal, Başar (2013), 'Energy Futures', in Ramia Mazé (ed.), *SWITCH! Design and Everyday Energy Ecologies*, 6–44, Stockholm: Interactive Institute Swedish ICT.

Merchant, Carolyn (1989), *Ecological Revolutions – Nature, Gender, and Science in New England*, Chapel Hill, NC: University of North Carolina Press.

Merchant, Carolyn (1996), *Earthcare – Women and the Environment*, London: Routledge.

Meyer, Jan, and Land, Ray (2005), 'Threshold Concepts and Troublesome Knowledge (2): Epistemological Considerations and a Conceptual Framework for Teaching and Learning', *Higher Education*, 49 (3): 373–388.

McGinnity, Frances, and Russell, Helen (2008), *Gender Inequalities in Time Use: The Distribution of Caring, Housework and Employment among Women and Men in Ireland*. Dublin: The Equality Authority, Economic and Social Research Institute, Brunswick Press. Available online: www.lenus.ie/hse/bitstream/10147/76678/1/EqualityInequalities.pdf (accessed 24 February 2017).

McGlinn, Malin (2014), 'Utanförskap I EU' (Exclusion in EU), *Socialpolitik*, 4.

Merrick, Helen (2003), 'Gender in Science-Fiction', in Edward James and Farah Mendlesohn (eds), *The Cambridge Companion to Science Fiction*, 241–252, Cambridge, UK: Cambridge University Press.

Mies, Maria, and Bennholdt-Thomsen, Veronika (1999), *The Subsistence Perspective*, trans. Patrick Camiller, Maria Mies and Gerd Weih, London: Zed Books.

Mies, Maria, Shiva, Vananda, and Salleh, Ariel ([1993] 2014), *Ecofeminism*, London: Zed Books.

Mies, Maria, and Ressler, Oliver (2016), 'The Subsistence Perspective', trans. Lisa Rosenblatt. Available online: republicart.net/disc/aeas/mies01_en.htm (accessed 16 August 2016).

Millar, Jody G. (2013), 'The Real Women's Issue: Time. Never Mind "Leaning In". To Get More Working Women into Senior Roles, Companies Need to Rethink the Clock', *The Wall Street Journal Online*, 11 March. Available online: www.wsj.com/articles/SB10001424127887324678604578342641640982224 (accessed 9 January 2015).

Milojevic, Ivana (1999), 'Feminising Futures Studies', in Ziauddin Sardar (ed.), *Rescuing All Our Futures: The Future of Futures Studies*, 61–71, Twickenham: Adamantine Press.

Milojevic, Ivana (2008), 'Timing Feminism, Feminising Time', *Futures*, 40 (4): 329–345.

Mogel, Lize, and Bhagat, Alexis (2008), *An Atlas of Radical Cartography*, Los Angeles: Journal of Aesthetics and Protest Press.

Mohanty, Chandra Talpade (2003), *Feminism Without Borders: Decolonizing Theory, Practicing Solidarity*, Durham, NC: Duke University Press.

Mohanty, Chandra Talpade, Russo, Anne, and Torres, Lourdes, eds (1991), *Third World Women and the Politics of Feminism*, Bloomington, IN: Indiana University Press.

Mol, Arthur P. J., Sonnenfeld, David A., and Spaargaren, Geert, eds (2009), *The Ecological Modernization Reader: Environmental Reform in Theory and Practice*, London: Routledge.

Molina, Irene (1997), 'Stadens Rasifiering: Etnisk Boendesegregation i Folkhemmet', PhD diss., Department of Social and Economic Geography, Uppsala University, Sweden.

Molina, Irene (2005), 'Etnisk Diskriminering i Boendet', in Expert Appendix to *Rapport Integration 2005*, Norrköping: Integrationsverket.

Morrow, Ruth (2000), 'Why the Shoe Doesn't Fit – Architectural Assumptions and Environmental Discrimination' in David Nicol and Simon Pilling (eds) *Changing Architectural Education: Towards a New Professionalism*, London: Spon Press.

Morrow, Ruth, ed. (2002), *Building and Sustaining a Learning Environment for Inclusive Design: A Framework for Teaching Inclusive Design within Built Environment Courses in the UK*, Centre for Education in the Built Environment, Belfast: Queens University. Available online: pure.qub.ac.uk/portal/files/13453576/CEBE_Building_and_Sustaining_a_Learning_environment_for_inclusive_design_full_report.pdf (accessed 24 February 2017).

Morrow, Ruth (2007), 'Building Clouds, Drifting Walls' in Doina Petrescu (ed.), *Altering Practices: Feminist Politics and Poetics of Space*. London: Routledge.

Morrow, Ruth, and Belford, Trish (2008), 'Soft Garniture: Developing Hybrid Materials Between Academia and Industry', in *Proceedings of the Oxford Conference: A Re-Evaluation of Education in Architecture*, 387–362, Southampton: WIT Press.

Morrow, Ruth, and Belford, Trish (2010), 'A Hybrid Practice, Between Design and Craft', in *Proceedings of the 7th Conference of the International Committee for Design History and Design Studies* ICDHS, Brussels, Belgium.

Morrow, Ruth, and Belford, Trish (2012), 'Fabrication and Ms. Conduct: Scrutinising Practice Through Feminist Theory', special issue on Women, Practice and Architecture, *Architectural Theory Review*, 17 (2–3): 399–415.

Mouffe, Chantal (1992), 'Citizenship and Political Identity', *October*, 61: 28–32.

Mouffe, Chantal ([2000] 2009), *The Democratic Paradox*, London: Verso.

Mouffe, Chantal (2005), *On the Political (Thinking in Action)*, London: Routledge.

Mouffe, Chantal (2007), 'Artistic Activism and Agonistic Spaces', *Art & Research* 1(2). Available online: www.artandresearch.org.uk/v1n2/mouffe.html (accessed 8 November 2016).

Mouffe, Chantal (2013), *Agonistics: Thinking the World Politically*, London: Verso.

muf (Fior, Liza, Clark, Katherine, and Bidgood, Juliet) and Ainley, Rosa, ed. (2000), *This is What We Do: A Muf Manual*, London: Ellipsis.

Murphy, Pat (2008), *Plan C: Community Survival Strategies for Peak Oil and Climate Change*, Gabriola Island, CA: New Society Publishers.

Mühsam-Werther, Charlotte (1913), *Was die Frau von Berlin Wissen Muß: Ein Praktisches Frauenbuch für Einheimische und Fremde* (What the Woman of Berlin Must Know: A Practical Women's Book for Locals and Strangers), Berlin: Loesdau.

MYCKET. Available online: www.mycket.org (accessed 9 February 2017).

MYCKET (2013), [Speech] 'The Tale from the Hide-Outs' (Talet från gömmorna), *Exclude Me In*, Göteborg International Biennial for Contemporary Art, Göteborg, Sweden.

National Property Board Sweden, 'About Us'. Available online: www.sfv.se/en/about-us (accessed 26 July 2016).

Naturvårdsverket (2012), *Konsumtionsbaserade Miljöindikatorer: Underlag för Uppföljning av Generationsmålet* (Consumption-Based Environmental Indicators: Basis for Monitoring the Generation Goal), Stockholm: Naturvårdsverket (Swedish Environmental Protection Agency).

Nightingale, Andrea J. (2011), 'Bounding Difference: Intersectionality and the Material Production of Gender, Caste, Class and Environment in Nepal', *Geoforum*, 42 (2): 153–162.

Nijkamp, Peter, and Perrels, Adriaan (2009), *Sustainable Cities in Europe*, London: Routledge.

Noddings, Nel (1984), *Caring: A Feminine Approach to Ethics and Moral Education*, Berkeley, University of California Press.

Notkin, Debby and The Secret Feminist Cabal, eds (1998), *Flying Cups and Saucers: Gender Explorations in Science Fiction and Fantasy*, Cambridge, MA: Edgewood Press.

O'Grady, Kathleen (1998), 'Theorizing Feminism and Postmodernity: A Conversation with Linda Hutcheon', *Rampike*, 9 (2): 20–22.

Olofsson, Jennie (2016), 'Normativa Strömmar och Underliggande Motstånd: Om Fluiditet, Läckage och Kvinnors Kroppar' (Normative Currents and Underlying Resistance: About Fluidity, Leakage and Women's Bodies), *Tidskrift för genusvetenskap*, 36 (4): 119–138.

Olsson, Lina (2008), 'Den Självorganiserade Staden: Appropriation av Offentliga Rum i Rinkeby' (The Self-Organised City: Appropriation of Public Space in Rinkeby), PhD diss., Lund University, Sweden.

Organisation for Economic Co-operation and Development OECD (1995), *Women in the City: Housing, Services and the Urban Environment*, Washington: OECD Publishing.

Parlour. Available online: archiparlour.org (accessed 11February 2017).

Parlour (2015), 'Parlour Guides'. Available online: archiparlour.org/ parlour-guides (accessed 7 July 2016).

Osborne, Peter (1999), 'Conceptual Art and/as Philosophy,' in John Bird and Michael Newman (eds), *Rewriting Conceptual Art*, 47–55, London: Reaktion Books.

Pelletier, Louise, and Pérez-Gómez, Alberto, eds (1994), *Architecture, Ethics and Technology*, Montreal: McGill-Queen's University Press.

Perry, Clarence (2007), 'The Neighborhood Unit', in Michael Larice and Elisabeth MacDonald (eds), *The Urban Design Reader*, 54–65, London: Routledge.

Petrescu, Doina, ed. (2007), 'Altering Practices', in Doina Petrescu (ed.), *Altering Practices: Feminist Politics and Poetics of Space*, xv–xx, London: Routledge.

Petrescu, Doina, ed. (2007), *Altering Practices: Politics and Poetics of Space*, London: Routledge.

Petrescu, Doina (2007), 'How to Make a Community as Well as the Space for It', *PEPRAV*. Available online: www.peprav.net/tool/spip.php?article31 (accessed 17 February 2017).

Petrescu, Doina (2010), 'Female Gardeners of the Ordinary', *Multitudes*, 42 (3): 126–133.

Petrescu, Doina (2011), 'Gardeners of the Commons', trans. Tom Ridgway, in Doina Petrescu, Constantin Petcou and Nishat Awan (eds), *Trans-Local-Act*, 317–322, London:aaa peprav.

Petrescu, Doina (2013), 'Gardeners of the Commons, for the Most Part, Women', in Peg Rawes (ed.), *Relational Architectural Ecologies*, 261–274, London: Routledge.

Philipson, Cecilia (1979), 'Kvinnors Erfarenheter Ska Tas Tillvara!' (Women's Experience Should Be Used), *AT*, 16.

Phillips, Adam (1994), *On Flirtation: Psychoanalytic Essays on the Uncommitted Life*, Cambridge, MA: Harvard University Press.

Phillipson, Chris (2011), 'Developing Age-Friendly Communities: New Approaches to Growing Old in Urban Communities', in Richard A. Settersten Jr. and Jaqueline L. Angel (eds), *Handbook of the Sociology of Aging*, 279–296, New York: Springer.

Pincetl, Stephanie (2007), 'The Political Ecology of Green Spaces in the City and Linkages to the Countryside', *Local Environment*, 12 (2): 87–92.

Pipkin, Lacey, ed. (2016), *The Pursuit of Legible Policy: Agency and Participation in the Complex Systems of the Contemporary Megalopolis*, Mexico City: Buró Buró Oficina de proyectos culturales, S.C. Available online: legiblepolicy.info/ (accessed 17 February 2017).

Plumwood, Val (1993), *Feminism and the Mastery of Nature*, London: Routledge.

Plumwood, Val (2001), *Environmental Culture: The Ecological Crisis of Reason*, London: Routledge.

Power Landscapes (2012), [Exhibition] Curator Po Hagström, Botkyrka Konsthall, Botkyrka, Sweden.

Prado, Luisa O. de Martins and Oliviera, Pedro (2014), 'Questioning the "Critical" in Speculative and Critical Design'. Available online: medium. com/a-parede/questioning-the-critical-in-speculative-critical-design-5a355cac2ca4#.9rj5o36ea (accessed 10 February 2017).

Precarias a la Deriva (2004), 'Adrift Through the Circuits of Feminized Precarious Work'. Available online: eipcp.net/transversal/0704/precarias1/en (accessed 21 May 2015).

Pred, Allan (2000), *Even in Sweden. Racisms, Racialized Spaces, and the Popular Geographical Imagination*, Berkeley, CA: University of California Press.

Public Wisdom 2015: Ageing, Creativity and the Public Realm (2015), [Symposium] Cubitt Education, London. Available at: vimeo.com/user23179512/videos (accessed January 2017).

Queer Nation Manifest ([1990] 2013), (Orig. Queers Read This, Queer Nation) trans. Elin Bengtsson and Lyra Ekström Lindbäck, Stockholm: Lesbisk Pocket.

'Queer Nations Manifesto' – anonymous from NY pride march ([1990] 2002), in Tiina Rosenberg, *Queerfeministisk Agenda*, trans. Brady Burroughs, 167–178, Atlas: Stockholm.

Querrien, Anne (2011), 'Mutual Schools', in Binna Choi and Axel Wieder (eds), *Casco Issues XII: Generous Structures*, 160–179, Berlin: Sternberg Press.

Raco, Mike (2007), 'Spatial Policy, Sustainability, and State Restructuring: A Reassessment of Sustainable Community Building in England', in Rob Krueger and David Gibbs (eds), *The Sustainable Development Paradox: Urban Political Economy in the United States and Europe*, 214–237, New York, NY: Guilford Press.

Rader Olsson, Amy, and Metzger, Jonathan (2013), 'Urban Sustainable Development – The Stockholm Way', in Jonathan Metzger and Amy Rader Olsson (eds), *Sustainable Stockholm – Exploring Urban Sustainability in Europe's Greenest City*, 195–211, London: Routledge.

Radcliffe, Sarah A. (2006), 'Development and Geography: Gendered Subjects in Development Processes and Interventions', *Progress in Human Geography*, 30 (4): 524–532.

Ramazanoglu, Caroline, and Holland, Janet (2002), *Feminist Methodology*, London: Sage.

Rancière, Jacques (2013), 'In What Time do We Live?', *Política Común*, 4. Available online: dx.doi.org/10.3998/pc.12322227.0004.001 (accessed 10 February 2017).

Rapp, Charlotte (1979), 'Kvinnliga Arkitektmöten på Gång' (Female Architect Meetings Are Coming), *Arkitekten*, 5: 7.

Ravel, Judith, and Negri, Antonio (2008), 'Inventer le Commun des Hommes' (Inventing the Common), *Multitudes*, 31. Available online: www.multitudes.net/inventer-le-commun-des-hommes (accessed 17 February 2017).

Raws, Peg (2009), 'Building Sexuate Architectures of Sustainability' paper, Luce Irigaray Circle Conference, Hofstra NY, 9.

Rawes, Peg (2013), *Relational Architectural Ecologies: Architecture, Nature and Subjectivities*, London: Routledge.

Re-Designing the East: Political Design in Asia and Europe (2010), [Exhibition] Württembergischer Kunstverein. Available online: www.wkv-stuttgart.de/en/program/2010/exhibitions/re-designing-the-east/ (accessed 23 July 2016).

Rendell, Jane (2004). 'Architectural Research and Disciplinarity', *Architectural Research Quarterly*, (8)2, 141–148.

Rendell, Jane (2005), 'Architecture-Writing', *The Journal of Architecture*, 10 (3): 255–264.

Rendell, Jane (2006), *Art and Architecture: A Place Between*, London: I.B. Tauris.

Rendell, Jane (2007), 'How to Take Place (but Not For So Long)', in Doina Petrescu (ed.), *Altering Practices: Feminist Politics and Poetics of Space*, 69–88, London: Routledge.

Rendell, Jane (2010), *Site-Writing: The Architecture of Art Criticism*, London: I.B. Tauris.

Rendell, Jane (2011), 'Critical Spatial Practices: Setting Out a Feminist Approach to Some Modes and What Matters in Architecture', in Lori A. Brown (ed.), *Feminist Practices: Interdisciplinary Approaches to Women in Architecture*, 17–56, Farnham, UK: Ashgate.

Rendell, Jane, Penner, Barbara, and Borden, Iain, eds (2000), *Gender, Space, Architecture: An Interdisciplinary Introduction*, London: Routledge.

Rendell, Jane, Hill, Jonathan, Fraser, Jonathan, and Dorrian, Mark, eds (2007), *Critical Architecture*, London: Routledge.

RFS Retail Forum for Sustainability (2013), 'Sustainability of Textiles,' *Issue Paper*, 11. Available online: ec.europa.eu/environment/industry/retail/pdf/issue_paper_textiles.pdf (accessed 7 July 2016).

Rhyzom – Collaborative Network for Local Cultural Production and Trans-local Dissemination. Available online: www.rhyzom.net/nomadicschool (accessed 10 February 2017).

Rice, Peter (1994), *An Engineer Imagines*, London: Artemis.

Robbins, Paul ([2004] 2012), *Political Ecology: A Critical Introduction*, Oxford, UK: Wiley-Blackwell.

Roberts, Marion (1991), *Living in a Man-Made World: Gender Assumptions in Modern Housing Design*, London: Routledge.

Robertson, Roland ([1994] 2012), 'Globalisation or Glocalisation?', *Journal of International Communication*, 18 (2): 191–208.

Rocheleau, Dianne, Thomas-Slayter, Barbara, and Wangari, Esther, eds (1996), *Feminist Political Ecology: Global Issues and Local Experiences*, London: Routledge.

Rose, Gillian (1993), *Feminism & Geography: The Limits of Geographical Knowledge*, Cambridge, UK: Polity Press.

Rosler, Martha, and Wallis, Brian, ed. ([1989] 1999), *If You Lived Here: The City in Art, Theory and Social Activism, A Project by Martha Rosler*, New York: The New Press.

Räthzel, Nora, and Uzzell, David (2009), 'Transformative Environmental Education: A Collective Rehearsal for Reality', *Environmental Education Research*, 15: 263–277.

Salleh, Ariel (1997), *Ecofeminism as Politics: Nature, Marx and the Postmodern*, London: Zed Books.

Sandercock, Leonie (1998), *Towards Cosmopolis: Planning for Multicultural Cities*, Chichester, UK: Wiley.

Sandercock, Leonie (2003), 'Out of the Closet: The Importance of Stories and Storytelling in Planning Practice', *Planning Theory & Practice*, 4 (1): 11–28.

Sargent, Pamela, ed. (1975), *Women of Wonder: Science Fiction Stories by Women about Women*, New York: Vintage.

Sassen, Saskia (2006), *Territory, Authority, Rights: From Medieval to Global Assemblages*, Princeton, NJ: Princeton University Press.

Savonick, Danica, and Davidson, Cathy (2016), 'Gender Bias in Academe: An Annotated Bibliography of Important Recent Studies'. Available online: blogs.lse.ac.uk/impactofsocialsciences/2016/03/08/gender-bias-in-academe-an-annotated-bibliography/ (accessed 10 February 2017)

Schalk, Meike (2007), 'Urban Curating: A Practice of Greater Connectedness', in Doina Petrescu (ed.), *Altering Practices: Feminist Politics and Poetics of Space*, 153–166, London: Routledge.

Schalk, Meike, Burroughs, Brady, Grillner, Katja, and Bonnevier, Katarina (2011), 'FATALE Critical Studies in Architecture', *Nordic Journal of Architecture* (2): 90–96.

Schalk, Meike, Gunnarsson-Östling, Ulrika, and Bradley, Karin (2017), 'Feminist Futures and "Other Worlds": Ecologies of Critical Spatial Practice', in Sherilyn MacGregor (ed.), *Routledge International Handbook of Gender and Environment*, London: Routledge.

Schirmer, Jennifer (1994), 'The Claiming of Space and the Body Politic within National-Security States, the Plaza de Mayo Madres and the Greenham Common Women', in Jonathan Boyarin (ed.), *Remapping Memory, Politics of Timespace*, 185–220, Minneapolis, MN: University of Minnesota Press.

Schlosberg, David (2013), 'Theorising Environmental Justice: The Expanding Sphere of a Discourse', *Environmental Politics*, 22 (1): 37–55.

Schmollac, Simone (2013), 'Nur "BamS" hat bald eine neue Frau', *TAZ*. Available online: www.taz.de/Medienschelte-von-Pro-Quote-Lobbyisten/!5059029 (accessed on 20 July 2016).

Schonfield, Katherine (2000), 'Premature Gratification and Other Pleasures', in muf (Liza Fior, Katherine Clark and Juliet Bidgood) and Rosa Ainley (ed.), *This is What We Do: A Muf Manual*, 14–23, London: Ellipsis.

Schüler, Ronny, Schneider, Dorit, and Drohsel, Karsten (2011), 'Fallstudie Stuttgart 21' (Case Study Stuttgart 21), *ARCH +*, 204: 158–169.

Scott, Kakee, Bakker, Conny, and Quist, Jaco (2012), 'Designing Change by Living Change', *Design Studies*, 33 (3): 279–297.

Sedgwick, Eve Kosofsky (2003), 'Paranoid Reading and Reparative Reading, or, You're so Paranoid, You Probably Think This Essay is About You', in *Touching Feeling: Affect, Pedagogy, Performativity*, 123–152, Durham, NC: Duke University Press.

Sedgwick, Eve Kosofsky (2003), *Touching Feeling: Affect, Pedagogy, Performativity*, Durham, NC: Duke University Press.

Seigworth, Gregory J., and Gregg, Melissa (2010), 'An Inventory of Shimmers', in Gregory J. Seigworth and Melissa Gregg (eds), *The Affect Theory*, 1–25, Durham, NC: Duke University Press.

Sennett, Richard (2012), *Together: The Rituals, Pleasures and Politics of Cooperation*, London: Penguin Books.

Serano, Julia (2013), *Excluded: Making Feminist and Queer Movements More Inclusive*, Berkley, CA: Seal Press.

Sharp, Joan (1996), 'Gendering Nationhood', in Nancy Duncan (ed.), *BodySpace*, 97–108, London: Routledge.

Shields, Rob (2012), 'Cultural Topology: The Seven Bridges of Königsburg, 1736', *Theory, Culture & Society*, 29: 43–57.

Shove, Elizabeth, Watson, Matthew, Ingram, Jack, and Hand, Martin (2007), *The Design of Everyday Life*, Oxford, UK: Berg.

Singleton, Benedict (2009), [Lecture] in Seminar 3 of 'DESIGN ACT Socially and Politically Engaged Design Today'. Available online: www.design-act.se (accessed 10 February 2017).

Singleton, Benedict, and Ardern, Jon (2008), 'Ark-Inc: An Alternative View of what "Designing for Sustainability" Might Mean', in *Proceedings of Changing the Change*, Torino, Italy.

Sjöstrand, Torkel (2007), *1207*, Stockholm: Dokument Press.

Skönhetsrådet (The Beauty Council), Stockholms Stad. Available online: www.stockholm.se/OmStockholm/Forvaltningar-och-bolag/Skonhetsradet (accessed 10 February 2017).

Smedley, Constance (1929), *Crusaders: The Reminiscence of Constance Smedley*, London: Duckworth.

Smith, Laurajane (2006), *Uses of Heritage*, London: Routledge.

Sofia, Zoë (2000), 'Container Technologies', *Hypatia*, 15 (2): 182–200.

Soja, Edward (2000), *Postmetropolis: Critical Studies of Cities and Regions*, Oxford, UK: Basil Blackwell.

Somers, Margaret R. (1994), 'The Narrative Constitution of Identity: A Relational and Network Approach', *Theory and Society*, 23 (5): 605–649.

Sontag, Susan ([1964] 1986), 'Notes On "Camp"', in *Against Interpretation*, 275–292, London: Anchor Books Doubleday.

Spaargaren, Gert, and Mol, Arthur P. J. (1992), 'Sociology, Environment and Modernity: Ecological Modernization as a Theory of Social Change', *Society and Natural Resources*, 5 (5): 323–345.

Spaargaren, Gert, Martens, Susan, and Beckers, Theo (2006), 'Sustainable Technologies and Everyday Life', in Peter-Paul Verbeek and Adriaan Slob (eds), *User Behavior and Technology Development*, 107–118, Berlin: Springer.

Spatial Agency. Available online: www.spatialagency.net (accessed 24 February 2017).

Spender, Dale (1980), *Man-Made Language*, London: Routledge & Kegan Paul.

Spivak, Gayatri, C. ([1988] 2002), 'Kan den Subalterna Tala?' (Can the Subaltern Speak?), trans. Monica Derntsson and Mikela Lundahl, in Mikela Lundahl (ed.), *Kairos nr 7: Postkoloniala Studier*, 73–146, Stockholm: Raster förlag.

Standing, Guy (2011), *The Precariat: The New Dangerous Class*, London: Bloomsbury.

Stanley, Autumn (1995), *Mothers and Daughters of Invention: Notes for a Revised History of Technology*, New Brunswick, NJ: Rutgers University Press.

Stanley, Autumn (1998), 'Women Hold Up Two Thirds of the Sky', in Patrick D. Hopkins (ed.), *Sex/Machine: Reading in Culture, Gender and Technology*, Bloomington, IN: Indiana University Press.

Starhawk, ([1979] 1999), *The Spiral Dance*, New York: Harper & Row.

State Capital Stuttgart Stadtplanungsamt (Urban Planning Office), ed. (1997), *Rahmenplan Stuttgart 21* (Reference Framework Plan Stuttgart). Available online: www.stuttgart.de/img/mdb/publ/2735/58825.pdf (accessed on 08 May 2016).

Statistics Sweden, *Ingen Avmattning på Bolånemarknaden* (No Slowing Down in the Housing Loan Market). Available online: www.scb.se/sv_/Hitta-statistik/Artiklar/Ingen-avmattning-pa-bolanemarknaden (accessed 29 September 2016).

Stavrakopoulou, Francesca (2014), 'Female Academics: Don't Power Dress, Forget Heels – and No Flowing Hair Allowed'. Available online: www.theguardian.com/higher-education-network/blog/2014/oct/26/-sp-female-academics-dont-power-dress-forget-heels-and-no-flowing-hair-allowed (accessed 10 February 2017)

Stengers, Isabelle (2008), 'Experimenting with Refrains: Subjectivity and the Challenge of Escaping Modern Dualism', *Subjectivity*, 22: 38–59.
Stengers, Isabelle, and Vinciane Despret (2014), *Women Who Make a Fuss: The Unfaithful Daughters of Virginia Woolf*, Minneapolis, MN: Univocal Publishing.

Sterling, Bruce (2009), *Shaping Things*, Cambridge, MA: MIT Press.

Stern, Robert A. M. (1976), 'Gray Architecture as Post-Modernism, or, Up and Down from Orthodoxy', *L'Architecture d'Aujourd'hui*, 186. Reconstructed for Michael Hays (ed.), *Architecture Theory Since 1968*, 240–245, Cambridge, MA: MIT Press.

Stockholm Resilience Centre, 'Resilience Dictionary'. Available online: www.stockholmresilience.org/research/resilience-dictionary.html (accessed 5 October 2016).

Stratigakos, Despina (2008), *A Women's Berlin: Building the Modern City*, Minneapolis, MN: University of Minnesota Press.

Strengers, Yolande (2014), 'Smart Energy in Everyday Life: Are you Designing for Resource Man?', *Interactions*, 21 (4): 24–31.

Sultana, Farhana (2011), 'Suffering for Water, Suffering from Water: Emotional Geographies of Resource Access, Control and Conflict', *Geoforum*, 42: 163–172.

Svenfelt, Åsa, and Höjer, Mattias (2012), 'Framtidsstudier och Osäkerheter' (Futures Studies and Uncertainties), in Susanne Alm, Joakim Palme and Erik Westholm (eds), *Att Utforska Framtiden: Valda Perspektiv*, 111–128, Stockholm: Dialogos.

Swyngegdouw, Erik (2002), 'Globalisation or "Glocalisation"? Networks, Territories and Rescaling', *Cambridge Review of International Affairs*, 1 (17): 25–48.

Swyngedouw, Erik (2007), 'Impossible "Sustainability" and the Postpolitical Condition', in Rob Krueger and David Gibbs (eds) *The Sustainable Development Paradox: Urban Political Economy in the United States and Europe*, 13–40, New York: Guilford Press.

Swyngedouw, Erik, and Heynen, Nicholas C. (2003), 'Urban Political Ecology, Justice and the Politics of Scale', *Antipode*, 35 (5): 898–918.

Swyngedouw, Erik, and Kaïka, Maria (2003), 'The Making of "Glocal" Urban Modernities: Exploring the Cracks in the Mirror', City, 7 (1): 5–21.

Syssner, Josefina (2012), Världens Bästa Plats? Platsmarknadsföring, Makt och *Medborgarskap* (World's Best Place? Place Marketing, Power and Citizenship), Lund, SE: Nordic Academic Press.

Fanny Söderbäck (2012), Revolutionary Time: Revolt as Temporal Return. *Signs: Journal of Women in Culture and Society*, 37 (2), 301–324.

Tafuri, Manfredo ([1980] 1987), 'The Ashes of Jefferson', in *The Sphere and the Labyrinth: Avant-gardes and Architecture from Piranesi to the 1970s*, trans. Pellegrino d'Arcierno and Robert Connolly, 291–304, Cambridge, MA: MIT Press.

Taylor Gatto, John ([1992] 2005), *Dumbing Us Down: The Hidden Curriculum of Compulsory Schooling*, Gabriola Island, CA: New Society Publishers.

Tham, Amelie (1980), 'Med Boendet och Hemarbetet som Aktionsbas' (Living and Housework as Action Base), *Arbetaren*, 12, 20 March.

The New Beauty Council (2009), 'Visklek' (Whispering Game), in Annelie Kurttila (ed.), *Drömbyggen Årsbok 2008/2009*, 86–93, Stockholm: Arkitekturmuseet.

The New Beauty Council (2010), 'Makten att Formulera Problemet' (The Power to Formulate the Problem), in Adam Bergholm (ed.), *Röster från Slussen*, 26–41, Stockholm: A5 Press,

The New Beauty Council (2010), 'The New Beauty Council om Talande Form' (The New Beauty Council on Talking Form), in Linda Johansson (ed.), *KOLLA!*, 8–11.

The New Beauty Council (2010), 'Über Geschmack läst sich streiten. Über die Stockholmer Initiative The New Beauty Council' (There is Some Accounting for Taste), *Objects, Journal of Applied Arts*, 4: 94–97.

The Norwegian Centre for Design and Architecture, 'Inclusive Design'. Available online: www.inclusivedesign.no (accessed 24 February 2017).

The Principles of Inclusive Design Guide, Design Council, UK. Available online: www.designcouncil.org.uk/resources/guide/principles-inclusive-design (accessed 24 February 2017).

Tillväxt (Growth). Available online: www.youtube.com/channel/UCkL2Z9rp588159G1KusiT4g (accessed 10 February 2017).

Topping, Keith, and Ehly, Stewart, eds (1998), *Peer-Assisted Learning*, London: Routledge.

Torre, Susana (2000), 'Claiming the Public Space: The Mothers of Plaza de Mayo', in Jane Rendell, Barbara Penner and Ian Borden (eds), *Gender Space Architecture*, 140–145, London: Routledge.

Tracy, Laura (1993), *The Secret between Us: Competition Among Women*, New York: Little Brown.

Trogal, Kim (2012), 'Caring for Space: Ethical Agencies in Contemporary Spatial Practice', PhD diss., University of Sheffield, United Kingdom.

Truelove, Yaffa (2011), '(Re-)Conceptualizing Water Inequality in Delhi, India Through a Feminist Political Ecology Framework', *Geoforum*, 42: 143–152.

Tuana, Nancy (2010), 'Viscous Porosity: Witnessing Katrina', in Stacey Aliamo and Susan Hekman (eds), *Material Feminisms*, Bloomington, IN: Indiana University Press.

Underground Urban Caretaking (2012), [Film] Dir. Sara Brolund de Carvalho and Anja Linna, Stockholm.

United Nations, Central Emergency Response Fund (2015), '2015 Annual Report'. Available online: docs.unocha.org/sites/dms/CERF/CERF_AR_2015_FINAL.compressed.pdf (accessed 23 July 2016).

Urban Tactics. Available online: www.urbantactics.org (accessed 10 February 2017).

Vandermeer, Ann, and Vandermeer, Jeff, eds (2015), *Sisters of the Revolution: A Feminist Speculative Fiction Anthology*, Oakland, CA: PM Press.

Vergragt, Philip (2010), 'Sustainability Future Visions', in *Proceedings of the LeNS Conference Sustainability in Design: Now!*, Bangalore, India.

Vogl, Joseph (2015), *The Specter of Capitalism*, Stanford, CA: Stanford University Press.

von Uexküll, Jakob (2010), *A Foray into the Worlds of Animals and Humans*, Minneapolis, MN: University of Minnesota Press.

Vrasti, Wanda (2012), 'This Courage Called Utopia'. Available online: thedisorderofthings.com/2012/11/09/this-courage-called-utopia-2/ (accessed 11 February 2017).

Wajcman, Judy (1991), *Feminism Confronts Technology*, Cambridge: Polity.

Wald, Priscilla (2008), *Contagious: Cultures, Carriers, and the Outbreak Narrative*, Durham, NC: Duke University Press.

Walker, Gordon (2011), *Environmental Justice – Concepts, Evidence and Politics*, London: Routledge.

Walter, Franz, ed. (2013), *Die Neue Macht der Bürger: Was Motiviert die Protestbewegungen? BP Social Study*, (The New Power of Citizens. What Motivates the Protest Movements?) Hamburg, DE: Rowohlt.

Wangel, Josefin (2011), 'Exploring Social Structures and Agency in Backcasting Studies for Sustainable Development', *Technological Forecasting and Social Change*, 78 (5): 872–882.

Wangel, Josefin (2012), 'Making Futures: On Targets, Measures and Governance in Backcasting and Planning for Sustainability', PhD diss., KTH Royal Institute of Technology, Sweden.

Ward, Colin (1973), *Anarchy in Action*, London: Freedom Press.

Warren, Karen J. (2000), *Ecofeminist Philosophy: A Western Perspective on What It is and Why It Matters*, Lanham, MD: Rowman & Littlefield.

We are Here Venice (wahv). Available online: weareherevenice.org (accessed 11 February 2017).

Webster, Helena (2007), 'The Analytics of Power: Re-presenting the Design Jury' *JAE*, 60 (3): 21–27.

Weeks, Kathi (2011), *The Problem with Work: Feminism, Marxism, Antiwork, Politics, and Postwork Imaginaries*, Durham, NC: Duke University Press.

Weisman, Leslie Kanes (1989), 'A Feminist Experiment: Learning from WSPA, Then and Now', in Perry Berkeley, Ellen and Matilda McQuaid (eds), *Architecture: A Place for Women*, Washington, DC: Smithsonian Institution Press.

Weisman, Leslie Kanes (1992), *Discrimination by Design: A Feminist Critique of the Man-Made Environment*, Illinois: Illini Books.

Weisman, Leslie Kanes, and Noel, Phyllis Birkby (1983), 'The Women's School of Planning and Architecture', in Charlotte Bunch and Sandra Pollack (eds), *Learning Our Way: Essays in Feminist Education*, 224–245, Trumansburg, NY: Crossing Press.

Werner, Helena (2006), *Kvinnliga Arkitekter: Om Byggpionjärer och Debatterna Kring Kvinnlig Yrkesutövning i Sverige*, (Female Architects: About Construction Pioneers and Debates on Female Professional Practice in Sweden), PhD diss., Acta Universitatis Gothoburgensis, Sweden.

Wheeler, Stephen M., and Beatley, Timothy, eds (2009), *The Sustainable Urban Development Reader*, London: Routledge.

Williams, Raymond (2011), *The Long Revolution*, Cardigan, UK: Parthian Books.

Woodward, Kathleen (1991), *Aging and Its Discontents: Freud and Other Fictions*, Bloomington, IN: Indiana University Press.

Woolf, Virginia (1929), *A Room of One's Own*, London: Hogarth Press.

World Business Council for Sustainable Development WBSC (2009), 'The Cement Sustainability Initiative: Recycling Concrete'. Available online: www.wbcsdcement.org/pdf/CSI-RecyclingConcrete-FullReport.pdf (accessed 7 July 2016).

Worldwatch Institute (2012), *State of the World 2012: Moving Toward Sustainable Prosperity*, Washington, DC: Island Press. Available online: www.worldwatch.org/stateoftheworld2012 (accessed 24 February 2017).

World Wildlife Foundation (2014), *Living Planet Report 2014*. Available online: www.wwf.se/source.php?id=1580066 (accessed 8 August 2016).

Yuval-Davis, Nira (1999), 'What is 'Transversal Politics?', *Soundings*, 12, 94–98.

Zack, Naomi (2005), *Inclusive Feminism: A Third Wave Theory of Women's Commonality*, Oxford, UK: Rowman and Littlefield.

Zeeuw, Gerard de (2010), 'Research to Support Social Interventions', *Journal of Social Intervention: Theory and Practice*, 19 (2): 4–24.